A CONCISE HISTORY OF
WORLD
SCULPTURE
Germain Bazin

A CONCISE HISTORY OF
WORLD
SCULPTURE
Germain Bazin

DAVID & CHARLES
Newton Abbot London

To Aimery Somogy

ISBN 0 7153 8225 X

Printed in The Netherlands
by Royal Smeets Offset Weert
for David & Charles (Publishers) Limited
Brunel House Newton Abbot Devon

CONTENTS

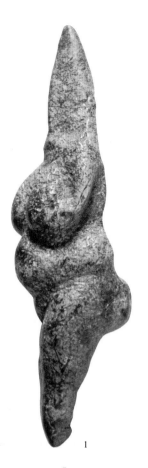

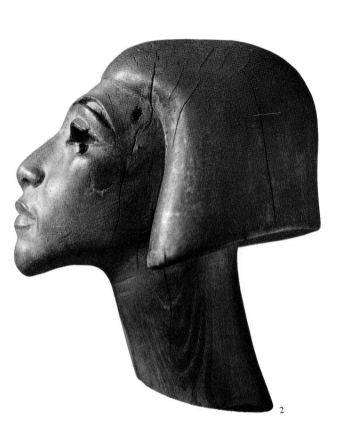

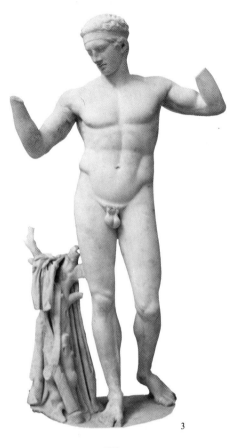

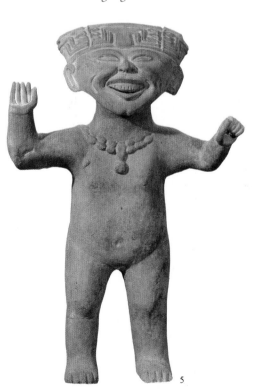

I
PREHISTORIC ART
Venus of Savigno

II
DEVELOPMENT OF SCULPTURE IN THE
NEAR AND MIDDLE EAST
Head from the period of Amenhotep IV

III
GREEK AND ROMAN SCULPTURE
After Polykleitos, *Diadoumenos*

IV
THE TWILIGHT OF SCULPTURE IN THE WEST
The Moone Cross

V
PRIMITIVE CULTURES
Laughing Child

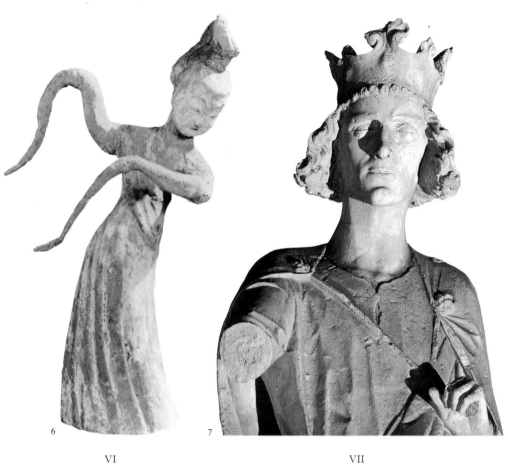

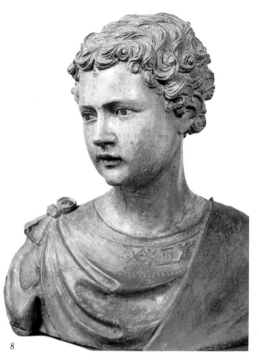

6

7

8

VI
THE FAR EAST
Statuette of a Dancer

VII
THE REBIRTH OF SCULPTURE IN THE WEST
Head of a king, known as Philip Augustus

VII
THE RENAISSANCE
Francesco Di Valdambrino, *San Crescenzio*

IX
MANNERISM
Vincenzo Danti, *Venus*

X
BAROQUE AND CLASSICAL
Gianlorenzo Bernini, *Angel Carrying a Crown of Thorns*

XI
THE NINETEENTH AND TWENTIETH CENTURIES
Jacques Lipchitz, *Song of the Vowels*

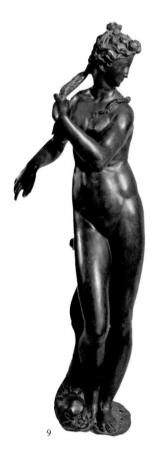

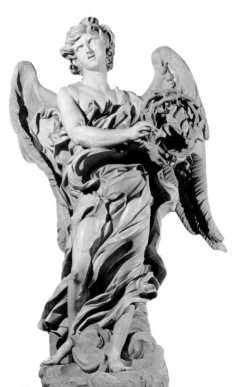

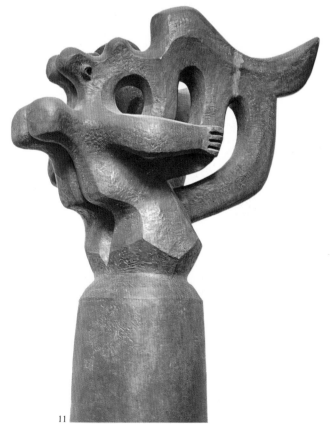

9

10

11

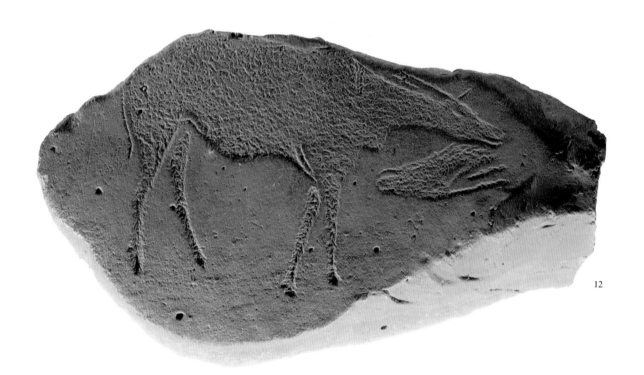

12

INTRODUCTION
THE ORIGINS

If I had to say which was the first basic artistic activity—sculpting or painting, I would choose the former. For primitive man, painting was a luxury, whilst sculpting was a matter of life and death. The making of objects in the round was closely linked with the rudimentary industry which allowed man to perfect his way of life through the use of tools, thus multiplying his possibilities of action. The very first tool was probably not even made of wood, since to work on wood—unless it was a mere stick broken off from a tree—a cutting instrument was required, and only stone could provide it. Some loose piece of flint may have provided man with his first tool and from then on, he started splitting those pebbles which he had originally used as missiles; that was around the year 600,000 B.C., somewhere in Africa. Man was still only a *hominid*. Soon, he learnt to cut flints by hitting them with a stone, then with a piece of wood, and later by dropping them onto a stone anvil. He obtained bifacially flaked tools, and was content with them for four hundred thousand years. Such a long period of stagnation is as surprising as the miracle of invention. At last came a new wave of beings deserving the name *homo,* and evolution progressed faster. Through that first stone, picked and worked on, nature had found its master; man became *homo faber* and would one day transform the world, perhaps even destroy it. Around 100,000 B.C., Mousterian man could already make differentiated tools; he used bone and ivory obtained from animals. Finally, the great breakthrough, which was at the start of an ever faster succession of civilizations, came around the year 35,000 B.C.,

during the so-called Aurignacian and Perigordian periods. *Homo sapiens* (Cro-Magnon man) became so proficient in his working of stone that he could fashion all sorts of tools adapted to various needs: hand-axes, choppers, chisels, burins, rasps, end-scrapers, penknife blades, arrowheads, barbed and tanged points. Modern experimenters have endeavoured to rediscover all the methods of primitive man and to reproduce his tools. What surprised them most was the speed of such workmanship—which explains why it has survived to this day: stone is the natural tool; it is more efficient than wood, and yet it is cut just as quickly. During the Solutrean period, the carefully retouched flaking of those forms which archaeologists have called "willow leaves" or "laurel leaves" was so perfect that one must assume some aesthetic intention on the part of the artisan. But by then, man had already produced works of art.

Some twenty-five thousand years later, around 7,500 B.C., another refinement was introduced in toolmaking: polishing. With the Neolithic era, prehistory was on the verge of proto-history, which opened the door to history. The Pre-Columbians made their tools from polished flint; they were still using them at the time of the Spanish conquest in the 15th century.

Man is essentially a stone carver. The art of carving stone is the oldest human skill. Nowadays, it may be on its way out, but it has remained a challenge to genius though the ages till our own century, when carving stone will soon be as rare an activity as cutting diamond.

12 *Antelope* **engraved on rock. African Paleolithic. Transvaal Museum, Pretoria.** Only the Bushmen live in the Kalahari desert, where they have been pushed by population expansion. Trusting their natural agility and cleverness, they fearlessly hunt even the biggest game. This masterly rock engraving reveals the gifts of observation of people living close to untamed nature.

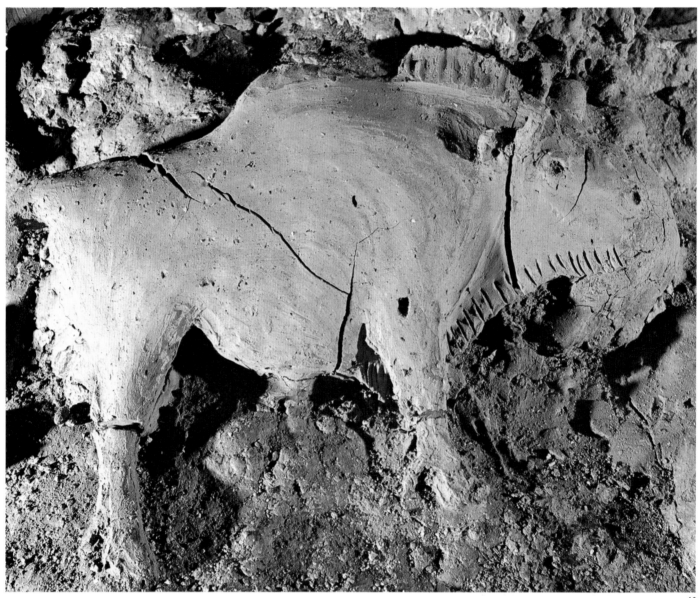

13

13 *Clay bison,* in the Tuc d'Audoubert cave. Paleolithic, Middle
Magdalenian, 13,000 to 10,000 B.C. Tuc d'Audoubert (Ariège), France.
Paleolithic artists were not content carving hard materials. This bison,
about 23 inches long, was modelled in crude clay that cracked as it dried.
It has been preserved by a deposit of stalagmitic material, an exceptional
circumstance, which allowed survival of the fragile work. Nearby, in the
same deposit, are the formless masses of works which did not survive.

The polishing of stone requires sedentary workshops, and time to spare, instead of a life made up of disconnected fleeting moments, like that of Paleolithic men. This transition from discontinuity to continuity implies some feminine influence, and in fact the dawn of agricultural civilizations in the Neolithic era coincided with women playing a more important role in patriarchic societies.

A Solutrean "laurel leaf" and a Neolithic hand-axe are the two starting points of future developments, and of two widely different worlds of thought. Those two artifacts contain *ab ovo,* the opposition between the intellect and the senses, the object and the subject, abstract ideas and outward appearances. They remain—even in our own age which prides itself on change—the two opposite techniques available to the sculptor. Man has used the one to fashion his gods, and the other to render human expression in its variety. From the beginning, the art of relief alternated between those two techniques and Michelangelo himself took part in the controversy, from the *S. Peter Pietà* to the *Rondanini Pietà,* he seems to have gone back through the ages to the original method of the creator who extracts the primeval form from inertia. Contemporary Mannerists, on the contrary, liked refined smooth shapes, polished like a mirror. Their chosen material was bronze, which Michelangelo did not use: he was a genuine stone carver, having had as a foster-mother the wife of a Settignano stone-mason.

It took humanity hundreds of thousands of years to progress from carved stone to polished stone. But in the following millennia, civilization evolved much faster. In the Middle East, the life of Paleolithic hunters was succeeded by the sudden flowering of agricultural civilizations, which brought about a whole range of technical inventions. The discovery of raw materials caused a greater differentiation of tools and gave the artist a marvelous field for experimenting. For instance, the use of clay for making pottery utensils. As far as we know, ceramics were introduced as early as the sixth millennium B.C., in Anatolia, on the Syro-Palestinian coast. Clay was first modelled by hand, then, after various intermediary methods, the foot-propelled pottery wheel was invented, probably at the same time as the cart wheel. Progress was relatively slow, if we consider that in Mesopotamia wheel-turned pottery was contemporary with the invention of bronze, i.e., with the beginning of the fourth millennium. The two techniques are linked: both derive from modelling since, to cast an object in bronze, one first needs a model made of some malleable material, then a corresponding hollow shape into which the metal alloy—composed mainly of copper and tin—will be poured. Combined with copper in the proportion of 10 to 20%, tin has three characteristics: it makes the metal more resistant, it lowers its melting point, and it increases the flexibility of the molten material. Therefore the invention of bronze provided new possibilities for sculpture; the previous technique of hammering metal leaves to produce a *repoussé* relief suggested yet another direction for human endeavour: the goldsmith's craft and the use of precious metals; as for wrought iron, it did not provide the sculptor with plastic material until the 20th century.

Already in the fourth millenium B.C., the whole range of techniques allowing man to carve, polish or model matter were known. Whilst the technique of painting developed very slowly through the centuries, the sculptor was in possession of all the resources of his trade from the very dawn of civilization, which demonstrates that carving is the original artistic activity.

I

PREHISTORIC ART

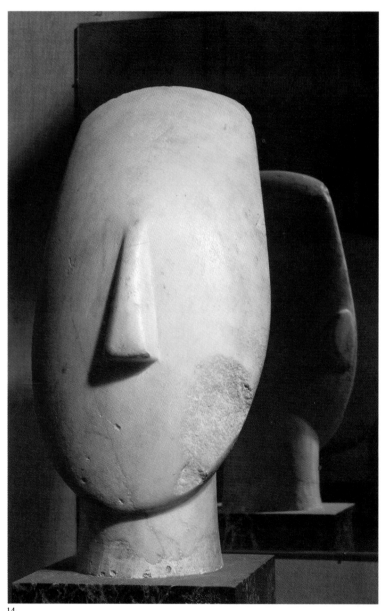

For a long time, prehistoric art was merely a controversial subject for paleontologists. It crossed the threshold into archeology rather late, and has only recently entered the domain of art history. Even now it often arouses a largely ethnological interest.

The childhood of art has nothing to do with the art of children. Nor is it related to the gropings for form of so-called primitive societies, whose outlook and way of life have been compared with those of Paleolithic men. Nothing in prehistoric painting suggests the conventions, stylizations, and distortions used to interpret nature by primitives cut off from naturalism by a whole system of thought that they project from within onto the outside world. Nothing is more direct, more "visual," than the prehistoric artistic rendering of animals, based as it is on an acuteness of observation achieved in later history perhaps only by a few Chinese or Japanese painters, by artisans from the steppes, or by Pisanello. More noteworthy still, this naturalism is not analytical: when Paleolithic men painted bison, mammoths or reindeer on their rocky walls, they had not studied dissected dead beasts; they had observed the living animals in action. They were able to suggest that synthesis of successive stages of movement that alone can evoke life, where a too exact reproduction kills it. Although the Limeuil "sketchbooks" and other drawings after models prove that already at that time there were specialized artists, and even schools of art, such an intimate knowledge of animals could have been acquired only through the experience of hunting. The fluid line that the artist cast from his memory onto the rockface had to be as exactly calculated as the trajectory of an assegai aimed at a vital spot on the animal. Art was at first naturalistic and figurative. For the prehistoric artist—if his magic were to work—the image had to be as close to the model as possible, to be in fact its *double*. To be sure, contemporary primitives who paint or sculpt images in which nature is distorted or caricatured also believe they have achieved this quality of the *double;* sometimes even—as has often happened in the evolution of art—the magic power seems to grow stronger as the image moves further from its model, until the depicted form becomes a mere sign wholly charged with symbolic force. Such primitivist stylization is not a primary state, however, but the result of a different outlook. It presupposes an antagonistic attitude to nature, whereas naturalism expresses a kind of mystic oneness with his world on the part of man. A Paleolithic image shows the "naiveté" of its maker's direct communion with nature—the dimly remembered origin, perhaps, of historical man's nostalgia for a golden age. The animal from which man extracted his sustenance was for him not an enemy but a partner whose strength and agility he tried to secure for himself, perhaps by eating it, certainly by depicting it. Killing the animal implied no hostility at a time when the boundaries between life and death were not clearly established. When he painted a mammoth, Paleolithic man thought he gave it life and attracted it into the trap that he depicted in front of it; he thought that by the act of painting a mare pregnant, he made it become so. Thus reproducing nature, he felt that he was creating it. Leonardo thought along similar lines; but he believed that his intelligence made him a godlike and supernatural creator; prehistoric man could not have prided himself on his creative power—he lived too closely bound to natural phenomena, and to the cycle of destruction and creation that is the great mystery of life.

That Paleolithic art was first practiced deep within the earth, in caves difficult of access, may indicate a wish to penetrate the mysteries of nature. Perhaps primitive man subconsciously identified those dark recesses with the womb in which life germinated. The mystery of conception appears to have led him first to suspect the existence of powers *other* than those he could sense, for it lies at the origin of what is probably the earliest religious cult, that of fertility, which centered on the fecundity of animals before taking on a more general significance.

For us, prehistoric man is first of all a painter. So famous are the great paintings of Lascaux and Altamira, of the Niaux and Trois-Frères caves, that we tend to overlook the rock engravings and reliefs, which are no less important. Aurignacian or Magdalenian painters often used the natural irregularities of a rock face to give relief to part or to the whole of the body of the animal represented, but true sculpure is much less frequent than paintings or drawings with engraved

14 *Marble head* **from Amorgos. Cycladic, 2600 to 2100 B.C. The Louvre, Paris.** Among the funerary effects brought to light in the Cyclades were several of these heads. This one, measuring 14 inches, takes the form of an elongated oval. Only the ears and the nose are carved in relief. The strongly defined nose evokes the absent facial parts, which were probably originally added with a brush.

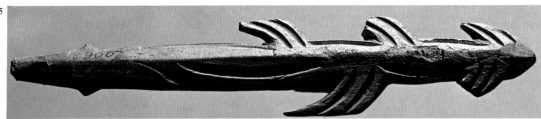

15

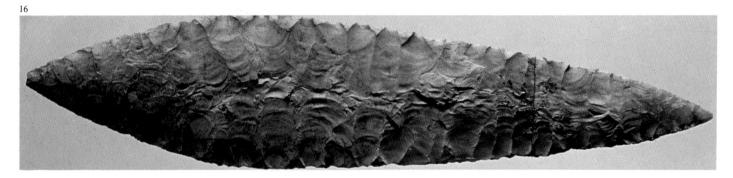

16

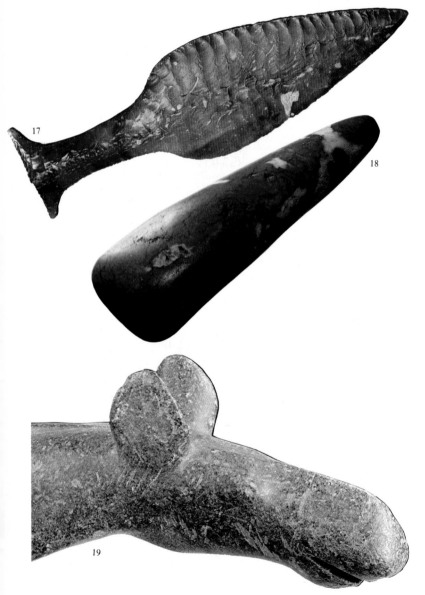

17

18

19

15 *Bone harpoon*. **Paleolithic, Magdalenian. Musée des Antiquités Nationales, Saint-Germain-en-Laye, France.** Bone tools were quite widespread during the Upper Paleolithic period. Most characteristic are the harpoons. The latest type, with barbs on both sides, is often less perfect in shape than the earlier ones.

16 *Bifacially flaked point*. **Paleolithic, Acheulian, 300,000 B.C. Musée des Antiquités Nationales, Saint-Germain-en-Laye, France.** In the 15th century these stones were considered of mysterious origin and were called splitting stones. This one was chipped out with the help of a hammering tool of wood or bone, which produced thinner flakes. The maker must have been aware not only of its functional value but also of the beauty of this finely worked implement.

17 *Dagger* **from Hindsgavl. End of Neolithic, after 2000 B.C. Nationalmuseet, Copenhagen.** Stone working achieved a high degree of virtuosity at the beginning of the metal age, as this dagger shows. That the artisan used the material to imitate metallic prototypes can be seen in the shape of the blade and the form given to the pommel. It appears as though the stone has softened to adapt to the metal's ductility.

18 *Polished stone axe*. **Neolithic. Musée des Antiquités Nationales, Saint-Germain-en-Laye, France.** During the Neolithic, the hunter played a very minor role, and men became more numerous due to the increase in basic sustenance. The polishing of stone was only one among many Neolithic innovations. However, this particular procedure, the polishing, resulted in a new aesthetic approach to stone and how it would be worked. After hundreds of thousands of years, faceted volumes were replaced by perfectly smooth shapes.

19 *Elk-shaped ritual axe,* **from Uppland. Neolithic, 4000 B.C. Statens Museum, Stockholm.** On the whole, Neolithic art was non-representational, and the type of figures most frequently found is the steatopygous female idol. During this period men formed communities and began to develop specialized skills. The polishing of ritual objects could be particularly refined, and sometimes the tool was shaped like an animal, indicating artistic intention.

20 *Neighing horse* **in the Montespan cave. Paleolithic, Middle Magdalenian, 13,000 to 10,000 B.C. Montespan (Haute-Garonne), France.** Climatic conditions similar to those prevailing in the cave at Tuc d'Audoubert insured the preservation of a horse drawn in damp clay in the Montespan cave. Engraved on the soft material with swift, precise strokes, it shows a masterful and sober draughtsmanship which is still admirable. Access to the cave is difficult, and it seems to have been visited by only a few generations of men, probably during the Middle Magdalenian period.

21 *Fawn with a bird,* **from a spear-thrower found in the grotto of Mas d'Azil (Ariège). Paleolithic, Magdalenian. Saint-Just-Péquart Collection, Saint-Brieuc, Côtes-du-Nord, France.** Cut from a length of reindeer antler, such implements seem to have been used to add impetus to the spear's flight. The poised fawn turns towards his dropping, on which two birds are billing and cooing. Could this be an example of early Gallic wit?

20

21

22

22 *Bison.* **Rock engraving in the La Grèze cave. Paleolithic, Gravettian, ca. 21,000 B.C. Les Eyzies (Dordogne).** This single bison is among the earliest Paleolithic rock engravings. The horns are seen frontally, while the rest of the animal appears in profile. The work is connected with the Gravettian, a term now used to identify a time chronologically equivalent to the final phase of Aurignacian culture as it was defined at the beginning of this century.

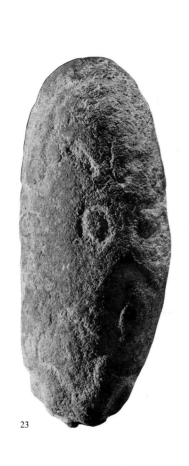

23

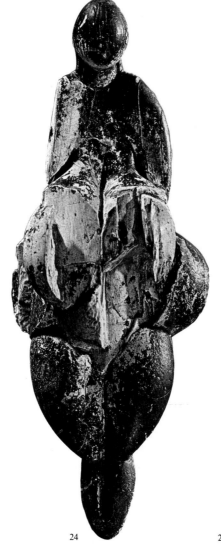

24

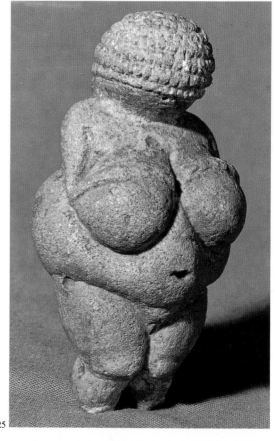

25

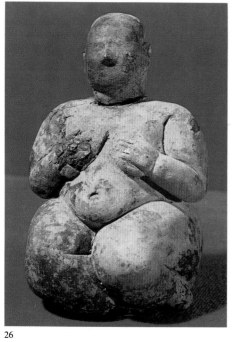

26

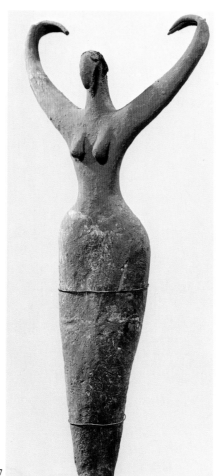

27

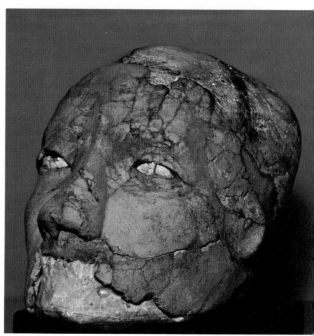

28

23 *Human head,* **from Aq Kupruk (Afghanistan). Paleolithic, ca. 20,000 B.C. Government of Afghanistan (on loan to the American Museum of Natural History, New York).** This small piece of limestone (about 2 1/2 inches high) is the earliest carbon-dated representation of the human face. Carving at the top may represent hair or a skin cap; a beard and probably a mustache are carved near the bottom, and the right ear is roughly outlined.

24 *Venus of Lespugue.* **Paleolithic, Musée de l'Homme, Paris.** The architectonic composition of this ivory from Lespugue contrasts with the expressionistic realism of the Venus of Willendorf. The legs, shoulders and head are made smaller to accentuate the middle part of the body, where the very low breasts, the buttocks pushed forward to the sides, the abdomen and the thighs are grouped in symmetrical volumes. The same stress on sexual forms, the same suppression of facial features, the same positioning of the arms characterize both statuettes and demonstrate iconographic kinship.

25 *Venus of Willendorf.* **Paleolithic, ca. 21,000 B.C. Naturhistorisches Museum, Vienna.** This limestone statuette belongs to the first known school of statuary art. This school, formerly referred to as Aurignacian, is now attributed to a more clearly defined age, called "Gravettian." The very full female body with abbreviated limbs reflects an aesthetic ideal and a religious symbolism. The intention of such works was, it seems, to promote human fertility as that of animals was promoted by animal representations. Later examples from the Neolithic Age, however, probably embodied the Earth Mother.

26 *Seated female figure,* **from Anatolia. Late Neolithic, 6th millennium B.C. Archeological Museum, Ankara.** This female figure of unfired clay was found in 1962 at Catalhüyük. Judging from such idols, fertility goddesses were worshipped at that time. They appear either seated or standing, but are almost always obese and massive, with the arms bent at a sharp angle to bring the hands to rest on the breasts. The nose and ears are usually carved in relief, while the eyes are indicated by slight hollows.

27 *Small female figure* **from Mamariyya (Egypt). Painted clay. Predynastic, 4000 to 3000 B.C. Brooklyn Museum, New York.** In the Predynastic era, sculpture made its appearance in Egypt in the form of male or female figurines in clay or ivory. The prehistoric heritage is evident in the theme: the highly schematized image is a symbol intended to evoke thoughts of the Great Mother. The simplicity of forms, the elegance of the curves, the feeling for organic synthesis, and the discretion in representing sex attributes make the figure characteristically Egyptian.

28 *Human skull,* **modelled in plaster from Jericho. Neolithic, 5th millennium B.C.** In 1953, in the excavations of Jericho, K. M. Kenyon discovered seven skulls in various states of preservation. The features have been "reconstituted" in plaster over the skulls to produce individual portraits. The eyes are created with shells, the skull cavity is filled with clay and the plaster is tinted to simulate skin. These heads may have been the skulls of ancestors, or, the heads of enemies killed in battle. They are the first known attempt at figurative sculpture that uses the skeleton as a point of departure.

contour. This may in part be explained by the greater length of time that relief carving demanded, for the images may have been executed in a state of magic trance in which the artist-sorcerer could grasp the essentials of reality. Furthermore, the flexible contour line was better adapted to the artist's aim of capturing the animal in motion—that is, alive—whereas relief, with its greater weight and substance, suggests inertia and repose.

Paleolithic reliefs exist, however, both carved in stone and modelled from clay. Of those cut in stone there are three types, that may represent three stages of working: the engraved outline, the relief with the background cut away from a flat silhouette, and true relief. The relief is usually roughly hewn, but occasionally it is polished. Often polished on the other hand, are the few little statues in the round that have been discovered—fertility figures with exaggerated female sex attributes, which may possible have been based on the biological reality of the pregnant state. The two most famous Paleolithic fertility figures are the *Venus of Willendorf* (*fig. 25*) and the *Venus of Lespugue* (*fig. 24*); they embody two artistic styles which our time has called naturalistic and abstract. The sexual attributes of the *Venus of Willendorf* are represented purely naturalistically, but those of the *Venus of Lespugue* are expressed by carefully polished geometrical volumes that could have been created by a Brancusi. The Lespugue figurine, the only instance known of abstract representation in Paleolithic art, indicates that our knowledge of the period must have great gaps.

Since polishing appears to have been practiced on stone sculptures long before it was used for stone artifacts, we may be allowed to suppose that when axes or knives began to be polished, some aesthetic intention was involved there, too. We know that already in Paleolithic times man wanted to give a pleasing appearance to everyday objects, for he decorated some of his weapons, such as hooked spearthrowers (*fig. 21*) and rods (of unknown use) carved from reindeer antlers. The sculptor also provided body ornaments, pendants or amulets of various materials—the earliest examples of the jeweler's craft.

In the perspective of time, prehistory appears as an episode beyond all memory, and we never wonder at the long duration of Paleolithic art, practiced with very little change for nearly three hundred centuries by a civilization of hunters. Probably those little human groups remained content for a long time with the state of equilibrium they had achieved: they lived in isolation, separate entities rather than real societies. The break came around 10,000 B.C., with the transition period called the Mesolithic, when suddenly naturalistic art tended to congeal into stylized symbols. The evolution was completed in the Neolithic era, about 7,500 B.C., when a technical civilization began to develop through the rational practice of agriculture and the domestication of animals. Excavations of cities like Jericho in Palestine, Jarmo in Kurdistan or Khirokitia in Cyprus have revealed the existence in the seventh millennium of urban civilizations based on agriculture and animal husbandry, in which, as indicated by the scarcity of cervidae (deer) remains found

in the excavations, the hunter played a very minor part. This period saw the end of small isolated groups; men became more numerous thanks to the increase in sustenance; they formed communities and began to develop specialized skills.

Since stores of grain were now available and animal husbandry provided permanent reserves of meat, it might have been expected that man, no longer needing to hunt for his daily food, could devote some leisure to artistic creation. In fact the opposite occurred, as if human energy, completely absorbed by the developing technical civilization, were no longer available for any other activity. Wall paintings disappeared completely, and the word "artistic" seems hardly applicable to the undecorated utensils and roughly hewn idols revealed by excavations of late and middle Neolithic strata in the fertile regions of Syria and Palestine, where that civilization seems to have first emerged. As for stone carving, apart from the manufacture of flint tools it was practiced only in making bowls and fertility idols. During

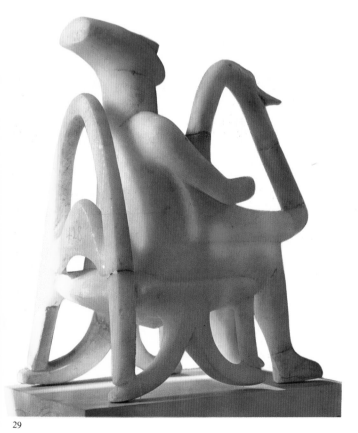

29

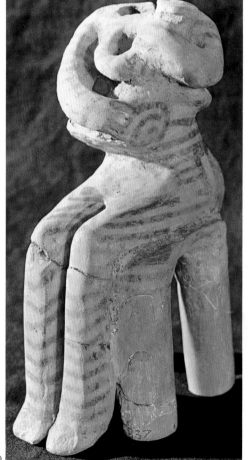

30

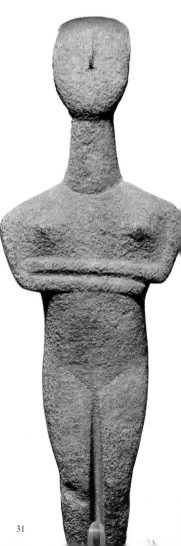

31

that pre-ceramic period, however—before some accidental fire had suggested the invention of fired heatproof pottery—man could still model that raw clay with which he built his dwellings. A kind of reproduction of the human form in the round appears in the skulls with their features reconstituted in plaster found at Jericho *(fig. 28)*. The custom of preserving heads must go back 80,000 years or so; but these skulls, apparently an attempt to represent the dead, are the ancestors of Eygptian mummies. The mother-goddess idols, no doubt because of their magic intent, remained fairly close to their female model; touches of paint probably represented the various details of figure and face, which would explain why the surfaces are usually quite smooth. On the whole, however, Neolithic art was non-representational, and the earliest pottery decoration, always geometric, whether painted or engraved, seems to have issued from an impoverished imagination. As man realized that he could exercise control over nature through the use of his

29 *Marble figure,* **from Keros. Cycladic. Early Bronze Age. The Louvre, Paris.** This statuette of a lyre player was unearthed in 1883. The human outline, the instrument and the chair are reduced to cylindrical forms. The harmonious perfection of its structure and its stylization place it at the apogee of Cycladic figurative art, of which it is the most complete expression. It stands apart from all other artistic efforts of its era.

30 *Seated mother with child,* **from Thessaly. Terra cotta. Neolithic. National Museum, Athens.** During the Neolithic period, the image of the Great Goddess underwent a transformation: In the early Neolithic, she appeared as a headless idol with atrophied arms and legs and hypertrophied female attributes; in the late Neolithic, she became more human and carried in her arms the infant which had made her flanks swell.

31 *Marble figure,* **found at Naxos. Cycladic. Early Bronze Age. The Louvre, Paris.** Cycladic idols are unique in that they are usually carved from local island marble, and differ from Paleolithic and Neolithic female figurines. There is a striving towards simple plasticity, as much in the construction of superposed geometric volumes as in the great simplification that eliminates all detail.

32 *Head of a large figure* **in terra cotta from Yugoslavia. Neolithic. Pristina Museum, Yugoslavia.** Images of the Great Goddess of fertility illustrate the influence in Yugoslavia of the Near-Eastern cult, transmitted by Greece. In the Balkans, late Neolithic figures increase in size (this one is 7 inches high) and take on a dramatic flavor, such as great enlargement of eyes and expressionistic stylization.

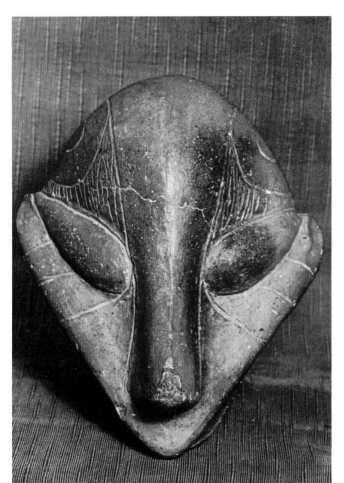

32

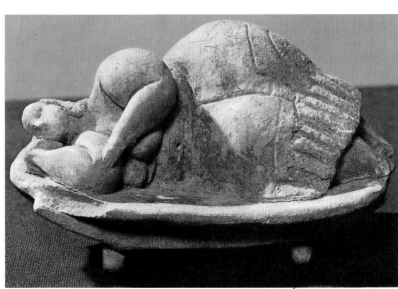

33

33 *Reclining woman,* **from the hypogeum of Hal Saflieni, Malta 2300 to 1450 B.C.** With its small head in relation to the rounded arms, this figurine is one of the most beautiful pieces modelled by the early inhabitants of Malta. Dressed in a long fringed skirt, which distends still further the volume of the hips and thighs, it resembles Cretan figurines with their naked breasts and their long, flowing skirts. It is also curiously Matisse-like.

intellect, he separated himself from the natural world; he broke the essential unity which made him one with the universe. Nature became for him the enemy he must tame and discipline to the service of man, forcing it to clothe and feed him, while trying to propitiate through magic and religion its mysterious forces, conceived as emanating from a "beyond" and "above" hostile to humanity. Magic, which in Paleolithic times was probably born of instinct, representing a spontaneous joining with universal forces, was now exercised in complicated rituals, meant to capture the cosmic energies. Those rituals interposed between man and the outside world, and art no longer sprang from direct visual experience; it became abstract.

The type of figure most frequently found on Neolithic sites is the markedly steatopygous female idol. As we have seen, it had appeared in Paleolithic times too—the first incarnation of the invisible; but it was so rare that the places where the few examples extant were found make but a sparse representation on the map. Neolithic figurines, however, made of the most various materials, have been unearthed by the hundreds. Around these female images crystallized the religious sentiment of those largely matriarchal civilizations founded on the fertility of animals and of the earth. The goddess in her universal power was beneficent to the living, and safeguarded the dead. She was the ancestor of that Great Mother whose cult was to be fundamental in Eastern religions in earliest historical times and who was later to emerge as Venus, whereas the mystery of the earth's alternately dying and reviving fecundity gave rise to the myths of Isis and Osiris, of Demeter and Persephone.

It would be interesting to make a typological classification of the numerous Neolithic fertility figurines that have been found around the Mediterranean and in the Balkans. They appear standing, sitting or recumbent; some are naturalistic, but most have schematized features, the earliest primitivist stylization in art: the proportions are sometimes elongated, or conversely swollen out, the bulges of the flesh exaggerated, the heads lengthened (perhaps as a phallic symbol), or the waist compressed to set off the expanding volumes of hips and breasts. In a progressive civilization,

such stylization may result from a tendency to simplify after endlessly repeating a particular form.

Neolithic civilization lived on through the third and second millennia B.C. in certain regions like the Cyclades, when other regions had already entered history or protohistory. The Cycladic artists, who carved the beautiful marble from the Greek islands of Paros and Naxos, refined and polished the sculptured shape until it retained only the most tenuous resemblance to the original human model. The violin-shaped idols and the heads like Neolithic hand-axes are sculptures responding not to material resemblances but to a sense of the magic residing in the created form as such; hence their expression of an elevated spirituality charged with the sense of magic. The idols of the Great Goddess found in the Cyclades are so stylized that the sex attributes,

34 *Mother Goddess,* **from Cyprus. Late Bronze Age, 14th to 13th century B.C. The Louvre, Paris.** During the last period of the Bronze Age, Cypriot art tended to become schematic, as can be seen in this curious statuette, quite flattened, made in red-varnished terra cotta. The subject is probably a fertility goddess holding a child in her slender arms.

35 *Chariot with solar disc,* **from Trundholm. ca. 14th century B.C. Nationalmuseet, Copenhagen.** This bronze horse is perhaps the first example of a European revival of animal art after the last Paleolithic age. The disk is sumptuously ornamented with motifs native to Nordic bronze art, and symbolizes the sun.

36 *Statuettes* **of cast silver, ornamented with gold leaf. From Ugarit. Late 2nd millennium B.C. The Louvre, Paris.** Excavations of the ancient town of Ugarit have brought to light an important site. Among the finds are these two cast silver statuettes, which are basically elementary in form. Only the heads are treated in detail.

37 *Warrior,* **from the Hallstatt era. Early Iron Age, 8th to 5th century B.C. Naturhistorisches Museum, Vienna.** Between the 8th and the 5th century B.C. the first Iron Age flourished in and around the Alps. Among a wealth of other metal objects displaying strong Italic influence, are squat, assertively modelled little figures in the round, decorating the handles of bronze receptacles. Most of these represent animals, but there are also human figures, like this bronze warrior, which stands 3 inches high.

38 *Female figure,* **from Boeotia 8th century B.C. The Louvre, Paris.** This terra-cotta statuette is distinguished by a bell-shaped tunic, inside which the moveable legs are suspended. Details of the dress and the ornament are picked out in a reddish-brown color. The hair trails down the inordinately long neck in wavy tresses; a necklace carries a pendant that falls between the breasts; the short arms are decorated with swastikas and the half-open hands have painted palms. The feet are painted with high, laced footgear, while the tunic is ornamented with rosettes and a row of dancing women. The figure is 33 inches high.

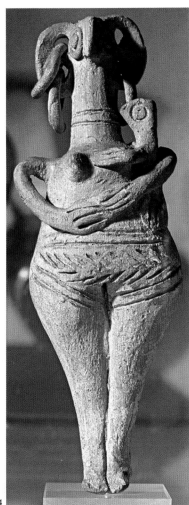

34

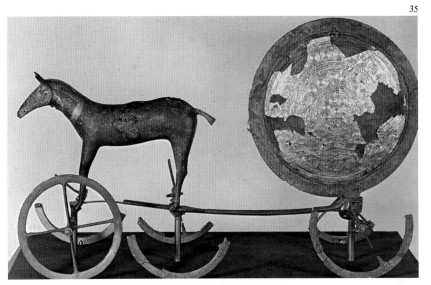

35

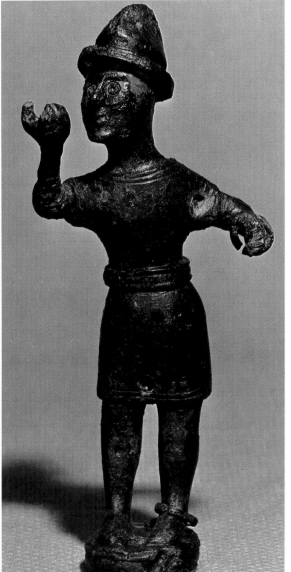

36

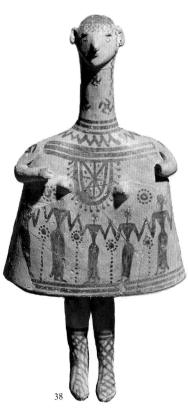

37

38

elsewhere exaggerated, have completely disappeared—a development typical for the Greek genius that constantly preferred the type containing within it all the distinct variations of a given form.

A terminal date cannot really be set for the prehistoric era; "prehistory" was prolonged throughout historic times, and in fact still exists in our day, for in the strictly etymological sense, the word applies to civilizations that have no writing, and hence, no written records. There are, however, cultures having no writing that are contemporary with other, historic civilizations that have left accounts concerning them; these are usually called proto-historic cultures. For our purpose, what matters is the persistence into historical times of artistic forms originating in prehistoric civilizations. The varying creative potential offered by bronze—which proto-historic societies usually learned from outside—did not materially affect the forms inherited from Neolithic art. During the Bronze Age, a so-called megalithic civilization developed around the Mediterranean and spread to the Nordic regions; it was characterized by huge monuments of rough-cut stone, fresh proof of the importance of stone for early men. Those stones are sometimes engraved, but rarely sculptured; yet in the most remote regions tombstones have been found bearing stylized human figures, or sometimes only a few human implements—weapons or tools.

The metal age appears not to have favored relief sculptures. It produced little other than figurines, and when these are of bronze, they closely resemble those of the subsequent Iron Age, contemporary with the historic civilizations developing in more favored regions. The little bronzes are sometimes figurative, but more usually stylized, often showing an elongation of proportions probably resulting from the limitations of primitive casting techniques. Clay statuettes follow the same pattern; their shape is coarse and childish, showing a regression in artistic invention.

In the steppes of Central Asia, groups of shepherds and hunters practising only the most primitive kind of agriculture continued the close association with animals that had characterized Paleolithic life. Since they led a nomadic existence, always moving on to find new pastures for their herds, the only artistic activities open to them were those involving portable objects: weaving or jewelcraft. Their gold jewels or ornaments for harnesses and saddlery mostly show animals, not realistically like the art of the Paleolithic hunters but strongly stylized. Those small objects usually represent the animals locked in combat, their forms interlaced in a dynamic unity.

We glimpse the zoomorphic style halfway on its route to the West in a work like the *Gundestrup cauldron (figs. 39–40)*, found in Denmark but probably produced by some Iron Age artisan from the Danube region rather than locally. The goldsmith used the *repoussé* technique to conjure out of the silver plates fixed to the cauldron a dancing ring of animals, some real, some fantastic, around the stag-horned Cervunnos, god of fertility.

In the Iron Age—sometime in the 8th century, or even as early as the end of the 9th—a people of horsemen from Southern Russia crossed the Iranian plateau and left on the slopes of the Zagros mountains megalithic tombs filled with bronze artifacts: axes, halberds, shields, quivers, jewels, harnesses, bridge bits, figurines representing men or hybrids *(fig. 76)*—all in a state of preservation indicating that they had never been used and were meant only as tomb furniture. This people of warriors and huntsmen were obviously under the influence of Mesopotamia. The conjunction of the fantastic style that had developed mainly in cylinder seals and of the zoomorphic steppes style engendered a multitude of imaginary forms, human and animal features combined into extraordinarily lively monsters reflecting their mystical beliefs. Transmitted by the barbarians who invaded the West, forms from this zoomorphic art followed obscure routes to reappear for the last time in Romanesque art.

After the fertile period that had produced the great Paleolithic picture book, there is in reality a dearth of large-scale artistic production. Man's creative activities again flowered in full only within a new type of society formed in historical times: the great urban civilizations that first appeared in the fertile valleys of the Tigris and Euphrates rivers, and of the Nile.

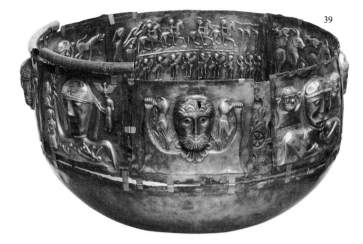

39

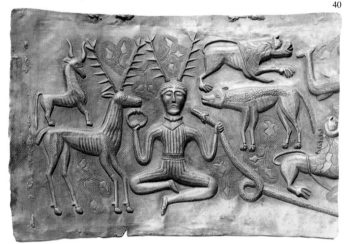

40

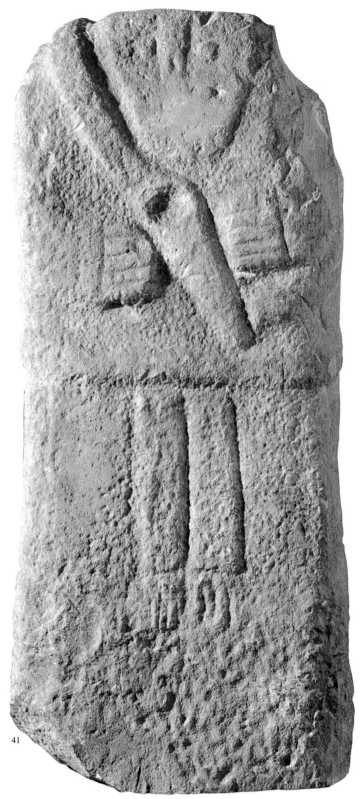

39 *The Gundestrup Cauldron.* **Celtic, 1st century B.C. (?). Nation-almuseet, Copenhagen.** The "cauldron," about 28 inches in diameter, is made up of a group of gilt silver plates, seven outside and five inside, with a disk at the base. The pieces were collected from a peatbog in northern Jutland.

40 *The Stag-God.* **On an inside plate of the Gundestrup Cauldron (fig. 39).** Seated in a Buddha-like pose, the horned stag-god Cervunnos brandishes in one hand a torque, in the other a serpent. He is surrounded by animals. The stag's branching antlers could be a divine symbol of regenerative power.

41 *Menhir,* **with a representation of a male figure. 7th century B.C. Musée des Antiquités Nationales, Saint-Germain-en-Laye.** This type of megalithic stele seems to have been produced over the course of about a thousand years. The upper part is carved in a crude low relief, schematically representing human figures, which may be male or female. The male figures bear an accoutrement, interpreted as the bow and tinderbox used to make fire.

41

II

DEVELOPMENT OF SCULPTURE IN THE NEAR AND MIDDLE EAST

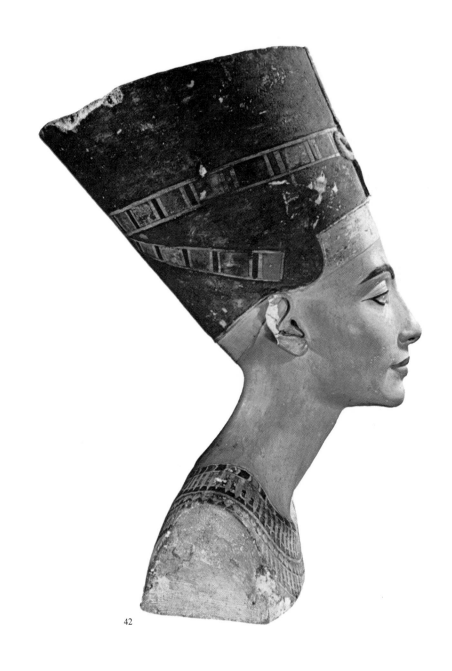

42

We must begin speaking of history, rather than of prehistory, at some time during the fourth millennium B.C., when what historians call the urban revolution was more or less accomplished, and men had grouped themselves together in the complex life of urban centers.

Cultural historians have not been in accord about the benefits of such urbanized existence. We may well agree with Lewis Mumford, in his *City in History,* that urban congregation engendered many of the evils that man has brought upon himself: the taste for wealth and power, and the consequent slavery, war, clash of empires and self-destruction of civilizations, by which the metropolis inevitably becomes the necropolis. But even if the Neolithic villages were as idyllic as Mumford imagines, we cannot evaluate its art in terms of its style of life: aesthetic values cannot be measured by moral standards. Others, like Strzygowski, have voiced the (romantic) notion that city and empire crushed the well-springs of true artistic inspiration, which he felt coursed free and clear among nomad populations. Their simple and unspecialized way of life allowed—so he thought—full rein to imagination and intuition, whereas artists serving prince and priest in the great Mediterranean empires could produce only academic, formal work in obedience to their masters' tastes.

However, unless one is prepared to set a higher value on a Neolithic figurine or Ostrogoth belt buckle than on the temple of Luxor, it is rejecting reality to deny that the first urban civilizations in the valleys of the Tigris and Euphrates and of the Nile favored the development of the arts. The organized and specialized life provided enough stability, continuity, wealth and leisure to make the prolonged development and enrichment of human thought and sensibility possible. The complex relationships engendered by urban association, and particularly by those two centres of city life, the temple and the palace, were the source of a whole matrix of ideas translatable into images; they also— a matter of some importance—provided a wide range of commissions, which encouraged diversified art forms.

It has been argued whether Sumer or Egypt first saw the dawn of true history, and which was the superior civilization. Opinions on the latter question depend on the historian's

parti pris, but as to the first, the true priority is most often conceded to Mesopotamia. In the Euphrates valley there existed during the fourth millennium a quite superior prehistoric (Neolithic) culture whose typical artistic products were the al'Ubaid clay figurines with curiously reptilian heads. Such spontaneously conceived and quickly manufactured terra-cotta creations continued to be produced throughout the evolution of Mesopotamian art in response to popular requirements. Prehistoric Mesopotamian civilization reached far afield: in the Indus valley, for example, centers of an advanced culture related to Mesopotamia were excavated at Mohenjo-daro and Harappa. The works of art found there are on a technical level far above a beginning awkwardness, though they are so few that we must assume the towns came to a violent end accompanied by thorough plundering. Upon Egypt, too, some daemonic wind seems to have blown from Asia; for in the beginning of Egyptian art, we find examples of the fantastic ornamental animal style that flourished from earliest times on Mesopotamian seals.

At all times the development of sculpture in Mesopotamia was conditioned by the scarcity of stone in that land of alluvial plains. A gypseous alabaster, easy to carve, was to be found in many localities, but steatite and hard stone, like diorite, dolerite or granite, had to be brought from the mountains. For executing his works, the sculptor depended on flint tools, even after the introduction of bronze; chisels, and also drills for making surface ornaments, or for making holes intended to be widened later with a burin, were all of flint. Bronze was rarely employed in sculpture, and then only for figurines. Architecture was grandiose, but elementary in form, since the scarcity of stone limited its design to what could be produced in sun-dried clay; palaces and temples bore few decorations, and these were seldom of stone. The sculptor's most important market, from the beginning of the third millenium, was for statues of gods and ex-votos of various kinds.

During the third and second millennia, rough shapes were gradually replaced by more carefully finished objects, which at the end of the evolution became somewhat mannered. The oldest statues worthy of the name are the group of alabaster

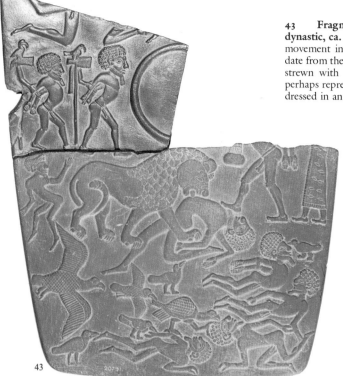

43

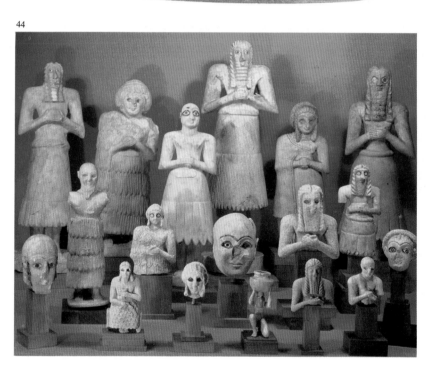

44

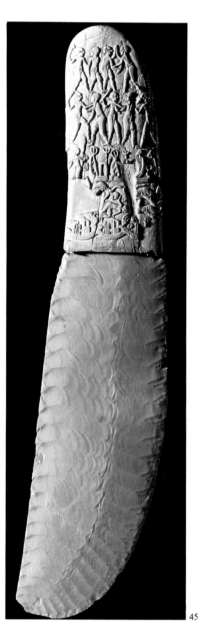

45

43 Fragment of a ceremonial *palette*. Schist. Egyptian, Late Predynastic, ca. 3000 B.C. British Museum, London. Attempting to depict movement in a realistic and energetic style, these palettes of green slate date from the end of the Predynastic Age. The fragment shows a battlefield strewn with corpses, over which birds of prey are squabbling. A lion, perhaps representing the king, tears at one of the bodies. Higher, a figure dressed in an embroidered robe leads a prisoner.

44 *Statuettes* from the temple of Abu at Tell Asmar. "Mosul-marble." Sumerian Early Dynastic period, 3000 to 2500 B.C. Oriental Institute, Chicago; and Iraq Museum, Baghdad. This group of alabaster statuettes definitely bears the mark of inexperienced local workmanship: there is no grace in the shoulders, chests or legs. The group's attitude of fervent adoration clearly shows the primarily religious inspiration, the mainspring of Sumerian art.

45 *Knife from Gebel el Arak.* Flint blade set in an ivory handle. Egyptian, Predynastic, ca. 3300 to 3000 B.C. The Louvre, Paris. The figurations on the ivory handle illustrate the relations between Pre-dynastic Egypt and the East at the dawn of history. On this side a battle unfolds: above, warriors confront each other; below, Eastern ships engage Egyptian ships. On the other side, a hero tames two rearing lions, while a hunting scene with a lioness, dogs and wild sheep appears below.

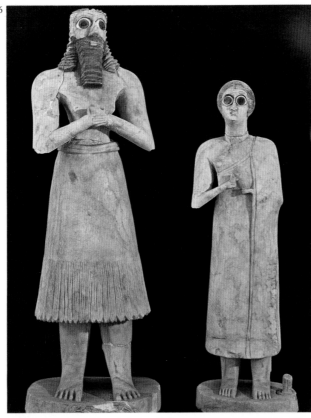

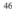

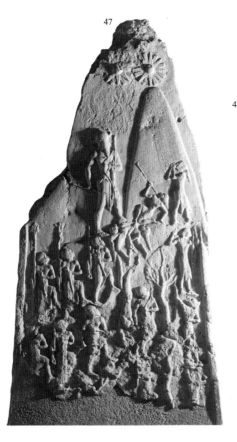

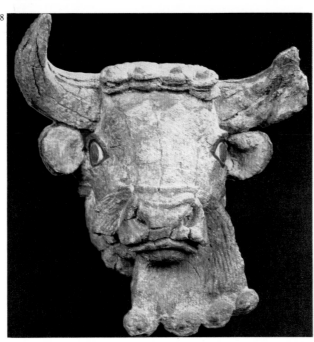

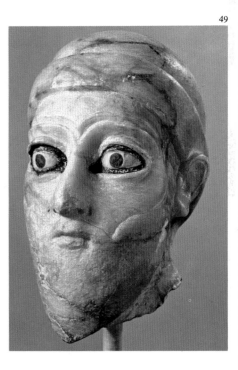

46 *The God Abu,* **from the temple of Abu at Tell Asmar. "Mosul-marble." Mesopotamia, al'Ubaid Period, 3000 to 2500 B.C. Iraq Museum, Baghdad.** These two large statues were found at Tell Asmar. Some scholars are inclined to interpret the figure of the God Abu as an effigy of a god, considering the size of the eyes as the sign of his omniscience; others believe these inhumanly staring eyes would be equally appropriate to a worshipper gazing into the divine light.

47 *Stele of King Naram-Sin,* **from Susa (originally from Babylon). Red sandstone. Mesopotamia, Akkadian period, 2500 to 2000 B.C. The Louvre, Paris.** The stele represents a victory of the king of Akkad, Naram-Sin, over mountain-dwellers from the east. To ensure the unity of the subject, the artist has discarded the traditional compositional method of dividing the scene into superposed bands. The part played by the gods in the victory is recalled at the top by celestial symbols of Shamash and Ishtar.

48 *Head of a bull.* **Bronze, Sumerian, Early Dynastic period, 3000 to 2500 B.C. City Museum of St. Louis.** The beginning of the 3rd millennium B.C. saw metal entering into general use in Mesopotamia, from which a great many masterpieces resulted. Here, the artist takes a middle course between the bestiality of other animal representations and the complete humanization seen in the man-headed bulls so numerous in Mesopotamian art.

49 *Head of a man.* **Alabaster, with shell and lapis lazuli inlay. Mesopotamia, Akkadian period, 2500 to 2000 B.C. Oriental Institute, Chicago.** The ethnic type of this head is Semitic: elongated skull, small mouth, aquiline nose. The beard is distinguishing, and characteristic of Akkadian custom, for Sumerians were always shown clean-shaven. The modelling demonstrates the Akkadians' immense contribution, on the level of human sensibility, to the Sumerian tradition.

50 *Impression from a cylinder-seal.* **Mesopotamia, Akkadian period, 2500 to 2350 B.C. British Museum, London.** The combat between the traditional hero and a savage beast remains the essential theme in gem-cutting, predominating over other religious and mythological subjects. In these miniature scenes the artist shows remarkable skill, owing to his originality and improvements on tradition. Severe composition and incisive quality are the dominant features of the work.

51 *Head of a female divinity.* **Terra cotta. Mesopotamia, Akkadian period, ca. 2300 to 2100 B.C. The Louvre, Paris.** The Sumerian civilization was capable of assimilating every influence without significant disruption of its own cultural tradition. Thus, the establishment of the Akkadian empire brought to Mesopotamian art the feeling and imagination that it lacked. With the Guti invasion these new elements did not disappear, as is demonstrated by the head shown here.

52 *Male head (Gudea?),* **from Lagash. Steatite. Neo-Sumerian, ca. 2100 B.C. Metropolitan Museum of Art, New York.** The head is only one example of a governor's portrait, but it displays the firmness of volumes, the understanding of the composition, the refined taste for continuous but varied surface modelling that mark a highly accomplished art.

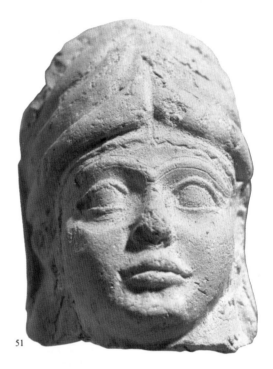

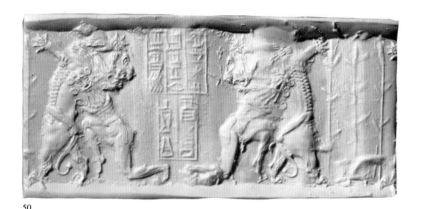

50

51

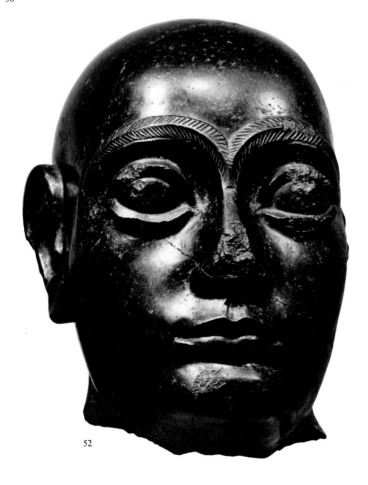

52

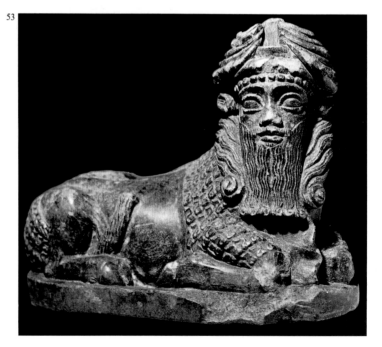

53 *Man-headed bull.* **Black soapstone. Mesopotamian, 2400 to 2300 B.C. The Louvre, Paris.** To maintain the expressive unity of the whole, the artist has invested the bull's features with a certain animality, which is nevertheless transformed by the supernatural force in the horns, emblem of divinity. The transition from animal to god is thus imperceptibly worked, and in the image the friendly spirit whom the bull represents becomes fully convincing.

worshippers and gods excavated from the Abu temple at Tell Asmar, who look as if conjured out of another world *(fig. 44)*. Roughly hewn into cubist shapes, with gigantic inlaid eyes, they are probably the first manifestation of the belief in the magic power of the eye—a belief still alive in modern Italy as the fear of the "evil eye." During the second half of the third millennium, the empires of Akkad and Sumer perfected the civilization of the city-states, and art grew closer to nature; but the Neo-Sumerians created the most striking works in early Mesopotamia. There, for the first time in history, we can connect a style with the initiative of one man. In Lagash, a *patesi,* or local governor, had his portrait as a worshipper sculpted over thirty times in hard steatite. A feeling of concentrated strength emanates from these muscular, thick-set figures *(fig. 54)*. The exaggerated ankles and wrists, the set jaws, and the hard forehead, show a stubborn refusal to communicate with or to accept the outside world—a refusal that also explains the inability of the artists to create that society of images: a composition. In these first attempts at monumental sculpture, the artist explores the basic forms under the individual features: the head is egg-shaped, the body a squared block of stone. Contemporary female figures are somewhat more human: one, wearing a horned headdress—the usual attribute of a goddess—displays a hint of a smile *(fig. 51)*. Later, this austerity softened to the point of sensuality in representing nudes. The cult of the stele inspired an art that prolonged the Neolithic period: Hammurabi had the 285 laws of his code engraved on what is in fact a menhir *(fig. 55)*.

Before the Assyrians, Mesopotamian sculptors conceived only isolated forms; we find no interest in compositions relating forms to each other, except on the cylinder-seals, where the artist's imagination was allowed an unusual freedom *(fig. 50)*; we are tempted to consider these tiny works as the "major art" of the period. The reliefs are roughly carved, with characters lined up or juxtaposed in a confused manner instead of being linked by common action. This inability to connect forms is all the more surprising as, during the fifth and fourth millennia, the pottery makers of Samarra and Susa had evolved an ornament using formal innovations worthy of Romanesque art.

The recent admiration for Sumerian art has been due in some ways to our contemporary preoccupations. On the one hand the taste for abstract and non-naturalistic art directs our appreciation to an art whose forms do not try to mirror natural forms; on the other hand, our disenchantment with the rule of reason and the growing dominion of psychoanalytic notions prompt us to seek in man's art an explanation of what is obscure in man himself. The renewed prestige of the word "sacred" and of the idea of magic incite us to look for hidden truths in forms that, because they do not imitate the visible, appear to reflect the invisible. Herein also originates our sympathy with Mesopotamian religion, which is somber and abstruse as compared, for example, to the Egyptian—the first religion to introduce the idea of salvation. Our confusions and fears themselves may attract us to the civilizations of the Tigris and Euphrates valleys, which witnessed so many bloody struggles and the collapse of so many empires, rather than to the peaceable kingdom of the Nile, whose art we may even blame for having followed so uninterrupted a course for so many centuries. Mesopotamian civilization seems to have suffered not only as a result of frequent eruptions of violence and the successions of peoples and rulers, but also from some inhibition. Haunted by thoughts of ever-present, inimical other-worldly forces, and by a conception of the afterlife as a miserable dark place where the soul could only vegetate, it could find no aim for life other than mere existence itself. Its art seems in the final analysis to have lacked the vitality and the rich all-inclusiveness that have characterized the arts of some other civilizations.

When we turn to Egypt, and if we look with an unprejudiced eye, Egyptian art must appear by contrast as far more truly precocious, richer, and certainly more sustained than the art of Mesopotamian cities and empires. In Egypt, art was first given that essential place in the human scheme of things that it maintained throughout the ebb and flow of later civilizations. By giving full scope to the creation of images, Egypt initiated the Western artistic tradition, while

54 *Votive statue* **of Gudea, from Lagash. Diorite. Neo-Sumerian, ca. 2100 B.C. The Louvre, Paris.** This is the only complete seated effigy of the governor of Lagash in the Louvre collections. Indifference to realistic proportion was intentional, like the even more complete indifference to the realistic human form displayed by the sculptors of the Tell Asmar worshippers. Only the expression of religious fervor mattered.

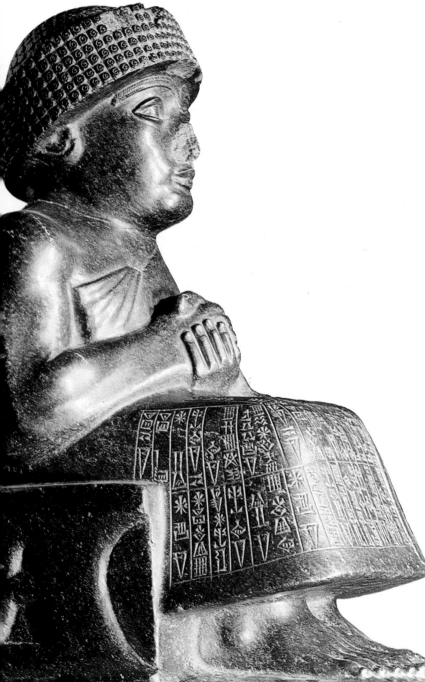

Mesopotamia, more haunted by the invisible than attracted by the visible, was the source of the Asiatic tradition.

The Egyptians were free from any terror of a dark world of shades, for they imagined an afterlife that was a replica of the world they knew; life simply resumed in eternity. For the Mesopotamians the world beyond was a cursed place, ruled by infernal powers; for the Egyptians, it was made up of the happiest moments of real life. To art the Egyptians assigned the task of recreating these moments truthfully, of assembling about the tomb, in enduring form, a faithful catalogue of the multiple good things and ways of earthly existence, confident that by magic translation into eternity they would be enjoyed by the dead forever in the afterlife. Hence, though almost all the Egyptian art that we know, from the earlier times at least, is funerary art, it impresses us with a spirit of cheerfulness and love for creation. Art will probably never again be endowed with such power: victory over death. Such a belief in the ability to recreate the world by simply reproducing its appearance had already moved Paleolithic artists. It implies a proud optimism, a faith in the efficacy of human actions, a self-confidence contrasting with the pessimism of the Mesopotamians, though the latter progressed further in science than the Egyptians, who were content with a pragmatic, empirical approach. The privilege of eternal life was at first the prerogative of the god-king, then of the courtiers whom he chose to take with him into the afterlife to look after him; and finally the Osirian faith extended immortality to all men, however humble—the first form of democracy in antiquity, though only in the afterlife, to be sure.

The nature of the ruler also differentiated the two civilizations. The inhabitants of the Nile valley believed themselves favoured by a divine power; divinity was in fact present among them in the shape of their god-king. In Mesopotamia, the ruler was a mere man, a terrified intermediary between men and god.

Egyptian art is first of all the art of the sculptor. Stone was the most lasting material and therefore was used most, and preferably hard stone, even though it had to be extracted from the desert a long way from the Nile: diorite, basalt, porphyry, black granite, green and yellow breccia were

55

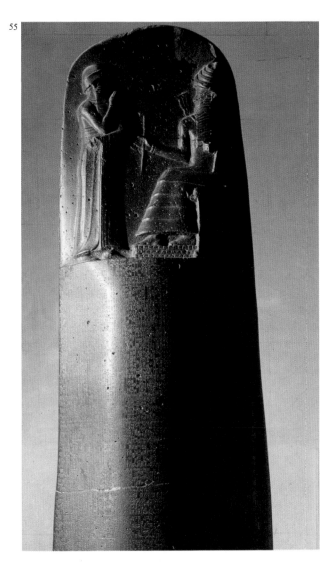

56

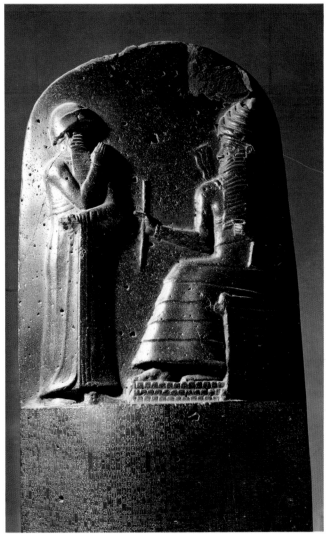

55 *Stele bearing the Code of the Babylonian King Hammurabi.* **Black basalt. Neo-Sumerian, 1800 to 1700 B.C. The Louvre, Paris.** The Babylonians often made use of blocks of stone left more or less in their original form, such as this stele, on which the 282 laws of Hammurabi's famous Code are engraved. Although it is well-known that he was neither the first nor the only ruler to have conceived such a code, the work remains remarkable nonetheless, for both its content and the quality of its execution.

56 *King Hammurabi* **before the god Shamash. Detail of upper part of fig. 55.** At the top of Hammurabi's Code stele, the bearded king stands before Shamash, god of justice, with his right hand raised in an attitude of prayer. The divine nature of the god is indicated by his long tiered robe, his horned tiara, and the flames leaping from his shoulders. King and god look each other full in the face and speak freely, one without cowardice in submission and the other without tyranny in authority.

fetched to the valley at great cost. Those near-precious materials were later exported by the Romans and by the Byzantines, until the Arab conquest of Egypt caused the quarries to be closed. Limestone, alabaster, sandstone and pink granite were found in the Nile valley itself. Wood was sometimes used, and became more frequent when the Osirian religion was extended to all, necessitating the manufacture of cheap funerary material in large quantity for the poor. The prestige of stone, dating back to the Neolithic period, was such that even the tools used to work hard stone were made of stone; later the Egyptians also used bronze implements, but they never learned to make strong tools out of iron. The skilled techniques of stone carving were transmitted from workshop to workshop throughout millennia. Apprentices had to copy models; models and copies have survived to this day in the dry Egyptian soil which preserves all *(fig. 64)*. Excavation of the workshop of the sculptor Tuthmosis, who lived in the Amarna period, has shown that to prepare for his portraits the artist took plaster molds of the faces of the living or dead model.

Egyptian art is primarily a mural art. There may even be some connection—although links are missing here and there—with Saharan rock engravings and paintings. Large relief panels actually appeared later than sculpture in the round, but the essence of the Egyptian relief style appear already in a work of the Thinite period: the stele of the Serpent King *(fig. 57)*. With its clever use of a frame, its firm silhouettes, its accurate modelling, this work achieves a fine equilibrium between realism and formal harmony. Mural art uses mainly profiles; it is born from the spectacle of the passing reality. Each form borrowed from perceived reality is not, however, registered as it is seen, but recomposed in the same spirit of synthesis as that shown by Paleolithic painters. The way the human figure appears in Egyptian reliefs demonstrates the wish, based on the requirements of magic, to represent the whole of a man, that is to say, a man in his ontological rather than optical truth: face and legs in profile, hips in three-quarter view, upper torso in front view, and also the eye, magnified as if to mirror the soul. What is most surprising is that the general effect does not shock us; the

power of art makes us accept it as natural. In sculpture in the round, too, that principle of frontality, for which Egyptian art has been criticized as static, has a deeper meaning. The statue, facing the onlooker, motionless, goes beyond the immediate moment and tends to the eternal. The being confronting us may be Kephren or Amenhotep, but before all else he is the pharaoh, to whom Kephren or Amenhotep lends his features. The stark confrontation of statue and spectator is intended to present, not to represent, the concept of a being in his self-defining integrity—like the creator god Aton-Ra, "all in himself."

In our era of formalism and abstraction, Egyptian art has also been criticized as too realistic. But it rarely becomes naturalistic, except during the final decadence, or perhaps in the Amarna period; even then, when we look at the masks of actual Egyptian faces excavated from the workshop of Tuthmosis *(fig. 63)*, we are surprised to find that they look so unlike the Egyptians depicted in a so-called realistic art.

Egyptian art, based on observation but bent towards an ideal, is the expression of a humanism born of a feeling of perfect harmony between god and man, between man and nature, between the visible and the invisible, between the present world and the world beyond. That humanism was strong enough to endure for millennia, miraculously surviving two periods of upheaval and invasion. Never has man held for so long to the conviction of living in an order without fault.

All human actions, all creatures of nature are sanctified in that sin-free world. If those hunted animals, those birds caught in nets, that cat watching young fledglings terrified by its approach—if all these creatures seem so alive, it is because the artist who created them was in deep sympathy with all living things. Even the "mystic naturalism" of the Christian Middle Ages did not express itself in such a pure outpouring of love for all creation. Looking at those hunting or fishing reliefs, we seem to witness "the adorable awakening of an April morning when the world was young" (to quote Christiane Desroches-Noblecourt). It is indeed a paradisiacal vision. All is new-made and pure in Egyptian art: each being, hunter or hunted, is pictured in his integrity, not mixed with

58 Prince Rahotep and his wife Nofert, **from Medum. Limestone, painted. Egyptian, ca. 2650 B.C. Egyptian Museum, Cairo.** These large statues were discovered in the statue-chamber of Rahotep's mastaba at Medum. A vivid life emanates from them, owing to the colours, which have remained miraculously intact. Rahotep's face leaves an unforgettable impression in its striking realism, but the candid expression lacks subtlety.

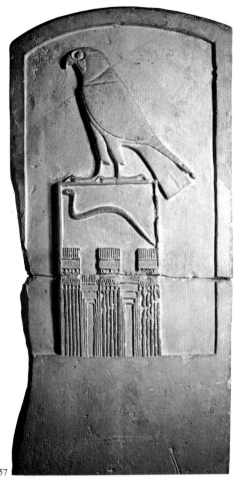

57

57 *Stele of the Serpent King,* **from Abydos. Limestone. Egyptian, Archaic Period (Ist Dynasty), ca. 2900 B.C. The Louvre, Paris.** The decoration of King Wadji's stele is essentially symbolic: the divine falcon, radiant with power, is the dynastic god Horus, who protects the king's name. The façade of the palace is decorated with niches and pilasters. The fact that it is pierced by two doors represents the dual nature of Upper and Lower Egypt.

59 *Portrait panel of Hesy-ra,* **from his tomb at Saqqara. Wood. Egyptian, Old Kingdom (IIIrd Dynasty), 2780 to 2680 B.C. Egyptian Museum, Cairo.** In the *mastaba* (tomb) of Hesy-ra at Saqqara, Mariette discovered three wooden panels at the back of niches that usually held statues of the deceased. One of them depicts Hesy-ra himself, an important personage from the epoch of King Zoser. The intensely energetic and aristocratic face is treated with the powerful realism characteristic of Old Kingdom works. Hesy-ra is shown in a walking pose. In his right hand he holds a baton, in the left a staff and his scribe's implements.

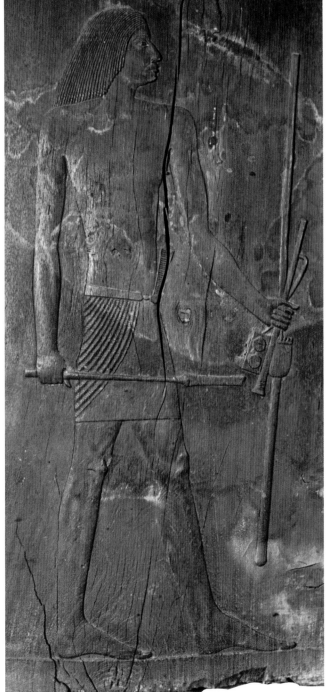

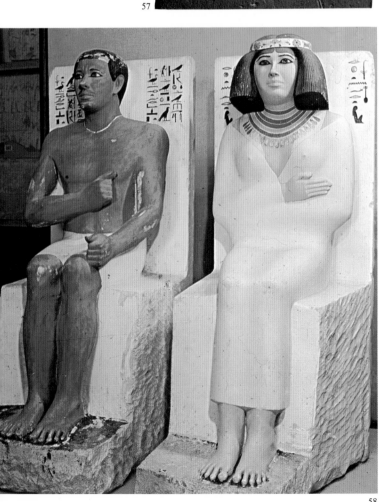

58

59

his opposite, and therefore shown as ideal, without any accidental deformations. There is no worm within the fruit, no tree of good and evil.

Egyptian art gave a substantial place to women. A charming figure with supple gestures and firm, delicate breasts, woman is everywhere, princess, or slave fetching the geese from the marshes; indeed, the slave is sometimes more a woman—for the princess must be dignified rather than natural. In this respect, the Egyptians surpass the Greeks: the latter deified female beauty and made of woman an erotic object; the Egyptians gave her a feminine soul. The chaste and graceful silhouettes remind us of the courtly ladies in Gothic illuminated manuscripts, or of quattrocento nudes, before Venice had rediscovered the weight of Eros in the female body. Egyptian art often represents woman as a wife or mother, sharing the life of man. In Mesopotamia she was allowed to appear only as a goddess; it was exclusively the female principle that was honored, that is, the power of fertility.

An unchanging conservatism has mistakenly been attributed to Egyptian art. It did preserve certain principles linked with religious beliefs, during its long life, but in fact it evolved much more than Mesopotamian art. The restless political state of the country of the two rivers gives a false impression of change, whereas the Egyptian empire, because it lasted so long, seems to have been immutable. But we tend to forget the progressively accelerated rhythm in which human evolution is measured: first in slices of a hundred thousand years, then of ten thousand years, then, on the eve of historic times, of one thousand years; only during the first millennium B.C., around the 7th and 6th centuries, does the century become the unit. Admittedly, at that time when other arts were evolving in the Mediterranean and in the Near East, Egyptian art was an empty survival; but it can hardly be considered stereotyped in its early and middle periods. The art-historical division into three "Kingdoms" in fact corresponds to the evolution of three broadly different styles. The austere, realistic style of the Old Kingdom characterized a period of discovery. During the Middle Kingdom, the pathetic realism of the South coexisted with a soft, graceful,

noble style in the North. During the New Kingdom, tradition was brutally interrupted by the aesthetic revolution accompanying the religious reform of Akhenaten (Amenhotep IV), probably the first time in history that a sovereign left so personal a mark on the art of his time. The heretic pharaoh must have realized that to shake off the dominion of the priests of Amon, he must also destroy the artistic rules they dictated. The individual emerged from the limitations of the type. Even the pharaoh and his circle at Amarna were pictured as a middle-class family united by links of human affection; their physical characteristics were exaggerated, obviously as a protest against the archetypal canon which had been imposed until then. Akhenaten's aesthetic revolution was short-lived, but when Egyptian art returned to its tradition, some traces of the Amarna style remained: a heightened awareness of ordinary mankind, more feminine influence, more refined furniture and useful objects, and a taste for small statues.

In Ramessid times, to protect itself against invasion Egypt had to conquer others; as its horizons were enlarged it acquired a taste for luxury and a greatly expanded commerce with other peoples. But under those alien influences, academism began to affect Egyptian art. Statues became lifeless, and the hastily completed reliefs, although adding new warlike themes to traditional iconography, became conventionally decorative. In the Saite period, during the 7th and 6th centuries B.C., artists tried to halt that decadence; they gave a renewed and exaggerated impact to statuary by strong modelling of the heads and by the use of the hardest materials; but the Egyptian spirit seems irredeemably lost.

Next to the historical civilizations that flourished in the Near and Middle East between the fourth and second millennia B.C., there are others that remain more mysterious to us owing to the lack of written documents. In Crete, for instance, only the latest script (Linear B) has yet been deciphered, and that recently; it was found to be in an archaic Greek language, a fact which perhaps caused more surprise than it should have, since at the time the script was employed (1450–1400 B.C.) Knossos was ruled by Achaens from the Greek mainland. There is little to be expected from the de-

60 *Memphite official and his wife.* **Early 5th Dynasty. Wood. Louvre, Paris.** Wood was commonly used in statue making as its surface was more easily carved than stone. The sculptor thus benefited from a greater freedom of expression which can be seen here in the spontaneous gesture of the woman's arm around her husband as well as in the tenderness that united this couple at the dawn of eternity.

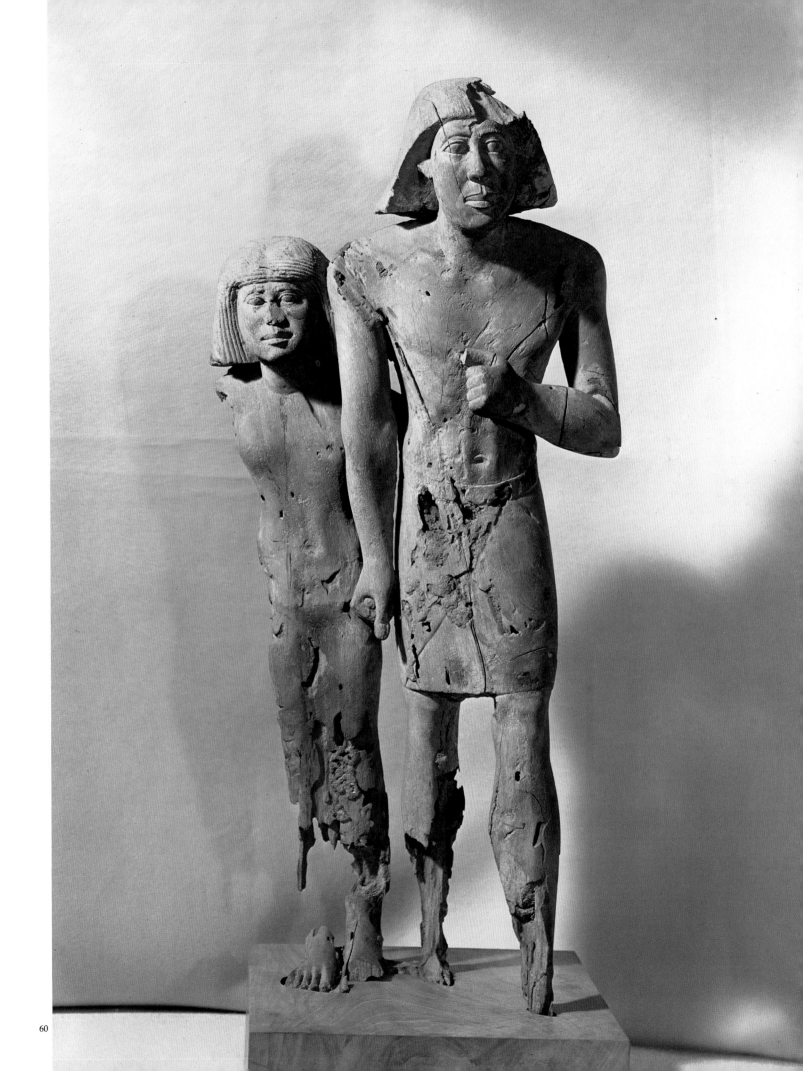

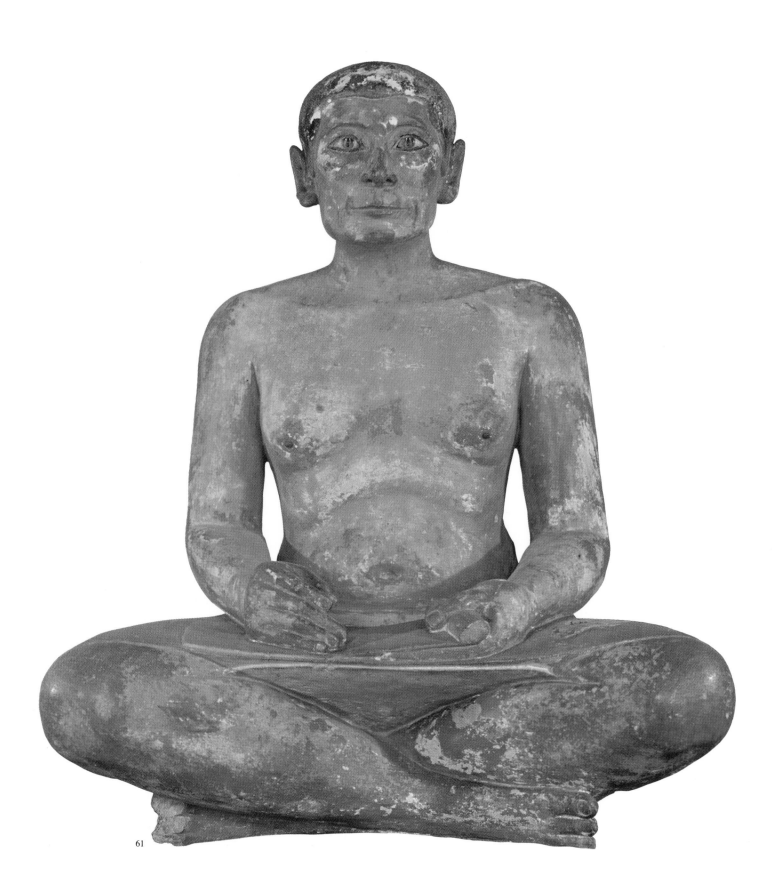

61

cipherment of tablets or stamp seals from previous periods, for like those in Linear B, they will no doubt prove to be only inventories, account books, or lists of civil servants. The cultures that succeeded each other on Minos's island seem to have differed greatly from the highly verbal civilizations of Mesopotamia and Egypt, where a feeling for history appeared concurrently with the development of cities and the worship of priests and rulers. Cities existed in Crete too, ruled over by kings surrounded by feudal lords, but no ruler is known to us individually; they are all confused under the name of Minos, whom the Greeks made into the King of Hades. These kings had a few soldiers who seem to have been required because of rivalries between towns; but Cretan art never reproduces the act of killing. Though extensive, the ruins at Knossos, Phaistos and Mallia do not prove the existence of a complex urbanized society: these palaces must have sheltered a culture very similar to that of the larger Neolithic villages, one based on agriculture and supplemented by resources from the sea. Those men seemed to sense not at all the tragic unrolling of time, the succession of lives and deaths that make up the warp of history. They seem to have evaded it by the cyclic conception of time characteristic of primitive agricultural civilizations, conceiving a world perpetually reborn, as is nature herself through the seasons. In contrast, man in the Middle East was haunted by a linear projection of time (which the Bible inherited and transformed into an instrument of terror) while the Egyptians, although they lived in history and made it, avoided the fear of mortality by imagining a duplication of time from life to afterlife.

Aegean art prolonged the prehistoric unconcern for monumental sculpture; it was content with small objects that, unlike the works from the Euphrates or the Nile valleys, do not obsess man with their presence. Cult objects were reduced to a few abstract symbols—the double axe, the sacred horns, the figure-eight-shaped shield, the sacred tree and the column (the last, an emblem of stability originating in baetylic stones), objects used simply as a focus for cosmic energy, and far less frightening than the personified gods of Mesopotamia or Egypt, where man set up gods who turned against him and tyrannized over him. There is nothing of that kind in Crete; the most individualized deity is the snake-goddess (*fig. 70*), a charming incarnation of the Mother Goddess and the first benevolent aspect of that divinity conceived by men. Her worship was pleasant: priestesses with full, flounced skirts and bared breasts indulged in sacred dances while the men invited nature to procreate by processions and joyous songs. Acrobats, men and women, leaping over a bull, played a part in some mimed drama whose meaning is unknown to us.

61 *Seated scribe,* **from Saqqara. Limestone, painted. Egyptian, Old Kingdom (IVth Dynasty), ca. 2680 to 2565 B.C. The Louvre, Paris.** The scribe, disciple of the ibis-god Thoth, who according to Egyptian myth invented writing, was possessed of a science that rendered him indispensable in the bureaucratic Egyptian society. A literate man could hope to attain the highest posts, and popular tradition often praised the merits of the scribe's profession.

62 *The great Sphinx at Giza.* **Egyptian, Old Kingdom (IVth Dynasty), 2680 to 2565 B.C.** This gigantic, human-headed lion represents the god Harmakhis, with King Chephren's features. Uniting, in one majestic form, animal, king, and god, the sphinx is a form of the solar deity; serene guardian of the other world, and guarantor of resurrection, he defends the necropolis.

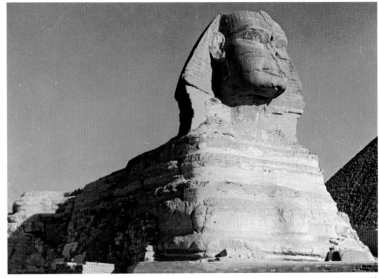

62

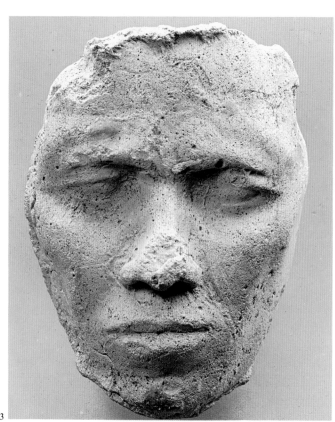

63

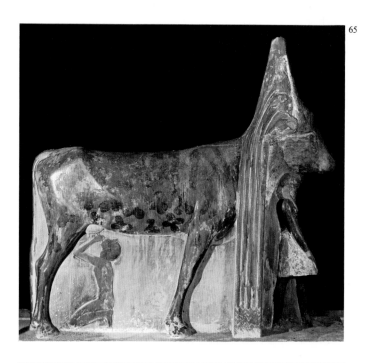

65

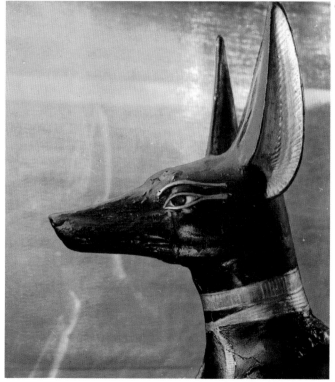

66

64

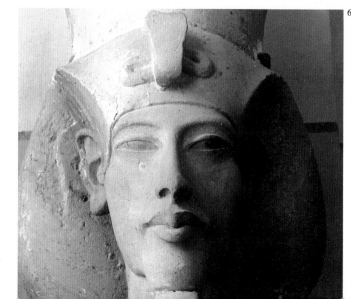

67

63 *Death mask of Amenhotep III,* from Amarna. Plaster. Egyptian, New Kingdom (XVIIIth Dynasty), ca. 1370 B.C. Staatliche Museen, Berlin. At the end of Amenhotep III's reign there were already clear signs of the religious and artistic crisis that was to occur during the following reign. An example is this mask, probably molded on the lifeless face of Amenhotep III, which was found in the workshop of the sculptor Tuthmosis at Amarna, the new capital of Amenhotep IV.

64 *Sculptor's model of falcons,* from Tanis. Egyptian, New Kingdom. Egyptian Museum, Cairo. Excavators at Tanis found two brick constructions from the time of New Kingdom, which must have been used as sculptors' workshops. Numerous models were discovered, including small square or rectangular plaques. The plaques were often squared-off for ease in establishing figure proportions.

65 *Amenhotep II under the protection of Hathor,* from Deir El Bahari. Egyptian, New Kingdom (XVIIIth Dynasty), ca. 1450 B.C. Egyptian Museum, Cairo. Discovered in the funeral temple of Deir El Bahari, this statue represents the goddess Hathor in the form of a cow. She was worshipped at Thebes as a goddess protecting the necropolis; she was also often identified with Isis, sheltering in the Delta reeds. It is in that double role that she appears here.

66 *Head of a jackal* reclining on a chest. Wood with inlay. Egyptian, New Kingdom (XVIIIth Dynasty), ca. 1340 B.C. Egyptian Museum, Cairo. The jackal surmounting the gilded wooden chest found in the treasure of Tut-ankh-amon is none other than the great god of the dead, Anubis. Invoked since the earliest times as protector of the necropolis, he also led the deceased into the other world.

67 *Head of a colossal statue of Amenhotep IV,* from his temple of Aten at Karnak. Sandstone. Egyptian, New Kingdom, (XVIIIth Dynasty), ca. 1360 B.C. Egyptian Museum, Cairo. A few colossal statues remain from a temple to Aten, the solar disc, built by Amenhotep IV. The ambiguous and disconcerting facial expression, the elongated, exaggerated features combine into a new harmony; and despite its curious ugliness, the face gives an impression of passionate force and mystical liberation.

68 *Amenhotep IV (Akhenaten) with his wife (Nofretete) and daughters.* Egyptian, New Kingdom (XVIIIth Dynasty), ca. 1360 B.C. Staatliche Museen, Berlin. Being the divinity of the sun, Aten is conceived as radiating throughout creation. Here the Pharaoh, whose unpleasing appearance is evoked with exaggeration, embraces one of his daughters, while rays from the sun-disc hold out symbols of life (the *ankh*) to parents and children.

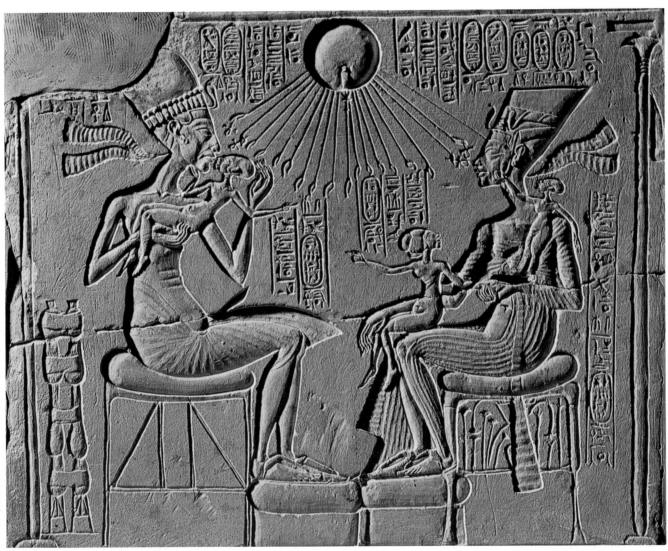

68

70 *The snake goddess,* from Knossos. Polychrome terra cotta. Minoan, ca. 1540 B.C. Archeological Museum, Herakleion. The principal interest of this figurine lies in the information it gives about Minoan religion and costume in early 16th century B.C. The Cretans frequently paired the snake with their goddess for symbolic reasons, as the snake was associated with fertility, regeneration and immortality.

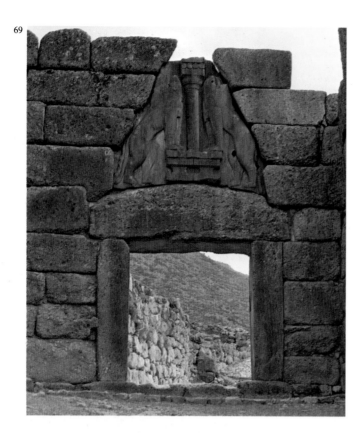

69 *The Lion Gate at Mycenae.* Mycenaean, ca. 1250 B.C. The gate opens in a wall that ancient Greek tradition ascribed to the mythical Cyclopes. Four enormous blocks frame the gate, and the relieving triangle above the lintel is occupied by the famous sculpture showing two rampant lions facing each other, the first known example of monumental sculpture in Greece. This taste for the monumental distinguishes the Mycenaean from the Minoan civilization.

The small objects found in Crete are beautifully shaped and polished. Their liveliness and perfection of form suggest a conception of life as one moment indefinitely repeated and free from the stigma of mortality. A feeling for monumental relief sculpture always seems to have been linked with a feeling for history, men wishing to leave on this earth lasting records of their existence, either on their own scale or on a superhuman scale—works that would act as man's double and immortalize him in enduring stone. These "imperishable monuments," these proud colossi cannot fool us; they were born of the greatest fear of all: the fear of death. Their huge mass weighs on human memory and leaves no escape from

historical destiny; only prime man was free from that fear, and his freedom seemed such a wonderful privilege to those following that they called it the Golden Age. Archaic Cretan culture prolonged that Golden Age into historic times. Minoan beliefs in supernatural powers who tormented humans were very shadowy, as we can see from the fragility and small size of the cult figurines, which can be held in one hand. That people living from the export of bronze chose brittle clay for their own artistic creations, shows their entire lack of interest in transmitting to the future their own historical moment. The Cretans lived in a world of "being" rather than "becoming"—a state of grace witnessed by the charming statuettes of women, exquisite, elegant objects; by the stamp-seals on whose tiny stone field they engraved the forms of familiar animals, while contemporary Mesopotamian artists were indulging in monstrous evocations. Aegean representations of humans and animals are not, like those of the Egyptians, the result of close observation, but rather of an instinctive feeling for natural life on the part of an insouciant people, little given to metaphysical or historical speculation, seeing the world as a huge network of exchanges from which man benefited.

Divinity was incarnated in a woman, which seems to have given the keynote of that peaceful civilization and endowed its art with elegance. But as soon as figures of warriors were introduced from the mainland, everything collapsed. The idols with raised arms created in the late Minoan period (1400–1200), when the island was invaded by the Mycenaeans, are a striking example of how a conquered nation's art may suddenly regress from the sophisticated to the popular. The sap has suddenly run dry; the mind proceeds through addition instead of synthesis, and the artist's hand, that skillful hand that had given life to so many graceful figurines, becomes a coarse and awkward instrument. To be sure, Minoan artists from the period of Mycenaean rule carved the ivory plaque excavated at Ugarit in Phoenicia, depicting a fertility goddess flanked by rampant goats *(fig. 72);* but even this charming little relief appears like a slightly confused and coarse redaction of the elegant works of the earlier Minoans. The art of the conquerors fed on the remnants of enslaved

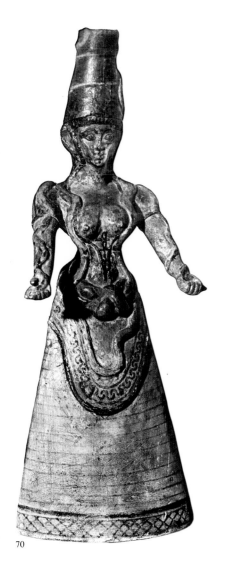

70

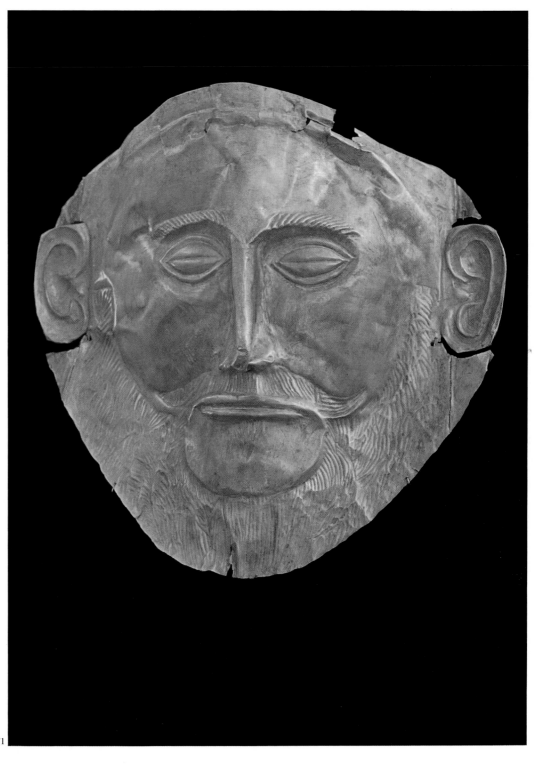

71

71 *Mask.* **Mycenaean. 16th Century B.C. National Museum, Athens.**
The fortress wall of Mycenae is surrounded by a circle of tombs discovered
by Schliemann in 1878. The men wore gold embossed masks. These masks,
because of the unusually crude face and beard, are very different from the
impersonal Minoan portraits. This one foreshadows the Classic Age of
Greece and is called "Agammemnon's mask."

72

73

74

72 *Fertility Goddess,* from Ugarit (Ras-Shamra). Ivory. Phoenician, 1400 to 1200 B.C. The Louvre, Paris. The uncovered breasts of the fertility goddess, the wide, flounced skirt and the hair held by a band are characteristic of the Cretan style. The facial features recall the "Parisienne" of Knossos rather than Semitic types. The work has a strongly Mycenaean appearance and shows how important Aegean influence was in Phoenicia towards the end of the 2nd millennium.

73 *Stele,* from Ras Shamra. Phoenician, 1300 to 1200 B.C. The Louvre, Paris. The Phoenicians combined artistic elements taken from their various neighbors into works of a hybrid nature. On this stele Baal, god of storms, is depicted brandishing a mace in one hand and a thunderbolt in the other. The general pose is taken from Hittite reliefs, the pointed cap is of Egyptian origin, the horns indicating divinity are a Mesopotamian motif, and the little worshipper beside Baal is dressed in Syrian fashion.

74 *Ashtart.* Bronze. Phoenician, 1400 to 1200 B.C. The Louvre, Paris. Ashtart is one of the great figures in the Phoenician pantheon, and one of the many names given to the Great Mother, goddess of motherhood and fertility, whose cult spread throughout the whole of western Asia, and who reappears in Greece with the names of Aphrodite and Cybele, among others. Dressed in a long robe and adorned with spiral-form jewels, she lifts her right hand in a gesture of peace; the left must have held a scepter.

75 *Statuette of a god.* Bronze. Iran, Luristan, 8th to 7th century B.C. Archeological Museum, Teheran. This god is the protector of a city. The work is striking for the studied refinement of the volume and for a certain plasticity, evident in the face and the arms.

76 *Idol,* from the Zagros mountains. Bronze. Iran, Luristan, ca. 9th to 8th century B.C. Cinquantenaire, Brussels. Production of these bronzes reached its peak in quality and quantity during the 8th and 7th centuries. They introduce a world of fantasy, in which imagination has rearranged forms in bold combinations.

77 *Lion,* from Marash. Basalt. Hittite, 9th century B.C. Archeological Museum, Ankara. When the Hittite empire fell, in about 1200 B.C., some traditions were kept alive in various little states in southern Anatolia and northern Syria, which developed a later form of Hittite art. This 9th-century basalt lion, typical for its mediocre quality and traditional treatment, illustrates the length of survival of the earliest Hittite art, up to the beginning of the 1st millennium.

Minoan art; the most remarkable work of Mycenaean art on the mainland is the *Lion Gate (fig. 69)* at the main entrance to the citadel of Mycenae, where two lions, now headless, face each other on either side of a column, a cult symbol inherited from the Cretans.

About 2,000 B.C., at the end of the Bronze Age, a people of Indo-European origin—and therefore unconnected with the races previously inhabiting the region—invaded northern Asia Minor. Their art of small earthenware or bronze objects resembled that of other metal age cultures, until the later second millennium B.C., when these Hittites, as they are called, built grandiose structures which they ornamented with numerous reliefs. Soft limestone was available and they used it to form the lower course of their sun-dried brick buildings; the interiors were then faced with great sculptured reliefs representing gigantic figures, animals or hunting scenes. Those decorations, conceived in a somewhat clumsy, hieratic style, are of little artistic value; but they are interesting from a historical point of view since they were later imitated by the Assyrians. To their Hittite enemies, whom they finally conquered, the Assyrians owe also the paired lions or bulls set on either side of palace gates, and also their understanding

of the art of fortification, which the Hittites had developed to a high level.

In the rival kingdoms that fought over Mesopotamia before the 9th century, the most important monuments were consecrated to the gods. An art devoted to the glorification of a sovereign, a true court art, waited for the unifying strength of an empire—Assyria, which for three centuries dominated the Middle East. The Assyrian king created the prototype of the autocrat; and to a greater or lesser extent, the various forms of imperialism that were to appear later in the Mediterranean and in the West were modelled on the Assyrian autocrat, around whose deeds and ceremonies everything gravitated. Even art was at his service—a new development. The kings of Egypt have left us only the dwelling places they built for their afterlife; their terrestrial homes were built of short-lived materials and did not last, but the kings of Assyria had a passion for grandiose palaces; each of them built at least one, and sometimes several, in each of the important towns of his empire. They inherited that practice from their predecessors, the despots who had ruled over the valley of the two rivers. These kings, although they claimed divine descent, were not god-kings like the pharaohs. In

Egypt the divine king was the beneficent channel through which the forces of nature reached the country and caused the work of men to bear fruit. The Assyrian king was a different kind of being—not god, but superman. His supremacy and his power over other mortals were expressed through strength. To reign, he had to be feared, and cruelty was for him a means of government as well as self-assertion; his politics, his ethics, and his very survival were based on cruelty. The texts discovered by excavators justify the Biblical maledictions against those despots, who never tired of repeating how their hearts rejoiced over burned cities, massacred or deported populations (*fig. 80*), tortured enemies, and hecatombs of prisoners. During the three centuries of Assyrian rule, Mesopotamia and its surroundings lived in a perpetual bloodbath. The instrument of power was the army; therefore, the glorification of the hero-king in art took the form of representations of the battles in which he vanquished his enemies, the tortures that followed victory, and finally, the wild-beast hunts with which, in time of peace (that is, a period between wars), the king sustained his instincts for violence, the source of his regal power. Throughout the ages, from despot to despot, that royal

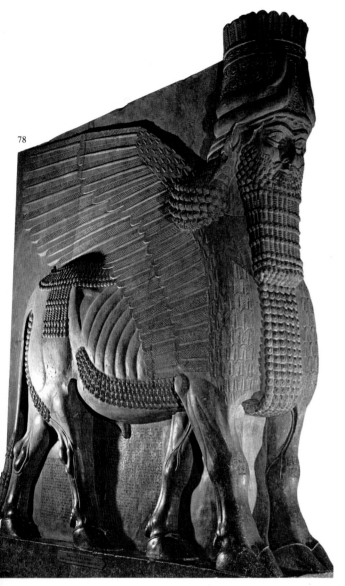

78

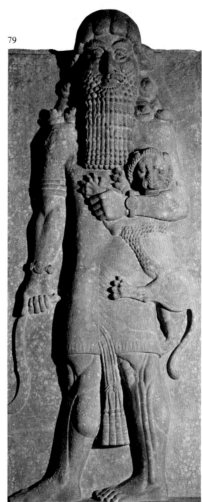

79

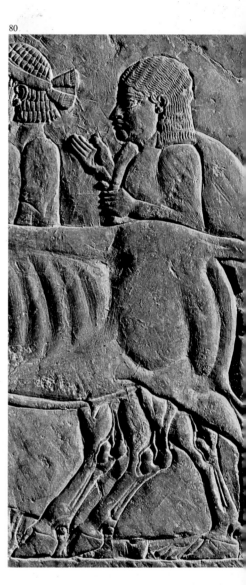

80

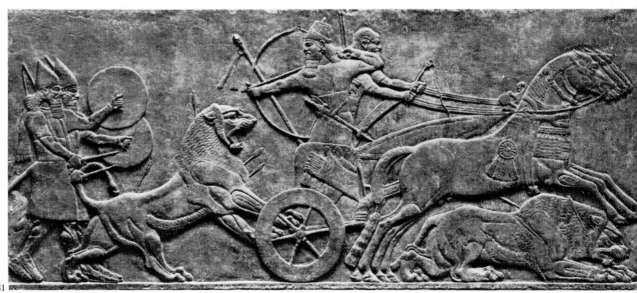

81

78 *Winged, man-headed bull,* **from Dur Sharrukin (Khorsabad). Chalk alabaster. Assyrian, 8th century B.C. The Louvre, Paris.** This winged bull with a man's head, carved from a single block, seeks to express a kind of pitiless machine capable of crushing any hostile visitor. The five legs present the beast as truly complete, from whatever angle viewed.

79 *The hero Gilgamesh,* **from the palace at Dur Sharrukin (Khorsabad). Alabaster. Assyrian, 8th century B.C. The Louvre, Paris.** Gilgamesh is one of the figures that Mesopotamian art loves to depict, often in scenes of his combat with wild beasts. The artist uses the convention of the body seen frontally, with the feet in profile.

80 *Deportation of populations,* **detail of a relief. Alabaster. Assyrian, 7th century B.C. The Louvre, Paris.** This detail is from a scene of deportation after one of Assurnasirpal's victorious campaigns. As though the artist here could express only violence whatever his theme, the forms are hard and muscles tensed, though the pace is calm.

81 *Relief of Assurnasirpal hunting,* **from Nimrud. Alabastrine limestone. Assyrian, 9th century, B.C. British Museum, London.** The hunt ranked with war among major themes imposed upon the Assyrian artist. It is also the theme which he treated with the greatest success, continuing a rich tradition of animal art. Here, all narrative incident excluded and the background mute, the scene is raised to a symbolic, didactic plane.

82 *A king in his chariot of state;* **detail of a relief. Alabaster. Assyrian, 7th century B.C. The Louvre, Paris.** The king, recognizable by his tiara and his regal stature, stands in a chariot with a huge spoked wheel and woven bodywork. The relief is carved with assurance, the clearly defined silhouettes outlined against a perfectly plain background, and then treated to a profusion of ornamental surface detail.

83 *The Demon Pazuzu.* **Bronze. Mesopotamian, 1000 to 500 B.C. The Louvre, Paris.** Pazuzu, "the king of the evil spirits of the air, who comes fiercely from the mountains in a high rage," is one of the Sumero-Akkadian evil spirits, along with the "Seven" and Labartu, terror of pregnant women. Depicted in the form of a lean naked man, with fiercely grinning jaws and two pairs of wings, the figurine, with a ring attached to the head, was meant to be hung around the ill person's neck to exorcize and destroy the power of the demon.

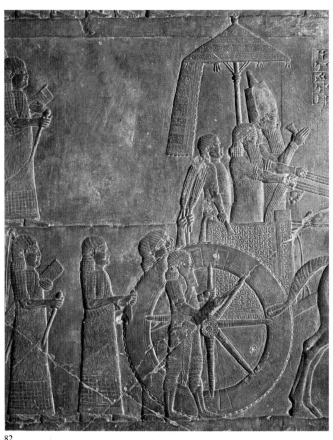

82

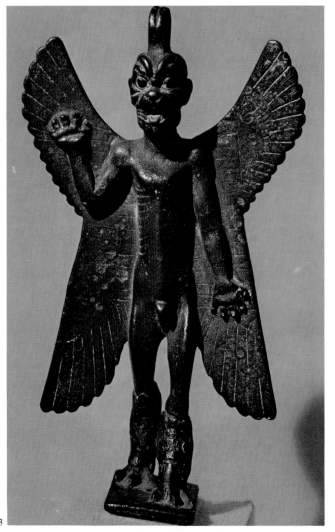

83

iconography has been perpetuated: Louis XIV of France was a great hunter, and even the learned Hadrian went lion-hunting in Africa, conforming to the imperial ritual. But in Egypt scenes of war or hunting are found only in the era of decadence under the Ramessides, when Egypt burst its frontiers and gave way to the temptation of power for its own sake.

The kings of Assyria lived in immense, maze-like palaces. The main halls were decorated with low reliefs in a manner learned from the Hittites, and in a soft gypseous alabaster that facilitated the manufacture of those endless scenes depicting the mighty lord's ceremonies, wars and hunts, in which the despot himself is depicted as larger than other men, and isolated by his own impassive cruelty. From the moment the visitor crossed the threshold, he was subdued to the proper frame of mind by the awesome doorkeeping genii between whom he must pass, and who were designed to "maintain fear in the king's subjects, and so please his heart." Hybrids of man, lion, eagle and bull (fig. 78), these beings combined the attributes of strength based on instinct and on intelligence. Provided with five legs so as to look complete either full face or in profile, they demonstrate a lack of three-dimensional vision on the part of Assyrian artists, who almost ignored sculpture in the round; and in fact, only very few Assyrian statues have been found. The exclusive use of profile is suitable for a narrative art showing passing forms in an ever-renewed action that knows no other cessation than in death. This art of the silhouette is interested only in gesture, showing men as well as animals in the midst of physical action. The animals are more lively, for they are free from the hieratic impassivity of the king, in whom only an awareness of the necessity of cruelty is expressed; no human faces have ever looked more inhuman, and even death leaves them untouched.

Needless to say, women are absent from these war-exalting themes with their exclusive virility, something quite alien to Egyptian art, whose repeated depictions of the divine royal couple evoke the ideally human in its two opposite incarnations. Classical Greek art emerges from its fierce primitivism with the kore's smile; and at all times art has become more

84

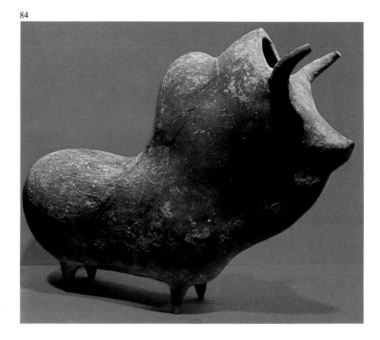

fully human when representations of woman as man's companion are introduced, bringing man to a better understanding of his inner self—man who, left to himself, extraverted, always tries to be superman.

The awareness of surrounding space, which some Egyptian art attempted and which was to be the greatest achievement of Greek art, is totally lacking in Assyrian art. The characters are rows of puppets, each acting separately, not linked with his neighbour even in battle scenes, where one might expect an exchange of passions between two men trying to kill each other. When they attempted to depart from the usual alignment of successive forms, and to suggest depth, Assyrian artists could only superpose the forms in an inextricable muddle on the surface.

Minor arts confirm this inability to achieve unity, which I have already proposed as one of the characteristics of the demonomaniac ethics and aesthetics of civilizations that lived in perpetual fear of occult menace; for demonomaniac acts are essentially a disruption, something that separates, while God is unity. Form is here defined by a heavy outline with jerky accents, the hard contours imprisoning the human essence. In those flattened reliefs, the ripple of muscles express-

84 *Rhyton in the form of a bison.* **Terra cotta. North Iran, 9th to 8th century b.c. Foroughi Collection, Teheran.** Discovered during fortuitous and often clandestine excavations, this rhyton in red terra cotta, of very fine paste, has the form of a bison, the animal which with the stag, most often inspired the coroplastes of Amlach.

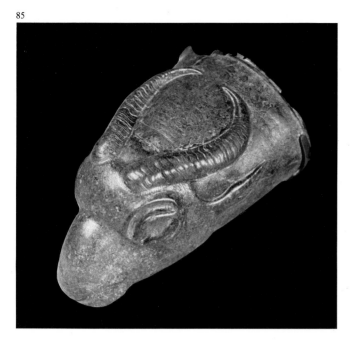

85

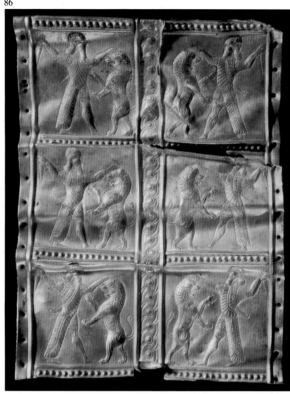

86

ing violence in action is shown by sudden bulges on the surface *(fig. 81)*, often with a harsh outline that seems to imprison this energy at the very moment of its release. In Assyrian art we find for the first time a stereotyped quality, which is one of the characteristics that have been called archaistic or primitive, but which has nothing to do with the art of the first men; it appears, rather, in derivative civilizations born of conflicting influences and trying to free themselves for a new start: in Greek art in the 6th century, for example, or in Romanesque art, or in the Buddhist art of the Chinese caves. The aesthetic created by Assyrian art combines stiffness of modelling with hieraticism, and was to emerge later as the true Asiatic tradition, which cast a gradual paralysis over the heritage of classical antiquity, to create what we call Byzantine art.

Before the creation of the Achaemenid empire, the Iranian plateau knew the art of two different peoples. One consisted of nomadic groups, whom some historians believe to have been the Cimmerians, and who settled along the Assyrian border, in Luristan, at the end of the 9th century. Although they had adopted a sedentary life, these horsemen and shepherds continued to make only small metal objects, mainly

horse gear and chariot parts—a portable "minor" art practiced by migratory steppe nomads. In these pieces Mesopotamian mythology appears mingled with the indigenous nomad tradition, and new forms full of symbolic meaning proliferated in the Luristan bronzes. When first discovered, these works aroused interest because of their resemblance to Romanesque art. The recently discovered zoomorphic objects of Medean prehistory, however, seem far more likely to have contributed to Achaemenid art. Their soft, supple modelling is the very opposite of the harsh abrupt contours of Assyrian bas-reliefs. But from the Assyrians, Achaemenid emperors borrowed the basic feature of the court art devoted to the greater glory of the ruler that ornamented their great palaces in Iran. This glory was no longer based on war: the Achaemenids had gone beyond the primitive stage of power based on force and exalted a power based on justice exerted through the state—a civilizing instrument whose main representative was the King. The religion of the Medes and Persians, based on a sky-god, the first to isolate the metaphysical essense of divinity; religious rites were elevated by the prohibition of sacrifice and of the soma-induced shamanist trance, leaving only the cult of fire. In their conception, two opposite prin-

85 *Rhyton in the form of a gazelle's head.* **Bronze. North Iran, 8th to 7th century B.C. (?) Foroughi Collection, Teheran.** Of unknown origin, this bronze goblet would seem to date from the time of the rise of metallurgy in the mountains of northwest Iran, 8th or 7th century B.C.

86 *Plaque from a revetment,* **from Ziwiye. Gold. Iran, Scythian, 7th century B.C. Archeological Museum, Teheran.** Repeated in several *repoussé* reliefs is this scene well-known from Mesopotamian art. The hero's dress and beard, and the treatment of his muscular calf are Assyrian.

87

87 *Warriors* **on a tile from a frieze, from Pazarli. Painted terra cotta. Phrygian, 6th century B.C. Archeological Museum, Ankara.** The two warriors on this plaque, wearing crested helmets and greaves, and carrying lances and round shields, very much resemble hoplites. Such tiles, molded in relief and then coloured, were most often intended as elements of friezes running beneath the eaves of a building.

88 *Capital with bulls,* **from the palace of Darius at Susa. Persian, Achaemenid, late 6th to early 5th century B.C. The Louvre, Paris.** Darius' private palace was built in Mesopotamian fashion. The architects show considerable boldness in capping the slender columns with these monumental capitals, placed on the fluted shaft over a cruciform section decorated with volutes. The roof beams rested on the necks of bulls.

88

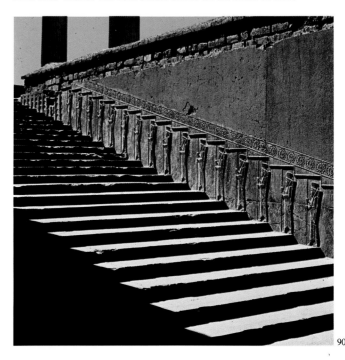

90

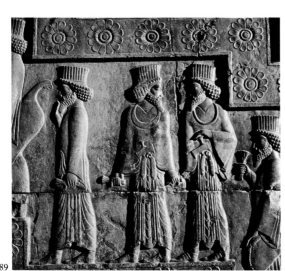

89

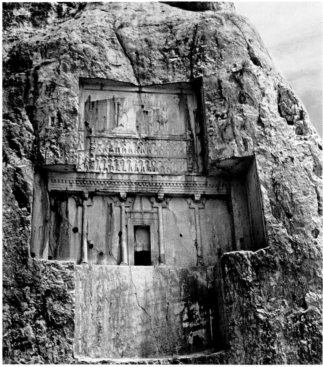

91

92

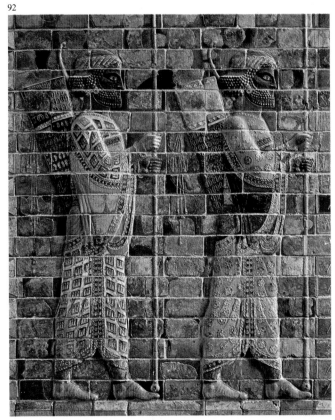

89 *Procession of dignitaries,* **relief on the staircase of the royal palace at Persepolis. Persian, Achaemenid, 5th century B.C.** Sculpture at Persepolis remained subject to the principle of the decorative frieze, uniform, and always dependent upon the architecture. The Achaemenids adopted this formula from the Assyrians, but made it more flexible. This is a detail from a bas-relief decorating the staircase of the Council hall.

90 *East staircase of the apadana* **of the royal palace at Persepolis. Persian, Achaemenid, late 6th to early 5th century, B.C.** Begun under Darius I, Persepolis, the royal Achaemenid town, is a grandiose showcase of an official art created for the court. The decoration of the staircase leading to the *apadana,* the royal audience hall, depicts a whole procession of courtiers all fixed in stone. The king went to Persepolis at certain festivals to receive the homage of the Empire's 28 subject nations.

91 *Rock-cut tomb of Darius,* **at Nagsh-i-Rustam (Laristan). Persian, Achaemenid, 5th century B.C.** In opposition to the Mazdean custom, the Achaemenid kings revived a tradition of Median princes and were interred in tombs excavated directly in the impressive cliff at Nagsh-i-Rustam, near Persepolis. The façade of Darius' tomb, about 73 feet high, takes the form of a Greek cross. The sculptured part imitates the entrance to a palace, with its columns surmounted by bull-shaped capitals.

92 *Archers of the royal guard,* **from the royal palace at Susa. Glazed brick. Persian, Achaemenid, early 5th century B.C. The Louvre, Paris.** On this frieze, scarcity of stone and proximity to the Mesopotamian plain are two factors explaining both the use of glazed brick, and the Neo-Babylonian influence, more marked at Susa than at Persepolis.

ciples were fighting over the universe, and the good would inevitably win. A new dawn was coming in an Asia so long crushed by fear; Mazdaism's leavening optimism was to be fully developed when Christianity, influenced by classical antiquity, separated it from Judaism, where it remained mixed with a fearfulness inherited from Babylonia.

A superficial comparison of the bas-reliefs at Achaemenid Persepolis with those at Assyrian Khorsabad might suggest only similarities in those endlessly aligned figures; in fact, all is different, beginning with the buildings themselves. Persepolis was not a fortress like the royal buildings at Nineveh or Assur, but an open palace, a symbol of the union of many peoples within the empire. At the end of the processional roads that led to the palace was a royal audience hall, in which the monarch might show himself to his subjects. The sculptured reliefs no longer celebrate the despot's cruelty in war, but his power, acknowledged by his subjects, to maintain peace. The processions depicted at Persepolis represent the New Year festivals, during which high dignitaries, governors and provincial delegations came from all parts of the Persian empire to bring their offerings to the King of Kings. Outwardly, the same conventions exist as in Assyrian art: an endless repetition of attitudes and gestures, a monotony even more marked because the personages are not in action *(fig. 90).* But the meaning is different. Those lined-up forms are still autonomous, but they are no longer separate; the spaces between them have become intervals, and there is a feeling of rhythm. All the forms are linked by a harmonious alternation of solids and voids; the series has become a sequence. The faces are set, but their rigidity is ceremonial dignity and not fierce impassivity. The modelling is softened and polished and the outlines make up a harmonious abstract design, with supple movements suggesting the existence of living forms.

It is very likely that the Achaemenids looked for models, and perhaps even for artists, in Ionian Greece, over which they ruled for a while, for Greek influence seems to soften the harsh forms borrowed from the Assyrians. Synthesizing the two influences, Persian art seems to testify to a sudden conversion of the Asiatic spirit from darkness to light.

III

GREEK AND ROMAN SCULPTURE

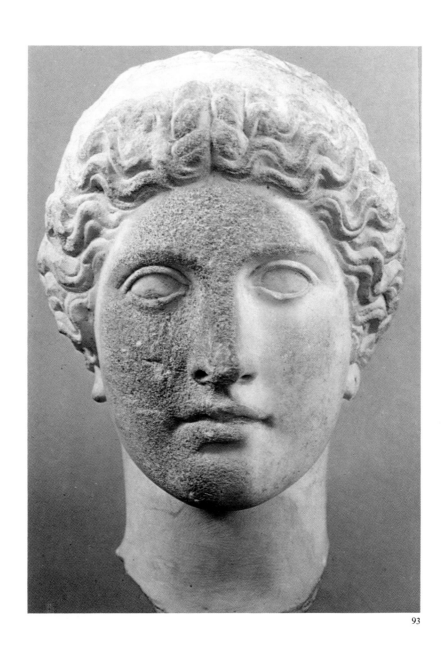

93

I. *Greece*

"The world of classical Greece is dying before our eyes today. What neither invasion, nor the infiltration of Christian barbarians, nor the underhand intrigues of the coarse monks of the Thebaid, nor even time, that tireless destroyer, could achieve, is now accomplished under our very eyes by the ephemeral triumph of a few political demagogues." Thus in 1905 Péguy lamented the gradual disappearance of Greek from the curriculum of the French schools. Nowadays classical studies are almost everywhere a thing of the past; relinquished even by the Roman Catholic church, Latin is joining Greek in the sepulcher of discarded languages. But the spirit of Greece is not dead; it still has what Péguy called a "living existence," having survived the demise of Homer's language to extend its message in another form: art. As the world becomes more internationalized, this nonverbal form for the communication of ideas is more and more appreciated; its prophetic value (in the etymological sense of the word prophet, that is, "spokesman") has nourished in modern culture a new interest in the past. Greece has never known greater prestige than she now enjoys through her art. Classicism, which she initiated, is the only aesthetic form to have survived the new barbarian invasions; in the name of primitive fetishes Raphael was dismissed, but not Phidias; and even Gauguin, in a passage often misunderstood because quoted only in part, paid homage to Greek art while trying to escape from its influence.

Our understanding of Rome will suffer more from the disappearance of her language, because the visual arts were but a secondary aspect of her genius. No amount of familiarity with Roman art can replace the knowledge of Latin, from which many European languages are more or less descended. The reality of Rome lies in the *Aeneid,* the *Commentaries,* or the *Pandects,* not in the Ara Pacis or the Pantheon; but Greece speaks to us through the Parthenon as much as through Sophocles.

The Greeks themselves thought differently: despite the admiration they accorded to their greatest artists they believed that the Gods made themselves heard through the voices of poets. To Greece we owe the pre-eminent place occupied by literature for so many centuries, and the corollary that the language of the visual arts was for so long relegated to an inferior position as a technical or mechanical skill. The Greeks in this respect did themselves an injustice: thought, in their culture, expressed itself through visible forms as much as through words. Incarnating the absolute in the simplest kind of human ideal, their art assumed the value of a principle which, despite an occasional eclipse, has remained a constant in western culture and still rules us today, inspiring even those, such as Picasso, who seem most to transgress it.

The Greek ideal expressed itself best in sculpture. Under the Greek sun sculptural form reached a perfection never attained again, and one more complete than we can now know, since the colour that originally enhanced the significance of the form has vanished. Writers on Greek art have evaded this matter of polychrome architecture and sculpture—as though Greek art were somehow tainted by the sin of realism (symbolized by the story of the *Aphrodite of Knidosi,* whose original colours were so lifelike, it is said, that she provoked an indecent assault); as though the truth of art had been sinned against by the very men who made it; and as though its beauty owed more to the work of time than to that of its creators. Describing a multi-coloured Parthenon, the French Hellenist Raymond Picard termed it "baroque." It is hard to see why color should make a work baroque rather than classical—unless our vision has become biased by the time-stripped white statues that we know. Under the word baroque seems to lurk some pejorative allusion to a polychrome Spanish sculpture. But can we imagine the sublime spiritual images of Martinez Montáñez filed down, reduced to the original wooden core and deprived of the intense liveliness of colour which gives them such radiance? The statues of the great Seville artist, though painted, represent one of the summits of classicism. The Greeks went as far as the Spaniards in their illusionism, and even made draped and articulated dummies with sculptured hands, feet, and heads—the acroliths, very similar to the *estatuas de vestir* carried through the streets of Seville during Holy Week.

If we pause to think, we will realize that the Greeks could

93 *Female head,* **from the west pediment of the Heraion at Argos. Greek, Classical, ca. 420 B.C. National Museum, Athens.** This head of a young woman is one of the few remaining fragments from the sculptured decoration of the new Heraion at Argos. The sobriety of style suggests that this head may be a work from the school of Polykleitos, who made the chryselephantine statue of Hera herself for the same temple.

not have done otherwise than to conceive their monuments in colour. The many comments concerning the famous Greek light that "sculpture forms" come from philosophers, professors, or writers, who have transferred to Greek skies their own notions (preconceived in academic seclusion) of an abstract light that appeared to them a necessary corollary of the rationalism they attributed to Atticism. But the Greeks—it is too often forgotten—were a sea people. Who thinks of their light as a chisel fit only for cutting out volumes has never seen it shining over the Greek sea, searching out each wavelet and transforming the waters into shimmering jewels. It would be surprising had the Greeks, a visual people, not been struck by the colourful intensity allied to the plastic values of their sea, which so little resembles the Atlantic's grey and misty fluidity. We must imagine in their full glory of colour those temples now naked and scalped by the light; instead of the wind-corroded skeleton on Cape Sounion, picture a temple whose glow answered the liquid fire washing the promontory's foot. Far from detracting from the form, such polychromy must have enhanced it. The Parthenon's "gaudy colours" must have underlined the relationships between the various parts of the structure and exalted the life

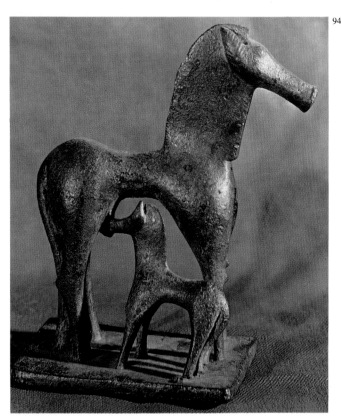

94

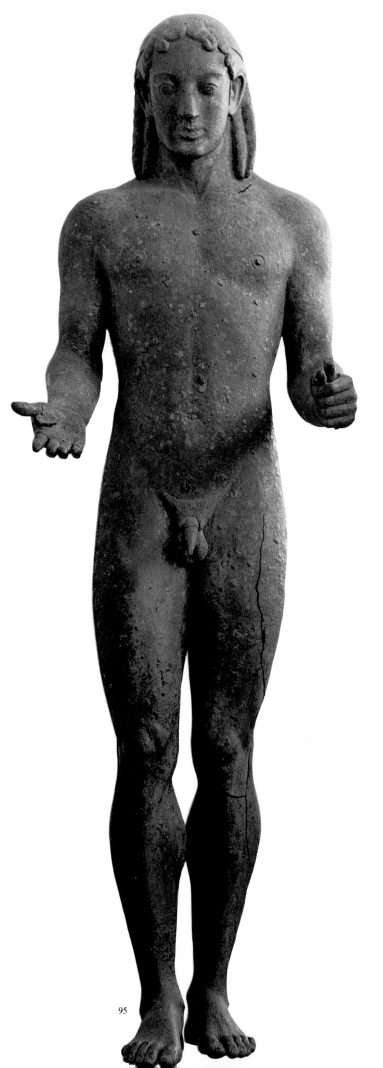

95

98

94 *Mare suckling her foal.* **Bronze. Greek, Geometric, 750 to 700 B.C. National Museum, Athens.** This group is a charming example of the small bronzes made during the Geometric period. The masses are stylized into simple volumes. The simple silhouette incorporates the barest essentials of form, with only the ears and knees as sharper accents.

95 *Kouros from Piraeus.* **Bronze. Greek, Archaic, ca. 520 B.C. National Museum, Athens.** In 1959, at Piraeus, this oldest known bronze kouros was discovered. The youthful figure (76 inches high) held a bow in his left hand, and probably a *patera* in his right.

96 *Female figure,* **formerly in Auxerre. Limestone. Greek, Archaic, ca. 650 B.C. The Louvre, Paris.** This female statuette, 26 inches high, is of unknown origin, but it must be attributed to Cretan art, and clearly illustrates the first phase in Greek statuary. Standing rigidly encased by her tunic, blocky curls of hair framing her face in the Egyptian manner, she holds her right arm pressed against her chest. Her costume is adorned with geometric designs.

97 *Hera from Samos.* **Marble. Greek, Archaic, ca. 570 to 560 B.C. The Louvre, Paris.** Taller than life (6 feet 4 inches high), the goddess seems to sum up the delicate refinement of Ionic art, which was represented at its most accomplished on Samos. Here the artist works his marble with great technical mastery and sensitivity.

98 *Kore 675* **from the Athens Akropolis. Marble, polychromed Greek, Archaic, ca. 530–520 B.C. Akropolis Museum, Athens.** In the lovely procession of kores dedicated to Athena, this one stands out because of the astonishingly well-preserved polychrome painting. The tunic, of a uniform bluish green, molded on the torso, is partly covered by a mantle of natural light colour strewn with red and blue designs which hangs from the right shoulder. The height of the figure as preserved is about 28 inches.

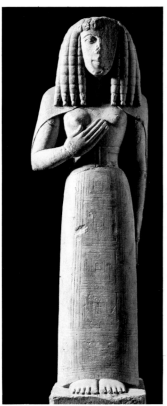

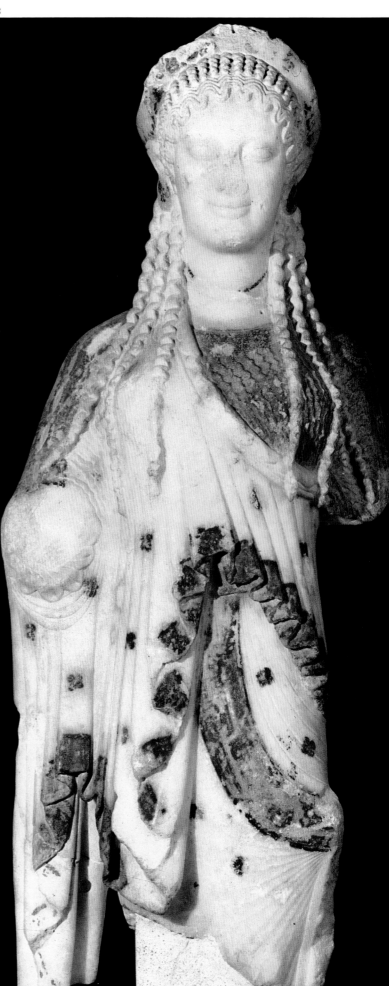

96 97

of its statues in space. The Parthenon today is probably as "absurd" as the nave of Amiens cathedral, where a cold light dissects an interior that its builders had intended to throb with the mysterious life still given Chartres by its stained-glass windows. In the history of art, periods in which architects did not use colour are more the exception than the rule. But of Greek colour, as of Greek painting, nothing is left; vase painting with the stylizations proper to it, is likely to give us only mistaken or limited notions of Greek colour. A whole aspect of Greek art has been lost forever, and we can only surmise that the Greeks were able to achieve a fitting synthesis of all the arts. Of that synthesis only *membra disjecta* are left, and when we study Greek sculpture we are constrained to a study of modelled volumes without the enrichment of the lifelike colours with which they were conceived.

In the course of time polychromy was actually used less and less in sculpture, and it appears to have been largely abandoned in the later periods. The simplified masses of the pediment sculptures at Olympia depended upon colour for secondary accents in the modelling; but already in the Parthenon, the forms are self-sufficient without the colours that once heightened their effect. In the 4th century the chromatic range became less bright, the hues less arbitrary and nearer to the refined nuances with which painters were then experimenting.

To understand the sculpture of Greece as it really was, we must not only reclothe the statues and buildings in lively colours, we must also attempt to reconstruct in imagination certain works for which the Greeks reserved their highest praises, the enormous chryselephantine *Athena Parthenos* or the *Zeus of Olympia,* both by Phidias. The historian's mind has boggled at the attempt: apart from the fact that it may appear naive to have tried to represent the gods' greatness by gigantic statues, the use of goldsmithery on such a scale has offended admirers of Greek art as an incomprehensible lapse into barbarism. To the dim interiors of the temples these idols, for such they were, contributed the shining hues of their precious materials, of gold and ivory richly worked, of jewels. Yet their expressiveness was not sacrificed to the gold-

smith's craft: the air of sovereign benignity that graced the head of the Zeus at Olympia, and which was so admired by those who saw it, can still be guessed at in the head from Cyrene which, experts tell us, most nearly resembles Phidias' conception of the god.

Perhaps what most inhibits our understanding of Greek statuary is the fact that so much of it is known only in copies. What could we understand of Michelangelo's art if all we knew of it were the Montorsoli copies, or imitations by even less gifted artists? The degradation suffered by Greek works is symbolized in this book by the juxtaposition of the Erechtheion karyatids with a Roman copy from Hadrian's time and a 19th century restoration by Thorwaldsen! *(Figs. 108–109.)* In a way we are better acquainted with Egyptian or Mesopotamian art than with Greek, for there, it is the original that we study. The study of most Greek sculpture proceeds by a system of induction that attempts to work its way back through bastardized imitations—and even through literary descriptions—to the original forms. It is as if the historian trying to grasp the principles of Gothic sculpture had as his only material the 19th-century statues designed by Viollet-le-Duc and executed by Geoffroy-Dechaume for Notre-Dame in Paris. However, we are not quite that badly off, for

99 ***Wounded warrior,*** **from the temple of Aphaea at Aegina. Marble. Greek, Archaic, 500 to 480 B.C. Staatliche Antikensammlungen, Munich.** This figure of a wounded warrior, fallen in the battle between the Greeks and the Trojans, is an interesting example of Aeginetan sculpture. Handled in the manner of bronzes, a cold effect is produced by the studied anatomical forms and delineated contours. The conventional smile and some awkwardness in the figure are the clearest notes of persisting archaism in its style.

100 ***Lapith woman,*** **from the west pediment of the temple of Zeus at Olympia. Marble. Greek, Early Classical, ca. 460 B.C.** The gestures are represented with a classic restraint, which softens the violence of the scene. The drapery, with conventional but harmonious curves, balances the figure of the young woman being ravished by a centaur.

101 ***Head of a Lapith,*** **from the west pediment of the temple of Zeus at Olympia. Marble. Greek, Early Classical, ca. 460 B.C. Museum, Olympia.** The young Lapith is being bitten in the arm by the centaur whom he is trying to overcome. To express the Lapith's pain, the sculptor has made the features more human. The conventional rendering of the hair does not diminish the sense of power emanating from this figure—as, indeed, from the whole pediment group.

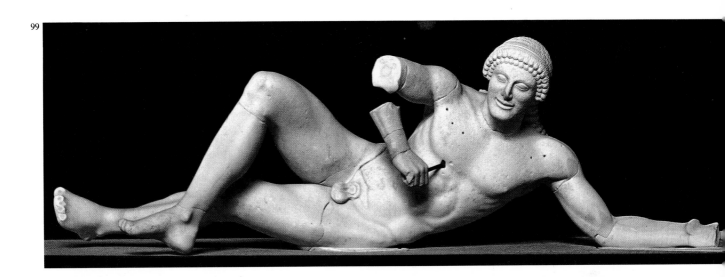

99

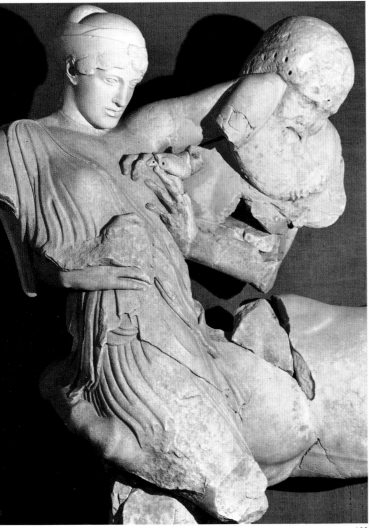

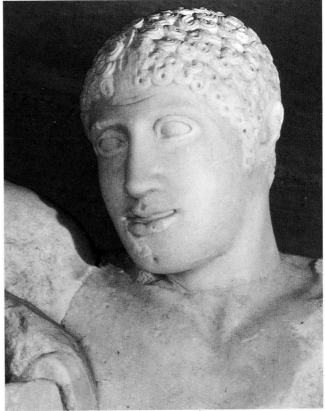

101

100

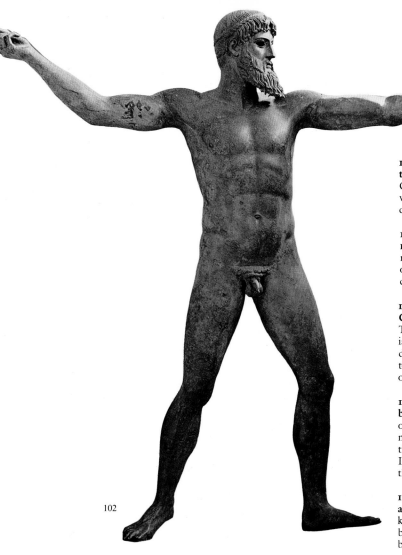

102

the principles embodied in Greek masterpieces were such that some trace of them survives even in vulgarized derivations. In fact, we seem to meet here with the Platonic concept that the truth of a form, be it in art or in nature, is not in its physical appearance, but in the idea that gave it birth. However lifelike a Greek statue may have been—and the marvel of Greek sculpture resided in the unity between nature and ideal—its supreme message was an abstract idea; that idea is what we search for, under the more or less coarse mold of matter in which it is now cast.

It is our great good fortune that, by the miracle of the Parthenon's preservation, we are able to apprehend the major achievement of Greek art not just through literary records but in the tangible reality of a related body of architecture and sculpture. The course leading up to the Parthenon can also be mapped out with relative clarity, for archaic works did not particularly attract the antiquarian-minded collector,

and many have been unearthed in their original locations. In the 4th century we become more uncertain; in the Hellenistic period increasingly so. It is here that the approach to Greek art becomes a kind of intellectual game, or creation of the imagination. Using the rare surviving texts as clues, we must interpret a crowd of copies and imitations left by the Roman empire. Their insipidity would soon discourage us if we did not each time make the effort to work our way back to the underlying principle, to the idea—which would have delighted Plato—to ensure our remaining within the *order* of things.

There is a gap in time between the last manifestations of Mycenaean art and the first of Greek; all attempts to fill it have been unconvincing. With a perfectionism no doubt inherited from his Greek origins, Christian Zervos has written a beautiful book entitled *The Birth of Greek Civilization,* but all the works which he has gathered in evidence around the

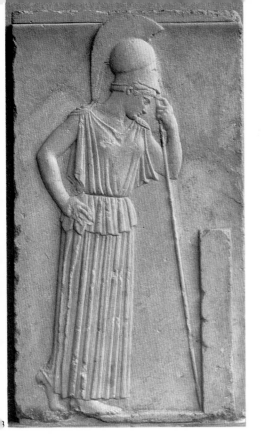

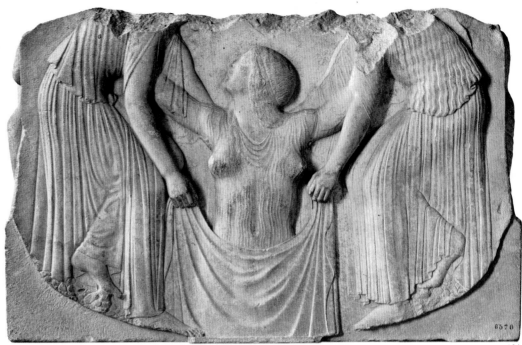

104

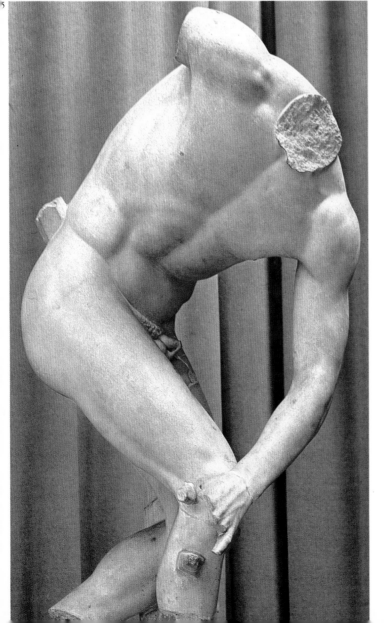

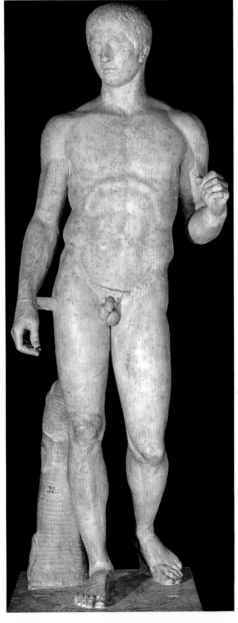

106

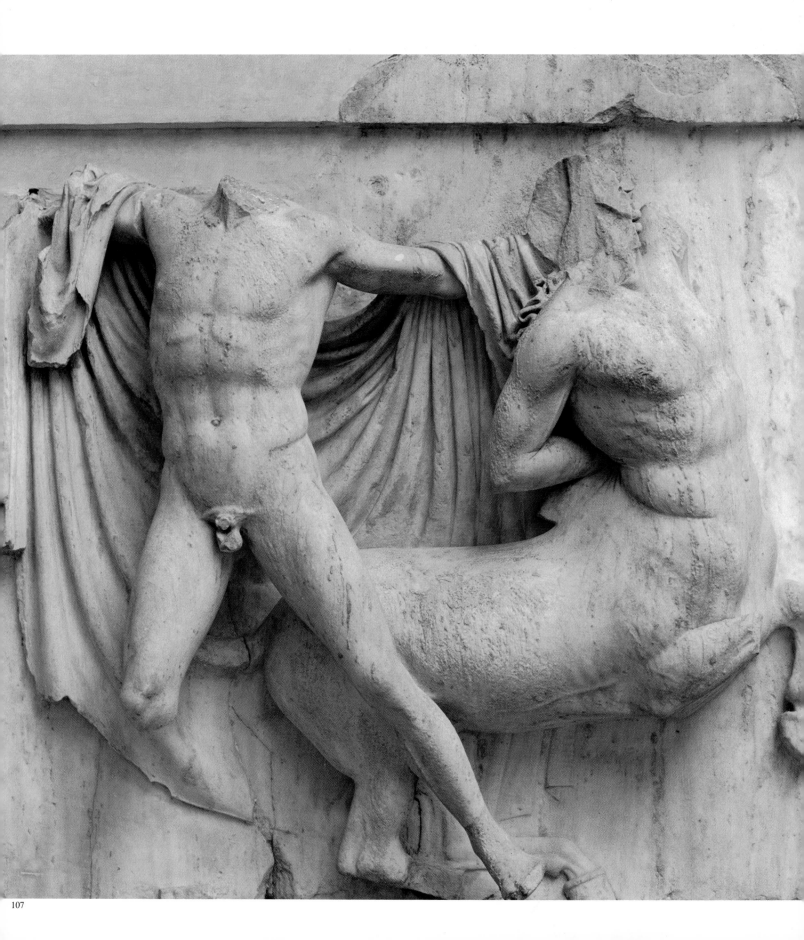

Mediterranean area appear to represent endings, rather than beginnings. The notion that Greek art must perforce have resulted from a slow process of maturation originates in the prevailing conception that all history is one continuous evolution—a conception refuted by history itself. There was, in fact, a "Greek miracle," just as there was a Romanesque and a Gothic miracle. In the beginning of the 8th century, all around the Mediterranean, in Ionia as in southern Italy, in the Aegean as on the Greek mainland, forces were germinating which within one century would give birth to Greek civilization. It is as useless to seek explanations of that phenomenon as to try to settle just why, around 1100, some sculptor created the Miègeville portal (and with it a Romanesque style) at St.-Sernin in Toulouse.

Can we agree with those who consider the smile worn by the first Greek statues a result of the sculptors' ineptness? That "hieroglyph of felicity" blooms on the stone faces as though welling up from an irresistible vital impulse; it animates even the dying warriors (*fig. 99*) from the Aegina temple pediments. It fades, then, in the first half of the 5th century, when the great trial of the Persian wars led the Greeks to a deeper awareness of their own forms of thought and life, and to an art of profounder import, both civic and theological—the art of Perikles and Phidias.

In the 6th century, Greek art became conscious of its own aims. Its great discovery was the statue as an autonomous organism and—what might seem contradictory—its adaptation to another organism of which it became an integral part: the monument. In Egypt and Mesopotamia sculpture in the round had made only a timid appearance, and the depicted human still clung to a supporting wall; or when he did stand free, he remained as rigid as the wall or as the block from which he had been carved. When, in Greece, shortly before 500 B.C., the statue won a mobility resembling that of its model, it was a parallel to the contemporary philosophers' concern with conciousness of self. From this time on a human being was to be a form inscribed in space; not just an outline, but a solid form occupying all three dimensions. This figure has neither back nor front, is not even to be viewed "from all sides," which would imply that it had "sides," but is self-defined as a unity of mass, volume, and direction organized within its own limits; this figure in the round is the first affirmation of humanity reduced to itself, stripped of any admixture of the divine or daemoniac. The man knows himself to be other than the gods; to stand facing them not in a spirit of pride but in a spirit of acceptance of the fate willed by the gods—who in any case differ from humans only in their aboundingness, which in humans would be excess, *hubris,* and the road to perdition.

The sculptors did not arrive at their new conception of the free-standing statue through representations of the gods: they experimented first in their renderings of humans. For a long time, in fact, the cult statue of the god or goddess retained its fetish-like form of a *xoanon* or baetylic stone, inherited from the original tree or rock, possessing the more mana for its indeterminacy of form. Even in marble the cult image still resembled the menhir-statue of early worship, or the column-statue reminiscent of the divine pillar held sacred by the Cretans and Mycenaeans. The Hera from Samos in the Louvre (*fig. 97*) has kept her columnar form, but she is an incarnation in metamorphosis: a blossoming human form issues from the stone, with voluptuous breasts and curving loins. When the idol finally assumed human form at the beginning of the 5th century B.C., it borrowed from the *kouroi* and *korai,* ideal youth and maiden figures representing mortals who had their statues placed near a temple to attract the favor of the god. In these male and female figures the Greek sculptors defined the two poles of humanity, in whose dialectical opposition resides the life principle. The Greek mainland, more imbued with the Doric spirit, created the masculine type, while Ionia is responsible for the feminine type. The Ionian influence entered Greece proper after 500 B.C., when the Greeks of Asia fled the advance of the Persians, and the confluence of Doric and Ionic styles produced Atticism. Until the 4th century the female statue remained clothed, the sculptors delighting in the study of drapery moving over the feminine forms, which are more salient than those of the male body. The male was represented nude, and allowed the sculptors to

107 *Centaur and Lapith*. **The Parthenon's Metope, Athens. Marble. Classical 447–442 B.C. British Museum, London.** Of all the Parthenon's metopes, those on its south side are the most familiar to us today (18 of 32 remain intact). Unlike Olympia, where the figures are one with the plaque, here they seem to move in front of a screen and the curved motif overshadows any vertical or diagonal lines.

108

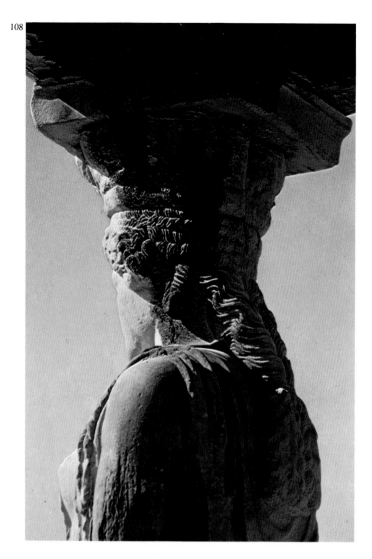

108 *Karyatid from the Erechtheion.* Coiffed by elegant sculptured cap-itals serving both as headdress and architectural elements, the karyatids successfully combine strength and elegance. Each maiden's peplos falls along her supporting leg in vertical folds which suggest the flutings of a column; but the reference becomes clearly human where the transparent material molds her breasts and her other bent leg.

109 *Karyatids from the Erechtheion.* **Marble. Greek, Classical, ca. 417 to 409 B.C.** The graceful karyatid portico was built about 420 B.C.; the maidens were *in situ* in rough form before 417, and by 410 or 409, were finished. The robust young women (height, 92 inches) in Pentelic marble revive a type of support created by the Ionian architects of the Archaic period.

110 *Wounded Niobid.* **Marble. Roman copy from a Greek original of ca. 440 B.C. Museo delle Terme, Rome.** The young Niobid is arrested in her flight by the celestial arrow that has struck her back; she is falling, her left knee nearly touching the ground, her torso stiffening with pain, and her mouth half open in a cry which is interrupted by death. With her right hand she tries to pull out the arrow, while her left holds up her peplos. Already in 5th-century Greek art the human body could become a vehicle for suffering.

109

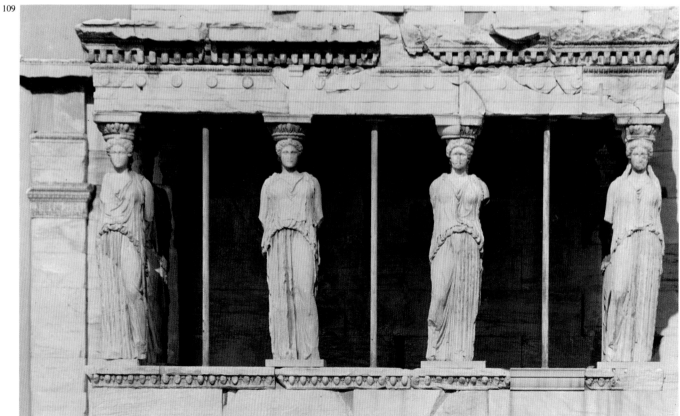

express that "corporeality" which is an essential element of Greek art. It is of interest to reflect in this connection on the development during the 7th and 6th centuries of the scientific spirit: science was no longer a technique by which men propitiated natural forces, but a search for pure knowledge; the sorcerer became a scientist; the magus became a philosopher. Such a development supposes that the thinking being defined himself first, then turned his attention to the surrounding world. It was the greatest revolution in human thinking since the technical leap forward of the Neolithic period, though operating in an inverse sense: the continuity linking all things and all beings—including man—was broken; nature became the object and each of its manifestations a phenomenon, hence observable. Reality was whatever was *tangible;* all things had a body, however minute, bounded by limits. At least that was so until Plato saw those appearances as a mirage and looked for reality beyond them. Even Pythagoras, although he conceived the universe as a sequence of mathematical relations, did not go beyond the bounds of that spirit of exact science. Plato carried it over into metaphysics; Aristotle was to bring the world back into the realm of the senses.

The aims of Greek art after the 6th century were very close to those of science: to discover the outward appearances of nature by reproducing them. Art, which has subsisted through centuries in a spirit of serene majesty, suddenly became alive with the rhythm of progress. Nature was best studied in her masterpiece, man: "Although there are many marvels in this world," Sophocles says in *Antigone,* "the greatest marvel of all is man."

It appears that pre-Hellenic art had so little to offer the early Greek sculptors that they turned to Egypt for the models for their first statues; but right away the undifferentiated mass of the Egyptian body was filled with muscular strength, compact at first, later sinuous and elegant. After form, movement had to be mastered. If painting showed the way, Myron's bronze *Diskobolos (fig. 105)* represented a decisive step: for the first time a complex set of movements was converted by analysis and synthesis into a shape molded in space, of which it takes possession in every dimension. That

110

twisted shape has neither profile nor full-face, nor three-quarter view; it is modelling in the round. Soon after, Polykleitos, in a spirit of aristocratic idealism perhaps inspired by Pythagorean theories, returned to the principle of frontality, and incorporated in his figures an ideal system of proportions. The Greeks' conquest of the individual form was always tempered by the search for the universal and typical; art, like science, must aim at general principles. The classicism that the Greeks first defined is badly understood in our time; we tend to forget that it rested essentially on naturalism, but a naturalism reaching for a truth deeper than that of the momentary and individual. It was the One that the Greeks sought in the unique; through men, they sought Man.

The speculative tendency, made possible by the individualism of a society in which subjects had become citizens, freed the artist from all kinds of limitations. From an obscure artisan destined to oblivion the artist is transformed into a creator, promoted to glory. Alongside the name of prince or

111 *Maenad with goat*. **Marble. Roman, perhaps after a lost Greek original of the late 5th century B.C. Palazzo dei Conservatori, Rome.** This graceful marble bas-relief (height 57 1/2 inches) is among the finest examples of a Dionysiac motif often reproduced by Roman sculptors. This kind of dextrous calligraphy characterizes a group of works usually attributed to the Athenian sculptor and goldsmith Kallimachos.

112 *Nike untying her sandal*. **Marble. Greek, Classical, ca. 410 to 407 B.C. Akropolis Museum, Athens.** The parapet formerly surrounding the small temple of Athena Nike at the entrance to the Akropolis is a masterpiece of the style that triumphed in Athens during the last quarter of the 5th century B.C. The firm design and broad curves of the figure give an impression of elegance and weightlessness.

magistrate the work of art now bore that of its author. On many an akropolis the vicissitudes of history have left us pedestals no longer bearing their statues, but proudly signed, so that we are sure of the names of certain sculptors famous in ancient writings, like Kanachos or Pythagoras, whose works have disappeared.

From this time the artist had an important part of play in the city-state. Phidias acted as a sort of Minister of Fine Arts to Perikles, who shared his downfall when he was accused—wrongly it seems—of having embezzled part of the ivory intended for the statue of Athena Promachos. Lysippos, a favorite of Alexander, whom he probably accompanied to Asia, was the first court artist. Religious commissions no longer constrained the artist to observe certain rules; on the contrary, he was expected to invent, through his inspired genius, the forms most likely to incarnate divinity, or the feelings and passions of the human soul. Exercising his art, the sculptor was free to indulge in personal philosophy; Polykleitos conceived his *Doryphoros (fig. 106)* to satisfy an aesthetic ideal (and incidentally sold the statue for a high price). The artist began to suffer from the torments of creation: the 4th-century sculptor Apollodoros, nicknamed the Madman, was never satisfied with his own works and destroyed them as soon as he had finished them.

But the autonomy acquired by the statue did not lead to a declaration of complete independence. Freedom did not mean liberalism in those city-states where the government was mostly in the hands of the citizens. The statue, having

111

112

achieved its individual existence, had yet to conform to the superior order imposed by a monument, the very heart of the city: the temple. The 6th-century Greek sculptor adapted his unit of sculpture to the architectural framework by the dynamism of line (as Romanesque artists were to do); the 5th-century sculptor (like the Gothic) by the balance of masses. Preserved almost intact, but deprived of their sculptures, the temples at Paestum demonstrate the essential importance of statuary in Greek architecture. The temples are like geometrical designs, too harshly outlined in space and refusing to relate to their surroundings. Although most of the Parthenon sculpture is no longer *in situ,* our imagination can bring together the scattered remnants and reconstruct a vision of the monumental synthesis in which structure and human forms enhanced each other in the expression of a civic and sacred ideal.

Before Greek art, the Mesopotamians, like the Egyptians, had been content with spreading their sculptures on flat surfaces with no other preoccupation than to pay tribute to a courtly or sacred hierarchy, or to relate a realistic narrative. Only the Persians, as we have seen, tried to introduce some rhythm in those endless processions—but that was under Hellenic influence. The Greeks gave rhythm to their buildings by the use of relief decorations at chosen points: the metope is inscribed on the entablature like a prosodic form, scanned by the triglyphs as if by caesurae. The frieze, in form probably originating in Ionia, might be descended from the Hittite or Assyrian processional reliefs, but the order of the figures is ruled by a definite rhythm, less strict than the regular alternation of triglyph and metope and as varied as life itself. During the 5th and 4th centuries the Greeks learned to link the forms in their friezes by rhythmic patterns of gesture underlined by drapery, and by the lines of action deployed in battle scenes. In the pediments crowning the structure appeared before the worshippers some epiphany of the gods, in vivid colours that the Mediterranean sun must have endowed with the metaphysical radiance of Byzantine mosaics. Although they look like very high reliefs, the classical pediment scenes are made up of groups of statues. Pediment figures had remained attached to the backgrounds in the archaic period, but in the 5th century they were carved in the round and simply set into the pediment.

The integration of the sculptures in the design of a monument may have been first achieved by the Italian Antenor, in a temple built at Delphi by the Alkmaeonidae, exiles from Athens. The pedimental groups from the temple of Aphaea at Aegina, sculptured in the first years of the 5th century, must have been arranged with a somewhat contrived rigidity, judging from the difficulties the Munich curators have experienced in attempting to discover their original order (*fig. 99*); but the figures from the pediments of the temple of Zeus at Olympia more readily take their places in the reconstitutions of the pediments. In these figures from Olympia (*figs. 100–101*) is expressed for the first time an equilibrium

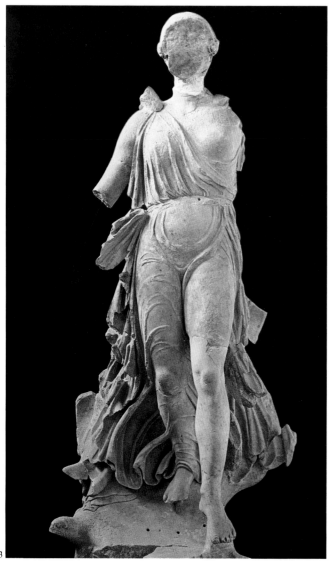

113 PAIONIOS *Nike,* **from Olympia. Marble. Greek, Classical, ca. 420 B.C. Museum, Olympia.** This Nike may have been a replica of a gilt bronze acroterion provided to the temple of Zeus. The calligraphic arrangement of the goddess' draperies is borrowed from Attic art, but the sensuous body visible through the material and the bared left leg betray the artist's Ionian origin. She is represented with her wings still outstretched, just touching foot to the ground.

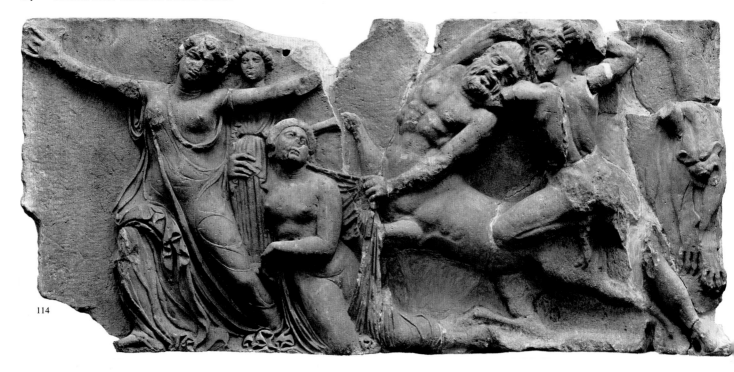

114

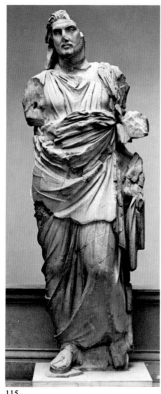

115

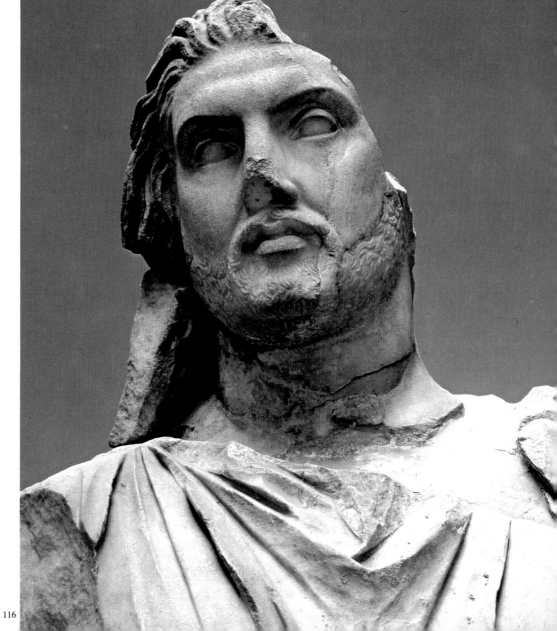

116

114 *Battle of Lapiths and Centaurs,* **from the frieze of the temple of Apollo at Bassae. Marble. Greek, beginning of the 4th century B.C. British Museum, London.** The Doric temple of Apollo Epikurios stands at Bassae in Arcadia. A groundless tradition attributes it to the Parthenon architect, Iktinos. Begun about 460 B.C., it was finished only after an interruption. This frieze (height 25 inches) is somewhat heavy in execution, and in its use of semi-transparent draperies reveals the influence of late 5th-century Attic art. The frieze decorates an interior Ionic colonnade.

115 *Portrait statue,* **from the Mausoleum at Halikarnassos. Marble. Greek, ca. 350 B.C. British Museum, London.** Bryaxis, probably Karian by birth, collaborated with Skopas, Timotheos and Leochares on the sculptural decoration for the monumental tomb that King Mausolus was building at Halikarnassos. Of this sumptuous building, one of the Seven Wonders of the ancient world, only a few fragments are left, among which is this statue from Bryaxis' shop, long mistakenly considered a portrait of Mausolus. It is 120 inches high and stood on the north side, between two columns.

116 **Head of the portrait statue** in fig. 115. The sculptured decoration of Mausolus' tomb included a number of portrait statues of relatives, ancestors and dignitaries standing round the dead king like a last guard of honor. This figure is robed in heavy, theatrical folds of drapery and the head is powerfully individualistic. The fleshy face, oriental in type, has an imperious forehead and nose, a slightly scornful mouth; its short beard and long hair are rendered somewhat summarily, since, owing to the placing of the statue, it would have been seen only from a distance and from below.

between the divine and the human, though Apollo and Zeus on their respective pediments are still set apart by a shade of Olympian hauteur, something that melts away in the more humanistic harmony on the Parthenon, twenty years later.

All these compositions incorporate one of the fundamental laws of classicism: each form in its physical unity is autonomous, but it is associated by action or by an idea to the whole and is essential to its unity. In principle this reflects a democratic society in which public order was based on respect for individual freedom.

Games, in which individuals competed and submitted to the judgment of their equals, were one of the most fruitful features of Greek life. Both the body and the mind took part: athletes performed in the palestra, men of letters wrote for the theater. The palestra provided the sculptor with models for the study of male nudes, but the theater offered a much wider field of experience. At first showing men acting in subservience to the will of the gods, Greek drama gradually turned to the study of human passions and, with Sophos Euripides, to problems of conscience. On the stage the sculptor could observe bodies moved by feeling and appreciate the plastic resources of drapery underlining and magnifying gestures and attitudes; there, too, could be seen movement of the dramatic theme, the train of episodes unfolding one upon the other, in a form that might offer inspiration for the composition of friezes.

When considering remote periods, the historian ought not

allow himself to give undue importance to such monuments as have chanced to survive in imposing or complete form. To understand the 5th century we must look at the Parthenon in its contemporary perspective as the canonical expression, in some way, of the cult of the city. From it we may derive the notion that Olympian serenity dominated 5th century art to the exclusion of all else. However, already in the 5th century both sculptors and painters were attracted by the rendering of passionate life. It quivers in the vibrant bodies of the Nereids from Xanthos, molded by their wind-whipped draperies. Paionios of Mende boldly represented Nike in rustling draperies, lifted off the ground *(fig. 113)*; the maker of the *Diskobolos* also sculptured a runner poised on tiptoe. The 5th century did not worship Apollo, Athena and Zeus alone: Dionysiac revels inspired Kallimachos' dancing maidens, whose forms are unfortunately known to us only through the numerous maenads reproduced for Roman amateurs *(fig. 111)*; their drapery expresses the exaltation filling their bodies, represented on the edge of trance, when ecstasy verges on orgy. The Nike adjusting her sandal from the temple of Athena Nike *(fig. 112),* whose body seems to throb in passage from action to rest,' also belongs to an art which tries to fill the marble with life. Draped, rather than nude bodies, allowed these artists to explore new realms of feeling. The expressive resources of draperies are endless: in the above examples they show us the stir of movement; elsewhere they give a feeling of stability, as in the Erechtheion karyatids, those descendants of the Cretan pillar-gods, watching over the ancient relic of Kekrops.

Already in the 5th century many artists were inspired by the pathos of death and suffering. During the first half of the century, Pythagoras of Rhegion carved a lame Philoktetes. The theme of the wounded figure, collapsing, begging for his life from his attacker, or dying with a last cry, also tempted artists of this period. A competition organized by the city of Ephesos for a statue of a wounded Amazon brought together in competition Phidias, Kresilas, and Polykleitos, who emerged victor. We have some notion what the Amazons of Polykleitos and Phidias looked like; as for that of Kresilas, Pliny gives high praise to a *vulneratus deficiens* by his hand.

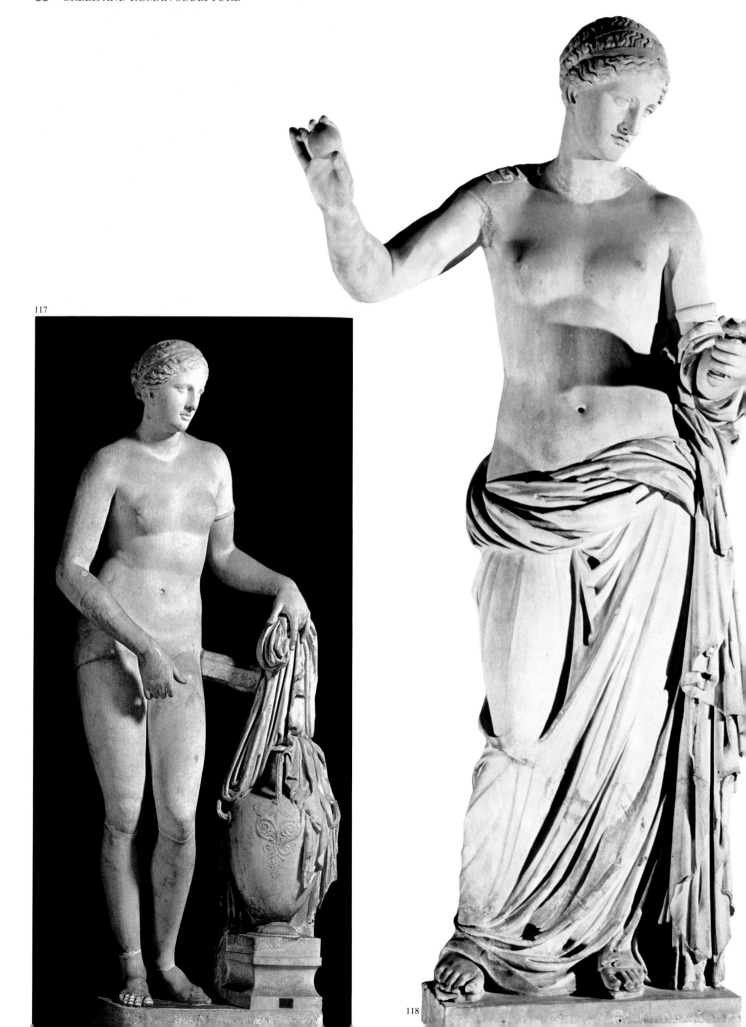

117

118

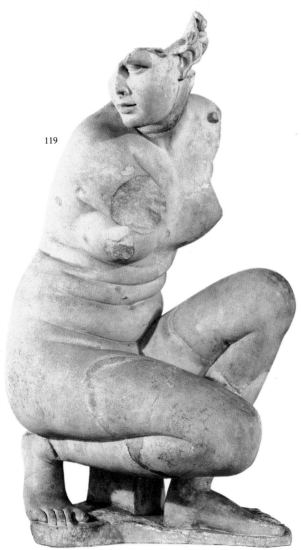

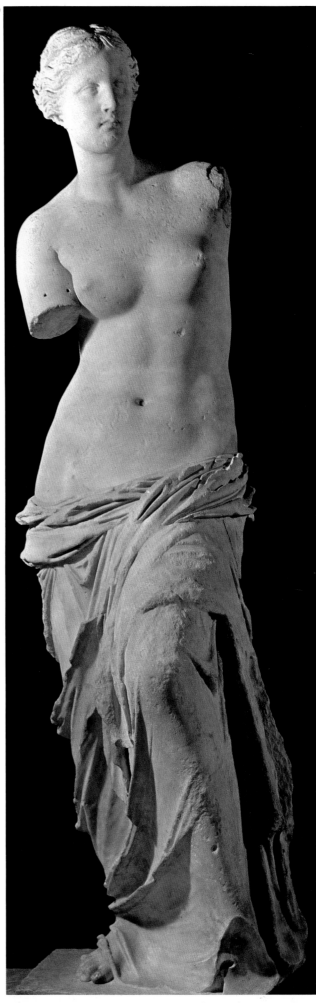

117 AFTER PRAXITELES *Aphrodite of Knidos.* **Marble. Roman copy of a lost Greek work of ca. 350 B.C. Vatican Museum, Rome.** The fame of the lost marble of Praxiteles is proved by the great number of copies which have come down through the ages. Although this copy is somewhat academic it permits a glimpse of something of the beauty of the original.

118 *The Aphrodite of Arles.* **Marble. Roman work of the 1st century B.C., reflecting a lost Greek original of ca. 350. The Louvre, Paris.** This Aphrodite was discovered in 1651 in the Roman amphitheatre of Arles. It was over-restored by the French sculptor François Girardon, who added the apple and the mirror, attributes of the beauty contest Paris judged on Mount Ida.

119 *Crouching Aphrodite.* **Marble. Roman copy of a lost Hellenistic bronze of ca. 275 B.C. Ny Carlsberg Glyptotek, Copenhagen.** The crouching Aphrodite enjoyed great fame—judging from the numerous Roman copies and replicas, of which this is one. Here the goddess is intimately seen in the usual position of the Greek woman at her bath.

120 *Aphrodite of Melos.* **Parian marble. Hellenistic, 2nd or 1st centuries B.C. The Louvre, Paris.** The Louvre *Venus de Milo* is as controversial as it is famous. In general form she belongs to the tradition of Classical Aphrodites, and was earlier thought to be an original 4th-century work. However, the twist of the body on its axis and other non-Classical features make it appear that she is an eclectic late Hellenistic creation.

121 *Head of a youth,* from Antikythera. Bronze. Greek, 375–350 B.C. National Museum, Athens. Detail of fig 124.

122 *The Farnese Hercules.* Marble. Perhaps inspired by a 4th-century Lysippian bronze, Greek, 2nd century B.C. Museo Nazionale, Naples. After the baroque fashion of his own time, Glykon has given this Hercules superhuman, swollen muscles, probably exaggerating the bodily power of the original.

123 AFTER LEOCHARES(?) *The Apollo Belvedere.* Marble. Roman copy of a lost Greek work of the late 4th(?) century B.C. Vatican Museums, Rome. This famous Apollo (height 88 inches) is a copy of a Greek bronze that has been attributed, on good grounds, to the Athenian sculptor Leochares. It may reflect the Apollo Alexikakos which he sculpted about 335 B.C. as a counterpart of the one by Kalamis in the temple of Apollo Patroos. The god, seeming hardly to touch the ground, held the Avenger's bow and the Healer's laurel branch.

124 *Statue of a youth,* from Antikythera. Bronze. Greek, 375 to 350 B.C. National Museum, Athens. This bronze ephebe was fished out of the sea just offshore from Antikythera in 1900. The nude young man raises his right arm: is he, perhaps, Paris offering the apple of discord? The head is slightly turned to the right and the face with its noble, energetic features gives an impression of gentleness, accented by the searching gaze of the deep-set eyes.

125 PRAXITELES(?) *Hermes from Olympia.* Greek, ca. 340 B.C. (or Ancient Greek copy). Museum, Olympia. Most likely an antique copy of an original by Praxiteles. There is an intentional contrast between the play of light over the softly modelled nude bodies and the deeply cut, folded masses of drapery.

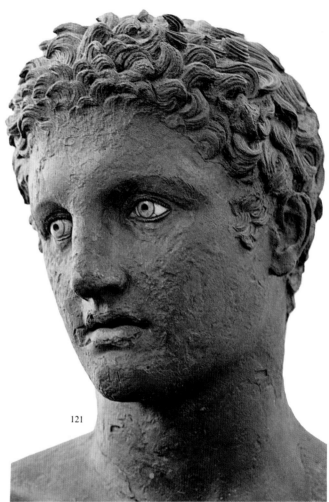

121

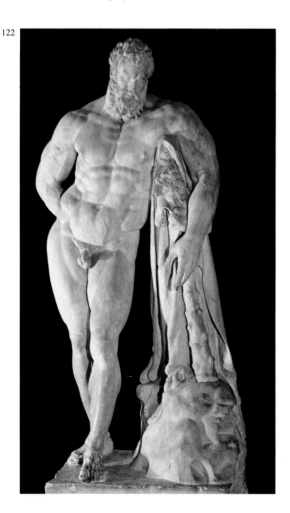

122

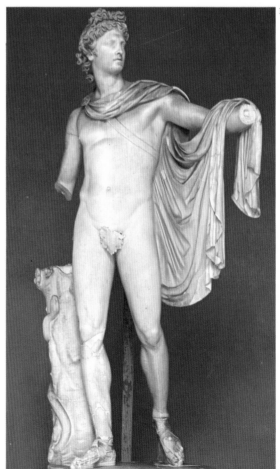

123

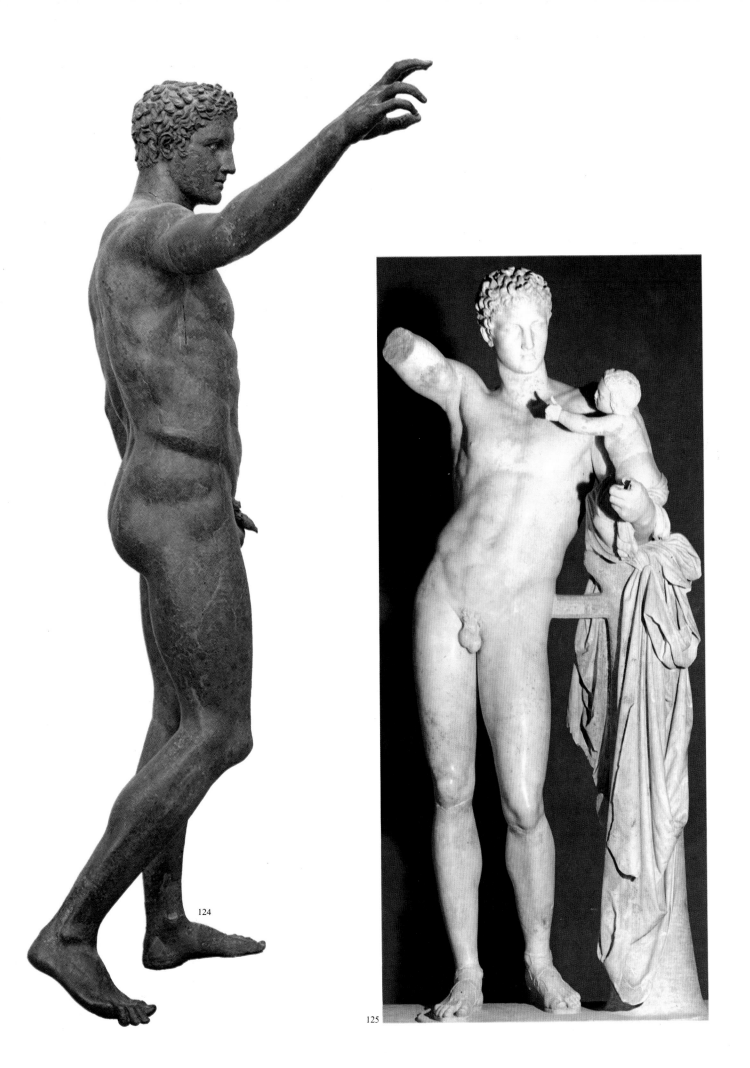

124

125

It is only through learned guesswork, progressing by induction and hypothesis through the enormous mass of marbles left to us by the Romans, that we can imagine what those original works were like. We rarely have an original to give us a direct contact with that art in all its truth. The remnants of a *Battle of Centaurs and Lapiths* and of a *Battle of Greeks and Amazons* from the temple of Apollo Epikurios at Bassae *(fig. 114)* show us how the choreographed contests of the west pediment at Olympia or the pediments from Aegina were transformed into an outburst of violence, a wild tussle. The despairing gesture of the woman with outflung arms will express centuries later the sorrow of Mary Magdalen at the foot of the Cross. The fierceness of the Bassae

frieze suggests some Peloponnesian influence, differentiating it from the Attic style, in which everything, even death, is graceful.

In the 4th century, the Mausoleum at Halikarnassos, on the west coast of Asia Minor, was as famous as the Parthenon had been in the 5th and was one of the Seven Wonders of the ancient world. Designed by Mausolus, a Graeco-oriental prince of Karia, and completed after his death in 353, by his wife and sister Artemisia, the gigantic tomb returns us to an atmosphere of Asiatic megalomania. It survived intact until 1522, when the Knights of St. John demolished it and incorporated its sculptures into a barricade against the Turks. The best-preserved statue, which probably represents a member of the prince's family, if not the prince himself, gives an impression of oriental sensuality and weighty majesty *(fig. 115–116)*. To carve the decoration, some of the most famous artists of the time were called upon: Satyros, Timotheos, Bryaxis, Skopas and Leochares; specialists have vainly tried to distinguish their individual hands in the various surviving fragments of sculpture. The most expressive elements are from friezes representing the battles between Greeks and Amazons and between Centaurs and Lapiths, and a chariot race. They are scenes of violence, but executed with a harmonious restraint that suggests a fairly conventional official teamwork in which individual talents were subdued. Their elegant classicism expressed the ideals of an artistic school that has left us other typical examples, like the reliefs on the columns of the temple of Artemis at Ephesos, and the two sarcophagi from the Sidon necropolis: the *Sarcophagus of the Mourning Women* and the so-called *Alexander Sarcophagus*. The latter is one of the most refined works of that century and the only Greek sculpture which has kept its original polychromy—intact when discovered, but now fading in the light of the Istanbul Museum.

Although fragmentary, the mutilated remnants of the temple of Athena Alea at Tegea, rebuilt about 340 with Skopas as sculptor and architect, are much more eloquent. The pediment figures representing the Hunt of the Kalydonian Boar and the Battle of Telephos and Achilles express a strange melancholy, which may overcome a warrior in the midst of

126 APOLLONIUS (?). *Belvedere Torso.* **Marble. Hellenistic, 1st century B.C. Vatican Museums, Rome.** This mutilated torso has been variously identified as Hercules, Marsyes and, most recently, the wounded Philoctetes. It seems to be an original creation of the Athenian sculptor Apollonius, son of Nestor, whose signature appears on the rough-hewn base. Apollonius appears to have been among the most important of the Neo-Attic sculptors working at Rome in the 1st century B.C.

action, giving a languid look to his deep-set eyes and pushing his head back in a pathetic attitude.

The 4th century was a great age for Greek sculpture, and its most remarkable achievements are to be found in statuary. Pliny attributed to Lysippos alone—who admittedly lived unusually long—over fifteen hundred statues. But unlike the previous century, the 4th was not a period of innovation; no 4th-century statue is as revolutionary as the *Diskobolos*. In the age of Alexander the most progressive art, the one which invented new forms, seems to have been painting. The 5th-century sculptors had discovered the beauty of man's body and the majesty of the gods; those of the 4th century instilled into their statues the breath of divinity, or of human passions.

The art of Praxiteles was for a long time considered a sort of genre sculpture, somewhat scandalous and possibly profane, if not outright sacrilegious. Charles Picard, however, has insistently pointed to the presence of a spirituality derived from Platonic philosophy in Praxiteles' figures. Several of them, closely linked with the sculptor's relationship to the courtesan Phryne, directly embodied the Platonic mystique of love. For the first time we are aware of an autobiographical element influencing artistic creation. Phryne inspired the *Eros of Thespiai,* the first example of a full-scale statue of the god of love; and the semi-nude figure of Aphrodite as a graceful, still-chaste young girl (known in a copy called the *Aphrodite of Arles, fig 118*) is Phryne herself, for she served as a model for that sculpture, as well as for the later *Knidian Aphrodite (fig. 117).* The latter was conceived under the influence of Asia, where Praxiteles went about 365 to fulfill commissions in Kos and Knidos. It has been as much misinterpreted as Bernini's *St. Teresa*. Picard reminds us that, far from being sacrilegious, its sensuousness is a poem to the divine beauty, incarnate in living and breathing flesh. Praxiteles' contemporaries believed that the goddess herself had inspired this "magically transcendent power of nudity," which caused in those who saw her, so an ancient author tells us, that shuddering sense of having looked upon something sacred.

After his return from Asia, Praxiteles was never again inspired by Aphrodite in the same way. But he expressed under

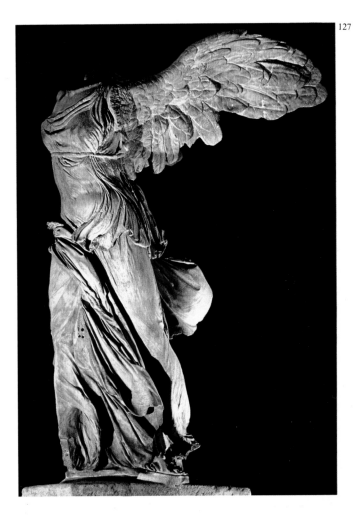

127

other forms his new philosophy of the divine, based not in Olympian majesty but in the idea of a breath of life communicated from soul to soul. That breath could animate either the frenzy of Dionysos or the wisdom of Apollo, each beneficent in its way; or it could permeate even more subtly the form of Hermes bearing the infant Dionysos at Olympia *(fig. 125),* symbolizing the soul saved by pity, for the infant whom the messenger of the gods has rescued from the fury of Hera is to become a living pledge for the salvation of the human soul.

Though Skopas sometimes measured himself against Praxiteles, as when he sculptured the statue of Pothos, an incarnation of languid amorousness, he was mainly inspired by

127 *The Victory of Samothrace.* **Marble. Hellenistic, ca. 190 B.C. (?) The Louvre, Paris.** This Victory commemorated a naval victory and has been related to the Nike blowing a trumpet on coins issued by Demetrios Poliorketes (336–283); but the discovery in 1950 of the statue's empty right hand has invalidated that identification, and she is now believed to have been an ex-voto from the Rhodians after their victory over Antiochus III of Syria, about 190 B.C.

the pathos of life. The threat of death makes the athlete's strength meaningless and the hero is he who overcomes pain and death by the strength of his spirit. Doomed to be unhappy, persecuted by the gods he defied, transfigured by love and death, Meleager was a fitting hero for Skopas, who illustrated his legend at Tegea. We can also recognize the Skopasian pathos in the terror of death gripping the figures in a *Massacre of Niobe's Children,* known from a copy now in the Uffizi.

Lysippos was something of a universal genius, comparable to Titian, and like him exceptionally long-lived. His art included all the tendencies of his age. Accomplished in the technique of bronze work, he explored all human passions, but since he moved in the circle of Alexander the Great, he devoted himself especially to the exaltation of virile heroism, of predestined genius. Some congenital weakness, as though from a surfeit of soulfulness, casts a pall over those over-elegant athletes with their elongated, counterpoised bodies. The arching of the back that expresses languor in Praxiteles' statues now seems a nervous reaction caused by profound lassitude. Even Herakles, whose hypertrophied muscles sag when at rest, seems to meditate on the vanity of his many labors *(fig. 122).* The interplay of curve on counter-curve makes the statue's contours vibrate and dissolve into the surrounding space. Such "impressionistic" sculpture was probably influenced by contemporary painting. Imitating originals by Leochares, the *Artemi* of the Louvre and the famous *Apollo Belvedere (fig. 123)* are further examples of silhouettes more pictorial than sculptural; they were probably designed as garden decorations, for the Asiatic fashion of domesticating nature around the house had already reached Greece in the 4th century. The Skopasian type of head has reverberations also in the cult statue of Demeter from Knidos (British Museum), one of the rare 4th-century originals. It is often attributed to Leochares and sometimes to Skopas himself. The tragic mother expresses through her eyes all the pathos of the loss of her beloved daughter. The elevation of human sorrow into a divine passion, that secret of the classical Greek genius, was rediscovered later by the sculptors of a few Pietàs.

Because of its preoccupation with emotion the 4th century

was a great period for portraits of all kinds: portraits—either real or commemorative—of famous men, heroic effigies, character studies. The sculptors of that age immortalized the features of Aristotle, Plato, Socrates, Thucydides, Euripides, and Sappho. To Leochares, and even more to Lysippos, Alexander's image was the type of the man of destiny, the tragic hero whose various moods found their way into statues of many gods and semi-gods. Moist eyes, accentuated eyebrows, foreheads creased with worry, hair like a lion's mane or a tempestuous sea—such are the elements derived from that super-human physiognomy. Artists such as Silanion, Apollodoros "the Madman," and Demetrios of Alopeke, who was called the Maker of Men, specialized in portraits. Their naturalism went so far that their imitators of the Hellenistic period could go no further. Silanion's bronze statue of the boxer Satyros of Elis with his battered face, or the wrinkled head of an old woman in the British Museum, whose original has been attributed to Demetrios, show how far those artists went in their search for characteristic features and individual marks left by life, age and trade.

In a general view of the history of sculpture, considering mainly the evolution of style, we might very well pass over most of the large Hellenistic production. If we strip from the Louvre's *Victory of Samothrace (fig. 127)* the prestige of its discovery and of its heroic mutilation, what meaningful addition does it make to Paionios' Nike or to the Nereids from Xanthos? Such a judgment would be unfair to the *Venus de Milo (fig. 120).* The sculptors of the Hellenistic period were haunted by the memory of the Aphrodite of Knidos. Exercising their hands in all manner of artificial variations on the symbolic theme of the ritual bath, they succeeded only in debasing the divinity of the goddess a little more each time—not surprisingly, since they worked in a period when scepticism was already undermining belief. But the *Venus de Milo* has kept some of the magic virtue of the inimitable model, though her carnal magnificence reveals the influence of Asia, where the female attributes always tended to take on something of the generosity of the ancient agrarian fertility idol.

It was in fact in Asia that the great plastic discoveries of the 5th and 4th centuries were to be followed by true inno-

129 *Athena and Alkyoneus,* **from the Altar of Zeus from Pergamon. Marble relief. Hellenistic, ca. 180 B.C. State Museums, East Berlin. It** was under Eumenes II that artistic activity reached its climax in Pergamon, with the construction of the great altar of Zeus, an immense structure with a sculptured frieze covering its entire exterior base. The subject was the traditional gigantomachy, the war between the Olympians and the giants. In each section the battle centers around one of the Olympian gods.

128 *Head of the Giant Klytios,* **detail from the great frieze on the Altar of Zeus, from Pergamon. State Museums, East Berlin.** The exuberant genius of the anonymous creator of the great frieze has given the work both tremendous vividness and great unity, although variations in execution suggest the hands of several sculptors. Over the faces, drawn with pathos, the tormented anatomy, the violently swirling draperies, light and shadow play in contrasts that heighten the battle's theatricality.

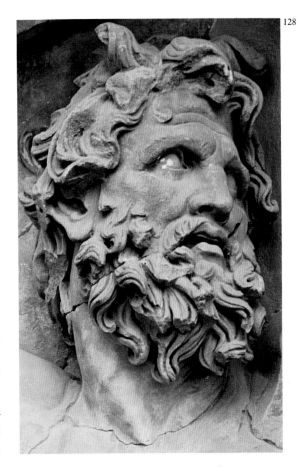

128

vations. The Greek mainland sculptors inherited the formulae created by Praxiteles and Lysippos and maintained by their imitators. The most original manner in Greece proper at that time was a Neo-Atticism that looked backwards to pre-classical forms, probably in the hope of shaking off the yoke of classicism. (Later, in a similar way, the Nazarenes and the Pre-Raphaelites attempted to free themselves from an idealistic tradition gone stale by seeking inspiration in the Early, rather than in the High, Renaissance. In all cases the result was the substitution for one kind of academism of another still more sterile.)

The main contribution of the Hellenistic period was a broadening of the scope of sculpture, which, probably influenced by the more progressive art of painting, increased its range of expression. Sculptors no longer attempted to cast reality in the mold of ideal beauty but explored the manifold individual aspects of nature. They developed an interest in the various forms and malformations of life, in exotic races

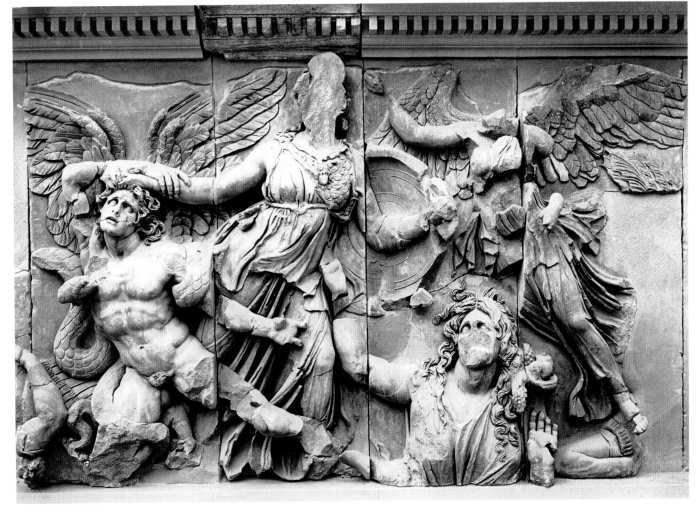

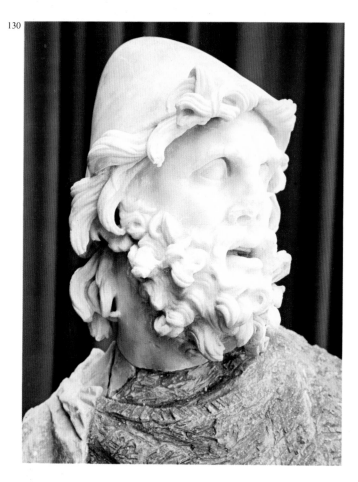

130

philosophers begun in the previous century. Whether imagined or taken from living models, these faces always radiate awareness, and old age ennobles without destroying their features. The rendering of character was practised in portraits of the Diadochi, Alexander's successors. For a while, the portraitists were dominated by the Skopasian images of Alexander: the head with its ruffled hair and deep-sunk eyes leaning slightly towards the shoulder in a heroic movement. But it was not long before it seemed that the prince was best flattered by being represented just as he was, even ugly—that is, as a unique individual. Through their portraits of the Diadochi the artists explored the whole human soul and all its moods and passions. They represented all the qualities befitting a prince: warlike audacity, indomitable energy, the instinct to dominate, an unshakable self-confidence, perspicacity, scorn, stubborn will, self-control. But they also detected the human faults: hypocrisy, deceitfulness, soldierly brutality, lack of restraint, heavy sensuality, and even cruelty. The Greeks had more psychological penetration than the Romans, who may have gone further in the literal reproduction of reality, but who stopped at the gates of the soul, rendering only the more superficial aspects of character.

During the Hellenistic period sculpture invaded all of private, as well as public, life. It penetrated inside temples, palaces, squares, porticoes, libraries, and gardens. It even entered the more modest households in the shape of those terracotta statuettes, intended not for cult purposes but for domestic enjoyment, that were mass-produced from molds at Tanagra in Boeotia, at Myrina near Smyrna, at Tarsus, in Cyrenaica, and on the shores of the Black Sea. It was in these statuettes rather than in monumental sculpture that classical forms were prolonged for a while, though to please their customers the makers also produced many naturalistic works. These statuettes often have considerable quality and have at least one advantage over their large sculptural models: they are intact. Sculpture also took possession of furniture, creeping over tables, candelabra, fountains. The designers of these decorative pieces showed great ingenuity, inventing forms which were to be taken up again later by the artists of the Renaissance and Baroque periods. For the

and half-breeds, in dwarfs, cripples, clowns, beggars, and morons, in the signs of age and illness. Ignoring nothing that made part of the experience of life, they explored nature's unpleasant manifestations, but also enjoyed the naive smile of a child, or the modesty of a graceful young girl. This aging world seemed to feel the need for extremes: man in his prime—the favored subject of the classical period—was no longer enough to give a feeling of life, which was sought in the child and in the aged, and in the marks of time and temperament on the human form.

With their passion for the human form as the product of the experience of life, at a time when many philosophers were investigating the human soul and wondering about its fate, Hellenistic artists multiplied individual effigies. The 3rd century completed the gallery of famous men, poets, orators and

130 *Head of Ulysses,* **from the Sperlonga cave. Marble. Hellenistic, late 2nd or 1st century, B.C. Museo Archeologico Nazionale, Sperlonga.** The most striking element in the decoration of the Sperlonga grotto must have been the large Rhodian marble group representing Ulysses' ship attacked by the monster Scylla. Only recently discovered, the group bears the signatures of the three sculptors of the Laokön group, hence new fuel has been added to the controversy concerning the dating of these Rhodian artists' activity.

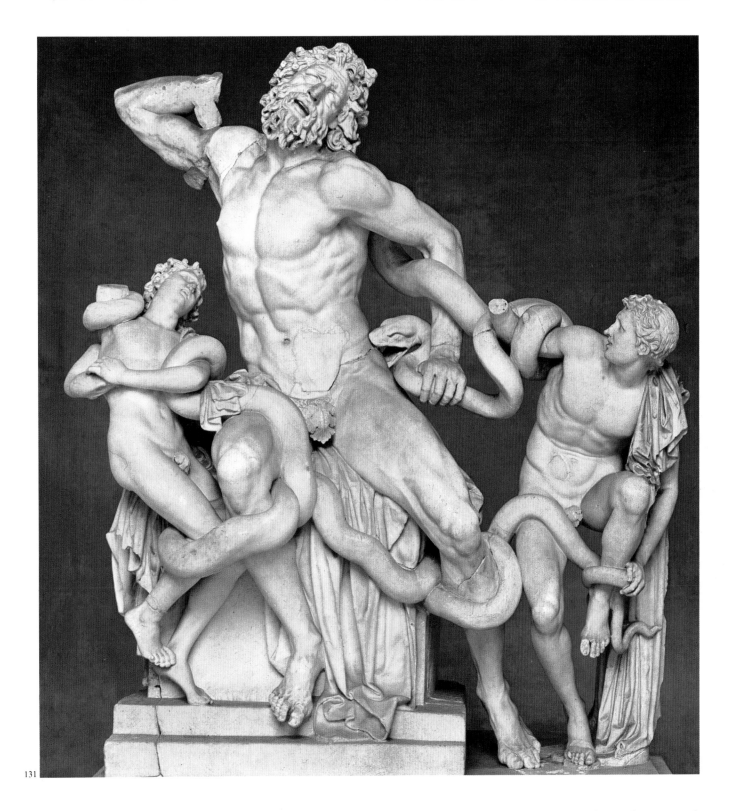

131

decoration of gardens dramatic groups set on rock foundations became popular. They were sometimes enormous, like the *Punishment of Dirke* sculptured by two artists from Tralles at the beginning of the 1st century B.C.

The athletic ideal was profoundly altered since the earlier days when sport was an exercise practiced by the aristocracy.

The perfect athlete was no longer the discus thrower or the runner, but the wrestler with overdeveloped muscles and battered face. The amateur had become a professional, and it is surprising that such a man, who was despised socially, although his achievements were admired, should at one moment in time have imposed his Herculean shape even on

131 *Laocöon and his sons*. **Marble. Hellenistic, late 2nd or 1st century B.C. Vatican Museums, Rome.** The theatrical group representing the death of the Trojan priest Laocöon was, according to Pliny's testimony, the work of three Rhodian sculptors, Hagesandros, Polydoros and Athenodoros. Clearly meant to be seen from the front, Maggi's restoration of Laocöon's right arm to its original flexed position shows an even tighter triangular composition than the traditional restoration indicated.

132 *Draped, standing woman,* **from Tanagra. Terra cotta. Hellenistic. The Louvre, Paris.** The Tanagra workshops concentrated their activity on the single theme of the draped young woman, but there are numerous variations in their gestures, attitudes and draperies. Their elegance and their slightly affected grace reflect larger works, particularly Praxitelean ones. After being fired, the statuettes were retouched and covered with bright colors of a sometimes doubtful taste.

132

representations of the prince. Such an exhibition of physical strength may have been a form of compensation for a hidden awareness of weakness.

One of the most expressive statues in the late Hellenistic style is the so-called *Borghese Warrior* signed by Agasias of Ephesos in the 1st century. It has been identified also as a gladiator, or as a torchbearer, but the question cannot be resolved, as the arms have been restored and only their general direction is known. The figure demonstrates the transformation of the Lysippan type in action. The projection of movement has distorted the form, which is no longer well defined in space; sculpture in the round reaches its extreme, with the solidity of the body—that "corporeality" of classical Greek sculpture—dissolved in the surrounding space. The sculptor borrows his technique from the painter, and the difficulty of achieving a "pictorial" sculpture becomes an end in itself.

The dying art of sculpture tried to revive itself through dilettantism or virtuosity, but its new lease on life came from contacts with barbarian styles: from Asia in the East, and from Rome in the West.

In Mysia, in the 3rd century, a family of satraps managed to free the country from Persian oppression and to create in Pergamon an independent principality which lasted until 133 B.C., when Rome intervened. The city they built is the Hellenistic center we know best. They used local artists to design grandiose monuments, but also called upon artists from Ionia and from Greece proper. The seat of these philhellenic princes was for a while the last stronghold of Greek civilization, successfully resisting the Galatian barbarians, Gaulish tribes from the west who filled Anatolia with terror. Proud of his victories, Attalos I (241–197) celebrated them allegorically by consecrating to Athena at the foot of the akropolis of Pergamon a *Battle of Gods and Giants* and a *Battle of Greeks and Amazons.* But he also immortalized them more directly by building in Pergamon itself, in 228, an ex-voto made up of groups representing the defeat of the Gauls. It was the beginning of an imagery of barbarians with firm moustaches and unkempt locks, around whom evolved a whole iconography of suffering. Those mercenaries were followed by their

families, and artists revelled in the representation of death ravaging their camp. Until the end of antiquity, there were numerous reproductions of statues showing a dying Gaul dropping his horn like Roland, or killing himself after having killed his wife to save her from slavery, or a Galatian child drinking from his dying mother's breast or fondling her corpse. Did the victors realize that by celebrating the bravery of barbarians who offered their bare chests to the bronze-clad hoplites, they confessed their secret admiration for the primitive strength of their enemies? Admiration or even pity for the vanquished suggests a troubled conscience on the part of the victors; the Assyrians or the Egyptians never knew such sentiments. But Greek philosophers had taught even the great that a man is a man and has a soul, even if he is a barbarian.

In 180 B.C. Eumenes II (197–158) celebrated in allegory style those epic struggles against the barbarians with a large altar consecrated to Zeus and to Athena Nikephoros, occupying the akropolis at Pergamon *(fig. 129)*. A team of sculptors completed a frieze 300 feet long and 6 feet high (only about 200 feet of it survive depicting all the episodes of the fight between the gods and the giants). Returning to the Asiatic use of a high plinth, the artist placed the frieze around the base of the altar, that is to say at human level and no longer in the heights of the pediment, where mythical exploits had formerly been celebrated. As a result, the figures, which are actually over life-size, appear truly colossal—appropriately for a war in which opponents hurled whole islands at each other. The giants are represented with human or animal features, or they are sometimes hybrids—men with lions' heads or snakes' bodies. The coils of the snakes and hydras, the flying drapery, the beating wings, the bounding horses of Helios, the wavy strands of manes, beards and hair all contribute to the composition's medley of forms. The Battle of the Gods against the Giants, represented through centuries on vases and on monuments, had been for the Greeks a symbol of the triumph of order over chaos, of intelligence over instinct. But at Pergamon the real heroes are the giants and not the gods. The conventional faces of the latter only express a sort of non-participation: they do not share in the

133 *Parade helmet in the form of a portrait.* Iron, gold, and silver. Syrian, 100–50 B.C. National Museum, Damascus. This full-dress helmet in silvered iron, with gold as well, was discovered during clandestine excavations at Homs, the ancient Emesa, in Syria. Helmet and portrait-mask combined, it protected the head completely; a hinge on the forehead allowed the opening of the face part, which could be fastened shut below the ear.

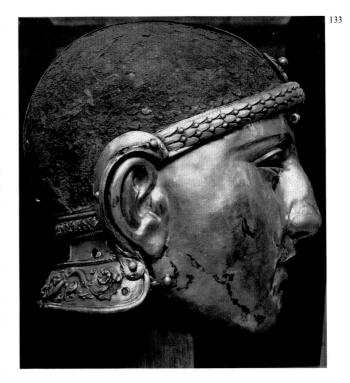

133

action. The gods are impassive, and only the giants are alive in their tragic fury, fear, and pain *(fig. 128)*. Ge, the Earth-Mother, begging Athena to spare her children *(fig. 129)*, is a sort of *mater dolorosa*. She herself has been mortally wounded, though, by time, which has worn her face to a horrid ruin in which only the entreating eyes are left. The giants are very much in evidence as symbolic representatives of those barbarians who were threatening the Greek world, and who were soon to be held back only by other barbarians, the Romans. Here, the meaning of the theme is reversed: the longing of a menaced frontier people for strength has resulted in the glorification of primitive violence. This attempt to go back to primeval sources is typical of declining civilizations.

The Pergamon Gigantomachy frieze offers great novelties. The bodies pressed one against the other, closely united in battle, leave no room for the rhythmic intervals that in classical friezes had introduced a feeling of measure and cadence. This is the first appearance of the compositional principle later called "baroque," of which Rubens' works are the finest realizations: unity is achieved by a movement which seizes

upon all the forms and sweeps them along together. At Pergamon the mixed assembly of gods, men, and monsters becomes one confused mass in which all the elements are bound by a unity of action. The vigorous relief with its exaggerated projections and deep hollows—a whole family of swallows could nest in one of those cavities!—gives a monumental impression fitting to the subject. The general impression is one of power, but a vividly coloristic power, with strong shadows contrasting violently to the projections struck by light.

Regenerated by contact with Asia, Greek art produced this last masterpiece, and Rhodes gathered up the inheritance of Pergamon; its artists specialized in the gigantic and the pathetic. They made a Colossus that towered over their harbor—a 60-foot-high bronze statue celebrating Helios, the patron god of the island. A lucky find has brought to light, in a grotto at Sperlonga on the Tyrrhenian Sea, the remnants of a group which seems to represent Ulysses' ship braving the monster Scylla. It bears the signatures of three 1st-century sculptors from Rhodes, Hagesandros, Polydoros, and Athanadoros, known from a text by Pliny as the makers of a Laocoön group. The frightened faces of Ulysses' seamen and the tense features of Ulysses *(fig. 130)* are reminiscent of the Pergamon giants. The most beautiful works from the end of the Greek period were those inspired by fear, suffering, and death. Two groups, very popular later, celebrated pain: the torture of Marsyas by Apollo, and the sufferings of the priest Laocoön and his innocent children *(fig 131)*, who were punished by the same Apollo, the terrible, avenging god. Here again the meaning of the themes is inverted: the compassionate interest in the sufferings of the victims poses the question of a god's injustice; it is as if man were turning against god to call him to account. But already that injustice of the Olympian gods was being challenged by religions of salvation, who took as their σωτήρ a demi-god or a hero and brought hope to men's hearts. Soon a sadistic people, heir to the frailties of the Pagan gods, would find pleasure in watching in the ampitheaters the agony on the faces of martyrs who sacrificed themselves to bear witness for the Saviour-God. Through the mystery of suffering, Greek artists, following the path traced by their tragic poets, discovered how deep was the human soul.

2. *From Greece to Rome through the Mediterranean*

From Ionia and from the Greek peninsula Hellenic art spread throughout the Mediterranean, encountering various other cultures and combining with them. All over the area old Mediterranean Neolithic aniconic styles still held sway in Greek times, in some remote regions continuing well into the Iron Age. The other principal current circulating in the Mediterranean area was a compound of Near Eastern traditions, which had remained alive even after the decline of the civilizations that had given them birth. At first these alien currents held Greek art in check, but then the Greek spirit combined with them to create hybrid forms, and in the Hellenistic period finally triumphed over them.

The Phoenicians, because of their rapid expansion throughout the Mediterranean, might well have offered cultural competition to the Greeks had they in fact had a true culture of their own. But the Phoenicians were traders capable of practical inventions but uninterested in abstract thought of any sort. For the ornaments of their daily life and for their religious objects they borrowed styles and themes from such surrounding civilizations as the Hittite, the Assyrian, and the Egyptian *(fig. 73)*—all of which came at various times under their power. The Phoenicians carried the bastardized art forms they had borrowed into their westernmost colonies and in the 5th century, in those colonies and in the mother-cities of Asia, the Hellenic influence only added to the confusion of an eclectic art. As is always the case when a lesser culture is influenced by a greater one, the forms were transmitted with some time lag; thus a 4th-century Punic mask shows itself to be a barbarian adaptation of the Greek 5th-century style. The curious iron helmet with a metal mask, found at Homs, probably made for a Syrian general towards the beginning of the Christian era *(fig. 133)*, shows that Semitic ethnic types persisted concurrently with the Greek types in the Hellenized East.

134 *Head of the God Zeus-Ahuramazda,* at Nimrud-Dagh, Anatolia. 1st century B.C. The colossal statues erected on one of the summits of the Antitaurus Mountains by Antiochus I were probably toppled by an earthquake. Their iconography and style reveal a combination of Greek and Iranian elements.

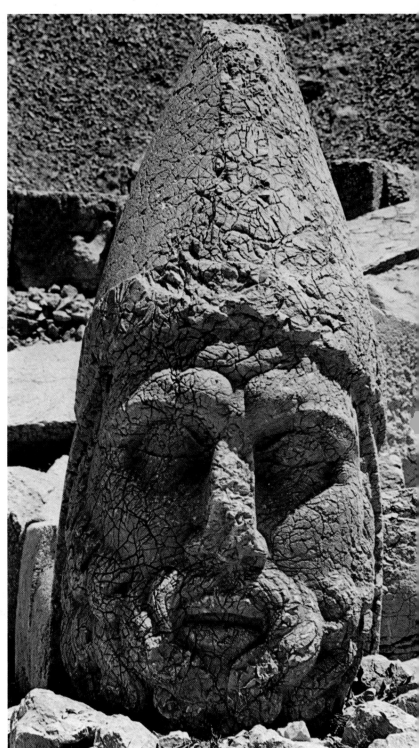

134

Carthage carried these mingled influences wherever she settled her colonies and trade outposts: to Malta, to the Balearic Islands, to Spain. The existence of a Phoenician *koiné* accounts for formal similarities in works from opposite ends of the Mediterranean, in Cypriote and Iberian sculptures alike.

But if Iberia was open to the oriental influences transmitted by Carthage, the native art of Provence, called Celto-Ligurian, was not. We do not know what the Greek art of Marseilles was like, for only insignificant remains survive from the ancient Massalia, colonized by the Phocaeans. It must have been but a small island of Greek civilization in the midst of the barbarian populations whose remains, going back to the 3rd and 2nd centuries B.C., have been found on the *oppida* of Roqueperteuse and Entremont (Aix-en-Provence). Entremont, seat of the confederation of the Saluvii, whose fractiousness threatened the Roman province of Narbonensis and the allied Greek city of Marseilles, was overcome in 123 B.C. by the Consul Gaius Sextius Calvinus. Excavations on those *oppida* have brought to light strange sanctuaries which seem to have been consecrated to deified dead heroes, and which appear to confirm the statements made by ancient authors concerning the cult of severed heads among some Gallic tribes. Although severely damaged, the Entremont warriors are still impressive. At the time when the artists who carved them were working, the only Greek style likely to have influenced them was the Hellenistic art of Marseilles. The formal power of their own art must have been strong, for when touched by refined Greek forms, the Ligurian barbarians seem to have reached back to the source, to the severe art of Greece itself at the beginning of the 5th century. However, some "severed heads" from Entremont, with half-closed eyes, show a depth of suffering reminiscent of the art of Pergamon, and unusual in barbarian sculpture.

What curiosities might result from the penetration of Greek morphology into the very heart of distant barbarian lands is apparent in the head from Mšecke Žehrovice, which in spite of its stylizations shows striking ethnic characteristics of a kind still associated with Central Europe.

The art of the Greeks themselves, practiced outside the main Greek centers, was not free from provincial decadence.

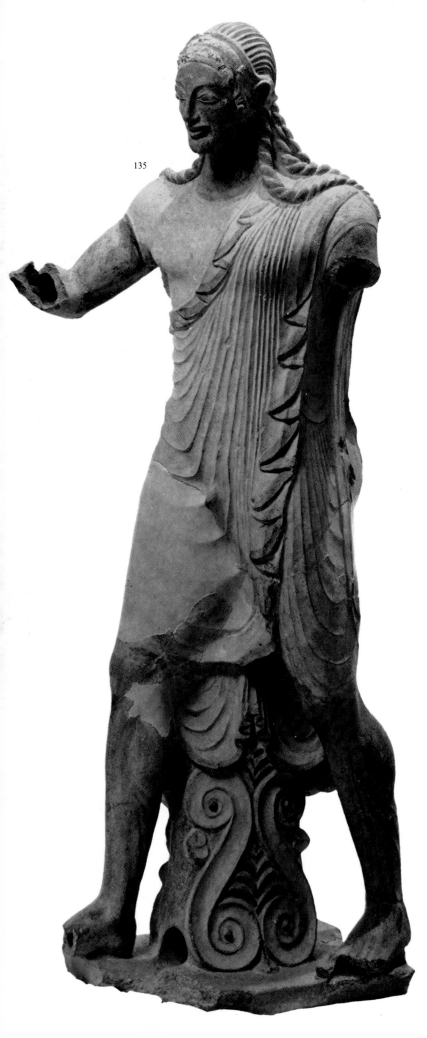

135

From remote Thessalia comes the early 5th-century relief excavated at Pharsalos, showing two women holding flowers, carved with a flavor somewhat rustic and archaic in comparison with contemporary works made at Olympia or Athens. The art of Southern Italy displays two main tendencies: a sophisticated one, linked directly with Greece, and an indigenous one. Although contemporary with the refined Greek classicism, the latter, nourished by the old Italiote popular art, produced a final version of the fertility goddess in the extraordinary ex-votos (*fig. 136*) recently excavated at Capua; Capua was, to be sure, on the southern border of the Etruscan territory. The more sophisticated style appears in the reliefs executed for the great temples of Sicily and for the temple of Hera at the source of the Sele river, near Paestum. It directly reflects the style of the sculpture employed on the great contemporary Greek buildings, but nonetheless has a roughness emphasized by the coarse sandstone material in which the works are carved. Marble was scarce; imported from Greece, it was rarely used, save for the nobler parts of statues, such as hands or heads.

The most unexpected developments in the Hellenistic period resulted from the transmission of the Greek ethos along the route of Alexander's army, to the borders of Iran and India. At the critical moment it brought to the Buddhist world forms adaptable to the expression of the developing oriental religious ideas. What would more properly be defined as Greek art, however, appears mainly on the coins minted by the philhellenic princes in these remote provinces of Greek culture, whose sites have yet to be systematically excavated. At Begram, forty miles from Kabul (Afghanistan), about fifty small plaster reliefs have been found, which may have been intended as models for silver or bronze sculptures. These do not represent a genuine provincial art, however, for their very pure Alexandrine style indicates that they were imported, or at least were molded on Hellenistic originals.

The art of Etruria has provoked controversy for the last two centuries or more. Humiliated by the long foreign domination that Italy had just shaken off, Risorgimento scholars passionately sought justifications for a nationalistic pride in their newly recreated fatherland. Therefore, they tended to

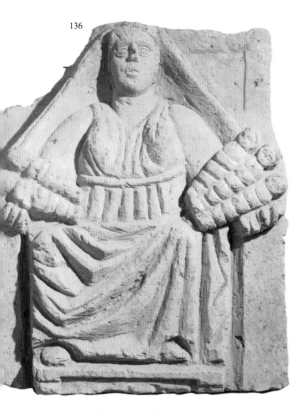

136

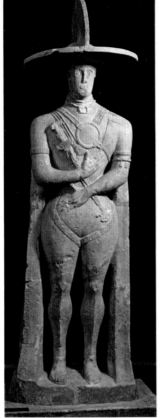

137

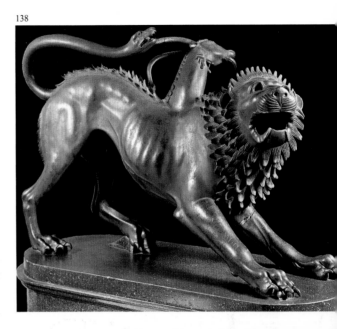

138

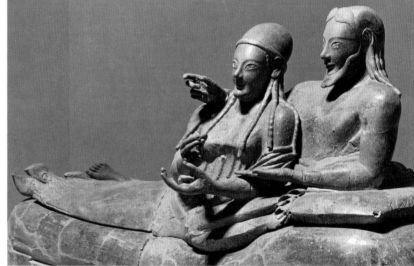

139

135 *Apollo,* **from Veii. Terra cotta. Etruscan, ca. 500 B.C. Museo Nazionale di Villa Giulia, Rome.** This terra-cotta statue of Apollo stood with other statues as an acroterium on the roof of the temple at Veii. Its extraordinary vitality is accentuated by the rich polychrome. It is tempting to attribute this masterpiece of ancient art to the only Etruscan artist whose name tradition has preserved: Vulca of Veii, who worked in Rome during the last years of the 6th century.

136 *Statue of mother-goddess.* **Tufa. Italic, 4th or 3rd century B.C. Museo Provinciale Campano, Capua.** This tuff-stone statue, representing a mother-goddess sitting on a throne and holding several infants in her arms, is one of the numerous ex-votos found in the Italic "Matres" sanctuary that was discovered at Fondo Patturella, near Santa Maria di Capua Vetere. The earlier ex-votos were clearly influenced by Greece, but later works, like this one, show by their expressive qualities a local, Italic, approach to sculpture.

137 *Warrior,* **from Capestrano. Limestone. Etruscan, late 6th century B.C. Museo Archeologico, Chieti.** This over-life-size representation of an armed chieftain comes from a necropolis hidden in the mountains of Picenum. The curious armor and the faithfully detailed weapons suggest to some that the statue illustrates the primitive custom of exposing the deceased at his funeral, standing, supported by his weapons, a custom apparently followed for a long time by Roman patrician families.

138 *Chimera,* **from Arezzo. Bronze. Etruscan(?), 5th or 4th century B.C. Museo Archeologico, Florence.** The chimera, a monster of Eastern origin made up of a lion's body and a dragon's tail, is depicted in a last desperate effort. The statue's origin and date have been much disputed: some consider its powerfully expressive quality as the mark of an authentically Etruscan creation; others regard this as an imported Greek work. The sculpture of the chimera's attacker, Bellerophon, has disappeared.

139 *Husband and wife,* **sarcophagus from Cervetri. Terra cotta. Etruscan, late 6th century B.C. Museo Nazionale di Villa Giulia, Rome.** The Etruscans often used terra cotta to produce large-scale works, as in this famous sarcophagus depicting a dead couple reclining. Their tender and intimate pose reveals the exceptional consideration that women enjoyed in Etruscan society. The decoration of the couch and the delicate, smiling faces with their incisive profiles and almond eyes reveal the Ionian inspiration in this work.

140 *Head of a tomb figure.* **Etruscan, Hellenistic period. Ny Carlsberg Glyptotek, Copenhagen.** On the lids of Etruscan urns and sarcophagi the dead person was represented reclining and partaking of an eternal banquet. The realism typical of such sculpture during the Hellenistic period contrasts with the heroic character of the sarcophagus decoration. Bodies are flaccid and stereotyped; the entire interest is in the heads, each individualized with powerful realism.

141 *Tydeus,* **one of the Seven against Thebes, detail of a relief on an urn. Alabaster. Etruscan, Hellenistic period. Museo Guarnacci, Volterra.** This detail, from an alabaster urn, depicts a bloody episode not to be found in the Greek literary tradition. Both the gate and the body of the hero, shown at an angle, attempt to create an illusion of depth. The great originality of the piece lies in the attempt to transpose into sculpture the spatial conquests of painting .

view Etruscan art as an indigenuous and original art, superior to that of the conquering Romans, which they regarded as derivative from it. Eighteenth-century English and Italian scholars had in any case launched a fashion for things Etruscan that had influenced the decorative art of the time, particularly in England. However, the abundant materials discovered in recent excavations oblige us to dim this roseate view of Etruscan art. All through its development it appears to have reflected Greek art, to whose stimuli it faithfully responded, though adapting Greek forms to its own peculiar needs. In the 7th century, from which mainly bronze objects and jewels have survived, Etruria followed the orientalizing style of Corinth or the geometric Attic style. Larger sculpture was rare, but also imitated the art of those sources; the strange, plump-thighed *Warrior* from Capestrano *(fig. 137)* is a personage from a Dipylon vase who has emerged from his geometric crysalis to take on a living shape. At the end of the 6th century, Etruria adapted the Greek archaic style to suit its own dynamic tendencies, contributing a heightened nervous tension. The Etruscans favored terra cotta and bronze, both materials well suited to

a creative spirit that expressed itself through movement, through the arching forms of the smiling faces, and through a mannerist taste for curves *(fig. 135)*. So alien was Greek classicism to the Etruscan spirit that the archaic style was prolonged throughout the 5th century; it was not until quite late, in the second half of the 4th century, that Etruscan art adopted the developed classical style, only to discard it after a relatively brief period; and after the Roman conquest, the Etruscans of Umbria and Tuscany continued to practice their own separate art. The surprising tufa or alabaster relief sculptures from Volterra *(fig. 141)* are popular derivations from Hellenistic Greek art; in the scenes of violence borrowed from Greek mythology with which they decorated these funerary urns the Etruscans felt at ease. The works that they produced between the 3rd century B.C. and the 1st century A.D. are much less stiff and academic than Roman art, and in fact rather resemble in their dynamic power the sculptures of Rhodes and Pergamon, recreated in a more rustic style. The cleverness of the compositions contrasts with the no doubt consciously careless execution—the artisans, working for a provincial clientele, did not bother

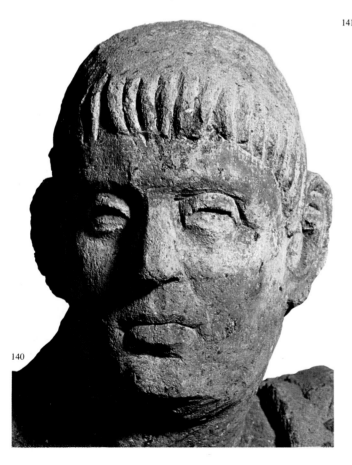

140

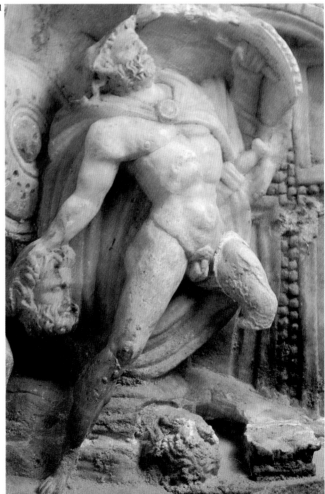

141

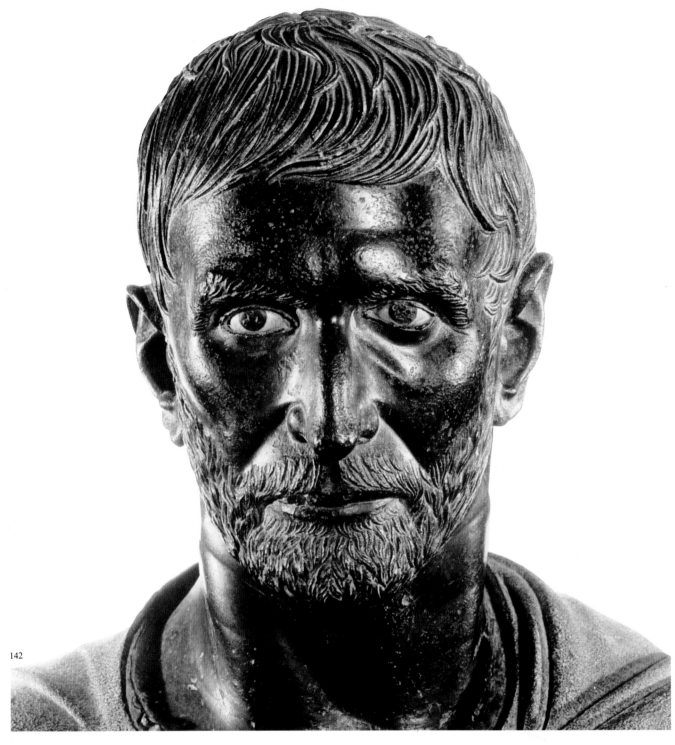

142

with "finishing," and to a certain extent the polychromy with which they covered the reliefs allowed them to be less particular. The reclining figures decorating the lids of the funerary urns show a complete disregard for the organic structure of the body—but the faces are realistic, and the heads from these urns and from the recumbent effigies on the large sarcophagi found on other sites are intensely alive (*fig. 140*). This realism has been acclaimed as an indigenous

feature afterwards inherited by the Romans; but it can also be shown that it reflects a parallel tendency in Hellenistic art. In fact, the Etruscan effigies differ from the Roman in that they are not really individual portraits, but strongly characterized types: the youth, the adult, the old man, the young or old woman, according to the age and sex of the departed. Even the *Obesus Etruscus* is a typical representation of the big landowner, at a time when eating rather

142 *The Capitoline Brutus*. **Bronze. Etruscan or Roman, 3rd century b.c. Palazzo dei Conservatori, Rome.** Many believe that this magnificent bust represents Lucius Junius Brutus, who in 509 b.c., according to tradition, liberated Rome from the Etruscan yoke.

143 *Procession,* **on the north wall of the Ara Pacis. Marble. Roman, 13 to 9 B.C. Lungotevere in Augusta, Rome.** Official Augustan art redis-covered the classicism of Greek reliefs.

144 *Allegory of the Earth,* **on the Ara Pacis. Marble. Roman, 13 to 9 B.C. Lungotevere in Augusta, Rome.** This, the best-preserved of the reliefs on either side of the doors, depicts a mother generally identified as Tellus, the Earth, flanked by Air and Water.

more than one's fill was an accepted sign of opulence.

Thus Greek aesthetic values collided with forms originating in earlier Mediterranean civilizations, which mingled with and then capitulated to Hellenism. After the beginning of the Christian era, however, those popular artistic streams springing from old Neolithic sources or from the surviving orientalizing traditions flowed into Roman art and gradually pushed it further and further away from Greek formalism. These and other currents from Roman provincial art and from the barbarian world all converged finally in a veritable flood that submerged Graeco-Roman aesthetics and cleared the way for a new beginning in the history of western art.

3. Rome

While the general assessment of Greek art has not altered much since Winckelmann published his *History of Ancient Art* (1764), for the last fifty years art historians have been making efforts to re-evaluate the art of Rome. The verdict enunciated by the author of the first systematic study of ancient art went unquestioned for over a century; in Winckelmann's opinion, Roman art only hastened the decadence of Hellenism, a decadence which for him had begun after Greek art in the 5th and, to a lesser degree, in the 4th century had achieved certain absolute values that made it inimitable and that at the same time, so he felt, made its imitation the only possible road to salvation for future art.

Vienna-school historians like Wickhoff and Riegl wanted to rehabilitate Roman art. Riegl attempted to justify that aspect of it which in the eyes of the classicists was most unjustifiable—the awkward naiveté of the late-Empire styles, in which he found a positive value as a reaction against the classicizing Graeco-Roman illusionism that no longer suited the outlook of the peoples of the empire. Wickoff, on the other hand, defended the originality of Roman art as compared to Greek art, and attributed to it the invention of spatial illusionism and of the realism expressed in portraiture, historical reliefs, and representations of scenes from daily life. There are still prejudiced Hellenists who would deny all originality to Rome; but even if it now seems clear that the spatial

illusionism of Pompeiian and Roman art was derived from Greek painting, it is nonetheless difficult to take seriously the Hellenophile who, to prove the Greek origin of realism, finds the precedent for Trajan's column on the bottom of a 6th-century Laconian cup.

More recently, critics have seen in Roman art a dual character which they attribute to a dual inspiration from two superposed cultures: Italic and Greek. But the difficulty here is to define what is "Italic." Anything that occurred on the peninsula before the advent of Rome—particularly Etruscan art, which some have described as the source of Roman art—appears to Hellenists as a more or less late and provincial extension of Greek art. This same dualism, furthermore, has been interpreted as having had a social implication in imperial times: the classicism practiced by artists of Greek origin, that is, appealed to the upper classes, impregnated with Hellenic culture, and took on the authority of an official art, while the indigenous style of less sophisticated creations was aimed at a middle and lower-middle class public of merchants, soldiers, and lesser officials. This class became more and more important in Roman history, and under Diocletian, at the very time when naiveté invaded official art, it emerged as the dominant one. In the last few years it has been thought that the "anti-classical" style, which some art historians had seen as the indigenous "Italic" contribution, in fact originated in all the provinces of the empire, rather than at its heart.

In all parts of the Roman world, and in Rome itself, excavations show that three sculptural styles existed concurrently: one dutifully following Graeco-Roman formalism in all correctness, and often a result of direct imports from Greece or Rome; a second awkwardly imitating the Graeco-Roman; and a third standing in some contrast to the Graeco-Roman. The last manner can be found throughout the Empire, showing that the Graeco-Roman style had not penetrated everywhere; but there is no art that can be called "Celtic," or "Iberian," "Dacian," "Berber," "Punic," or "Germanic"; all the provinces of the Empire alike offer the complete range of primitive or naive styles, from abstraction to mere ineptness in copying the more sophisticated style. If these works appeal to us it is not only because our taste has

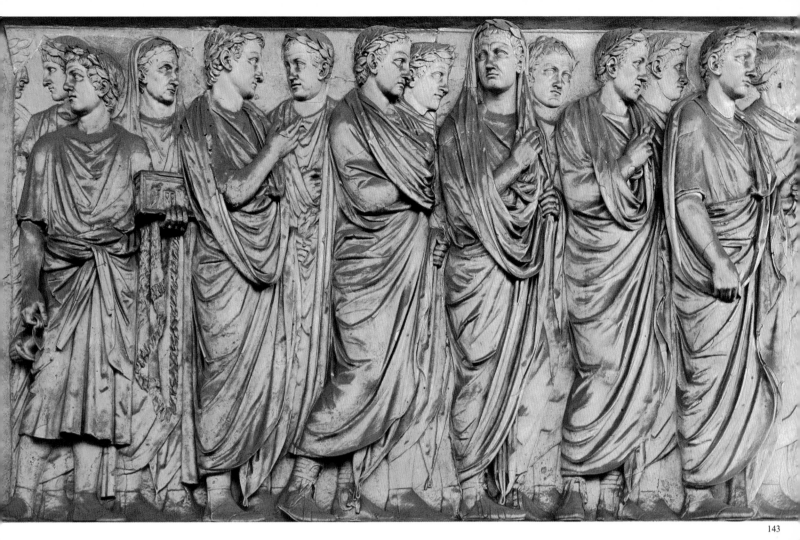

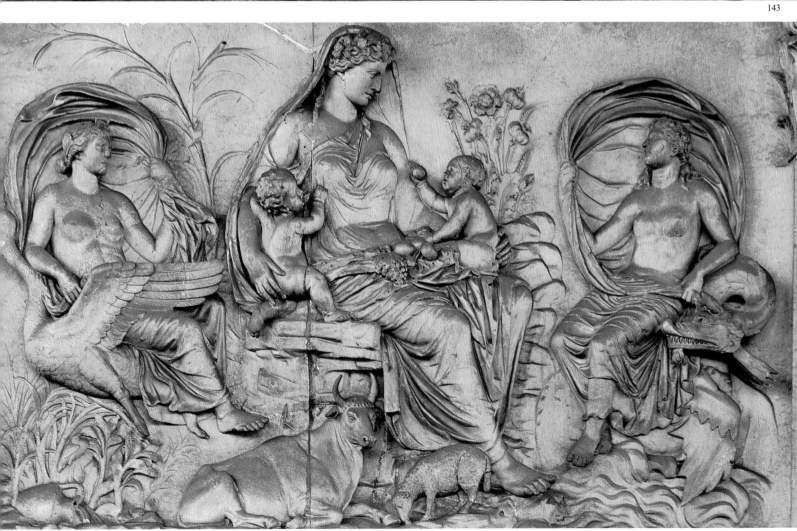

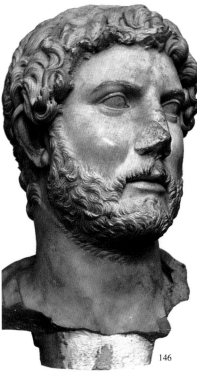

145 *Bust of L. Caecilius Jucundus*. **Bronze. Roman, 1st century A.D. Museo Nazionale, Naples.** When the Flavian dynasty, which was of plebeian stock, came to power, realism reasserted itself in portrait art. The Roman bust format was the ultimate stage in the Etrusco-Italiote tendency to concentrate on the face as most revealing of expression and personality. Here, despite emphasis on individualism, the work preserves the organic coherence of Hellenistic portraits.

become attuned to such forms over the last fifty years, but also because those humble and spontaneous native artists recaptured some freshness of feeling, some breath of the spirit that had long since vanished from the formalized Hellenic art, or had, in Rome, been quashed by an automatic realism.

While Wickhoff and Riegl were rehabilitating the art of the late Empire, the Austrian historian Strzygowski was describing the decline of Rome and the triumph of the East, whose "spiritual values," he claimed, had furnished Byzantium with the inspiration for a new style. There was, to be sure, at the time of the Empire, a provincial art in Asia Minor that perpetuated a traditional oriental hieraticism, well-exemplified in the Palmyra tomb statues; but it can be shown that in Byzantium itself Early Christian artists took up the Hellenistic style again and prolonged it until the 7th century, whereas in contemporary Rome, flooded with barbarians, truly new aesthetic values were being explored. Indeed, the Ravenna mosaics have been considered much closer to a "late Roman" style than to a Byzantine style.

All things considered, we come closer to the truth if we evaluate the Roman Empire on the basis of what it actually was: a union of peoples linked by a political and juridical concept rather than by a culture, an agglomeration of ethnic groups who did not even use a common language (the *pars orientalis* never gave up the use of Greek even for official documents), and who present an altogether less cohesive artistic *koiné* than the Greek world, which had never known political unity. While Hellenism pursued its course and the East its tradition, Rome elaborated an official art, which the barbarians in turn translated into more primitive forms.

The picture is not so simple as that, however, for in Rome itself there were artisans practicing a naive style, and throughout the Empire travelling workshops exchanged influences with one another. We can illustrate these cross-fertilizations in the case of sarcophagi brought to Rome from the East whose style, modified by Roman artisans, was then transmitted to the western part of the Empire; or with the example of the sculptors who came to Rome from Aphrodisias in Karia at the time of Augustus, and later can be traced as far away as Tripolitania and Spain. Too great importance should

146 *Hadrian*. **Marble. Roman, 2nd century A.D. Museo delle Terme, Rome.** Hadrian's reign, in fact the whole Antonine era, represents the golden age of the Roman Empire, seen as a huge and homogeneous world state. This marble bust, a little larger than life-size, reproduces the emperor's mobile face in an idealized fashion. Hadrian was the first ruler to adopt the short beard of the Greek philosophers, thereby establishing a fashion which was to become quite widespread.

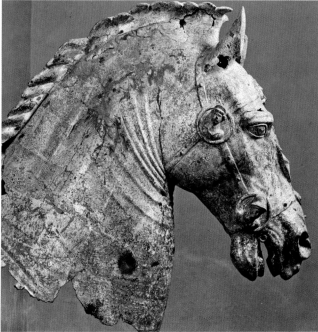

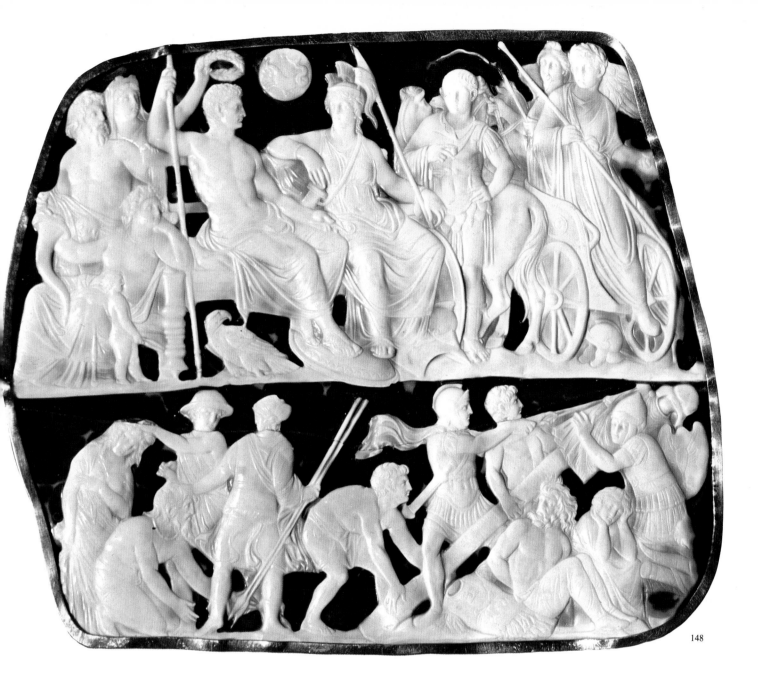

not be given to the fact that so many Roman artists were of Greek origin; to deny the originality of Roman art for that reason would be like denying that Sisley was a French Impressionist simply because he came from England, or like refusing to grant an indigenous value to 16th-century French painting because many of its artists were Italian or Flemish.

The existence of a Roman art cannot be denied, though it might more justly be argued that in some ways there was never a true Roman style; that the Romans created an imagery for which they found suitable forms but that they lacked the artistic impulse and even, through the mouths of some of their greatest men, expressed scorn for those who gave art an important place in the City; that they wanted to be known

as a people of soldiers and lawgivers, not artists; and finally, that their passionate interest in classical Greek works, for which they paid large sums, was more the result of snobbery than of real taste.

What can be considered Roman sculpture, properly speaking, was first created in the Urbs, and later spread throughout the Empire at the will of the emperors. It embodied an official imagery that, in its semi-civilian, semi-religious ceremonial and ritual representations, guaranteed the legitimacy of the Roman *potestas,* whose virtue was entirely concentrated in the person of the Emperor through the special grace that devolved upon him with the *imperium.* Order in the civilized world depended on the adoption of the Roman po-

147 *Horse's head,* **from Cartoceto di Pergola (Pesaro). Bronze, gilt. Roman, 1st century A.D. Museo Nazionale, Ancona.** This head was part of a group of separately cast bronze pieces welded together, fragments of which were found in 1949. The statues seem to have been purposefully and methodically destroyed. The importance of the figures represented is demonstrated by the sumptuous trappings of the horses, which wear *phalerae* decorated with busts of the gods.

148 *Gemma Augustae.* **Engraved cameo (sardonyx). By a Greek artist working in Rome in the 1st century A.D. Kunsthistorisches Museum, Vienna.** In the reign of Augustus, Dioskurides the engraver founded in Rome a whole dynasty of gem-cutters. The Gemma Augustae, an exceptionally large cameo (8 by 9 inches), commemorates the triumph of Tiberius after the surrender of Dalmatia and Pannonia in 9 A.D., and it offers a veritable manifesto of official Augustan mythology.

litical system by lands twice conquered, once by force and a second time by the beneficent powers of the *Pax Romana.* The most famous sculptures illustrating that propagandist iconography is the group believed (though this has been questioned recently) to have ornamented the *Ara Pacis Augustae,* or Altar of Peace, probably dedicated soon after 13 B.C. by Augustus, just returned from pacifying Spain. (The various pieces of this altar, discovered over the course of four centuries, were reassembled by the Fascist government on the banks of the Tiber, where the Campus Martius once lay.) In style, the altar has been called Pergamene, at least as far as the ornamentation is concerned; but it might more accurately be described as Neo-Attic, for the Ara Pacis meant to the Romans what the Parthenon meant to the Greeks. As on the Parthenon, classical forms are at the service of political order, but the Altar of Augustus celebrates men and individuals, and not gods, or even "citizens." A natural majesty, not unduly emphasized, seems to emanate from the persons of Augustus and his followers, but the sculpture of the frieze is a consciously programmed art in which history and allegory replace myth. The Ara Pacis expresses the fullness of a historical moment, while the Parthenon transcends history.

This official and propagandistic classicizing style was kept up in Rome and in the Roman provinces, with many transformations, until the end of the Empire. It flourished under Claudius and Titus, and even under Trajan (98–117 A.D.). (Although Trajan favored another style, he did not neglect the classicizing manner, as proved by the reliefs from his triumphal arch; these were later incorporated into Constantine's arch.) The grecophile Hadrian (117–138) gave classicism a new lease on life, and the images of his oft-sculptured favorite, Antinous *(fig. 150),* pushed the Greek ephebe type one step further in its evolution towards the hermaphrodite. In the late Empire, Gallienus (253–268) imposed the official style still, and even in a period officially Christian, Theodosius (378–395) adopted it.

This classicizing style in which Roman officialdom became "nobilified" might be called the style of The State Triumphant; but there was another style competing for attention, one which might be termed the style of The State Militant.

149 *Column of Trajan.* **Marble. Roman, 106 to 113 A.D. Forum of Trajan, Rome.** Trajan, soldier-emperor, created an iconography appropriate to the militance of Imperial Rome. The triumphal column expresses the conquering spirit far more effectively than battle scenes in the Greek tradition, in which individual combatants are opposed as symbols. Here, the figures are placed in superposed ranks, as if the viewer, like the commander, surveyed the battlefield from a high viewpoint. Dynamic composition binds the participants into a single action.

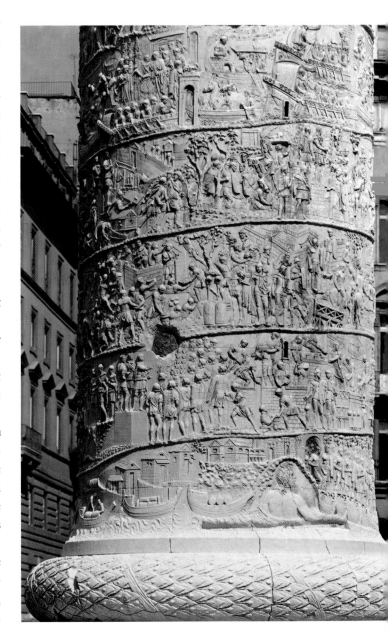

150 *Head of Antinous.* **Marble. Roman, ca. 140 A.D. Museo Nazionale, Naples.** The death of his young favorite, Antinous, left Hadrian inconsolable. He established an official cult to him and caused numerous effigies of the departed to be carved. Commissioned for the most part from Asiatic artists, these statues belong to the tradition of classical ephebe sculpture. The contrast between the polished flesh surfaces and the complex locks of the hair is characteristic of portraits from the Antonine era.

The imagery of works in this style reminded the citizen that the providential Roman order could be maintained only through ceaseless fighting against the thrust of barbarian forces, which had not only to be kept in check, but also to be won over to the cause of civilization. The Roman state rested on the principle of continuous expansion and conquest; when Rome was finally placed on the defensive, it was the beginning of her end. The Roman first came in the guise of a soldier; the soldier introduced to the conquered land the lawyer, the administrator, and the colonizer; these persons organized justice, administration, and the economy. It was Trajan, soldier by trade, who created an iconography expressing the force of the militant expansion of Imperial Rome. In the triumphal column that he had set up to celebrate his victories against the Dacians, the story of his campaigns is narrated without interruption in a spiraling relief, 215 yards long, wrapped around the column *(fig. 149)*. The "continuous style" in which the reliefs are carved expresses an unfaltering fighting and conquering spirit far more effectively than could any Greek battle scene, where balanced reliefs portray con-

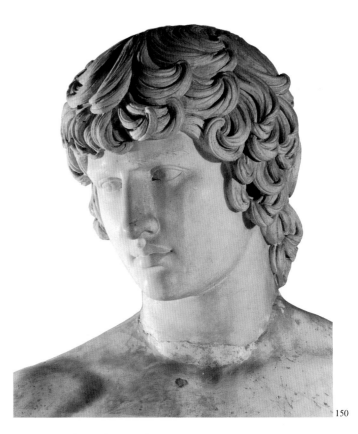

150

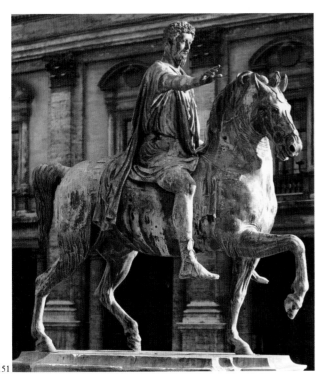

151

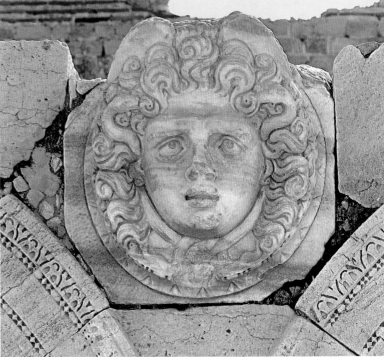

152

151 *Equestrian statue of Marcus Aurelius.* **Bronze. Roman, ca. 170 to 180 A.D. Piazza del Campidoglio, Rome.** During his reign, Marcus Aurelius saw the stability of the Roman Empire shaken. This large equestrian statue in gilded bronze probably adorned the upper part of a triumphal arch. The effigy was placed by Michelangelo at the center of his Piazza del Campidoglio. Its influence over equestrian monuments of the Renaissance was considerable.

152 *Medusa head,* **from the Quadri-Portico of the Severan Forum at Leptis Magna Roman, beginning of the 3rd century A.D.** In each of the spandrels between the arches of the great Quadri-Portico in front of the basilica at Leptis Magna, there was a Gorgon or Medusa head in *imago clypeata,* in the form of a shield. There are 70 of them, either still in place, or in the Castle Museum in Tripoli. The most beautiful exhibit a sense of grandeur, making them masterpieces of antique monumental art.

tests between individual combatants who are symbols rather than persons, and are connected only by the requirements of visual rhythm. On Trajan's column the organized might of the marching legions clashes with the native violence of the barbarians in a relentless melee, until the final victory of the Romans. It is a purely Roman style: a new outlook has given birth to new forms. Abandoning the illusionistic and rhythmic elements of Greek classicism, the sculptors of Trajan's column have disposed the figures in ranges one above another, as if the spectator, like the commander-in-chief, dominated the scene from a high point, viewing the various episodes of the battle unfolding in isometric projection. They did not hesitate to alter the scale of human figures in relation to each other or to elements of the settings, which are treated as mere accessories though represented with great realistic accuracy. A dynamic composition irrevocably binds the actors of this tragedy into one single action and movement. Trajan's column represents one of the greatest achievements of ancient art; in that column Rome revealed her whole personality— her will for power supported by an awareness of her civilizing influence. That grandiose spiral frieze is the best expression we shall ever see of the clash of antagonistic forces that divide men and set them at each other's throats in war, that war which Rome held necessary to the safeguarding and extension of her greatest gift to the conquered countries: peace in the state.

The originality of this realistic Roman recording is undeniable: Hellenistic realism is quite different and anecdotal in character, and it was Roman positivism which discovered the plastic equivalent for a sense of history. It has even been suggested that the artist who designed Trajan's column must have had at hand some epic Latin poem that did not survive its illustration in marble. The column itself had in any case a votive and commemorative significance deriving from the triumphal monuments erected in Rome from the Republican period on to celebrate victories, as well as in the tableaux representing battles and campaigns that inevitably formed part of the triumphal processions accorded to victorious generals on their return to Rome. The column is a *monumentum,* a memorial, in the etymological sense of the word. The artist

in no way reorganized the teeming thematic material of his reliefs so that the spectator could grasp their meaning more easily, nor did he make any attempt to correct the optical diminution of the figures as they wind higher and higher up the column. In fact not before the lapse of centuries and the advent of the modern telephoto camera lens could the reliefs on Trajan's column be really seen and accorded the admiration due to their great quality.

To compare Trajan's column with the Pergamon frieze highlights the profound differences between the Greek and the Roman spirit. To celebrate a historical event, the Greek immediately linked it with some mythical, heroic archetype, his imagination overarching history to find some essential form and idea that would raise man above the specific event; the Roman, on the contrary, represented the actual man, not heroes, recognizing only the facts, struck only by the actually experienced aspects of history. Rome gave us Tacitus; Greece gave us Homer. The same impulse that made the Greek artist go beyond events also helped him to move with ease in the world of formed concepts. At Pergamon, the artistic intention was primary, and the artist of the altar organized his colossal frieze into a grandiose spectacle; but in Rome, the imagery on Trajan's column escapes the eye's grasp. What the two monuments have in common is a certain conception of composition in which the individual actors are bound together by a continuous stream of movement. It is not surprising that the Romans adopted this style of composition, later called baroque, since one of their contributions to architecture is precisely that baroque quality of moving, coloristic surfaces; however, we can hardly appreciate this quality now, as the buildings have lost nearly all their ornament of columns, moldings, and panelings of colored marble.

Trajan's column is the starting point of a style which was to evolve more and more towards a sense of the tragic. Conceived three-quarters of a century later, but on the same principle, and designed to celebrate the victories of a philosopher-emperor who hated war and yet had to wage it throughout his reign, the reliefs on the column of Marcus Aurelius (161–180) bear the marks of a spiritual malaise that had begun to affect both private citizens and public men in the late 2nd

153 *Arch of Constantine.* **Roman, 315 A.D. Rome.** The triumphal arch celebrating Constantine's victory over Maxentius is largely decorated with reliefs taken from monuments of Trajan, Hadrian and Marcus Aurelius. However, there is a long frieze that was executed *in situ* when the architectural sections of the arch were completed. These reliefs, formerly painted, demonstrate the appearance of a popular, narrative genre in official art, echoing the style of sculpture made during the Tetrarchy.

153

154 *Stele of Bellicus the Blacksmith.* **Gallo-Roman. Musée Archéologique, Sens.** The characteristic production of Gallo-Roman sculpture is the funerary stele. The deceased usually wanted to be depicted engaged in their daily activities, and these candid scenes reflect the hard-working, prosperous life of Roman Gaul. In its naiveté and spontaneity Bellicus' stele is a good example of this popular art, unpolished but full of life.

century. The faces of the actors in Trajan's reliefs, adhering still to a classical tradition, express very little of the impulse that moves their bodies, and their dignified look makes them appear actors in some great historical drama. On the column of Marcus Aurelius the faces of both barbarians and Romans reflect the virulence of battle, the relentless mechanical force of the legions turning to ferocity, the primitive violence of the barbarians turning to fury. With their flaming beards and hair, their coarse, ravaged features, and their burning eyes, the Sarmatians and Germans have an aura both "demoniac and pitiful," as Charles Picard has put it. The demon urging them on is rage against the invaders; all the evils that conquest brings upon them—torture, burned villages, razed towns, mass deportations—are fully pictured here. The *Pax Romana* advanced with cataclysm and misery. The victorious army took booty, not only of gold and precious materials, but even more, of human cattle. One result of the Roman victories was an enormous increase in slavery; Caesar is said to have sold a million Gauls. Many of those slaves had to fight again, but against each other in the arena, for the amusement of their conquerors. Some deep sense of remorse regarding so many outraged human lives must have tormented the Romans, for they insistently depicted the tortures inflicted on their enemies.

To the end of the ancient world the vanquished barbarian remained for sculptors the type of human suffering. It was frequently represented on Roman sarcophagi, which are among the most original creations of the declining antique world, for in them all traditions from both East and West converge. On the sarcophagi an expanded mythical imagery may be found, drawn from traditional sources by the mystery religions and carried by them everywhere. This mythical imagery dwelt on themes of the spirit, of suffering, of afterlife: hunting myths (Meleager, Hippolytus, Adonis), the hunt of the camel, lion, or deer, Bacchic myths, nuptial myths (Alcestis), myths of the underworld (Hermes, Psyche, Persephone, the Nereids), moral myths (Achilles, Hercules), pastoral scenes, and groups of philosophers. (Philosophers were again in fashion, probably because of the influence of Plotinus in the second half of the 3rd century,

when the ideal of *homo spiritualis* won out over the ideal of a life of action.) In these funerary monuments the Romans often scorned allegory and had themselves pictured engaging in some military, religious, or civilian act of public life, or the deceased was represented with his right hand linked with that of his wife. Styles used on those sarcophagi, the manufacture of which was an important luxury industry, varied from the classical to what might be called the romantic, more or less according to the subject depicted. The assemblies of philosophers are direct forerunners of the apostle groups of the 4th century. In the lion hunts and in the themes of vanquished barbarians, a more "Roman" style, with the accentuated overtone of pathos found on the reliefs of Marcus Aurelius' column, was used for turbulent compositions in which the tragic barbarian faces take on the look of martyrs. Was not the stoic philosophy of Epictetus then spreading, with its conception of man as a "martyr," that is, bearing witness to the divine through suffering?

It has been in turn affirmed and denied that portraiture was one of the original forms of Roman art. An Italic origin for portraiture cannot be claimed because Etruscan effigies, however characteristic they may be, tend to follow a rather monotonous typology. On the other hand, the rare portraits of the Republican period, such as the beautiful bronze *Capitoline Brutus (fig. 142)*, reflect the Hellenistic manner, although the physiognomies are typically Roman. But lest excessive analysis and speculation make us lose sight of the object, it should be stated that there is indeed a Roman form of portraiture quite distinct from the Hellenistic. The Romans conceived the portrait as a physical reconstitution of a person, represented without the psychological interpretation with which the Greeks endowed their most individual effigies. The Greek portrait is a character study, but the Roman portrait is a lifelike reproduction of the sitter's every feature, so faithful that it allows the spectator to speculate for himself on the person's character, viewing its marks in the plastic material of the face. This realistic tradition had its origin in the ancestor portraits that the Romans kept in cupboards in their houses and which served them as a genealogy. They were funerary masks molded in wax or plaster on the face of

the dead, using a technique invented by Lysistratos, brother of the great Lysippos, at the end of the 4th century. The ancestral portraits were carried at funerals, receiving the honor of the *laudatio funebris* along with the effigy of the deceased, and they were also taken out for certain public ceremonies. Their possession was a right reserved to noble families by the *jus imaginum maiorum,* and those who had been subject to a condemnation were deprived of their right. To have a cupboardful of portraits was a sign of nobility—hence the practice of bust portraiture (the Greek portrait consisted of the head alone, set on a herm), and also the habit of truthful representation, typical of Roman psychology, according to which every man was an individual in his own right and existence. Rome was affected only later by ontological problems, and then the faces began to exhibit the inner turmoil of a spiritual life, particularly in the eyes, which, however, tended to contrast with the straightforward realism of the face. In the East, in the so-called Fayum portraits stemming from the Greek tradition, the state of the soul imprints itself in the morphology of the face *(fig. 158)*.

Paralleling the realistic series of portraits is another type: the official effigy, depicting a person in the performance and garb of his functions, either *togatus,* or clothed with the *lorica* and the *paludamentum.* The women of the imperial families

155 *Cippus decorated with female dancers.* **Stone. Gallo-Roman. Archeological Institute of Luxemburg, Arlon.** The female dancer who decorates this cippus found in the *vicus* of Orolanum, near Trier, derives from a Greek prototype, but the rationalized Hellenistic model finds a new vitality in the smooth volumes of this provincial version. Carved from a somewhat coarse local stone, the cippus retains traces of vivid polychrome.

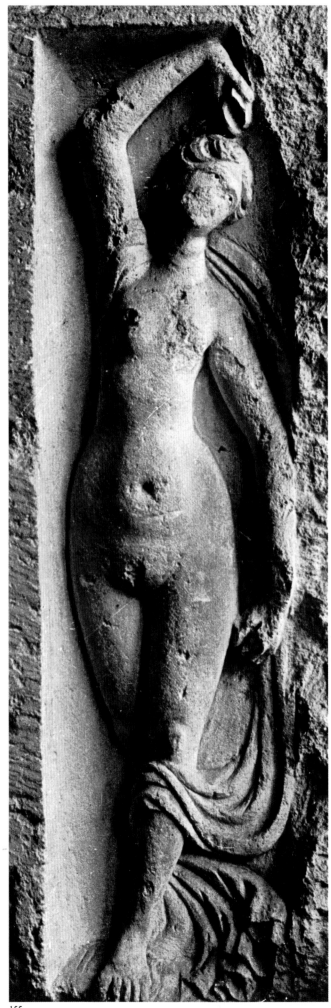

have their own attributes and typology. Certain portraits of emperors triumphant took the form of equestrian monuments, though paradoxically, the only one in that form that has reached us is the portrait of the least warlike of all emperors, Marcus Aurelius, whose equestrian statue now stands on the Capitol, in Rome, having been spared by medieval iconoclasts under the mistaken impression that it represented Constantine *(fig. 151)*. Recent excavations at Cartoceto, near Pesaro, have brought to light the remains of what must have been an important imperial group in gilt bronze, dating from a period prior to the Marcus Aurelius statue and finer in execution and finish *(fig. 147)*. It is presumed that it represents Nero and his brother Drusus III on horseback, with Livia and Agrippina.

Since the excavations at Leptis Magna we know precisely the moment in time and space when Graeco-Roman sculpture began to undergo profound alteration *(fig. 152)*. Under Septimius Severus, who came from Leptis, important workshops were opened to carry out the sculptures for a triumphal arch, a basilica, and a forum in that town. To execute these large projects, artists were summoned from various corners of the Empire, but mainly from the East—not surprising on the part of an emperor who hastened the decadence of Rome and its aristocracy to the profit of the provincial bourgeoisie. The sculptural decoration reflects various styles, and most important, carvings on the arch, probably made by oriental artists, show a new style in which great use is made of the drill. The result is what has been called "negative relief," since instead of modelling the relief with the chisel, and bringing it out of the background in rounded form, the background is cut away by making incisions with the drill around the forms. Modelling is achieved mechanically and loses all its three-dimensional quality, no longer appearing to vary according to its direction in space and the intensity of the light. The sharp-edged raised areas appear rather flat, and are surrounded by deep black grooves. The figures are rigid, lifeless, and hieratic, initiating that trend towards the dehumanization of the figure which accelerated over the course of the 3rd century and ends in the flat, schematic representations of the early Middle Ages. The change is already complete in the reliefs of the *Arch of Constantine* in Rome *(fig. 153)*, and when the Emperor wished to celebrate his triumph over Maxentius, it appears that he could find in Rome only artists capable of working in this coarse and rather primitive style. He incorporated into the decoration of his arch several reliefs borrowed from monuments of his predecessors, Trajan, Hadrian, Marcus Aurelius, so that we can follow in that one triumphal arch the progressive "degradation" of antique sculpture. Comparing the Constantinian reliefs to those on the Porta Romana in Milan, built in 1167, Maurizio Bonicatti stated that Constantine's artists had inaugurated medieval sculpture. All suggestion of realistic illusion is banished, all rounding of form in space; figures are spread monotonously on one plane; sharply detached from the background by the edgy silhouetting produced by the drill, they lose all organic connection with the whole; the proportions of one figure to another and of the various parts among themselves are no longer governed by nature, but by principles of moral hierarchy. The break is complete with the aesthetic of Phidias and Polykleitos, who had made the harmonious human body a symbol of truth. Corporeal beauty and physical existence as such had long been deprecated as inferior to the inner life, whose secrets men now sought in mystic communities, escaping from the shapeless and hard reality that burdened them. Instead of the religions of classical paganism, which had been practiced in the full daylight that glorified the bodies of gods as well as those of men, religions of initiation, secret religions, now flourished. Christianity, not the first mystery religion, took over the secret and initiatory form, and on becoming the official religion, drew to itself the provincial styles and eastern abstractions, from which to create the principles of a new art opposed to that of paganism. The Christians destroyed the pagan idols, and broke into a thousand pieces those divine bodies which men had so much admired. In the Sperlonga grotto we can see how huge sculptures were patiently reduced to dust by fanatics of the triumphant new religion, who were determined to annihilate even the memory of those myths that had enchanted men's minds, and to impose on them new ones concerned with spiritual salvation.

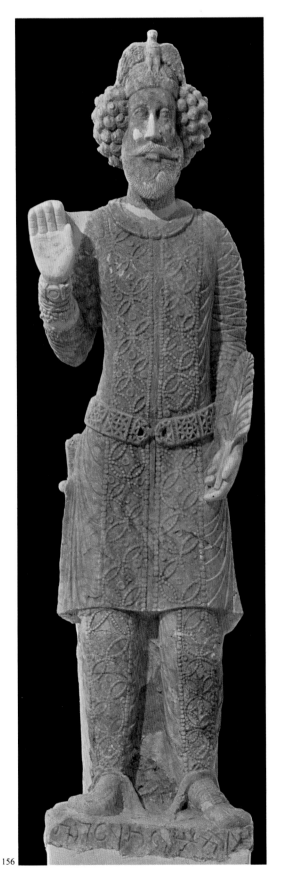

157 *Triad of deities.* **Palmyrene. The Louvre, Paris.** The ethnically mixed population of Palmyra paid honor to gods of a thoroughly syncretic nature in which a Semitic element predominated. The three gods Aglibel, Baalshamin and Malakbel are represented on this bas-relief, oddly combining coiffures made up of astral elements with the uniforms of Roman generals. Congealed in a hieratic pose three times repeated, the gods are shown frontally, their symbolic immobility emphasized by a neutral background enlivened only by some inscriptions in Palmyrene writing.

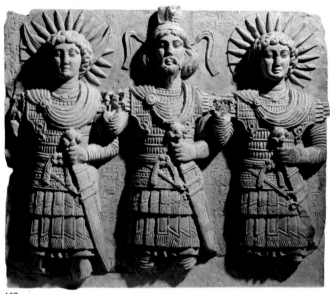

157

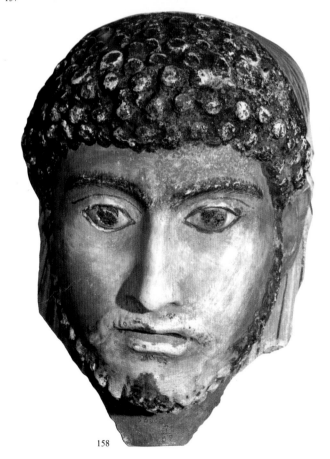

158

156 *Sanatruces II, King of Hatra.* **Marble. Iran, Parthian, 2nd century A.D. Iraq Museum, Baghdad.** Hatra enjoyed great prosperity in the 2nd century A.D., when it was the capital of a small kingdom on the Upper Tigris. This statue, found in a temple, represents King Sanatruces II in prayer, one hand raised, and holding in the other a sacrificial palm. The king is wearing a diadem surmounted by an eagle.

158 *Mask from a mummy.* **Graeco-Roman. Egyptian Museum, Cairo.** From the time of the Old Kingdom in Egypt it had been the custom to cover a mummy's face with a mask cut. The mask was intended to serve the deceased as a head, should his own be destroyed. Between the 1st and the 5th century the Greeks and Romans adopted this custom but they transformed the masks into true portraits.

IV

THE TWILIGHT OF SCULPTURE IN THE WEST

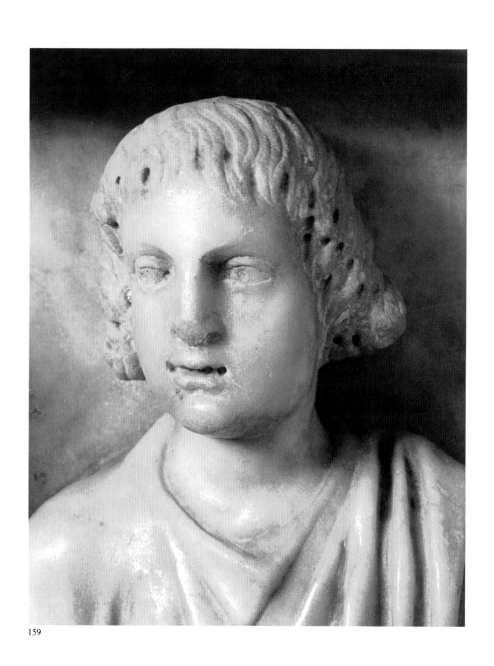

159

It is the convention to date the beginning of a new era in art history with the official recognition of Christianity under Constantine in the early 4th century. Like all overprecise dates for styles and trends in art, this one may cloud the issue rather than clarify it—or, one might better say, prove confusing by overclarifying a situation that is actually muddled. It is true that Constantinian artists produced flat and weightless forms that seem to initiate a new, anti-natural and otherworldly art. Some critics (as noted already) have even placed the beginning of the new style as early as the 3rd century in what is still a fully pagan era. On the other hand, it is equally possible to regard the art of the 4th and 5th centuries as a last—though Christian—phase of antique art, to whose borrowed forms the new religion simply gave new meanings. The togaed figures that we find on sarcophagi or in mosaics of the 4th and 5th centuries are not Roman officials, but Christ and the Apostles, new iconographic personages robed in antique clothing; and in the effort to find a worthy semblance for Christ himself, these centuries hesitated between a beardless, youthful head inspired by the Apollonian image *(fig. 159)*, and a sterner, bearded, patriarchal head adopted from the type of Jupiter (or Dionysos or Asklepios)—an image that eventually prevailed owing to the weight of Oriental and Semitic influence. It was not only in dress and facial types that the new art maintained antique appearances, but also in the style. In sculpture, in fact, there seems to have been a revival of the Graeco-Roman ideal in the second half of the 4th century, after the pronounced primitivism of the figures on the arch of Constantine; this revival, contrary to what was once believed, was most vigorous at Constantinople. The first Christian emperors, having shifted the base of their empire to that city, attempted to resuscitate antique forms in the service of the new triumphal, imperial, and theological art. Something of the measure and idealism of Greece remained in Byzantine art, especially in the court art, however far it departed from naturalism, persisting even up to the 11th century, when the Byzantine style clearly contrasts with the perfervid northern Romanesque.

The turn away from the ancient concept of beauty centred on the human figure in its harmonious, natural, and corporeal form, towards an aesthetic responding to the Christian ideals of the other-worldly, was by no means definitive until later. Hence it is possible to interpret 4th- and 5th-century art as either a last phase in ancient art, or a beginning, for contradictory and overlapping stylistic currents actually do present themselves (as so often in troubled times, including our own) and had, for that matter, already been present in the art of the late Empire.

This fluidity of style must be borne in mind in approaching the monuments of the early Christian era. We find, for example, the same subject—the Entry of Christ into Jerusalem—treated on two contemporary sarcophagi; but where one demonstrates the disintegration of the ancient sculptural style *(fig. 160)*, the other shows its continuation. The latter, the sarcophagus of Junius Bassus *(fig. 161)*, is, in fact, one of the most accomplished monuments of late antique art. The two tendencies may also appear in one and the same work: the figures on a sarcophagus from Sidamara, for example, are modelled with the chisel in true relief form, while the architecture and ornament are worked with the drill, which produced a characteristic kind of bodiless lacework *(fig. 164)*. The latter was the style of the future; the former, of the past. Some figures have a kind of hybrid look, like the statue of an official from Aphrodisias, whose body is adopted from the antique manner, while the head conforms to the "modern" style, like the head identified as a portrait of Eutropius *(fig. 163)*, which is already a saintly, emaciated, El Greco type. The 4th and 5th centuries produced an abundance of sculptures, in which the mixture of styles can be studied. For St. Helena's porphyry sarcophagus *(fig. 162)*, clearly a work of great cost, an artist was still found who could emulate all the classical techniques of producing three-dimensional figures, in a deliberate effort to revive the great "neo-Attic" style of the time of Augustus; but the three-dimensional figures fall out of context, as it were, for there is no rhythmic unity among the various personages, each being treated as separate, and they float on the compositional field like astronauts in weightless state, neither action nor rhythm linking them. Though the artist reached for the sculptural volumes of Graeco-Roman forms, the spirit that moved him was no longer that of an-

159 *Head of Christ,* **detail from the Sarcophagus of Junius Bassus (fig. 161) Vatican Grottos, Rome.** The Christ who sits enthroned as lawgiver between Peter and Paul is a descendant of the youthful gods of antiquity. The light, flowing hair, the wide-set eyes, the straight nose, the full cheeks and the fleshy mouth all bring to mind certain Apollo types. Through its central position and its radiance, this figure sheds a religious aura over the series of narrative scenes set around it.

160 *Sarcophagus of Valerius and Adelphia,* **detail. Marble. Early Christian, 330 to 340 A.D. Museo Nazionale, Syracuse.** Its popular character, the lack of any strong accent in sculptural rhythms, the stocky figures, the clumsiness in rendering drapery—all these features characterize the sarcophagus at Syracuse. It appears to offer a last echo from the long friezes on the Arch of Constantine. The charm of the work rests in its naive spontaneity.

161 *Sarcophagus of Junius Bassus,* **detail. Marble. Early Christia ca. 359 A.D. Vatican Grottos, Rome.** The sarcophagus of Junius Bass the Prefect of Rome, is one of the finest creations of post-Constantini art. The figures, set off by thoroughly classical architecture, have a ne fullness, an independence as regards the background of the relief whi makes them almost sculpture in the round. The quality of the drapery particularly noticeable on the figure of the youthful Christ.

162 *Sarcophagus of Saint Helena.* **Roman, early 4th century A.** **Vatican Museums, Rome.** This sarcophagus shows very realistic figur doing battle on an imaginary terrain. The arbitrary spatial arrangement this early 4th-century composition foretells some aspects of Byzanti painting. Sarcophagi in porphyry were no longer made after the midd of the 5th century when relations between Constantinople and Egypt b came strained. It is not known whether this is a real battle or a symbo struggle between the faithful and infidels.

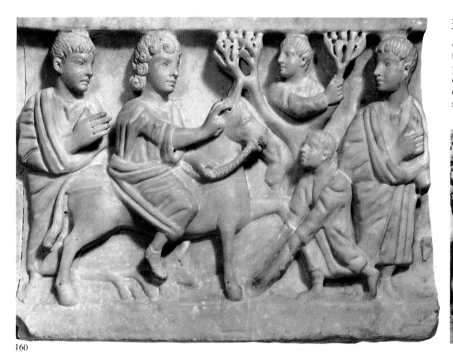

160

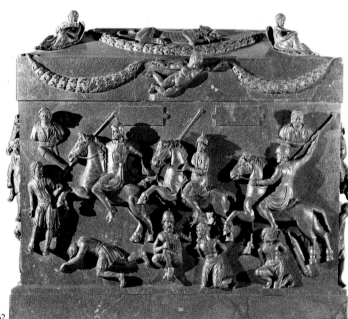

162

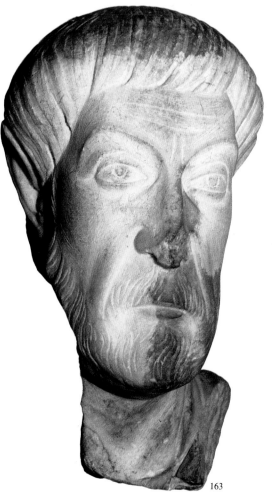

163

163 *Portrait of Eutropius(?).* **Marble. Early Christian, 5th century, A.D. Kunsthistorisches Museum, Vienna.** Although still bearing the stamp of Roman realism, this remarkable head also possesses that glance seeming to penetrate a world beyond the spectator, and those stylized, even schematized, features characteristic of portrait art from the 4th century onwards. Found at Ephesus, it was first believed to be part of a religious group, doubtless because of its intense spirituality; but it is now connected with a base that bears an inscription praising Eutropius.

164 *Sarcophagus from Psamathia (Constantinople).* **Marble. Early Christian, ca. 400 A.D. Staatliche Museen, Berlin.** This sarcophagus fragment was discovered in Constantinople in the Psamathia quarter; its form was inspired by the pagan funerary sculpture of Asia Minor, the most famous example of which is a sarcophagus found at Sidamara. There, the figures are inscribed in a rhythmic architecture of twisted columns surmounted by a triangular pediment, and framed by architraves and conches. The sarcophagus employs only the central part of this composition.

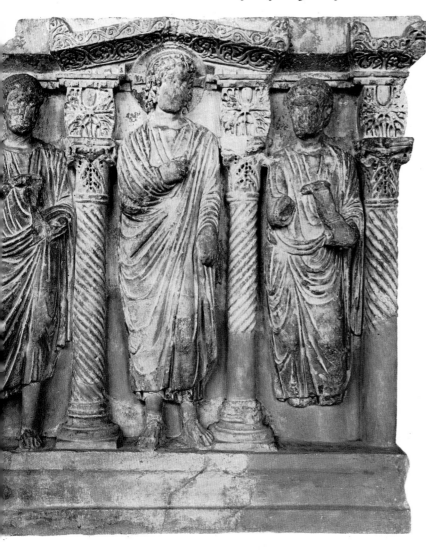

165

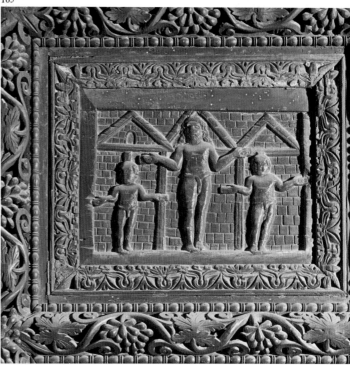

165 *Crucifixion,* **on the door of St. Sabina. Wood. Early Christian, ca. 430 A.D. Rome.** Totally unknown before the 4th century, the subject of the Crucifixion became widespread in Early Christian art after the theologians began to emphasize the dogma of incarnation in their struggle against Docetism (the doctrine that Christ's humanity and suffering were apparent rather than real). The Crucifixion on the door of St. Sabina is one of the very first examples of this scene, which remained triumphant for centuries in religious art. The building with a triple facade may be an evocation of Jerusalem.

166 *Colossal statue of an Emperor,* at Barletta. Bronze, 5th century A.D. **Italy.** All the power of the emperor-strategus is displayed in this gigantic statue. The head has the nobility produced by that stylized realism characteristic of Roman and Byzantine portraits from the 4th century onwards. It results in the creation, not only of an individual, but also of a type—which explains why this sovereign, here identified as Marcianus, has been taken for almost every emperor from Valentinian I to Heraclius.

167 *The Tetrarchs (?).* Porphyry. Roman, late 3rd or early 4th century A.D. **Southwest corner, façade of St. Mark's, Venice.** If this image represents the Tetrarchy, then the two Augusti here greet the two Caesars. This hypothesis would account for the presence of four figures, and also, in dating the work to the late 3rd century, would in part explain its stylistic vigor—the large, simple forms, and the faces conforming to types rather than individuals. The hardness of porphyry contributes to the style.

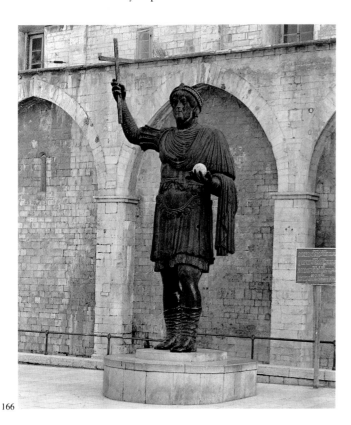

166

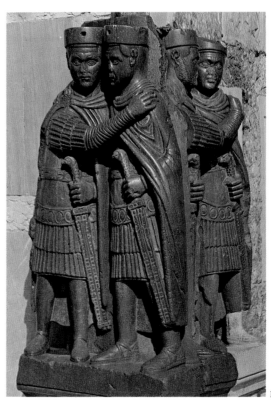

167

tiquity, and his solid forms are not set in space, but move on a single, abstract plane. The result is paradox, for all the artist's efforts to make the forms round and solid, working as relief forms, have only resulted in a bumpy surface. Other misconceptions of the spirit of the ancient style produced ridiculous results like the statue of the Emperor Marcianus at Barletta *(fig. 166),* which is a sort of blown-up dummy proclaiming on a gigantic scale the death of an art. On the other hand, the two pairs of emperors embracing each other on St. Mark's in Venice *(fig. 167),* earlier by a century than the Barletta puppet, are masterpieces of the new style in which the reduction of reality to hieraticism is worked through a deft simplification of volumes and modelling. Two slightly later but similar groups, now in the Vatican, demonstrate the lack of consistency in the style of the time, for these appear to be grotesque puppets. Both sets are now believed to have been detached from triumphal columns.

What might be called a kind of rearguard action in the retreat of ancient forms was engaged in by the artisans practicing minor arts—the gem cutters, ivory carvers, and, especially, the goldsmiths. These makers of luxury objects seem to have resisted for some time the evolution taking place around them. Metal workers in particular continued to employ the old mythological motifs on repoussé silver dishes for their rich clients; and even under Theodosius, those of the Roman aristocrats who had remained faithful to the old gods had this pagan imagery embossed on their richest table vessels. In the 6th and in the 7th century, in Asia Minor and in Constantinople, mythological subjects appear as diversions for those Christian aesthetes who retained a fondness for antique culture. The art of these workers in silver and gold is extremely important, for through it was transmitted to the West a technique of working in relief, a technique that was rapidly disappearing from sculpture in stone and marble.

If we try to imagine some marble or bronze group of sculpture in the round set in the atmosphere of Hagia Sophia

168

168 *Corinthian capital* in S. Costanza 4th century A.D. Rome. In its development through Early Christian times the capital reveals a progressively more pictorial treatment of the sculptured elements. At S. Costanza, the capitals are still true composite Corinthian capitals, but they lack the opulence of the heavy forms of antiquity, and appear rather dry. The abutment of the arches necessitated a stout entablature with diverse moldings; in this entablature originated the impost block, which was finally reabsorbed into the capital.

169 *Capital,* from the gallery of Hagia Sophia. 6th century A.D. Istanbul. In some cases, for example this Ionic capital from a gallery, the impost has been kept, but for aesthetic reasons the combined capital and impost were intended to give the illusion of a single block. Pressing apart the acanthus leaves, the monogram takes its place in the ornamental frame of abstract leaves. Unlike this one, most of the capitals at Hagia Sophia move, without the transitional impost, directly into the decorative patterns of the arches.

170 *Capital,* from San Vitale, Ravenna, ca. 525 to 547 A.D. Italy. In the church of San Vitale, pilasters of green porphyry divide and accent the marble panels below the famous mosaics of Justinian and his Empress. The capitals crowning these pilasters are carved in very low relief, and the plant decoration of which they are formed is treated in a strictly two-dimensional, symmetrical manner. Here, sculpture tends towards drawing, and the structure of the capital is reduced to a play of balanced lines.

169

170

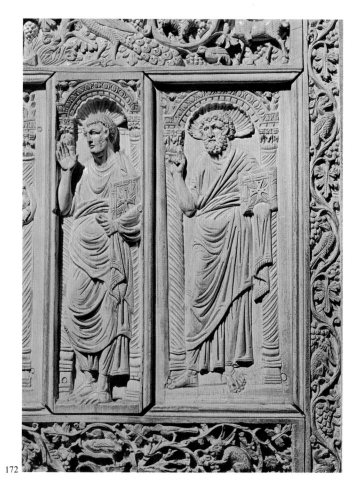

172

172 *St. John and another Evangelist.* **Detail of Maximian's throne (fig. 171).** The four evangelists on the front of the throne, turning towards the central figure of St. John the Baptist, have the authoritative stance of ancient philosophers. Each stands before an aedicula with twisted columns, a scallop shell haloing his head to emphasize his sacred nature. Of the two on the right, the younger, who is beardless, is doubtless John. Despite the classicism of the architecture, the monumentality of the figures and the broad sweep of the draperies, the tendency of Byzantine sculpture to compress volumes is already felt.

171 *The Throne of Maximian.* **Byzantine, mid-6th century A.D. Archiepiscopal Museum, Ravenna.** Several hypotheses have been put forward concerning the origin of this splendid ivory throne. According to the most widely held opinion it belonged to the Bishop Maximian, as the monogram visible on the front part of the seat would seem to show. It may have been a gift from Justinian.

in Constantinople or of San Vitale in Ravenna, we realize how incongruous it would look, like a presence from a quite different world. By this period a new spirit had so transformed architecture as to exclude relief sculpture entirely from the role of architectural ornament. The evolution towards this moment had already begun in the late Empire, for surely only a group as huge as the Farnese Bull could have made an effect in the Baths of Caracalla (where it was found) while all the other statues that clustered in that building must have been dwarfed by its gigantic voids. It is impossible to conceive reliefs enlarged to the gigantic dimensions such buildings required. The ornament proper to these late Empire buildings was the mosaics and marble paneling that provided this new kind of architecture with a colored skin. The Greek temple, with its strict volumes and plain surfaces, presented itself in space with distinct dimensions, as a real presence, and called for relief sculpture to enrich its forms by articulating them under the light and tempering their contours with human images. The late Empire building, with its cellular structure, was not conceived for outward effect. It was instead a series of hollows excavated in a mass. The Romans' highly developed vaulting techniques allowed them to construct a succession of enormous voids unobstructed by supports, and the architects delighted in varying the volumes of these interior spaces with curving planes that produced undulating, advancing, and receding surfaces unsuited to sculpture. Sculpture had perforce to be absorbed into the wall, as it were, taking on the quality of a kind of chasing on stone, so that the light would not be caught by too strong projections and break the unity founded on the spatial interplay of colored surfaces. The ultimate and logical end of this kind of symphonic unity was finally achieved not by Roman architects, but by Byzantine, in the great monuments of Constantinople and Ravenna. This logical evolution of forms is strikingly illustrated in miniature by the evolution over the 5th and 6th centuries of the Byzantine column capital, based originally on the antique composite capital *(figs. 168–170)*. The early examples still retain the original's profile and ornament in quite pure form, but worked with the drill, which turns the ornament from relief forms into a kind of

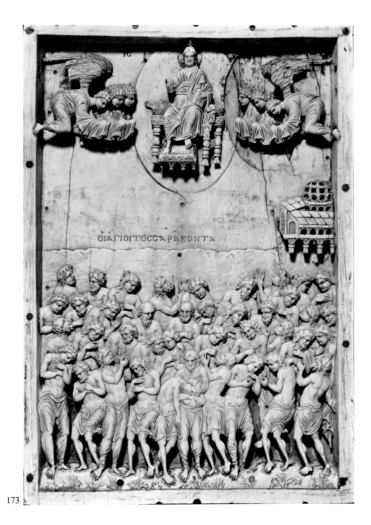

173

173 *The Forty Martyrs.* **Ivory. Byzantine, 12th century A.D. Staatliche Museen, Berlin-Dahlem.** This ivory depicts the death agony of the forty martyrs of Caesarea. The elegance of the style, a certain affectation of the poses, a taste for pathos and for the human have caused this work to be placed alongside 12th-century Constantinopolitan art. The representation of some of the martyrs is inspired by ancient sources, such as Pan instructing Daphnis.

fretwork. The inverse truncated pyramid serving as an impost block is merely a geometric simplification of the piece of entablature that in late Empire architecture was interposed between arcade and capital. The curving profile of the composite capital gradually became a truncated cone surmounted by volutes, then a kind of ribbed basket-form; finally it dis-

appeared completely as the capital was reduced to the form of a reverse truncated pyramid similar to the impost block surmounting it, no longer a volume curving in space but an assemblage of four faces, flat planes, calling for a flat lacework decoration. The monotonous embroidery that ornamented the capital also covers the walls of the arcades, and nothing breaks the continuity of the luminous surfaces that merge one into another to make up the interior of a building like Hagia Sophia. One no longer stands before the monument to look at it as a spectator, a position implying a certain distance, both physical and intellectual, between spectator and object; the worshipper is immersed in a space bounded by vibrant, shifting colored surfaces flowing one into the other without interruption, and even the intervals open only onto other shimmering colored surfaces. The worshipper is no longer required to see clearly or to understand; but simply to allow the mystic luminosity to fill his soul as it submits itself to those effluvia of light symbolizing the world beyond.

The only kind of object that can be imagined set in the interior of a Byzantine church is one like the so-called *Throne of Maximian* in Ravenna *(fig. 171).* With the same kind of lacy, ornamental carving spreading over all the surfaces, it is a paradoxical monument and seemingly little suited to sitting. This unique piece, once regarded as Alexandrine but now believed to be from Constantinople, shows a fine balance between the antique sculptural style, still observable in the figures, and the flat, chased carvings of graceful foliated scroll ornament in the decorated panels, filled with animals symbolizing paradise—a kind of ornament that seems to have been characteristic also for the columns of ciboria. These subtle reliefs carved in soft ivory hues must have been invisible from a distance: enveloped in the semi-darkness of the church, they must have seemed a bodiless presence; the cold light of the museum robs them of this mysterious existence.

It seems clear why monumental sculpture fell into disuse by the 7th century in Byzantium. It did not absolutely disappear, for later Greek builders were in the habit of inserting sculptures in the outside walls of their churches, and a whole provincial school, the Armenian, continued to erect stone buildings and carve stone sculpture. The Armenian sculptors

174 *Diptych of Anastasius.* **Ivory. Byzantine, early 6th century A.D. Cabinet des Médailles, Paris.** From 399 onwards, a consul was appointed annually for each capital city. At his accession to power, the consul sent to his acquaintances ivory diptychs fitted with wax tablets. Here, in a splendid robe decorated with a rosette pattern, the enthroned Flavius Anastasius holds a scepter and the *mappa* that he will throw as a signal for the beginning of the games celebrating his entry into office.

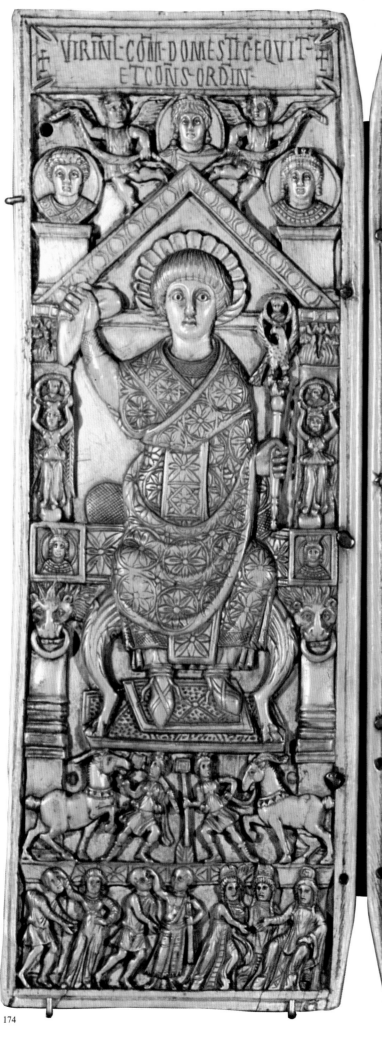
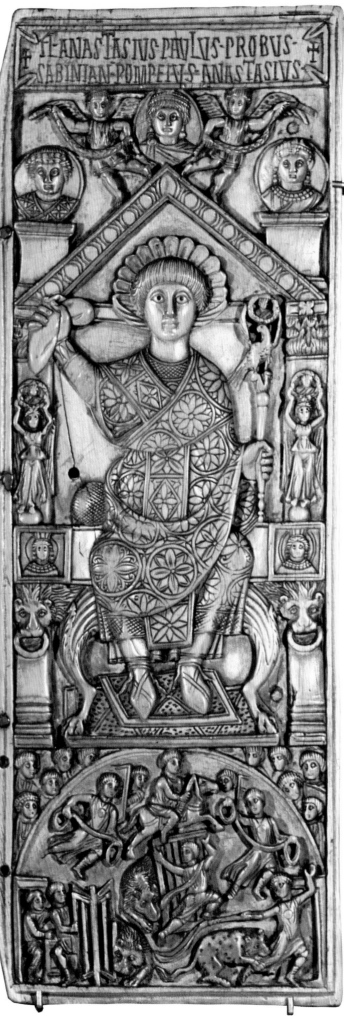

VIRINI·COM·DOMESTI·EQVIT·
ET·CONS·ORDIN·

H·ANASTASIVS·PAVLVS·PROBVS·
SABINIAN·POMPEIVS·ANASTASIVS·

174

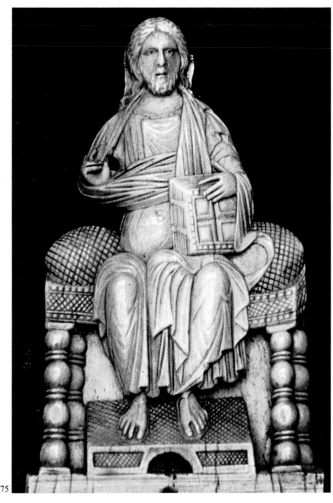

175

175 *Christ blessing.* **Ivory. Byzantine, 10th or 11th century A.D. Victoria and Albert Museum, London.** Seated on a voluminous cushion placed on a throne, this majestic Christ gives a blessing with his right hand and in his left holds a book. The ivory was obviously detached from a book cover, for three holes still mark the point where the clasp closed. Traces of polychromy also remain.

176 *Christ as Pantocrator.* **Ivory. Byzantine, 9th century A.D. Victoria and Albert Museum, London.** On the face of Christ, with its regular features and grave expression, the severity characteristic of works produced during the reign of Leo VI can be seen. This 9th-century ivory may be the pendant of a plaque depicting the Virgin and child, also in the Victoria and Albert Museum.

177 *The Crowning of Romanos and Eudoxia by Christ.* **Ivory. Byzantine, ca. 950 A.D. Bibliothèque Nationale, Paris.** Because of its style, and also because it closely resembles the ivory depicting Otto and Theophanou (Musée de Cluny), which is probably an imitation of it, we may conclude that this ivory plaque depicts Romanos II and his wife Bertha of Provence, who took the Greek name of Eudoxia.

178 *Virgin and Child.* **Ivory. Byzantine, late 11th century A.D. Victoria and Albert Museum, London.** This statuette is the only known example of a free-standing sculpture depicting the Virgin Hodighitria. Very classical in style, all the elements reappear in several triptych panels. Only this statuette possesses that finished beauty of a work originally created to be seen from different angles; although some triptych figures have been cut out and reworked to give them an independent existence.

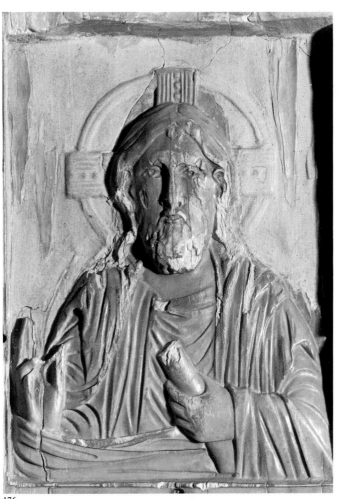

176

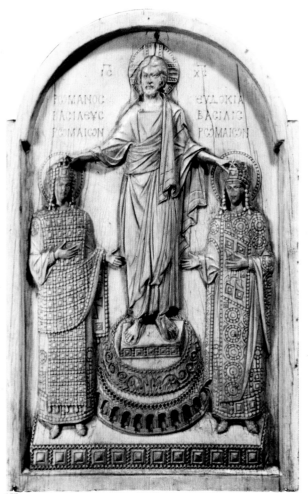

177

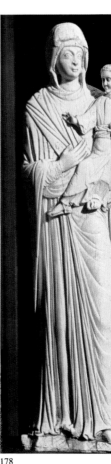

178

179 *Venus in a shell.* **Architectural niche fragment. Coptic, ca. 400 A.D. Coptic Museum, Cairo.** Despite the sharp division between the Greek spirit reigning in Alexandria and the Christian and monastic attitudes prevailing over the rest of Egypt, mythology remained in favor throughout the land, and especially at Ahnas, where this niche was found. This Venus belongs to a group of works dating from about 400, characterized by a soft, gentle style.

180 *Male bust.* **Coptic, beginning of the 3rd century A.D. Coptic Museum, Cairo.** This funerary monument clearly imitates provincial Roman art. The overall form is like an obelisk, but one whose sculptural relief displays all the characteristic Roman elements. The bust of a man of mature years, doubtless a Roman citizen, is dressed in a tunic and *pallium*. His face is individualized and realistic, and does not display the schematization of Coptic portraits.

181 *Funerary stele.* **Coptic, late 3rd or early 4th century A.D. Ikonenmuseum, Recklinghausen, Germany.** The sarcophagus was unknown in Egypt during the first centuries A.D.; steles in both the Roman and Egyptian traditions are therefore very numerous. This stele owes much to ancient Egyptian art, from which it inherited the subtle use of sunk relief, the beauty of pleated fabrics and combined frontal and profile views.

182 *Virgin of the Annunciation.* **Wood, polychromed. Coptic, 5th or 6th century A.D. The Louvre, Paris.** With the naiveté and the spontaneity characteristic of Coptic art, the young girl perched on a high stool makes a gesture of surprise. Mary, seated, is placed at the left of the scene, according to the iconography in Egypt during the 5th and 6th century.

179

181

182

183 *Tiger and gazelle,* from Ordos. Bronze. Art of the Steppes, 4th to 1st century B.C. Musée Cernuschi, Paris. The people of the Ordos steppes developed metalwork similar to that of the Russian steppes. Their culture, as well as its dating, is still puzzling. Depictions of animals make up most of the metal production, in a style lying somewhere between Chinese art and the abstraction of the Scythians and Sarmatians. The shape of the tiger's body is characteristic of this barbaric art.

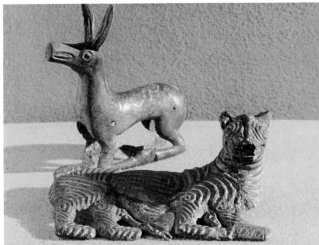

183

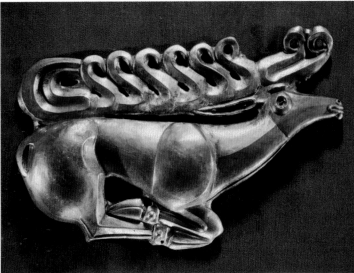

184

184 *Engraved gold stag,* from Kuban. Pontic Scythian art, 7th to 6th centuries B.C. The Hermitage Museum, Leningrad. The Scythians loved gold ornaments and jewelry, and their art was confined to those small objects, created under the contradictory influences of Greece and Asia. The Asiatic flavor is obvious in this engraved gold piece representing a stag found in the Kostromskaia *kurgan* in Kuban. The horns of the animal are stylized into spirals. The object, about 12 inches long, may have been the umbo of a shield.

185 *Sculptured portal,* from the Stave Church at Urnes. Wood. Scandinavia, ca. 1050 A.D. When Norway converted to Christianity there was, as a result, a great upsurge of architecture. This first Christian art is characterized by the *Stavekirke,* churches built entirely of a wooden frame and rubblework. The decoration on the portal of the church at Urnes has given its name to a style and is a focal point for the development of Norwegian Romanesque art. The style of Urnes is the latest incarnation of zoomorphic art.

185

186

187

188

186 *Tombstone,* from Hornhausen. Frankish, 7th or 8th century A.D. **Landesmuseum für Vorgeschichte, Halle, D. D. R.** The Frankish domain was more subject to the influence of late antiquity than other parts of Europe at the time of the invasions. From the 6th century onwards, numerous items of minor art can be seen decorated with this stylized figure.

187 *Tombstone,* from Niederdollendorff. Stone. Frankish, 7th century A.D. **Rheinisches Landesmuseum, Bonn.** The art of sculpture in the round disappeared in the West with the barbarian invasions. Reduced to imitating minor arts, sculpture was confined to relief carving in purely ornamental forms. No longer was there any attempt at realism; the artistic conventions were derived from the aesthetic of primitive civilizations. Here, accessories are given as much emphasis as the personage himself.

188 *South cross of Castledermot* (Kildare). Ireland, 9th century A.D. The structure of Irish crosses developed very little: a pyramidal base, a rectangular shaft, and arms linked by a circle. With the passage of time, pure ornament disappeared and carved scenes covered the cross completely. Erected in the 9th century, this cross is of the same type as the Moone cross.

190

189

191

189 *Stucco panel* from Nishapur (Iran). Islamic, 10th century. Metropolitan Museum of Art, New York. The site of Nishapur, in Khorasan, has yielded a number of stucco decorations from the 9th and 10th centuries. The panels were originally painted white, yellow, blue and red. The decoration consists of palm leaves—so stylized that they are reduced to abstract schemata—enclosed in multifoil forms, with all the intervals filled and the surface perforated.

190 *Wooden door.* Islamic, Seljuk, ca. mid-13th century. Archeological Museum, Istanbul. From the Konia region comes this door made up of three planks. The work is characteristic of the profoundly original and creative aspect of Seljuk art. Its main decorative element is the ornate central panel. The decoration—quite distinct in style from the Syrian and Egyptian carved panels, and even more so from inlaid woodwork—is reminiscent of ivories, and especially Persian ivories, that were to be found almost·everywhere between the 11th and 13th centuries.

191 *Fragment of a frieze,* from Mshatta. Islamic, Ommayad, 8th century A.D. Staatliche Museen, East Berlin. The Ommayad castle of Mshatta was built by Al Walid II in the middle of the desert. The ornament is closely related to that lavished by Byzantine craftsmen on the Dome of the Rock. It is largely inspired by Persian forms, and executed by cutting away the background in a technique like champlevé. Characteristic of art of the Ommayad dynasty, the surface is amazingly varied.

192 *Statue of an Iranian prince.* Stone. Islamic, Seljuk, 13th century A.D. Metropolitan Museum of Art, New York. In this example of Seljuk art, the headdress, with its horns rising at either side of a central motif, closely resembles that of Chosroes in the fresco at Qusayr' Amra representing the caliphs' victory over the princes. The human forms are very generalized, and the face and hands are treated schematically. The figure clearly exemplifies an art more concerned with producing symbols.

193 *Detail of an Incense-Burner,* from the Gurgan region. Bronze. Islamic, Seljuk, 11th or 12th century A.D. Archeological Museum, Teheran. This incense-burner represents a quadruped with a feline head. In its composition this piece may be compared with the griffin of the Camposanto in Pisa, and with a number of bronze lions of the Fatimid epoch which are quite similar although intended to be used as ewers and therefore not perforated.

194 *Lion,* from the fountain of the Harem Court in the Alhambra, Granada. Islamic (Spain), 1350 to 1400 A.D. Twelve lions support the basin of a monumental fountain in the Alhambra's great court. The fountain is of a type commonly made everywhere in North Africa up to the beginning of the 19th century, a type repeated in the French colonial period.

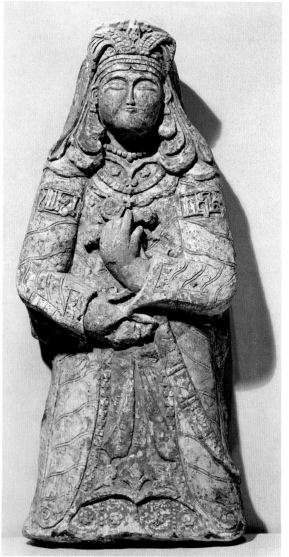

192

have been somewhat too hastily acclaimed as forerunners of western Romanesque art; they are perhaps more comparable to the fresco decorators of Serbian churches, for however profusely the low reliefs may ornament the exteriors of Armenian churches, they are as yet without organic ties relating them to their supporting architecture. The abundance of stone and the relative scarcity of wood and clay in that region, rather than the genuine sculptor's instinct, perhaps induced artists to carve stone figurative decorations.

The art that developed in the eastern capital of the Empire was a Greek art, and from the Greek mind Byzantium inherited the principles that led it to destroy the illusionistic Graeco-Roman style, which, although already faltering in the late Empire, had reigned over the Mediterranean for nine hundred years. The tendency of classical Greek art to reach

for an ideal, which Plato raised to a philosophical principle, had set limits to illusionism—though never opposed to it—by obliging the creator to reject individual phenomena and appearances in favor of a generalization within which all the multiple appearances could be included. Neo-Platonism, which was in a way an abuse of Platonism, incited the Byzantine mind to demand of reality only vague allusions or symbols, empty of corporeal substance, deprived of solidity, movement, expression, or life, and ultimately transforming reality into a transcendental and immobile sign. The forms Byzantine artists created owe nothing to observation; born of memory, they belong to an intellectual universe that was transmitted from age to age, and upon this world of remembered forms Byzantine art evolved without any reference to nature. Centuries were to elapse before an artist again turned

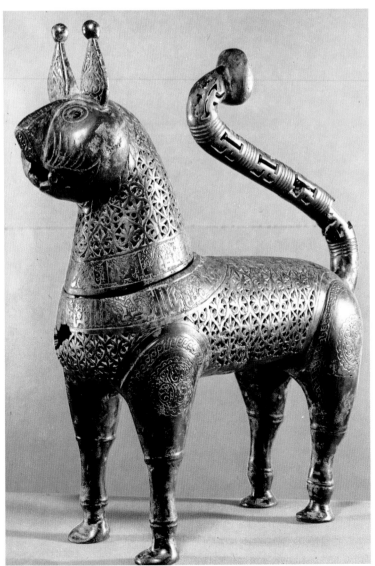

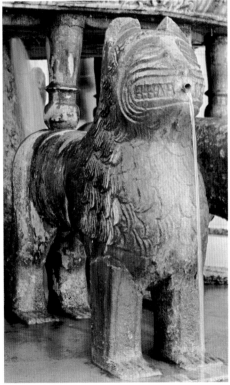

194

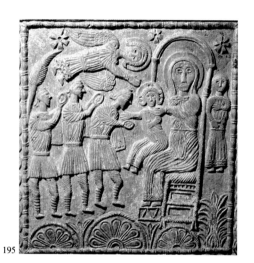

195

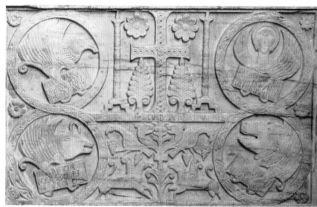

196

a curious eye towards nature. In a penetrating article written twenty years ago, André Grabar demonstrated the remarkable similarities between Byzantine imagery and Plotinus's system of vision. Plotinus placed the seen phenomenon at the level of the object and not of the subject; the distinction between subject and object on which the Greek rationalistic system rested is thus destroyed in Plotinus. Perceived as if from within, instead of being considered as at a remove from the subject, the object is apprehended by direct intuition, which is what, for Plotinus, makes things intelligible. In an ivory such as the Consular Diptych of Anastasius *(fig. 174)*, each part seems to be considered in itself and not in relation to the others or to the whole; the hierarchy regulating the relationships of the forms is of a mental, not a visual, order, and the composition as a whole, therefore, is a purely intellectual synthesis of various elements gathered around a theme, that is to say, an idea.

Subjected to ever more complicated speculation, this imagery might eventually have become entirely ossified had the artists not renewed it—not by looking at nature, but by a return to antiquity, whereby their forms acquired an element of truth, giving the illusion of a new naturalism. This metamorphosis created a real renaissance in Byzantine art under the Macedonian dynasty (867–1056). After monumental sculpture finally disappeared, the successive stages in the evolution of relief sculpture in Byzantium must be followed in

a study of ivories. Of a size suited to the hand, these ivories, both religious and profane, were not subject to the limitations that govern monumental art; like the miniature, therefore, they could evolve independent values. In the late 5th and 6th centuries, while the new intellectualizing style was providing such typical examples as the Anastasius diptych, the ancient illusionistic style was still used. In the 7th century, however, the latter style was altogether given up in favor of the former, which became gradually more stereotyped. For reasons still not entirely clear, the art of ivory-working seems to have been near demise even before the Iconoclastic Controversy; but it was brilliantly revived in the 10th century and saw two centuries of splendor. Among the most beautiful of ivories are those belonging to a well defined group of caskets all bearing similar ornament in the form of rosette borders. They were intended for profane use, and are exemplified at their finest by the Veroli casket, in which is apparent a vigorous revival of Hellenistic themes and even Hellenistic style, with naked figures modeled in a convincing half-relief. The style can also be observed in religious works, such as the plaque depicting the Forty Martyrs *(fig. 173)*, whose artist, more like a Hellenistic Greek sculptor than a product of the Byzantine spirit, exercised considerable ingenuity in differentiating the attitudes and expressions of suffering in his various martyrs. The Christ Enthroned at the top of the plaque still has the traditional schematic look, which we find un-

195 *Adoration of the Magi,* **from the Ratchis Altar. Lombard, mid 8th century A.D. San Martino, Cividale.** Decorating one side of the altar presented to the church by the Lombard King is this frequent 8th-century theme. Among disparate stylistic elements combined in the altar, the basic formula is barbarian. The composition is made up of superposed figures, sized according to their religious importance, and so stylized that the details are almost mechanically repeated.

196 *The Sigwald Altar.* **Marble. Lombard, ca. 730 to 760 A.D. Cathedral, Cividale.** The old marble altar-frontal, reused in the decoration for a baptismal font in the Cividale Cathedral, was presented by the Patriarch Sigwald in the mid 8th century. The carver has exactly imitated cloisonné metalwork forms. In subject matter, one relief is a kind of abstract picture-puzzle inspired by Eastern motifs, mingling with age-old monsters and ornamental plants and lacework. The relief incorporates the cross, the Tree of Life and symbols of the Evangelists.

197 *Pulpit* **of Santa Maria Maggiore. Panels are Lombard, 8th century A.D. Tuscania.** In the study of medieval Italian sculpture the pulpit occupies a special place; in Italian churches it was not merely a piece of liturgical furniture, but an independent structure of monumental character and often lavishly ornamented. This pulpit is one of the last offshoots of Lombard art in Latium. Confronting his marble, the sculptor has created a world of continual linear movement, of ceaselessly self-gestating forms in perpetual metamorphosis.

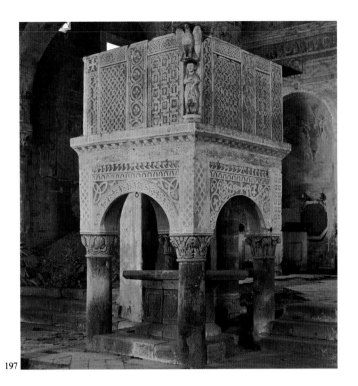

197

changed in another Christ Enthroned in the Victoria and Albert Museum *(fig. 175);* but a bust of a Christ Blessing in the same museum *(fig. 176)* is so free from convention that it would not seem out of place under the portal of a Gothic cathedral. The equilibrium between the divine and the human that had inspired Phidias seems again to animate the *Christ Crowning Romanos and Eudoxia (fig. 177).* An occasional artist was even emboldened by his feeling for life to make a sculpture in the round: a 10th-century Virgin points forward to the French Virgins of the time of St. Louis. When we consider such ivories it might appear that Byzantine art, two centuries before French, was on the brink of the discoveries that gave birth to Gothic art. But ivory carving, which lacked the fruitful limitations of monumental art, failed to achieve other than a minor refinement; and even more defeating was the impossibility, owing to the very nature of the Byzantine mind, of a renewal through direct contact with nature. The Macedonian renaissance in the arts was ephemeral, and ivories soon returned to an elegant formalism and a mannerism betrayed in the elongated proportions of the figures. This was the swan song of that art; in the 11th century ivories practically disappeared, probably as a result of the economic decline of Byzantium. Ivory was replaced by steatite, a less costly material, and the sculptors who worked it only imitated and stereotyped the dead forms of the ivory workers. Sculpture disappeared from Byzantine civilization with the ivories, and even the mosaics began to decline. For economic reasons, the future belonged to painting. Its more fluid process was to allow the 13th and 14th centuries some progress towards naturalism, perhaps with the help of western influences.

Inclined towards aesthetic as well as theological speculation, Byzantine art was in the main an erudite and sophisticated art; but it also had its provincial aspects. In painting, the rustic style is represented by the frescoes of the rock-cut chapels of Cappadocia, where monastic communities practised a realistic and dramatic art in contrast to the principles of the then official art. In sculpture, the land richest in provincial orthodox art is Coptic Egypt, whose productions recently acquired an exaggerated popularity originating rather in the anti-classical tastes of our era than in actual qualities in the objects admired *(figs. 179–182).* The imagery of Coptic art is very complex, mingling pagan and Christian themes. The preponderance of pagan themes in which Bacchic, Apollonian, and Aphrodisian mythologies are prominent—in quite coarsely executed works of a heavy sensuality, and often representing women with accentuated sex characteristics—has suggested that pagan magic cults may have survived fairly long in the Egyptian countryside, while the Greeks of Alexandria had already adopted Christianity, and there, where the institution of monasticism was founded, Christianity was to undergo an individual development. In 451 the Council of

Chalcedon condemned the Monophysites, and with them Dioscorus, Patriarch of Alexandria; Christian Egypt then broke with Byzantium and through nationalistic reaction entered upon an independent development. All the prerequisites to the birth of a popular art, whether Christian or pagan, thus coalesced. The resultant art interpreted and modified formal influences from all sides—from the depths of Egypt, from Palmyrene Syria, from the Hellenistic world of Alexandria, from the classical Graeco-Roman repertory, and also from Byzantium—mingling in the popular melting pot all the styles of sophisticated or unsophisticated cultures. The forms of this art, unlike those of Roman provincial art, are popular, and not primitive. Among them can be found certain themes resumed in later western art, like the *gisant* (the recumbent tomb figure), or the figure in a niche. Their vitality is unconstrained by limitations of style or form, though the execution is usually coarse and hasty, the artisans only roughing out the shape and expending their efforts on the head, while the lower parts of the figures are left to atrophy. This popular trend was prolonged up to the Arab conquest and remains alive to our time in Ethiopian art, where its survival, however, affects only painting and not sculpture.

Towards the middle of the 8th century monumental art in the West entered on a long night. As a consequence of the Saracen and Frankish invasions, the last marble workshops in the Pyrenees closed down one after another; Gaul no longer received the capitals, the carved altars, and the sarcophagi in which Gallo-Roman sculpture had proceeded by more and more degraded forms towards a kind of orientalism. The art the barbarians had practised in their lands of origin, before they invaded the West, was not actually non-figurative, since it was inspired by animals, but it concerned itself not at all with the modeled relief form. The steppes metal workers who cast and chased the jewelry and dress ornament, or trappings for carts and harnesses, metamorphosed into linear ornamental variations the dynamic, non-human—almost frightening—vitality of the animals *(fig. 183)*. This art of metamorphosis, seizing upon natural forms only

to project them into an imaginary world, was to be one of the primary sources for the Romanesque style. Once settled in the West, the barbarians seem to have somewhat lost the impetus for their art, their metal work becoming more abstract; but the Vikings retained it in all its purity, producing their most beautiful chimeras at the very time when Carolingian artists in Europe were proposing the return to the human figure. In 11th-century Christianized Scandinavia, it was this barbarian spirit that still enriched and vitalized the interlace on the wooden door panels of the stave church at Urnes *(fig. 185)*. This interlace is the later equivalent of that in the Irish miniatures, and the predecessor of the complicated Romanesque fantasies. As for sculpture in relief, the coarsely worked, cut-out figurations of Hornhausen or Niederdollendorf are the last manifestations of a completely degenerated monumental art *(figs. 186–187)*. The Irish sculptors, educated no doubt by their miniaturists, were skilled in endowing their compositions with a unifying rhythm, though their relief was no more refined *(fig. 188)*.

In the 8th century it seemed as though the human form, earlier apotheosized in Western art, would disappear from it entirely. It was effaced in the art of Italy and Gaul, and in Byzantium encountered the prohibitions of the iconoclasts. Over the Mediterranean, from Syria to Spain, Islam spread a sort of desert spirit that reduced the human dwelling or place of prayer to a mirage covered with weightless fretwork ornament. The beautiful Syrian rinceaux at Mshatta *(fig. 191)*, in which relief still makes a play with light and shade, were soon to become a dry lacework; the sculptured capital followed an evolution similar to that of the capital in Byzantine art of the 4th and 6th centuries; the few statues in the round produced by Islam clearly display the Moslem inaptitude for expressing volume, resembling as they do wooden dolls rather than human beings *(fig. 192)*. The animal forms that the bronze workers evoked in their aquamaniles or incense burners *(fig. 193)* conveyed more vitality, as do the famous Alhambra lions, which are their stone equivalents *(fig. 194)*. As for ivory, it lent itself in particular to the linear interlace combinations beloved of Islamic artists.

The fate of sculpture during the Dark Ages in the West

198 *Statue of Charlemagne,* **from the church of St. John the Baptist in Mustair. Stucco. Carolingian, 9th century A.D. Cantons des Grisons, Switzerland.** This life-size statue once stood against the wall of the monastery church, which Charlemagne is said to have founded; it was removed during the 15th century, at which time it was damaged, then restored. The work appears to be the simple production of an isolated artist working without models and without guidance from traditions.

has been debated for more than thirty years. The north of Italy, inhabited by the Lombards, offers more material for consideration than do other regions, for remains from that period are fairly abundant there. As during the Roman Empire, there seem to have been two prevailing currents, one more sophisticated and one more rustic. In the little town of Cividale, in Friuli, are two 8th-century stone altars with figures in relief. One of them, the Ratchis altar *(fig. 195)*, is clumsily executed. On the other, the Sigwald altar *(fig. 196)*, a technique like *champlevé* has been employed to produce a regular relief depicting the Cross with the symbols of the Evangelists (one of the earliest representations of the subject known), organized as a very effective composition. It probably imitates some embossed metal altar frontal, for it is ornamented with rosettes copied from the ornaments used to conceal the nails with which repoussé metal plates were fixed to a wooden core. Also in Cividale, in the church of Sta.

Maria in Valle, are fine stuccos of elegant design and refined execution, whose date, much disputed, has been set as early as the 8th and as late as the 11th century. As is the case with the equally surprising frescoes at Castelseprio, it has even been suggested that a Byzantine artist might have worked for the Cividale court—although in fact at that time Byzantium had nothing of the kind to offer. It has been discovered, from a study of the remaining early medieval stuccos, most numerous in Spain and Italy, that the ancient techniques for working stucco—much easier than carving stone—were used throughout the early Middle Ages in ornament for buildings, until sculpture in harder materials was revived in the Romanesque period.

The Carolingian reform of the arts is one of the most striking instances in history of a civilization's drawing from an awareness of its own decline the will to look back in

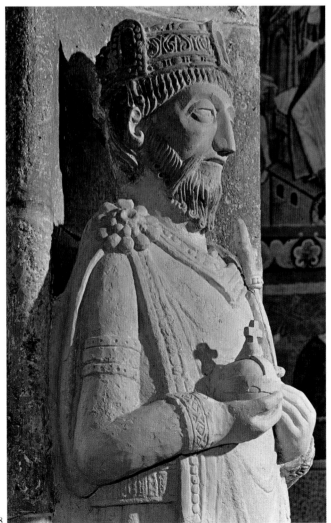

198

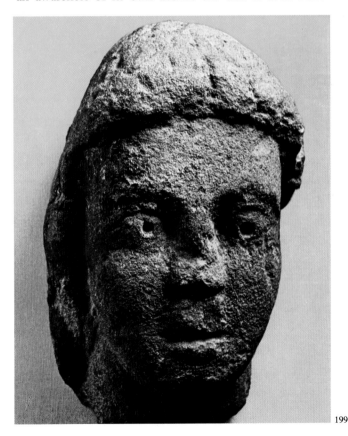

199

199 *Head of Christ,* **from Lorsch. Carolingian, early 9th century A.D. Landesmuseum, Darmstadt.** The mutilation of this head has accentuated the rather weak modelling in the face of Christ. Closer to ancient than to Byzantine art, it in some ways recalls the head of Christ on the sarcophagus of Junius Bassus. In reaching back to antiquity, Carolingian artists made a break with the current of barbarian art.

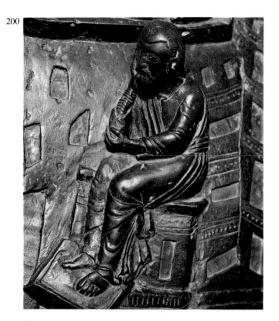

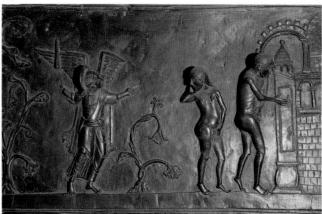

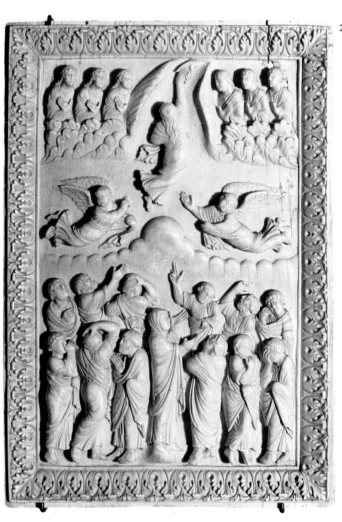

200 *St. Joseph,* **detail of the Nativity, St. Bernward door, Hildesheim (fig. 201).** Despite the panel's size, the sculptor has treated the little figure as though it were a large-scale statue in the round, without either neglecting or simplifying any of the details. The supple folds of drapery, the simple and natural gestures, the successful handling of the face, round and full without being too soft, all allow the action its full expressive value. The figure of St. Joseph seems to bend out from the background with a very natural movement.

201 *Adam and Eve banished from Paradise,* **detail of the St. Bernward door, church of St. Michael. Bronze. German, ca. 1015 A.D. Hildesheim.** The Archbishop Bernward of Hildesheim commissioned these famous doors and also provided their iconographical theme. The first doors cast in one piece in the West since Roman times, they rank as masterpieces of Ottonian art. The sculptor or sculptors seem to have worked from a painted model or to have been inspired by Carolingian miniatures.

202 *Ascension of Christ.* **Ivory. Ottonian, 10th century.** The Ascension of Christ from the Bamberg Treasury, attributed to 10th century Lorraine workshops, has all the characteristics of the Carolingian art that it seeks to propagate. However, the Ascension scene is conceived with great expression, like a human, not an other-worldly, drama. The roundness of the figures, the animation of the group formed by the Virgin and the mourning apostles, and the rising figure of Christ, literally drawn up by God's hand, are characteristically German features.

search of the means for its regeneration. Charlemagne wished his palace at Aachen to be a *Roma Secunda,* and summoned from Rome, from Ravenna, from the East, and from the whole empire, materials, works of art, and also artisans, to create a worthy imperial culture in his metropolis. The invention of the Caroline minuscule script as the vehicle for written thought (resumed after the interval of Gothic writing by the Renaissance humanists, who developed modern script from it) would be enough to prove that genuine progress does not always rest on gradual evolution. The political failure of the Carolingian Empire has somewhat masked the tremendous impulse given to culture by

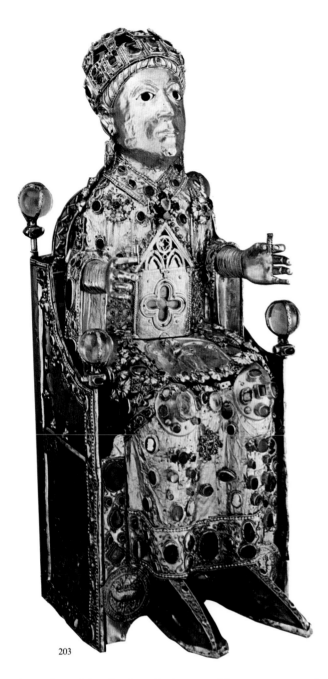

203

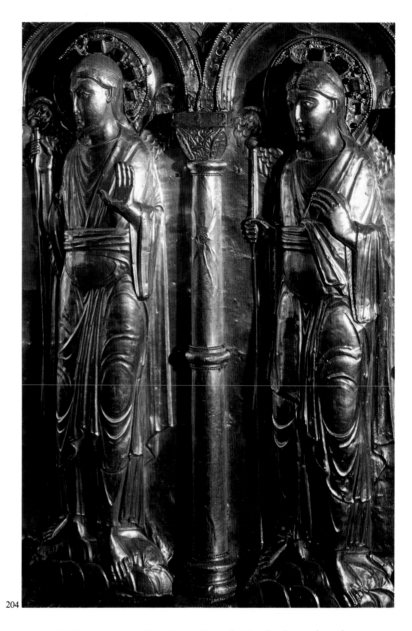

204

the Palace School (though German historians are perhaps more conscious of its cultural contribution, since the Carolingian achievement was prolonged without a break through the Ottonian empire until the start of Romanesque art).

Today miniatures and ivories offer the only remaining evidence of what the arts were like under Charlemagne. The palace chapel at Aachen retains only its basic plan, having been rebuilt rather than restored. The only remaining original elements are the beautiful bronze balustrades in the galleries, ornamented with acanthus scrolls as graceful as those of antiquity. Little is left of goldsmith work from the time of Charlemagne. In the case of ivories, the late antique period

203 *Reliquary statue of St. Foy enthroned.* **Carolingian. 5th and 9th centuries A.D.(?) Treasury, Church of St.-Foy, Conques.** This figure is perhaps the prototype of all reliquary statues. Consisting of a wooden core entirely sheathed in gold set with enamel, its aesthetic value must be calculated by the goldsmith's measure rather than the sculptor's. It is really an idol, more symbol than figure. Enthroned, the saint attains magical force. Reliquary statues were rejected by some contemporary clerics.

204 *Two archangels,* **detail of an antependium from Basle. Gold and precious stones. Ottonian, 1002 to 1019 A.D. Musée de Cluny, Paris.** A humanized style of representation and an understanding of drawing and relief reappeared in the North first in metalwork, and from there found their way into stone sculpture. In Ottonian Germany understanding of three-dimensional form had been kept alive through the techniques of *repoussé* metalwork, many examples of which are to be found in church treasuries such as this splendid gold antependium.

had left in church treasuries many fine models of classical style so that Carolingian artists could reproduce them in all their purity. The art of stucco, already mentioned above in connection with the survival of antique techniques, could produce in Charlemagne's time the tondo supposedly portraying the monk Sola, which appears to point directly to the reliefs of Gilduin's altar in St. Sernin in Toulouse. Sculptures in the round offer conflicting evidence. The bronze equestrian statuette in the Louvre representing Charlemagne himself is such an accurate imitation of the antique that it was once believed to be a Renaissance work; on the other hand, the life-sized stone statue of the emperor, now in the cloister of St. John Baptist in Müstair *(fig. 198)*, is so childish in style that it shows a complete lapse of all traditions, a sort of sculptural nullity. A head presumed to be that of Christ *(fig. 199)*, found in excavations of Lorsch Abbey, is far better executed, betraying the influence of ivory carvings. The difference between a sophisticated art based on the antique and a provincial art was probably never more marked than during that period.

Ottonian art represents the ripening of Carolingian art, for Gaul itself was plunged into anarchy after Charlemagne's death. The Carolingian reliquary statue of St. Foy *(fig. 203)*, a compound of parts done in various periods, including the gold head from the late Empire (5th century?), is a mere agglomeration of precious materials and far inferior to the goldsmith work produced in Germany at the time. At the beginning of the 11th century Ottonian art, nearing its end, produced its best sculptural works. The bronze workshop created at Hildesheim by Bishop Bernward was capable of casting in one piece such works as the 16-foot doors of St. Michael's cathedral *(figs. 200–201)*, or the 13-foot column imitating Trajan's column, with a spiral relief representing twenty-eight scenes from the life of Christ—a noteworthy progress in technique if we consider that the Louvre equestrian statue of Charlemagne had to be cast in several pieces later soldered together. The two monuments with which Bernward decorated his cathedral are by two different men. The reliefs on the doors are more perfect and better finished,

more alive and nearer to antique models; those on the column are harsher and more primitive, and anticipate the Romanesque spirit. In the column reliefs the background sets up a tension with the relief forms; but on the doors, the figures are placed on an inert surface as though simply applied. The doors of Augsburg cathedral, thirty years later, offer a sort of farewell to the past, on the eve of the flowering of Romanesque art, for they are made in strict imitation of Hellenistic figures. The gold antependium from Basle *(fig. 204)*, contemporary with the St. Bernward doors, is undoubtedly the most perfect work of Ottonian art. The artist of the antependium rediscovered the dignity of the classical style, and through it expresses the divine world, transfigured into gold. Such works were the creation of two artists: a woodcarver who sculptured the wooden core, and a goldsmith who hammered the gold leaves applied to the core. What sculptural qualities the underlying wooden carvings might have can be seen in the Madonna that Bishop Imad gave to Paderborn cathedral in about 1058: the gold leaves that covered it have been removed and melted down, and all that remains is the core of wooden sculpture in the round, as smoothly and softly carved as an ivory.

Thus, despite the vicissitudes and transformations resulting from its having been handed down through the centuries, the perennial classicism derived from the antique still inspired Ottonian art. If the mystique of the Germanic Holy Roman Empire was a political failure, it nonetheless succeeded on the artistic plane, for there it was able to recapture the principles of the antique. In such ways the world of the imagination may sometimes compensate for the insufficiencies of reality. Ottonian classicism stands in strong contrast with the expressionism that appears to have been a constant in German art of later periods: must it be concluded, then, that this romantic attitude, which may be detected in certain Carolingian miniatures, never touched Ottonian art? Not, indeed, if the famous wooden crucifix *(fig. 205)* in the Cologne cathedral (which I have described elsewhere as "Schopenhauer crucified") was actually given by Bishop Gero (969–976). If so, it is the first surviving monumental crucifix in the West, a witness to earlier works that have not survived.

205 *Christ on the Cross (Gero Crucifix).* **Wood, gilt and polychromed. Ottonian, late 10th century A.D. Cathedral, Cologne.** Ottonian art exploited the principles of Carolingian art right up to the 11th century. Regarded as the oldest monumental crucifix in Europe, it is a remarkable example of imperial Germany's renewed interest in monumental sculpture. The type is derived from Carolingian miniatures, onto which is grafted a Byzantine influence. Although the date is disputed, it has all the characteristics of Ottonian art.

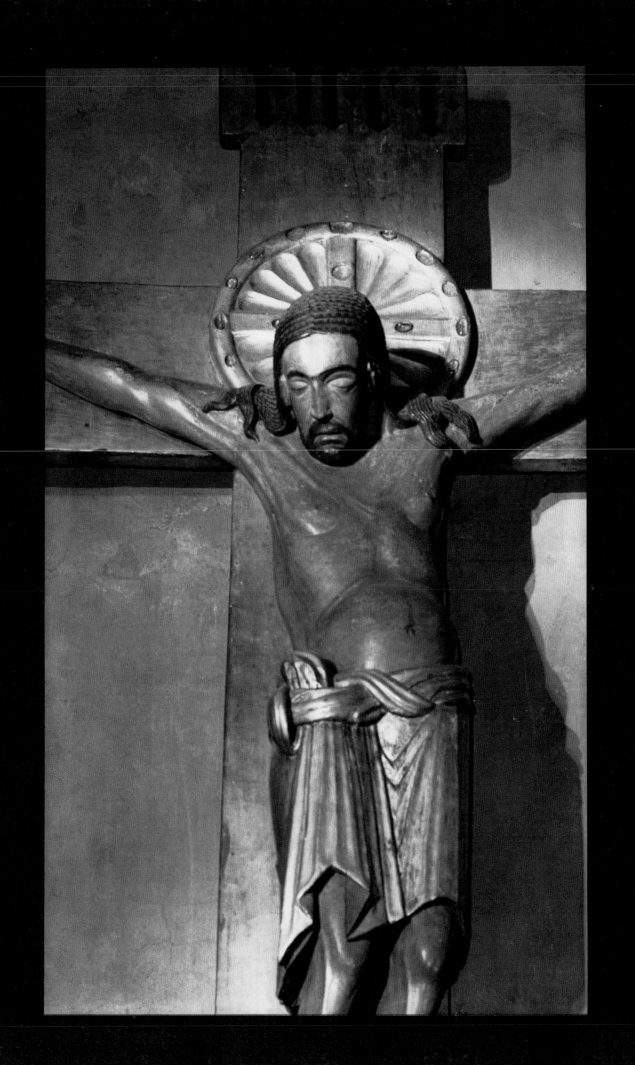

V

PRIMITIVE CULTURES

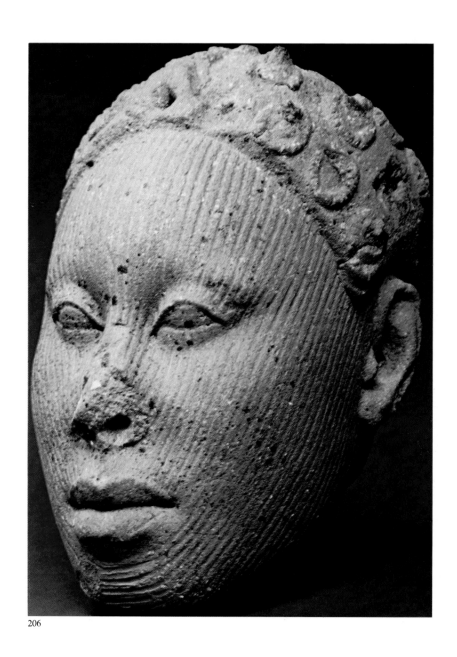

The word "primitive" is so broad in its connotations that it is difficult to define it accurately. How can we narrow down a term that might include both a Baule mask and a painting by Duccio, or even one by Fra Angelico? One is tempted to reduce its meaning to the concept of "primary"— that which comes first—as applied to all human activities: thus alchemists would be the primitives of chemistry and astrologers the primitives of astronomy. But when we come to ethnology, our concern in this chapter, this limiting concept could no longer apply, for some primitive societies seem to be regressions of more evolved civilizations, and the most primitive of those still in existence usually reveal an ossified state of an earlier "primary" situation. Furthermore, the word "primitive" is not usually applied to the very first artistic products—those of the Paleolithic period. Finally, if we want to be understood when we use the word, we must be aware of contemporary reactions—those of young nations who have suddenly emerged from primitive societies to become democracies, and even more, those of Western thinkers whose self-punishment complexes make them consider primitive thought and ways of life superior to those of more advanced civilizations.

Although it has recently been disputed, there does exist such a thing as a "primitive mentality" characterizing both the so-called "savage" tribes still flourishing on this planet, and also the more advanced ancient societies, like those the Spaniards found in America on their arrival. Individuals from these societies differ from those of more advanced civilizations by their behavior in relation to themselves and to their surroundings. Western civilization developed when thinking man became able to differentiate between the knower and the known, which involves the definition of the former as an individual and the objectification of the latter, whose phenomena are linked by causal relationships in which only observed facts are taken into account. Western thought is based on this relationship between subject and object which with existentialism reaches a state of crisis in which neither term can free itself from the other, but each refuses the other. Indian thought, while transcending the subject-object distinction, admits it as a first stage of ontological meditation.

The mental activity of a civilized man consists at the same time of taking apart and bringing together—of separating objects, then connecting them through chains of causality ever more inclusive; of generalizing more and more and freeing the object from its subjective wrappings to make it tend towards the idea (in the scholastic acceptation of the word). The idea in turn permeates reality like a fertilizing spring, promotes newly observed facts into the serial categories of registered phenomena, which they can alter or even reverse, for in the ever-active thought of Western man, the idea always has the value of a hypothesis, while with the primitive, it is immutable and stiffens into a dogma. The primitive does not distinguish among objects, any more than he separates himself from his environment; he thinks and behaves with the assumption that his ego is inseparable from the non-ego. His mental universe includes a conglomeration of odd facts which, since they are not "known" but only "perceived," are linked by mythical chains of causality in which the visible is only a sign of the invisible. In such a situation, man lives in fear, since he depends on an animate world that he can affect only if he enters it through magic ways, ways that are like traps designed to catch reality—and unreliable traps at that. Civilized man is led by the basic principles of reason and uses science to control the working of universal forces. The primitive is unable to defend himself against the primordial feeling of terror, whose survival in the more evolved cultures, like the Pre-Columbian, can be considered as a primitive feature.

Aesthetically, there is such a thing as primitive style, appearing as a lack of continuity in forms; we can find it in such apparently dissimilar works as a Negro fetish, a statue by a Western folk artist, or an Aztec bas-relief. A Negro statue extracted from a wooden trunk with the help of an adze shows suddenly swelling volumes and abruptly arrested lines; the exaggerated swelling is a symbol of erection, of growth, of fertility. The work is conceived in separate parts whose cohesion is achieved by the intuitive feeling for rhythm, absent in the Western folk artisan, who tends to put together disproportionate pieces. Michelangelo projected an idea into a block of marble; the work was complete in the artist's mind

206 *Head of a woman.* **Terra cotta. Nigeria, Ancient culture of Ife, 11th to 15th century A.D. Museum für Völkerkunde, Berlin.** Ife, the religious center of the Yoruba, enjoyed a moment of great splendour in the 13th century when it contained several hundred sanctuaries. The sober and delicate modelling of this small commemorative head (6 1/2 inches) permits us to glimpse, over and above its obvious naturalism, the serenity and dignity that characterize the aristocracy of this Nigerian people.

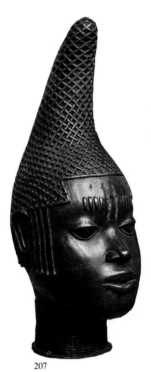

207

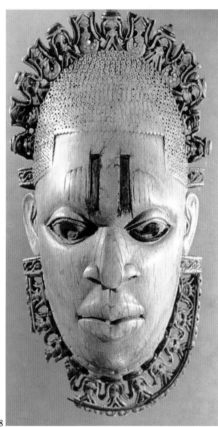

208

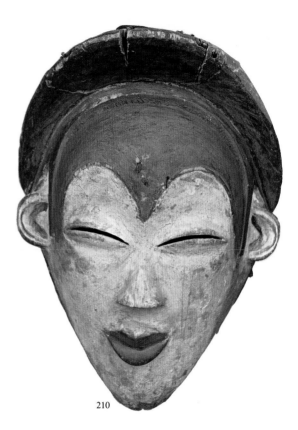

210

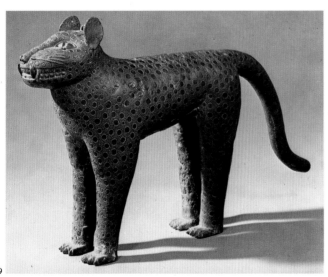

209

207 *Female head known as "the Princess from Benin."* **Bronze. Nigeria, Benin, 16th century A.D. Property of the Government of Nigeria, on loan to the British Museum, London.** This bronze female head, cast by the lost wax process, belongs to the first classical period (16th century) of Benin art, when it was still under the influence of the idealized realism inherited from Ife.

208 *Royal head; pectoral mask.* **Ivory. Nigeria, Benin, 16th century A.D. Museum of Primitive Art, New York.** This pectoral mask representing an *Oba* (ruler) is in the style of the classical period of the kingdom of Benin and dates from the 16th century when the kingdom attained its greatest political power.

209 *Leopard.* **Bronze. Nigeria, Benin. Museum für Völkerkunde, Munich.** During the 17th century European bronze was imported by the rulers of the kingdom of Benin. The result was an intensified production from the foundries, and the fabrication of works of increased dimension. This leopard, intended for the *Oba,* figures among the more refined objects.

210 *Spirit mask.* **Wood, coated with clay, and painted. Lower Congo, Gabon. Pitt Rivers Museum, Oxford.** Many people in the Gabon region exploit the set of the mask as part of their worship of the dead. The masks represent the ancestral guardian spirits with feminine characteristics. This example is strikingly subtle and delicate in modelling.

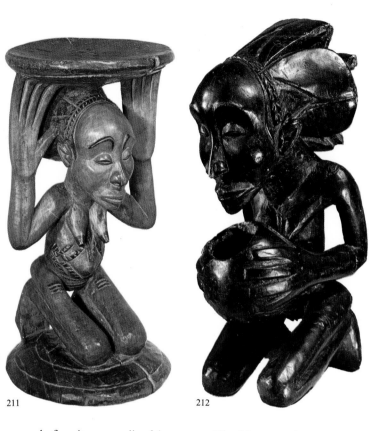

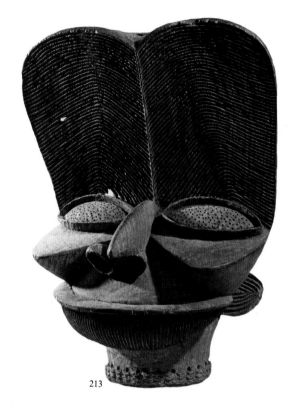

211 212 213

before it was realized in matter. The Negro sculptor extracts an image from a block of wood; the sequence of his gestures is like a ritual. An Aztec sculpture seems a puzzle of figurative or abstract fragments stuck together. All primitive works translate into stone or wood the drama of life for men oppressed by the plurality of phenomena: the primitive has not reached the state of awareness when man, faced with an interlocking network of data, isolates them and then includes them in a scheme of successive generalizations, ordering the properties of things according to the calm perspective of reason, ruling over the chaos of appearances through intellectualized order, and translating the power that he feels surging within himself into the concept of a Transcendent Being, supreme light of the spirit, a God who banishes to the kingdom of shades the terrifying horde of wandering spirits, gods, and demons. It is clear why the revolutionary painters and sculptors of the early 20th century found so much to borrow from Negro sculpture. They wanted to break up the unity that characterized the traditional outlook of European art and to replace it by discontinuous forms that would express the anguish of Western conscience faced with the rethinking of all its values.

A knowledge of Negro art, more than of any other, has allowed us to understand the primitive processes of artistic

211 *Chief's stool.* **Wood. Eastern Congo, Baluba. Royal Museum of Central Africa, Tervuren.** The seat borne by a crouching figure is a sign of authority for a Baluba-chief. The female figure represents the protective ancestor of his line, assuring prosperity to the people through the intermediary of her heir on the throne.

212 *Kneeling woman with a bowl.* **Wood. Eastern Congo, Baluba. Royal Museum of Central Africa, Tervuren.** The famous Kabila figurine (19 inches high) known as "The Beggar Woman" is one of the most highly esteemed works of African art, in part owing to the sensitive expression on the dramatic face.

213 *Dance mask.* **Wood. West Africa, Cameroon, 19th to 20th century. Rietberg Museum, Zürich (E. von der Heydt Collection).** This large dance mask of the Cameroon plateau region is elaborated according to a rhythmic conception of volumes which confers on it an astonishingly architectonic quality. It is attributed to an artist of the Bacham from the Bamenda region.

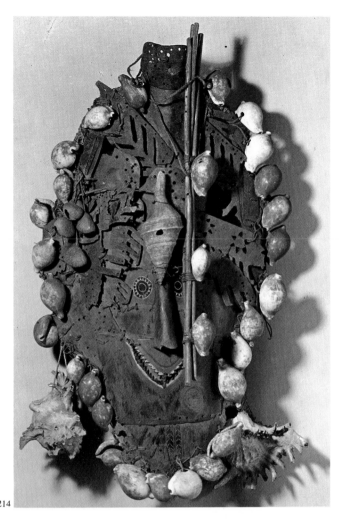

214

214 *Mask.* **Tortoise shell. Polynesia, New Guinea, Island of Dewar. Nationalmuseet, Copenhagen.** The use of tortoise shell in this mask is typical of the art produced in the Torres Strait. The mask, adorned with selected shells, is the intermediary through which supernatural beings communicate with the living.

215 *Ancestor mask.* **Wood, painted. Borneo. Nationalmuseet, Copenhagen.** Primitive cultures showing common characteristics developed in the group of islands situated in southeast Asia. For the natives of Borneo, as for most primitive cultures, masks represent the figures of ancestors. This mask is painted, and decorated with feathers and other materials.

216 *Boat ornament.* **Micronesia. Wood. 32 cm. high. Rautenstrauch-Joest Museum, Cologne.** As navigators and skillful craftsmen, Micronesians depend on sailboats and (balanciers) to travel among the archipelago's islands. The extraordinary beauty of these crafts bears witness to the natives' creative ability. This well-proportioned wooden decoration ornamented one of these boats.

217 *Stone images.* **Easter Island, Polynesia. Volcanic bedrock. Approximately 16 m. high.** It is uncertain whether Easter Island's monoliths were intended as images of gods, statues of the dead, or if they were symbols of other-worldly powers. Controversy never ceases to arise over their abundance on the island (several hundred), their monumental size, the strange facial expression created by their prominent noses, their thin lips and their long ears.

216

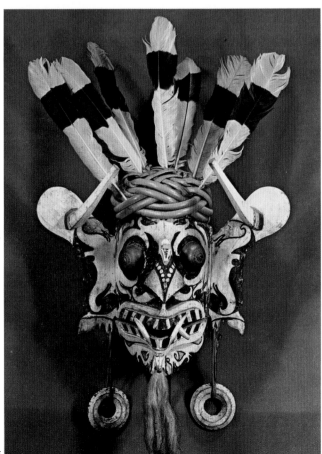

215

creation. Our understanding has come about with the help of observations collected by ethnologists, and particularly Marcel Griaulle's famous studies of a people whom he knew as still free from European influence: the Dogons. Those investigations are now part of history; the popularity of Negro art in the West and its industrial and commercial exploitation have debased its value. Decolonization, which gave independence to African peoples, has hastened the decline of African art even more than did colonization.

When he was carving a fetish or putting together the elements of a mask, the Negro artist had originally no other aim than to produce an object whose magical efficacy was guaranteed—an instrument, not a work of art. This magic power could be dangerous, and the masks through which communication with the other world took place used to be kept hidden when they were not exhibited in a ritual, in which only the initiated took part before it became a spectacle in which all the inhabitants of the village participated. In unspoilt societies like that of the Dogons, the concept of the artist as such was unknown: the making of masks was a sort of "public service" undertaken by all the men in the village; elsewhere, art was one of the prerogatives of the witch doctor. In Western and Central Africa, it was the blacksmith who carved wooden idols, since his being in permanent contact with the mythical world of fire made him the most valuable intermediary between society and the cosmic forces of fertility and death; he provided the tribe with all its material and spiritual tools. He lived somewhat apart, both honored and feared. In some societies the artist had a separate status, professional and corporate. It is interesting to note that this privileged social condition, which was accompanied by an *aesthetic* appreciation of the works, was found not in a tribal framework, but in societies in which there was a ruler surrounded by an aristocracy, as in the ancient kingdoms of Benin *(fig. 208)* and Dahomey, where we find real palace schools. Africa at the end of the 19th century presented all stages of artistic creation, from the tribal stage to court art.

Negro art is a peasant art. It only developed in a limited region of Africa, in the West and in the center, in societies

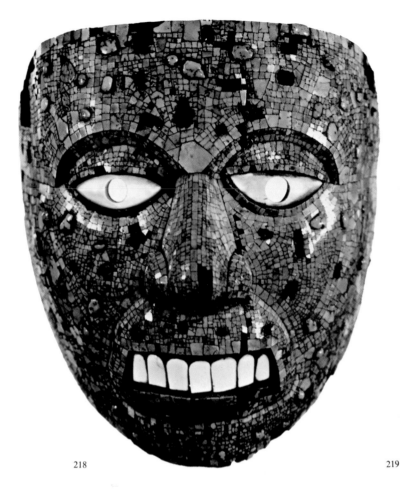

218

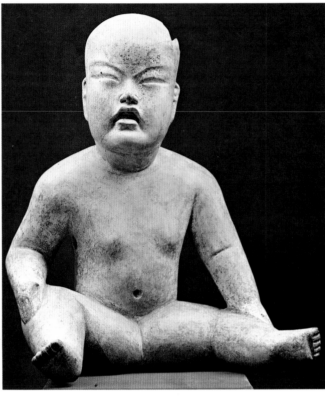

219

based on agriculture. We do not find it in the parts of South or Central Africa inhabited by pastoral, nomadic, or semi-nomadic populations. Even if the presence of Islam did not make it impossible to confuse Africa and "Negro culture," it would be wrong to think of what we call Negro art as the sole expression of the whole "black continent." Africa has revealed to European explorers some societies that have remained primitive, or become so again, but it would be as mistaken to consider a Congolese fetish or an Ivory Coast mask the deepest manifestations of the African soul as to evaluate Western art on the basis of Polish folk sculpture. In Africa, empires and kingdoms have existed that produced advanced societies, and excavations—now just beginning—may one day recover their remains. To our present limited knowledge, the heart of Africa, the Mediterranean part aside, yields three chronological phases. The oldest is the prehistoric; it is characterized, as in the West, by rock-cut art, found in South Africa and along the northern Sahara border. The

second phase could be called proto-historic; it relates to civilizations excavated in the present territory of Nigeria, such as the Nok culture, before the Christian era, or the Ife culture, whose oldest remains seem to go back to the 12th or 13th century *(fig. 206)*, and also the Kingdom of Benin, which reached its apogee in the 17th century *(figs. 208, 209)*. It would be paradoxical to denominate the third phase as "historical," for the primitive societies of Africa colonized by the West are far removed from the sense of history; but nonetheless, those societies entered history through the Europeans who discovered them. The still rare finds from ancient Africa, and particularly the bronze sculpture of the Yoruba kingdom, show us a world very different from tribal primitivism. The German Leo Frobenius, who in 1910 first discovered works from the Ife culture, even believed them to be the production of a Greek artist. Others tried to explain the classical outlook of that art, inspired by the observation of nature, by assuming Egyptian, Roman, or Phoenician influences. External influ-

218 *Mask of Quetzalcoatl.* **Turquoise mosaic inlaid on wood. Mexico, Mixtec, 1300 to 1450 A.D. British Museum, London.** A culture hero of the Toltecs, the erudite prince who in the 10th century built his capital at Tula, established the cult of Quetzalcoatl—the mythical serpent covered with feathers of the firebird—and considered himself the incarnation of that fertility god who ruled over sun and water. This funerary mask may well have been meant to represent the hoped-for divine benefactor.

219 *Seated child.* **Clay. Mexico, Olmec, 8th or 7th century B.C. Private collection, Mexico.** This clay figurine (14 1/4 inches high) is covered with a white slip. The suppleness of the modelling, the naturalness of the pose and the feeling of life emitted by the statuette testify to a simple humanity in the civilizations of the archaic epochs; later the empire of the Maya, Toltecs and Aztecs will engender an increasing cruelty, expressed by a progressively inhuman stylization.

220 *Recumbent figure*. **Mayan. 4th to 9th century. Stone. Anthropological Museum, Mexico.** This amply-proportioned recumbent figure, with its piercing stare, represented the god of the "Chacmoul" rain—Quetzalcoatl. A bowl for alms is held in his hand, resting on his stomach.

ence may certainly have brought into consciousness some indigenous tendencies, but the sequence of various cultures that flowered in the Gulf of Guinea indicates a clear internal evolution, not just a random stratification. Preceded by the lively Nok terra cottas, the serene beauty of Ife *cire perdue* bronzes was translated into more primitive forms in the Benin bronzes so much admired by our contemporaries; we know that these last derive from the Ife works, for in 1280 A.D. a king of Benin asked his liege in Ife to send him a specialist to introduce bronze art to his court. The degradation of classicism into neo-primitivism becomes more and more pronounced in Benin art the nearer it gets to the contemporary period; it is an example of how, in Africa, advanced civilizations could disintegrate and regress to a tribal state: works produced nowadays in Nigeria have returned to the "savage" stage of so-called Negro art.

While the Africans are farmers, the Melanesians and Polynesians are seafarers. The Africans are gifted for sculpture in the round obtained with the use of the adze, which is derived from an agricultural tool, the hoe. But islanders, who only leave the infinite world of the sea to enter the more impenetrable world of the forest, are not attracted by statuary. When they carve wood, they prefer cutting it out into lacework patterns, reproducing the design of the spirals that they like to paint on the façades of their dwellings or on their own bodies.

When Cortez's soldiers invaded Mexico, they were surprised to find a well-stocked market; there was even a shop that sold knives made of obsidian—strange meeting between the stone age and the age of firearms! When we look at the grandiose monuments built by the Maya and the Aztecs, it is hard to believe that those gigantic structures were made with stone tools, without the help of draft animals or carts, or even pack animals, and that their potteries were made without any wheel. This strange technical lag of America, even in its highly organized ancient societies, is explained by the isolated position of those peoples, who were cut off from other civilizations. To progress, man needs other men, even if they are his enemies. The exchanges between Asia and the West were many, and even Africa never lost contact with the Mediterranean. But once America had been populated by waves of immigrants from

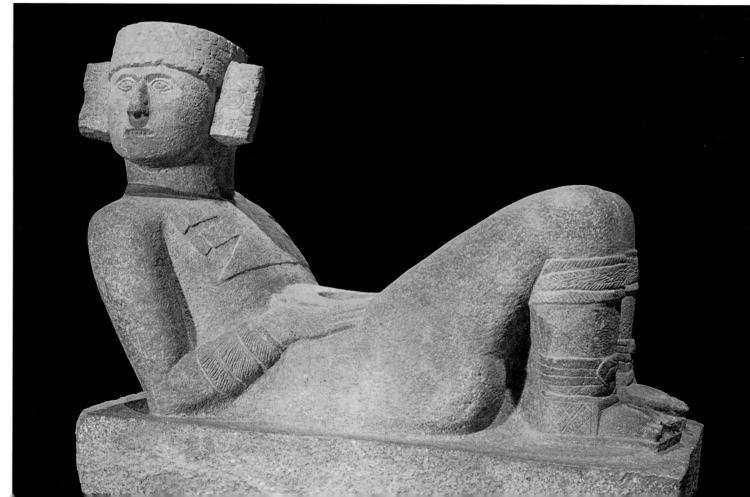

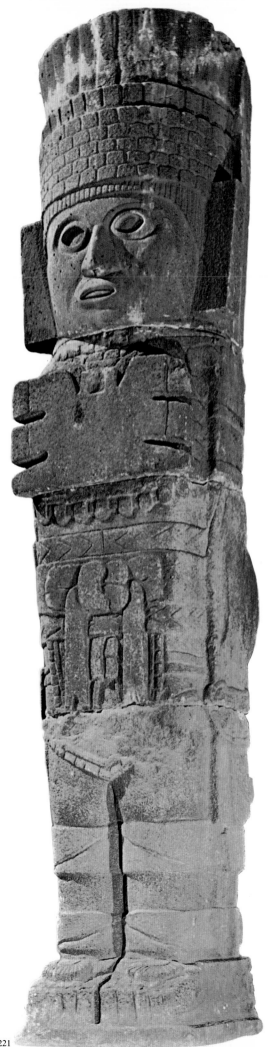

221 *Atlante,* **from Tula. Toltec, 10th to 12th century A.D. Mexico.** Four such Atlantes stood at the entrance to the sanctuary on top of the pyramid at Tula, the religious city of the Toltec people. This five-stepped pyramid was devoted to the worship of the sun and of death. A feeling of power emanates from this figure, which symbolizes the sun-warrior armed with shafts of light.

Asia and perhaps also from Oceania, the continent seems to have been closed to all outside influence; it had to be content with its own resources of fauna and flora, which were infinitely poorer than those of Eurasia. It is not surprising that the Mesoamericans should have deified corn since that plant was almost their only resource; they regarded it as miraculous. Deprived of the stimulation of a generous natural environment, the human spirit seems to have lacked the ingenuity that in the rest of the world led it to increase the efficiency of effort through practical inventions. In any case, we know now that all the discoveries that tended to give man some control over natural forces were achieved in a privileged part of the Middle East, and from there spread to the whole world. But to reach America they would have had to traverse the insuperable barrier of the oceans, and at that time the continent seems to have already received its immigration quota.

Therefore, however developed they may have been, the ancient American civilizations were primitive. They still lived in the state of primeval fear; it seems to have been more acute there than anywhere else in the world. Nowhere had man found the earth so unproductive, nowhere the universe so hostile. The inefficacy of their actions, compared to their aspirations, fostered in these ancient peoples the frustrating sense of their own innate weakness and of the unreliability of a world subject to the blind power of invisible forces. To be, to endure, or to grow, everything demanded blood— human blood: the progress of time itself was secured only by the sacrifice of victims, as was also the growth of the corn. Priests walked in procession clothed in human skins from victims who had been skinned alive to symbolize the hulling of corn; children were tortured so that their tears might attract rain over the dry fields. Man was pledged to war to provide holocausts for the gods. Alone in a hostile world, he was literally helpless and could only try to placate the invisible powers by magic. Far from weakening with time in an evolution such as occurred in all the great European and Asiatic civilizations, this terror grew through the centuries: the populations of America experienced a sort of evolution in reverse.

222 *Jar in the form of a deity.* **Pottery. Peru, Mochica culture. Museum of Archaeology and Ethnography, Cambridge.** The Mochica culture is known for its funerary materials, among which the painted ceramics take pride of place. The artists were inspired by religious themes in particular. This red and white jar, 16 inches high, represents the deity in anthropomorphic form, seated, holding a human head and a copper axe. Living in the valleys of the northern coast of Peru, they favored the ancient feline god.

221

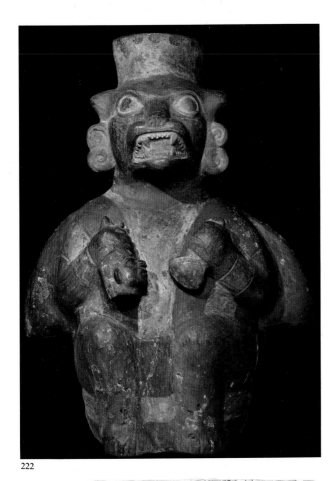

222

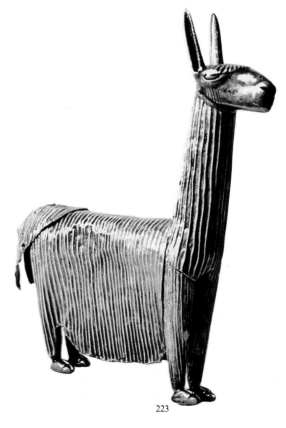

223

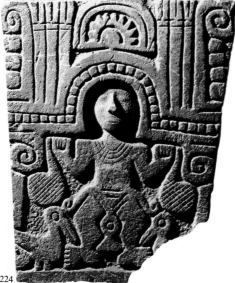

224

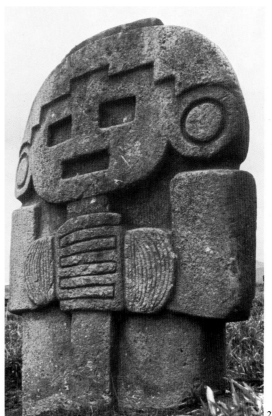

225

223 *Llama*. **Silver. Peru, Cuzco style. American Museum of Natural History, New York.** The Central Andes gave rise to civilizations of high level in which work in gold and silver reached real artistic and technical heights of varied quality and expression. The llama was valued not only as a beast of burden but also for flesh and wool, and it became the ideal animal for sacrifices. This statuette is made of silver leaves assembled with ingenuity. It came from Cuzco, capital of the empire established by the Inca in the first half of the 15th century.

224 *Hunting with a snare*. **Volcanic tufa. Ecuador, Manabi culture. Musée de l'Homme, Paris.** The Manabi culture of Ecuador sculptured works that were almost always carried out in volcanic stone. This relief has a bird-hunt as its subject: the bird-catcher is shown in a rigidly symmetrical frontal position, in the middle of complicated geometric patterns. Only the essential features of the face are represented; more detail, however, is introduced into the pectoral and loincloth.

225 *Stele*, **from San Agustin, Colombia. Stone.** A monumental stele, rather than a statue modelled in the round, this strictly symmetrical figure portrays a deity or a high dignitary. Extreme schematization is achieved by a reduction of anthropomorphic elements to a minimum, giving the massive silhouette the appearance of a pillar. These megaliths are considered extremely old, and are found in company with ceramics of a very archaic nature.

Human sacrifices, still rare among the Maya of the Old Empire, became more frequent during the New Empire under the influence of the Toltecs. The Aztecs lived in a perpetual bloodbath; implacable divinities urged them to constant wars against their neighbors, to feed the altars. War had become a vital necessity, not for reasons of aggrandizement, but to keep the world's clockwork going! This progression of terror is reflected in art. Very ancient civilizations, before the Christian era, left funerary terra cottas that reveal them as optimistic people, enjoying the representation of details of daily life (*fig. 219*). At Tlatilco excavations brought to light "female and male figures, young and old, with thin or obese bodies, healthy or humped, sitting or standing, nude or half-dressed. Many of them are adorned with varied elegant hairstyles, long plaits, earrings, necklaces, little dancers' skirts or dresses. The latter have been called 'pretty women.' They are neither goddesses nor portraits, but may be representations with intended magic properties, designed to awaken or increase human or agricultural fertility. . . . Some of the characters represented are carrying children, dancing, crying, playing with dogs, others are acrobats, dancers, ballplayers, magicians or fantastic creatures. . . ." (The quotation, illustrating the variety in these figurines, is from the catalogue of the exhibition "*Chefs d'oeuvres d'art mexicain,*" Paris, 1962.)

Excavations in the region of Los Remojadas, where the Totonac lived, have brought to light figurines depicting a whole population whose one aim in life seems to have been to play practical jokes on each other, to play on swings, wear fancy dress, tell funny stories, sing, dance, and roar with laughter. The children—who were numerous—laughed loudest of all. Did these people try to combat terror by a ritual of optimism?

These statuettes demonstrate that, as in prehistoric art, naturalism may be found at the origins, and stylization—which has been considered a sign of primitivism—may occur as a later development (contrary to the idea of a "life of forms," outlined by art historians from Deonna to Focillon, which can only be applied consistently to Western art). We are surprised by the freedom of these ancient figurines: they are really sculptured in the round, with limbs moving freely in three-dimensional space, and some of the dancers twist around in bold, spiraling movements. Modelled in soft clay by hand and fired once only, these figures can ignore the limitations of stone carving; but even figures carved in stone are sometimes animated by the same vitality. The Maya's organization of city-states brought about a great demand for monumental art to serve the aristocratic and religious hierarchies. That was the end of the freedom of expression and liveliness of archaic art; artists now had to submit to great sculptural programs for reliefs in stone or stucco to ornament buildings. The human figure was subjected to conventions similar to those of the Egyptians, who showed the body full-face and the legs in profile, and in the New Empire the Maya adopted a uniform, hieratic frontality and concentrated on the representation of gods rather than mortals. During the Old Empire, the manner in which the figure is set in the center of the relief, surrounded by monstrous apparitions and hieroglyphic decorations pushed back towards the edges of the composition, still shows some feeling for design, but design is lacking in later periods, as Mesoamerican plastic art gradually became stereotyped. Aztec bas-reliefs are composite agglomerations of figures, ornaments, and truncated forms, all mechanically thrown together. In these inhuman compositions, jaguar snouts, snakes' jaws, death's heads, and fragments of dismembered human bodies are the terrifying tokens of a hostile universe governed by demonic forces. In no other part of the world was man so far removed from the soothing concept of God that pervaded all the civilizations of the Eurasian continent from Greece to China.

The cultures of the Andes seem to have been spared that philosophy of terror, thanks to the materialistic tendencies inspiring the Inca social organization, which was bound to the monotheistic cult of the sun. Less artistically gifted than the Mesoamericans, the Andean peoples rarely practiced sculpture. But they gave human faces to their pottery vessels, thus producing an extraordinary portrait gallery in which the sick, the deformed, the crippled, and the tortured were not forgotten (*fig. 222*).

Folk art is not to be despised. It has aroused much critical controversy (including Berenson's invective against our pres-

227

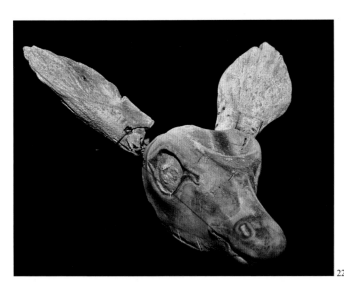

226

226 *Head of a deer.* **Wood tinted with ochre. North America, Florida, Mound-builder culture. University Museum, Philadelphia.** In southeast North America, the wooded plains of Florida and the Mississippi Valley first saw the rise of what was termed the mound-builders' civilization. A Central American influence seems to have found its way to these maize farmers, who built mounds in the shape of animals or pyramids. Some mounds served as pedestals for temples. This graceful deer head (5 1/2 by 7 1/2 inches) is one of a series of masks found at Key Marco in Florida.

227 *Great totem pole.* **Wood. North America, Northwest coast Indians. Musée de l'Homme, Paris.** Along the coast of northwest America, a civilization flourished that was particular to the "salmon fishers," producing numerous works of art and particularly wood carvings. The erection of a huge pole, such as this one, decorated with clan's emblems, most frequently animals like the crow, bear, beaver, shark, or eagle, gave the signal for the aristocrat's grandiose celebrations of honor and wealth.

228

229

230

228 *Funerary stele.* **Southern Ethiopia. Museo Africano, Rome.**
Funerary sculpture is the most interesting artistic manifestation in southern
Ethiopia. Commemorative effigies in the form of wooden posts sur-
mounted by carved heads are raised to the glory of important deceased
men and famous warriors. They are set beside megalithic monuments bear-
ing symbolic figures. This stele shows a half-length figure in a totally con-
ceptual representation.

229 *Funerary statue.* **Wood. Afghanistan, Kafiri peoples. Museo
Nazionale di Antropologia, Florence.** Outside Europe distinctions be-
tween great, folk and tribal art are difficult to make. This funerary sculpture
is the work of the Kafiri. The carved wooden effigy represents the deceased.
The rosettes and interlace shown on his clothing are universally employed
ornamental motifs.

230 *Stele of Saint Valentino. 1662.* **Museo di Castelvecchio, Verona.**
The thirteen Veronese communes have posed many ethnological problems.
Their population was composed of very ancient Latin or Germanic stock,
joined in the 14th century by mountain dwellers from Bavaria. The au-
tochthonous art that sprang to life in these lands produced steles and
crosses, made for centuries in the same popular style and set up at intervals
along the roads. Here the simplification and geometrical rendering of the
forms make the figure a perfectly legible ideogram.

ent craze for it); the great Austrian historian Alois Riegl was
among the first scholars to take it seriously. Folk poetry had
already attracted interest in the Romantic era, and towards
the end of the 19th century this interest extended to everyday
utensils and objects; the so-called folklore museums in the
Scandinavian countries were founded at this time. As early
as 1860, Kraszwski, in a study of Slavic art, demonstrated the
indigenous character of Russian folk art. In 1871, however,
the Englishman E. B. Tylor put forward an opposite theory;
for him folk art represented the survival of universal tradi-
tions going back to the prehistoric period and persisting un-
changed throughout the ages in the midst of advanced civi-
lizations. This theory has now been generally accepted; André
Varagnac has coined the word *archéocivilisation* to describe
the sum of those popular customs that were born with the
first agricultural cultures and resisted the great developments

of history to die only now, killed by industrialism. In the case of artistic production, this hypothesis is least open to verification; however, a common decorative vocabulary made up of abstract ornaments used by folk artists in districts as remote from each other as Roumania and Portugal does seem to go back to the proto-historic period when these ornamental elements were signs possessing magic connotations. As for other folklore products, the fact that they are alike throughout the world proves mainly that there are feelings and frustrations, common to all people and all times, that influence the attitudes of the masses of ordinary people—for civilization is above all an effort to differentiate. Folk art is probably most original and most consistent in its use of colour. A popular taste for polychromy reduced to a few strong, even acid, hues may be found alike in Mexico, in Poland, and in Spain. Fabrics and ceramics are the most appealing creations

of popular art. Ancient fabrics of popular origin have rarely survived; some ceramics have. But it is sculpture, more enduring, that shows throughout the ages the unchanging uniformity of popular conventions. In sculpture, not originality, but the arbitrary simplification of forms obtained by hesitant hands trying to "reproduce" rather than invent, may be observed. The artisan is not moved by the need to create that torments the artist and forces him to go one step further every time; the works of the artisan are analogous to industrial mass production. In all civilizations, alongside the skilled artistic creations, there has existed an almost universal form of "provincial" or "popular" art, in which a Punic sculpture contemporary with Rome finds a strange kinship with Bogomil reliefs from the Middle Ages or with an Italian 17th-century stele made by peasants at the time of Bernini *(fig. 230)*. It is an art of timeless forms situated outside history.

231 *Monument of the Postman Cheval*, at Hauterives (Drôme). ca. 1879 to 1900 A.D. France. The country postman Ferdinand Cheval wrote that daily, as he climbed the paths of the Drôme region, "in order to entertain my thoughts, I built a fairy palace in my dreams. . . ." In 1879, when he was in his forties, he undertook the realization of those dreams. The work was completed in thirty-three years of hard labour, often done at night, by candlelight. The temple is built up, cut, and modelled in astonishingly fantastic forms, entirely consistent symbolism.

VI
THE FAR EAST

It is told that, just having completed the Kailasanatha temple at Elura, its designer exclaimed, "Could it have been I who made that?" He had so merged himself with his work that he was unable to see it as a thing apart from himself until the Vishvakarman had withdrawn. Only then did he regain consciousness of himself as an individual, an ephemeral being momentarily raised by the Creative Principle to the transubstantiated world and now fallen back into the universe of differentiated forms. His attitude is opposite to that of the Greek artist, for even when the Greek created sacred images (and in the classical period this was all he created), he considered his work from the beginning as the object, a product discovered by his mind searching for a concept in an external world; the divine spirit entered the sculpture after it had left his hands, when the god descended into the man-made form. In India, the god, the formless one, comes to the artist clothed in the form in which he desires to reveal himself to man; in the golden age of India men did not need to borrow from the world of illusion, for they contemplated the gods face to face, and art did not exist.

Herein may lie the explanation of why in this culture, attracted to sculpture more than to any other art, to the point of allowing it to dominate architecture completely, there is so little attempt to create free-standing statues. The statue is an object. For the Greeks, it served to define man himself, as an *ego,* but this ego that in the Greek mind was the aim and end of being, in Indian ontology was only a transitory incarnation, destined in the perfect human being to be annihilated, merged in the Supreme Self, the universal One, the Absolute. In Indian art the sculptured figure is rarely treated as an isolated entity; it emerges from the stone but remains attached to the background—a background neutral, nonspatial, and as indeterminate as the infinite. The figure is usually linked with others, and even when it is alone, like the *yakshi* on the gate of the Sanchi stupa *(fig. 238),* the pulsations of the ecstatic state that twists the body suggest its interdependence with the sky behind it. In general, the multifarious beings invade the whole field, obeying no compositional principle, but simply accumulating all over the available surface; or they mass their twisting bodies over the flanks of the

temples in an endless repetition of forms that mirrors the swarms of ephemeral beings engendered by the life process. Such groups as those on the Mamallapuram rocks seem to have been conceived extemporaneously, unrelated in an overall plan. Indian thought is ruled by the impossible aim of synthesizing the many and the one: in the Hindu religion, the universe is a pullulating swarm of living beings— plants, animals, humans, gods and anti-gods—engendering each other in successive transmigrations that leave their souls unsatisfied and that endlessly delay the promised ultimate identification of all individual being in the Absolute. This sense of a germinating swarm inspired all Indian creations, whether of religious and philosophical sects, or in the arts and literature. The Purana poems relating the stories of the gods fill 1,600,000 lines, and India is said to have 300,000,000 gods!

Greek sculpture came into being along with Greek architecture, and was dependent on it; even the free-standing statue had to respond to architectonic laws. In India, on the contrary, it was the sculptor who was the architect. He hollowed the temple or monastery out of the mountain flanks, or opened a vast trench, reserving a rocky mass out of which he would carve a sanctuary like the Kailasanatha of Elura where the rock was excavated to nearly one hundred feet to free the mass for the temple. Delving into the earth's entrails, the Indian satisfied a need to feel nature, the Holy Mother, immanent. The Kailasa, the temple of the Holy Mountain dedicated to Shiva, had to be extracted from a veritable mountain. At Mamallapuram the rocks along the coast were carved into temples or animals *(fig. 250);* but the designer of this sacred place preserved a few natural rocks, some of them close against the temples, so that the contact with the original earth-stuff should not be broken. After the classical period Hindu temples began to be built, rather than excavated, yet they were still conceived as the original mountain, as a heap of cut stones, in the heart of which the dim and narrow sanctuaries imitated the caverns of the primitive period. The Indian concept of architecture never moved beyond this heaping-up of stones; to be sure, the earliest architecture was constructed, but it was made of

232 *Head of a Lokapala.* **Stone. China, T'ang Dynasty, 618 to 907 A.D. University Museum, Philadelphia.** This head of the statue of a lokapala, from the rock temple of T'ien-lung Shan, illustrates the violent aspect of T'ang art. The features recall the central Asiatic origin of its iconographical type, but also discernible is the influence of Indian Tantric models, combined with a feeling for caricature that is specifically Chinese.

233

234

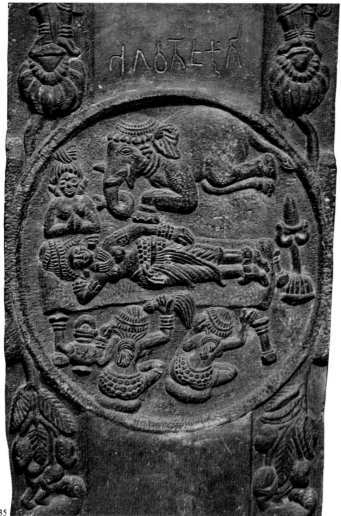

235

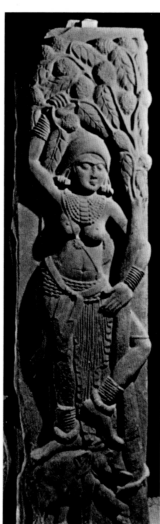

236

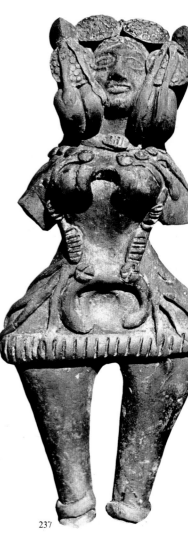

237

233 *North Gate of Stupa No. 1* (The Great Stupa), Sanchi (Madhya Pradesh). India, Early Andhra period, 1st century B.C. The *torana* (gates) of the Great Stupa at Sanchi correspond with the cardinal points and lead into the corridor intended for the ritual circumambulation of the stupa—that is, symbolically, the Path of Life around the World Mountain.

234 *Capital with lions.* Polished sandstone. India, Maurya period, ca. 274 to 237 B.C. Archaeological Museum, Sarnath (Uttar Pradesh). This capital, which bears the Buddhist symbol of the Wheel of the Law on its plinth, has now become the emblem of the Indian Republic. The influence of Achaemenid architectural sculpture is obvious here.

235 *The Dream of Queen Maya,* pillar medallion, from Bharhut. Red sandstone. India. Shunga period, 1st to 2nd century B.C. Indian Museum, Calcutta. The episode of the miraculous conception of Siddhartha is depicted on a medallion which decorated one of the pillars of the balustrade of the Stupa at Bharhut. The artist has set down one figure beside another, inventory-fashion.

236 *Yakshi on an elephant,* and railing elements, from Bharhut. Red sandstone. India, Shunga period, 2nd century B.C. Indian Museum, Calcutta. An inscription enables us to identify this yakshi as Chulakoka Devata—"the goddess Chulakoka." The attitude is typical of the female human and divine figures that appear on the balustrades and the *torana* (gates) of the stupa.

237 *'Mother-Goddess'* from Mathura. Terra cotta. India, 2nd century B.C. Prince of Wales Museum, Bombay. The dating and object of terra-cotta female figurines, like this example, is still controversial. They are certainly of the fertility goddess type, but they may have lost their original significance and become mere charms. This one displays analogies with the "baroque ladies" of the northwest frontier.

wood, and soon its forms, borrowed from Iran, were transposed, paradoxically, to caves hollowed out with chisels by the architects of the 2nd- and 3rd-century Buddhist sanctuaries.

Indian art begins where others end: with naturalism. Stylization and conceptualization, which have generally preceded the imitation of nature (particularly in Greece), in India follow upon it. Attempts have been made to explain this anomaly by postulating the existence of an earlier, primitive and stylized wooden sculpture, since destroyed. As an argument in favor of this hypothesis its supporters point to two large statues dating from about 200 B.C., from Parkham, and

now in the Mathura Museum. In fact, no such "explanations" of Indian naturalism are called for; Indian naturalism springs from the *genius loci*. It is already present in the prehistoric Indus Valley culture of 2500–2000 B.C., where it contrasts strongly with the entirely hieratic approach to art predominating in the coeval Mesopotamian civilizations, from which the Indus Valley culture largely drew its forms. Stella Kramrisch rightly saw in two sandstone statuettes from Harappa the two tendencies found in all Indian art. One figure is static, and represents life contained at rest; the other, a dancer, has a vital, twisting body, unique at that stage in the history of art, and totally different from the block-like forms of the figures carved by contemporary artists at Telloh. The two Harappa statuettes are also distinguished from contemporary Middle Eastern works by their sensuously described nudity. This ingenuous sensuality was from the beginning characteristic of Indian sculpture. In both Greek and Hindu cultures, neither of which has made a "sin" of life, the body has been glorified. Unlike the Greek artist, the Indian was not interested in anatomical structure, representing it only very approximately; but the body of an Indian figure is shot through with a vital pulse, the essence of being itself, the breath of life. In the Hindu philosophy the body is not hostile; rather, it is the medium through which liberation is attained; ascesis is not the mortification, but rather the mastery, of the vital mechanisms, obtained through a complete awareness of body and soul. The sense of touch plays a basic role in the ritual of possession of the vital centers, and as for sexuality, one of the yoga methods exploits eroticism as a path to transcending the Ego and attaining unity with the Supreme Self.

It is understandable why the ideal type in Indian sculpture tends to the female, in contrast to the Greek, where the virile type came first and the appeal of the feminine only later. In Indian art, the characteristic female forms influenced the representation of the male body, and a viscerotonic type—that is, somewhat adipose—was favored, and became the type for the representations of the Buddha. In the female figures the female attributes—breasts, hips, fleshy folds—are strongly accentuated, as in the old fertility idols, and are emphasized

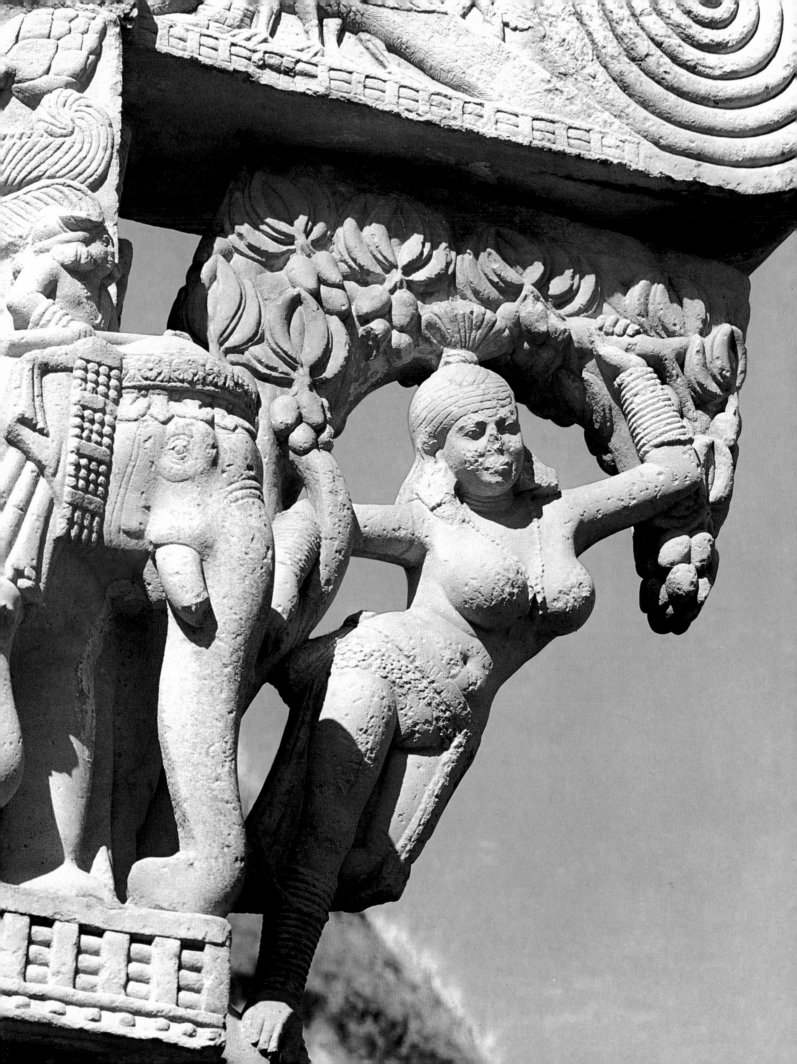

238 *Yakshi,* **east gate of the Great Stupa, Sanchi (Madhya Pradesh). India, Early Andhra period, 1st century B.C.** Placed as a bracket for the lower architrave of the east *torana,* this was only technically a free-standing statue.

by the s-curve (*tribhanga*) in which the body is twisted, and which accentuates its curves. The most characteristic of Indian female figures, the *yakshi,* appears again and again, with her rounding body ornamenting temples and gates. She is the guardian spirit of the vegetable sources of life. At Bharhut, she barely emerges from her pillar and must deploy her movements sideways instead of out into space *(fig. 236);* at Sanchi, her body issues from the tree like a juicy fruit *(fig. 238);* at Mathura, her elegant, even affected, attitude reflects the refinements of the Emperor Kanishka's court, where poetry and philosophical subtleties flourished *(fig. 239).* In the Medieval temples of Bhuvaneshvara, Khajuraho, and Konarak, the female bodies are seized in an erotic frenzy (difficult to view simply as a symbolic union of essence and substance) that so contorts them that the bust manages to twist back completely over the haunches.

There are many Indias; the immense territory is divided and subdivided into sects and principalities, and all attempts at political unification have failed. Psychologically, there are certainly two Indias at least. The first is the heart of the country, the Deccan and the south, where pre-Vedic peoples were probably pushed back by Aryan conquerors, but where was preserved the basic thread of the old proto-historic naturalistic civilizations that worshipped plant life and the generative organs. That continental India gave to Vedantism its magic materialism, which continued to exist as a substratum of Indian spiritualism. The god Shiva, benevolent and terrible, is probably also a pre-Vedic survival. The other India, which might be called the international India, is that of the northwest, the India of the Indus and the Ganges, open to contact with Iran, the Hellenic lands, the world of the Scythian tribes, and through the oases of Tarim, with China. It was the path of the invaders who time and again attempted to remodel the Indian continent and the Indian soul. In that region, open to so many races and influences, Indian art was born. Paradoxically—though in India all is paradox, everything being both the thing itself and its opposite—it was Buddhism, religion of the Absolute, that gave India its art and its world of images. When the 3rd-century Emperor Ashoka, the Constantine of Buddhism,

239 *Pillar with a yakshi,* **Bhutesar, Mathura. Red sandstone. India, Kushan period, 2nd century A.D. Indian Museum, Calcutta.** This pillar from a stupa is one of the most famous works of Mathura sculpture.

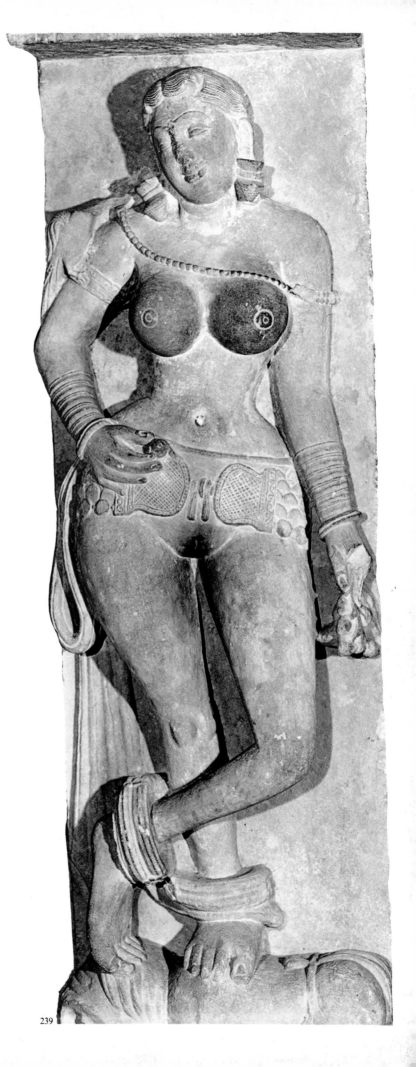

239

240 *Spirit with flowers,* from Hadda. Stucco. Afghanistan, 4th to 5th centuries A.D. Musée Guimet, Paris. Among the many fragments of Gandharan stucco art this bust has enjoyed special popularity. It probably represents a genie offering flowers to the Buddha. Despite a certain calligraphic facility typical of Gandhara art, the fluidity of the planes calls to mind the stucco medallions at Begram.

241 *Bust of an ascetic,* from Hadda. Stucco. Afghanistan, 4th century A.D. National Museum of Afghanistan, Kabul. The identification of this figure is uncertain: it probably represents an ascetic, although there is no characteristic *jata* (coil of hair over the forehead). This head is famous for its effective contrasts of light and shade, which appear to dissolve the figure's material solidity, owing to Hellenistic influence.

242 *Head of a demon,* from Hadda. Stucco. Afghanistan, 3rd to 5th century A.D. National Museum of Afghanistan, Kabul. Scenes of demonology seem to have interested Gandharan sculptors as much as they did Bosch and Breughel. There are many schist reliefs showing the Buddha vainly tempted by the demon Mara, accompanied by packs of demons of terrifying appearance. In the stuccos—particularly those from Hadda—these demoniacal figures were endlessly multiplied and varied during the evolution of Buddhism, exploring all possible human and animal aspects and producing very effective combinations.

243 *Head of the Buddha,* from Gandhara. Limestone composition. India, 5th to 6th century A.D. Victoria and Albert Museum, London. This head is typical of images of the Buddha in the later phase of Gandhara art, the so-called Stucco period; the classical reminiscences of the earlier Gandhara sculptures in stone are evident. Like all Gandhara stucco sculptures, this work was originally painted.

244 *Head of Buddha,* from Hadda. Stucco. National Museum of Afghanistan, Kabul. The Chinese pilgrim Fa-hsien, who visited the site of Hadda in the 4th century A.D., spoke of a great Buddhist sanctuary there with 1,000 stupas. Later, the French archeologist Barthoux excavated the ruins of 531 stupas. The stucco statuettes found on the site are molded over a core of chalk and straw that makes them extremely fragile. The Hadda period dates between the 2nd and 5th century A.D., but between these limits the works are difficult to date.

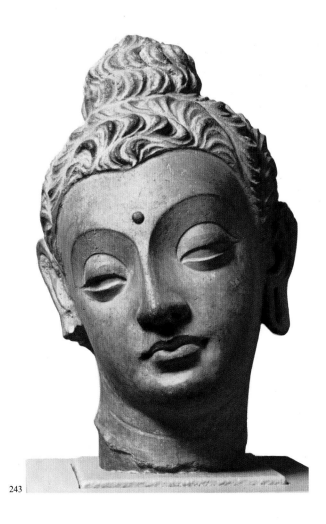

243

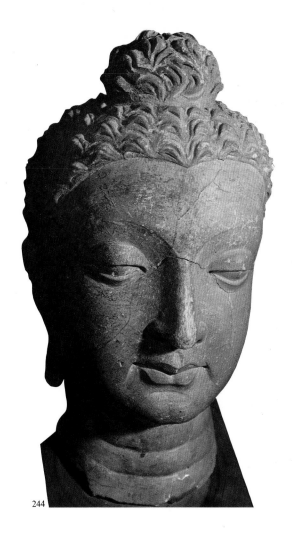

244

wished to celebrate the places sanctified by Buddha, he was obliged to borrow forms from Persian art; but already in the following century, an indigenous Indian art appears at Sanchi and Bharhut. On these temples the figures telling the story of the Buddha are calm and smilingly graceful, the scenes diffused with a sense of peace; but near the Deccan, in the Kingdom of Andhra, on the Kistna River, Buddhist imagery took on a more dramatic aspect, in compositions crowded with figures which, seized as by a kind of sacred frenzy, writhe in ecstatic attitudes. These are the two principal stylistic currents in Indian art. The more serene style, expressing silence and an inward life, which Buddhism spread in the north, was enriched by contacts with Graeco-Roman art and communicated its spiritualistic optimism to China and Japan; the Amaravati style, of greater intensity and passion, was to be the source of Brahminic art.

In the earliest Indian art the image of the Buddha himself does not appear; at Bharhut, Sanchi, or Amaravati, in the stories about the Buddha, his figure was replaced by symbols. This aniconic tradition was perfectly orthodox, since once

the Enlightened One had attained Nirvana he was then "extinguished," that is to say, no longer in existence. Scholars of Indian art still dispute the source of the Buddha image, Indian historians holding to an Indian origin and giving Mathura as the place of its creation, while Western scholars tend to believe that the idea of giving human form to the Buddha was inspired by Graeco-Roman anthropomorphism. It seems most likely that the idea of representing the Buddha resulted from foreign contacts, and from historical evidence, these probably entered through the Gandhara region. In works at Mathura, contemporary with the Gandharan epoch, the Buddha is still represented with some reserve, as if the artist were tentatively practising a strange custom. In the scene of Paranirvana that illustrates his death, for instance, he is still present only as a symbol. In Gandharan art, on the other hand, the figure of the Buddha is never avoided. Not only does he appear in the scenes taken from his life, but the cult images depicting the Buddha, standing or sitting Indian-fashion in poses that were to become traditional, begin to multiply there, as do the Bodhisattvas of

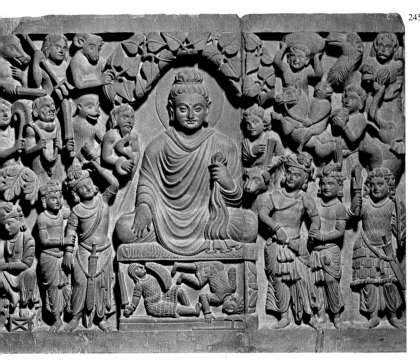

245

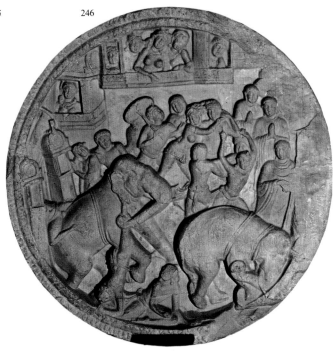

246

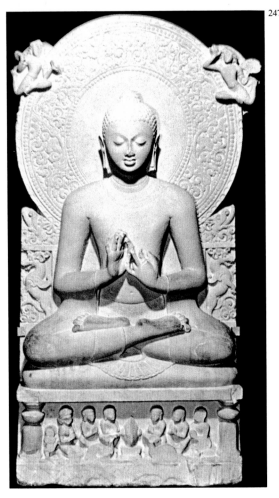

247

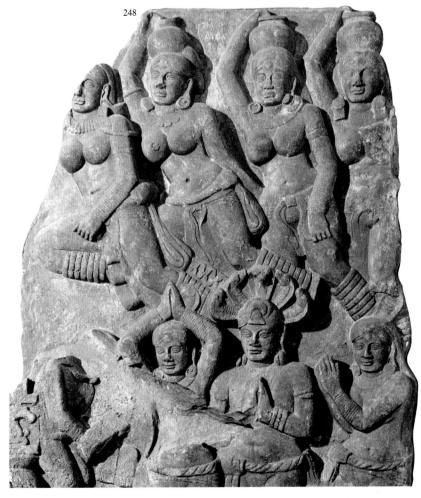

248

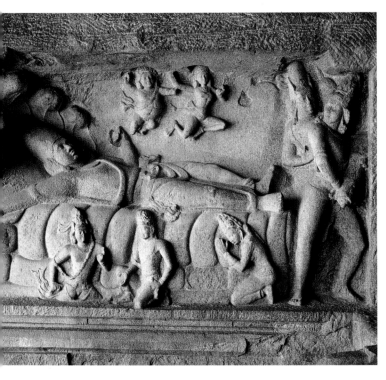

245 *The Enlightenment of Gautama.* **India, 2nd century A.D. Freer Gallery of Art, Washington, D.C.** This relief represents the culminating moment in the life of the Buddha: the Blessed One, sitting in the shade of a pipal tree, lowers his right hand towards Earth.

246 *The Buddha taming the maddened elephant,* **railing medallion from the Stupa of Amaravati. Marble. India, Andhra period, late 2nd century A.D. Government Museum, Madras.** The school of Amaravati evolved stylistic themes and motifs that have a more purely Indian appearance than the Gandhara and Mathura schools. In this medallion, the strongly spiraling movements that generally characterize works of the school are entirely absent.

247 *The Buddha preaching his first sermon,* **from Sarnath. Sandstone. India, Gupta period, 5th century A.D. Archeological Museum, Sarnath.** One of the most beautiful works of Gupta art is this image of the Buddha giving his first sermon in the Deer Park, his hands in the *dharmachakra mudra*—the gesture of the turning of the Wheel of the Law. The earliest Siamese and Cambodian Buddhas derive from this type, as do those from Borobudur (Java).

248 *Bodhisattva bathing in the Nairanjana,* **from Amaravati. India, Andhra period, 70 B.C. to 300 A.D. Museum of Fine Arts, Boston.** The voluptuous and powerful Buddhist style from Sanchi and Mathura has affinities with the Amaravati style, particularly towards the end of its development, when the figures become more elongated and more sinuous, the poses more animated, and the compositions more confused and dynamic. It was at Amaravati that the future Medieval style of India was formed.

249 *Vishu Anantasayana,* **rock-cut relief at Mamallapuram. Pallava period, mid 7th century A.D. India.** In the various rock-sculptured sanctuaries created in Mamallapuram in the middle of the 7th century, Hindu mythology received one of its purest expressions. This granite relief represents Vishnu resting on the coils of the serpent Ananta; Brahma the creator rises from his navel. The clear, restrained style conveys the presence of divinity in which the creative power is concentrated.

the Greater Vehicle, who now people the arcades of stupas and the corners of monastic cells. The *prabhamandala,* the halo, inherited from the Graeco-Roman world, also first appeared in Gandharan art.

Owing to the wave of Buddhist piety that swept the region in the first centuries of our era, the monasteries and stupas decorated with sculpture multiplied in the Gandhara area (now divided between Pakistan and Afghanistan, but then part of the Indian empire founded by the Scythian Kushan dynasty). On the Eastern frontiers of Iran, Hellenistic influence had worked deeply into Bactria, and at Begram in Afghanistan, Greek and Indian works have been found hidden away together. In Bactria, the Graeco-Indian king Menander (Milinda in Indian), who reigned in the later 2nd and early 1st centuries B.C., was converted to Buddhism by a monk whom he had invited to his court; the conversations between monk and prince were collected in a famous work that became one of Buddhism's holy books.

The Western influence exerted over Indian art has been called Greek, and yet it has been objected that at the time of the "Graeco-Buddhist" art of Gandhara *(figs. 241, 243),* Rome, not Greece, held the power in the East. For the Indian, however, Rome and Greece were alike in their artistic approach, based on anthropomorphism; moreover, what Rome had to offer as an art form, especially on the Eastern frontiers of Western art, was Hellenism. Indian sculptors learned from the West what relief was; until then they had simply covered the surface before them by spreading out the figures all over it, like primitive artists. The Greeks taught them monumental art, and how a much more convincing image could be obtained by the use of a few figures linked together in common action and modelled in relief against a background over which they cast shadows, than by an all-over swarming of forms. Greece also provided an example of how to represent heads and bodies in order to emphasize the monumental aspect of a figure. Finally, they taught the Indian artists, who knew only the nude, how to exploit draperies in order to accentuate a gesture or to give the composition a feeling of rhythm. It has even been said that Apollo lent his features to the Buddha. Olympian anthropomorphic pagan-

ism seems, at any rate, to have appeared in the East just when the Indian sculptors felt the need to devise the image of a man who had attained divine serenity. The Gandharan Buddha heads, often preserved without their bodies *(figs. 243, 244)*, express the varied moods of the Enlightened One, ranging from his indifference on the threshold of Nirvana to his infinite mercifulness, expressed in a radiant smile. The smile, which had appeared with the earliest Buddhist art, took on an enigmatic cast at Gandhara. The capacity to give the face a profound sense of life is another gift of Hellenism; until then, the head of an Indian sculpture had been only a part of the body, but now it became, as for the Greeks, the mirror of the soul. The various faces of the Buddha, of the Bodhisattvas or minor deities, of princes, soldiers, ascetics,

and demons, of Greek, barbarian, and Indian ethnic types, might be considered as stemming from Hellenistic expressionism. Overtones of later Greek art are especially marked in the Gandharan stucco statues done later than the blue schist reliefs, which adhered more docilely to Graeco-Roman models *(fig. 241)*. The malleability of stucco gave the artists a freer range and contributed to the creation of a specific style peculiar to the art of that time and place. The forms resulting from this encounter between a spiritualistic religion and the Graeco-Roman aesthetic are in some way comparable to those resulting from the rediscovery of antique classicism by Christian Gothic art, the expression of a religion of God-made-man.

In the 5th century the Chinese pilgrim Fa-hsien counted

250

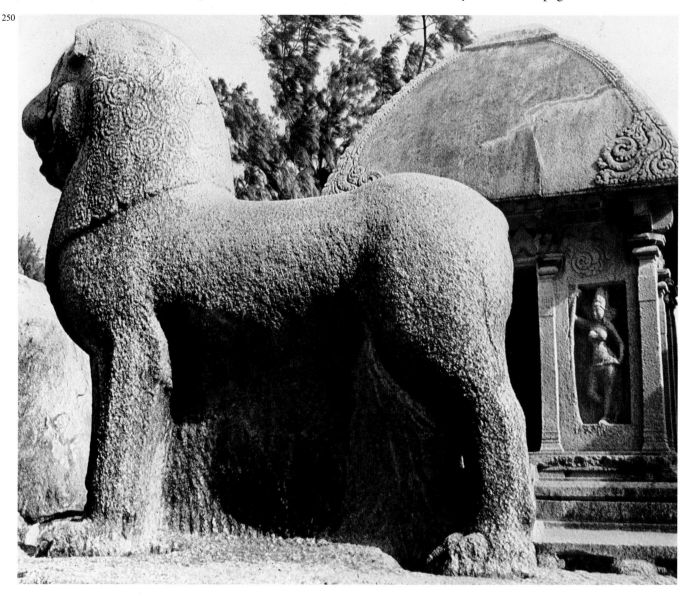

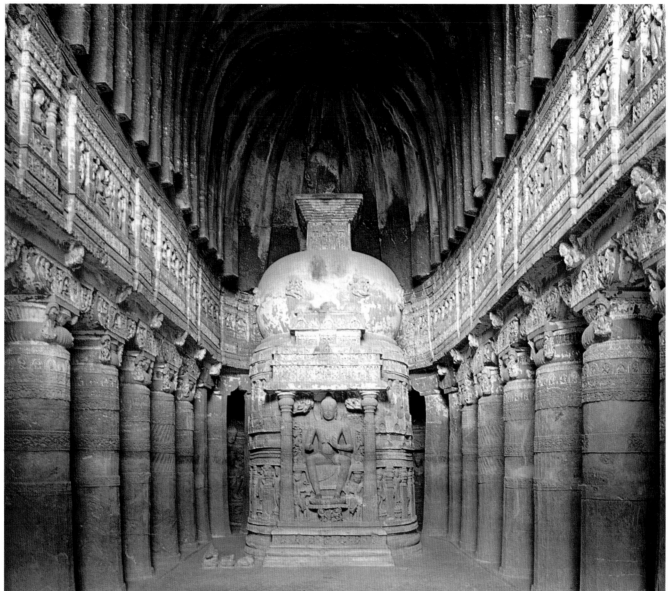

251

one thousand stupas in Hadda and its surroundings. Unfortunately, the White Huns who repeatedly attacked India overran Gandhara, leaving nothing but ruins, as witnessed by the laments of another Chinese pilgrim, Sang Yün, in 520. Although entombed—and not brought to light until the 20th century—Gandharan art left a deep impression on India. Under the Gupta dynasty, which tried and failed to reunite the continent, a true Indian style developed in the north, in the 4th and 5th centuries, on the basis of Gandharan art. It appears incorrect to term this style "classical"; its tendency to stylization is, from both the classical and the naturalistic points of view, a regression, similar to that of Byzantinism in relation to Graeco-Roman art. In Gupta art the typology

of the Buddha was definitively set *(fig. 247)*. The attitudes of the Buddha were classed in categories and his gestures into types, as were those of the Virgin Mary in Byzantine representations: the Buddha *abhaya mudra* and *dharmachakra mudra* became established types like the Byzantine Virgin *theotokos* or *hodigetria*. In the perfectly oval, smoothly modelled, and impersonal faces, the pilgrim no longer could find the humanity that had given such mysterious appeal to the Gandhara figures. The breath of life that throbs in most Indian figures seems here to have withdrawn itself. The stylized mouths and half-closed eyes are geometric patterns, the eyebrows follow elegantly drawn curves, and the merciful smile is a mere formula. Transparent folds of clothing cover the

250 *Rock-cut beast and one of the five Ratha,* at Mamallapuram. Pallava period, early 7th century A.D. India. On the banks of the Mamallapuram near Madras are granite rocks which in the early 7th century were sculptured into various forms. Illustrated here is one of the five *ratha* (chariots), replicas of temples of the period and named for personages of the *Mahabharata*.

251 *Interior of the chaitya,* Cave 26, Ajanta, India, ca. 600 to 642 A.D. The *chaitya*, or naved Buddhist temple carved out of the rock, appeared in the 1st century B.C. At the end of the central nave there is a stupa or *dagoba* commemorating the *Paranirvana* or the supreme state reached by the Buddha, whose teaching was directed towards the achievement of this state.

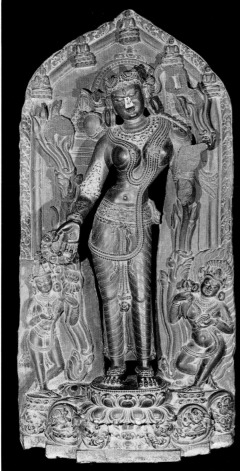

252

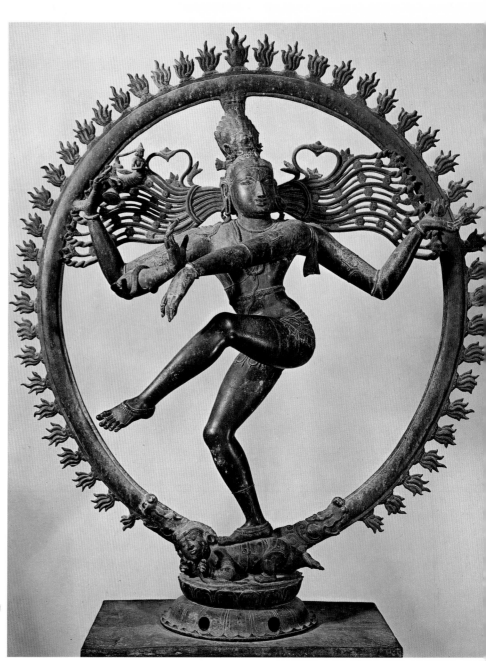

2

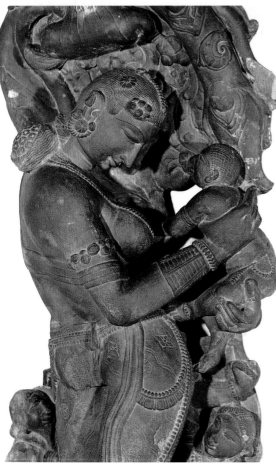

253

252 *Tara*. **Stone. India, Medieval, Pala period, 11th century A.D. Indian Museum, Calcutta.** This figure from Bihar shows characteristics typical of Pala art in its maturity: a fairly pronounced *tribhanga* (S-curve, of the body), minute attention to detail, and exuberant floral ornamentation.

253 *Mother and child*. **India, Medieval period, 11th century A.D. Indian Museum, Calcutta.** This group, said to be from Bhuvanesvara, seems to resemble more the sculpture of Khajuraho. The initial architectonic function is felt through the rigorous superposition of the component parts, which contribute to the twisting movement.

254 *Shiva as Nataraja* **(Lord of the Dance). Bronze. India, Chola period, 12th to 13th centuries A.D. Museum van Aziatische Kunst, Amsterdam.** Such representations of Shiva as universal destroyer and regenerator are typical of the schools of southern India, and are among their most dramatic expressions.

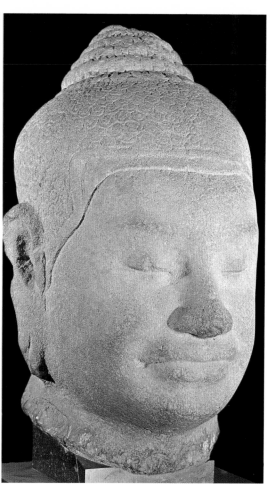

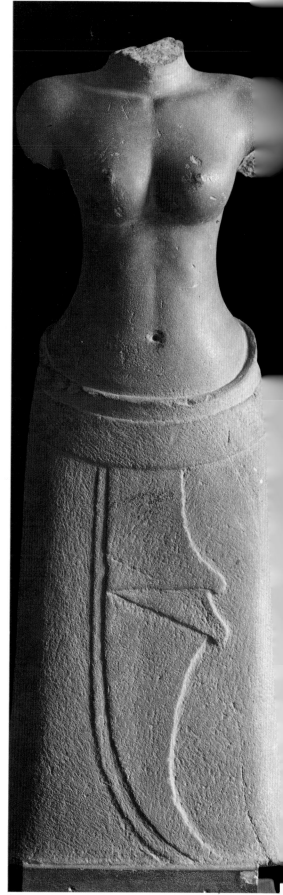

255 *Marching army,* **gallery relief from temple of Angkor Vat. Second Angkor period, ca. 1112 to 1153 A.D. Cambodia.** Angkor Vat, perhaps the high point in Khmer art, was dedicated to Vishnu by Suryavarman II. The sculptors did not aim at rendering realistic spatial effects, but the infinite variations of light give an illusory depth to the compositions, enhanced by surprisingly pictorial effects. The scene is taken from the great epic poem of India, the *Ramayana.*

256 *Head of a Bodhisattva.* **Cambodia, Second Angkor period, 11th to 12th century A.D. Musée Guimet, Paris.** In the Second Angkor period, Khmer art became more naturalistic. Here, the face symbolizing beatitude and supreme wisdom becomes more accessible to the worshippers because of its more human appearance.

257 *Female deity.* **Cambodia, First Angkor period, 11th century A.D. Musée Guimet, Paris.** The Angkor Vat period produced some admirable partly draped female statues, equalling classical Greek sculpture in the beauty of their modelling. The drapery of this example is unfinished.

259

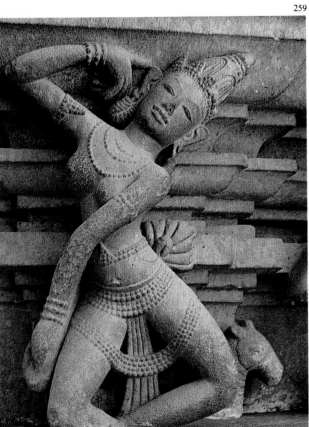

258

260

261

262

259 *Celestial dancer,* from Mi Son. Sandstone, Cham school, 10th century A.D. Musée Henri Parmentier, Da Nang, Vietnam. In the kingdom of Champa, a type of art was produced that has been rightly distinguished from Khmer art. The natural twist of the dancer's body contrasts effectively with the rigid profiles of the cornice. This work, like the sculpture of Borobudur, shows how Pallava art spread outside India.

260 *Head of a Buddha.* Bronze. Thailand, Sukhodaya period, early 14th century A.D. Musée Guimet, Paris. The Buddhist figures made in Thailand during the Sukhodaya era appear like crystalline abstractions of Buddhist wisdom, so stylized are the facial features. The sacred protuberance, the *ushnisha,* is often surmounted by a flame symbolizing spiritual life.

261 *Bodhisattva,* from Fondukistan. Terra cotta. Afghanistan, 7th or 8th century A.D. Musée Guimet, Paris. This Bodhisattva is a perfect illustration of the refined linearism characteristic of the Indo-Iranian style of Fondukistan. From the iconographical point of view, this art was evidently susceptible to numerous influences. These sculptures in rough clay, painted and sometimes gilded, were supported by a wooden core.

262 *Female torso,* from Fondukistan. Terra cotta. Afghanistan, 7th or 8th century A.D. Musée Guimet, Paris. A group of particularly important sculptures has been brought to light by the French Archeological Delegation. The figures are of an extremely linear design and produce subtle calligraphic effects elaborating on motifs from Pala India. From the stylistic point of view one might equally compare them with work from Chinese Turkestan.

258 *Head of a Bodhisattva.* Stucco. Central Asia, 7th century A.D. Musée Guimet, Paris. This head was found in thirteen pieces in a monastery on the site of Duldur-Akhm in Central Asia. The Graeco-Buddhist smile of beatitude is expressed with exquisite delicacy; that smile spread from one monastery to the next along the routes of Central Asia to China.

smooth and impersonal bodies with thin, parallel ripples. It has been suggested that this "string-type" drapery might have come from China or Japan, but it is more likely that it was not imported but resulted from the same drive towards abstraction that turned the folds around the Buddha's neck into three perfect circles. Of all the images of the divine that man has created, these are among the most perfect expressions of a theological belief. They incarnate the state of Perfection, of the Supreme Self, the depersonalized being who has extinguished his will to exist and has therefore "realized" himself fully. Art has never invented a formula that so adequately expresses a conception of what lies beyond life.

Not long after northern India created these images of silence, another religion was being elaborated under the Pallava dynasty, in the Deccan: Hinduism. At Mamallapuram, Elura, Ajanta, and Elephanta, 7th- and 8th-century artists cut from the rock thousands of images depicting the divine Power that moves the world, or illustrating the eloquent sacred poems. Coming into deeper India, Vedantism, once probably an aniconic religion, gave rise to an endlessly proliferating mythology describing a universe of whirling forms in perpetual migration, in a creation ceaselessly renewing itself. Out of the cosmic chaos emerge a few significant images, such as the Dancing Shiva *(fig. 252),* and Vishnu asleep on the Serpent Ananta at Mamallapuram *(fig. 249).*

This creative vein persisted until the 13th century, moving, after the 9th century, into the northwest part of India, where Buddhism had at last been rejected. The gradual weakening of religious feeling made it necessary for the divine manifestations to assert themselves in more exaggerated spasms of activity and in neurotic repetitions. From the realm of Consciousness we have descended into that of mere Existence. The Mogul invasion completed the stereotyping of that powerful art, which survived only in a few bronze statues.

India eventually turned away from the religion of the Buddha, but Buddhism, and with it the art it had created, spread throughout the Asiatic East under various forms: Ceylon, Siam, and Burma adopted the *Hinayana,* or Lesser Vehicle, while Cambodia, Java, China, and Japan took up the sense and imagery of the *Mahayana,* or Greater Vehicle. The art

of the Gupta nourished an international style, and transmitted iconographic themes that were variously interpreted in other centres, just as the Byzantine icon was transformed in the different Western countries. But in China, which communicated with Gandhara and the Punjab through the oases of the Tarim basin, Graeco-Buddhist art retained some of its original strength, reinforced by traditional Iranian influences already marked in archaic China.

The severity of the Hinayana doctrine is reflected in the austere art of Ceylon and Siam, where the Gupta stylizations lost their elevated theological connotations to take on a more formal, and even mannered, character. But in Java, Buddhist art seemed to recover its youthful vigor. Though the seventy Dhyani Buddhas sheltered under the miniature stupas at Borobudur are in the abstract Gupta tradition, the miles of high relief surrounding the terraces of the great monument narrate the endless stories of Buddha and his previous incarnations in a style of restrained naturalism almost classical in effect. The bodies that Gupta stylization had dematerialized were now brought back to life and roundness, though they lack the Indian sensuality. What is expressed in the figures' smiling grace, the suggestion of joy brought by retreat in meditation, the moderated curvilinear movements, the compositions limited to a few personages, the picturesque views of nature and human creations, is the harmony of all things and beings that stems from love.

In its great creative periods, both Buddhist and Hindu, Indian art was entirely dedicated to the figures of sages and gods. In Java, representations of the external world and of human life were introduced as a discreet background to Buddhist legends. Under the Khmers, Cambodian art was invaded by worldly subjects. In the vast galleries of the Angkor Vat temple *(fig. 255)* violence is unleashed in gigantic battles: heroes clash weapons, dash their chariots at each other, and trample the dead piled up on the ground—all this a rather orderly array, the sculptor observing the successive movements of the battalions, their progress, their clash, and finally the onslaught. Further along are evil rampages in Hell, with hideous demons inventing ingenious tortures for the damned, while nearby is the place of celestial sojourn, where

beautiful palaces are inhabited by blissful creatures. In great historical triumphal processions infantrymen and horsemen parade, dominated by their chiefs mounted on elephants. All these animated scenes are staged as episodes from the legends of Shiva or Krishna or from the sagas of the Ramayana or the Mahabharata. But in fact they give us detailed information about life under the Khmers, illustrating the deeds of a warlike people governed by an absolute ruler. Like the Egyptian pharaoh, the Khmer ruler, the Devaraja, was a god-king. He is identified with Vishnu or Shiva, or with the Buddha, for in Cambodia Buddhism and Hinduism intermingled in an extraordinary syncretism that provided artists with a very rich iconography. Through the divine sagas the god-king proclaimed his own glory, as Louis XIV of France used to illustrate his through the myth of Apollo and the story of Alexander. In this art, no longer a theological but a theocratic art, we have moved from a land of the gods—India—to a world where it is the hero who is all-powerful. Like the Indians, the Khmers crowded their walls with figures, but unlike them, created well-ordered and rhythmically controlled compositions. The cosmic swarming beloved of the Indians repelled the Khmers, even when representing the World emerging from Chaos in the Churning of the Sea of Milk. Stylistic as well as historical comparisons with the West may be made; as in Egypt, the discipline that held the empire together also ruled art. Generally, Khmer artists arranged their relief scenes in superposed tiers, like the Egyptians, but, alone in the Indian world, they also made approaches to a Western type of perspective. In the procession scenes the soldiers are silhouetted against a background of forests whose trees appear to move into depth, their size diminishing relative to their distance from the foreground, where the human action takes place. Like Western artists, and unlike the Indians, the Khmers also represented human bodies isolated in space—that is, they made true free-standing statues. Their figures stood vertically, in proud autonomy, not flexed in the contorted attitudes of Indian figures, which were possible only in relief and expressed the powerful pulses that merge the human being into the total life process. The Indians loved

263 *Bodhisattva,* **from Kumtura. Cuina, ca. 7th or 8th century A.D. Musée Guimet, Paris.** The centers of Kucha art, while lined with Indian or Indo-Iranian traditions, gradually departed from them after the Chinese conquest in the 7th century. Contact with models of T'ang art is evident in this Bodhisattva, which comes from the rock sanctuary at Kumtura. Perfect preservation of colour makes the piece precious.

264 *Statuette of a woman.* **Terra cotta. China, Han Dynasty, 202 B.C. to 220 A.D. Museum of Fine Arts, Boston.** An austere, serious expression characterizes this lady; her attitude is of withdrawal, almost of reverence. The figure is a *ming-ch'i,* one of a type of Chinese funerary terra cottas. The living dedicated them to the dead in memory of their past existence, furnishings intended for use in afterlife.

265 *Bodhisattva.* **Stone. China, Wei Dynasty, 5th century A.D. Musée Guimet, Paris.** This figure in very high relief is one of the most important works from the Yünkang caves. In the first half of the 20th century these grottoes were stripped of their reliefs, which were sold in the Occident. The smiling face of this Bodhisattva expresses the infinite mercy of one who, to save others, has consented to delay his moment of entrance into supreme beatitude.

266 *Tiger.* **Bronze. China, Chou Dynasty, 10th century B.C. Freer Gallery of Art, Washington, D.C.** This object is stylistically related to the Middle Chou period, although it dates from an earlier time. The large opening on the back has led some to believe that this was a vase, but it was more probably the foot of a canopic vase or of a throne. The soft, heavy forms, lacking any details of muscular structure, are freighted with hook and spiral decorations (*lei-wen,* thunder motifs).

267 *Funerary relief.* **Stone. China, Han Dynasty, 114 A.D. Rietberg Museum, Zürich (Collection von der Heydt).** This plaque, which was part of the Tai family tomb, belongs to a kind of funerary art particularly fashionable in China during the Han dynasty. As in all reliefs of this type, the subjects are scenes from everyday life, mixed with mythological themes relating particularly to Taoist tradition.

268 *Kneeling worshipper,* **from Kumtura. China, 7th century A.D. Musée Guimet, Paris.** This devout kneeling figure, holding an offering, comes from Kumtura, a religious and artistic center whose activity extended over almost five centuries. The excellent state of preservation of the polychromy makes the work exceptionally important. The simplified structure and rounded features make it a late work.

263

264

265

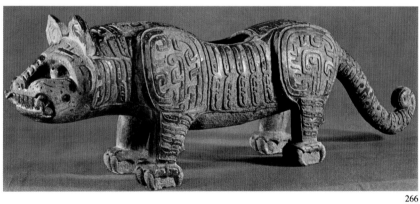

266

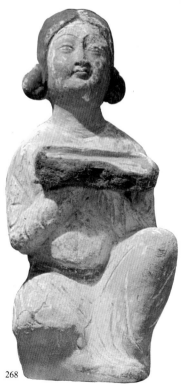

268

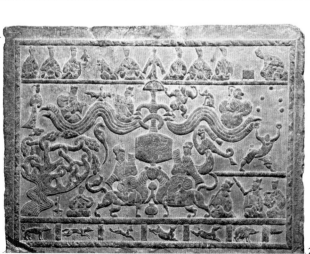

267

269 *Stone relief,* **from Lung-Men, Honan. China, ca. 495 to 550 A.D. Museum of Fine Arts, Boston.** This is the portrait of the prince Siddhartha, seated in an attitude of contemplation. The position was to become characteristic for the iconographical type of the Maitreya Buddha. From the stylistic point of view, the work belongs to the first phase of Chinese Buddhist sculpture. The figure nevertheless expresses an intense spirituality.

270 *Chimera.* **Stone. China, Wei Dynasty, ca. 500 A.D. University Museum, Philadelphia.** The skill that Chinese art had already achieved in its earliest phase in representations of animals is illustrated by this sculpture of a fabulous beast. Like others of this type, the beast was intended originally to guard the *shen-tao* (paths of the spirits)—the paths that led to the tombs. The most frequent representations are of lions guarding princely tombs.

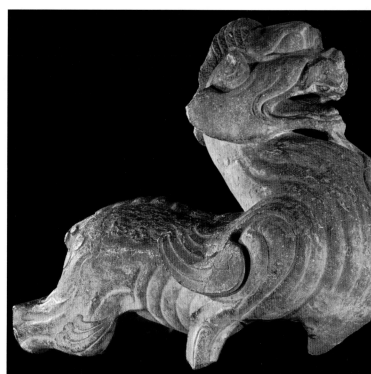

270

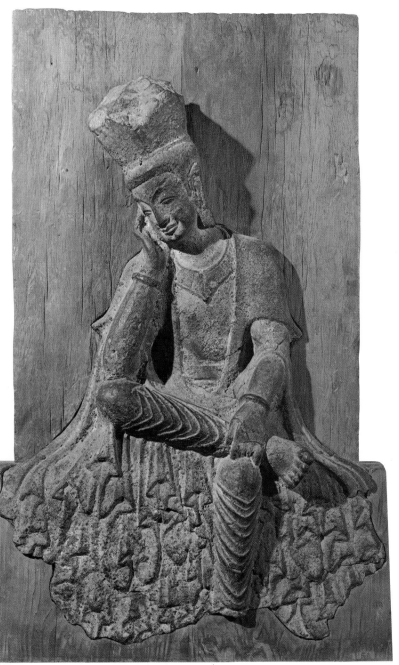

269

271

271 *Flying spirit (apsaras.)* **Stone. China, Wei Dynasty, 385 to 535 A.D. Fogg Museum of Art, Harvard University, Cambridge.** This relief originally decorated Cave 2 at T'ien-lung Shan, the most beautiful Buddhist rock temple in China. It represents an *apsaras* in a flying position, with long tags of drapery stylized like tongues of flame. It was incorporated into the Buddhist pantheon as a *deva,* a spirit still subject to the cycle of rebirth.

272 *Horseman*. Stone. China, T'ang Dynasty, 7th century A.D. University Museum, Philadelphia. The minute rendering of details on this realistic relief is reminiscent of Parthian and Sassanid art. The relief was part of the group, the "Six Horsemen" of Emperor T'ai-tsong (who died in 640), which decorated a building near his tomb. According to an ancient tradition, the relief was executed after a drawing by the scholar and court painter Yen Li-pên (about 600-673).

272

273

274

273 *Base for a statue*. Grey limestone. China, Wei Dynasty, 385 to 535 A.D. University Museum, Philadelphia. This relief represents a genie emerging from a lotus flower and holding with both hands a large perfume-burner on his head. At either side crouch lions with thick manes, in almost heraldic positions. Above them are phoenixes. Floral motifs fill the empty spaces of the composition. This relief is characterized by its essentially graphic style.

274 *Torso of a Bodhisattva*. Stone. China, T'ang Dynasty, 618 to 907 A.D. Collection A. Patino, Paris. This statue comes from the temple at T'ien-lung Shan, the type-site for T'ang stone sculpture. The bending body, the elegantly proportioned limbs, the manner in which the drapery is arranged and the rich bracelets endow this figure with the realism and worldly ease typical of Chinese Buddhist iconography during the T'ang era, influenced by Indian art and the late Gupta style.

the soft texture of ripe flesh, but neglected anatomy; the Khmers modelled their bodies firmly, and polished the forms to suggest a dense muscularity. As was suitable for a race of warriors, their preferred physical type was somatotonic, robust and physical, rather than viscerotonic, and it was the male body that provided their canon of proportions and imposed its athletic forms on the female body. As a natural corollary, the Khmers were the only Far Eastern people to conceive architectonic orders and patterns for their monuments, and to employ articulating cornices. It is a matter for reflection that so small a kingdom, however aggressive, should have created an individual art closer in formal values to Western art than to the Indian art that inspired it.

At Bamiyan in Afghanistan and at Tun-Huang in Kansu, over a thousand miles away from each other, two colossal rock-cut Buddhas keep watch over the opposite ends of the arduous silk route, which traverses the oases of central Asia to link China with India and Iran. Along that road Buddhism filtered into China. At the halting places for the caravans, numerous monasteries were established, thriving on the gifts of merchants who wanted to elicit from the divine powers protection against brigands. As earlier in India, Buddhist sanctuaries were excavated in the earth's heart; the progress of Buddhism in China is marked by a string of grottoes dedicated to the "thousand Buddhas"—sites like Tun-Huang, Yün-kang, Lung-Men, T'ien-lung Shan, and others newly discovered, like Mai-Chi-Shan.

Explored during the first third of this century by various German, French, English, and Japanese expeditions, the oases of Turkestan yielded rich archeological finds indicating a prolonged occupation from about the 3rd century, extending to the 9th century in western sites, and to the 11th in eastern sites. These were vital discoveries for the history of painting in the Far East, but the rock-sculptures are of mediocre quality. The finest specimens of sculpture are fragile models in unbaked polychromed clay, a popular art derived from the more sophisticated stuccos of Gandhara. The charmingly naïve figurines (*fig. 268*) represent a sampling of the various types produced by the mixture of races in this

region situated at the crossroads between Iran, the Russian steppes, and China.

Monumental sculpture was introduced into China by Buddhism. Archaic China hardly knew the art of relief forms, though some of the Chou bronzes in animal shapes (*fig. 266*) suggest some capacity for sculpture. Under the Han dynasty the human victims of burial sacrifices, the last of which occurred at the funeral of the Emperor Che-Huang-ti, were replaced by a whole range of terra-cotta objects and figures destined to furnish the tomb. In China as in the Middle East, art helped man to free himself from the cruel rites made necessary by the belief in an afterlife duplicating life on earth. From the Chou period we know only ritual vessels bristling with symbols, but the Han tombs have yielded a crowd of figurines evoking for us the busy life of the Chinese in the Great Empire. Unlike those of the later T'ang period, the Han tomb models are not overloaded with naturalistic details; a gesture, an attitude, or a movement is summed up in a single shape or silhouette (*fig. 264*). Artisan production of such high quality must be considered a reflection of a refined

275 *Female figurine*. **Terra cotta. T'ang Dynasty, 618 to 907 A.D. Musée Cernuschi, Paris.** It is difficult to date works created in the three centuries of the T'ang Dynasty. In this statuette there is still a dynamic stylization, a quality of synthesis tending towards the simplification of forms, and an élan characteristic of work of the Han period. It is an exquisite image of femininity.

276 *Equestrian statuette*. **Glazed terra cotta. T'ang Dynasty, 618 to 907 A.D. Alberto Giuganino Collection, Rome.** This rider's costume seems to be of Persian style; it is, in fact, not unusual to find T'ang statuettes showing influences from Central Asia and Iran, or inspired by Western Asiatic iconography. Iranian models can sometimes be seen in the figures, but the influence of Central Asia is clearest in the animals.

277 *Bodhisattva*. **Wood, polychromed. China, Sung Dynasty, 960 to 1279 A.D. Museum van Aziatische Kunst, Amsterdam.** This statue represents the Bodhisattva Avalokitesvara seated in the position called the *maharajlila* ("the repose of the great king"), his right arm hanging relaxed on the raised right knee. It is an iconographical type characteristic of Chinese Buddhist art of the Sung era.

278 *Guardian figure*. **Stone. China, T'ang Dynasty, 618 to 907 A.D. University Museum, Philadelphia.** This figure comes from a group of statues of *lokapalas,* portraying the guardians of the four points of the compass. They were appointed to defend the world from attack by evil spirits. The inspiring force behind them created an iconographical type peculiar to Buddhist art.

275

278

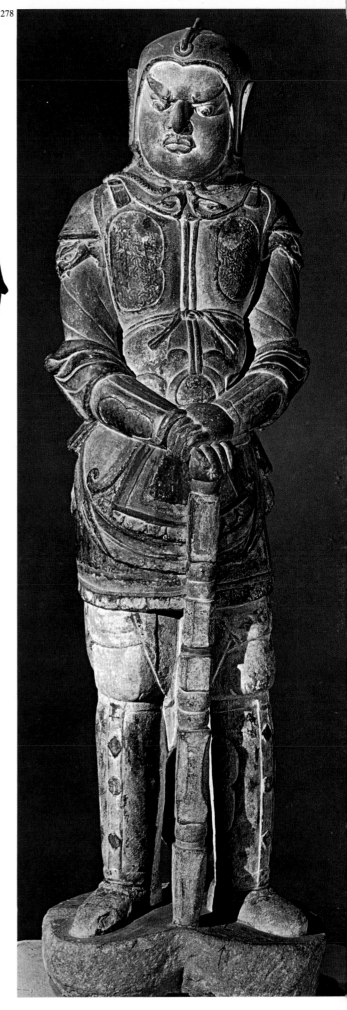

276

277

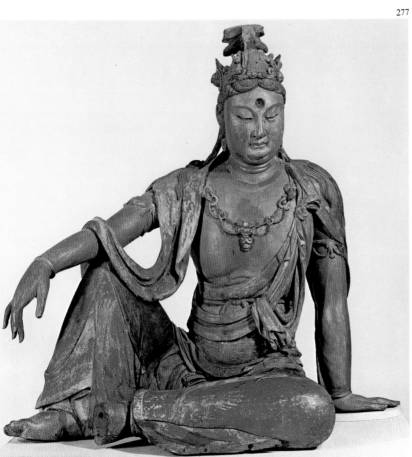

279

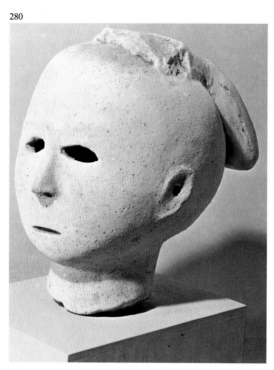

280

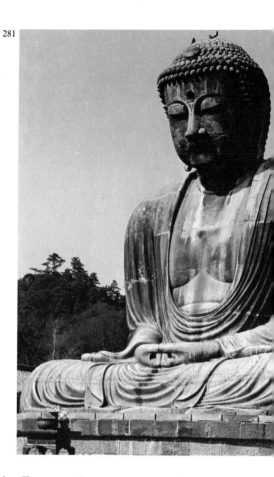

281

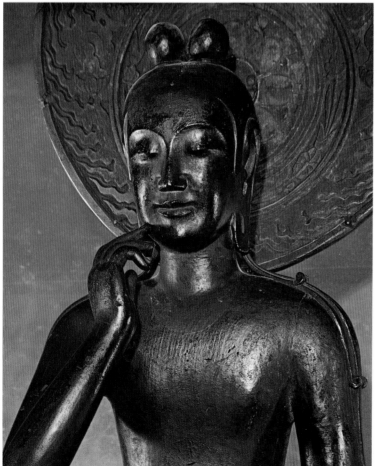

282

279 *Female figurine.* Terra cotta. Japan, Jomon period, 1st millennium B.C. Takeo Nakazawa Collection, Tokyo. This figurine is one of the many terra-cotta idols from the late Neolithic culture of the Japanese archipelago. The treatment is schematic. The facial features have been stylized and rendered by small terra-cotta pellets. Like all terra-cotta statuettes of the Jomon group, it is a symbolical portrait of a mother-goddess, and part of a cult of abundance and fertility.

280 *Head,* from a haniwa. Japan, Kofun period, 4th to 6th century A.D. National Museum, Tokyo. This specimen of human head,' from a *haniwa,* is a typical product of Japanese art in the Kofun era, that is, the "ancient tombs" era.

281 *Great Amida Buddha.* Kotoku, Kamakura. Bronze. Japan, Kamakura period, ca. 1250 A.D. According to tradition, this 37-foot figure was cast by Ono Goroyemon or by Tanji Hisatomo. From the stylistic point of view, it reveals the influence of the sculptors Kokei and Unkei, who worked in the later 12th and early 13th centuries.

282 *Kwannon.* Lacquered wood, Japan, Asuka period, 7th century A.D. Chuguji Convent, Nara. This statue, carved in camphor wood and blackened by smoke from cult ceremonies, dates from the first phase of Japanese Buddhist art. It represents the Bodhisattva of Mercy, Avalokitesvara. According to legend, the work was executed by the famous Shotoku Taishi (572–621). Some authorities identify this figure as the Maitreya Buddha.

civilization, as was Greek pottery. Some of the horses' heads are as fine as those carved in marble by classical Greek artists—perhaps the resemblance is due to the fact that the Han emperors brought their horses from western Asia, from Samarkand. The quality of Han figurines might suggest the existence of a monumental sculpture, but the few statues that survive, which originally surrounded princely tombs, are inorganic masses of stone. On the other hand, the reliefs from the tombs, which we know mainly from rubbings, are delightful (*fig. 267*). Wandering through elegant palaces or in pleasant landscapes, the animated personages appear to comport themselves according to the laws of perspective; the line is nervous and full of life, particularly in the figures of horses, warriors, jugglers, and hunters. However, these "reliefs" are hardly more than smooth, flat silhouettes, slightly raised against a gritty background, and they are really a kind of negation of sculptural qualities. This should not be surprising, for they are a transposition into the permanence of stone of now-lost painted scenes; the art of painting was born during the Han period and was destined to be China's major art form. These funerary scenes filled with picturesque details hint at a naturalistic phase in Chinese painting preceding the philosophical painting that developed later.

With the decline of the Han Empire the spread of Buddhism in China accelerated. Buddhist monasteries became the only institutions capable of maintaining some sort of order amidst the general disorder, just as, in the West, the monks of St. Benedict and St. Columbanus sustained islands of civilization in the barbarian flood that submerged the Roman Empire. When Turkish invaders from eastern Mongolia managed to establish a stable regime, called the Wei dynasty, in the north of China, they relied on Buddhism, which they made their state religion. Around the middle of the 5th century they employed thousands of sculptors to excavate rock-cut sanctuaries at Yün-kang, near their capital Ta-t'ung. When in 499 they transferred their capital to Lo-yang in the Honan, they again needed temples at the gates, and had them cut in the rock at Lung-Men. After the collapse of the Wei Empire at the end of the 6th century, political unity was again achieved temporarily by the Sui, who created a new group

of rock temples at T'ien-lung Shan. In these three groups of sanctuaries work continued throughout the following periods, and here we can trace the progress of Chinese Buddhist sculpture. At Yün-kang the Buddhas and Bodhisattvas still have the fleshy look and the rounded modelling of Indian reliefs and Graeco-Indian sculpture, whose traditions they incorporate (*fig. 265*). Lung-Men, before the art trade pulled it to pieces forty years ago, was one of the greatest of the world's sanctuaries (*fig. 269*). (Now, in private or public collections everywhere, the visitor may suddenly find himself facing a mutilated Bodhisattva from Lung-Men; though torn from its sacred context, the smile of the Merciful One still exerts its mysterious charm, and the figure takes on an even more unreal significance.) At Lung-Men the bodies have become thinner and the proportions more elongated; the frontal poses give the figures a hieratic aspect contrasting with the meditative faces radiant with the sense of mercy; the stylized draperies contribute to the disembodiment of these holy images. Hastily carved in grey-black rock, the Lung-Men sculptures are summary, even clumsy, but Wei bronzes still maintained the traditional Chinese artisan techniques from remote epochs. If the Indian art of the Gupta gave the most profound interpretation of Buddhist theological inspiration, the divine message of salvation offered by the Mahayana received its most intense artistic expression in Wei China. The Chinese aptitude for mystic evocations was strengthened by a natural disinclination for relief form, and by an inclination towards metaphysical speculation, which found its natural outlet in the art of painting. The Chinese conception of the cardinal points as ordered in groups of four around a fifth at the center displays a feeling for a radiating space incompatible with sculpture, which is by nature a solid form bound within three dimensions. The progressive resorption of relief can be traced at T'ien-lung Shan, where the style gradually became more and more linear. In the same way modelling became flatter in Quattrocento art, especially among the Sienese, who had certain spiritual affinities with China, as Berenson noted when he discovered Sassetta. Some of the T'ien-lung Shan apsaras are reminiscent of Duccio angels.

In the T'ien-lung Shan caves, the Buddhist figures of the T'ang period (fig. 274) contrast with the earlier ones in that they demonstrate a revival of the feeling for solid form. In that warlike dynasty, which achieved and maintained the unity of China for three centuries, Buddhism was still favored, but the T'ang artists were no longer moved by a spiritual fervor; their plump figures with apathetic expressions and inflated cheeks are no longer illumined by the flame of saintliness. The T'ang emperors turned their interest to profane subjects. Ceramic techniques were perfected, and painting gave rise to subtle intellectual speculation. Terra-cotta funerary pottery, often glazed, was plentiful—which shows to what extent Buddhism had become "paganized," for these pottery tomb figures were intended to provide for the dead in the afterlife, whereas the religion envisioned the complete abolition of all life for the Blessed. The T'ang figurines, inspired by the daily life of the time, have had such appeal for Western collectors that the manufacture of fakes has flourished; but their self-conscious realism makes them in reality less attractive, less "true" than those of the Han period. The T'ang terra cottas (fig. 276) are difficult to study, as we lack precise chronological landmarks among the throngs of figures, but stylistic analysis seems to suggest an evolution of the elegant Sui style towards heavier and more naturalistic forms. The massive horses surrounding the tomb of the Emperor T'ai Tsung have been thought to be later copies—the tombs of the T'ang rulers, destroyed by rebels early in the 10th century, were restored by the first Sung emperor—but their weighty compactness seems very characteristic of T'ang materialism. In quality, none of the T'ang sculptures even remotely approaches the rare paintings preserved from that period.

Sculpture affirms a physical presence, and is therefore at odds with the sense of transitoriness that permeates Chinese thought. It was only for a brief period, under the first impact of Buddhist mysticism, that China was successful in creating a sculpture based in the idea of solid form.

Arrested in its westward progress by the frontiers of pagan or Christian civilizations, Buddhism expanded towards the east, and in the 6th century reached that Land's End of the Far East, Japan. After some struggle, the new faith was accepted as the state religion, and gradually won the whole country. Buddhism settled there, undergoing an evolution, but not being subjected to the persecutions and upheavals that afflicted its course in China. For that reason Korean, Chinese, and Japanese cult objects from the T'ang period have been preserved on the islands of Japan, while none are left in China, where we have to rely entirely on rock-cut sculptures and tomb contents.

Transmitted by Korea, then by China, the Buddhist themes adopted by Japan were illustrated with great refinement. From the beginning, Japanese sculptors handled hard lacquer, wood, and bronze with virtuosity. In Wei China, Buddhist art had throbbed with inner life; in Japan, it became intellectualized and assumed an iconological and theological character wherein it resembles Gupta art, but the Gupta stylization is absent, for already the Japanese tended towards the realism that was to reflect their indigenous artistic spirit. They painted portraits and were inspired by warlike themes. These last had already appeared in the proto-historic period in some of the Jomon figurines (fig. 279), with strongly magical overtones, and one personage of the Buddhist mythology served the taste for bellicosity: the "guardian of the faith," the lokapala, who defends the temple against the machinations of earth and hell. Represented as a samurai who blasts the evil-doer with his sword and terrorizes him with fierce grimaces, this St. Michael of Japanese Buddhism seems more akin to the demonic than to the angelic. The concentrated power of certain T'ang lokapalas (fig. 232), however, is more impressive than the display of force in the Japanese versions, where strength is dispersed in action. The Chinese artists always seem to keep some power in reserve, which gives their work a margin of mystery.

However perfect in technique, 7th- and 8th-century Japanese sculpture never reaches the heights of religious expression attained in the frescos of Horyu-ji—now only a memory because they were destroyed by fire in 1949. There the purity of line assumes a transcendental significance, and there, at the end of its tremendous expansion in the Far East, the Buddhist ideal of supreme detachment is fully expressed.

283 *The guardian spirit Shitsukongoshin,* **from the Sangatsudo (Hokkedo) of the Todai-ji, Nara. Painted clay. Japan, Nara period, mid-8th century A.D.** A *Sukongoshin,* a Buddhist guardian spirit, is here portrayed as a terrifying creature. Because it inspired such fear, it acquired the reputation of possessing miraculous powers. Because of the atmosphere of magic that still surrounds it today, it is cited as one of the "secret statues." It is kept in a closed shrine that is opened only on rare occasions, during solemn ceremonies.

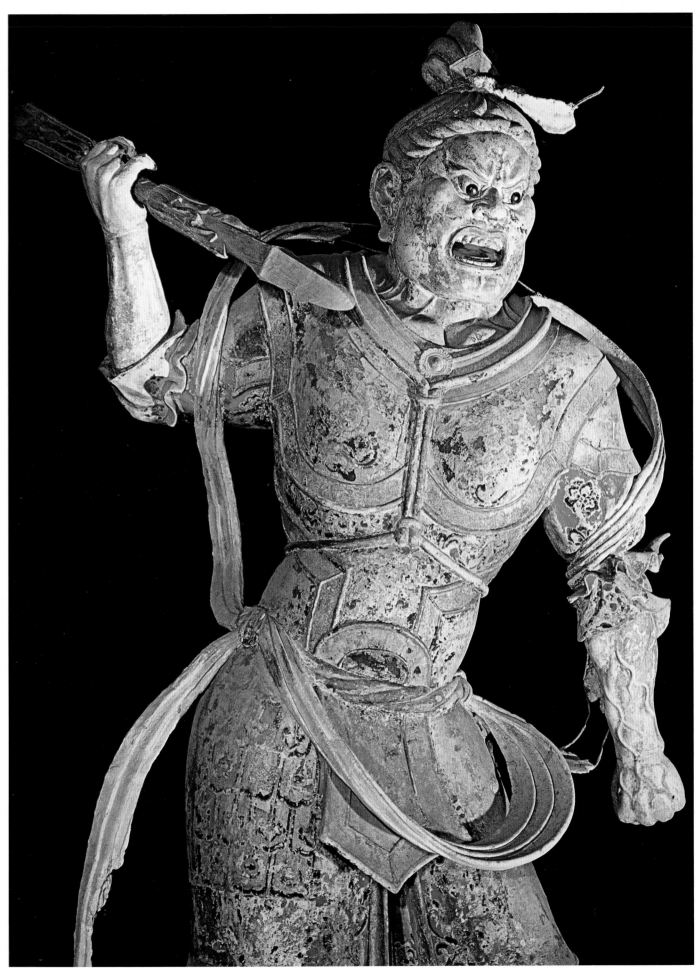

VII

THE REBIRTH OF SCULPTURE IN THE WEST

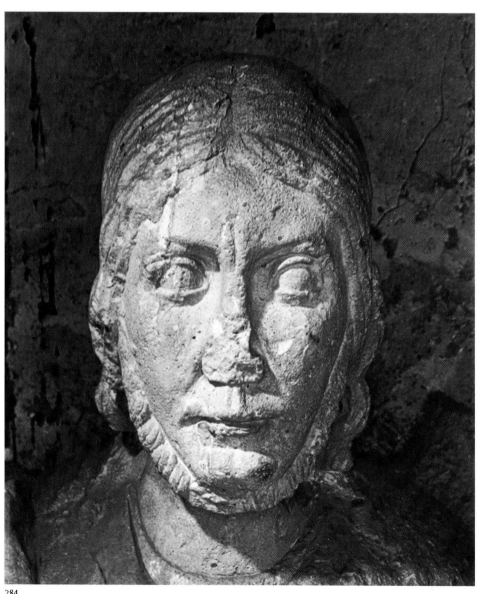

284

1. *Romanesque Sculpture*

Two almost exactly contemporary art works from opposite ends of Europe, the gold antependium (ca. 1020) from Basle on the Rhine *(fig. 204)*, and the lintel on the church of St.-Genis des Fontaines (1022) at the foot of the Pyrennees *(figs. 285, 286)*, give the measure of the great cultural gap separating the last works of Ottonian art from the first of Romanesque. The calm figures on the Basle antependium, still responding to antique "illusionistic" aesthetics and standing comfortably in the spaces allotted to them, are in considerable contrast to the figures subjected to a purely ornamental treatment at St.-Genis des Fontaines. Here, the personages on the central field of the lintel are linked in complex compositional interrelationships, while the apostles at either side are tightly fitted into the arcades, which in fact impose their form on the human figures. The lintel is among the first works in which the sculptured forms are clearly adjusted to an architectural framework. In its flattened relief forms the lintel may still partake of the spirit of the early Middle Ages, but its compositional precocity points forward to the coming art.

The St.-Genis lintel remains an isolated work, however, for the experimental phase of the Romanesque, lasting from about 1020 to 1070, revolved largely around an architectural element that until then had elicited rather uninteresting treatment: the capital. Early medieval artists had attempted to rescue its monumental function through a revival of the antique types, or had simply reduced it to an elementary cubic shape; but now the capital became the first architectural form to be "sensitized" to stylistic novelty. The very recalcitrance of its shape proved a stimulating challenge to artists. No compulsory iconographic program restricted the sculptors of the 11th-century capitals at Tournus *(fig. 287)*, St.-Benigne in Dijon, the Trinité in Caen, St.-Benoit-sur-Loire, Bernay Chatel-Sensoir, St.-Hilaire in Poitiers, or other churches in Spain and Germany, and the artists indulged freely in juggling imaginative and imaginary elements. They combined forms from middle eastern civilizations, from classical antiquity—such as it was known to the barbarian world—and even from the depths of Asia. The wellspring of French Romanesque sculpture is this play with forms multiplied and metamorphosed in which the sculptor indulges a sense of competing with the demiurge in his creation of "monsters" (analyzed and discussed by Henri Focillon and Jurgis Baltrušaitis). In the first overpowering impulse to create new forms and images, after a long period of stagnation, the sculptors began by establishing between themselves and the outside world the protective screen of a fictional universe populated with imaginary beings, which took on reality as they were embodied in three-dimensional form. The concreteness of the sculptured volumes in turn sustained the artist's creative power—indeed, painting and the minor arts, and even the wooden statues that imitated goldsmith work, remained within the scope of the earlier aesthetic, which they prolonged until the height of the Gothic period. The bronze workers of the Meuse region perpetuated the classicizing Ottonian manner up to the 12th century, and the baptismal font of St.-Barthélémy in Liège, cast by Rainier de Huy between 1107 and 1118, nearly a century after the lintel of St.-Genis des Fontaines, reflects a serenity totally dissimilar to the seething Romanesque dynamism then prevailing in the rest of the land which had been Gaul.

The first artist to employ a frank and vigorous relief, though softened by shadows from undercutting, was Bernard Gilduin, who signed the St.-Sernin altar in Toulouse, which was consecrated in 1096, and who was also responsible for the remarkable figures of apostles and angels accompanying the Christ in Majesty surrounded by the symbols of the Evangelists, in the ambulatory of the same church. Details in Gilduin's work show the influence of goldsmithery: the decorative rosettes on the blind arcades and the modelling of drapery folds, imitating *repoussé* metalwork. In the first Romanesque works, the volumes seem so pronounced and so solid that one would expect that the relief figures would soon take on a separate existence in space, as statues; the development was, in fact, the contrary. On the slightly later Miègeville portal of St.-Sernin, each figure, without entirely renouncing its individuality, is

284 *Head of St. Metronus.* **Abbey Church, Gernrode. German, 10th or 11th century A.D.** This is one of the most extraordinary heads in northern Romanesque art. With great economy of means the sculptor has created a face of astonishing realism; the expression is powerful and the chin and forehead suggest will and determination. A sense of deep, all-encompassing faith radiates from this head, which is already imbued with German expressionism. The dating of the head has been much discussed.

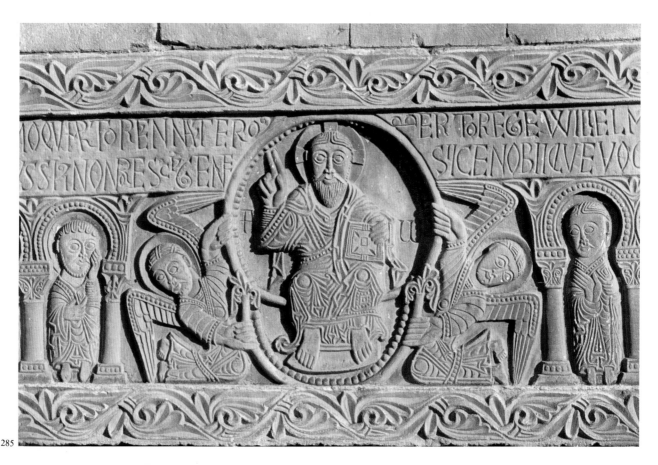

285

286

287

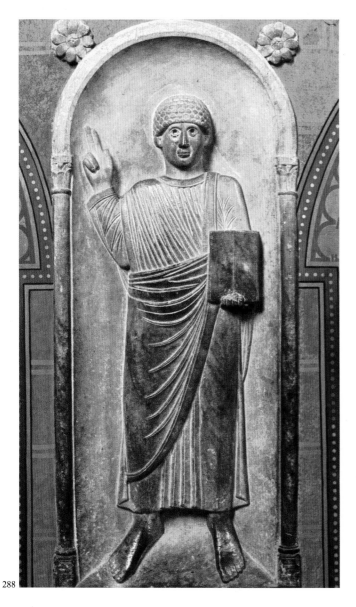

288

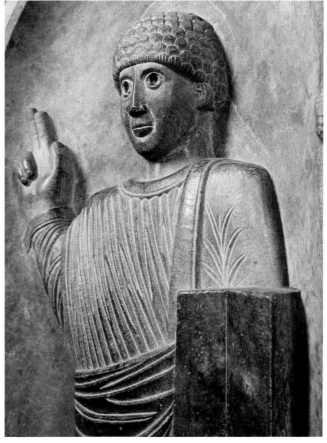

289

285 *Christ, Angels, and Apostles,* **detail of fig. 286.** This is one of the oldest sculptural examples of the theme of Christ in Majesty. The image of Christ teaching, seated on a throne in the center of a mandorla, was developed by miniaturists interpreting a text of Saint Matthew. The two angels holding the mandorla are reminiscent of winged spirits on ancient sarcophagi. Their spread wings and twisting bodies entirely fill the space allotted to them; Romanesque sculptors could not tolerate empty space.

286 *Lintel,* **Saint-Genis des Fontaines (Pyrénées-Orientales). French, 1019 to 1020 A.D.** The first hesitant step in Romanesque sculpture is movingly attested in this lintel, dated exactly by an inscription placing it in the "twenty-fourth year of King Robert." From this point on, the primacy of the architectural frame is established. This flat relief technique is closer to engraving than to sculpture.

287 *Capital,* **Saint-Philibert, Tournus (Saône-et-Loire). French, late 10th century A.D.** This sculptured double capital shows a technique that is crude, an art unpolished; but this first appearance of the human figure is striking; it is probably the first portrait in French art.

288 *Apostle,* **Saint-Sernin, Toulouse. Marble. French, late 11th century A.D.** The Languedoc school witnessed an early revival of monumental sculpture. This Apostle, attributed to the sculptor Bernard Gilduin, can be dated from the very end of the 11th century. The classical type is worked like a Byzantine ivory. The figure conforms entirely to the limited space defined by the frame.

289 *Apostle,* **detail of fig. 288.** Although it is in relief, this figure is without a true third dimension, which could have been obtained only by presenting a succession of planes modulating the forms in space, or by a greater naturalism. Psychological analysis and naturalism are sacrificed in favor of monumentality—an approach to the human figure indicating a primitive or archaic phase in art.

linked to the others in an overall compositional scheme. This first attempt to impose unity on a monumental group of sculptures was characteristic of the Languedoc school. Contemporary Spanish artists were content with juxtaposing disconnected relief panels, but at Moissac, where the volume of relief is even further reduced to become a kind of swelling of the wall surface, the undulating linear forms constitute an intensely vital ideological as well as architectural focal point on the building, for the figures are disciplined by a deeply significant unifying iconographic scheme *(fig. 290).*

Forty years after the starting point of the revival of sculpture, we find ourselves proceeding in a direction opposite to the original one. The Isaiah at Souillac is already hardly more than a wavering flame compared to the older figures in the cloister, immobilized against the wall that holds them stone-

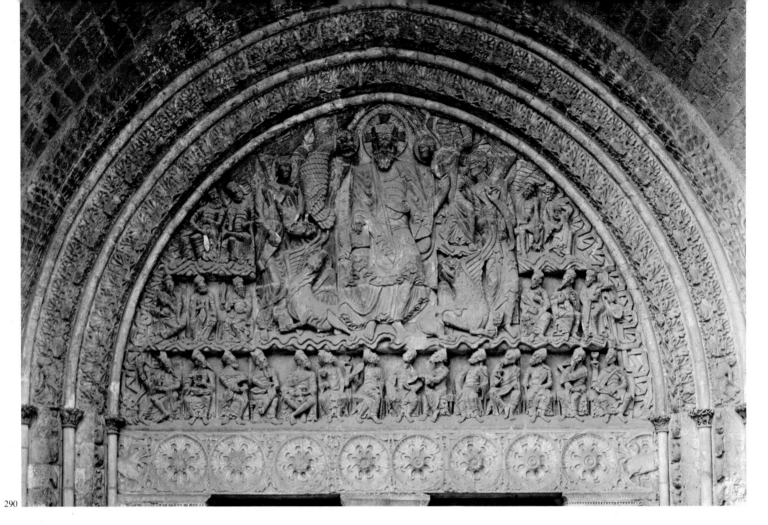

290

291

292

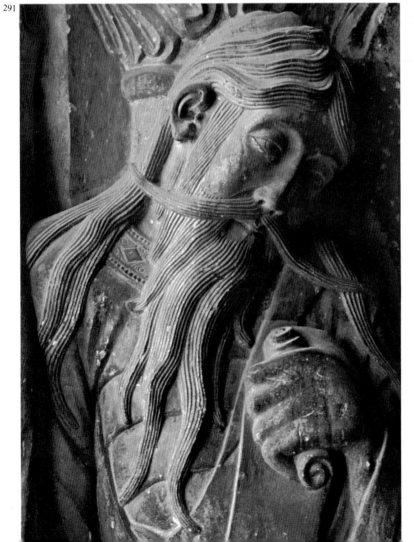

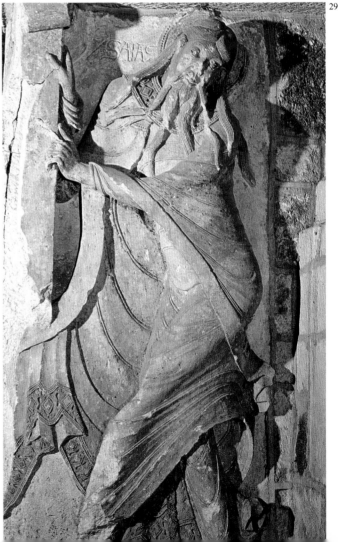

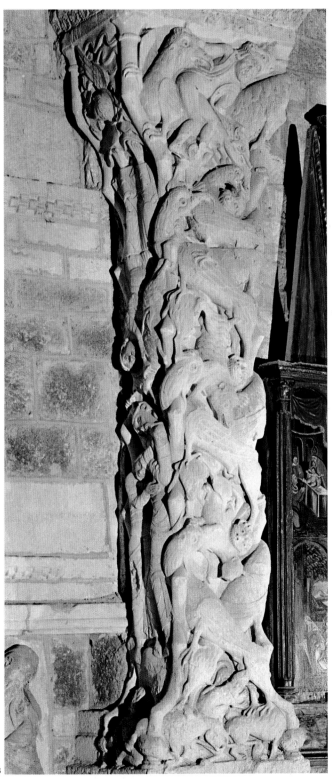

293

290 *The Second Coming of Christ,* **tympanum of the south porch, Saint-Pierre, Moissac. French, 1110 to 1120 A.D.** One of the most famous tympana in Romanesque art, this was executed for the west porch and soon after moved to the south porch. The fierce and majestic Christ is surrounded by the symbols of the four Evangelists. In its monumental size and in such details of execution as the flat, curving drapery folds, the composition is characteristic of the art of Languedoc.

291 *Head of the Prophet Jeremiah,* **Saint-Pierre, Moissac. French, early 12th century.** The Prophet Jeremiah is represented in a dance-like posture on the trumeau of the south portal of Moissac. This figure, with its fine head, is testimony to the stylistic evolution of Languedoc sculpture. In less than half a century the works of this school developed from the squat, heavy, inexpressive figures at Saint Sernin to the vital, elongated form of Jeremiah, whose expressive head suggests contemplation.

292 *Isaiah,* **church of Souillac (Lot). French, ca. 1130 to 1140 A.D.** While the figure of Isaiah prophesying the advent of the Virgin is still gripped to the plane of the block, its fragile, attenuated forms nevertheless express a characteristically Romanesque febrility. In the fleeting, ruffling draperies the Romanesque artist gives free rein to an extraordinary play of linear patterns and exuberant decorative and rhythmic details. The sculpture at Souillac issues logically from that at Moissac.

293 *Trumeau* **of the old portal, church of Souillac (Lot). French, 1130 to 1140 A.D.** The depiction of fantastic beasts can be traced to a very early Eastern origin. Animal imagery in Romanesque churches is found mostly on the piers, columns and capitals. The artist of this trumeau dizzily piled up his creatures to cover the whole surface, obedient to the demands of both symmetry and *horror vacui;* intoxicated with forms and volumes, the sculptor bends and twists his feline creatures' bodies as he will.

bound. In the figure of Isaiah *(fig. 292),* the animated rhythm becomes frenzy, and on the trumeau from the dismantled portal of Souillac monsters swarm like knots of vipers *(fig. 293).* At St.-Etienne in Toulouse, the apostles on the jambs simulate with their crossed legs a feverish gait matched in the rhetorical quality of their gestures and expressions.

The beginnings of the Burgundian school have been all but lost in the almost total destruction of the great abbey of Cluny, the work of St. Hugh. The apse capitals *(fig. 296),* miraculously preserved, have given rise to a lively polemic. Are they earlier than the Toulouse reliefs, as Kingsley Porter thought, or do these refined works date from a later period, as the French school believes? Some light is shed on the earliest Burgundian Romanesque sculpture by the few remnants of the west portal of Cluny identified or excavated by Sumner Crosby. One of these, a head with empty pupils that originally contained lead inlay, is smoothly shaped and somewhat archaic, despite the quivering life of the mouth *(fig. 295);* it tells us nothing, however, about the composition of the tympanum from which it came, carved about 1100. To judge from the portals of Autun and Vézelay, the Burgun-

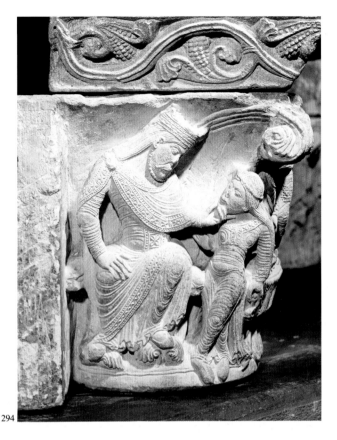

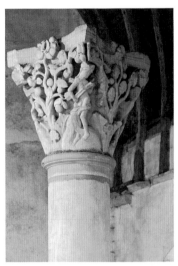

294

295

296

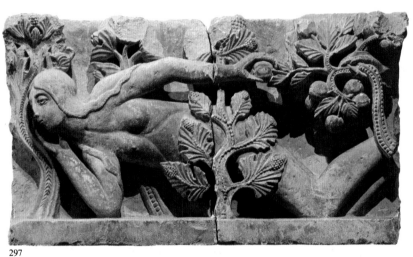

297

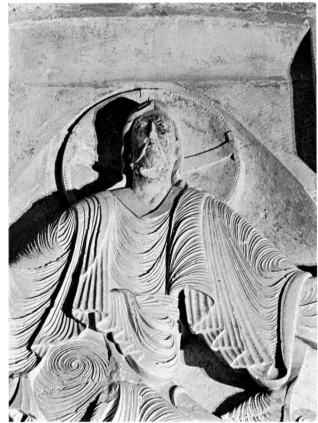

298

294 *Herod and Salome,* **capital from the Cloister of Saint-Etienne, Toulouse. French, ca. 1120 A.D. Musée des Augustins, Toulouse.** St. John the Baptist's fate is narrated on this capital. The style is supple and nervous, the many tight folds outlining the bodies; Salome seems to sway, and Herod resembles a *raffiné* prince. In respect to gesture and feeling, the scene's realism is striking and accentuated by the very minute treatment accorded to the details.

295 *Head of the Virgin,* **from the portal of the Abbey of Saint-Pierre, Cluny. French, before 1115 A.D. Musée du Farinier, Cluny.** The very moving remains from the portal of Cluny are filled with a sense of elevated spirituality. The small head of a young and beautiful Virgin, from the lintel, is one of the most refined in Romanesque art. Confidently carved, it unites mystical purity with monumental grandeur.

296 *The Four Rivers of Paradise,* **capital from the Abbey of Saint-Pierre, Cluny. Musée du Farinier, Cluny.** This capital is a beautiful piece, with sinuous, boldly formed foliage swollen with sap, and an allegorical male nude representing a river at each corner. On each face of the capital the composition is finely balanced, and the decorative elements are raised in true relief modelling.

297 *Eve with the Forbidden Fruit,* **Saint-Lazare, Autun. French, 1120 to 1135 A.D. Musée Rolin, Autun.** The Eve of Autun originally formed the right half of the lintel of the north portal of Saint-Lazare. The sculptor, possibly Gislebertus, was in no way hampered by the lintel form, which obliged him to arrange his figure horizontally; on the contrary, he has exploited it in creating an Eve of femininity and subtlety. The artist shows a knowledge of anatomy, complete technical mastery and a remarkable feeling for linear elegance.

298 *Christ,* **from the** *Ascension and Mission of the Apostles,* **tympanum in narthex, La Madeleine, Vézelay. French, ca. 1125 to 1130 A.D.** The portal leading from the narthex into the nave was executed by the "Master of the Tympanum" and his school. In type the head is still Romanesque, but it is already animated by an inner spirituality, bringing the Son of God, preoccupied with his evangelical mission, closer to mankind. This Christ is of a type halfway between the avenger-prince and the man-god.

299 *Capital,* **from a church in Arles. French, late 12th century. Museum, Arles.** The theme of this late 12th-century capital has its origin in a distant eastern prototype. But the modelling, with its assertive relief and its plasticity, belongs to Roman sculpture. The two monsters, male and female, are in no way frightening or enigmatic; their supple, free bodies and amiable faces are a far cry from the traditional representation of beasts. The composition is perfectly balanced but its arrangement has more in common with that of a frieze or a bas-relief than with the more compact, blocklike decoration appropriate to a corbel or a capital.

300 *Juggler,* **from Saint-Pierre-le Puellier, Bourges. French, late 12th or early 13 century A.D. Musée de Lyon.** This fragment is characteristic of Romanesque art towards the end of the 12th and the beginning of the 13th century. Whirling, dynamic forms, linear arabesques, and the fantasy natural to Romanesque invention here combine with a 13th-century sense of realistic observation, creating a work where accurate analysis of movement fuses with Romanesque fervor.

299

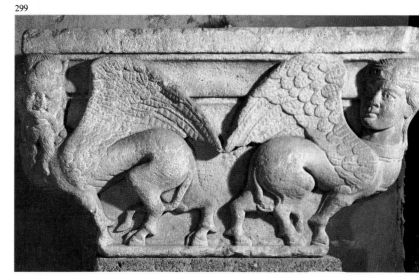

dians were not so expert in the art of composition as the Languedoc masters. Less attracted to formal experimentations, they slid easily into a vein of expressionism; it could be demoniac, as portrayed on the Vézelay capitals, or humorous, as in the work of Gislebertus at Autun. The sculptors of Aunis, Poitou and Saintonge, however, introduced a rhythmic grouping in the swarming forms in which they sheathed their façades, and to them is due the invention of a particularly successful form, later adopted by Gothic art: the figured voussoir.

In the Romanesque period, endless variety went into the melting pot: subtle creations like the *Juggler* from St.-Pierre-le-Pucellier, Bourges *(fig. 300),* are contemporary with coarse, popular reliefs like the Cluny *Cobbler* or such formalistic academic works as the head of Lothar in Reims, from that king's cenotaph at St.-Remi.

In Provence (St.-Trophime at Arles), in the Rhone valley area of Languedoc (St.-Gilles du Gard), may be found a quite different approach to monumental sculpture. Relief is replaced by statues, or almost-statues, standing against an architecture of forms borrowed from the remnants of antique art still found in those regions. It was a different world, turned towards the Mediterranean and linked to the Italian

300

301 *Last Judgment,* **tympanum of the west portal of Saint-Foy, Conques (Aveyron). French, 1125 to 1150 A.D.** This tympanum is the most important ensemble of sculpture in Auvergne. While the arrangement and the division of the scenes into registers reveal the perfect sense of compositional balance inherited from the Languedoc conception of the scene, the style comes closer to popular art.

302 *Façade* **of Notre-Dame la Grande, Poitiers. French, 1100 to 1150 A.D.** The two extremes between which Romanesque art fluctuates—"Asianism" and "Atticism," the East and Rome—are reconciled in this façade. Onto the predominantly Roman structure, based on the triumphal-arch type of façade, is grafted a sculptural ornament in which Eastern and barbarian elements are prominent.

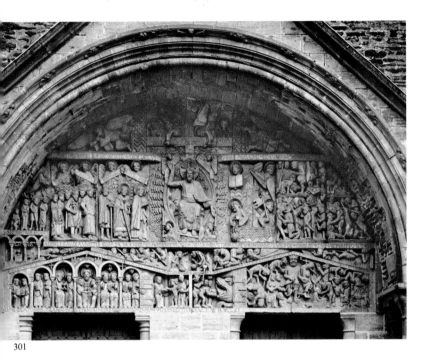

301

school. In Auvergne too the tympanum, Conques-en-Rouergue *(fig. 301),* was composed of statuary masses balanced like weights in the two pans of a scale—a principle of monumental composition that was to become characteristic for Gothic tympana.

The Romanesque school of northern Italy, once considered a minor one, has recently been studied in many publications. These somewhat invalidate Kingsley Porter's thesis, which tended to minimize the influence of French Romanesque sculpture in Italy. The Emilian workshops, however, were apparently nourished by the main currents of Romanesque France, springing from the schools of Languedoc and Burgundy, and from Chartres—particularly the last, which seems to have had close links with Emilia. However, Italy imposed its native genius on the imported forms, so much so that their origins are sometimes unrecognizable, the adopted motifs being clothed in an utterly alien style. Emilia, where the liveliest branch of Romanesque art developed, persistently elaborated and pursued certain forms basic to Italian sculpture up to the time of Donatello, forms utterly divergent from the French.

Roughly speaking, two main currents prevailed in northern Italy. The first is the Lombard, which tended to develop barbarian elements, its artists showing little interest in human figures but indulging instead in endless repetitions, in frieze-like arrangements, of the old migration period zoomorphic or ornamental motifs. San Michele in Pavia shows the final stage in that tendency, the columns and the arches around the portals covered with these designs as if by tattoo or embroidery. Inflated to monumental scale, this barbarian heritage could give rise to such strange and powerful works as the ambo in the basilica of Isola San Giulio *(fig. 304),* Orta. The second current can be found in Modena, Piacenza, Parma, and Ferrara. Its main aim was to resuscitate the human figure. The evolution begins in the work of Wiligelmo's school on the façade of Modena Cathedral (1099 to 1166 according to Roberto Salvini; 1106 to 1120 according to René Jullian); it reached its height at the end of the 12th century in Benedetto Antelami, whose art looks forward to the Dugento, and who was responsible for a complex of sculptures at the Parma Baptistry, which were continued by his workshop into the 13th century *(fig. 305).*

The revival of form in sculpture developed along divergent paths in France and in Italy. In France, sculpture tended to express itself as relief, adhering to the wall and closely linked with the architecture. Emilian sculpture, on the contrary, unhesitatingly favored statuary, from the beginning on. The contrast between the two approaches is nowhere more evident than in Italian works directly inspired by French sculpture. The Eve in the Lodi Cathedral *(fig. 307),* for instance, is obviously inspired by a Languedoc model; but the instinctive Italian tendency to render full justice to the volumes works at cross-purposes with the artist's awkward imitations of the clinging drapery folds that give surface animation to the French sculpture. The crossed legs, which in the Toulouse reliefs suggest a dance movement, have become a heavy stamping. Burgundian sculpture, according to Roberto Salvini, inspired the strange reliefs in the museum at Modena, which look as though they might have been excavated at Selinunte, and which, by analogy with some Greek works, have been called "metopes"; but if that is the case, their maker

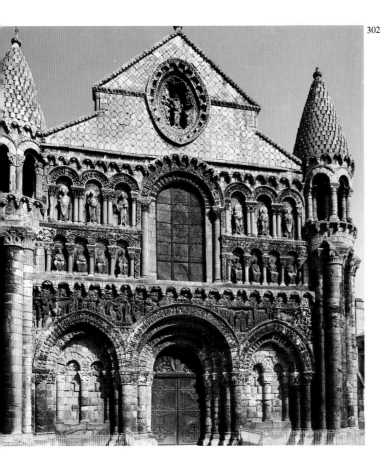

302

303

has created the most static works in all Italian sculpture, and far removed from the supple style of Cluny or Autun (*fig. 306*).

The very essence of Italian Romanesque sculpture is inertia, while the French school tends towards movement. The anarchic dynamism of barbarian art, disciplined by stylistic rules, which have been defined by Baltrušaitis, produced monumental rhythms. The lack of architectonic feeling on the part of North Italian Romanesque or even Gothic artists is revealed in their disinclination to design façades decorated with other than monotonous bands of Lombard ornament— blind arcades row on row, or naively juxtaposed series of reliefs in cases where figurative elements were introduced.

The favorite motif of the Italian Romanesque sculptor was the human figure. Desiring to give it its full individuality, he was unwilling to distort it by imposing architectural rhythms upon it; even less was he inclined to mix it with animal forms in chimerical combinations like those produced by the French sculptors; even the Emilian school, the most open to French influence, preferred borrowing its beasts from antique models, while the Lombard school directly perpetuated the barbarian

tradition of monsters, but still without subjecting them to the endless metamorphoses that delighted French artists. To be sure, some parts of France were also interested in the statue, particularly Provence, which exchanged motifs with Emilia, and was in some ways closer to it than to the rest of France. Still, the Provençal school was not cut off from other French schools, but shared with them the linking of sculpture and architecture, with the difference that at Arles or St.-Gilles the statuary dominated the organization of the architecture, rather than submitting to it. Moreover, if the Provençal sculptors obtained their effects by balancing masses rather than by modulating their surfaces in linear rhythms, they still employed drapery to create subtle, almost pictorial effects; nor were their figures' volumes so brusquely static as those of Emilian artists, for Romanesque vitality links the stocky forms in continuous rhythms. In Provence as in Emilia, Romanesque sculpture drew copiously on the antique. Ancient remains were especially plentiful in Italy, of course, and the digging necessary to establish cathedral foundations frequently uncovered more of them. In southern Italy, which remained isolated from the Romanesque stylistic trends, the

303 *Voussoirs* **from the portal of Saint-Pierre, Aulnay (Charente-Maritime) French, 1150–1200.** The decorations on the voussoirs of the central door are of exceptional richness. Closest to the door are foliated scrolls in low relief, followed by a ring of Saints; the Elders of the Apocalypse are next, and finally, fabulous monsters, rampant along the axes of the radially placed blocks on which they appear. The little figures are arranged in a harmonious synthesis of all influences and with a keen awareness of compositional values.

imitation of the antique style went on without interruption up to the 13th century. Capitals like those in the church of Monreale *(fig. 308)* belong to the pure classical tradition.

French forms traveled to Spain along the pilgrimage routes, which meandered through the countryside on the way to Compostela, to allow the faithful to visit various sanctuaries on their way; in the northern provinces of the peninsula, Oviedo, León, and Compostela became centers of a Spanish sculptural revival. There seem to have been exchanges in both directions, for certain works at León and Oviedo, apparently dating earlier than St.-Sernin, may even have influenced the beginnings of Romanesque there. Spanish sculpture differed from the French mainly in its lack of architectonic discipline. A feeling for monumental forms first appears during the second half of the 12th century, develops in the Silos cloister, at San Vicente of Avila, and finally produces the rigorously architectonic Portico de la Gloria at Santiago de Compostela *(fig. 313)*, the work of Master Mateo, done from about 1169 to 1188. Its relation to the first great Romanesque Gothic portals is so close that a French origin has been suggested for this artist; some Spanish historians believe him to have been a pupil of the French artist Fruchel, to whom the façade of San Vicente of Avila is attributed. Compostela sculpture also reveals the first organized iconographic program in the French manner to be found in Spain. Many different influences meet in the Portico de la Gloria, for we also find reminiscences of the Romanesque art of Poitou. Nonetheless, the architectonic order here constricts the statuary rather than giving it a rhythmic unity.

Catalonia offers no such monumental sculptural ensembles as those of northwest Spain. But in the remote Pyrenean valleys may be found a few examples of an art that has largely vanished elsewhere, that of altar frontals. In the richer monasteries these might have been magnificent products of the goldsmith's art, of the type surviving in the gold antependium from Basle and the paliotto of Sant' Ambrogio in Milan; but in Catalonia we find imitations in stucco or wood, made for poor churches and preserved from destruction by their very lack of value and by their isolation in the mountains *(fig. 311)*.

During the 12th century, Romanesque sculpture spread in successive waves through Europe; brought by the Crusaders, it even spread to Palestine, where it took on a strangely Asiatic cast. In Germany, Romanesque sculpture evolved without the French concern for architectonic rhythms, as shown by the decoration of the portal of the Jacobskirche in Regensburg, for instance. It continued, however, up until the 13th century, and the Prophets around the choir at Bamberg *(fig. 314)* are but slightly earlier than the first works from the High Gothic Reims workshop. The impassioned dialogue of these figures of apostles and prophets expresses the dialectical spirit of early medieval apologetics, and contrasts with the evangelical serenity of the apostle groups on contemporary French cathedrals. It also reveals the beginnings of the German expressionistic tradition.

Maintaining itself rather apart from the main stream of Romanesque art, the art of bronze-casting continued to yield works of art, especially various objects of liturgical furniture, in various parts of Europe—in the Meuse region, in Germany, and in Italy. Founders' workshops cast several notable doors for churches during the 11th and 12th centuries. At the end of the 11th century in Verona, a very primitive artist, little affected by contemporary developments, made the doors for the church of San Zeno *(fig. 315)*. The easternmost products of the bronze-workers' art can be found in Novgorod, in Russia, and Gniezno, in Poland, in doors from a Magdeburg metal workshop. The doors made for Monreale and Pisa *(fig. 317)* by Bonannus of Pisa at the end of the 12th century show the latest developments. Such doors were often export objects: Byzantium exported doors to many parts of South Italy, and there they were imitated by local workshops. Stone was the artist's favored material in France, but Italy and Germany never lost the tradition of bronze-working, which in Italy was to undergo a magnificent revival at the time of the Renaissance.

2. *Gothic Sculpture*

"Lord, let me know through love what I sense through knowledge; let me feel with my heart what I apprehend with

306 **SCHOOL OF GUGLIELMO** *Antefix* **from the south portal of Modena Cathedral. Italian, ca. 1125 to 1130 A.D. Museo del Duomo, Modena.** This iconography is very original, deriving from a mixture of literary sources and hagiography. The very Italian design is based, in contrast to the linear French style, on a balancing of large masses, here obtained with the curious inversion of one of the figures. Various sculptors working at Modena gradually gave up rigidity and forcefulness for charm.

304 *Pulpit,* **San Giulio, Orta. Italian, early 12th century A.D.** This pulpit is rightly considered one of the major works of Lombard sculpture in the beginning of the 12th century. The "barbarian" strain in Italian Romanesque art produced few works of such expressive force and such powerful vitality, employing means of such economy. An intense life and a wild, spirited force lie under the apparent monumental solidity of the decoration.

305 **BENEDETTO ANTELAMI (Italian, 1150 to 1230 A.D.).** *The Descent from the Cross,* **on the pulpit of the Cathedral of Parma, 1178 A.D.** The first known work by Antelami is this Deposition at Parma. His rigorous and severe style has roots in Provencal sculpture and particularly in the conception of statuary inherited from antiquity. He disregards picturesque, anecdotal, or formal devices; his compact, firm forms have affinities with classical antiquity.

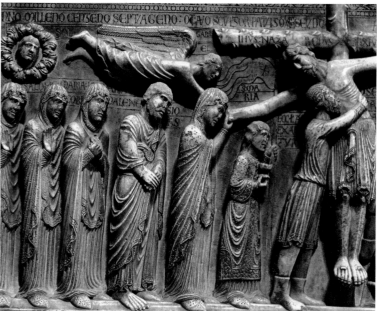

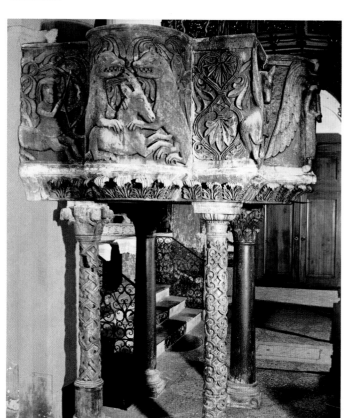

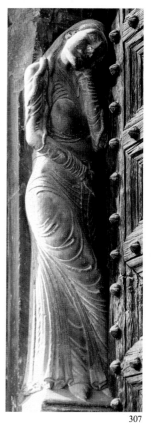

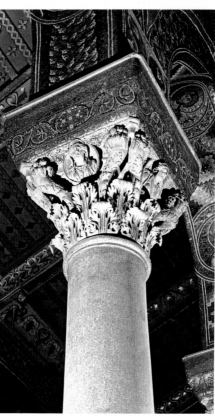

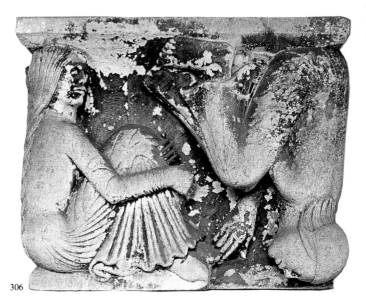

307 *Eve.* **Portal, Lodi Cathedral. Italian, 12th century A.D.** Although the *Eve* is set against a pier, in execution it is close to the French style. It was probably carved by an Antelami follower. The expressiveness of the sorrowful face, the dynamic movement emphasized by the folds of the contemporary dress, and the linear formulations are all characteristic of the 12th-century Lombard school, in which the tradition of antiquity is enlivened by an awareness of transalpine, and especially Provençal, style.

308 *Capital,* **Monreale Cathedral. Italian, ca. 1180 A.D.** The Monreale basilica outside of Palermo was built from 1174 to 1182 under the auspices of the King of Sicily, William II, who had artists brought from all over the world. The result is an extraordinary combination of styles. The composite capitals in the nave are directly inspired by Hellenistic models, and are the work of a classicizing Campanian workshop employing Roman, Apulian, and Byzantine sculptors.

my mind . . . Catch me up in your love, possess me wholly! Take me into the sanctuary of your love, I ask that grace, I entreat that favor. I knock at the door of your sanctuary and beseech you to open it . . . O comfort my soul hungry for your love! Let love of you fill it, let your love fill it; take hold of me and possess me entirely . . ."

Thus stammered the ecstatic St. Anselm, discovering "the very sweet Jesus, the beloved friend." Not since the passionate St. Augustine six centuries earlier had like cries of love risen from the soul to God. Night had ruled in men's hearts; the Christian religion of love had become a religion of precepts under which the faithful bent in fear. Western culture was to be reborn in the return to the sources of the Gospel, in the rediscovery of God made Man. A new love and knowledge, mysticism and philosophy, came from it; creation and all its creatures were to be justified by the rediscovery of the truth that in identifying himself with human nature, God had sanctified all of nature. As a result, the veil that had hidden the world since the end of antiquity was torn away. The sculptors in the cathedrals could again carve out the forms of the human body, since that *corpus verum* was the body of God himself. As once before, when the free-standing statue took form under the Greek sun, it was in sculpture that the body was first rediscovered. Three-dimensional form tends to lure the artist closer to nature, while painting may tempt him to ornament and abstraction. Sculpture in the Gothic period became an open-air pursuit, done in a yard, sometimes even done from the model, whom the sculptor could see face to face with the created work. Pygmalion breathed life into a statue—not a painting. Manuscript illumination, painting, stained glass, and enamels still clung to Romanesque formalism, but in the earliest years of the 13th century Christ and the Virgin stepped down from the tympanum onto the trumeau of the church door, showing to the faithful merciful faces in human likeness.

It was logical, then, that the human figure first returned to natural form in sculpture; but before that occurred there were many conditions that were long in being fulfilled. When St. Anselm uttered his burning prayers sculptors were only just attempting their first clumsy figures in the great abbey of Cluny or at St.-Sernin in Toulouse. Figurative sculpture had to serve a long apprenticeship through the 12th century before the image of the benign Christ could be born. Art had to emerge from the cloister, a seeming paradox, since it was in the cloister that mystic speculation was born and developed. Yet in the religious community the mystic could be disruptive; dedicated to self-abnegation, he was yet an individual whose behavior might transgress community discipline—the ecstatic trance might seize him just when the bell summoned the brothers to common prayer. The greatest among those called to mystic union with God, men like Johannes Eckhart or St. John of the Cross, all had trouble with the ecclesiastical hierarchy. The faith of the convent was a faith based on order. For centuries, liturgical duty was the sole motivation for the monastic vocation. Until the time of St. Anselm (ca. 1033–1109) and St. Bernard (1090–1153) a monk entered the cloister to praise God, not to love Him. The monastery imprisoned a mortified soul and body in the never-ending round of the liturgical years, as the monk endlessly circled his cloister, cut off from the world. From his very isolation mysticism was born, a bridge traversing the forbidden world of existence to reach the essence. As long as art remained in the hands of monks in the overheated mental world of the cloister, it ignored nature and reveled in monsters incarnating those obscure terrors called sin. In the shadow of the monasteries, privileged places isolating men from life, all the old symbols, all the archetypes deposited in the collective unconscious of humanity, throve and found expression in the stone monuments, until that radiant figure appeared who would put all the chimaeras to flight.

Before this voice of love, first heard through a few exalted monks, could find its echo in the world of images, the monastery workshops had to be replaced by those of the cathedrals, the abbey by the immense open church to which the worshipper came not simply as a pilgrim-guest but as one of the faithful who had contributed to the building with his own hands, with his own faith, love, and self-confidence based on a trust in God made Man. Most important, the artist was no longer necessarily a member of the cloistered, all-male society, but was a man who often went home from

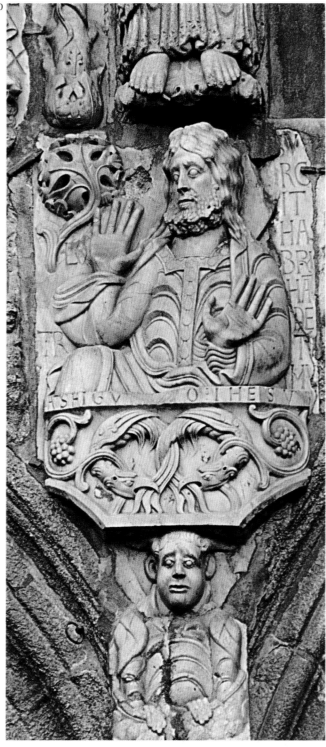

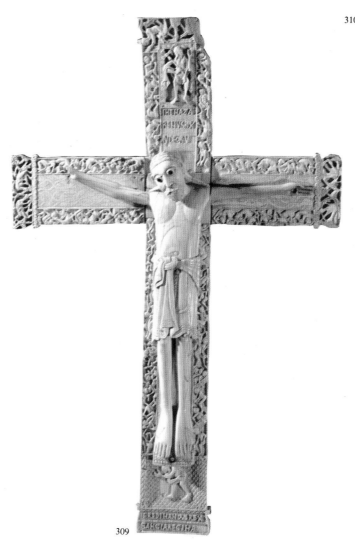

309

309 *Crucifix.* **Ivory. Spanish, ca. 1063 A.D. Museo Nacional Arqueologico, Madrid.** This crucifix marks the first known appearance of the theme of Christ on the Cross in Spanish art. The decoration on the cross itself and the frieze of intertwined animals and foliage around the edges recall Cordovan or Mozarabic ivories, while in the body of Christ, Ottonian and Italian types mingle. Characteristics of a truly Spanish style can already be felt through this Byzantinism. The crucifix was given to San Isidoro de León Cathedral by Ferdinand I of León.

310 *King David.* **Puerta de las Platerias, Santiago de Compostela, Cathedral. Spanish, ca. 1100.** The prophet David is still impregnated with elements from the art of Toulouse almost contemporaneous with the Puerta de las Platerias, carved at the very end of the 11th century. However, the less numerous folds, the more strongly affirmed relief, and the general simplification result in a more realistic, if less refined, art than the Languedoc models.

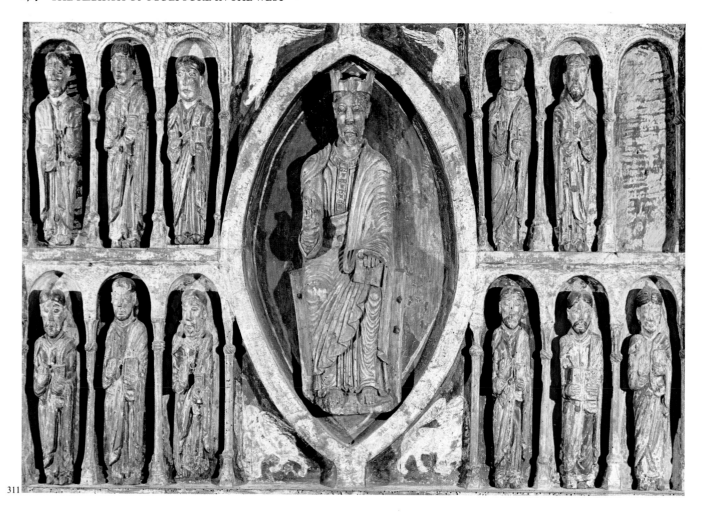

311

the workshop at night to embrace his wife and play with his children, children he might take walking in the fields or woods to pick flowers; in his house lived an old father who might serve as a model for the prophets. The framework of his life need no longer be the monkish ranks, but that human microcosm mingling sexes and ages, the family, and beyond that, that wider family of the town, no less a City of God for being an earthly city.

Once the impulse had been given, the evolution was rapid. Before the death of St. Francis of Assisi (1226), who celebrated with such overflowing love the sun, the moon, the animals and plants of God's creation, the cathedral sculptors had already turned to nature. Though many years were to pass before they manifested much interest in animals, in 12th-century Ile-de-France they had already discovered delight in the flowers and plants that each spring brought life to the countryside around the towns where the cathedrals were rising, their lofty vaults visible from every point in the surrounding plains. For those who have long known these churches intimately, nothing is more moving than the spring-

like vegetal ornament, still intact where other decorations have been destroyed, that gradually crept over the stone building. As we know through a lover of botany who devoted her life to the study of this ornament, Denise Jalábert, the sculptors at first borrowed from nature only generalized floral forms, which they adapted to an architectural function. Then gradually, from the first quarter of the 13th century, they began to copy the distinct species: lilac, violet, oak, hawthorn, ivy, grape, trilobate hepatica, holly, fig, walnut, watercress, thistle, hops, buttercup, arum lily, fern, maple, sweetpea, hollyhock, rose-mallow, briar, crowfoot, plantain, mugwort . . . the cathedral became a huge stone herbarium. The monsters entirely lost their prominent place on the capitals, which they had occupied for more than a century. Put to flight by nature, they took refuge in the cathedral's upper parts, where they made themselves useful as gargoyles spitting out rainwater—a sad end for images that had occupied a place of honor within the sanctuary.

The Ile-de-France in the 13th century offered a combined political and cultural progress paralleled only in 5th-century

311 *Christ in Majesty and Apostles,* altar frontal, Ginestarre de Cardos. Stucco, polychromed. Spanish, 1251 A.D. Museum, Barcelona. In Spain the early Romanesque tradition of gold or silver altar frontals was carried through to the 13th century in the frontals of polychromed stucco or wood. That of Ginestarre is one of a mass-produced series which invariably treats the theme of Christ surrounded by Apostles.

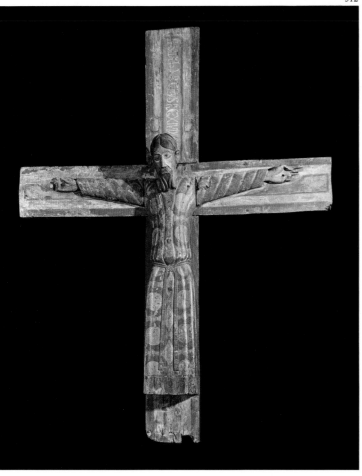

312

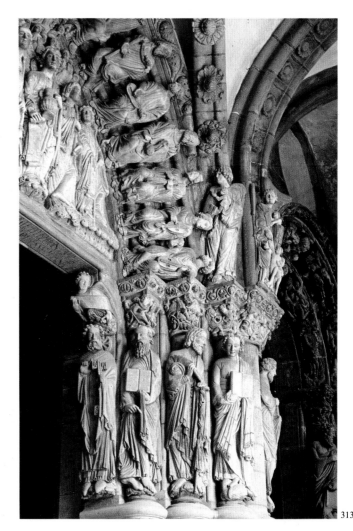

313

Athens. France would crystallize around the nucleus of the Capetian Kingdom. There more than anywhere else the monarch was mindful of his duties towards his subjects. Louis VII, the king under whom St.-Denis, Sens, Laon, and Notre-Dame de Paris were built, said: "Divine kindness has decreed that all men, since they have the same origin, should be gifted from birth with a sort of natural freedom. But Providence has allowed some of them to lose, through their own fault, their original dignity and to fall into a servile condition. It belongs to our Royal Majesty to elevate them to freedom again." The freeing of serfs, the emancipation of the communes, and in general, the protection of their subjects against feudal brigands were the ruling policies of the kings of France, supported by the bishops. There was no question of divine right at that time, as on the other side of the Rhine; the king was only an agent, delegated by Providence. Louis IX, St. Louis, went further. This is how he admonished his son: "My son, I beg you to win the love of your people. For I would prefer that a Scotsman come from Scotland should govern the Kingdom well and loyally, rather than that

you should govern it badly." This love comes from the same source as the love of God: "Dear Son, I teach you first of all to love God with all your heart and all your might, for without love, nothing is worth anything."

Like the Greek temple, the cathedral is the monument of the city; marvelous expression of unity, it was born of the aspirations of the people, grouped around the bishops and the king. As Robert Branner wrote, the art of St. Louis' period was a courtly art, from a court where sanctity did not exclude elegance. Chartres was a country cathedral, while Paris, Amiens, and Reims reflect the aristocratic graces of a society where feudalism no longer ruled, a society open to the influence of southern France, where woman was made an ideal being whose beauty and virtue were celebrated by the poets. Influencing religion, this courtly love spread the cult of the Virgin Mary next to the cult of Christ. The Virgin, once elevated unattainably in that theological symbol, the tympanum, came down to preside over the trumeau; there, though she kept her sternness for a while, she soon became a courtly lady. We like to imagine Marguerite of Provence,

312 *Majestad de Battlo.* **Wood, polychromed. Spanish, 11th or 12th century A.D. Museo de Arte de Catalunya, Barcelona.** This *Majestad* is one of the most original expressions of Catalan art. Its iconographical theme is Oriental and first appears in miniatures and the minor arts. The polychromy suggests the "colored splendor" of the Romanesque world, and the rich tunic emphasizes the conception of the victorious Christ.

313 *Prophets and other figures.* **Portico de la Gloria, narthex of the Cathedral of Santiago de Compostela. Spanish, 1168 to 1188 A.D.** Influenced by French art and still impregnated with Romanesque elements, the Portico belongs at the very beginning of Spanish Gothic art. Conceived and carried out between 1168 and 1188 by Master Mateo, it combines Spanish traditions with a new conception of the church portal.

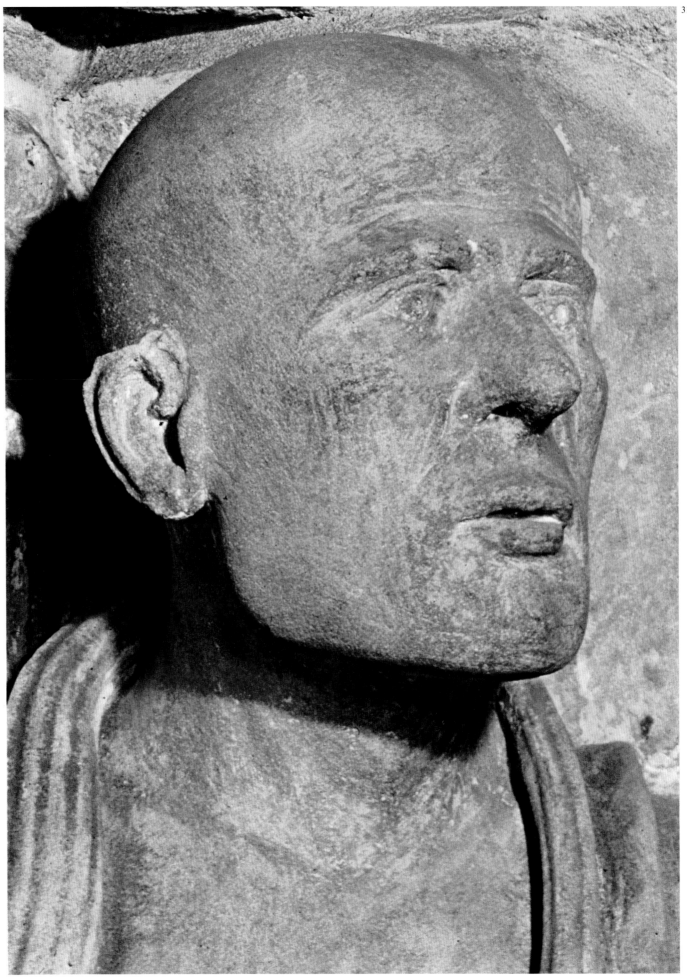

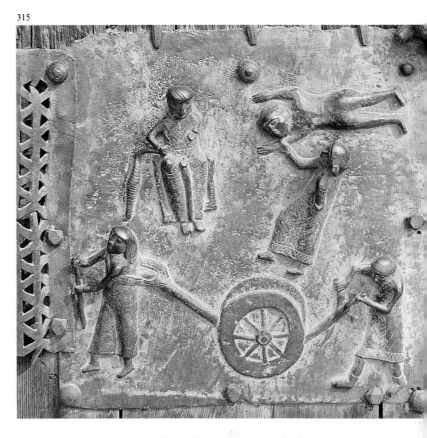
315

314 *Head of the Prophet Jonah.* **Choir screen, Cathedral of Bamberg. German, early 13th century A.D.** This image is one of the finest examples of German statuary in the first quarter of the 13th century. It forcefully conveys the prophet's tension.

315 *Adam and Eve; Cain and Abel,* **door of San Zeno, Verona. Bronze. Italian, 11th century A.D.(?)** These doors have undergone a number of transformations after suffering through various fires, wars and earthquakes. The crude style has an evocative force.

316 *Baptismal font.* **Brass. Saint-Barthélémy (Liège). Mosan, 1107 to 1118 A.D.** This font was made on commission from Abbot Hellinius (1107 to 1118) for the church of Notre-Dame-des-Fonts in Liège. It represents the logical issue of the art of the 10th- and 11th-century Mosan ivory and bronze workers. The poses and the handling of the drapery presuppose a deep understanding and a total assimilation of antique models.

317 **BONANNUS OF PISA (Italian, mentioned 1174 to 1186 A.D.)** *Nativity,* **doors of the Cathedral of Pisa. Bronze. ca. 1175 to 1180 A.D.** These doors, made of 24 panels, have many points in common with those at Monreale.

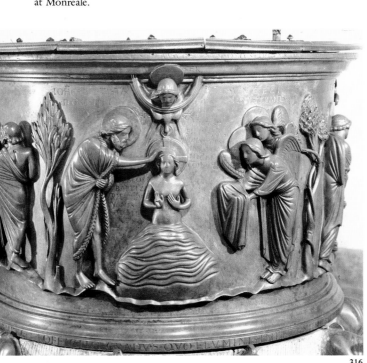
316

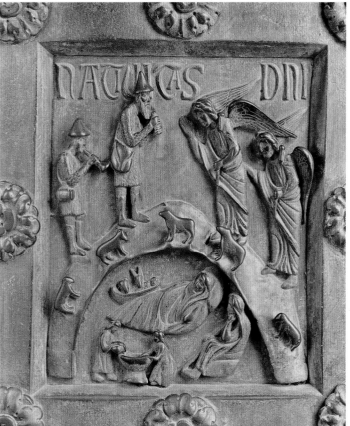
317

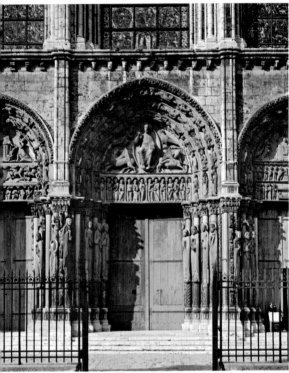

318

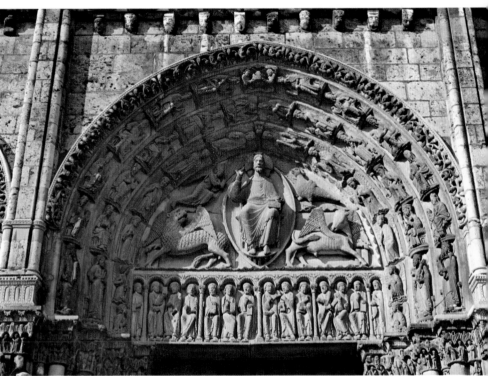

319

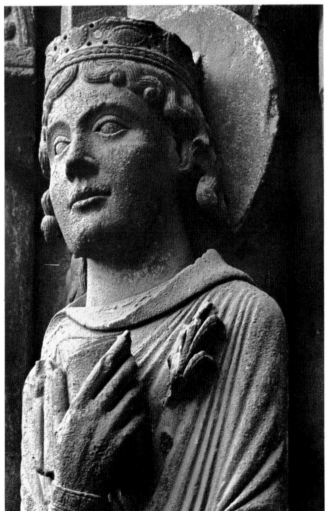

320

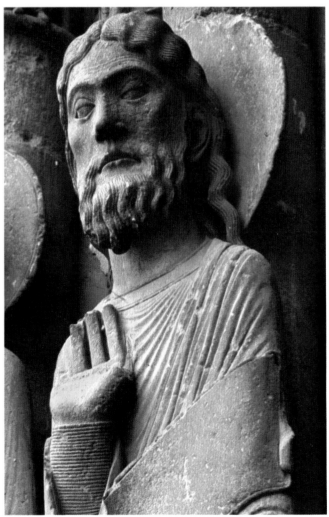

321

318 *The Royal Portal,* **Chartres Cathedral. French, ca. 1150 to 1170 A.D.** This portal offers an iconographical and technical conception of sculpture that is partially inherited from Romanesque portals. The theme is an illustration of the Christian doctrine and of the links between the Old and New Testaments.

319 *Christ of the Apocalypse,* **central tympanum of the** *Royal Portal,* **Chartres.** Christ in Glory, surrounded by symbols of the four Evangelists, was a usual theme after 1150. In this example, the tympanum is occupied only by the mandorla and symbols of the Evangelists, without any of the confusion of a Romanesque tympanum.

320 *Head of a jamb statue, Royal Portal,* **Chartres.** This young King of Judah could easily be a Capetian prince. The personages of Holy Scripture are no longer mysterious and unapproachable; they are made more human and are identified with contemporary society.

321 *Head of a jamb statue,* **detail,** *Royal Portal,* **Chartres.** Here the long, bony face, characteristic of the first school of Chartres, and the calm expression are the very opposite of the contorted features of Romanesque heads. It was at Chartres that the new ideal in French sculpture first appeared, in which keenness of psychological observation combines with asceticism, and spirituality is balanced by a humanistic feeling.

322 *Jamb statues, Royal Portal,* **Chartres.** Here, the sculptor's concern with realism is evident from the care with which he has handled the contemporary dress, faithfully describing the embroidery, the belts and the hairstyles. The statues are completely integrated into the architecture. The faces are naturalistic and of extraordinary variety.

323 *Jamb statue,* **detail,** *Royal Portal,* **Chartres.** This detail is a good illustration of the classical concepts that were to underlie Gothic art. The perfect precision of the carving is proof of the degree of skill that French art had achieved at the dawn of the Gothic era.

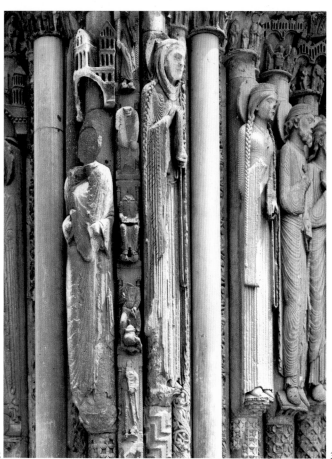

322

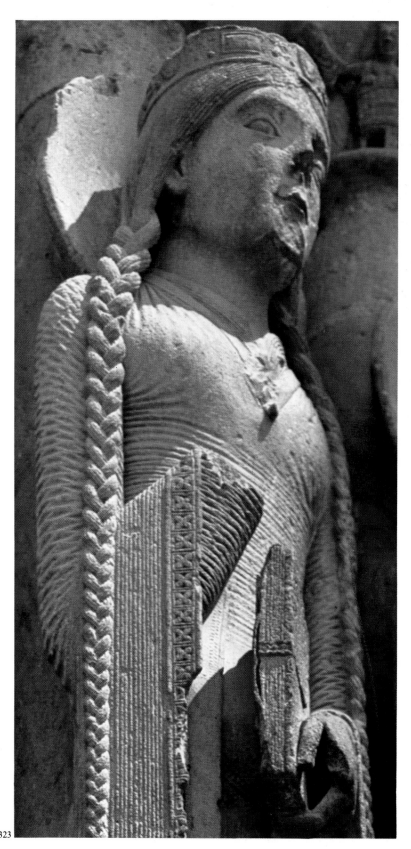

323

324 *Dormition and Coronation of the Virgin,* tympanum of the Portal of the Virgin, west façade, Notre-Dame, Paris. French, ca. 1210 to 1220 A.D. This work synthesizes the elements of the future classic style of sculpture: simplicity and clarity of composition, high relief modelled fully in the round, and a harmonious adaptation, but not subordination, to the architectural framework.

325 *The month of August.* Portal of the Virgin, Notre-Dame, Paris. French, ca. 1210 to 1230 A.D. Here the Gothic sculptor, taking as his themes simple actions of everyday life, treats them as admirable little scenes where realistic observation is combined with sobriety of expression and noble simplicity.

326 *Virgin and Child,* portal of the church at Longpont-sous-Monthléry. French, ca. 1220 A.D. Although damaged, this statue is interesting because it undoubtedly echoes a Virgin who once stood on the Paris Cathedral. The movement of the drapery folds is still rather stiff, but the dress is contemporary; the sculptor's effort to give life to his statue is at odds with the architectonic rigidity of the body and drapery.

327 *St. Etienne,* trumeau of the central door, west front, Sens Cathedral. French, ca. 1215 to 1220 A.D. Sens Cathedral was rebuilt after a fire in 1184. The statue of St. Etienne is still a column-statue, but the figure is further developed than those at Chartres. The young Saint's refined and slightly elongated head is full of charm and delicacy. The 13th century was not to advance many years before such finely adjusted balance between idealism and naturalism was lost.

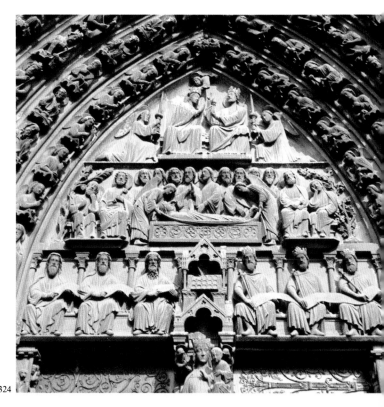

324

325

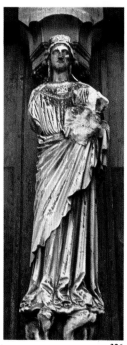

326

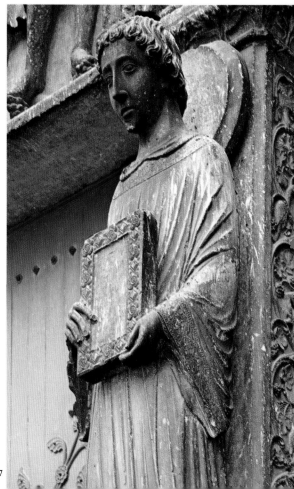

327

the dainty wife of St. Louis, with the features of the Virgin on the north portal of Notre-Dame de Paris—a figure spared, possibly because of her beauty, when the *sansculottes* of 1793 destroyed all the other statuary of the cathedral *(fig. 334)*.

Born in the Ile-de-France, of elements borrowed from Languedoc and Burgundian art, the Gothic church portal achieved its definitive form as early as 1150, at Chartres. Sculpture was no longer submerged in the architecture: it created its own mirror of architectural forms. On the tympana, lintels, or arches, equilibrium was reached by a static balancing of statuary. Column-statues were no longer the ornament for the supports, but became the columns themselves—a development that is also symbolic. Standing solemnly, they are courtiers and ladies, clothed in rich contemporary dress instead of in the conventional draperies of the Romanesque period *(figs. 318, 320)*. Their heads are no longer schematized but are real human faces, some with a hint of the smile that in St. Louis' time bloomed full, and even affectedly, on the faces of the statues at Reims, whence it spread to the rest of France and Europe. The first to mention that very French facial expression was the Capetian king who reigned when the Chartres Royal Portal was built. To his cousin Henry II of England, who had taken Aquitaine from him by marrying the wife he had repudiated, Louis VII wrote: "We are not rich! We own only three things: bread, wine, and a smile."

After 1200, the great cathedral workshops opened one after the other, developing their separate traditions, but influencing each other. This created a very complex situation from the historiographic viewpoint, since in the Gothic period the sculptural style, like the architectural, underwent such rapid transformations that no building program was completed in the style in which it had been begun, however speedy the work. From one statue to the next, the sculptor pursued his search for new forms and expressions, and new artists constantly brought fresh ideas. The avant-garde reigned in that golden age of Gothic classicism.

Despite reciprocal influences, until about 1250 each workshop tended to keep its own style. The sculpture at Chartres shows a strange mixture of rough rusticity and asceticism; it embodied theological aspirations, and as a result, when its style became less rigid, around 1215, it produced one of the most beautiful of all representations of God made Man, the human and the divine combined in perfect unity. The Amiens workshop is distinguished by a natural grace tempered with religious serenity: the *Beau Dieu* of Amiens is more human than divine. The Paris atelier was characterized by a nobility of style befitting the royal metropolis; without any direct imitation of antiquity, it achieved quite spontaneously the most beautiful classical rhythms, nearest to those of 5th-century Greek art. At Reims, the book of stone is the most difficult of all to decipher, successive changes of program having resulted in puzzling crosspaths in the statuary. The thread through the stylistic labyrinth of Reims has been unraveled by fifty years of patient research, mainly by German scholars. (The first was Wilhelm Vöge, a man of genius so devoted to Reims cathedral that his health and his morale were deeply shaken by his countrymen's persistence in trying to destroy the sublime building during the first World War. As if in retribution, he left his chair at Freiburg University, giving up his research and interrupting a career that would have made him one of the pioneers of art history.) We now know that the famous classicizing atelier of Reims belongs to the beginning and not to the apogee of the evolution. To it belong the angels on the chevet, set in place as early as 1221, and statues of Christ and various apostles and saints; these were adjudged of inferior workmanship by Jean le Loup, the second *maître d'oeuvre,* who demoted them to the north transept. From the same workshop came other pieces that were considered fine enough for the west front: notably the *Visitation (fig. 328)*. The elegant draperies falling in clinging folds may be derived, as has been claimed, from an antique tendency in the 12th-century art of the Meuse and Rhine regions, best exemplified in Nicolas of Verdun, which links up with Ottonian and even Carolingian art: the similarity of these draperies of the Lorsch Gospel covers has been noted earlier. However, some statues, notably the figures of the Visitation group, undeniably wear Greek chitons and himations, which the artists cannot have seen in local examples. It is more logical to suppose that some Reims artist saw the

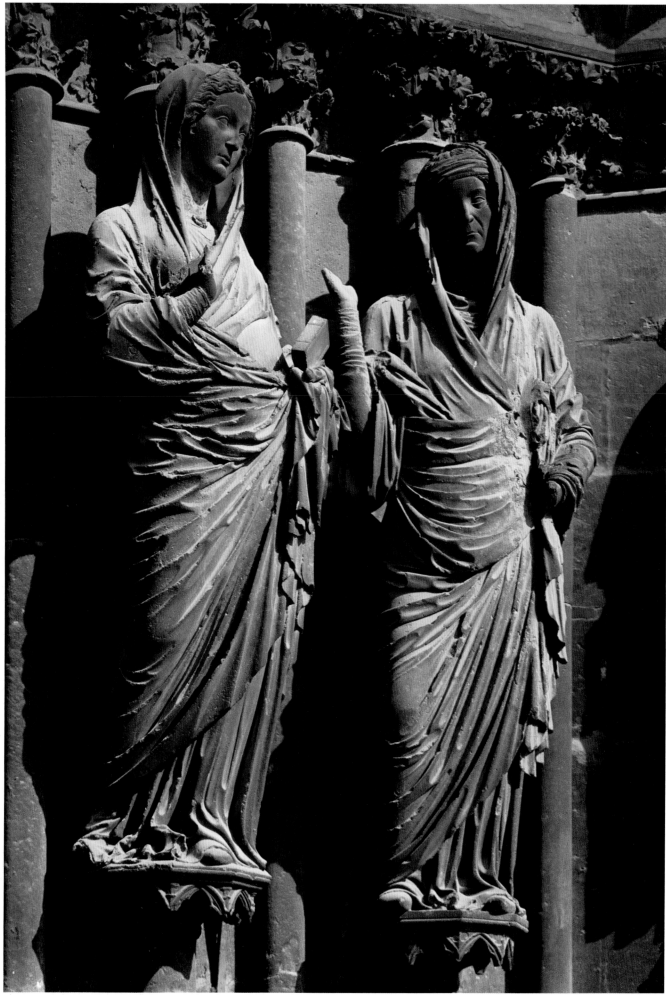

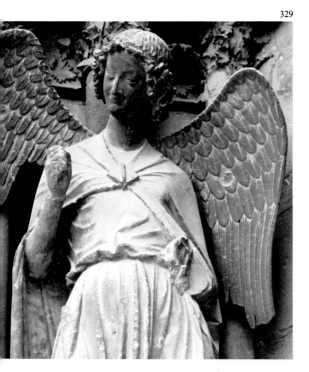

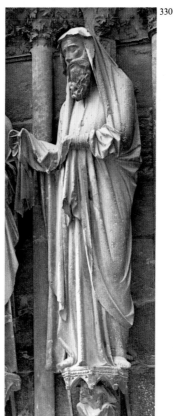

328 *Visitation: Mary and Elizabeth,* **west façade, Reims Cathedral. French, ca. 1220 A.D.** Art historians now believe that the figures at Reims that owe a strong debt to antiquity were produced about 1220 by the workshop responsible for the first façade. This renewal of the antique must have been brought about by a master acquainted with the art of the Meuse Valley and with Greek and Roman marbles, and able to adapt these models to local traditions.

329 *Smiling angel,* **west façade, Reims Cathedral. French, ca. 1240 A.D.** This famous "smiling angel," carved about 1240, when the west façade was being finished, represents the final phase in the development of sculpture at Reims. It is a long way from the noble realism of the first years of the century. The sculptor's virtuosity in rendering fabrics, as in the facial modelling, displays complete technical command. Gothic art had reached the height of its possibilities and was not long to remain on this level.

330 *Presentation in the Temple,* **detail, west façade, Reims .Cathedral.** The portals of the west façade show some revisions in the iconographic program. The statues of the "classicizing" atelier (fig. 328), which had been intended for another location, were mingled with works that were more "modern"—that is, more Gothic, proceeding from the style initiated at Amiens Cathedral. This tradition will constitute the true Reims style.

331 *The Month of May,* **west façade, Amiens Cathedral. French, ca. 1225–1235.** The façade of Amiens cathedral is decorated with reliefs representing the seasons and the labors of the fields, associating nature with the mysteries of the faith. Gemini, the twins, the zodiac sign for May, is illustrated here. Below it, as the Labor for the month, is a familiar and thoroughly human scene of a seated man happily contemplating blossoming trees; like the zodiac sign, the scene is neatly inscribed in a quatrefoil frame.

332 *Head of Christ teaching,* **known as the** *Beau Dieu,* **west façade, Amiens Cathedral. French, ca. 1225 to 1235 A.D.** The *Beau Dieu,* set against the trumeau of the central door, is one of the great landmarks in the humanization of the type of Christ. The Chartres Christ is imbued with greater spirituality and a slight melancholy; the *Beau Dieu* of Amiens is more majestic, more idealized, as if to say that the Son of God can be only the most beautiful, the most perfect of creatures.

Greek originals that were still above ground in Athens. After all, a Reims artist brought back from Greece the Byzantine motif of the angels bearing the instruments of the Holy Liturgy, unusual in the West, which he transposed into statuary in the angels of the apse buttresses. Such a contact was historically possible after the capture of Constantinople by the Crusaders. In 1205 Athens was conquered by Othon de la Roche, whose lands in France were near Champagne, and Guillaume de Champlitte, from Champagne, conquered Morea (the Peloponnese). Othon de la Roche was made a duke and used the Propylaea as his palace and the Parthenon as a cathedral. Thus a meeting occurred at least once between Greek classicism and the new Gothic classicism.

But the Reims "first manner," because of these antique influences, and because it was rooted in the traditions of the early Middle Ages, was considered outmoded by Jean le Loup, who became master of works about 1228. To rejuvenate the Reims workshop, he turned to the more modern workshop of Amiens, whose façade had been begun about 1225. The Reims Virgins of the Annunciation and Presentation, in contemporary costumes, and *Simeon (fig. 330)* are inspired by the Amiens style. Their more elongated proportions, their drooping shoulders and oval faces, tend away from the antique towards that Gothic verticalism which began in the column-statues of the Chartres Royal Portal. But the drapery is no longer a mere ornament; its broad movements and deep folds set off the shape of the bodies. The Gothic canon moved rapidly towards a refined elegance, of which the Reims Queen of Sheba, reduced to a stump during the first World War, was the most perfect example. An elevated theological tone allied to classical nobility was maintained in the monumental statues on the upper parts of the north transept (the Church and the Synagogue; Adam and Eve). Owing to civil disorders, the Reims workshop was closed in 1233. Reopening in 1236, its style began to evolve towards a somewhat affected grace, which was accompanied by the appearance of the famous smile; over-emphatic and mannered on the St. Nicasius angel *(fig. 329)*, it is more subtle and human on less-known

333

334

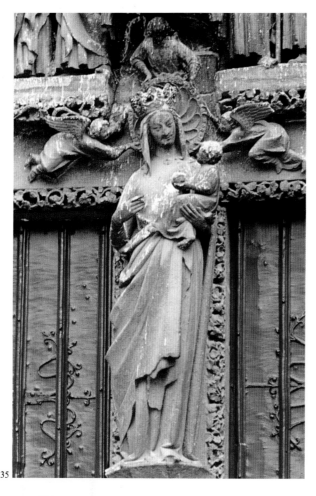

335

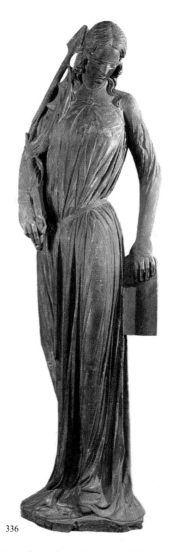

336

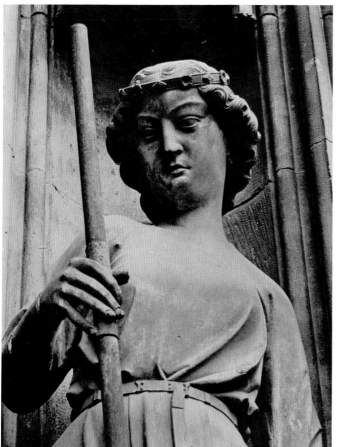

337

333 *Virgin and Child.* **Ivory. French, early 14th century. Hospice, Villeneuve-les-Avignon (France).** The tender or playful exchanges between Virgin and Christ Child provided an inexhaustible variety of themes for French Gothic sculptors from 1250 onwards. The Virgin's contrapposto, counterbalancing the weight of the Child, follows quite naturally the shape of the elephant's tusk that gave the sculptor his ivory. This beautifully finished statuette touched with gold and colours retains all the natural grace of the 13th century, not yet displaying that dryness in the forms which is so characteristic of the following century.

334 *Virgin and Child,* **north portal, Notre-Dame, Paris. French, 1250 to 1260 A.D.** The trumeau statue of the Virgin and Child on this portal embodies a new conception of the Mother of God. Standing with her weight slightly off-center, she is an elegant, but not pretentious, figure, proudly presenting her Son to the Faithful. Under the influence of courtly poetry and the developing cult of Mary, the *theotokos* element disappears: she is no longer the throne for her Son, but a mother pleased to display him.

335 *Virgin and Child (The Vierge Dorée),* **south transept, Amiens Cathedral. French, 1280 to 1288 A.D.** The decoration of Amiens was completed in the years after 1260. *The Vierge Dorée* on the trumeau of the south transept portal is the most famous statue from this workshop. She is in the same tradition as the Virgin on the north portal of Notre-Dame in Paris, but moves still further in the direction of humanization.

336 *The Synagogue,* **from the Cathedral of Strasbourg. French, ca. 1230 to 1250 A.D. Musée de l'Oeuvre Notre-Dame, Strasbourg.** The master masons and sculptors of Strasbourg had worked in the Reims stone-yards, whose style they brought with them to the Rhenish city. The art of Reims had enormous prestige and influence during the Middle Ages, when it was considered the model of all arts by the whole of Europe.

337 *A Virtue,* **detail, west front, Strasbourg Cathedral. French, beginning of the 14th century A.D.** The influence of classical Gothic statuary is still visible in this 14th-century work, but the Strasbourg sculptors succeeded in avoiding a stilted academism.

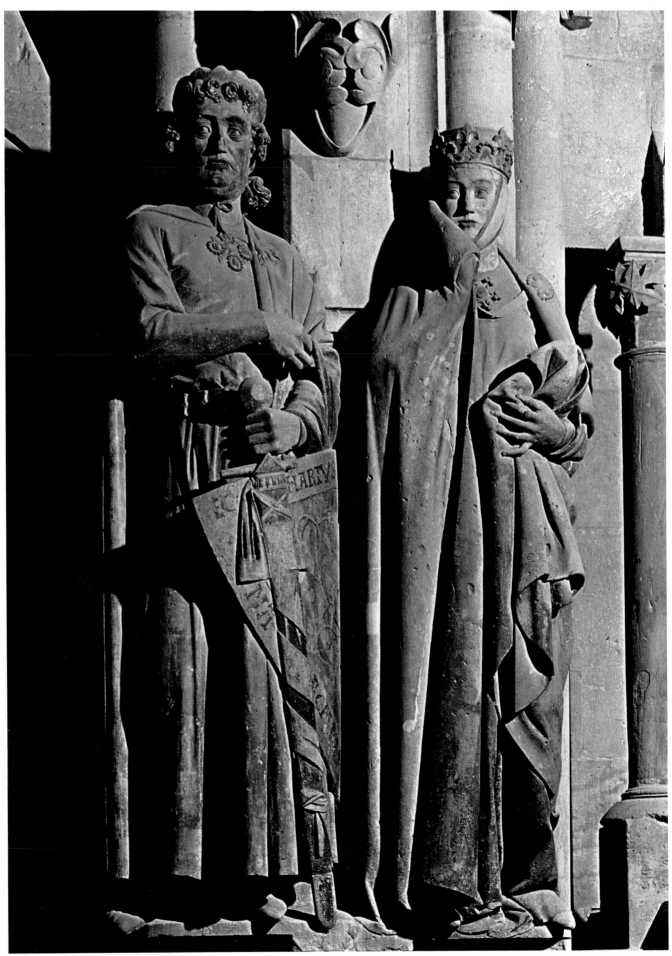

339

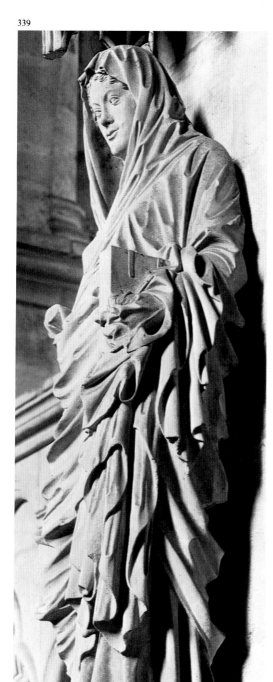

340

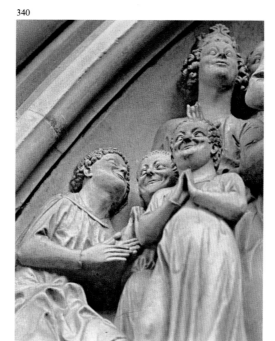

341

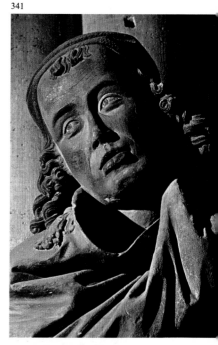

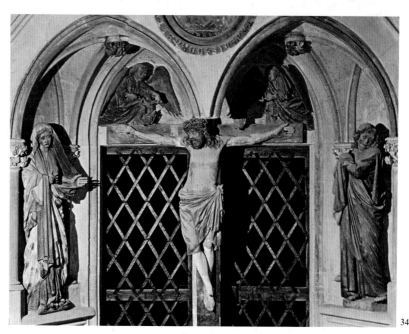

342

338 *Ekkehard and Uta,* west choir, Naumburg Cathedral. German, ca. 1260 to 1270 A.D. The "Naumburg Master," trained in France, carried his program of sculptural decoration over to the cathedral interior. In 1249 he began the series of portraits of the ten founders of the church. Countess Uta stands next to her husband Ekkehard. The modelling is restrained, and the straight folds fall in broad planes, without any ornamental effects. All the expressive force of the work is concentrated in the faces.

339 *Virgin* from *The Visitation.* Bamberg Cathedral. German, ca. 1225 A.D. About 1225 sculpture at Bamberg switched very suddenly from the Romanesque to the Gothic style. As at Strasbourg, the new sculpture was an adaptation of the Reims style: the Bamberg *Visitation* is a more dramatic version of that of Reims. The artist's chisel has been irresistibly drawn by the decorative possibilities of this bunched-up material and he achieves admirable plastic effects at the expense of anatomical rendering.

340 *Last Judgement,* detail, Fürstentor, Bamberg Cathedral. German, ca. 1230 to 1240 A.D. The "Counts' Portal," installed during the second building campaign, is the first entirely Gothic work at Bamberg. The art of Bamberg is here clearly expressionistic, even bordering on caricature.

341 *Count Wilhelm von Camburg,* detail, west choir, Naumburg Cathedral. German, ca. 1260 to 1270 A.D. In the statues of the west choir the Master of Naumburg sloughed off French influence to produce a typically German art. Real people were portrayed. Not truly portraits, these extremely realistic personages form a gallery of human temperaments.

342 *Crucifix, Virgin and St. John,* choir screen, Naumburg Cathedral. German, ca. 1260 to 1270 A.D. This Crucifixion group is traditionally expressionistic in both the tragic intensity of the faces and the treatment of the drapery, and the Master has clearly explored a new style moving decisively away from French models.

343 **NICOLA PISANO.** *Adoration of the Magi:* detail from pulpit (fig. 344). Nicola Pisano was directly influenced by ancient sarcophagus reliefs in carving the five relief panels of the Pisa pulpit. He assimilated the ancient heritage and created an art that was his own in this clearly ordered composition.

statues. One of these was the Bathsheba from the great rose-window, whose head, found among the rubble and unfortunately now fixed into place with an iron clamp, miraculously survived the destruction of her figure and the entire group to which she belonged.

The workshops of the large cathedrals were active until the second half of the 13th century. Then differences became less marked, and individual manners tended to merge into one style, in which the Reims manner was predominant. The *Vierge dorée* of the Amiens north transept *(fig. 335)* is directly derived from the St. Nicasius angel and has become so human

344 **NICOLA PISANO** *Pulpit,* Baptistry, Pisa. 1260 A.D. Nicola Pisano, a native of the south, introduced Gothic sculpture to Tuscany, while also displaying, in his relief scenes, a strong classicizing element no doubt linked to his Apulian training. Some art historians believe that Nicola had been to France, but this theory does not fit in with known facts.

345 **NICOLA PISANO** *Hercules,* detail from pulpit (fig. 344). Nicola Pisano gives great emphasis to the corner statuettes, which are treated as sculpture in the round. The Fortitude summarizes Pisano's vision of humanity—man elevated to the dignity of the hero—and his conception of sculpture—firm modelling emphasizing the body's planes and its anatomical structure. The influence of antiquity is most clearly shown in these statuettes.

346 **GIOVANNI PISANO** (Italian, ca. 1250–after 1314) *A Sibyl,* pulpit, Sant'Andrea, Pistoia, ca. 1300. The pulpit of Sant'Andrea in Pistoia was completed by Giovanni Pisano in 1301. Moving, sometimes vehement poses, expressive faces, linear rhythms, and deeply undercut relief characterize this sculpture, where pictorial values arising from the contrasting rhythms of light and shade take precedence over spatial values. Giovanni's highly expressive style illustrates the growing importance of the individual vision.

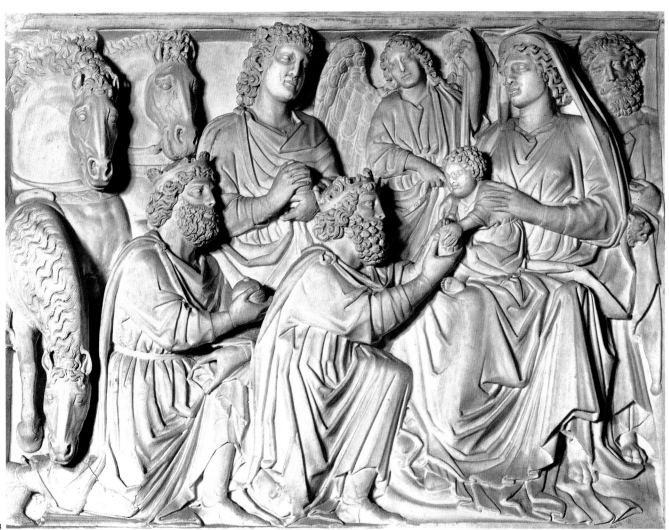

343

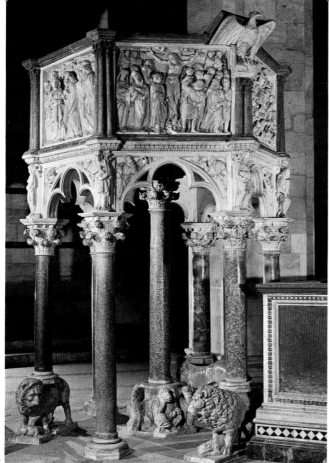

344

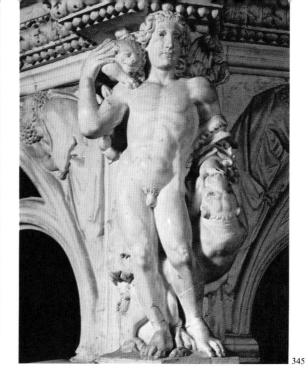

345

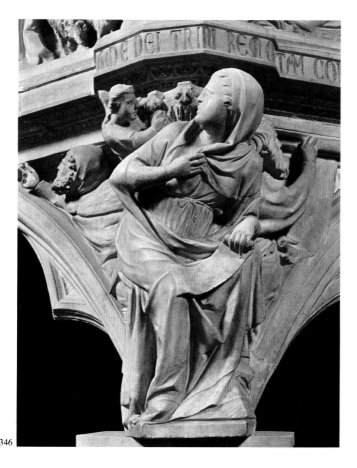

346

347 **GIOVANNI PISANO Head of *Simeon,* from the façade of Siena Cathedral. 1284 to 1296 A.D. Museo dell'Opera del Duomo, Siena.** The first work for which Giovanni alone was responsible was the façade of Siena Cathedral. He carved a series of over life-size prophets, philosophers and sibyls, which were placed above the portals, as was customary in Italy, not against the jambs, as were French Gothic figures.

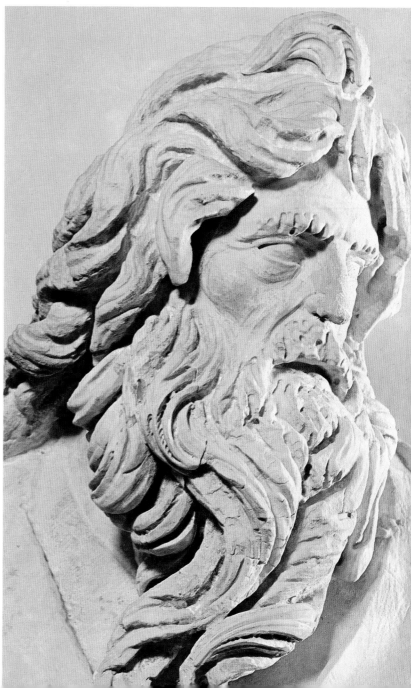

347

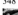
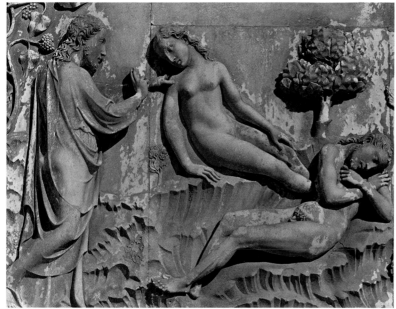

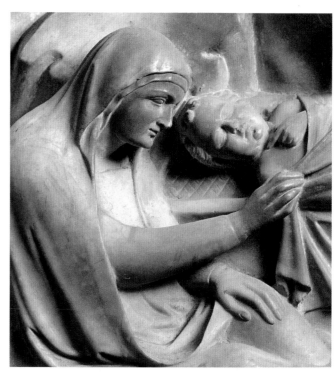

that she has lost her transcendental character, to become merely a happy, if elegant, young mother playing with her baby. The large Bourges workshop, source of a magnificent set of portals, produced a very elegant Last Judgment, while the apostles of the Sainte-Chapelle best exemplify a sculptural perfection devoid of inspiration. From the end of the 13th century classicism inevitably ossified into academism; artists were no longer able to render the subtle psychological meaning of the smile, which appears as a mere convention in the *Virgin* at St.-Amand-les-Pas. During the 14th century, sculpture became completely stereotyped and mannered. A few artists, like the sculptor who made the tomb of Cardinal de Lagrange at Avignon, could still recapture the grand style. Apostle groups of the type made famous by those in the Sainte-Chapelle in Paris became essential to the ornament of episcopal and princely chapels. A southern French artist working in Rieux between 1324 and 1328, however, could still use that formula to make a series of powerful statues whose expressionism looks forward to Sluter: the features of his *St. Paul* suggest to us Sluter's Moses.

We must picture the workshops of the great French cathedrals as schools of apprenticeship, which provided the whole

of Europe with young artists who could bring the new artistic forms to the numerous workshops set up everywhere by bishops desirous of rebuilding their cathedrals. Thus, the Gothic style born in the Ile de France and in Champagne spread in successive waves as far as Scandinavia. Its infiltration into Germany is most interesting. The influence of Reims over the Bamberg workshop, for instance, has been asserted and denied and has provoked passionate controversies between French and German art historians. Investigations at Bamberg, proving that all the statues were *in situ* for the dedication in 1237, have pushed back the date of the Reims statues to some years earlier than 1250, a date that has been generally accepted by French historians. The Bamberg sculptors impressed their own strong personality on the French models. As interpreted at Bamberg, the classical clothing of the Reims Visitation becomes a turmoil of baroque folds, and the gentle face of the Reims Virgin is replaced by a plump, naturalistic face from a very different world—the world of Germanic expressionism, which was born at Bamberg (*fig. 339*). On the portal, the *Fürstentor*, the artist meant to endow the elect with the smile of Reims, but their expression can hardly be distinguished from the satanic grin of the

348 LORENZO MAITANI (Italian, ca. 1275 to 1330) *The Creation of Eve,* pier of the façade, Orvieto Cathedral. 1310 to 1316 A.D. Lorenzo Maitani was first and foremost an architect. He almost surely designed, at least, the reliefs on the piers of the façade of Orvieto Cathedral. The scenes from *Genesis* are narrated with economical but telling forms and gestures, expressed principally in terms of line, and the figures are not arranged in depth, but are strung along the surface as in a frieze.

349 ANDREA ORCAGNA *The Virgin Mary:* **detail of the Nativity, tabernacle of Or San Michele, Florence.** The quality and style of the sculptures on the tabernacle are rather uneven; the hands of less experienced assistants can be seen as well as traces of Andrea Pisano's influence. The relief is synthetic, all superfluous detail eliminated in order to render the feeling of space. Orcagna's style of naturalism has sometimes been called academic because it is rather hieratic and set.

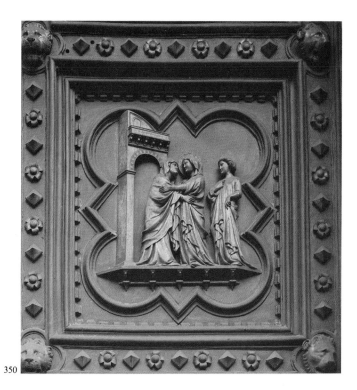

350

damned *(fig. 340)*. A few years later, sometime between 1249 and 1270, this naturalism came into its own in the west choir built by Bishop Dietrich at Naumburg cathedral *(figs. 338, 341)*. The iconographic theme is unusual; in a very Germanic show of feudal pride, twelve barons and baronesses from the Saxon Marches, early benefactors of the church, stand around the choir, among them the margraves of Meissen, Bishop Dietrich's own family. The stress on individualism and on psychological accuracy is remarkable, all the more so as these historical portraits are purely imaginary. The artist even gave one of them the face of a rogue because Timo was known to have been a traitor. In the Crucifixion on the choir screen, Mary is for the first time shown weeping at the foot of the cross, her face twisted in grief *(fig. 342)*. In the 14th century and until about 1430, German art begins to display that typical oscillation between the extremes of a somewhat affected feminine charm and a cruel expressionism—the eternal torment of the Germanic soul in search of equilibrium.

Set halfway between France and the heart of Germany, Strasbourg assimilated much more faithfully the spirit of Chartres and Reims, adding a touch of exquisite elegance to the latter style in the statues of the Church and the Syn-

agogue *(fig. 336)*, while the Germanic influence is more obvious in the expressions of the Virtues and Vices of the west façade. In the *Dormition of Mary*, south transept, the faces of the apostles are inspired by Chartres, but the supple drapery is typical of the "antique manner" once prevalent in the Meuse and Rhine districts.

Gothic Spain was more closely dependent on the French workshops. The most faithful imitation of the Chartres column-statues is to be found on the way to Compostela, at Santa Maria la Real de Sangülsa. By the 13th century artistic forms were no longer transmitted along the route followed by Compostela pilgrims. Public life had become laicized, and international exchanges were no longer dominated by monastic orders, but by political expediency. There were numerous exchanges at that time between Castile, strengthened by the *reconquista,* and France, for the French queen-mother was a Castilian. The great center from which the French Gothic style spread through Spain was Burgos Cathedral, whose workshop dominated Spanish art until the end of the 15th century. A master from Amiens sculptured the *Sarmental Portal*, where a Christ like the *Beau Dieu* gives his blessing, surrounded by archaic and awkwardly naturalistic symbols of the evangelists; clearly in those times of humanistic classicism, monsters were no longer acceptable. On the Coroneria Portal, whose composition shows considerable uncertainty, we find a noble *apostolado* also inspired by Amiens, and in the upper parts of the towers, monumental statues in the style of Reims. In the upper cloister, the statues of the founders, St. Ferdinand and Beatrix of Swabia, reflect mundane aspects of the Reims style. In León, the west façade has a porch with doors that seem inspired by the north and south transepts of Chartres, but the workshop used Spanish sculptors familiar with the new style and capable of working out artistic forms of their own.

In England there was little interest in monumental sculpture; tombs were the most original English productions of the 13th century.

Italian sculptors prolonged the Romanesque style well into the 13th century, particularly in Emilia. The Parma Baptistry shows the continuation of Antelami's workshop grad-

350 **ANDREA PISANO** *Visitation,* **detail of the south door, Baptistry, Florence. 1330 to 1336 A.D.** Andrea succeeds in composing his narrative scenes without concessions to the picturesque or to superfluous details which might have disturbed the overall balance. However, the very clarity and simplification of his presentations detracts from the rendering of spatial values. The linear style of the figures and the folds of the draperies clearly show a Gothic and French character.

352 **CLAUS SLUTER** (Active 1380 to 1406 A.D.) *Moses with two prophets,* on the "Well of Moses," Chartreuse de Champmol, Dijon. **1395 to 1404 A.D.** The Netherlander Sluter worked in a monumental, robust style that breathed new life into late Gothic sculpture, which had begun to degenerate into mannerism or academism. At Dijon he carved six life-size prophets to ornament the so-called Well of Moses. Treated with exceptional force, the strongly differentiated types accentuate the dramatic poses and reflect Sluter's ardour and intensity.

ually replacing Romanesque by Gothic. Elsewhere in the Parma area, in the Veneto, in central Lombardy, imported Gothic regressed towards Romanesque, or sometimes even became Byzantine. In southern Italy the Romanesque style was even more persistent, dominating the Ravello ambo as late as 1272; only the hint of a smile in the head surmounting the ambo shows some Gothic influence.

In Italy as in France, the new style appeared in districts other than those in which Romanesque art had flourished. During the second half of the 13th century, in painting as in sculpture, Tuscany assumed leadership of the cultural movement in the peninsula, creating the first really Italian style, a style that was one day to dethrone the Gothic even in France, where it had been born.

The sources of Nicola Pisano's art are obscure. Historians too facilely explain his style by citing a document stating that he came from Apulia. The literal imitation of the antique practiced by a few sculptors under the patronage of Frederick II of Hohenstaufen has left only the impoverished works from the Porta Capuana (Capua museum), and was probably as ephemeral an influence as the inspired policy of the Emperor himself, so progressive for his time that it was misunderstood. (The cruel Charles of Anjou, who became King of Naples in 1266, soon drowned in blood Frederick's dreams of universal harmony.) Those few examples cannot have influenced Nicola Pisano. The stamp of antiquity is so strong in his work that it can only have been impressed in Rome. It has been suggested that he was inspired by sarcophagi, but their real relationship to his art is not so simple; searching for antique forms Nicola Pisano found Early Christian sarcophagi that derived from them, but where could he have found, in either pagan or Christian sarcophagi, compositions as orderly as his reliefs on the Pisa Baptistry pulpit *(figs. 344, 345)*? Paradoxically, it is the rather confused reliefs on his Siena pulpit, under a different influence, that suggest the entangled compositions on late Roman sarcophagi. In 13th-century Rome so many relics of paganism still remained above ground that there was no need to dig for them. Nicola Pisano must have gone directly to the antique sources and not to the bastardized forms of Early Christian art. In the

latter he could have found no model for the Hercules representing Fortitude in the Pisa Baptistry—a magnificent study in anatomy, with the sex clearly represented, which exemplifies the marked difference in approach compared to French statuary, which always remained deeply religious: here only the theme is theological, while the spirit remains pagan.

Only in the Pisa pulpit do we find that revival of the antique relief, that interest in the corporeal reality of the human figure. Against a borrowed Gothic architectural structure the grandiose cadences of the reliefs and the quiet authority of the statues give an impression of strength that must be understood as springing from an underlying humanism very different from Gothic humanism, in which flexible bodies are

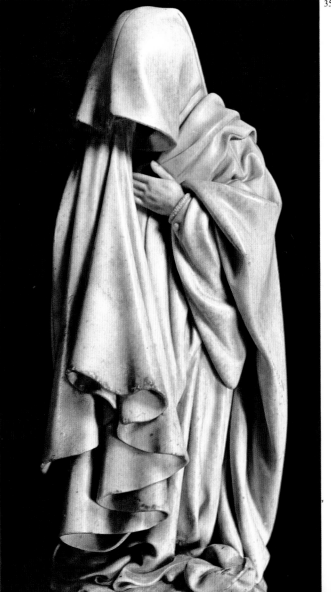

351

351 **CLAUS SLUTER** *A mourner,* from the *Tomb of Philip the Bold.* **ca. 1404 to 1410 A.D. Musée des Beaux-Arts, Dijon.** The sculptor had the original idea of transforming the traditional row of figures set in niches into a procession of mourners. Despite their small size they are works of remarkable monumentality. No volume is without function in the art of Sluter, and the powerfully built body beneath the rough homespun is clearly indicated. The figures realistically suggest the funeral cortege.

352

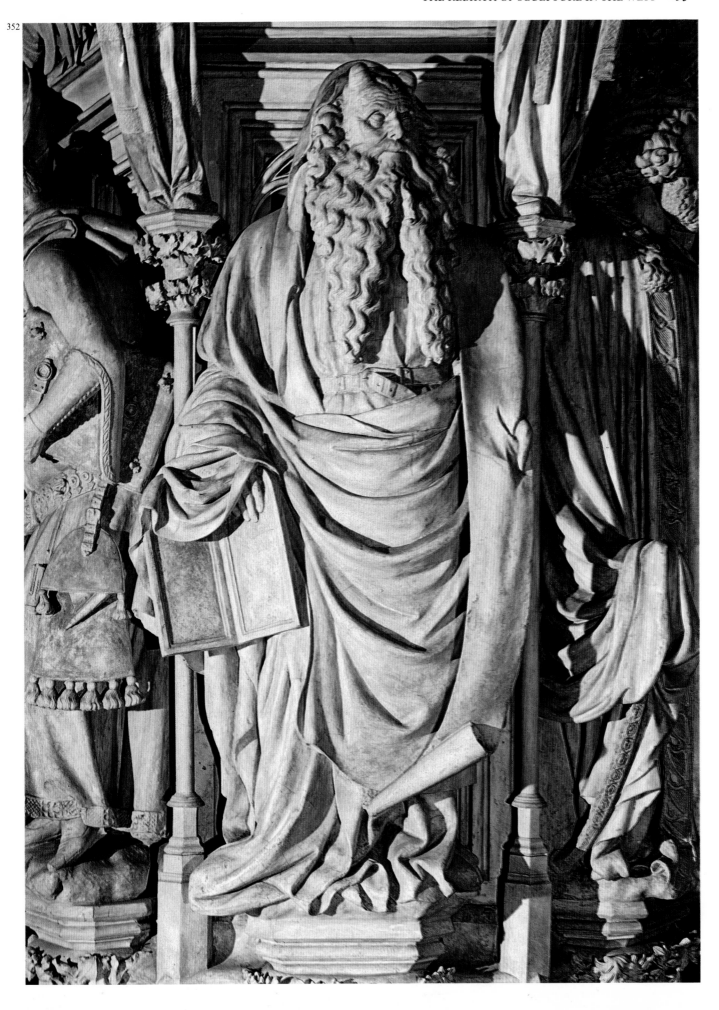

354

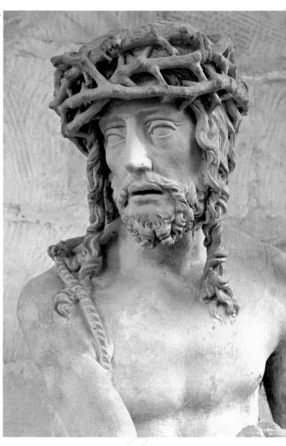

353

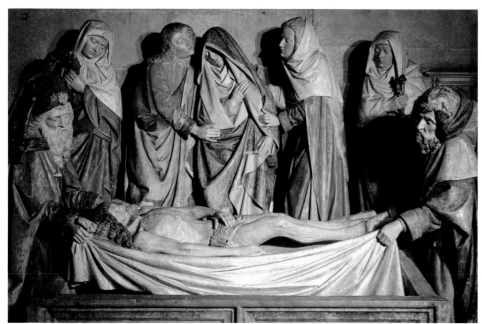

355

353 *Entombment,* **Church of Notre-Dame, Semur-en-Auxois. French, end of the 15th century A.D.** The theme of the Entombment was very much in favor during the 15th century. The Burgundian school represented it frequently and exploited all its tragic possibilities. The *Entombment* at Semur unites Sluter's realism and grandiloquence with more genuinely Flemish and even Rhenish influences. The French spirit of classical restraint governs the pathos and physical suffering, transmitted through the expressiveness of the angular faces and through the stiff fabrics.

354 *Christ at the Column,* **detail, church of St.-Nizier, Troyes. French, 15th century A.D.** During the 15th century Christians were constantly reminded of the Passion and death of Christ. This Christ presents a tortured face. Treated schematically in large planes, the forehead crushed by the crown of thorns, this is no longer the visage of a willing and lucid victim, but of a man tormented, scourged and beaten, whose bruised face is set in an expression of overwhelming pain.

355 **JAN BORMAN (Flemish, active 1479 to 1520 A.D.)** *Two scenes of martyrdom,* **detail of the St. George Altar from the church of Notre-Dame, Louvain. 1493 A.D. Royal Museums of Art and History, Brussels.** In the 15th century, the Flemish excelled in wood carving. The legends of the martyrs were among the favorite themes for their sculptured decoration, as can be seen in this typical work by Jan Borman. The essentially narrative style occasionally descends to coarse caricature.

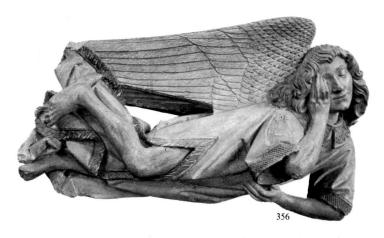

356 *Mourning angel.* **French, late 15th century. Museum, Semur-en-Auxois.** This is one of a pair of mourning and praying angels that no doubt once surmounted some Crucifixion or Entombment group. The harsh gestures and the angular limbs accentuate the angel's convulsive movements of sorrow and prayer. The drapery folds are used purely for effect and the full faces surrounded by thick hair recall Sluter.

356

357 *Pietà,* **church of Bayel (Aube). French, early 16th century A.D.** The school of Champagne provides another example of the change towards a less tense and fervid style at the end of the century. At the beginning of the 16th century, a workshop at Troyes became famous under the direction of an unknown master; it is known as the Workshop of St. Martha, after its masterpiece. The *Pietà* from the church at Bayel issues from this workshop. Choosing simplicity, the artist rejects all the facile developments permitted by the theme.

358 *Entombment,* **Abbey Church of Solesmes (Sarthe). 1496 A.D.** The *Entombment* at Solesmes was formerly thought to be one of the first works of Michel Colombe. This scene has certain elements that set it apart from both the Gothic tradition and the Early Italian Renaissance. The dramatic subject is treated with a reserve characteristic of the end of the 15th century. Suffering is completely interiorized, restrained with noble dignity. The disposition of the group is a masterpiece of balance, and invests the work with a remarkable monumental grandeur.

359 *The Magdalen,* **detail from** *Entombment,* **Abbey Church of Solesmes (Sarthe). 1496 A.D.** The sculptor's reserve in no way diminishes this figure's powerful realism. This *Magdalen,* her physical and spiritual sorrow transcended in prayer and by an act of faith, is one of the noblest expressions of Christian mysticism.

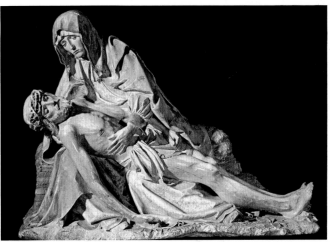

357

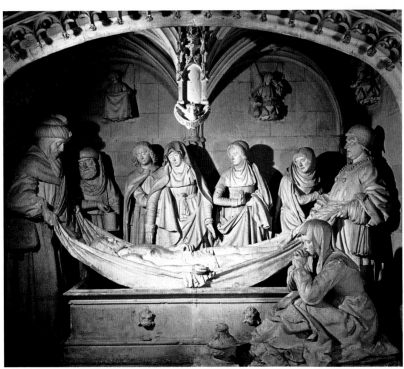

358

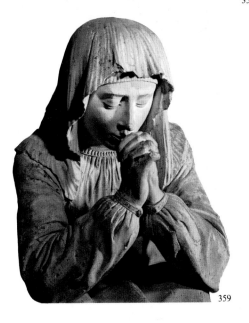

359

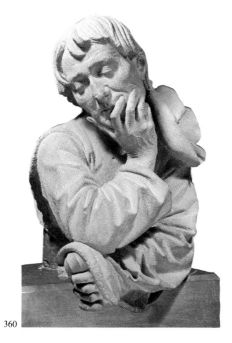

360

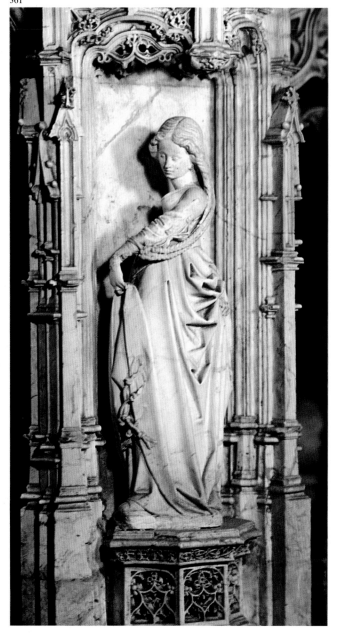

361

360 NIKOLAUS GERHAERT VAN LEYDEN (Dutch, active in Germany, 1463–1473). *Man meditating* **1462–1473. Musée de l'Oeuvre, Strasbourg.** Outstanding among the strong personalities directing the numerous sculpture workshops in the Germanic countries is an artist of Dutch origin: Nikolaus Gerhaert van Leyden. In this etched face and tensed hands the artist has succeeded in rendering the most intense inner emotion. The spirituality emanating from this physically stricken being demonstrates the wide scope of its author's talent.

361 CONRAD MEIT (German, ca. 1480 to 1550 A.D.) *Sibyl from the tomb of Philibert le Beau,* **Church of Brou, Bourg-en-Bresse.** One of the most beautiful groups of Flemish-style sculpture is to be found in the votive church of Brou. In 1506 the hapless Margaret of Austria built the church in memory of her husband. Jean de Room submitted the scheme for the sculpture in 1516; the complete scheme was finished in 1532, sculpted mainly by Meit. His art is extremely refined, and elegant gestures are balanced by ample patterns.

362 GREGOR ERHART (German, active first half of the 16th century A.D.) *St. Mary Magdalen.* **Wood, polychromed. Early 16th century A.D. The Louvre, Paris.** Little is known about this sculptor except that he was a native of Ulm who lived in Augsburg and died before 1540. His female figures combine a realistic elegance reflecting the tastes of the German bourgeoisie and a special sweetness of countenance: they appear to hold their breath, listening to the voice of God. Erhart collaborated with the older Holbein on the Kaisheim altarpiece.

molded by the soul. The Siena pulpit is entirely different from that at Pisa. The compositions are encumbered with a tangle of characters, curved folds replace the fluted folds of Pisa, the bodies are restless—the whole spirit is altered. This new style may be due to Giovanni Pisano, son of Nicola. His share in the Siena pulpit was important enough for him to have received a fee half as large as his father's. Surprisingly, the two pulpits are fairly close in date, that at Pisa having been completed in 1260 and that at Siena begun in 1265 and finished in 1269. Giovanni Pisano's birthdate is unknown, but when the Pisa pulpit was commissioned he was probably only a young apprentice. When he had become his father's main assistant a few years later, his personality was certainly strong enough to have influenced Nicola's style. In 1284 he undertook, alone, the pulpit in Pisa Cathedral, and in 1295 that of Sant'Andrea in Pistoia. Developing his own style, he remained aware of antique art, but rejected his father's limiting paganism; if we look at Giovanni's interpretation of the figure of Hercules, we see that his father's athlete has now undergone a course of asceticism, emerging as a lean hero

whose head suggests that of a prophet rather than that of a demigod. Giovanni had been converted to Gothic. How did he come in contact with it? Probably through ivories: the confusion of his compositions is understandable if they were an imitation of the scenes on ivories, narrative scenes intended to be read at close range. Entirely different from his father's, Giovanni Pisano's genius tended towards dramatic action. An apocalyptic vein runs through his work, twisting the shoulders, lowering heads, bringing passion to the faces. That is why his masterpieces are the Old Testament figures on the upper part of the façade at Siena *(fig. 347)*: they are even more prophetic and visionary than the sculptures of the Bamberg choir, and express a mood recaptured by Sluter, Donatello, and Michelangelo. Italy was to excel in the rendering of the suprahuman symbolized in the herculean power of bodies and the unleashed force of action. The dialogue between mother and child, which French sculptors had depicted with such human tenderness, became dramatic with Giovanni Pisano. The strange *Virgin of Prato* stares passionately at the young colossus on her arm; the draping of the heavy folds of her garment expresses the pent-up violence in her body. This Virgin is a direct precursor of Sluter's *Virgin* on the portal of the Chartreuse of Champmol. As at Champmol, Virgin and Child are linked in the same tragedy: that of the human condition.

Giovanni Pisano's tormented genius found no imitators, as though he had offered only an interruption in the true tradition of Tuscan art, represented in the second half of the 13th century by Nicola's style as it had appeared in all its purity on the Pisa Baptistry pulpit. Tino di Camaino and Fra Guglielmo, who made the Arca di San Domenico in Bologna, followed Nicola docilely; Arnolfo di Cambio, who had worked on the Siena pulpit, interpreted him more freely. At Orvieto Cathedral a talented artist, probably Maitani, assimilated Gothic flexibility and combined it with Hellenistic grace *(fig. 348)*. The lesson of nobility taught by 13th-century French art would have remained without sequel in Italy had it not been for Andrea da Pontedera, known as Andrea Pi-

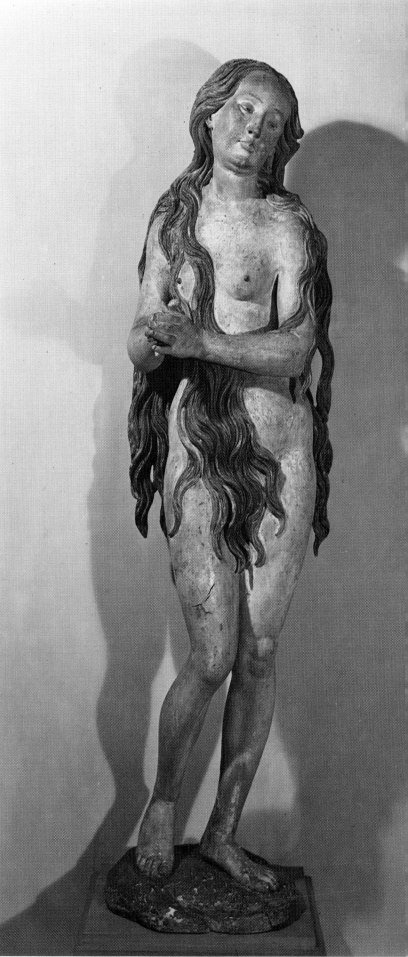

362

363 VEIT STOSS *Head of St. John:* detail of fig. 364. The paths by which Sluter's principles may have come to this German master are obscure, but Sluter's figure of St. John can be linked to the Franconian tradition of Nuremberg. Borrowing the powerful and vigorous plebeian types favored by the Gothic style, Stoss so transfigures them in this generous idealism that the craftsmanlike concern for exactitude and tiny detail is quite submerged in the overall emotional and plastic intensity.

363

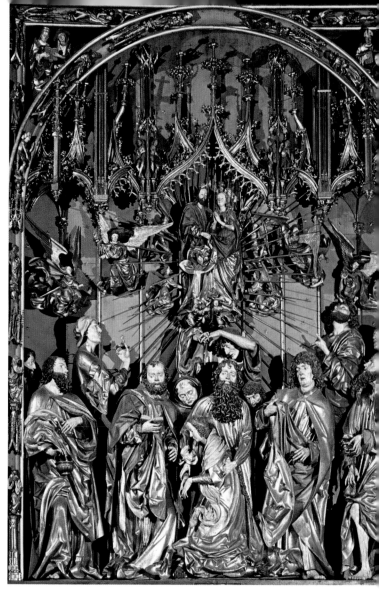

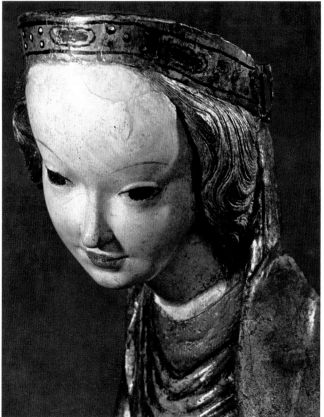

365

sano, who made the first of the bronze doors for the Florence Baptistry *(fig. 350)*. It took Italy one century to overcome both the Olympian humanism of Nicola Pisano and the dramatic instinct of Giovanni, and to assimilate finally the rhythmic cadences of Paris, Amiens, and Reims. This late assimilation was to become, three-quarters of a century later, the source of one of the great traditions of Italian sculpture, but during the latter half of the 14th century it appeared to dry up; Andrea di Cione, known as Orcagna, was as conventional in sculpture as in painting.

Northern Lombardy fostered families of architects and sculptors who, from the early Middle Ages to the 17th or even 18th century, handed down through the generations the traditions derived from abroad. From the 12th to the 14th century, the sculptors known as the *Maestri Campionesi* remained faithful to the massive Romanesque style, even when they attempted a few Gothic innovations. Nicola's style was

365 *Head of the Kruzlow Madonna.* **Poland, Cracow school, first quarter of the 15th century. Nardowe Museum, Cracow.** Gothic art reached Poland late, at the beginning of the 15th century, and succeeded best there in painted and carved altarpieces and polyptychs. In such "beautiful Madonnas" maternal love is idealized, and the Virgin's gentleness and sweetness translated by the rhythms of gentle curves and an ingenuous grace.

364 **VEIT STOSS** (German, ca. 1450 to 1533) *Dormition of the Virgin,* **central scene of the high altar, Marienkirche, Cracow. 1477 to 1489 A.D.** The largest altar made at the end of the Gothic period is the masterpiece of Veit Stoss. In this, the central panel, the Virgin's death and her reunion with her Son are depicted. Combining a primitive violence of emotion with mastery over the handling of forms, Stoss created an style that found imitations in Bohemia, Hungary, Poland and Transylvania.

brought late to the north, in the 14th century by the Pisan Giovanni di Balduccio, who worked about 1335 on the Arca di San Pietro Martire at St. Eustorgio in Milan. In the second half of the 14th century, the workshops of the colossal Milan Cathedral were initiated; they produced innumerable statues, fully Gothic, but of a purely formal style that in its worst examples was stereotyped into senility.

Like ancient art, Gothic represents a principle rather than a style. Romanesque art was born, reached its flowering, faded, and died within a relatively short period, without going beyond the limits of a style that would have ended in hollow rhetoric had it been prolonged. But the vital force within Gothic never died completely, and has had sequels in Western civilization until the 20th century. The possibilities of the Gothic style were so all-encompassing that it soon turned into its contrary. This is perhaps more obvious in architecture than in sculpture, for under the seemingly frivolous ornament, 15th-century religious buildings are more solidly constructed than the bold churches of the 13th. Only the study of the historical sequence and continuous evolution that links the serene French portals of the 13th century with the tormented sculpture of the 15th can explain how the one could have engendered the other, apparently its opposite—revealing the truth that Gothic art, like Greek art, contained within itself the limitless possibilities of life itself. (In 1913 the classical archaeologist Wladimir Deonna pointed to the analogous historical developments of Greek and of Gothic sculpture; both evolved from classicism to baroque. From this analogy Henri Focillon deduced the principles of a system of evolution leading from primitivism to baroque through the various stages of classicism, academism, and mannerism. But, as has already been observed in connection with prehistoric and primitive art, this process that he called "the life of forms" applies fully only to Greek and Gothic art.)

By the end of the 14th century in France, its country of origin, Gothic sculpture had become static and stereotyped, in spite of the new life infused by Flemish art, just then beginning to assert its individuality. Gothic inspiration seemed to have run dry when a Netherlander from a region previously barren of artistic talents took advantage of a fa-

vorable combination of circumstances to bring about the revolution needed to revive this dying style. Claus Sluter, working at the end of the 14th century at the Chartreuse of Champmol, built by the Dukes of Burgundy as their pantheon, liberated statuary from all architectonic limitations and gave it a new compactness and solidity. Through an almost theatrical exaggeration of gesture and expression, through acutely naturalistic observation, and through the force of action in the sculptured bodies, he gave his statues an intensely material presence, which Gothic art, for doctrinal reasons, had always avoided. That body which had been only an outer wrapping suddenly became a prime reality. The workshop formed at Champmol, which first executed the statues for the base of the Calvary *(fig. 352),* now called the "Well of Moses", for the church portal, and for the tomb of Philip the Bold *(fig. 351),* continued to be active well into the 15th century. It is now thought that Sluter's nephew, Claus de Werve, played an important part in the workshop, particularly in the making of the tomb of Philip the Bold: he probably not only carved but also designed the *pleurants* (mourners), in which dramatic feeling is brilliantly expressed by masses of drapery alone—for that is all that is visible in these figures.

During the 15th century, while the stone carver's art was evolving on the basis of Sluter's style, another style was developed in Flanders and in Brabant by the wood-carvers, transposing the style of Roger van der Weyden into relief. Their compositions are filled with a confusion of elongated, mannered figures quite unlike Sluter's powerful, massive forms; the draperies are broken by innumerable folds, and the background is tangled lacework. The most beautiful example of this Brabant style is in stone: the funerary church of Brou, at Bourg-en-Bresse, dating from the beginning of the 16th century *(fig. 361).*

The history of sculpture in northern Europe divided into these two currents, which sometimes mix. In France, the Brabant style invaded Champagne, where unknown artists carved some of the most moving expressions of the Passion; it was known also in Burgundy, clearly influencing the Semur Entombment *(fig. 353).* But Burgundy was the main center

of Sluterian art, which through the Rhone valley reached as far as southern France and inspired the Provençal school and the statues around the choir at Albi. Sluter's style also penetrated to the Loire region under the Bourbons and gave a solid foundation to the Loire school, which during the second half of that century created many wonderful works, buried in country churches and anonymous, and therefore less famous than many contemporary Italian statues of lesser artistic value.

After 1460 the Sluterian style was progressively softened, and religious imagery became less dramatic. Drapery was more supple, expression—even the expression of pain—less intense, physiognomic types were less individual, and the pathos more restrained—shown, in the French manner, by a concentration on inner life and not by its physical effects. As in the 13th century artists were attracted by femininity and again inspired by the group of the Virgin and Child; sculptors no longer selected models from the aristocracy but from the ordinary people, thus giving their characters a simple, human flavor, devoid of vulgarity and typical of French art.

A century of that tradition resulted in a masterpiece once attributed to Michel Colombe but now anonymous: the Solesmes Entombment, a liturgical work of profound and noble pathos (figs. 358, 359). Gothic art had gone back to its own source: the dead Christ with serene features has the same face as the *Beau Dieu* of Amiens.

In Germany, the Sluterian and the Flemish trends met and mixed in a tumultuous conjunction. A few artists, such as Nikolaus van Leyden, working in stone, tried to preserve the autonomy of the free-standing figure, but polychrome woodcarving invaded the whole of Germany, with the resultant reign of the *Zackenstil,* the "broken style," with cut-out, broken, involved forms reminiscent of the interlace of medieval Irish illuminators; the structure of a garment, for example, becomes impossible to decipher. In the works of Veit Stoss, Sluter's influence is still visible, through this entanglement, in the weight of the clothes and the depth of the heavy folds. A passion for naturalism introduced into the imagery the most vulgar popular types: cripples, idiots, deformed or diseased characters—medical specialists have delighted in diag-

nosing the various illnesses represented by Veit Stoss in his Cracow altar (*fig. 364*).

This *Spätgotik,* as the Germans term it, continued into the first third of the 16th century. Its dying gasp produced even more exaggerated works, like the Niederrotweil Altarpiece in which the draperies are tangled around the convulsed forms as if by a blast of madness. Expressionism, unrestrained, piles exacerbation on exacerbation and ends by destroying itself with its own excesses. Beyond a certain point, the only way to render the patient conscious of his soul is by torturing him: the Gothic German sculptor became a torturer of the form, which he cut up, clipped, and tore to pieces. Art was an outlet for his cruel instincts. This tendency to torture form is characteristic of schools of art that were not, like Italy, Flanders, or France, involved in the search for new forms, and on receiving forms from outside, they could only exploit them to "express" their own temperaments, eventually deforming them entirely.

Thus, that passionate century that in France ended in a renewed serenity, in Germany finished with torments. A Würzburg artist contributed a soothing melancholia to that tense style; the profound sadness of Roger van der Weyden was revived by Tilman Riemenschneider. Bent heads, long

367 **TILMAN RIEMENSCHNEIDER** *Assumption of the Virgin,* **central panel, altar of the Herrgottskirche at Creglingen-am-Tauber. Lime-wood. 1505 to 1510 A.D.** Riemenschneider's work comprises tombs, statues and furniture as well as church decoration. The Creglingen altarpiece is one of the last of those thorny, visionary compositions of the German Flamboyant Gothic style, and Riemenschneider was in fact the last of the great German altarpiece sculptors.

366 **TILMAN RIEMENSCHNEIDER (German, ca. 1460 to 1531 A.D.)** *The Virgin,* **detail from the Creglingen Altar (fig. 367).** Riemenschneider is one of the last great Gothic illustrators in a long line of painters and sculptors whose aim was to achieve sublime expression of the story of the Virgin. His manner is far removed from his colleagues' artisan harshness—often bordering on brutality. He had a gift for depicting the young, and particularly the youthful feminine figure.

368 *High altar* of the Cathedral of Toledo. Spanish, ca. 1498 to 1504. One of the loftiest expressions of Spanish art is to be found in monumental altarpieces. In the Toledo cathedral Flemish, German, and French schools are combined into a surprising Spanish mixture. This enormous polychrome and gold screen, with its proliferation of forms over which the gaze of the worshipper may wander endlessly, belongs to the very end of the Gothic tradition.

369 *Tomb* of Martin de Arce, Cathedral of Sigüenza. Alabaster. Spanish, 1486 A.D. 15th-century Castile saw the development of several schools originating in various influences. The type of tomb showing a reclining effigy was treated by a certain Master Sebastian, who succeeded Egas Cueman as the principal artist of the Toledo school. Carved by an unknown artist, the funerary monument of Martin Vasquez de Arce has all the characteristics of this style. The foliage decoration is still Gothic in style, and carved with great delicacy and precision.

369

noses, and emaciated features, lean bodies, draperies drooping as if dislodged, soft, sad Madonna faces, the pained gentleness of the Saviour—everything is a translation into wood of the ascetic imagery of Roger, who was the genuine founder of the Flemish style that, eclipsing the style of Van Eyck, invaded the whole of northern Europe and penetrated even to Spain.

In fact, 15th-century Spain seems a province of northern art. German, French, and Flemish artists all went there, attracted by workshops offering numerous commissions. We are not sure of the nationality of Gil de Siloë, who worked at at the Charterhouse of Miraflores, near Burgos, where he carved in wood the main altar, and in alabaster the tombs of Juan II and Isabella. According to some documents, he might have come from Antwerp. The style of the tomb, in which the garments of the Virtues fall in noble folds as do those of Sluter's figures, is very different from the style of the main altar—a triumph of the *Zackenstil*. In the latter, the mannered style reminiscent of 15th-century Germanic saints and madonnas suggests a German origin for Gil de Siloë. The Spaniards were to delight in huge, elaborate altarpieces set against the windowless wall of the *capilla mayor* in their churches. Not intended to be deciphered, but rather to rise like a permanent prayer in images, figures and details blurred by the twilight reigned over a sanctuary closed to the worshippers and glimpsed from a distance as a vague and mysterious glow of gold and colours. Such accumulations of forms appear as a mirage replacing reality.

Those huge altarpieces could be realized in stone as in wood. In the Isabelline style, architecture, covered with a network of sculpture, resembles some aspect of nature, a forest or a grotto. On the façade of the Colegio San Gregorio in Valladolid, even man reverts to nature and becomes hairy like a savage *(fig. 370)*. Wherever *Spätgotik* reigned, that is, in most parts of Europe, architecture admitted its failure by returning to natural forms: columns were replaced by trees, moldings by rocks. This tendency was particularly marked in Portugal, in the excesses of the Manueline style, artists desperately piling up creatures and plants, agricultural or fishing tools, as if they had lost all power of creating forms.

370 *Two Wild Men*, façade of the Colegio de San Gregorio, Valladolid. Spanish, 1486–1496. A number of "wild men" line the jambs of the façade of the Colegio de San Gregorio. Their iconographic meaning is uncertain. On this façade plant life is so ubiquitous that man appears to be assimilated into it, and merges into the decoration as he had done in Romanesque art. This represents the last burst of vitality in Spanish Gothic art, before the introduction of Renaissance motifs.

370

VIII
THE RENAISSANCE

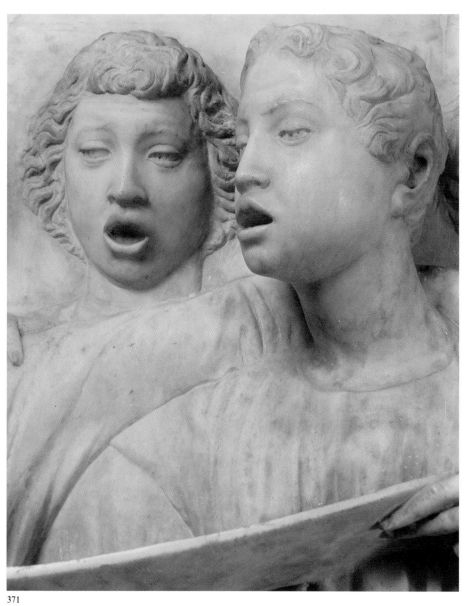

The course of Italian art, by nature highly inventive, was punctuated by returns to traditional sources whenever the development of new forms led it too far from those sources. In sculpture, its essential tradition is a grasp of the corporeal reality of the human body, which Italian artists—Guglielmo in the Romanesque period, Nicola Pisano in the 13th century, and Nanni di Banco in the Quattrocento—repeatedly sought in the art of antiquity. But at the beginning of the 15th century, after the Gothic style had run its course, it appeared possible to demand rejuvenation from the Gothic itself. Ghiberti, making the second door of the Baptistry in Florence, quite naturally looked at the door cast three-quarters of a century earlier by Andrea Pisano, and found there the principles of a classicism which Andrea had borrowed from French 13th-century art. For that reason Ghiberti has been considered a medieval artist. The author of an outstanding work on Italian sculpture, John Pope-Hennessy, has placed him in the volume devoted to Gothic while giving Donatello pride of place in the Renaissance volume. In reality, the distinction between Gothic and Renaissance is nowhere less operative than in Italy, even though it was the humanists themselves who invented it, and it must be set aside if we want to understand the spirit of Italian art. That distinction is particularly artificial if the criterion used to differentiate one style from the other is the degree of imitation of the antique. The Florentine sculptors who created the Renaissance style in the years before 1430 sought to imitate the antique, not as an end in itself (even if they themselves believed so), but as a means to find nature, which they considered to have been lost by medieval art. Such is the aim Alberti claims for sculpture in his *De Statua*: "to make works so that they resemble as much as possible the real bodies created by nature." Imitation of the antique did not always result in a closer resemblance to nature: Nanni di Banco's group of the *Quattro Santi Coronati* (*fig. 372*) is a mere pastiche of the ancient forms, and at the end of his short life he reverted to the Gothic style in the Porta della Mandorla of Florence Cathedral.

There are two ways to reach nature: through its essence, or through its reality. Ghiberti illustrates the former, and Donatello the latter; the former tends towards classicism, the latter towards what would be called naturalism, if that name had not been appropriated by a 19th-century concept alien to our present subject. Donatello based his formal research on an acute observation of nature, including a study of the nude and even of anatomy in corpses (though not through systematic dissection, which awaited Leonardo), to discover the structure, the rhythms of action, and the play of axes in the human body, so that he might bring that body to life in palpitating relief and vibrant contours. Ghiberti's bent towards the classical, on the other hand, enabled him to apprehend beyond all the singular features of the real form, which includes all the particular possibilities of a gesture or an expression. He had a predilection for drapery because it allowed him to exteriorize the rhythms of action and also to link together the various forms in a composition. For Ghiberti worked towards the total unity of his compositions; no artist after him knew how to create in reliefs a world so vivid, a world no less animated for being ruled by order; nobody could bring bronze to life as he did. With unsurpassed virtuosity he exploited the whole range of relief, from figures almost in the round in the foreground, to elements worked in very flat relief in the backgrounds, effectively suggesting infinite recession into depth. Donatello, on the other hand, was a maker of statues; creating isolated forms and studying the human body and the human soul, he gave "character" to all his creations, borrowing the faces of his prophets from live models. In all honesty, from the purely formal point of view, the reliefs from the Santo in Padua (*fig. 377*) and those of the north pulpit in San Lorenzo must be counted as semi-failures. He exploited the flattened relief, which Ghiberti had used to obtain nuances in perspective, to suggest a medley of pictorial effects that are actually anti-sculptural; and his perspective is unclear. The rhythm of a Ghiberti composition may be seized at a glance, after which the eye may dwell on its lively details; Donatello's relief forms are confused, less clear even than those of Luca della Robbia, as can be seen by comparing Donatello's doors in the old sacristy of San Lorenzo with Della Robbia's doors for Florence Cathedral. In fact, Donatello, always so precise in his statuary, eluded the

371 LUCA DELLA ROBBIA (Italian, 1399/1400 to 1482) *Singing Angels*, detail from a *cantoria*, 1431 to 1439. Museo dell'Opera del Duomo, Florence. In 1431 Luca della Robbia received the commission to carve a marble singing gallery for the Florence cathedral. His work includes ten reliefs depicting children singing and playing musical instruments, framed in architectural elements strongly reminiscent of Brunelleschi, if not actually designed by him. Discarding all remnants of the Gothic, Luca returned to a measured Classical style.

372 **NANNI DI BANCO** (Italian, active 1419 to 1451) *The Quattro Santi Coronati*, 1408 to 1413. **Or San Michele, Florence.** Although the theme of his works is always Christian, Nanni di Banco, who belonged to the first generation of Quattrocento Florentines, deliberately drew his inspiration from the antique. In the attempt to escape Gothic tendencies, he chose the path of formalism, and his proud and solemn figures stand firmly with a typically Roman dignity.

374 **LORENZO GHIBERTI** (Italian, 1378 to 1455) *Gates of Paradise*, 1425 to 1452. **Gilt bronze. Baptistry, Florence.** Called by Michelangelo the "Gates of Paradise" because of their sculptured themes and their great beauty, these doors mark the zenith of Ghiberti's art. Using all possible gradations of relief, he suggests deep space by combining flatly treated figures, in the distance, and figures in quite high relief, some of them almost fully in the round, in the foreground.

372

problems of relief by a *non finito,* or *bozzetto,* technique which appeals to us because we find it more "modern," but which hides a weakness. On the other hand, the free-standing statues by Ghiberti, his *St. John the Baptist* and his *St. Matthew* at Or San Michele, are admittedly conventional. Owing to a kind of instinct of sociability, he could conceive a form only in relation to another; he belongs to the same artistic family as Raphael and Mozart. He gave his full measure only in the third set of Baptistry doors, the *Porta del Paradiso* (fig. 373). Here he was allowed to discard the proposed division into twenty-eight small reliefs, a repetition of the scheme of the two earlier doors, which would have tied him to a limited space and few characters, and to adopt instead ten larger panels grouping several scenes in each relief; the new scheme gave his vision a much wider field, and allowed him to create a self-contained microcosm.

The two tendencies of Quattrocento Florentine sculpture are already visible in the two surviving works out of the seven entered in the competition organized in 1401 by the *arte di Calimala* for the second Baptistry doors. One, by Brunelleschi, represents the naturalistic style later adopted by Donatello; the other, by Ghiberti, to whom the contract for the

373 **GHIBERTI** *Self portrait,* **detail from the** *Gates of Paradise* (fig. 374). Already on the North Door Ghiberti had introduced a self portrait among the tiny heads in high relief at the corners of each plaque. He did it once again later, on the Door of Paradise, where he appears among the heads of the prophets which alternate with statues of biblical personages in the framework of the door. Here we can closely observe the remarkable skill of the metal sculptor. In the earlier portrait on the North Door, his face is still young and not particularly individualized, still very much subservient to antique models. Here, however, the depiction is entirely realistic, and he portrays himself as the intellectual with prominent facial features and wrinkled brow.

373

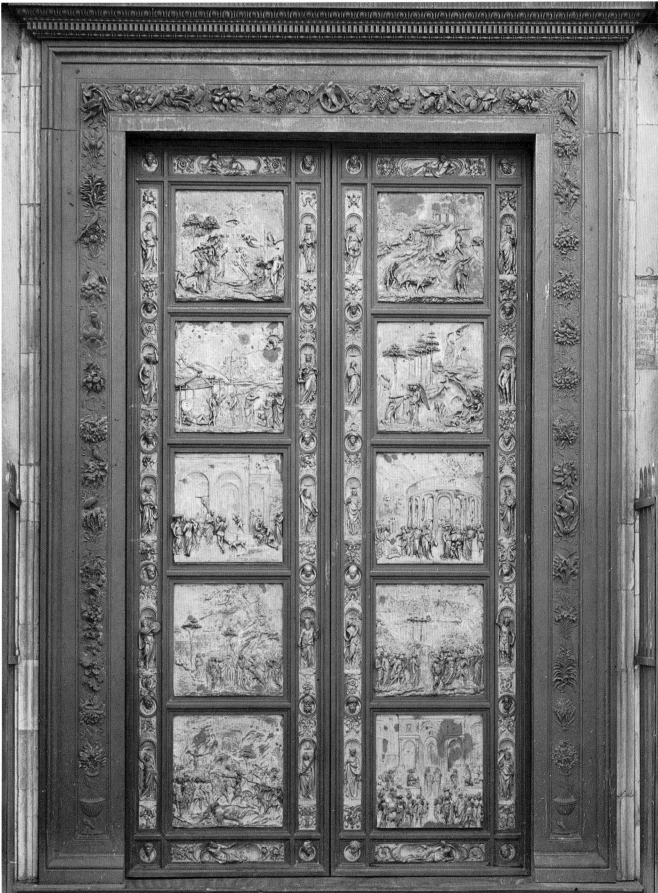

374

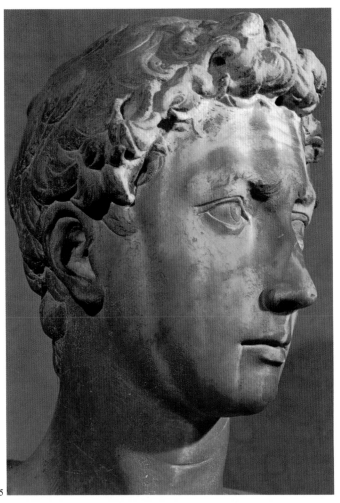

375

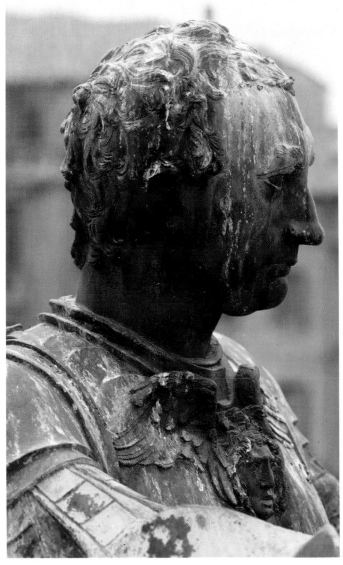

376

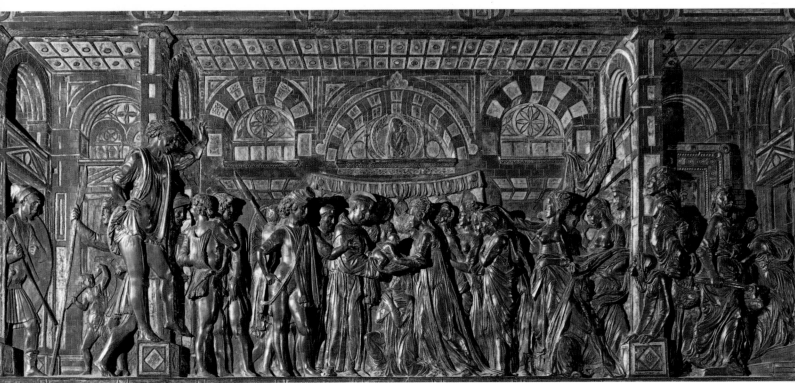

377

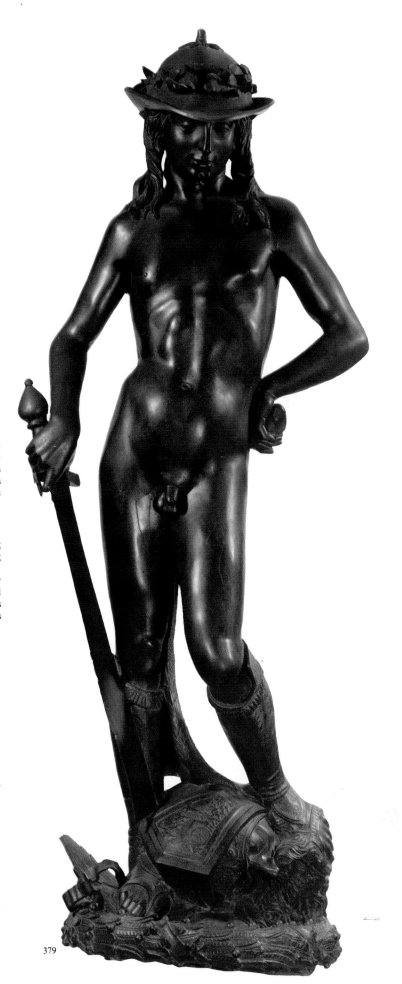

378

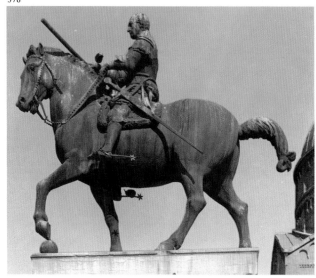

375 **DONATELLO (Italian, 1377 to 1446) Detail, head of *St. George*. Marble. ca. 1415 to 1417. Museo Nazionale, Florence.** The type of the young Christian warrior is perhaps taken from Byzantine representations, but the head is principally inspired by Hellenistic models. It is marked, however, with the pent-up energy characteristic of all Donatello's works. This is not an individual portrait like the pitilessly realistic ones which the artist was to create later, but rather a youthful symbol of controlled energy, an ideal Quattrocento soldier type.

376 **DONATELLO *Head of Gattamelata*, detail of fig. 378.** During the fifteenth century the equestrian statue symbolized reason overcoming the brute force of the animal. The tense-faced figure personifies the *imperator*, the leader of men. The kind of force that he embodies is very different from the savage violence of the Colleoni monument, sculptured later by Verrocchio on the model of Donatello's statue. Although it is treated with profound realism, this figure radiates intelligence as well as power.

377 **DONATELLO *Miracle of the Talking Babe*, high altar, San Antonio, Padua. 1446–1450.** In Padua, Donatello was asked to execute bronze figures and reliefs for the high altar of San Antonio; he finished them in 1450. In the reliefs for this altar, an electric emotional current sweeps through the swarming figures, which are often shown in drastic foreshortening, and reverberates in the vast architectural settings. In contrast to the harmony of Ghiberti, Donatello pushes his violent art to paroxysm, but the psychological and formal coherence is never lost.

378 **DONATELLO *The monument to Gattamelata*. Bronze. ca. 1450. Piazza del Santo, Pauda.** In executing this commission the sculptor shows his dedication. He seems to have decided by himself on the idea of an equestrian monument. The equestrian effigy had already been employed during the Renaissance to honor a hero, but Donatello infuses into it an intellectual energy and a mood of philosophical humanism that was unknown in earlier times.

379 **DONATELLO *David*. Bronze. ca. 1440 to 1442. Museo Nazionale, Florence.** Donatello's first David was a marble; later he returned to the same theme for the Casa Martelli *David*, and for this bronze *David* executed for the Medici family. Standing in a relaxed contrapposto, this *David* has a subtle, complex mannerism in its rather sharp and angular forms which contributes to the ambiguity of the representation. History and myth come together in a mysterious, almost esoteric climate, which was to be still more marked in the Amor-Atys.

379

doors was awarded, represents the more classical style. Brunelleschi abandoned sculpture for architecture, and it was Donatello who continued the experimental studies of humanity in all ages and with all expressions.

If one artist could be singled out to exemplify the prolongation of the medieval spirit in the Quattrocento, it would be Luca della Robbia. In his bronzes as in his facile, polychrome terra cottas, he remained within the limits defined a century earlier by Andrea Pisano, but his art is softened by the influence of Fra Angelico, whose mysticism he changed into piety—a transformation similar to that which Memling wrought in the art of Rogier van der Weyden. Jacopo della Quercia, in contrast, through his dramatic intensity and his powerful rendering of the human body, took the first step on the road to Michelangelo's tragic humanism *(figs. 381, 382)*.

In Florence in the first part of the Quattrocento, sculpture was the pioneering art. It was not until around 1425 that painting embarked upon the "modern" style, reaping the benefit of experiments already realized in sculpture; it remained dependent on sculpture, so much so that certain painters, Andrea del Castagno, or later the Paduan Mantegna, created pictures illusionistically imitating reliefs. Architecture was slower still to develop, and it was the painters who first experimented with classicizing architecture in the backgrounds of their pictures. For twenty-five years the sculptor bore the responsibility of creating new forms. His art was now once more autonomous, emancipated from architecture and even commanding it: it was the sculptors, not the architects, who invented the tabernacle niche for statues, and from them came the new type of funerary monument, the baldachin tomb decorated with reliefs whose iconography celebrated the virtues of the dead "hero" in a manner more pagan than Christian. Venice took that idea further and made the tomb into a triumphal arch.

The architect gave an important place to sculpture until the end of the century, when Bramante, at the *Canonica* in Milan, following the path marked out by Brunelleschi in San Lorenzo and Santo Spirito in Florence, rationalized architectural design and restored to the architectural orders the place they had occupied in antiquity. The sculptor's art flourished especially in the decorated pilasters and capitals which, inspired by antiquity, offered a great variety of imaginative forms. The finest are those in the sacristy of Santo Spirito in Florence, made by Giuliano da Sangallo, who himself sculptured the ornament for the buildings he designed. Throughout the 15th century sculptors enjoyed experimenting with a decoration inspired by antiquity and exhibiting this richness of invention reminiscent of the Gothic period. Antique grotesques, discovered in the last third of the century, also inspired artists; schools of decorators were formed in Florence and Rimini, then in Milan and Venice. The purest forms are found in the castle of Urbino, created by teams of decorators from Florence and Rimini. This inventiveness came to an end when the austere regulation of the architectural orders eliminated figures from the ornament.

The new conceptions of the funerary monument, which tended to make an antique-style hero of the deceased, revived a type of commemorative monument that had virtually disappeared since antiquity: the equestrian statue. It is true that during the 14th century sculptors in Verona, Venice, and Milan had represented a man on a horse, but the horse was only a lifeless accessory. At the funerals of *condottieri* the catafalque was often decorated with an equestrian statue made of some temporary material; Jacopo della Quercia made such a statue in Siena for the burial of Giovanni d'Azzo Ubaldini, and Vasari describes the making of it in great detail. Agnolo Gaddi also made one in Florence for the funeral of Piero Farnese in 1390; it was soon destroyed, and so it was decided that Piero Farnese and his companion, Sir John Hawkwood, should be commemorated in Florence Cathedral by frescoed images, also commissioned from Agnolo Gaddi. A quarter of a century later the Gothic painting of Sir John Hawkwood seemed out of fashion, and in 1436 the young Paolo Uccello was asked to renew it; wanting to give the illusion of a statue in bronze, he painted it as a kind of monochrome, a demonstration of the geometry of illusionistic perspective. Uccello had already been in Venice and seen there the 4th-century horses of San Marco, which he used as models for his own horse. A marble equestrian monument planned in 1435 for the condottiere Niccolò da Tolentino in

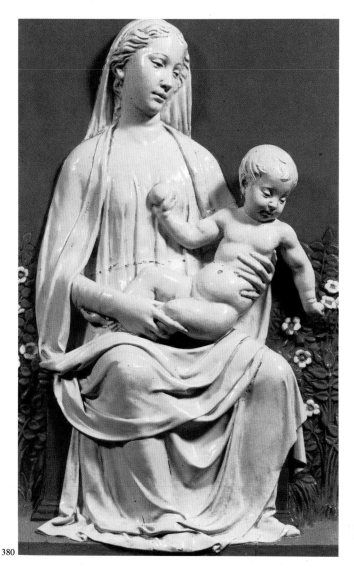

380

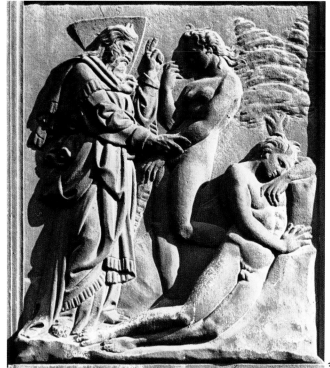

381

380 LUCA DELLA ROBBIA *Virgin and Child.* **1450–1460. Museo Nazionale, Florence.** Luca della Robbia is best known as the founder of a flourishing workshop that produced enamelled terra cottas. The Virgin and Child are united by a gentle and relaxed affection. The group stands out in front of a rose-garden which reveals the naturalistic taste of Luca, particularly noticeable in the garlands of fruit and flowers that often decorated his reliefs.

381 JACOPO DELLA QUERCIA (Italian, ca. 1374 to 1438) *Creation of Eve,* **central portal 1425 to 1438. San Petronio, Bologna.** This episode of Eve's creation, captured at its most serious moment, does not have the radiant lyricism of Ghiberti's art: two massive, naked bodies balance the dramatic figure of God, who is dressed in a vast mantle with heavy angular folds. The intensity of feeling is conveyed in the heavy forms, whose shapes and proportions are distorted for the sake of expression.

382 JACOPO DELLA QUERCIA *The Christ Child.* **Detail from a Madonna with Saints, 1425. San Martino, Siena.** Although wooden statues were rare during the Quattrocento, their production continued throughout the Renaissance in Siena, and this work belongs to the Sienese tradition. Weaknesses in the handling of form demonstrate that the saints of this group were carved by the workshop, but the Madonna and Child can be attributed to the Master himself. The Gothic folds offer strong contrast to the solid forms of the child.

382

Florence Cathedral was not executed—no doubt because of lack of money—but it was partially realized twenty years later in a monochrome fresco by Andrea del Castagno, quite similar to Uccello's.

Painters, as we can see, preceded sculptors in exploiting the equestrian theme. In 1444 in Ferrara, Lionello d'Este commissioned a statue of his predecessor Niccolo, but we do not know what it looked like, for although it was put up in 1451, it was destroyed in 1796. It was the work of Baroncelli and earned him the nickname Niccolo del Cavallo. Pisanello, on medallions and in paintings and sketches, brought his considerable skill to the rendering of the horse; the horses tossing their heads in the fresco of Sant'Anastasia in Verona are very lifelike. The earliest equestrian statue to have survived is that of Erasmo da Narni, called *il Gattamelata*, captain-general of the Republic of Venice, who died in Padua in January 1443. Donatello was then in Padua working on the main altar of the church of St. Anthony. A statue was commissioned from him, first intended as a funerary monument to stand inside that church. But the monument, completed

in 1450, was erected outside, in the square *(figs. 376, 378)*. It is usually said that this work was inspired by the horses of San Marco and by the Marcus Aurelius now on the Campidoglio in Rome. Those monuments could have given the artist only a very general idea for his equestrian statue; Donatello did not start from the antique, but worked from nature to recapture the antique, and both man and horse are the result of intensive study. The group gives the impression of self-assured power, of a strategist whose clever manoeuvres have won him victory. Although the general is wearing armour, he is represented bareheaded, like the *Imperator* in a triumph, and intelligence radiates from his uncovered forehead. Later, in Venice, Verrocchio portrayed the Colleoni as a tense warrior gathering up the reins before launching his mount into battle; this is not an *Imperator,* but a bully. These two statues express the divergent theories of war held by opposing factions named after two famous *condottieri,* the *bracceschi* and the *sforzeschi.* The former believed in strategy, the latter sought victory in unexpected, violent action. Verrocchio's quasi-romantic statue is inferior to Donatello's se-

383

384

385

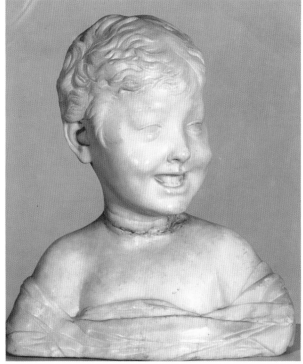

386

387

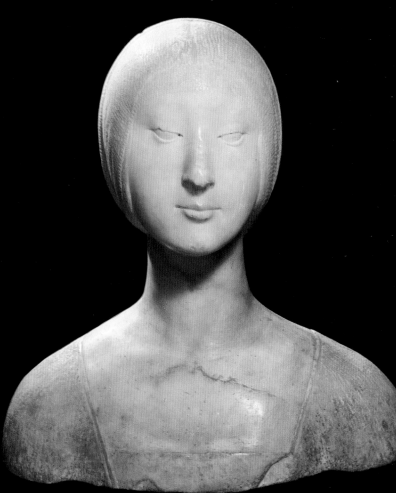

383 ANTONIO ROSSELLINO (Italian, 1427 to 1479) *Monument of the Cardinal of Portugal.* 1460 to 1466. **San Miniato al Monte, Florence.** In 1444 Bernardo Rossellino had carved the tomb of Leonardo Bruni in Santa Croce. This sculpture, more suggestive of pictorial effects, is less dependent on the architecture than that in Bruni's tomb. Its vividness and movement free it from the wall.

384 ANTONIO ROSSELLINO *Angel,* detail from fig. 383. Rossellino tends not to represent figures in movement. The design owes its animation largely to the masterful complexity of the elegant folds worked into the draperies of the two flying angels and of the two angels alighting on the tomb.

385 BENEDETTO DA MAIANO (Italian, 1442 to 1497) *Bust of Pietro Mellini,* 1474. Marble. **Museo Nazionale, Florence.** Like Ghirlandaio, Benedetto belonged to a generation for whom the great problems of the 15th century were already solved, and he attained a technical skill that makes him one of the most accomplished artists of the end of the century.

386 DESIDERIO DA SETTIGNANO (Italian, ca. 1430 to 1464) *Laughing child.* ca. 1450 to 1460. Marble. **Kunsthistorisches Museum, Vienna.** The combination of insolence and childish innocence here is the mark of a new and less heroic generation working for a cultured middle class. Desiderio explores the textures and evanescent surface changes with miraculously soft modelling.

387 FRANCESCO LAURANA (Italian, ca. 1430 to ca. 1502) *Eleanora of Aragon.* Marble. ca. 1467. **Museo Nazionale, Palermo.** The young Francesco Laurana did this bust of Eleanora of Aragon for her tomb in the cloister she had founded. The art of Laurana attained its highest expression in his portraits of women, using a style of extreme purity of line.

388 BERTOLDO (Italian, ca. 1420 to 1491) *Bellerophon.* **Bronze. ca. 1480 to 1485. Kunsthistorisches Museum, Vienna.** A pupil of Donatello, Bertoldo specialized in small bronzes, statuettes, plaquettes and medallions. The Bellerophon, one of his three signed works, has a vitality beyond mere placid imitation, although the treatment is somewhat hesitant. Bertoldo's main merit was his cultural influence as a de'Medici curator.

389 ANTONIO POLLAIUOLO (Italian, 1431/32 to 1498) *Arithmetic,* **relief from the Tomb of Sixtus IV. ca. 1490 to 1493. Vatican Grottos, Rome.** After the death of Sixtus IV (in 1484), Pollaiuolo journeyed to Rome to execute a bronze tomb, which he signed in 1493. In the series of the ten Liberal Arts Antonio attained the balance of mature years. Among the compositions best illustrating this final harmony is the young woman Arithmetic.

rene group, which has never been equalled. Leonardo resumed the theme of a man on horseback, calmly triumphant or caught up in the thick of action. In a first version of the monument to Francesco Sforza, he posed himself the problem of bringing equilibrium to a rider on a rearing horse. His numerous sketches for this group inspired a host of statuettes, but like most of the attempts of that experimenter of genius, they came to nothing, and sculptors dropped the theme of the equestrian statue until the Mannerist period.

Youth was one of the favorite subjects for Early Renaissance sculptors. Luca della Robbia and Donatello competed on that theme on the two *cantorie,* or singing galleries, for Florence Cathedral, now in the museum of the Opera del Duomo *(fig. 371).* Luca's figures are a too-literal imitation of living models, but Donatello, in the frenzied dancing of his *putti,* expresses the dynamic vitality of Eros, symbol of universal life. The *putto,* his creation, was destined to grace all the monuments of the end of the century, bearing garlands, inscriptions, or medallions, as an Eros or as an infant angel. Around those naked children are robed angels (the specialty of the Rossellinos, particularly Bernardo), youths in the flower of adolescence, who flutter or alight, holding candelabra around a tabernacle *(figs. 383, 384).*

The resuscitation of the portrait bust cannot be credited to Donatello, as it once was: the earliest works of that kind to reach us are those portraying Piero de' Medici (1453) and Niccolò Strozzi (1454), by Mino da Fiesole. Reviving an ancient procedure described by Pliny, the Florentines took plaster casts from life; often the result was a gross naturalism that defeated its own purpose, for art and nature are two different things and the former can only render the latter (when it aims to) if it interprets reality in a manner appropriate to itself. Those portraits are indeed lifelike—but "horribly so," as Cézanne would have said. They force us to see as ordinary persons, not only physically imperfect but also characterless, those Florentines whom we imagine as princes of the spirit. Portraiture represents the false note in Italian Quattrocento sculpture. The only genuine character studies are Donatello's prophets for the Campanile, which retain from the living models only what outwardly expresses

the inner soul. Sculptors were not sure how far down they should represent the bust: they sometimes took it right down to the waist, showing too much of the arms, which looks awkward. The busts of laughing children by Desiderio da Settignano are affected *(fig. 386),* and female portraits were no better than those of the male; Francesco Laurana's are the exception *(fig. 387).*

In the second half of the century, the famous Florentine *soave austero* degenerated into academicism; grace turned to affectation, realism to vulgarity. Verrocchio and Pollaiuolo, trained as goldsmiths, were sidetracked into surface effects; Donatello's near-pagan art produced as its offspring the bronze statuettes of Bertoldo *(fig. 388)* and Pollaiuolo, and the Venetian Riccio, that are pastiches of the antique, or sometimes even attempts to fake it; they are mere collectors' curios.

Siena made its contribution to the Florentine relief production with Agostino di Duccio, who worked on the decorations of the Tempio Malatestiano in Rimini. To the Florentine definition of contour he added a sort of Gothic dryness characteristically Sienese. His talent was for line, and relief for him was only a pretext for surface undulations and linear variations reminiscent of 12th-century French Romanesque art, which gave his figures a feverish liveliness. However, until the 16th century Siena also sustained her tradition of polychrome wooden statues, deriving from the art of Nino Pisano in the 14th century and attractive in their archaism.

Artists from Florentine workshops continued to spread the new style all over Italy. At the beginning of the 16th century the style exported by Florence was a sort of classicizing formalism, probably influenced by Leonardo; Andrea Contucci, known as il Sansovino, took it to Genoa, Rome, and Loreto; reaching Sicily, the style was kept up for a long time by the Gaggini family.

Lombardy modified the Florentine style in the most interesting way by interpreting it as Gothic. Accustomed to consider sculpture as an applied decoration on buildings, the Lombards deprived that art of its autonomy, its very essence, and treated it as ornamentation. In this spirit Amadeo, architect and sculptor, designed the Colleoni Chapel in Ber-

390 ANTONIO POLLAIUOLO *Hercules and Antaeus.* **Bronze. ca. 1475 to 1480. Museo Nazionale, Florence.** Pollaiuolo had already illustrated the struggle of Hercules against the giant Antaeus in one of a series of paintings done for the Medici about 1465. A decade later, he returned to the same theme, in bronze, introducing to sculpture a subject which was to be treated often during the 16th and 17th centuries.

391 ANDREA DEL VERROCCHIO (Italian, 1435 to 1488) *David.* **Bronze. ca. 1475. Museo Nazionale, Florence.** This work strongly resembles Donatello's but is without the inward, mysterious feeling of Donatello's statues. It was intended to be seen about eye-level, from the height of its base. Verrocchio's training as a goldsmith is revealed in the refined finish of details and the elaborate forms of Goliath's head.

388

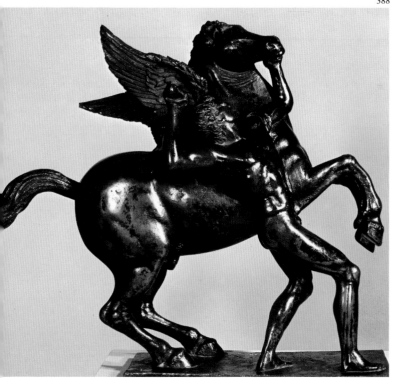

389

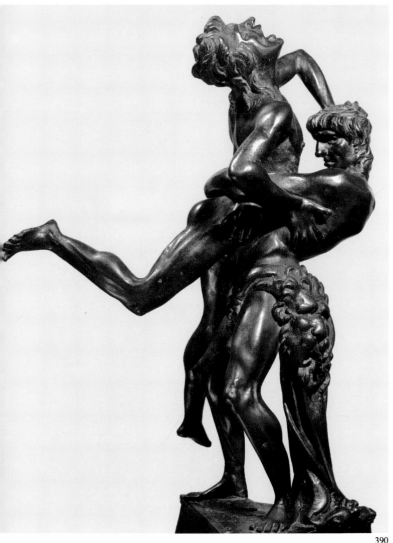

390

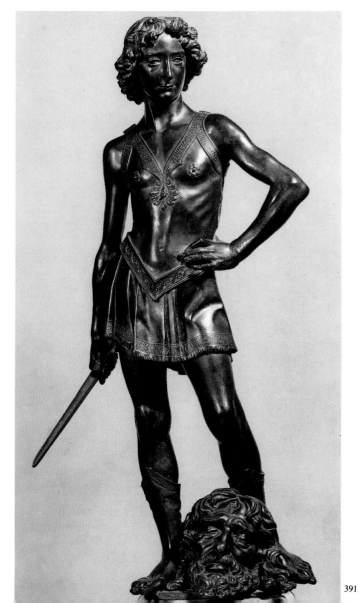

391

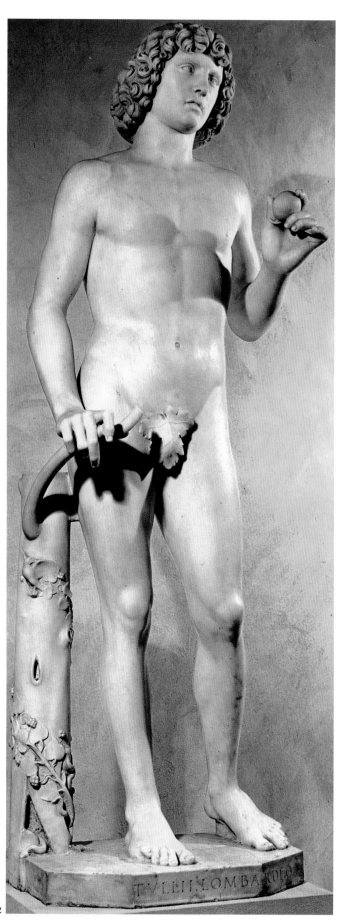

392

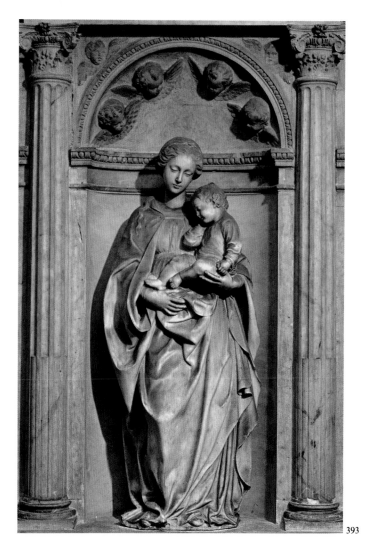

393

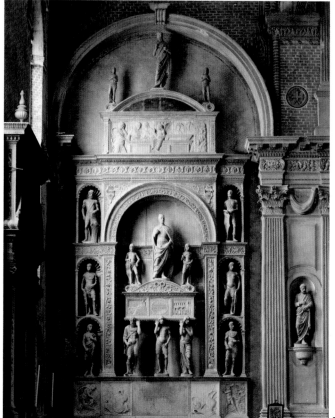

394

392 TULLIO LOMBARDO (Italian, ca. 1455-1532) *Adam.* **Marble. ca. 1495. Metropolitan Museum of Art, New York.** About 1495, Tullio Lombardo finished the monument of Doge Andrea Vendramin; it is now in the church of Santi Giovanni e Paolo in Venice. The statues of Adam and Eve adorned the lower niches of the high wall tomb. All the figures on the monument show a study in depth of the antique. In his Adam the artist has united the influence of a head of Antinous with that of a body of Apollo.

393 ANTONELLO GAGGINI (Italian, 1478 to 1536) *Madonna del Buon Riposo.* **Marble. 1528. Museo Nazionale, Palermo.** Antonello Gaggini, the finest Sicilian sculptor of the sixteenth century, carried on the traditions of his father, Domenico. There is a rather conventional sweetness in Antonello's earlier works, but at the height of his career he achieved a more convincing expression.

394 PIETRO LOMBARDO (Italian, ca. 1435 to 1515) *Monument of Pietro Mocenigo.* **1476 to 1480. SS. Giovanni e Paolo, Venice.** Pietro Lombardo was a Venetian architect and sculptor; he presumably completed his training in Florence. He specialized in funerary monuments. In his last one, completed in 1480, he returned to a scheme that had been used in the Gothic period, placing the deceased under an arch.

395 *Façade of the Certosa.* Pavia. The façade of this Carthusian monastery was contracted for in 1473 from the brothers Cristoforo and Antonio Mantegazza. The following year a half-share of the work was allotted to Giovanni Antonio Amadeo. With its abundance of sculptures, set off by the contrasts of white, red and green marble in the decorative bands, the façade is the most perfect example of the 15th-century Lombard decorative exuberance.

gamo, its facade a jumble of polychrome marbles and decorative and figurative sculpture. The huge workshop of the Certosa of Pavia, begun about 1464, became one of the main centers of the Lombard style; through the works of the Certosa shop, and not through good Florentine examples, the Renaissance was revealed to northern European artists—still Gothic spirits, to whom the Lombard mixture was, in any case, more comprehensible than the revolutionary Florentine experiments. The decoration of the Certosa, begun in terra cotta in the cloisters, was continued in marble for the interior of the church and the façade *(fig. 395)*. The latter is entirely covered with columns, candelabra, foliated scrolls, classical ornamentation, statues and reliefs, with no interval of wall left bare; it is neither architecture nor sculpture, but an enormous piece of goldsmith's work. Amadeo worked on it with the brothers Mantegazza, who influenced him. Renaissance art interpreted through this exaggerated Gothicism resulted in an anti-classical mannerism anticipating by more than half a century the strained art of Alonso Berruguete. Imported from Lombardy into Venice, this style mixed with direct Florentine influences and became more subdued under the impact of ancient inspiration, still alive there. Tullio Lom-

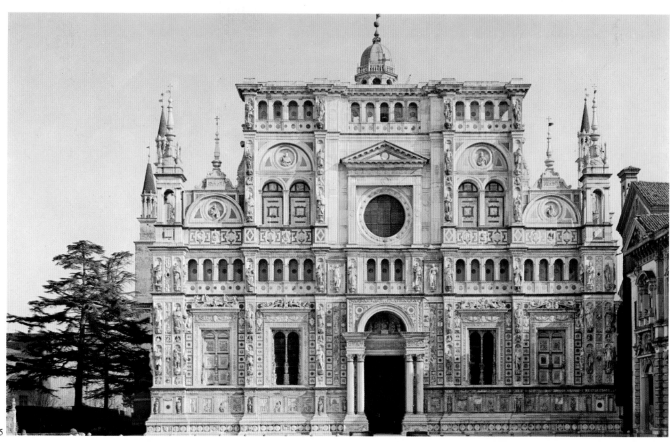

395

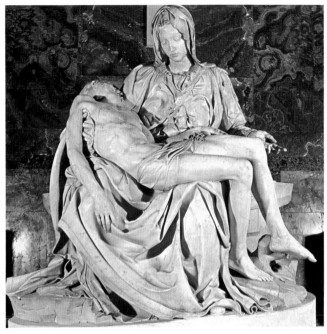

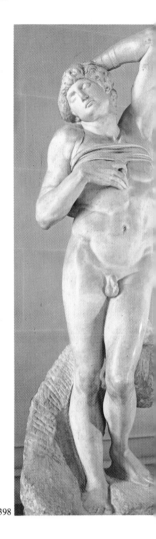

396

397

398

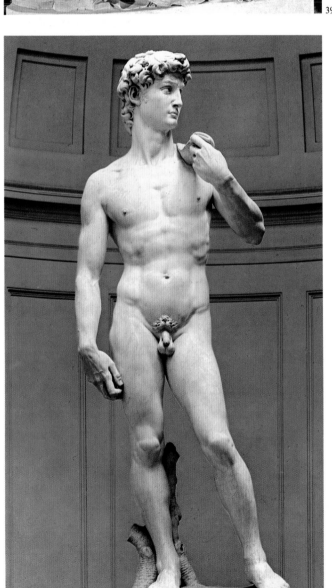

396 MICHELANGELO (Italian, 1475 to 1564) *Pietà.* **Marble. 1499. St. Peter's, Rome.** Commissioned from Michelangelo during his first Roman sojourn, this *Pietà,* done just after the Bacchus, is the artist's only signed work. Here, contrary to tradition, she does not gaze at her Son's face; with downcast eyes she submits to the Divine will, offering the Divine sacrifice with a gesture of resignation. Leonardo's influence appears in the gentleness of the face and in the firmly built pyramidal composition turning around a core, while the perfectly polished marble figures, especially the Madonna, belong still in the refined tradition of the Florentine Early Renaissance sculpture.

397 MICHELANGELO(?) *Crucifix.* **Sacristy, Santo Spirito, Florence.** Serious considerations have led art historians to identify this work found in the sacristy of Santo Spirito with the wooden cross mentioned by early writers as having been carved by Michelangelo in 1492 for the prior of that church. The way the head and legs are treated in contrapposto suggests a search for classical harmony. The extremely soft modelling of Christ, his tender facial expression and the complex anatomical structure have no counterpart in any of Michelangelo's youthful works, and some critics have reservations about its attribution to him.

398 MICHELANGELO *Dying slave.* **Marble. 1515 to 1516. The Louvre, Paris.** In 1505 Michelangelo was summoned to Rome by Julius II, who commissioned from him a grandiose tomb destined to stand in St. Peter's. But the artist was forced to limit its scope gradually, until, many years after the Pope's death in 1513, and after at least five different projects, the matter was settled in 1545 with a much reduced design. The two Louvre slaves belong to the second design, from 1513. They probably symbolize the imprisoned human soul.

399

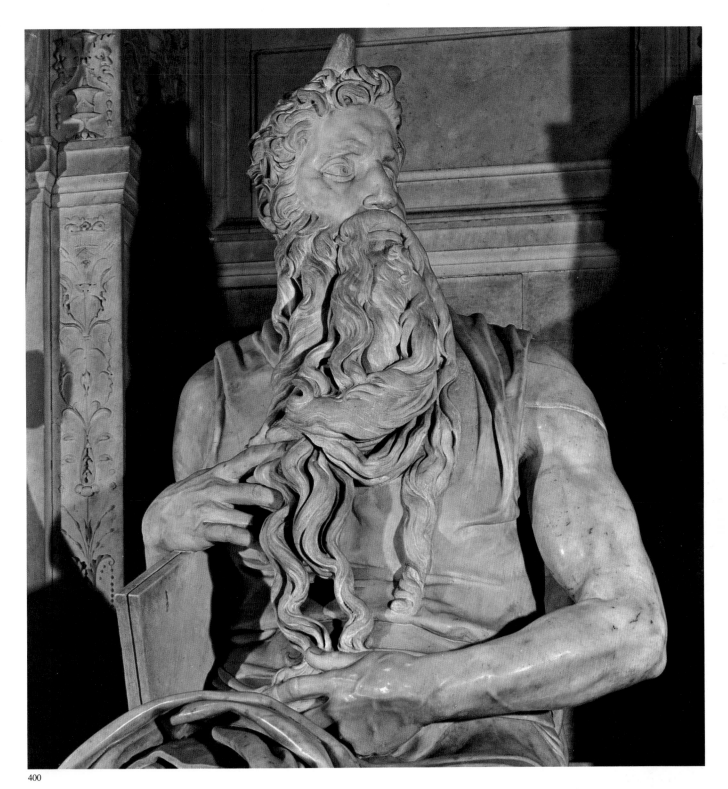

400

399 **MICHELANGELO** *David*. **Marble. 1501 to 1503. Accademia, Florence.** A great marble block partly cut into by Agostino di Duccio was finally allotted to Michelangelo. In this heroic *David*—Michelangelo's version of a figure who had long symbolized the Florentine republican ideal—are expressed the *fortezza* and *ira* traditionally associated with Hercules. The duality between the classicizing ideality of the figure type and the inner spiritual tension is paralleled in the contrast between the calm stance and the nervous movements of arm and of the head.

400 **MICHELANGELO** *Moses*. **1515 to 1516. S. Pietro in Vincoli, Rome. Marble.** The *Moses* was executed for Michelangelo's second project for the tomb of Julius II. Inspired perhaps by the medieval conception of man as microcosm, he brought together the elements in allegorical guise: the flowing beard suggests water, the wildly twisting hair fire, the heavy drape earth. In an ideal sense, the *Moses* represents also both the artist and the Pope, two personalities who had in common what is known as *terribilità*.

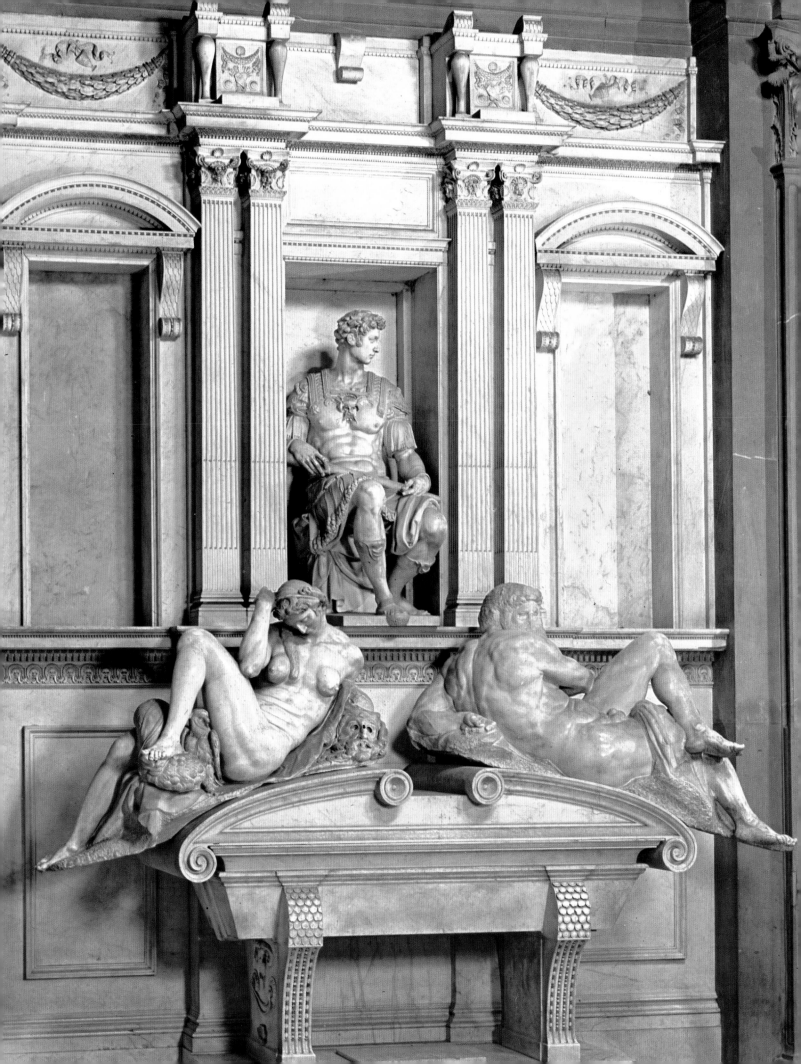

401 MICHELANGELO *Tomb of Giuliano de' Medici.* **ca. 1525 to 1530. Medici Chapel, San Lorenzo, Florence.** Michelangelo accepted the commission for the Medici Chapel in 1520, but the statues of the dukes were not installed until 1559 and the whole work remained incomplete. The artist was influenced by Brunelleschi's Sagrestia Vecchia, but he interlocked the architectural elements so as to produce in the interior untraditional dynamic tensions that are released only in a vertical sense.

bardo's *Adam (fig. 392)* announces Michelangelo's *Bacchus*, from which it seems less removed in time if we consider that in 1493 Tullio was still working on the Vendramin Tomb, for which he made the Adam, while the Bacchus was made between 1496 and 1501. In the whole of Italy at that time, no artist had so closely imitated the antique.

Antonio Rizzo, Pietro Lombardo, and Tullio Lombardo developed the funerary monument in the direction of the ancient triumphal arch, creating structures adorned with numerous statues and reliefs of a slipshod, classicizing finish; these had a largely decorative value, subordinated to the architecture *(fig. 394)*.

The history of sculpture in Florence could be summed up in five statues, all illustrating the theme of David, the perfect symbol of the hero since it shows the weak served by intelligence triumphing over brute force. The first of the five is that carved in marble by Donatello in 1408 and 1409, an amiable clothed adolescent whose listless attitude and effeminate face are somewhat equivocal; his own triumph seems to leave him indifferent. Donatello's bronze *David (fig. 379)*, probably cast about 1450, appears in heroic nudity. His left wrist still rests on the hip in a noble attitude inherited from the Middle Ages, but his right hand now grips a sword. The adolescent stands relaxed after action, his bones showing through the flesh of the thin, muscular body, and a broken outline boldly defines the figure in space. Verrocchio, in his bronze *David*, completed before 1476, exaggerates the slender tautness of a feverishly nervous *ragazzo*.

Between 1501 and 1504 Michelangelo carved the marble colossus for the Piazza della Signoria *(fig. 399)* from a block roughed out years before by Agostino di Duccio; when he did so, he abandoned the myth of childhood that the Quattrocento had exploited to stress the contrast between the hero and the giant. He represented David at the moment preceding action, as a wrestler standing on guard for the attack: he will owe his triumph not to skill but to his muscles. But in this transitional work, the muscles seem grafted onto the bony structure; the pectoral muscles do not seem to correspond with the athletic anatomy proposed; no more does the musculature of the too-slender arms. When he carved the *Slaves* for the tomb of Julius II, Michelangelo for the

first time exchanged the intellectual for an overtly physical type, represented in genuinely powerful bodies. The last stage in the evolution of the athlete is the marble *David* carved by Bernini in 1623–1624. Represented dramatically, in mid-action, his body twists through space in the act of casting the stone from the sling; he is no longer a hero; he is a professional.

Michelangelo was a Florentine and a maker of statues. His attempts at relief were few and date mostly from his youth. His statues are isolated forms tormented not by action, but by passion, and hopelessly imprisoned in their marble solitude. Even in the statues most carefully finished—in the Florentine manner—like the *Bruges Virgin* or the *Pietà* in St. Peter's *(fig. 396)*, we are aware of the block from which those statues were hewn, but the very material throbs under the stress of myriad pent forces. This epiphany of superhuman power is best illustrated in the frescoes of the Sistine Ceiling, from which certain figures reappear in marble a little later, around 1513–1516, when Michelangelo carved the first figures for the tomb of Julius II: the Louvre *Slaves* and the *Moses*. The latter *(fig. 400)*, indeed very near in spirit to the Sistine Ceiling, is the last of Michelangelo's creations to affirm an inner force, a power born of Yahweh's anger. The power in the *Slaves (fig. 398)* is held captive, a symbol of the human condition in which the soul is chained

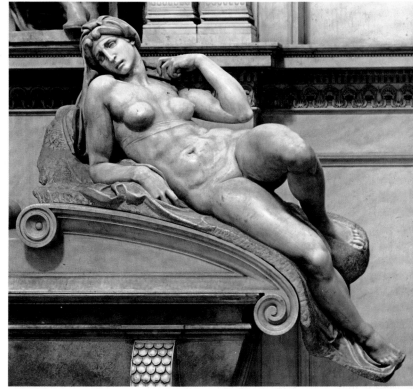

402 MICHELANGELO *Dawn.* **Medici Chapel, San Lorenzo, Florence.** It would appear that in the Medici Chapel Michelangelo wished to represent the spiritual victory of the soul, according to the Neo-Platonic doctrine. Dawn and Dusk, reclining on either side of the sarcophagus of Lorenzo de' Medici, are symbols of the passage of time, which corrupts the body laid in the sarcophagus, but which the spiritual element of the Duke, represented as an ideal figure, overcomes. The figures of Night and Day complete the temporal cycle.

402

403 MICHELANGELO *Virgin and Child*. ca. 1530 to 1534. **Medici Chapel, San Lorenzo, Florence.** Flanked by Saint Cosimo and Saint Damian, the *Virgin* forms the spiritual center of the Medici Chapel. The dynamic interlocking spirals in space of the two figures suggest a different order of movement than that visible in the other figures, and it has been suggested that the group was originally intended for one of the earlier versions of the tomb of Julius II, and was later employed in the Chapel.

404 MICHELANGELO *Rondanini Pietà*. Marble. 1550 to 1564. **Castello Sforzesco, Milan.** When he stopped work on the Florence *Pietà*, Michelangelo returned to a marble group in which clearly he had already outlined the right arm of Christ and the head of the Virgin. Re-attacking the block about 1555, he carved the smooth legs of Christ with more slender proportions. At the end of his life, the artist again modified his interpretation. The Virgin no longer supports Christ, but leans over him.

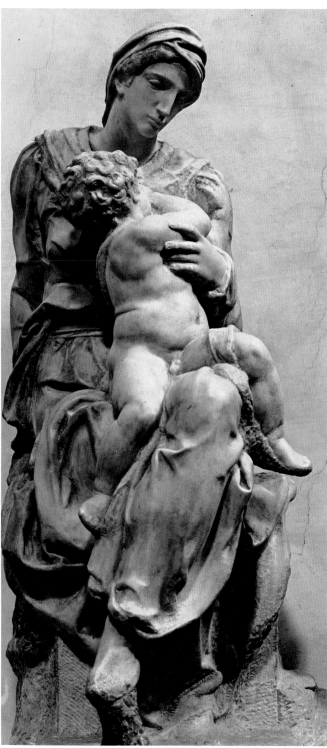

403

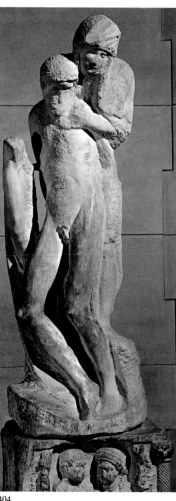

404

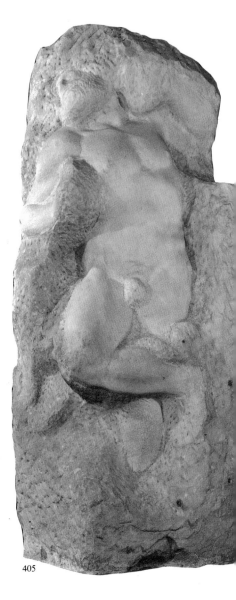

405

405 MICHELANGELO *Slave.* **ca. 1532. Accademia, Florence.**
Probably carved for the 1532 project for Julius II's tomb, the four slaves in
the Accademia take up the theme of the Louvre versions, but in larger
dimensions. Partly emerging from the rough-hewn marble block, the naked
figure is still one with the material from which the artist gradually frees it.
Caught at this stage of its creation, the work illustrates the dramatic effort
of the sculptor to embody an idea. It is over life-size.

406 MICHELANGELO *Pietà.* **ca. 1550. Florence Cathedral.** Dur-
ing the pontificate of Julius III (1550–1555), Michelangelo finished this *Pietà*,
which he had meant to have on his own tomb. Dissatisfied with the work,
he defaced it, but his pupil Tiberio Calcagni gathered the fragments and
restored it. Unfortunately Calcagni also finished the figure of the Mag-
dalen, which Michelangelo had scarcely outlined, and which now appears
timid and stiff and is dwarfed by the monumentality of the other figures.

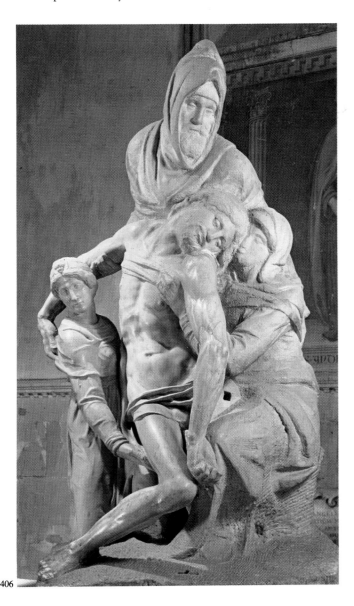

406

to the body. In the Medici Chapel sculptures *(figs. 401, 403)*,
all energy seems drawn off by death; the powerful bodies
fall in upon themselves, or twist on their own axes in a last
spasm of agony. The four allegories of the times of day
probably represent the greatest effort ever made by a sculp-
tor to invade with a single form all the dimensions of space.
The bodies of the two princes, however, are elongated, as
though Michelangelo had been affected by the Mannerism
dominating Florentine art at the moment when he was
working on those statues. This elongation may also be the
first sign of a tendency to spiritualize matter, less pro-
nounced just after Michelangelo's return to Rome in 1534,
but later resumed more strongly. The *Slaves* formerly in the
Boboli grotto, with their gigantic athletic forms still unfin-
ished and half-imprisoned in the block, seem to have been
turned to stone by some divine curse *(fig. 405)*;
their tremendous struggle symbolizes the struggle of the
spirit against matter. In the later *Leah and Rachel,* made
around 1542–1545 for the Tomb of Julius II, the modelling
became drier, more abstract, possibly as a result of near-sight-
edness. As if aware of it, Michelangelo more and more often
left his works unfinished, according to the *non finito* proce-
dure invented by Donatello in his Paduan bronzes. Practiced
by Michelangelo in his youth as a way of bringing marble to
life, it later became his way of spiritualizing matter. The bod-
ies of the Florence Cathedral *Pietà (fig. 406)* are longer, more
emaciated, almost skeletal. The crumpled, lifeless body of
Christ and the weeping creatures around him are empty of
power. The Rondanini *Pietà,* two merged and drawn-out
forms, is a yearning, not a state of being *(fig. 404)*.

Michelangelo despised bronze, considering its apparent
hardness a deception, since the building up of the clay and
wax models from which the bronze is cast is an easy tech-
nique; only direct carving in stone seemed to him worthy of
a great artist, for he conceived it the artist's end to liberate
the forms and forces hidden within a block of marble. He
exerted over his period a sort of fascination that paralyzed
other sculptors, who only emerged from that trance after his
death, with the second generation of Mannerists.

The French sculptor Michel Colombe is known to us only

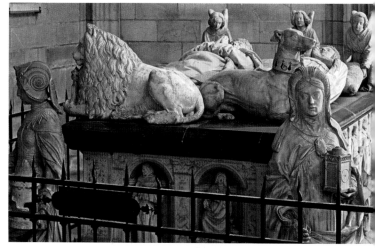

407 MICHEL COLOMBE (French, ca. 1430 to ca. 1515) *Prudence,*
detail of fig. 410. This tomb is the first documented work by Colombe.
The four figures of Virtues at the corners are an Italian theme. Two faces
and a mirror, attributes in the Italian manner, characterize Prudence. A
trace of the Gothic style remains in the idealization of the faces and in the
way the draperies are handled in broad, harmonious folds. The sculptor's
preoccupations were on the verge of becoming purely aesthetic.

408 GIOVANNI DA UDINE (Italian, 1487 to 1564) *Shell orna-*
menting an apse in the loggia. Stucco. ca. 1520. Villa Madama, Rome.
Giovanni da Udine, a pupil and assistant of Raphael, played a decisive role
in the decorative productions of the master's workshop. Vasari says that
he rediscovered the ancient formula for white stucco, permitting a very
soft relief. He first used it in Raphael's Loggie in the Vatican, then at the
Villa Madama, where in the apse of the loggia he set out little panels
illustrating the story of Galatea.

409 MICHEL COLOMBE *St. George.* 1509. The Louvre, Paris.
Colombe was born in Bourges, into a family of stonecarvers and illumi-
nators. Active in Tours, where he died, he is the greatest master of the
Loire Valley, where artistic production enjoyed a tremendous boom as a
result of the court's presence in that district. Colombe treated the legendary
episode shown realistically, placing it in an acutely observed landscape
offering no concessions to the fanciful or to the picturesque.

410 MICHEL COLOMBE *Tomb of Francis II of Brittany and his*
wife Marguerite de Foix. 1502 to 1507. Nantes Cathedral. The last Duch-
ess of Brittany, Anne—who added her duchy to France by marrying first
King Charles VIII and then King Louis XII—erected this monument to
her parents. A new conception of the human form, a preoccupation with
plastic qualities, a pronounced inclination towards harmony and balance
and a great refinement in execution distinguish this work as one of the
great landmarks of the Renaissance in the northern countries.

from his old age, as all the earlier works mentioned in documents have disappeared. The tomb of the Duke of Britanny in Nantes Cathedral (figs. 407, 410) is not entirely by his hand, since it was designed by Jean Perréal, another famous unknown. The recumbent figures and the four *Cardinal Virtues* are of a high quality, but the figures on the base must be by an assistant. The *St. George from Gaillon* (fig. 409), from his own hand, exhibits a rather feeble Italianate inspiration. For masterpieces dating from the beginning of the 16th century we must look elsewhere than to the workshop of this aging artist. The admirable *Vierge d'Olivet* belongs to the naturalistic tradition born in France in the later 15th century, but reveals an idealistic touch showing Italian Renaissance influence. That native trend of naturalism found expression in many works, such as the first sculptures around the choir in Chartres Cathedral by a man whose name, Jehan de Beauce, reveals his origin. But after about 1535 Mannerism was brought to France by the Italians whom Francis I called to Fontainebleau. The frame of Michel Colombe's *St. George* is Italian; in France, Italian art was at first known mostly as ornament, produced by transalpine artists or imported from Genoa or Lombardy.

The Renaissance spirit was assimilated more quickly in Germany. From the second third of the 15th century Nuremberg was a center for humanists, poets, philosophers, and scholars; it is therefore not surprising that a bronze monument such as the Shrine of St. Sebald in Nuremberg, dating from the early 16th century, should have been invaded by the new manner. This is true largely for the figures (fig. 412); the intricate architecture, although generally Renaissance in style, is still dominated by the first design, known from a project dated 1488, which shows a sort of Gothic church forty feet high. This ensemble is a forest of forms in the true German manner, but the individual nude or draped figures, as well as the ornament, are so closely inspired by ancient and Italian statuary that they presuppose a direct knowledge of it, obtained on the spot. The messenger who brought the new style across the Alps was probably Peter Vischer the Younger, who had probably traveled in Italy in 1507–08. He was twenty-one when the shrine was commissioned from his father, Peter Vischer the Elder, in 1508. His older brother, Hermann, who crossed the Alps in 1515, reinforced this influence even more.

The extravagant project for the tomb of Maximilian at Innsbruck, conceived at that time by the founder of Hapsburg glory, synthesizes several ideas. The idea of a gathering of ancestors in a church issued from family pride, as had the benefactor statues in the west choir of Naumburg. The medieval theme of the burial procession, illustrated by Sluter on the tomb of Philip the Bold and brought back to Innsbruck by the humanists, merges curiously with the memory of the ancestor portraits that accompanied the funeral cortege at patrician burials in Roman times. Dynastic pride never inspired a more grandiose project; it was to have included forty statues larger than life, a hundred statuettes, and thirty-two busts of Roman emperors. Begun in 1509, it was set up only in 1593 in the Hofkirche (figs. 411, 415), built from 1553 to 1563 by the Italian Andrea Crivelli in the form of a *Hallenkirche,* whose wide interior was particularly well suited to the unrolling of such funeral display in bronze. The project was continued by the Emperors Ferdinand I and Leopold I, but in the end the monument had only forty statues, twenty-three statuettes, and twenty busts; not only the ancestors of Maximilian and his wives, but also his relatives, and a gathering of historical heroes as well were to have been grouped around Maximilian's tomb. The monument is actually a cenotaph, since the Emperor was in fact buried at Wiener-Neustadt. It was the first great expression of the Hapsburg imperial concept, which, inherited from the Germanic Holy Roman Empire, claimed to be universal, whereas the French concept of royalty was exclusively territorial and dynastic. Many artists worked on the monument; we know that Peter Vischer was paid for two statues after sketches by Dürer, but they are not specified, and therefore the two best are usually attributed to him: those of King Arthur and of Theodoric. The other statues, loaded with sumptuous robes, lacework, precious stones, and the parade and tournament armor that was worn then, resemble barbaric heraldic trophies, though they display extraordinary virtuosity on the part of German bronze casters, traditionally expert in metalwork.

In the 16th century, Spain continued to borrow from the rest of Europe to provide sculptors for its workshops, in great demand particularly for the making of tombs, altarpieces, and church furniture. Artists already impregnated by the Renaissance spirit came to join the Spaniards, and very soon, at the end of the reign of the Catholic kings, the peninsula adopted the new style, which it used almost exclusively for religious ends. At that time many Italians were working in Andalusia: Domenico Fancelli, Torrigiano, Francisco Fiorentino, Jacopo Fiorentino, known as *el Indaco,* and Giovanni Moreto.

In Burgos, it was the Frenchman Felipe Bigarny, "from the diocese of Langres," who introduced the Renaissance. In 1498 he was given a commission for three reliefs for the *trasaltar* of the Cathedral, and he made them in the style typical of the Loire region. Spanish artists also went to Italy to study. Two men from Burgos, Bartolomé Ordóñez and Diego de Siloë, the son of the famous Gil de Siloë, worked together in Naples in 1517, where several of their works have survived. Alonso Berruguete, the son of the Castilian painter Pedro Berruguete, stayed in Rome and in Florence, where we find evidence of his presence in 1508 and 1512; we know that he copied the *Laocoön* and that he knew Michelangelo. Returned to Spain, Bartolomé Ordóñez was asked to take over from Domenico Fancelli, who had just died, the uncompleted commission for the tomb of Philip the Handsome and Joanna the Mad in the Capilla Real in Granada *(fig. 416)*. In October 1519 he went to Carrara to fetch marble and to carve on the spot the figures for the tomb, in a workshop he opened with Italian assistants. He died in December 1519. This beautiful work is in a late 15th-century Florentine style.

Italian and French influence met and joined in Burgos in

411

412

413

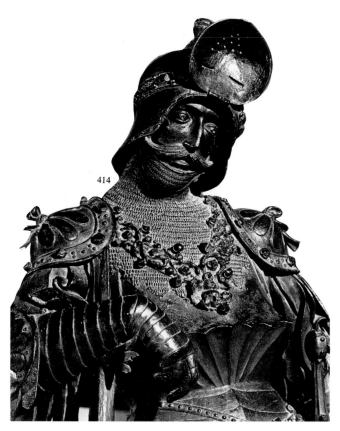

414

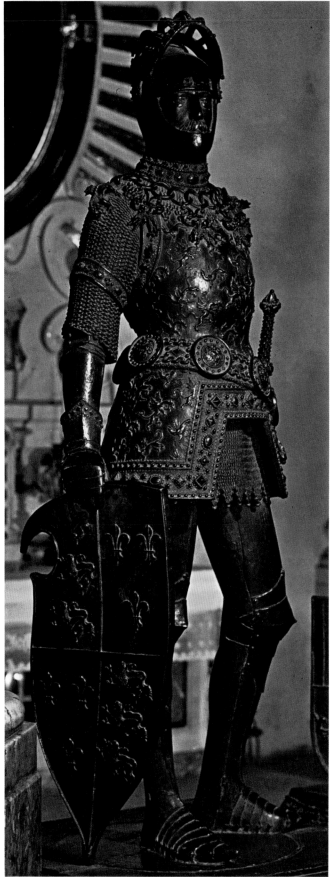

415

411 GILG SESSELSCHREIBER (German, 1460/65 to 1520) *Cimburgis of Massovia.* **1516. Cenotaph of Maximilian, Innsbruck.** Sesselschreiber's straightforward style as in this minutely executed statue brought German sculpture to a degree of perfection that it was never again to attain after this period of flowering in the early 16th century.

412 PETER VISCHER (German, 1460 to 1529) *St. Paul,* **detail of the shrine of St. Sebald. 1507 to 1512. Church of St. Sebald, Nuremberg.** The Apostles adorning the base of this shrine show the first signs of the tendency of Late Gothic art to take on soberer forms. This work was the outcome of thirty years' labor and is remarkable for an artist who never visited Italy.

413 LOY HERING (German, 1485–1554). *Virgin and St. John;* **detail of a Crucifixion from the Eichstätt Mortuarium, Bavaria.** Hering specialized in high-relief works in a fine-grained stone called Solnhofer Stein. With great enthusiasm, he adopted the Renaissance forms that he had studied in Italy; he diffused the new style widely in Swabia, leaving more than one hundred works, which embody forcefully the Germanic power of concentration and intense religiosity.

414 PETER VISCHER *Theodoric the Great,* **from cenotaph of Maximilian. Hofkirche, Innsbruck.** Like the statue of King Arthur, this is not a funerary effigy. It represents one of the deceased emperor's tutelary ancestors, whom an inscription (rather late, it is true) allows us to identify as Theodoric the Great. The impetuosity of this legendary figure is conveyed with an expressionistic note.

415 PETER VISCHER *King Arthur.* **From cenotaph of Maximilian. Hofkirche, Innsbruck.** The statue of Arthur is set apart from the rest by its marked relationship with new ideas. The figure is still a medieval paladin, but its relaxed and clearly articulated pose denotes an undeniable influence of Italian Quattrocento sculpture, and a move towards a more simple and natural ideal of beauty; one has but to compare it with the ornate iron machine alongside.

416 **BARTOLOME ORDÓÑEZ** (Spanish, ca. 1490 to 1520) *St. John the Baptist,* **on the tomb of Philip the Handsome and Joanna the Mad. 1519 to 1520. Capilla Real, Granada Cathedral.** Ordóñez was born in Burgos and is identified with the school of that city. However, his career took him to all parts of Europe. He opened a workshop in Carrara and completed the tomb in one year, just before his sudden death in 1520. He may have met Michelangelo at Carrara.

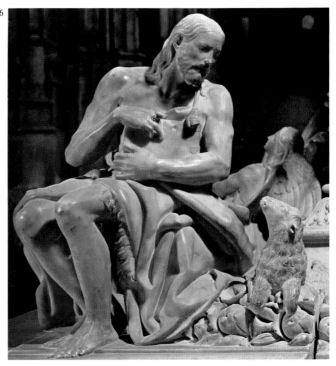

416

1523 when Felipe Bigarny and Diego de Siloë received a joint commission for the altarpiece for the Du Guesclin Chapel in the Cathedral *(fig. 417)*. It is just possible to distinguish the two hands, although Felipe's somewhat heavy style softened in contact with the freer manner of his colleague Diego. The latter is much more modern; he was influenced by Donatello, the main source of Spanish Renaissance sculpture, and from Michelangelo he borrowed a feeling for the majestic. In 1528 Diego again worked as an architect in Granada, where he created a new type of building, imitated even in America. Experienced in both arts, he conceived sculpture as integral to architecture and created a type of monumental sculpture particular to Andalusia, making a great use of columns and statuary, mainly caryatids. The masterpiece of that style is the San Salvador Chapel at Ubeda, a church designed by Diego and commissioned from him and Andrés de Vandelvira. The latter opened the sculpture workshop responsible for the admirable façade and the statues inside the church and the sacristy. The iconography of San Salvador is a harmonious mixture of Christian imagery and pagan themes; it is filled with an enjoyment of life, no doubt the result of the freedom granted the artist to create according to his inspiration, which was very rare in Spain. San Salvador is typical of Andalusia, which tends to a classicizing taste, in contrast with the tormented art found in Castile with Alonso Berruguete and Juan de Juni. Castilian architectural decoration is completely different; the most representative example is the mysterious façade of Salamanca University *(fig. 419),* of which we know only that it was already completed in 1533. The arabesque motifs and the grotesques covering the façade are of French origin, and the Lombard influence that can be noticed may have been brought by French artists from the Loire working in Spain; if so, they were completely assimilated to Spanish art. The façade of the Colegio San Gregorio, Valladolid, shows similar qualities in another style. Its ornamentation is very free, as the building imposes no structural limitations. The eye roves over the whole façade without finding any landmark; always attracted by new accents, it feels the pull of the infinite. This impression is reinforced by the flatness of the relief, which casts only very faint shadows. The quality of the sculpture is such that the spectator becomes irritated at his own inability to fix those images, which elude him like a mirage. The name Plateresque, which means goldsmith's style, often generally applied to Spanish art of the 16th century before the Escorial, should be restricted to Castile; in Andalusia, sculpture often remained dominated by architecture.

The main ornaments of Spanish churches, from the 15th century onward, were the great altars rising at the back of the *capilla mayor* like high cliffs covered with sculpture. Plateresque sculptors carried over into the new repertory of statuary and ornamentation, in wood or in stone, the spirit of the Gothic altarpiece, a sort of Jacob's Ladder put up for God, enthroned above it on his Cross, accompanied by the mourning figures of the Virgin and St. John.

In Portugal, after the exaggerated lyricism of the Manueline period, Frenchmen like João de Ruão and Nicolas Chanterene introduced the peaceful style of the Loire Renaissance. The Portuguese were faithful to that style, and the melancholy serenity of their Virgins and Saints remained a tradition until the end of the 17th century. Another Frenchman, Hodard (Odarte), created in Coimbra exceptional terra-cotta works directly influenced by the Lombard style of Guido Mazzoni or Niccolò del' Arca *(fig. 433)*.

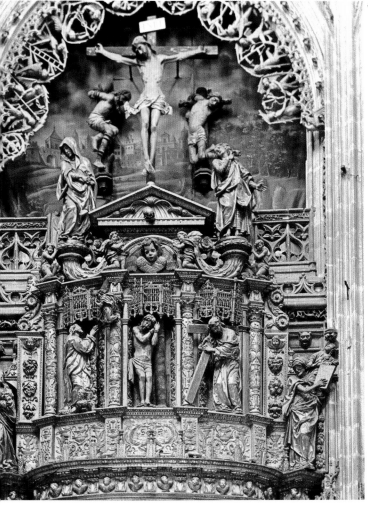

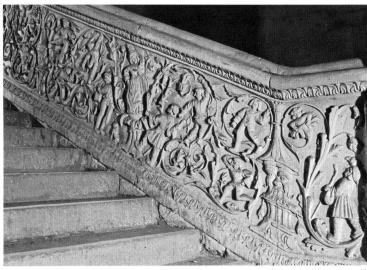

418

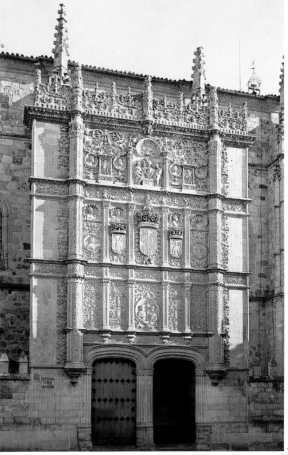

419

417 **FELIPE BIGARNY and DIGO DE SILOË (Spanish, 1495 to 1563)** *Main altar.* **1523–1526. Du Guesclin chapel, Burgos Cathedral.** The architectural elements of the Burgos altar are probably the work of Bigarny, as is also the Annunciation group, while the Holy Family must be attributed to de Siloë. This altar exemplifies the last phase of Bigarny's art, showing that the sculptor had assimilated the Renaissance style: in both decorative elements and also in the modelling of the figures, the Italian influence is now marked.

418 *Handrail of the staircase,* **Salamanca University. 1500–1525.** On this handrail at Salamanca University the imitation of engravings from both Italy and the northern countries can be seen. One of its panels, depicting satirical subjects, reproduces an engraving by the German artist Israël van Meckenen, who died in 1503. The staircase, executed in the first quarter of the 16th century, illustrates the virtuosity of the Renaissance decorators at Salamanca.

419 *Façade* **of Salamanca University. Spanish, early 16th century.** The Plateresque style, so called because of its resemblance to goldsmith work (*platería*), is characterized by an exuberant decoration of Italian Renaissance inspiration covering a medieval structure. The façade of the University is the masterpiece of this style. Built by several anonymous artists, it was completed in 1533. In style, some of the reliefs suggest Lombard-Venetian influence; others appear to be influenced by the French school of the Loire.

IX

MANNERISM

420

It has taken nearly three-quarters of a century to reverse the concept of Mannerism propounded by Romain Rolland in 1895, to make it positive instead of negative. What Rolland and so many others considered as the decline of Renaissance painting is now viewed as an independent and worthwhile phase of Western art. The many studies published during the last thirty years have revealed Mannerism as an expression of a neurosis, of a state of anxiety, and also as deep-rooted reaction against classicism, finally resolved not in a return to classicism, but in the Baroque introduced through the divergent styles of the Carracci and Caravaggio. A reaction against the Renaissance had begun in Florence even before the death of Raphael; in some cases it paralleled a kind of classicism, as in Spain, where Alonso Berruguete was the contemporary of Diego de Siloë.

The Mannerist revolution was initiated in Florence between 1515 and 1525 by painters who soon found a following. In sculpture, Mannerism came later, developing about 1535 as an interpretation by others of Michelangelo's style: one of the focal points of Mannerism was the Medici Chapel and its tombs, completed between 1525 and 1534.

Mannerism in sculpture was inaugurated in Florence by Bandinelli, a rival of Michelangelo, who managed to take from him the commission for a monumental group intended as a companion piece to the David in the Piazza della Signoria; the marble block was delivered from Carrara in 1525 and subsequently passed from Michelangelo to Bandinelli. The result was Bandinelli's *Hercules and Cacus*, completed in 1534, an inflated colossus which from the moment it was set up to our own day has provoked endless jeers from amateurs, critics, and tourists alike. It is a negation of sculpture, the product of a puny talent. Luckily, ten years later Florence again had a real artist when Benvenuto Cellini returned from France after making his famous saltcellar for Francis I. In 1545 Grand Duke Cosimo I commissioned from him the bronze Perseus, which was set up in the Loggia dei Lanzi in 1554 (*fig. 421*). Cellini is one of the few artists of his time who did not imitate Michelangelo. The sinewy body of his Perseus shows the influence of Verrocchio and Pollaiuolo, and the careful finish came naturally from his goldsmith's hand. The theme of the conquering hero is renewed in Cellini's figure, presented at the dramatic moment of triumph, holding aloft the Medusa's bloody head. The arms reach out from a body outlined against space rather than twisting to occupy it; the work was meant to be seen in profile. In his bust of Cosimo I, Cellini put an end to the deadlock of naturalism in which the Quattrocento portrait had stuck fast and inaugurated a new genre, revived from antiquity: the heroic portrait. The prince is represented in action, his head turned to the right, his hard eyes expressing command; the modelling subtly indicated the successive planes and the chasing of the armor is remarkable. The arms and the bust are cut at the right level and are well balanced on the small pedestal.

The 16th-century bronze was unaffected by the irrevocable decline of stone-carving. The latter was too straightforward to express all the subtle nuances to which the artists were attracted. Working in bronze, artists were also freer of Michelangelo's influence, which reappeared in marble works as exaggerated, bulging muscles and blown-up proportions. Bronze was the medium suited to the flowing, smooth, feminine shapes that sculptors preferred in reaction against the athleticism of the Michelangelesque male bodies. Sculptors of 16th-century Italy expressed better than any before or since the suppleness and grace of the female body. Following in the wake of the painters, they elongated that body to make it more flexible and more elegant; with the double contrapposto of the hips and bust emphasizing the body's curves, they created the *linea serpentina,* the line that doubles back on itself after describing a capricious arabesque and gives a flowing beauty to the forms. Michelangelo saw in the human body a reflection of divine beauty; but for him, as for Quattrocento artists, that beauty was an attribute of the male body. Cinquecento sculptors found it in the female body, less easily analyzed and containing secret harmonies that led them towards the goal of their art: the discovery of the *disegno,* or rather of the *disegno interno,* an intangible intellectual quality, a divine shadow of the tangible. It could most surely be apprehended in the nude, and therefore the nude was the main subject of study for painters and sculptors. Beauty was no longer thought to reside in a system of proportions, as in

420 **VINCENZO DANTI (Italian, 1530 to 1576)** *Venus,* detail. ca. **1570. Bronze. Studio of Francesco de'Medici. Palazzo Vecchio, Florence.** In this bronze Vincenzo Danti gave the *Venus* a sinuous movement accentuating her tapering form and her mannered grace. Intended to be seen from the front, she turns her head in profile. This attitude displays to full advantage the incisive modelling of the facial features; modelling underlined by the wavy hair and the curves of the heavy plaits.

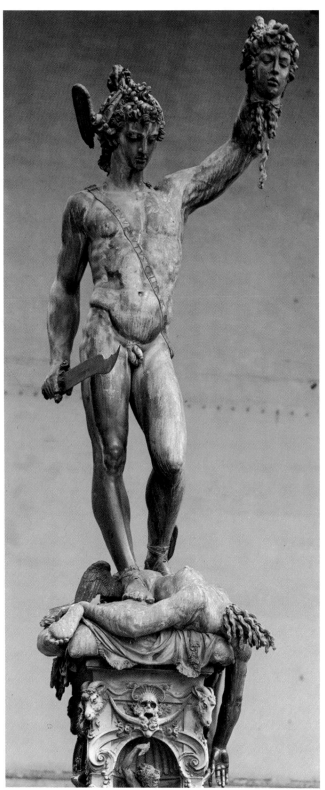

421

the Quattrocento. Alberti, in his *De Statua,* had worked out for the sculptor a complete table of measurements, but Michelangelo had said one must have a compass in one's eye and not in one's hand. As for the study of nature, it became a mere stimulus for the imagination; it induced the artist to draw from memory and to find within his own imagination the creative spark.

In Michelangelo's work, woman borrowed some of man's strength; in Mannerist bronzes, on the contrary, the male body derives its qualities from female anatomy: Giovanni da Bologna's Apollo and Mercury are androgynous. The idea of force, inherited from Michelangelo, more generally found expression in stone-carving. One subject particularly interested Mannerists: the combat between two wrestlers. Michelangelo first used the theme in a figure intended for the Tomb of Julius II, Victory, who pins down a subdued enemy with his knee. He again proposed to render the forces of conflict in a group of Samson and two Philistines (the commission taken from him by Bandinelli). His sketches for the project, some still surviving, inspired Pierino da Vinci when he made a statue on the same theme. Michelangelo also wanted to carve a Hercules and Cacus, which we know from a damaged model. All through the century sculptors made marble groups illustrating figures locked in combat: Vincenzo Danti made an Honor triumphant over Falsehood, Ammanati a Victory, Vincenzo de' Rossi a Hercules and the Centaur; and Giovanni da Bologna used the theme four times—for Florence triumphing over Pisa, Samson slaying the Philistine, the Rape of the Sabine, and Hercules and the Centaur. Exploiting the *linea serpentina* to enclose the supple surfaces of the two bodies—in the Rape of the Sabine, of the three—he alone was able to unite the figures into one contorted composite form symbolizing effort. A twisting shape, penetrating space like a gimlet, was achieved by Giovanni da Bologna in his famous *Mercury (fig. 423);* the statue is no longer boxed in within its own space; it moves in all directions and creates around itself a living space. The Mercury was the boldest attempt a sculptor had yet made to defy the laws of gravity. It is the opposite of Michelangelo's statues, which bore down into the ground with all their weight.

421 BENVENUTO CELLINI (1500 to 1571) *Perseus with the head of Medusa.* **Bronze. 1554. Loggia dei Lanzi, Florence.** The *Perseus* set the stamp on Cellini's fame in Florence. It was placed in the Loggia dei Lanzi, across the piazza from Michelangelo's *David* and Donatello's *Judith.* The artist's training as a goldsmith is revealed in the refined modelling, which recalls Donatello's *David,* and in the abundant ornament covering the base between the small bas-reliefs.

422 GIOVANNI DA BOLOGNA. *The Appennino.* **Villa Medici, Pratolino. Late 16th century.** When he was commissioned to decorate the gardens of the most famous of the Medici villas, Giambologna first modelled a reclining river-god. But the mountain god Appennino was substituted for the river-god, for a triangular composition was better suited to the natural setting. The giant raises himself wearily. Handled in such a way as to suggest that it was carved out of the living rock, the colossus is hardly distinguishable from the element it personifies.

423 GIOVANNI DA BOLOGNA *Mercury.* **1564. Museo Nazionale, Florence.** Mercury in flight was one of Giambologna's favorite subjects, which he treated several times. Here he shows his debt to the refined art of Cellini, but he goes beyond it in giving an impression of extraordinary weightlessness in movement. The possibilities of contrapposto are exploited to the full. The lifted arm anticipates the pose of the *Sabine.* One leg is raised in a running movement, and the entire weight is borne on the toes of the left foot, which barely rest on the jet of air from the mouth of a putto, symbol of the wind.

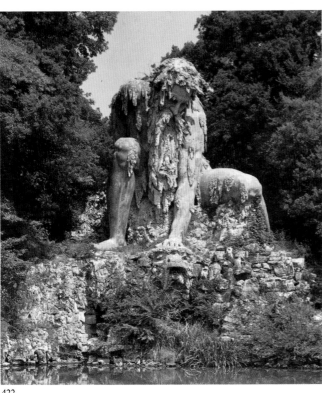

422

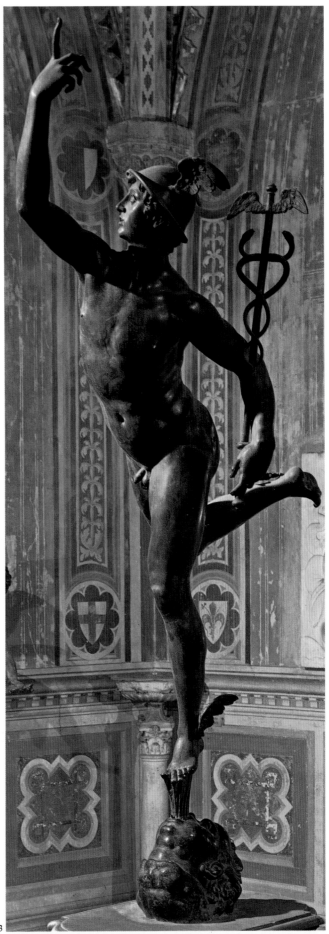

423

There is nothing material in that body of Mercury; it is an abstract work made to enchant the mind.

Feverish experimentation went on in the workshops that sustained Florence's leading role in sculpture after she had lost it in painting. They created the princely portrait and a modern type of commemorative monument illustrating the theme of glory. Giovanni da Bologna's equestrian statue of Cosimo I—compared with the works by Donatello and Verrocchio—embodies the abstract concept of the prince. Tribolo, Giovanni da Bologna, Ammanati and Buontalenti (who was not a sculptor, but a *projettista*) elaborated the motifs of the fountain and the tomb with an expanded use of statuary. They created a new figurative vocabulary for garden decoration, rich in the fantastic and the grotesque, and sometimes made their works look like rock to express nature in the rough. Buontalenti placed Michelangelo's unfinished Slaves in the rockery of a grotto. We must think of 16th-century Florence not as a dead town, but rather as a sort of laboratory for experimentation in modern sculptural forms. When the Fleming Giovanni da Bologna settled in Italy, he chose the court of the Grand Dukes as the most likely place to develop his talent as a sculptor; he worked there for half a century, making of Florence a rival to Rome.

But in the 17th century Florence declined into a nostalgia for her past: Pietro Tacca, a pupil of Giovanni da Bologna, ignored the new Roman Baroque to imitate his master's manner (*figs. 424, 425*).

A Tuscan, Leone Leoni, established a workshop in Milan, afterwards continued in Madrid by his son Pompeo, who produced the finest series of princely portraits in Europe: the bronze statues of Charles V, Philip II, and their wives, for the tombs in the Escorial (*fig. 426*).

The Mannerist experiments continued in central European bronze workshops. At the end of the 16th century and at the beginning of the 17th, Hubert Gerhardt, Hans Krumper, and Hans Reichle cast commemorative monuments, allegories, and garden statues for the court of Munich. They also made fountains in the Florentine fashion: Hans Reichle even designed one for Danzig in 1619. The greatest of those sculptors, and the real heir to Giovanni da Bologna's art, was the Dutchman Adrien de Vries. In Italy when he was called to the service of Emperor Rudolph II, he brought Florentine Mannerism with him to Prague. He was particularly intrigued by the theme of two wrestling figures, which he treated several times as a mythological subject. Wanting to exceed the virtuosity of Giovanni da Bologna's

424 **PIETRO TACCA (Italian, 1577 to 1640)** *Moorish slave,* **on the monument to Ferdinand I de' Medici. 1624. Piazza della Darsena, Leghorn.** Pietro Tacca was the most gifted disciple of Giambologna, whom he succeeded as sculptor for the Florentine court. Early in the 17th century the city of Leghorn commissioned from him a base adorned by four chained slaves for the monument to Ferdinand I done earlier by Giovanni Bandini. One of Tacca's finest works, the story is that Tacca sketched from life the handsomest galley slaves available.

425 **TACCA** *Grotesques,* **detail of a fountain. 1627. Piazza dell'Annunziata, Florence.** The city of Leghorn commissioned from Tacca two bronze fountains intended to flank a monument to Ferdinand de' Medici. When they were cast in 1627, however, the city refused them; later they were placed in the Piazza dell'Annunziata in Florence. The sea monsters spitting into the water, back to back, show the artist's imaginative powers. The apish animals forcefully renew and prolong the Cinquecento strain of fantasy.

426 **POMPEO LEONI** (Italian, 1533 to 1608, active in Spain)
Charles V and Isabella. 1597. **Tomb of Charles V, royal mausoleum,
Escorial.** In accordance with the iconography traditional for Spanish
tombs, the figures are kneeling on their prayer-stools. His sisters and his
daughter Mary are portrayed behind Charles. The faces are not studied in
an effort to revealing the individuality of the sovereigns, but these official
effigies compose a group of austere majesty.

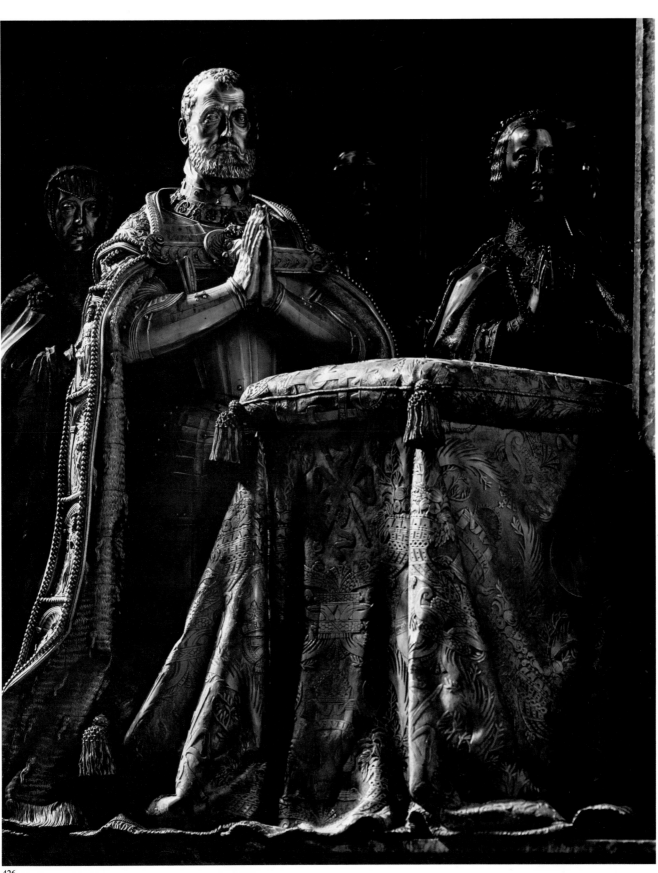

426

427

428

Mercury, he represented in his *Hermes abducting Psyche* not one, but two, figures supported by the tip of a single foot. Hubert Gerhardt took up the same theme and imitated Gianbologna's group of three figures (the Sabine) in a *Hercules abducting Dejaneira*; he also transposed the wrestling theme in his *Horses Fighting*. More eclectic than Adrien de Vries, he also imitated—somewhat clumsily—Benvenuto Cellini's *Perseus*.

In the Low Countries, stone carvers apparently rejected all feeling of solidity in their statues or reliefs; their loose modelling seems to look forward to the soft fleshiness of Rubens' nudes. When Cornelis Floris designed the choir screen in Tournai, he was inspired by Sansovino's *loggetta* in Venice, which he transformed into a Mannerist façade with statues and reliefs arranged as if by chance, and unrelated in scale.

In the Mannerist epoch, architects employed sculptors to decorate building interiors. For the Villa Madama in Rome, Raphael and Giovanni da Udine had invented a stucco decoration drawn largely on the grotesques discovered in Nero's *Domus Aurea* and still very close to the spirit of antiquity *(fig. 408)*. Stucco ornament, which could be rapidly executed, became a normal type of decoration for palaces and especially for villas and country houses. It spread even over the exterior and sometimes covered a whole façade with its figures and ornaments. In the north, such decoration was usually cut in stone, and façades bristled with herms, caryatids, and imitations of the paper or leather scroll work used in decorations for festivals. Engravers like Dietterlin in Germany, Vredeman de Vries in the Low Countries, and Hugues Sambin in France acknowledged no limits to their graphic

427 JÖRG ZÜRN (German, 1583 to 1635) *Adoration of the shepherds,* **detail of the High Altar, church of St. Nikolaus, Überlingen.** In this center portion of the Überlingen altar, the figures move in a play of light and shadow against the pierced background, and the effect created repeats the mystical atmosphere of Christmas eve evoked in a picture by Altdorfer. The composition has not gone beyond the conception of a *crèche* scene set on a stage, but the execution is striking, revealing a liveliness and a still-Gothic feeling, despite the use of Renaissance innovations.

428 HUBERT GERHARDT (Dutch, 1540/50 to 1620) *St. Michael slaying the Devil.* **St. Michael's Church, Munich.** Gerhardt, after a period of work in Augsburg, joined the court of the Dukes of Bavaria. Under the direction of Friedrich Sustris, like Gerhardt a native of the Low Countries, he participated in the program of decoration for the Jesuit college church of St. Michael in Munich. The most beautiful piece is the group of *St. Michael slaying the Devil,* which greets the worshipper on the lower level of the façade.

429

inventions; their frenzied ornamentation, spread by printed books, was taken up by sculptors who transposed it into stone. The carvers of altarpieces were also inspired by it; this paranoiac, overloaded style comes not from the 16th century, but from the early 17th, in those places where Mannerism continued up to the Thirty Years' War; just as the Spätgotik produced its most extreme examples in the 16th century during the Renaissance, the Überlingen altarpiece by Jörg Zürn (*fig. 427*), echoed a century later that of Niederrotweil.

The destruction of the church of San Benito y Real in 1842, an aftermath of the French Revolution, brought Alonso Berruguete's works out of the gloom of a *capilla mayor* and down to eye level in a museum, where they could be—and were—appreciated (*fig. 431*). But it was the handsome exhibition of his works in 1933 in the Colegio San Gregorio,

transformed into a museum, that brought Berruguete's name to a position second only to that of the somewhat later El Greco, with whom he has certain affinities.

His contemporaries evidently realized the revolutionary character of Berruguete's art, for after he had completed the San Benito altarpiece in Valladolid, afer six years' work, it was rejected by the committee of experts convened on July 29th, 1533, to declare, according to custom, whether the work fulfilled the terms of the contract. The committee asked for several alterations, but we do not know whether the artist had complied with their wishes when the abbot finally accepted the work on January 14th, 1534. This criticism—of which no detailed account exists—may have sprung from professional jealousy. It may have been directed not at Berruguete's aesthetic approach, but at the technique, which

429 ADRIEN DE VRIES. *Victory of Rudolph II over the Turks.* **1609. Hofmuseum, Vienna.** This bronze relief has a highly complicated iconography. On it appear allegories of rivers, the imperial lion attacking the Ottoman dragon, and the Emperor crowning Hungary, who has been liberated by Minerva and Hercules; on a battlefield bristling with banners and weapons, cavalry skirmishes at the foot of the Raab fortress, while in a sky strewn with astrological symbols a flourish of trumpets sounds the victory. (Height, 28 inches.)

430

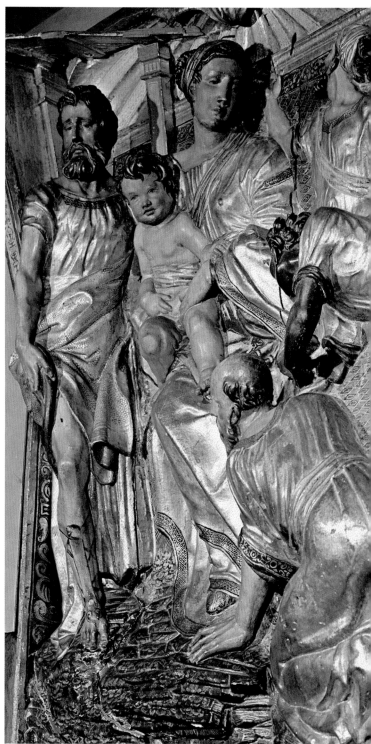

430 BERRUGUETE *Eve,* **on the choir stalls, Toledo Cathedral.**
Between 1539 and 1561 Berruguete worked in Toledo, where he came into
contact with Bigarny. He received the commission for the execution of
half the choir stalls in the cathedral. Two registers are decorated with panels
showing Old Testament figures in the Cathedral. In the panel of *Eve,* there
is much that recalls Italian sculpture, especially Michelangelo's. In his To-
ledo figures Berruguete employed more thick-set proportions and a fuller
modelling than he did in those for the Valladolid altar.

431 ALONSO BERRUGUETE (Spanish, 1480/90 to 1561) *Ado-*
ration of the Magi, **from the San Benito altar. 1526 to 1532. Museum,**
Valladolid. In about 1520 Berruguete entered Charles V's service and later
created an important workshop in Valladolid. The altar for San Benito was
commissioned in 1526 and completed in 1532. It was later dismantled and
has been partially reassembled in the Museum. The polychromed wood
altarpiece was conceived as a drama, and Berruguete's talent reveals itself
as pictorial rather than sculptural.

431

even now some historians consider "hasty" or "popular." But that is probably the crux of the matter: Berruguete's genius expressed itself through the form as well as through the conception. The technique he chose for that altarpiece was polychrome sculpture, which was widely used in Spain throughout the 16th century. After the wood had been carved and all the cracks had been filled with stucco, the forms were coated with a mixture of plaster and clay. They were then completely covered with gold leaf, and afterwards *estoffado,* that is, coloured. Sometimes the painted layer was engraved to reveal the gold, meant to suggest ornaments on the clothing; silver was also used. Emerging on the surface through engraving, or underlying the colour, the precious metal gives a mysterious reverberation to the forms. This technique exploits the possibilities of both relief and painting; Berruguete, who had been trained as a painter by his father, understood it so well that he handled relief as a painter, summarily, so that it retained a fluidity that would lend its movement to the coloured end product. The technique evolved by Berruguete remained very popular during the whole of the 16th century, a period during which the sculptors themselves were responsible for the polychromy of their statues. In the 17th century the situation was different: the statue completed by the sculptor was afterwards handed over to a painter, and therefore the sculptor was more inclined to treat it as a pure work of statuary; when he carved it, he could not envision its final, coloured state. The sketchy carving of Berruguete at San Benito is certainly intentional, as is proved by the careful finish he gave to the reliefs for the of Toledo Cathedral which were never meant to be polychromed *(fig. 430).*

Berruguete had been schooled during a long stay in Italy, where he knew Michelangelo and studied the works of Donatello; but he placed himself in violent opposition to the Renaissance spirit as early as the first quarter of the century, just when another Castilian, Diego de Siloë, was beginning to spread it throughout Spain. Diego may have sensed that Castile was not favorable to his aesthetic approach, and while Berruguete was working on the San Benito altarpiece he moved to Andalusia, where the Italianate style was to prosper. Berruguete, on the contrary, laid down at Valladolid the

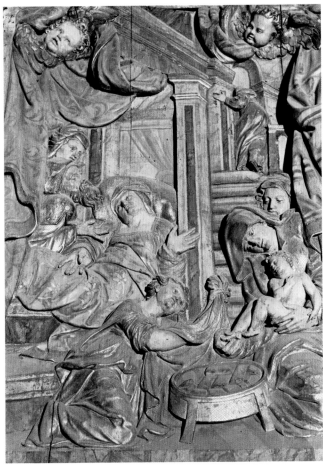

432

foundations of a truly Spanish art, of which Old Castile remained the sanctuary. Those figures bent by a stormy wind, their souls seeming to be thrust outside the matter of their bodies, are a passionate affirmation of Christian spiritualism in the face of the Renaissance cult of Man. Human beings are not intended to enjoy this earthly realm, but must rather strive desperately and at all times towards a state of ecstasy in which the soul, freed from the body, can hope to approach the divine principle. The 16th-century revival of mysticism in Spain produced saints, but also sects with a following of illiterates, such as the *alumbrados,* derived from Arabic mysticism and preaching a direct contact with the divine mind through a sort of conditioning of the soul intended to reduce all the faculties to passivity. It was to combat those sects that

432 JUAN DE JUNI. *The Birth of the Virgin,* **panel of the Antigua Altar.** Juni was above all a statue maker, as can be seen from the relict representing the birth of the Virgin. His main preoccupation is the rendering of the third dimension. The carving is self-assured, the volumes well-defined in the expressive composition. The influence of Durer's woodcuts has been suggested as the explanation for such clarity of outline.

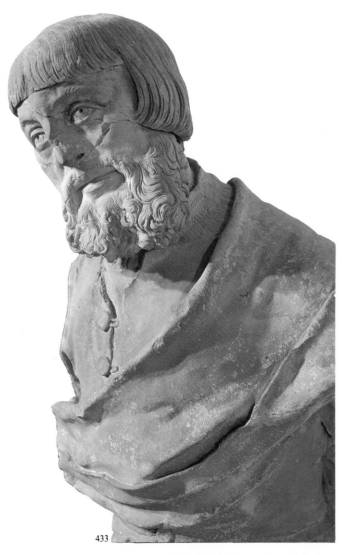

433

433 PHILIPPE ODARTE (French, d. 1538) *Apostle,* **from a Last Supper group. 1530 to 1534. Museu Machado de Castro, Coimbra.** Though various contemporary references to him leave no room for doubt that Odarte was of French origin, his exaggerated Mannerism is as alien as possible to the French Renaissance spirit. His style must have been formed as a result of contacts with expressionistic Milanese artists such as Guido Mazzini or Nicolo dell'Arca. This terra-cotta statue comes from a Last Supper scene composed of lifesize figures which have reached us in a very mutilated state.

434 DE JUNI *The Entombment.* **1544. Museum, Valladolid.** The polychromed wood *Entombment* group in the Valladolid museum was executed for the Bishop of Mondonedo, Antonio de Guevara. Originally it formed the decoration of the lower part of the altarpiece. The attribution to Juni is not disputed. The artist took great pains with the composition of his group: the six lifesize figures surround the body of Christ in an oval; the accentuated contrapposto and the related gestures create a dynamic balance drawing the protagonists into a concentrated group.

435 ESTEBAN JORDAN (Spanish, ca. 1566) *St. Peter and St. Paul,* **detail of the Main Altar. 1571. St. Mary Magdalen, Valladolid.** Jordan represented the group of *St. Peter and St. Paul* several times. These sculptures reveal the artist's dilemma: attracted at the same time by the expressionism of Juni and the grandeur of Michelangelo, he produced works either lifeless or pretentious. The conventional attitudes, the artificial draperies, show no epic inspiration, no classic harmony. The remarkable development of Spanish sculpture languished towards the end of the 16th century, but Italian artists summoned by Philip II, such as Pompeo Leoni (see fig. 426) were to revive it.

434

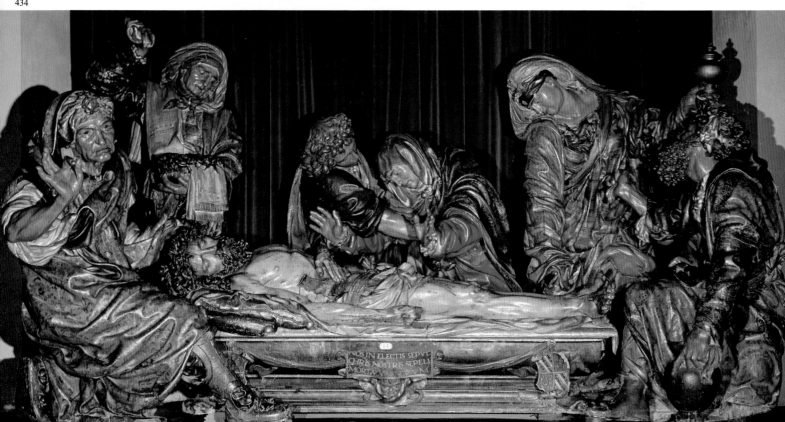

in 1527—just when Berruguete was working on the San Benito altarpiece—Francesco de Ossuna published his *Tercio Abecedario Espirituale,* which was to influence St. Teresa of Avila so deeply. Written in ordinary language, it unfortunately popularized mystic thought, thus encouraging the very excesses it was meant to suppress.

Berruguete has been called "Gothic"; I do not agree. Just as the classical Gothic style contained its opposite, the Flamboyant style, so the rich vein of Renaissance classicism could provide material for the style that would react against it. Berruguete used all the forms he had learned in Italy, but he interpreted them as a Mannerist, that is to say, out of context. His characters are seized by a trance which dislocates the whole organization, just as Pontormo's and Rosso's feverish figures engender chaos in their compositions, each character wrapped in himself, quite detached from his companions—something typical of mysticism, which produces an individual turned wholly inward, cut off from the world in an attempt to get closer to God.

In reality, the Plateresque style, of which Berruguete was the greatest exponent, was much more than the late transformation of another style; it was the first original artistic form created by Spain, until then under the influence of other countries. Spanish art historians have understood this, since they consider *Plateresco* one of the high points of their country's art.

Berruguete never surpassed the San Benito altarpiece; his later works seem rather mass-produced. Working on the choir of Toledo Cathedral, he adopted the elegant, aristocratic style of the Renaissance and indulged in "formal" experiments quite alien to the ideas of his youth. But the revolution he had started spread all over Spain. Even Damian Forment, from Catalonia, who had not much personality of his own, became a convert; starting as a Gothic artist, he went on in a Renaissance style and finished as a Mannerist. The chosen land for Berruguete-imitators was Navarre. In that remote province, this passionate style later produced some remarkable altarpieces, which have been studied by a great scholar—the first to "discover" polychrome Spanish sculpture—George Weise.

435

In Valladolid, Berruguete's style was made even more dramatic by Juan de Juni *(fig. 434),* said to be of French origin, but obviously trained in Italy. He was very much influenced by Michelangelo and by the Laocoön, whose face he borrowed for his Christ. With Juni, interior drama becomes theatrical and a cry of pain takes on the overtone of rhetoric. But his technique is admirable, even superior to that of Berruguete. In his reliefs he used the Italian *schiacciato* technique and produced works that are not painted sculpture, but a genuine combination of sculpture and painting, the colour adding life to the relief. Unlike Berruguete, Juni gave his statues heavy, powerful, Michelangelesque bodies, expressing tragedy through physical effects: his style might more truthfully be called proto-Baroque.

Juan de Juni's passionate style, like Berruguete's, gradually

calmed. He was influenced by the Romanizing tendency in Spanish art after 1560, which developed as a reaction against Mannerism. The more subjective style was replaced by a solemn, impersonal, and abstract art imitating High Renaissance formalism, a change similar to that instigated by the Carracci in Italy. It was not only Herrera's reforms that caused this change, as has been claimed; the stylistic reversal had already begun by about 1550, when the *Plateresco* was still in full bloom. Before Herrera designed his Escorial altar of 1579, Esteban Gaspar Becerra had submitted his overall designs to an architectural discipline, and his sculptures to the new Roman formalism, in his high altar for Astorga (1558). He was closely followed by Esteban Jordan in the Valladolid altar *(fig. 435)*, and in the altar for Santa Maria de Mediavilla at Rioseco.

While Spain became more deeply Christian under the impact of the Italian Renaissance, France, on the contrary, turned pagan. When he built Fontainebleau, Francis I called upon Italian artists to create a court art capable of serving his

purpose of modernizing culture. From then on, French art negated its tradition to become more profane than religious. Francis I summoned one of the founders of Florentine Mannerism, the painter Rosso, who created an orignal work, a completely new kind of court decoration, in the Galerie des Réformés. He combined stucco with painting—which Giulio Romano had already done in the Palazzo del Tè in Mantua—but he gave the stucco figures the importance of real statues *(fig. 437)*. Unfortunately the very flat painting of the artists who worked under Rosso's direction conflicts with the three-dimensional effect of the stucco. The lack of unity between the paintings and sculptured frames is characteristic of Mannerism. Rosso, Benvenuto Cellini, and Primaticcio introduced to Fontainebleau the elongated female nudes smoothed into flowing curves which were to become a traditional French genre until the 18th century. The most famous work of that kind is the Diane d'Anet by an unknown sculptor *(fig. 441)*. Under Henry II the new style was assimilated and France produced original architects and sculptors. While

436 PRIMATICCIO (Bologna 1504– Paris 1570) *Decorations* for **the Duchess d'Etampes' apartment. Stucco. 1532. Fontainebleau.** Influenced by Parmigianino, Primaticcio persists in the quest for grace and elegance. These elongated and voluptuous bodies surrounded by garlands in a fantastically elegant Olympus frame a medallion decorated with mythological scenes. Together with the Rosso figures, this is one of the best examples of the Fontainebleau school.

437 GIOVANNI BATTISTA ROSSO (Italian, 1495 to 1540) *Stucco decoration.* **Gallery of Francis I. 1534–1536. Fontainebleau.** The Florentine Rosso, summoned to France in 1530 at the instigation of Francis I, devised in 1534 a compartmented decoration, stuccoed and painted, for the gallery at Fontainebleau. He completed it, with the aid of numerous assistants, in 1536. The soft, pliant modelling and the grace and femininity of the bodies are characteristic of the Fontainebleau school.

438

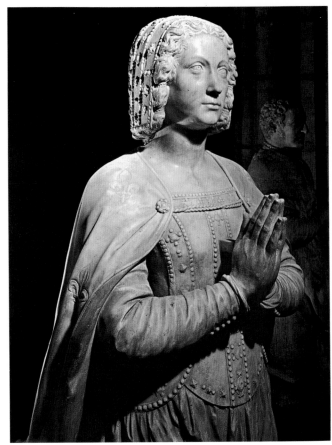

439

440

438 CORNELIS FLORIS (Flemish, 1518 to 1575) *Crucifixion*. **Detail from the** *jubé* **of Tournai Cathedral. 1573.** The influence of Cornelis Floris, architect and sculptor from Antwerp, was decisive in the diffusion of Italian art forms in the north of Europe. In the *Crucifixion,* Floris has subordinated the carved relief work to the effect of the architecture. He was above all a decorator and incorporated the sculptured scenes into the decorative whole. The panel representing the Crucifixion with the three Maries, set in the main face of the *jubé* (choir screen), is divided by the verticals of the three crosses. Floris was gifted with a real technical skill.

439 PIERRE BONTEMPS (French, active 1536 to 1567) *Claude de France*. **Tomb of Francis I and Claude de France, Abbey Church of St. Denis, Paris.** The tomb of François I^{er} and Claude, daughter of Louis XII of France, is the most important 16th-century French funerary monument. Five marble statues of praying figures flank the recumbent figures. Three of these, including those of the sovereigns, are attributed to Pierre Bontemps.

440 GERMAIN PILON *Head of Henry II*. **Detail from his tomb. ca. 1570. Abbey Church of St.-Denis, Paris.** Pilon combines French traditions with Renaissance influence. The tombs of Henry II and Catherine de' Medici were designed by Primaticcio. The death of various artists who had been engaged on its execution left Pilon on his own as a sculptor. He gave the recumbent figures a feeling of realism without any macabre element.

441 *The Diane d'Anet* French, mid-16th century. The Louvre, Paris. At the end of the 18th century, Alexandre Lenoir attributed the *Diane* to Jean Goujon. However, Du Colombier sees in this work a painter's hand, and suggests as its author Primaticcio, or one of his followers, for the group is reminiscent of Italian Mannerism. The statue type itself was established in France by Cellini in 1543 at Fontainebleau. The *Diane* must be the work of an Italianized Frenchman.

441

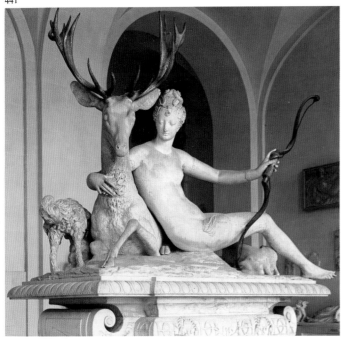

442 **JEAN GOUJON** *Nymph.* **1548 to 1549. Fontaine des Innocents, Paris.** Goujon, the 16th-century French sculptor, began work on his masterpiece, the *Fontaine des Innocents,* at the end of 1548. While he may have been inspired by Rosso, he rejected the Mannerism of the Fontainebleau School and devoted his masterly talents to a revival of the classical purity of later 5th-century Greek art, thus paving the way for modern French sculpture.

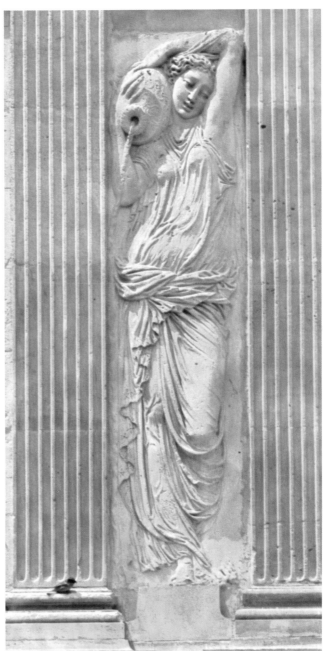

painting continued to bear the stamp of Mannerism, sculpture tended to shake it off: Goujon's forms leaned towards classicism; his Nymphs of the Fontaine des Innocents *(fig. 442),* with their clinging draperies symbolizing flowing water, are reminiscent of such late 5th-century Greek statues as those on the temple of Athena Nike in Athens. For the second—and not the last—time, French sculpture bowed to classical Greek art across the centuries, whereas Italian sculpture always remained closer to Roman or Hellenistic art. The psychologically penetrating portraits by Clouet or Corneille de Lyon had no equivalent in sculpture; but Germain Pilon endowed his funerary portraits with traditional French naturalness *(fig. 440)* and added to his models a restrained dignity that looks forward to the 18th century.

In the Ile-de-France and in the Loire district a style of architecture developed that required no ornament, but in other parts, in Toulouse or Burgundy, Mannerism inspired sculptor-architects like Hugues Sambin and Nicolas Bachelier to produce those decorations of caryatids and herms so popular in the Low Countries and Germany during the same period.

442

X
BAROQUE AND CLASSICAL

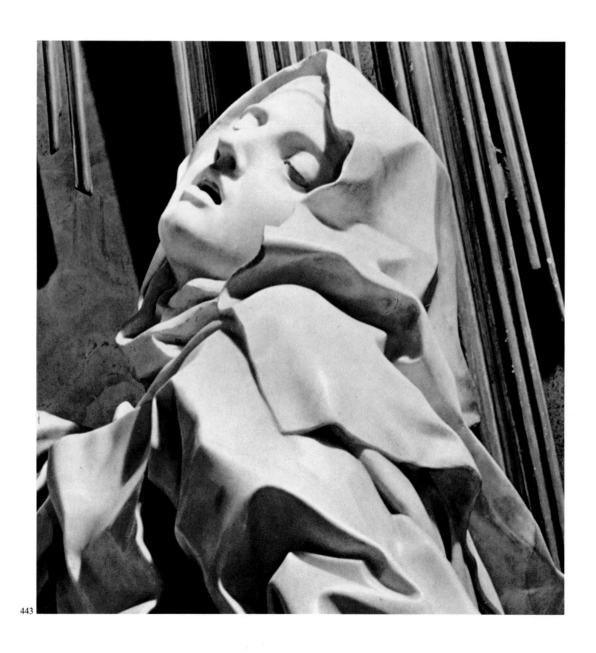

The relationship between architecture and sculpture has been constantly shifting throughout the history of art; in some periods the architect has laid down the law to the sculptor and in others the sculptor's work dominated architecture. An extreme at one pole is the Escorial, where the stone-carver's contribution is limited to a few austere moldings, but this severe limitation followed upon half a century during which the opposite extreme was the rule, when proliferating statuary had been allowed to smother the architectonic structure of buildings. The most fruitful periods for sculpture, however, have not been those allowing the image-makers such unbridled freedom; the finest statues, the most impressive reliefs, have been created during periods of classicism, when the sculptor has accepted a self-imposed discipline and even contributed, with his work, to an orderly architectonic scheme.

The 17th and 18th centuries made great use of sculpture, as indeed of all the arts. After the ascetic catharsis of the Counter Reformation, which in any case was fully effective only in Spain, sculpture once more invaded the monuments, and in countries where the Baroque triumphed, began to overrun them inside and out. The earlier part of this epoch produced the last of the great sculptors. Masters like those of Chartres, Paris, or Reims, like Nicola Pisano, Ghiberti, Donatello, Michelangelo, or even Giovanni da Bologna, saw their last great descendants in Bernini and Montáñez. In the later 17th and 18th centuries sculpture tended more and more to degenerate into a merely ornamental art, though it was subservient to architecture only in appearance, and in fact lent itself, as did painting, in support of the architects' experimentation with interior space. Sculpture exists in great quantity in Rococo buildings like Ottobeuren or Neubirnau, but each statue or relief is nothing in itself and counts only as an element of the total symphony of forms in which architecture, painting and sculpture all combine in the swansong of a civilization. Understandably, the museum setting is fatal to Baroque sculpture, which always appears impoverished when detached from the surroundings within which it was conceived, from that coordinated whole that the Germans have termed *Gesamtkunst*. Even the masterpiece of Bernini, his Apollo and Daphne, might lose some of its magic if it were to be removed from the Villa Borghese, where it has always stood, to some clinical museum decor.

Once more it was Italy that invented the new style, which all of Europe eventually adopted as its artistic language, though sometimes giving it an opposite interpretation—an evolutionary development common in all great stylistic creations, as we have seen.

Florentine Mannerist sculptors had concentrated their efforts on making the statue self-sufficient, even when it involved two or more figures. At the end of the 16th century sculptors in Rome had turned their efforts once more to an attempt to reintegrate sculpture, and particularly the relief, with architecture. Among the earliest important works in this vein were the Sistine and Borghese chapels of Santa Maria Maggiore, which proved veritable laboratories for experiment in Baroque decoration.

The end of the Mannerist period in Rome also saw an archeological movement that led to a revival of imitation of the antique in an altogether literal manner. Nicolas Cordier, from Lorraine, admired ancient art so passionately that he even made up statues from excavated fragments. Gianlorenzo Bernini, who received his grounding from his father Pietro, learned directly from antiquity by restoring antique works, the most famous of which is the Ares Ludovisi, to which he added an *amorino* in Hellenistic taste. At the age of fifteen he carved the statue of the goat Amalthea, whose authorship was soon forgotten; it was taken for a genuine antique, and was only recently discovered to have been carved by Bernini. The four groups and statues commissioned from the young Bernini by Cardinal Scipio Borghese, and still in the Villa Borghese, show marked Hellenistic influence. His *David (fig. 445)* is reminiscent of the Borghese Gladiator, and the slender body of Apollo in Bernini's *Apollo and Daphne (figs. 446, 447)* looks back to the *Apollo Belvedere*, though the *Aeneas and Anchises* and the *Rape of Proserpina* also show a strong Mannerist inheritance. The *Apollo and Daphne* is probably the most beautiful group sculptured during the 16th and 17th centuries; since Michelangelo, no one had been able to endow marble with so much life—a life that is shown just as

443 GIANLORENZO BERNINI (Italian, 1598 to 1680) *Head of St. Teresa.* **Detail of fig. 448.** With half-closed eyes and a half-open mouth, the Saint sinks in a trance. A shudder seems to pass through her cloud-borne body, and beneath the crushing folds of the cloak her hand and foot hang down limply. The similarity between this mystical ecstasy and the ecstasy of profane love has often been pointed out; but the connection is literally made in the Saint's own account of her vision, which Bernini followed closely.

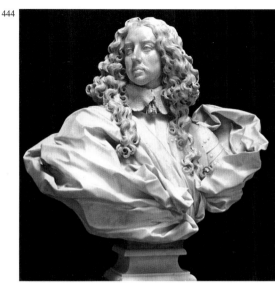

444

444 GIANLORENZO BERNINI *Bust of Francesco d'Este I.* **1650. Galleria Estense, Modena.** Bernini did not know his model and had to do his portrait after paintings by Sustermans; the artist complained, but it had the advantage of giving him considerable freedom in execution. The vivid turn of the head and the richly folded and agitated drapery, pulled diagonally, help to create an impression of pomp and grandeur in this state portrait.

445 GIANLORENZO BERNINI *David.* **1623. Galleria Borghese, Rome.** Born in Naples, Gianlorenzo, son of the Florentine sculptor Pietro Bernini, first worked under the direction of his father. Later, in Rome, he executed works inspired by biblical and especially by mythological themes. Preparing to hurl the stone from his sling, *David* leans back to gather his strength. The old base, now transformed, must have accentuated the movement, for on it the figure appeared to be slightly off-balance. Designed along a plunging diagonal, the statue frees itself from the Renaissance tradition by taking full possession of space.

446 GIANLORENZO BERNINI *Apollo and Daphne.* **1624. Marble. Galleria Borghese, Rome.** Bernini interrupted work on the *David* to do this statue. The works he executed for Cardinal Borghese were intended to be set up against a wall rather than to be seen in the round, and in this respect he did not break with the Renaissance tradition. That, however, he was moving away from it is shown by the fact that here one forgets that the figures were carved from a block of marble, for they seem to take flight into space.

445

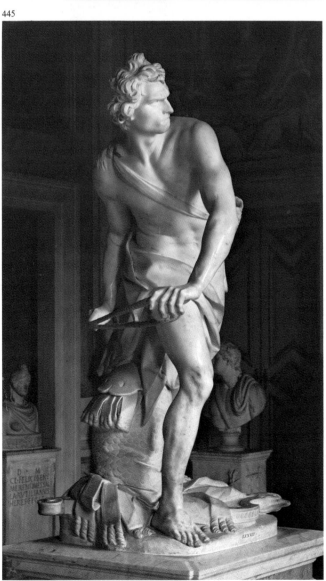

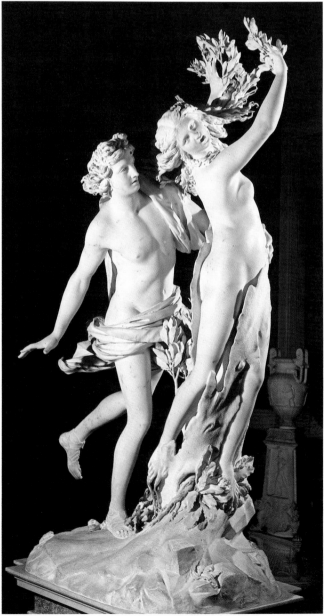

446

447 **GIANLORENZO BERNINI** *Head of Daphne,* **detail of fig. 446.** The subject of Apollo and Daphne was a familiar one in painting rather than sculpture, and Bernini must have drawn his inspiration from the painters, among whom he admired especially the Bolognese school and in particular Annibale Caracci. With supreme virtuosity the sculptor gave his marble the translucency of wax. Although the two personages seem idealized, Bernini interprets their drama in a highly realistic manner.

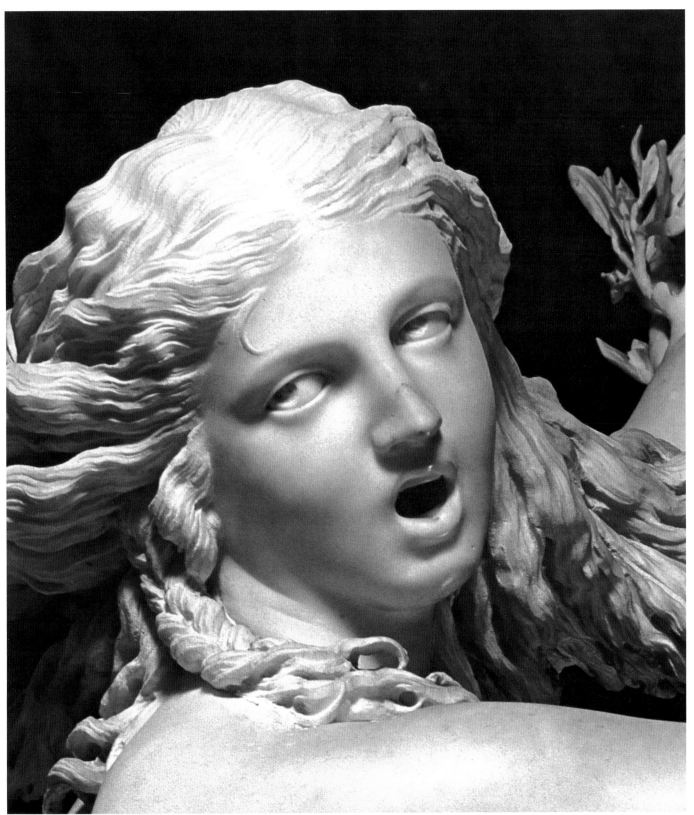

447

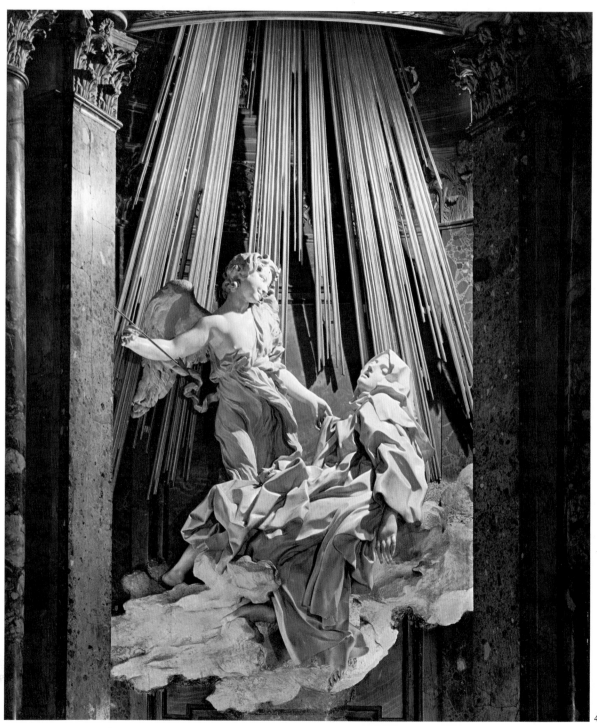

450

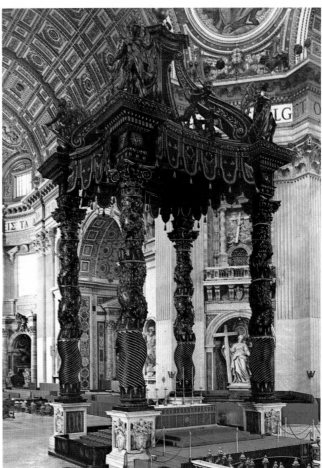

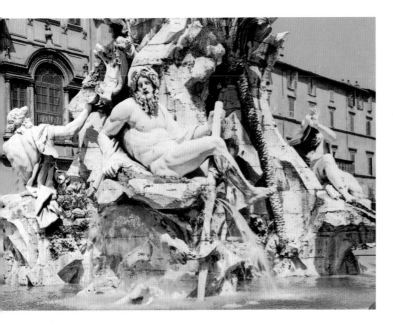

448 GIANLORENZO BERNINI *The Ecstasy of St. Theresa*. **1645 to 1652. Cornaro Chapel, Santa Maria della Vittoria, Rome.** In the churches of the barefooted Carmelite friars, the Vision of St. Theresa had often been represented since the beginning of the 17th century. In keeping with tradition, Bernini chose to depict that supreme moment of ecstasy when the Saint's heart is about to be pierced by the arrow of Divine love.

449 GIANLORENZO BERNINI *Fountain of the Four Rivers*. **1648 to 1651. Piazza Navona, Rome.** Bernini, out of favor at the time, managed to submit his design for a fountain to decorate the Piazza to Innocent X, and it was immediately accepted. The artist isolated the figures of the four great rivers of the world from the obelisk, and further emphasized the illusion by the arbitrary poses of the men.

450 GIANLORENZO BERNINI *Baldacchino*. **1624 to 1633. St. Peter's, Rome.** Immediately after his election, Pope Urban VIII commissioned a bronze *Baldacchino*, to be raised above the supposed position of St. Peter's tomb. The twisted columns were inspired by the ancient columns used to decorate the old basilica of St. Peter; these Bernini reintegrated in the decoration of four great pillars of the crossing. The 92 1/2-foot structure animates the great void under Michelangelo's dome.

it is arrested in a cry, the ultimate act of one who is about to enter forever the world of silence.

The four works dating from Bernini's youth were still conceived somewhat in the Mannerist spirit, that is to say, with the statue considered as a self-sufficient entity, but when Urban VIII ascended the papal throne and began to employ Bernini on monumental works all over Rome, the sculptor gave up his interest in free-standing statues. From then on his work was designed to be seen in an architectural setting—an outlook characteristically Baroque. In later years the architect and sculptor completely merged within him. Bernini, like Michelangelo, approached architecture as a sculptor, composing buildings in masses, and when he created sculptures (except in the portraits) it was for the purpose of animating an architectural or natural setting. Even the Ponte Sant' Angelo angels are designed with the background of the Roman sky in mind, and it is better, therefore, to see the copies on the bridge than to see the originals in Sant' Andrea delle Fratte, where they were placed because Clement IX, who commissioned them for the Ponte Sant' Angelo, found them so beautiful that he refused to expose them to the inclemencies of the weather.

Bernini's statues appear to move with the purpose of breaking out of their limiting contours—those contours that had enclosed all Mannerist statues in a kind of prison symbolized by the *linea serpentina,* the artificial condensation of the statue's life and pulse within which all movement was rigidly contained. The human beings Bernini represents appear to long for escape from their self-sufficiency—that is, from their loneliness; a Bernini statue always implies an invisible antagonist or interlocutor—God, in the case of the religious statues. The portraits, imaginative evocations or life studies, show the model caught in the midst of conversation. Even in the face of death there is no silence: on the tombs of Urban VIII and Alexander VII, the Virtues are witnesses called to God's Tribunal to plead for the deceased. Nor is the spectator allowed to remain passive before Bernini's

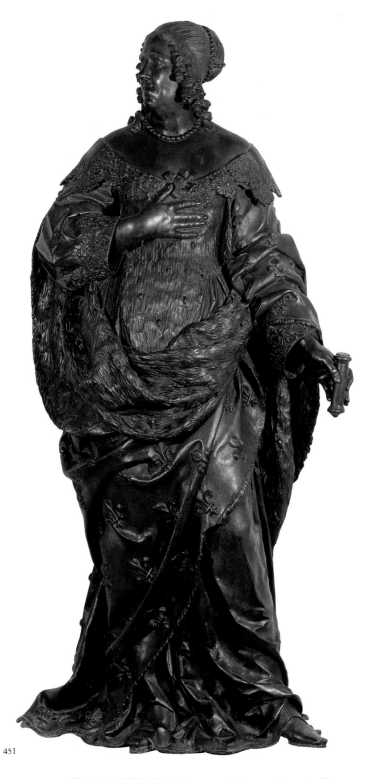

451

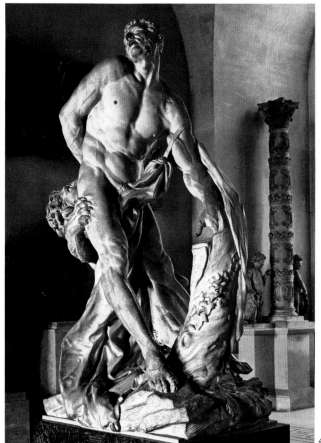

452

451 SIMON GUILLAIN (1581 to 1658) *Anne of Austria.* **Bronze. 2 m. high. 1647. The Louvre, Paris.** This masterpiece of Simon Guillain depicting Louis XIV between Louis XIII and Anne of Austria was erected at the Pont-au-Change's entrance in commemoration of the young king's introduction to the Parisian populace. The style is influenced by the art of Germain Pilon and combines a rigorous realism with monumental forms.

452 PIERRE PUGET (French, 1620/22 to 1694) *Milo of Crotona.* **1671 to 1682. The Louvre, Paris.** Having suggested to Colbert the idea of a statue of Milo for Versailles, Puget took an exceptionally large block of marble and carved out of it the hero, his hand caught in a split tree trunk, about to be devoured by a lion. Among the sculptures made for Versailles, Puget's *Milo* represents the erruption of the Baroque.

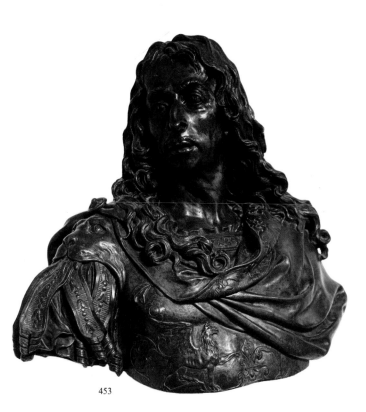

453

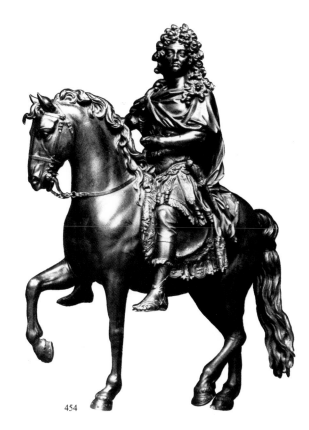

454

work: he is caught up, appealed to. With Bernini we are at the theater, and sometimes the spectators even appear, as in the Cornaro chapel in Santa Maria della Vittoria, where members of the Cornaro family watch from stage-boxes the representation of St. Teresa's Ecstasy, chatting among themselves, some even turning their backs on the sacred drama *(figs. 443, 448)*.

One must talk, shout, act, run, fight, love, pray—anything rather than remain alone, face to face with oneself, questioning the needs of the inner life. Such was contemporary Rome, capital city of the Church, a community of believers that had become a defensive association against pessimism. Since the 16th century Italian mystics like St. Philip Neri or St. Mary Magdalen dei Pazzi had lovingly tendered to the faithful their assurances of a God "more Father than Judge." This optimism was rooted in the humanists' beliefs according to which human nature, created by God, could clearly be only good. There was no question of repressing natural tendencies, but only of directing them towards God. The Augustinian anguish that tortured the Spanish mystics, demanding a terrifying confrontation between man and his conscience, was most violently rejected in Rome. The Italian saints preached happiness as a genuine sign of sanctity. "My children, be cheerful," said St. Philip Neri, the most amiable of

saints, ". . . a cheerful spirit is closer to Christian perfection than a melancholy spirit." St. Mary Magdalen dei Pazzi asserted that "God does not like sad hearts. He wants free and joyful hearts." Maulde La Clavière wrote in his *Life of St. Gaetano* that for Italian humanists, "Christianity is less a final knowledge of things than a link uniting men with God and with one another, a link of love and grace. The role of religion is to touch the feelings, to soften men's hearts, and therefore to give them a genuine personal incentive and other social virtues such as kindness, unity—in other words, happiness." All these saints lived in a constant state of emotional uplift, echoed in their verbal and written outpourings. During her ecstasies St. Mary Magdalen dei Pazzi preached so volubly that she had to be provided with six secretaries, who wrote under her dictation for hours and sometimes for whole days.

Michelangelo had led sculpture into a path that none could follow, and thus led it to sterility: Bernini brought it back to life. Few artists have had such a following and few have been so fully understood by their imitators; it was impossible to work in the manner of Michelangelo, but easy to be Berninesque. Some artists in Rome resisted his influence, however; the most stubborn of these was Algardi, whose avoidance of Bernini led him to a cold classicism derived from Mannerism. While Bernini's star climbed in Rome,

453　　**ANTOINE COYSEVOX (French, 1640 to 1720)** *Bust of the Grand Condé.* **Bronze. 1688. The Louvre, Paris.** The perfect sculptor for Louis XIV, Coysevox had the most forceful temperament among the artists working at Versailles. His portraits constitute the most personal expression of his sculpture. This bust captures the traits of the Victor of Rocroy.

454　　·**FRANÇOIS GIRARDON (French, 1628 to 1715)** *Small bronze model of the equestrian statue of Louis XIV.* **The Louvre, Paris.** Girardon executed for the Place Vendôme in Paris an equestrian statue of Louis XIV which was destroyed in 1792, but which is known from engravings and drawings, small bronze versions, and a marble bust.

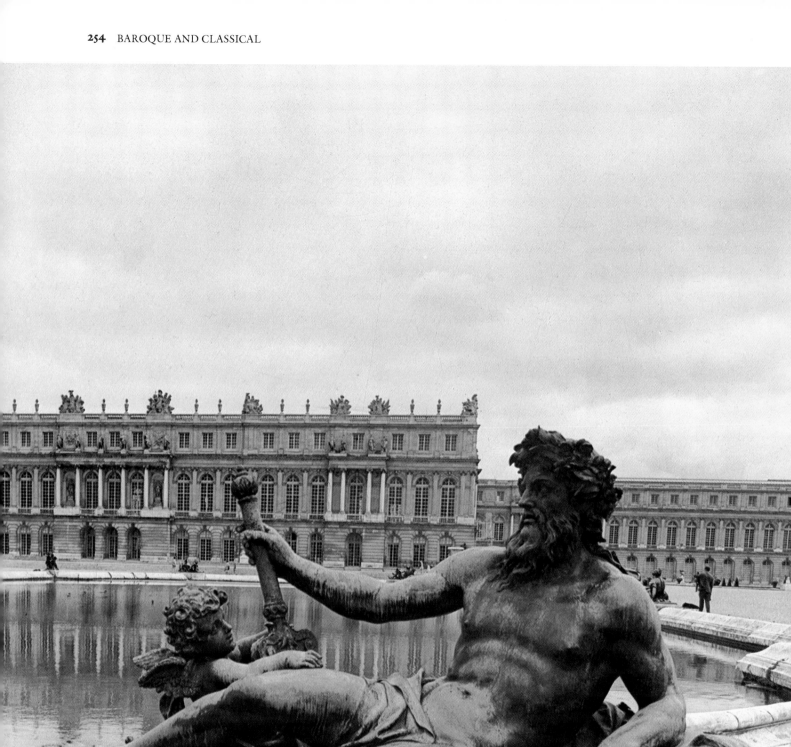

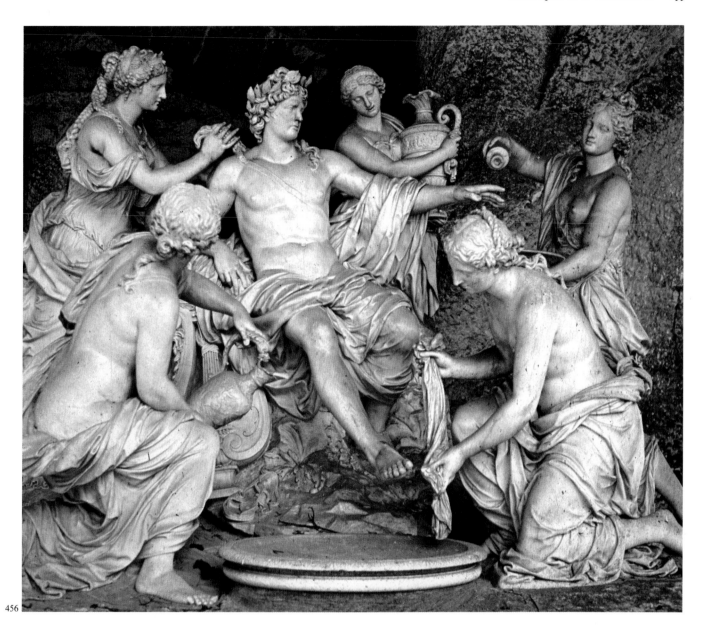

Francesco Mochi in Piacenza worked for thirteen years on equestrian statues of two Farnese princes; in these monuments rider and horse were caught up together in the same impulse of movement, rather than rider dominating horse.

Jacques Sarrazin lived for a long time in Rome, but when he left for Paris in 1628 he brought with him, not the influence of Bernini, who, younger than Sarrazin, had not yet produced his greatest works, but rather the influence of the antique. Like Bernini, Sarrazin had restored numerous antique sculptures; but while the Italian artist had been interested in Hellenistic works, the Frenchman turned to the classical style. Through his many pupils Jacques Sarrazin was the real founder of the French classical school.

Simon Guillain, with his bronze statues of Louis XIII, Anne of Austria, and Louis XIV as a boy, a group intended for the Pont-au-Change in Paris, is representative of French humanism, which stands for an act of conscience translated into deed through control of self. French classicism blossomed in what was called the "School of 1660"; peopled with antiquities and copies from the antique, the gardens of Versailles became a huge workshop, which put artists on their mettle. In his *Apollo Tended by the Nymphs (fig. 456)*, François Girardon revived the noble art of Phidias. French sculpture having always remained close to Greek classicism, 17th-century French artists felt that the genuine sources of antique art were in Greece and not in Italy. La Teulière,

455 JEAN-BAPTISTE TUBY, the "Roman" (Rome 1630-Paris 1700) *The Rhone*. Bronze. 1685–1687. The "Parterre d'eau," Versailles. This sculptor of Italian origin became, by marriage, the nephew of Le Brun. Accepted into the Academy in 1676, he pursued a successful career as official sculptor, completed important work for Versailles such as tombs of famous people. His sound knowledge of antique statuary served to tone down his Baroque tendencies.

456 FRANÇOIS GIRARDON *Apollo tended by the Nymphs*. **Grotto of Thetis, Gardens of Versailles.** Girardon became the leading figure among the sculptors at Versailles, where he collaborated closely with Lebrun. In 1666 he received the commission for the group of *Apollo tended by Nymphs*, intended for the Grotto of Thetis. The influence of Hellenistic art and a knowledge of nature allied to the artist's personal sensitivity make this work the most purely classical of all 17th-century sculptures.

457

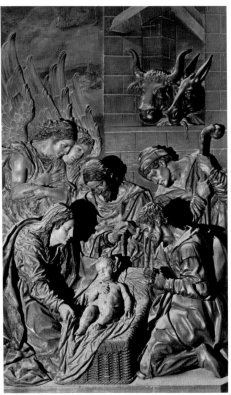

458

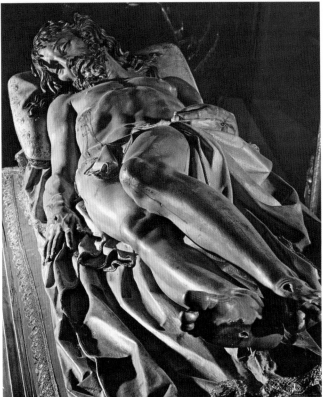

459

457 ALONSO CANO (Spanish, 1601 to 1667) *Eve,* ca. 1607. Cathedral, Granada. Cano's was a life of considerable drama; before he became a priest, he had been unjustly accused of murdering his wife. He was a painter, an architect, and a sculptor. The *Eve* shows him already in the 17th century looking forward to the effeminate, elegant imagery of 18th-century Granada. This face sparkles with intelligence and its coquettish charm has a hint of voluptuousness.

458 JUAN MARTINEZ MONTÁÑEZ *The Adoration of the Shepherds,* detail of the reredos of San Isidore del Campo. 1609–1613. Santiponce. A Baroque element gradually made its appearance in the style of Montáñez, and his most beautiful works are those executed in his youth. They are also more clearly stamped with his individuality, for as time went on, his success obliged him to make use of his assistants. The Santiponce Altarpiece is his masterpiece.

459 GREGORIO FERNANDEZ (Spanish, d. 1636) *The dead Christ.* El Prado, Madrid. The theme of the dead Christ, crucified or *gisant,* was treated frequently by Fernandez. After the 16th century the scene was reduced to the representation of Christ alone, without the traditional mourners. Here anecdote is suppressed—the extreme expression of realism in sculpture. The very realistic polychromy accentuates the physical aspect of the Passion. Such conceptions emphasize the function of image that 17th-century Spanish sculpture served.

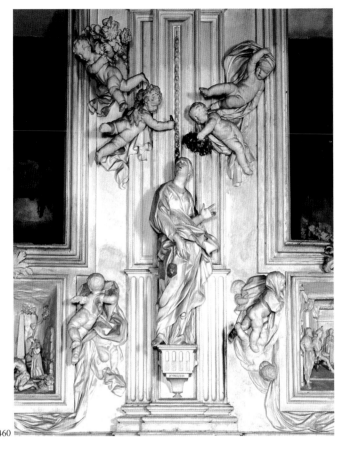

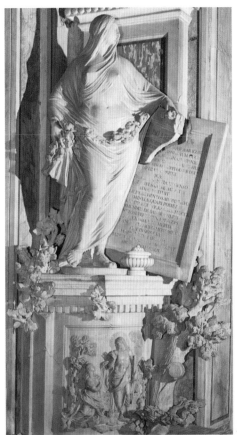

461

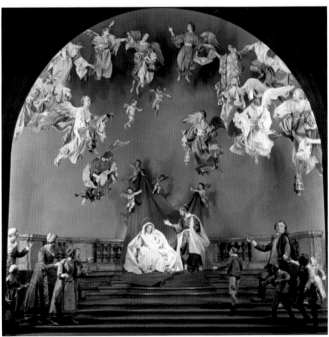

460 GIACOMO SERPOTTA (Italian, 1656 to 1732) *Humility.* ca.
1700. Oratory of San Lorenzo, Palermo. With the scenes of San Lorenzo
is one of the artist's most graceful works, the figure of Humility, repre-
sented as a young woman with fluttering draperies, surrounded by four
groups of flying putti. Executed entirely in stucco—a material that de-
mands speed in working and allows no vacillation—the group shows the
artist's great virtuosity.

461 ANTONIO CORRADINI (Italian, 1668 to 1752) *Modesty.*
Cappella Sansevero, Naples. When called to Naples by Raimondo di
Sangro, Corradini had come to the end of a career that had taken him
through Germany, Austria, and Bohemia; his Rococo style was under-
standably permeated with foreign influences. He executed the statue of
Modesty as a tribute to Cecilia Gaetani, Raimondo's mother, who had
suggested to the artist that he should portray her in a new allegorical form,
derived from the iconography of Spring. Taking up his favorite theme of
women thinly veiled in transparent drapery, the artist concentrated almost
exclusively on the surface finish, creating his last bravura piece.

**462 *Neapolitan presepio* 18th century. Bayerisches Nationalmuseum,
Munich.** The art of presenting the Nativity in three-dimensional form goes
back to the Middle Ages but reached its climax in the eighteenth century
in Genoa and Naples especially. This became the specialty of a great many
craftsmen, but at times even distinguished artists like Lorenzo Vaccaro and
his disciple Bartolommeo Granucci did not disdain to turn their hands to
this humble but charming art.

462

director of the French Academy in Rome, dreamed of creating a school in Athens, in that city "where there are still beautiful remains," as he wrote.

The art of Versailles, dominated by Le Brun and regulated by and for the king, favored sculpture rather than painting; the latter sank to the level of mere decoration while a group of talented young sculptors was forming in the Versailles "nursery." For the monument of Louis XIV in the Place Vendôme, Girardon created the prototype of the royal statue, representing the sovereign in antique dress, serenely triumphant on a pacing horse. Unfortunately, we have been robbed of that masterpiece by the revolutionaries, and we know it only through the reduced models which have survived *(fig. 454)*.

Undoubtedly the bust of Louis XIV that Bernini sculptured during his sojourn in Paris in 1665 was the model for many later French state portraits, carved or painted. In it Bernini duplicated the proud attitude of his earlier Francesco I d'Este (1650), but gave the French king a truly sovereign appearance. Coysevox, in portraits of artists or magistrates done early in his career, retained the sobriety of the French manner which characterizes his busts of Louis XIV (1679 and 1681); but he was inspired by Bernini's heroic style in his posthumous portrait of the Prince de Condé *(fig. 453)*, commissioned by the Prince de Conti in 1688.

French 17th-century sculptors evolved a type of funerary monument with numerous figures grouped around the deceased—represented in his death throes, or awakening to eternal life, or taking leave of his family, or praying. These tombs are reminiscent of contemporary funeral orations, which rank among the most beautiful literary expressions of the time. The passionate rhetoric of death is restrained by a

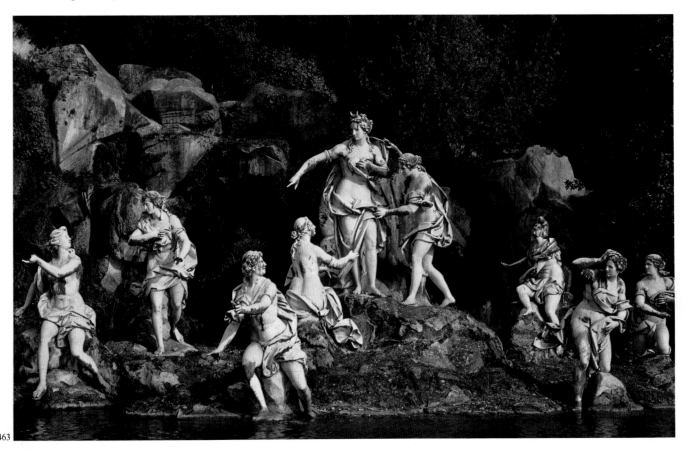

463

463 LUIGI VANVITELLI (Italian, 1700–1773) *Diana and Acteon,* **gardens of the royal residence, Caserta (Naples). Designed ca. 1770.** Luigi Vanvitelli designed simultaneously the palace and the gardens of Caserta for Charles III Bourbon. The fountains, which he planned for either side of the waterfall, were to illustrate ancient myths related to the theme of water.

464 JOSÉ CHURRIGUERA (Spanish, 1665 to 1725) *Main altar.* **ca. 1700. San Esteban, Salamanca.** This grandiose altar, whose construction required more than four thousand pieces of wood, inaugurated Baroque 18th-century architecture. It is the first example of the 18th-century Baroque style *entallador,* which obtains its effects from the rhythm of the decorated surface, supported by a robust, monumental structure.

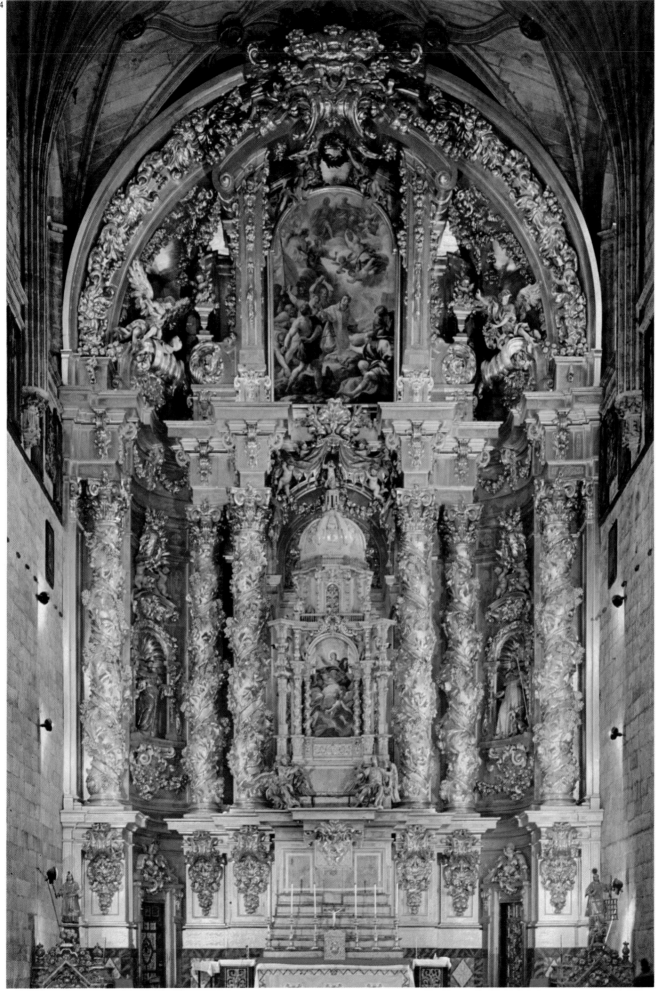

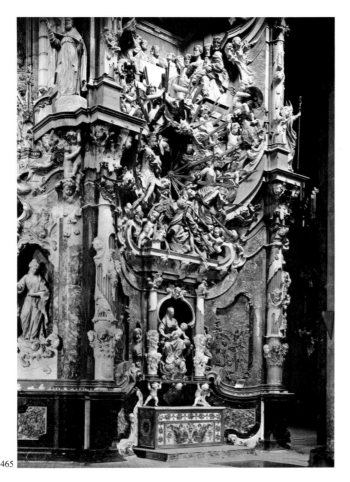

465

466

self-control that slows the gestures and forces them to conform with the classical laws according to which the forms must be completely self-sufficient.

In this classical concert there were a few discordant Baroque notes. These were sounded most noticeably by the Marseillais Pierre Puget, who had a taste for representations of effort or pain. The muscular contractions of his statues (*fig. 452*) contrast with the smooth surfaces modelled by other French 17th-century sculptors.

In Spain, most sculpture was designed not for the open air, nor for large, well-lit cupola churches, but for gloomy chapels, where often only the polychromy and gilt covering the sculptures enable them to be seen in the darkness of the sanctuary. These sculptures were not the work of sophisticated artists who had traveled to Rome, but of artisans who, shut up in their workshops, considered the exercise of their trade as an act of prayer. As before, sculpture centered around the altarpiece, which now obeyed a strict architectural organization designed to include statues and reliefs. Spain was divided into two artistic schools: in Castile reigned the Ba-

roque, introduced by Berruguete and Juan de Juni; Valladolid remained the capital for sacred images, its principal exponent, Gregorio Fernandez, practising a rhetorical style much less moving than the profoundly meditative style of Juan Martínez Montáñez of Seville. The classicizing tendencies of Andalusia were inherited by Montáñez, and they also found their way into the art of Zurbaran; there are some indications that Zurbaran was deeply influenced by the older Montáñez. The masterpiece of Montáñez, the main altar in the church of San Isidoro del Campo at Santiponce (1609) (*fig. 458*), dates from the beginning of his career. The faces of his figures are full of deep sadness, of commiseration for the human condition; the sculptor expresses a mood opposite to the optimistic Catholicism of Rome, a mood prevailing in a country where Augustinism predominated, where man, sensing himself unworthy of divine solicitude, examined the depths of his soul with anguish and found there only nothingness. In Granada, Alonso Cano, a reluctant priest, chose less earnest subjects; his graceful statues look forward to the 18th century (*fig. 457*).

465 **NARCISO TOMÉ** (Spanish, active 1715 to 1742) *Transparente.* **1721–1732. Cathedral, Toledo.** The extraordinary *Transparente* set behind the main altar of the *capilla mayor* in Toledo Cathedral originated in the wish of Bishop Diego de Astorga y Céspedes to mark the presence of the Holy Sacrament with a glorious monument. Owing to its fantastic nature, the complexity of the forms, the mingling of stucco, painting, bronze, and all varieties of coloured marbles, the quality of this decoration cannot be grasped from a photograph.

466 **JACINTO VIEIRA** (Portuguese) *St. Gertrude.* **ca. 1725. Monastery Church, Aruca (Portugal).** With the gaps that still exist in present-day scholarship, the sculptors of the numerous 18th-century religious images decorating Portuguese churches are mainly anonymous. But we do know the author of the group of Benedictine female saints decorating the *coro* of the Aruca monastery church. Carved in wood, the statues are painted white to simulate stone; they are exquisite examples of the cult of femininity that inspired so many 18th-century artists.

467

468

469

467 ANTONIO FRANCESCO LISBOA, known as o ALEIJA-DINHO *The Bad Thief.* **1796 to 1799. Sanctuary of Congonhas do Campo.** The Stations of the Cross at Congonhas do Campo consist of 66 statues divided among the six chapels; so numerous a group could only have been carried out in collaboration. The less important figures, entrusted to helpers, are on the whole rather crude in workmanship. However, the *Bad Thief* from the scene of the *Nailing to the Cross* is definitely by Aleijadinho's own hand. In the muscular body and enraged expression is expressed the supreme revolt of the man who rejects God's grace.

468 o ALEIJADINHO (Brazilian, 1738 to 1814) *Christ Carrying the Cross.* **1769 to 1799. Congonhas do Campo (Brazil).** At the end of the Baroque era, in the state of Minas Gerais, Brazil, the greatest artist was a mulatto architect and sculptor. A strange disease that caused the shriveling of his hands and feet earned him the nickname of O Aleijadinho (the little cripple). He built churches, carved altarpieces, and created wood and stone sculptures. These images of Christ are the last great renderings of this theme of the Passion, which had inspired masterpieces for so many centuries.

469 o ALEIJADINHO *The Prophet Daniel.* **1800 to 1805. Sanctuary of Congonhas do Campo (Brazil).** Between 1800 and 1805 Aleijadinho executed twelve stone statues of prophets, just over lifesize, for the terrace in front of the Congonhas do Campo Sanctuary. He took up the old theme of the Dispute of the Prophets, revivifying the exhausted topic by infusing into it an expressionistic force reminiscent of the Middle Ages.

To understand 18th-century Italian sculpture, it is essential to see the convent-palace of Mafra in Portugal, built by King João V in emulation of Philip II's Escorial. More than fifty statues from Italy were ordered to decorate the church—a type of exchange common in 17th- and 18th-century Europe. These sculptures are in the moderated Berninesque style that was practiced in Rome and Florence at the time. In Naples and in Sicily more interesting developments were taking place. Neapolitan sculptors illustrated the theme of death with frenzied statues in the Cappella Sansevero, using illusionistic devices and even *trompe l'oeil;* virtuosity appeared the only possible way of being original. More convincing are the works of Serpotta, from Palermo, at the end of the 17th century. Serpotta decorated several oratories with stuccos in which may be seen all the elements of the Rococo style that was to flourish in Germany *(fig. 460).* Serpotta was the Guarini of sculpture. In Naples the fashion grew

for the Nativity scene, the *presepio:* numerous figures of terra cotta, or more usually, of wood, dressed in real fabrics, were assembled in crowds teeming with natural life around the scenes of the Nativity or the Adoration of the Magi *(fig. 462).* In Naples the naturalistic content of these scenes was exploited, but the elegant style of the statuettes greatly influenced Spanish art. Southern Italy had been in close contact with Spain since the 15th century. The façades of Sicilian buildings in Apulia and in Campania were often sheathed in a carved decoration compounded of deliriously contorted vegetable, human, and fantasy shapes.

The flight from reality that is Baroque art suited the Spanish temperament. Artists created in the churches in Spain theatrical structures like the famous *transparente* in Toledo cathedral *(fig. 465),* which delighted their contemporaries. The name for this type of structure, *transparente,* is significant; in Italy, Germany, and Spain the statuary groups, pierced and open, were often given a setting in which the light came from behind, blurring the contours and mingling further the already complicated forms. The Spanish altarpiece now reached the apogee of its evolution. During the last years of the 17th century José Churriguera designed the colossal altar of San Esteban in Salamanca *(fig. 464),* in which powerful twisting columns symbolize the aspiration of the whole towards heaven. In Portugal carved wood decor spread over the walls and ceilings of the churches, so that the interiors resembled caskets for precious jewels. The altarpiece was such an important element of Spanish art that from the 17th century on it influenced the decoration of the church façades as well.

Reaching New Spain—that is, South America—the Baroque forms proliferated like a plant transplanted to the tropical climate, though native stone carvers sometimes seem to rediscover spontaneously forms reminiscent of Pre-Columbian.

In Spain after Montáñez art declined into a naturalism that lost all nobility; Pedro de Mena turned Montáñez's idealistic expressions of faith into mere devotional images. In the 18th century Francisco Salzillo brought from Naples to Murcia the graceful art of the Neapolitan *presepio,* which he

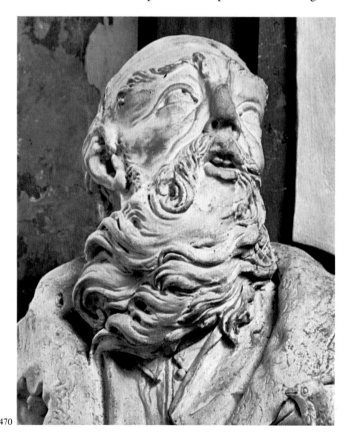

470

470 FRANZ JOSEPH IGNAZ HOLZINGER (Austrian, 1691 to 1775) *Head of St. John the Baptist,* **on an altar in the church of Metten. 1722–1724. Bavaria.** As a sculptor and as a stucco-worker, Holzinger was one of the most skillful practitioners of his time, but kept to the forms of the first Rococo phase. This head is from a great sculptural and decorative ensemble, including various altars and the entire interior design of the church, all by Holzinger.

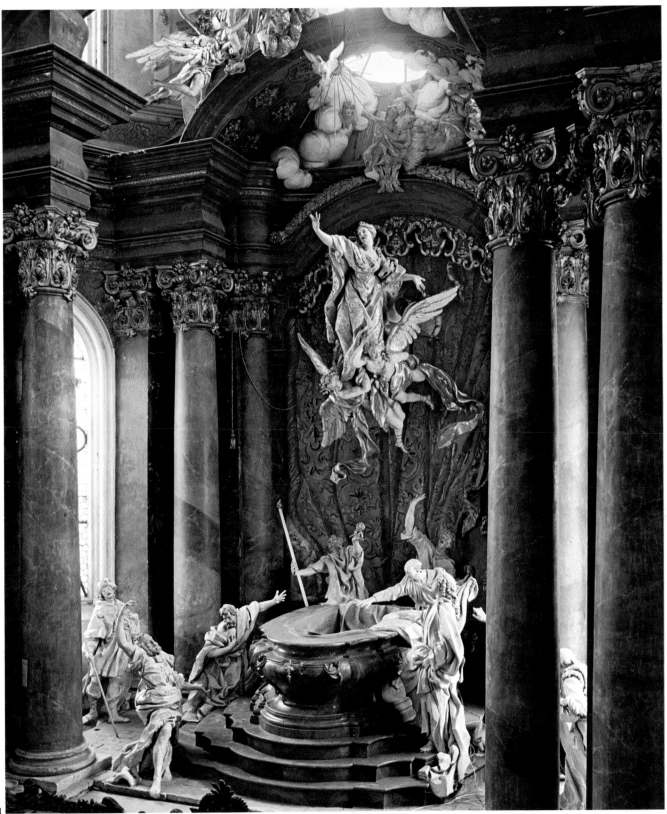

471

471 **EGID QUIRIN ASAM** (Bavarian, 1692 to 1750) *The Assumption of the Virgin*. **1718 to 1725. High altar, monastery church, Rohr, Bavaria.** E. Q. Asam, architect and sculptor, studied in Rome under Pietro da Cortona, then collaborated with his brother, Cosmas Damian Asam. In the work reproduced, the lifesize stucco figures, lightly touched with gilt and colours, assume animated poses of wonder and awe, as the Virgin rises airily from her massive sarcophagus.

transposed into a type of sacred imagery that later spread to Portugal. Portuguese sculptors, however, still maintained a tradition of restraint, of interiorized reaction. This tradition echoed in Brazil where, at the end of its evolution, it produced the last great Christian image-maker, Antonio Francesco Lisboa, called o Aleijadinho ("The Cripple"). In the spirit of this mulatto, instinct combined with deep faith, and he refreshed the etiolated Rococo with a primitive strength in his scenes of the Passion of Christ (*fig. 468*), which are as powerful as the works of Montáñez.

The true heirs of Bernini throve in Central Europe and in Germany, where his theatrical compositions combining architecture, painting, and sculpture were imitated and expanded. Painting and sculpture tended not so much to develop within a framework imposed by the architecture as to become associated arts and to merge with it. On ceilings where carved decoration continues painted decoration and figures grow out of an animated architecture, it is often impossible to define where one ends and the other begins. The building interior becomes a shifting, moving world created by the sum of the parts. These interiors are often the work of a family whose members shared the responsibility for the various techniques, as did the brothers Asam in Bavaria, or the brothers Zimmermann in Swabia.

Any material could be used for relief effects: stucco, wood, marble, stone, or bronze. Adopting Italian stucco techniques, the Germans exploited stucco as a principal element of their interior decoration. The town of Wessobrunn, in southern Bavaria, specialized in training stucco workers who were then employed throughout the German-speaking world. Their stuccos are painted in bright colours that appear unreal and facilitate the transition between relief figures and paintings—though in any case the moving, jagged, Rococo framing elements constantly lap over into the painted scenes. All these lavish and spectacular reliefs do not have as much feeling for sculptural form as a single mutilated Greek statue in a museum. An occasional statue or group does stand out, and sometimes the whole decoration of a church may be organized around that one statue. In Bavaria, Egid Quirin Asam produced some very effective compositions: his *Virgin of the*

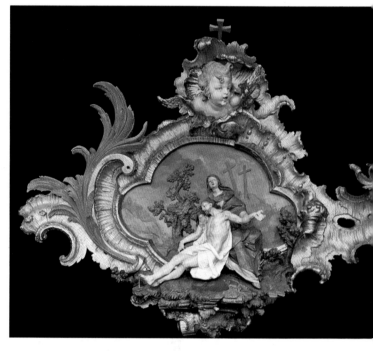

472 JOSEF-ANTON FEICHTMAYR. *Pietá,* **St. Mary, Neubirnau (Lake Constance).** This Station of the Cross is one of eight surviving from an original fourteen attributed to Feichtmayr and his collaborators. Trained among stucco-workers at Wessobrunn, he became representative of the Bavarian Rococo.

473 IGNAZ GÜNTHER (German, 1725 to 1775) *The Annunciation.* **1763. Parish church of Weyarn (Schliersee).** Sculptor and architect Ignaz Günther left behind a considerable production. His works of 1763 at Weyarn are especially interesting: they consist of *The Annunciation*, a Pietà, and figures of Saints. This Rococo imagery, animated by a gentle religious fervor, achieves a luminous mystical effect through its flowing grace and the lightly curving upward movements.

474 JOSEPH CHRISTIAN (Austrian, 1706 to 1777) *Bust of the Prophet Ezekiel.* **ca. 1764. Benedictine abbey church, of Ottobeuren.** Joseph Christian played a major role in the decoration of this church. He achieved a sensitive and coherent ensemble in the decoration, which offers an excellent example of successful collaboration. He exploited his gifts to the full without ever overreaching himself, working with the humility and conviction of a servant of both art and religion.

475 DOMINIKUS ZIMMERMANN (German, 1685 to 1766) *Pulpit.* **1746 to 1756. Pilgrimage Church, Wies.** This pilgrimage church achieves a poetic rendering of space and responds to a popular demand for enchantment and religious euphoria. The pulpit, executed in collaboration, is one of the most striking manifestations of Bavarian fantasy and illustrates the metamorphosis of the weightier religious Baroque style into the lilting, musical forms of the Rococo.

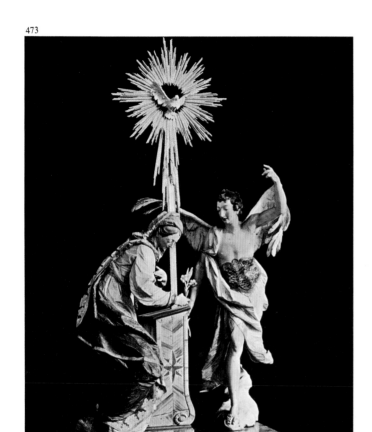

473

475

474

476

Assumption (fig. 471), suspended in space in the church at Rohr, is a triumph over the law of gravity, a law that true sculpture obeys.

At the end of its evolution the excesses of the Rococo produced a sort of anarchy in which the unity of the decoration was destroyed, but which gave back some individual value to the separate statues, as exemplified in the Zwiefalten monastery. At that time Josef-Anton Feichtmayr found an intensity of expression worthy of Alonso Berruguete. In the pilgrimage church of Neubirnau, a kind of madness seems to seize the figures: propelled out of the sacred scene, they circle like dancing dervishes, desperately contorting their bodies without managing to establish any connecting link with one another *(fig. 472)*.

According to a Christian aesthetic requiring that the soul be closed to alien influence, the church so effusively ornate on the interior was decorated on the exterior almost exclusively by architectural motifs. Palaces were quite another

matter: they might be covered with stone reliefs. Atlantes supporting the weight of the balconies, staircases, or upper floors were the favorite motif of princely dwellings—a significant display of captive strength. Just as the glorification of religion overlaid a growing unbelief, this royalist rhetoric preceded the overthrow of kings. In an art apotheosizing a way of life that was rapidly nearing its end, princes and churchmen wrapped themselves in a screen of make-believe that hid the impending upheaval of society; they intoxicated themselves with a dream whose realities were already fading. It is interesting to note that it was the enlightened King Joseph II who closed the Baroque workshops in Austria.

Amidst this riot of images it is difficult to find a genuine sculptor, an artist devoted to the eternal problems of three-dimensional form. A rare example in Austria is the bronze sculptor Raphael Donner, and in Prussia, Andreas Schlüter, who made one of the proudest equestrian statues of a period swarming with them—that of the Great Elector in Berlin,

476 JEAN-BAPTISTE PIGALLE (French, 1714 to 1785) *Mausoleum of the Maréchal de Saxe.* **1753 to 1776. St.-Thomas, Strasbourg.** The *Mausoleum of the Maréchal de Saxe*, begun between 1752 and 1753 and resumed in 1770, was inaugurated in 1776 in the Lutheran church of St.-Thomas in Strasbourg. Standing before the pyramid of Immortality, the Maréchal moves towards the sarcophagus opened by Death, while France tries to intercede; the stricken Hercules symbolizes the French army; the leopard, lion, and eagle represent conquered nations.

477 LAMBERT-SIGISBERT ADAM (French, 1700 to 1759) *Prometheus.* **1737. The Louvre, Paris.** Adam's art was influenced by the Italian Baroque, which he had assimilated in Rome. *Prometheus*, the artist's presentation piece for the Academy in 1737, reveals a facile inspiration, great technical skill ostentatiously displayed, and a real sense for the decorative. His *Triumph of Neptune* and *Amphitrite* at Versailles, created with his brother Nicolas-Sébastien, is an exemplary work of French Rococo sculptural style.

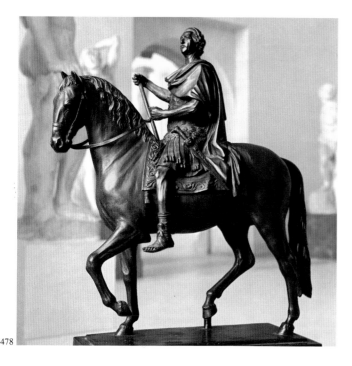

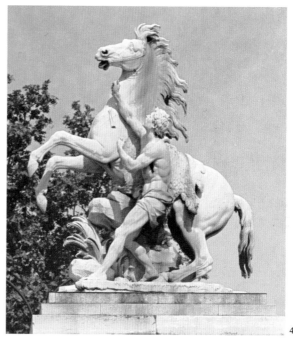

478

479

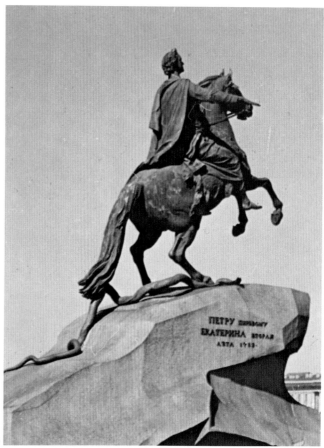

478 After **EDMÉ BOUCHARDON** (French, 1698 to 1762) *Model of the equestrian statue of Louis XV 1748–1758*. **Bronze. The Louvre, Paris.** Born at Chaumont, Bouchardon became a pupil of Guillaume Coustou in Paris, and then worked in Rome between 1723 and 1732. His style falls within the trend of the Classical reaction against Rococo excesses. The Roman-style equestrian statue of Louis XV, commissioned by the City of Paris in 1748 for the Place Louis XV, was preceded by a number of preparatory drawings. Cast in 1758 and inaugurated in 1763 after the death of the sculptor, it was destroyed in the Revolution in 1792. It is known to us, however, through engravings and such small bronze models as one in the Louvre, made by Louis Vassé. The original pedestal was completed by Pigalle. (Height, 27 inches.)

479 **GUILLAUME COUSTOU** (French, 1677 to 1746) *Rearing horse,* from Marly-le-Roi. 1740 to 1745. **Place de la Concorde, Paris.** The two horses, which have stood since 1794 in the Place de la Concorde at the entrance to the Champs-Elysées, were executed in 1740–1745 for the Terrasse de l'Abreuvoir in Marly, as a replacement for the *Mercury* and the *Fame* by Coysevox, which were transferred to the entrance to the Tuileries gardens in 1719. In each of the marbles by Coustou a rider tries to tame a wild horse; through the overlay of classicizing antique inspiration the naturalism and impetuosity of Baroque forms emerges.

480 **ETIENNE-MAURICE FALCONET** (French, 1716 to 1791) *Monument to Peter the Great.* 1766 to 1777. **Bronze. Leningrad.** Falconet, who was born and died in Paris, was, with Pigalle, the favorite sculptor of Mme. de Pompadour. His masterpiece is the statue of Peter the Great commissioned by Catherine II for St. Petersburg. This work breaks away from the traditional equestrian statue: here the horse is rearing up on a rock. The sovereign, in heroic garb, is shown as a lawmaker, a reformer. His face was sculpted by Marie-Anne Collot, a pupil of Falconet. The monument is theatrical but simple in conception, devoid of allegory except for the crushed snake.

480

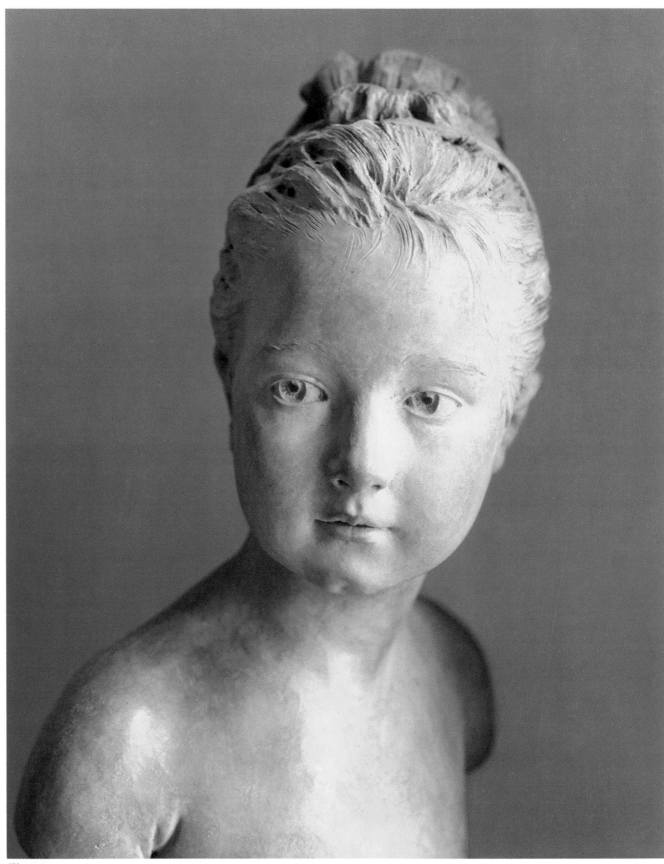

481

481 JEAN-ANTOINE HOUDON (1741–1828). *Bust of Louise Brongniart as a child.* **Terra cotta. 1777. The Louvre, Paris.** This bust of the architect Brongniart's daughter is one of Houdon's first great works of a familial subject. In his final work he carries through with the model of his first casts where the rendering of the head is so exact that even the smallest detail is realized with an extraordinarily light touch.

482 JEAN-ANTOINE HOUDON (French, 1741 to 1828) *Diana.* **ca. 1776. Gulbenkian Collection, Lisbon.** The idea of a statue of Diana leaving for the hunt was conceived in 1776. The marble original was intended for the gardens of the Duke of Saxe-Gotha. In the bronze version in the Louvre, the tuft of rushes used as a support for the marble statue could be eliminated, enabling Houdon to accentuate the lightness of the figure, which is entirely Classical in inspiration.

inspired by Girardon's Louis XIV, which Schlüter might have seen during a visit to Paris before the statue was erected in the Place Vendôme.

France, unlike Central Europe, produced sculptors still faithful to the basic tenets of their art. A few were influenced by the Baroque, such as Lambert-Sigisbert Adam and Pigalle; most remained classicists, and most noteworthy among these is Bouchardon. Houdon brought back naturalism in his portraits, and in his nudes returned to the smooth, elegant style traditional in France. With Pajou and Clodion that style degenerated into sugary statuettes and clock ornaments. The rest of Europe, in the throes of the Baroque, realized that France alone had sustained the spirit of sculpture; whenever important monuments were needed, French artists were called upon to provide them. Falconet, who in his own country had produced only minor works, was called to St. Petersburg, where he set up on a rock a vivid equestrian statue of Peter the Great, reviving the theme of the rearing horse.

French 18th-century sculpture is full of charm and liveliness; it produced graceful figures and portraits sparkling with wit. Nonetheless it remained fairly superficial, an art without a vital spirit to animate the accomplished silhouettes.

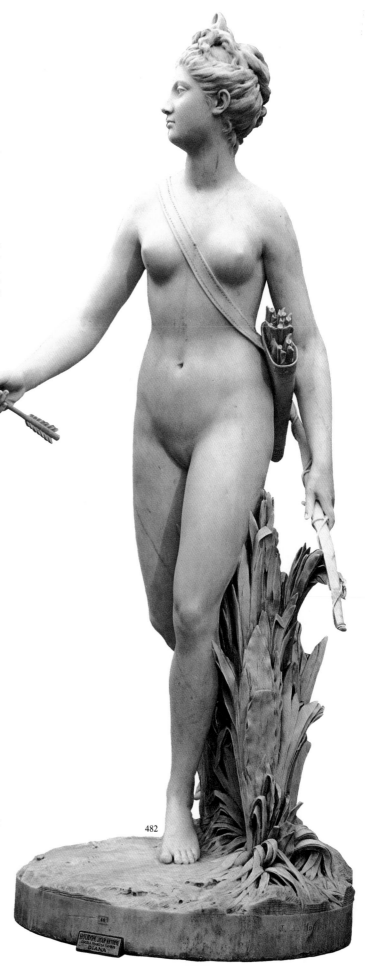

482

XI
THE NINETEENTH AND TWENTIETH CENTURIES

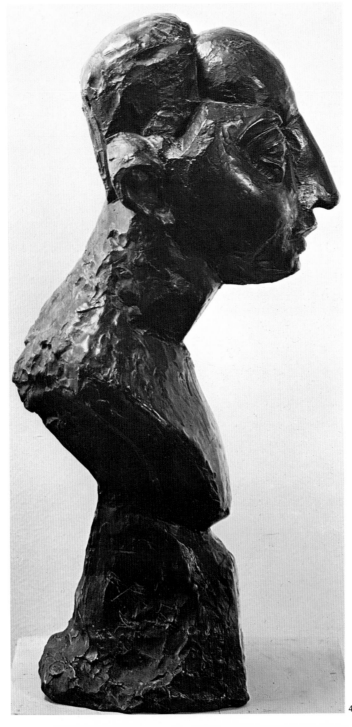

The 19th century saw the path of artistic creation divide in two: the official one was strewn with honors and the other, that of living art, with infamy. Posterity has reversed this relationship, casting into disrepute all who had once been laden with honours and commissions, while promoting to glory the unknowns. Failing to receive popular acclaim in their own time, these artists advanced with great difficulty; yet it is because of them that the art of the 19th century may figure among the greatest. But this may be entirely due to the work of painters. If necessary, they could live in poverty while working at their easels in a cramped garret full of unsold paintings. The sculptor, on the other hand, had no such option, for his art required an initial agreement between himself and a public for which he provided his work. This is not to say that there was no demand for sculpture during the 19th century: our monuments, our public squares, and our sculpture gardens are brimming with statues and bas-reliefs. Still, this profusion attests to how impossible it was for artists of the period to retain even the most elementary principles of their art. Paradoxically, it is the moment when sculpture sank to such mediocrity that it exercised the greatest influence: during the first half of the 19th century, trends in sculpture even dominated painting.

At the end of the 18th century, Neoclassicism put an end to the pictorial freedom of the Baroque and prevented any spontaneous flight by Romanticism. This style forced painters to compose their paintings like bas-reliefs and to polish these illusionistic volumes. Jacques Louis David set the example for architectural painting with the *Horatii* and the *Brutus*: Jean Auguste Ingres preferred Greek cameos and vases to sculpture. Nor could Théodore Géricault free himself altogether from the yoke of this new fashion. Eugène Delacroix broke away from the Neoclassicist style, but at the risk of losing the most basic sense of anatomy. The Italian Antonio Canova *(fig. 484)* was a sculptor whose work endeared itself to the German art historian Johann Winckelmann. One day, in the octagonal courtyard of the Vatican's Pio-Clementine Museum, two of Canova's statues would have the honor of being placed alongside the most celebrated of ancients: the *Laocöon* and *Apollo Belvedere*. Such

was the goal to which sculptors of the time aspired: to imitate the classical to the point of passing for it. Nonetheless, the marbles of Canova are quite easily distinguishable from the marbles of the ancients. His cool nudes seem to be caressed by moonlight. It is this pallid clarity that Romanticism introduced into the art of the period; for the moon, daughter of the night, truly haunted the early 19th-century painters: the Frenchman Anne-Louis Girodet-Trioson, the Swiss Henry Fuseli, and the Englishman William Blake. In the Europe of Canova's time, sculptors of all nationalities propagated the Roman style: the Englishman John Flaxman, the Dane Bertel Thorvaldsen *(fig. 485)*, the Prussian Gottfried Schadow, the Swede Johan Tobias Sergel, and the Frenchman Antoine Denis Chaudet are some examples. Some tended toward gracefulness, others toward virility—in either case they practised this style of art that owed its cold appearance less to the ancients themselves than to the plaster castings that represented them in all the academies. Original Greek sculpture appeared in all the major museums of Europe in vain because Roman sculpture outshone Greek statuary. From 1815 to 1817, Thorvaldsen had in his Rome workshop statues that had been found in 1816 at the Temple of Aphaia in Aegina. Ordered by King Louis the First of Bavaria to restore them, he succeeded only in Romanizing them.

Romantic sculptors, such as Antoine Préault *(fig. 488)* and Duseigneur in France, did their best to revitalize these statues, but managed only to turn them into grimacing and gesticulating mannequins. Antoine Louis Barye did not fare much better in his attempt to recapture nature by observing animal life: losing himself in anatomical details, his fawns prove tiresome. His (unfortunately few) figures are more successful; here, less a slave of imitation, he approached artistic truth by regaining some of the equilibrium inherent in the classical Greek statues.

The sole sculptor of the second quarter of the century who possessed a true feeling for sculpture in the round was the Frenchman François Rude, the son of a coppersmith. It is undoubtedly his Burgundian origins that inspired a healthy naturalism that often allowed him to break loose of the con-

483 HENRI MATISSE (French, 1869 to 1954). *Portrait of Jeanne Vaderin* (final version). **1911. Museum of Modern Art, New York.** Matisse was the creator of French Fauvism, and besides his paintings, which were essentially dominated by line and color, he executed a number of highly original and witty sculptures. In 1910 and 1911 he sculptured five versions of Jeanne Vaderin's portrait, entitled *Jeannette*, the first two done from the model, the other three freely interpreted from these.

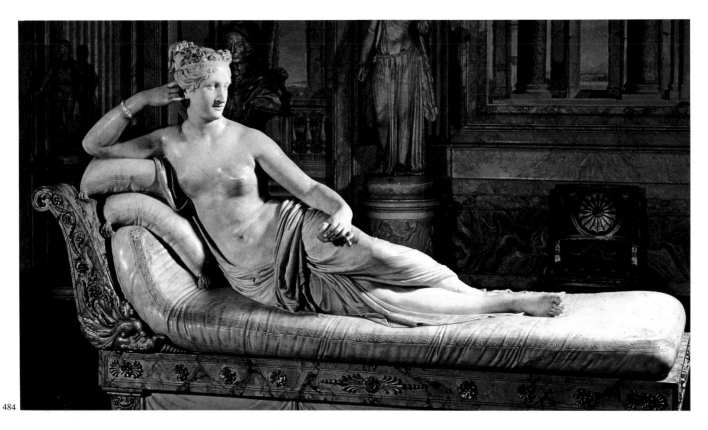

484

straints imposed by classical forms. A fervent advocate of the Revolution and a continued supporter of Napoleon, Rude, who voluntarily exiled himself in Brussels from 1814 to 1827, had an epic vision. He knew how to pose the statue of a great man powerfully in the light of an open space, or evoke a heroic episode such as the group of volunteers for the revolutionary campaign of 1792, which he entitled *La Marseillaise (fig. 490)*. Jean-Baptiste Carpeaux, born in Valenciennes, was the son of a mason. Carpeaux's first job was mixing plaster for a plasterer. For both the Fleming and the Burgundian, manual labor had been a fact of childhood. Both were indelibly marked by this experience, which is why they managed to escape the intellectualism then sapping the academies of all vitality. For both artists, sculpture was above all a manual gesture. Rude, who had learned to forge iron, later learned how to wrest reliefs from blocks of stone. The plasterer Carpeaux remained a modeller: he loved to handle glaze or clay as well as fashion bronze. His marbles have the fluidity

of moulded reliefs as well. Drawing on the tradition of the Flemish Baroque in order to rid himself of the pervasive obsession with the classical, Carpeaux worked with an unswerving awareness of the uniqueness inherent in each piece. The grouping *Danse de l'Opera (fig. 492)* evokes the studies done by the 16th-century Florentine Mannerists.

Finally Rodin appeared. Already possessing an infallible technique, Rodin unveiled his *Age of Bronze* at the Salon (an annual art exhibition in Paris) of 1877. It was the first time in years that a human body had come to life in bronze; this created quite a scandal, since the public could not bear to part with its favoured lifeless art. Rodin dominated the world of sculpture at the end of the 19th and the beginning of the 20th centuries. It may be said of him that he was a Romantic for whom the expression of ideas and of passion counted more than the rendering of reality. For although Rodin was also a realist, his realism was not based on any a priori anatomical or logical truth. The expressive deformations, the

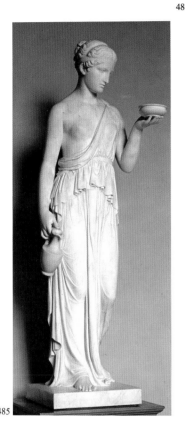

485

486

487

484 ANTONIO CANOVA *Pauline Bonaparte as Venus Victrix.* **1808. Galleria Borghese, Rome.** In 1804 Canova received a commission from Pauline Borghese, Napoleon's sister, for a statue portraying her as a victorious Venus. The artist took his idea for the figure from a painting he owned, a Venus and Satyr inspired by Titian. The formal purity of the art of Canova is demonstrated in this work.

485 BERTEL THORVALDSEN (Danish, 1768 to 1844) *Hebe.* **Marble. 1806. Nationalmuseet, Copenhagen.** For all that Thorvaldsen's statue of Hebe is rigorously subservient to imitation of the Greeks, it contrives to create an impression of calm and harmony. Lack of expressive force is compensated here by a sort of romantic reverie.

486 SIR FRANCIS LEGGATT CHANTREY (English, 1781 to 1841) *Mrs. Siddons.* **Westminster Abbey, London.** Sir Francis Leggatt Chantrey enjoyed enormous popularity in England during his lifetime. Among the eleven funerary monuments that he executed for the Abbey is that of Mrs. Siddons, the great actress, who died in 1831.

487 JAMES PRADIER (French, 1792 to 1852) *Victory.* **Napoleon's Tomb, Les Invalides, Paris.** The most famous sculptor during the July Monarchy, Pradier was commissioned to execute the twelve Victory figures who stand guard around Napoleon's tomb. Set against the columns of a circular gallery, these colossal marble figures have the grave expression of Greek caryatids. Pradier's elegant, cold style harmonizes in every way with the architecture of the tomb.

488

489

surface marks that he imprinted on his figures, no less than the extraordinary power with which these forms rise up out of the marble or stone itself, show that reality is borne of a confrontation with matter. The figures in *The Gates of Hell,* for example, emerge from a door that has been transformed from a simple backdrop into the agitated, tormented surface that presents itself to the eye. In the same way, the massive column of stone in the extraordinary portrait of Balzac seems to give birth to the head of the novelist. Rodin broke with the tradition of narrative portraiture, exemplified by Rude's *La Marseillaise,* in which figures on an imaginary ground reproduce a historical moment. In so doing, he opened up a new channel for the language of sculpture.

Medardo Rosso adopted a fluid way of working marble comparable to Rodin's. There is something stylistically quite modern in the lianoid quality of these two sculptors' works: the undulating wave that travels along the surface and the use of blurring, for which one finds an equivalent in painting, are characteristic of their work. Rosso attempted to unite things with their planes and to project them in space. His

atmospheric planes refused to enclose sculpture within precise lines. This "impressionistic" playing with surfaces was countered by the severe return to order by sculptors like Emile-Antoine Bourdelle and Charles Despiau, both of whom worked in Rodin's workshop. The floral quality of Rodin and Rosso's sculpture was succeeded by a more monumental conception, characterized by the organization of masses and by an almost linear geometry that resulted from the introduction of abstract architectonic elements. There is a kind of inflexibility in Bourdelle's statues that marks the beginning of a new Neoclassicism *(fig. 498)*. The sensitively shaped female nudes of Despiau show full volumes and peaceful, polished surfaces that exude a certain elegance. Aristide Maillol affirmed for the last time the radiant splendour of the human body by erecting his marble and bronze giants. Unfortunately, the sensual quality of these statues was to disappear with the return to order evident in his work of the 1930s.

Several painters of this period took up sculpture, and the strength of their attempts brought some life to what was

488 ANTOINE-AUGUSTIN PRÉAULT (French, 1809 to 1879) *The Killing.* 1834. Musée des Beaux-Arts, Chartres. A typically Romantic character, Préault mixed 19th-century social ideas with his art. This daring and nightmarish vision, possibly inspired by a popular melodrama of the time, is the work most characteristic of his extremism, of his passionate concern with movement, ugliness and the colossal.

489 ANTOINE-LOUIS BARYE (French, 1796–1875). *Theseus Slaying the Minotaur.* Bronze. 1841–1846. The Louvre, Paris. Barye has a place among the most forceful French sculptors and Romantic masters of the 19th century. This statue shows how he drew inspiration from antiquity, adding to it the profound acquaintance with anatomy, the keen sense of life, and the qualities of power and tension.

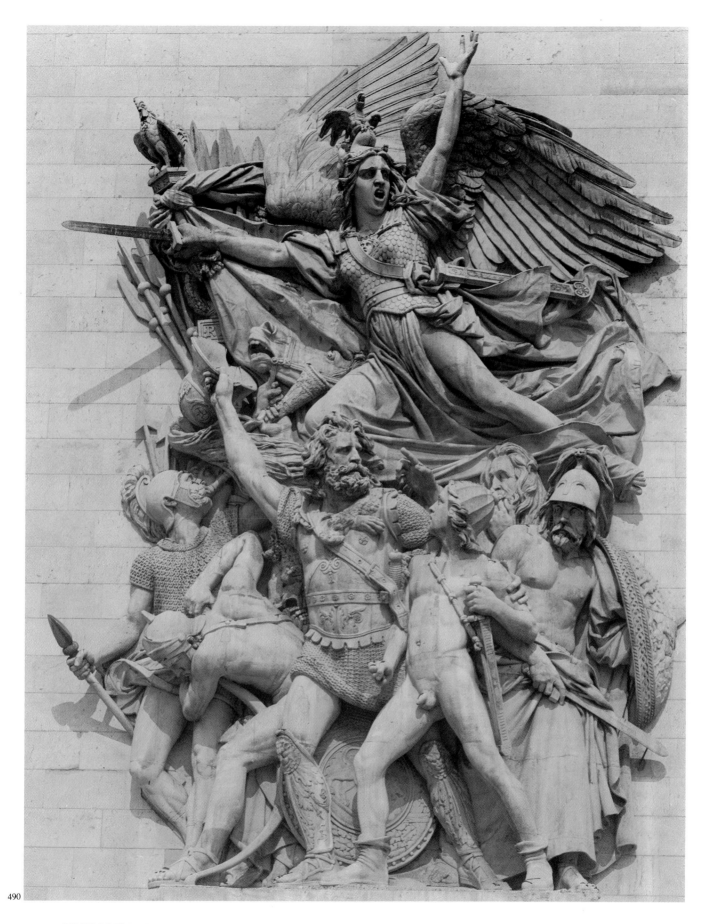

490

490 FRANÇOIS RUDE (French, 1784 to 1855) *Figure of La Marseillaise;* **detail of the *Volunteers of '92,* Arc de Triomphe, Paris.** 1833–1836. Rude worked on the decoration of the Arc de Triomphe in Paris; for the east face of the arch he carved the stone relief representing the *Departure of the Volunteers of 1792,* also known as *La Marseillaise.* In this epic work rooted in popular sentiment and patriotism, the shouting figure of the Marseillaise is incomparable for its passion and movement.

491

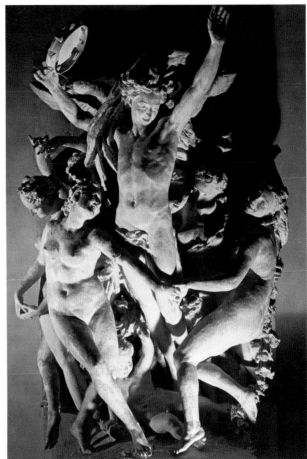

492

then a highly academic domain. The rare attempts by Géricault were strikingly beautiful; Honoré Daumier made some astonishing reliefs. But it was primarily at the end of the century that painters manifested the desire to express themselves in three dimensions. It was a phenomenon of the epoch, a prelude to the 20th century. Auguste Renoir did not take up sculpting until rather late in life and never made his own casts. His figures, reproductions of his paintings, express a charming femininity *(fig. 499)* but, unlike Edgar Degas' sculpture, these transpositions into another medium were not particularly innovative. In the case of Degas, who like Renoir retained his favourite subjects, the sculpted work is much more important; he devoted nearly half a century to it. The result was a daring and free work, which in certain aspects prefigured works of the 20th century. "It is the single truly modern attempt in sculpture," said J. K. Huysmans of Degas' *Fourteen-year-old Dancer,* composed of diverse materials, some of which were borrowed directly from real life: the lace tutu, the toe shoes.... "An uneven treatment," criticized Rodin.

But the appearance of spontaneity should not be confused with an absence of structure. Paul Gauguin was bold and

independent enough to find in non-European wood sculpture a new source of inspiration that renewed a sense of primitivism tied to an image of the artist as artisan—an idea we will find developed later on by artists such as Ernst Ludwig Kirchner and Ernst Barlach. Many artists, painters above all, collected African and Oceanic sculptures. They were attracted by the wood and by the shapes that gave witness to an abandoned technique: the carving of artifacts. Two 20th-century painters understood the full importance of this lost art—Henri Matisse and Pablo Picasso. It is impossible to separate their work into painting on one hand and sculpture on the other.

Matisse took courses at the workshop of the Ecole de Ville de Paris under the guidance of Rodin; he was already thirty years old when he took up sculpting. Even in his first standing bronzes he took liberties with the proportions of the human body, accentuating its linear qualities, as in *The Serpentine.* The series of *Nus de Dos (fig. 523),* bas-reliefs approximately two meters high, show a unity of composition and an expressive quality that achieves the monumental. As in the series *Head of Jeanette I, II, III,* one has moved from concentrating on one pregnant moment to the presentation

491 **JEAN-BAPTISTE CARPEAUX (French, 1827 to 1875)** *Mademoiselle Fiocre,* **ca. 1870. The Louvre, Paris.** Carpeaux executed a series of brilliantly realistic busts in the tradition of French portraiture of the 17th and 18th centuries. The Louvre possesses the original plaster model of this bust of Eugénie Fiocre, *prima ballerina* at the Opera. Through its quick, spontaneous technique, the bust conveys all the animated naturalness and *joie de vivre* of art.

492 **CARPEAUX** *The Dance.* **1869. The Louvre, Paris.** Upon his return to Paris from Rome in 1862, Carpeaux became official sculptor for Napoleon III. In 1865 Garnier entrusted him with execution of a sculptured group for the façade of the Opera. The result was *The Dance* which provoked a scandal. A masterpiece of animation, rhythm and grace, this ring of nymphs around a leaping sylph reflects the round of feverish pleasure to which the Second Empire abandoned itself.

493 **HONORÉ DAUMIER (French, 1808 to 1879)** *The Emigrants.*
The Louvre, Paris. Daumier is best known as a caricaturist, but worked
in other media as well, in which he appears as both a Romantic and a
Realist. The theme of *The Emigrants,* which he treated in paintings and
sculptures several times over the course of the years, first attracted him
during the period of bourgeois reaction which, at the end of 1848, followed
the February Revolution. Two bas-relief sketches, cast in plaster from the
clay models, remain timeless symbols of suffering.

493

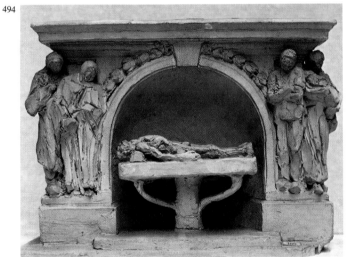

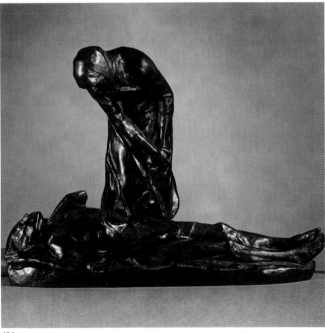

494 **JULES DALOU (French, 1838 to 1902)** *Project for the Victor
Hugo Tomb.* **1886. Musée du Petit Palais, Paris.** During the 1880 s Dalou's
talents were fully recognized in France, and he became much sought-after
for public monuments. When Victor Hugo died in 1885, Dalou was anxious
to execute the large monument planned for the Panthéon. However, nei-
ther his model for that project nor the sketch shown here was ever executed.
In this model he shows his strong links with the art of the mid-19th century.

495

495 **CONSTANTIN MEUNIER (Belgian, 1831 to 1905)** *Firedamp.*
Bronze. 1893. Musée Constantin Meunier, Brussels. At the age of 50,
Meunier turned seriously to sculpture, continuing the feeling for the se-
riousness of his subject he had shown in his paintings for two decades. To
express his view of the dignity and the tragedy of the coal miners in
southern Belgium, he developed a strong, simple figure style, realistic but
with all detail and sense of anecdote suppressed.

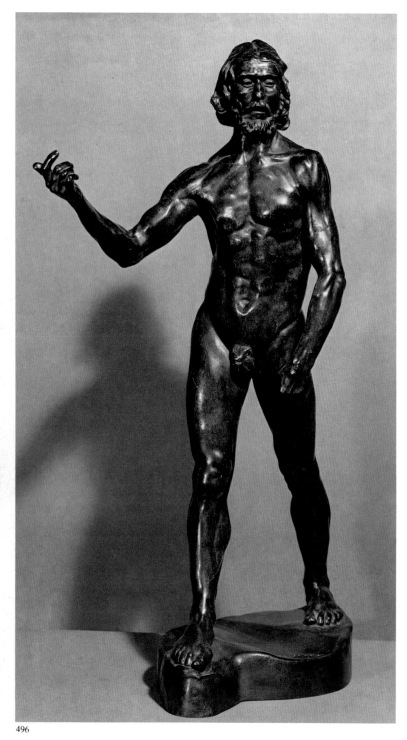

496

496 AUGUSTE RODIN (Paris 1840-Meudon 1917) *Saint Jean*
Bronze. Musée Rodin, Paris. Saint Jean's muscles bulge beneath the
weight of a cross he carries on his shoulder. Our attention is drawn to the
hand of his ill-proportioned right arm. It is this malformation, along with
the rather "heavy-handed" sculpting, that are most artistically expressive.
The influence of great Italian sculptors is very evident in this work, espe-
cially in his copies of Donatello and Michelangelo.

of stages in the production of an object. In addition, this
series indicates how heads present a problem of primary im-
portance for sculptors; this problem was the point of depar-
ture for their experiments with volume: *viz.* Picasso's heads
of 1905, 1906, and 1909, Constantin Brancusi's series of bowed
heads beginning in 1907, or *Baudelaire* by Raymond
Duchamp-Villon. Picasso needed no instruction until 1924
when, with the help of his friend Julio González, he began
to sculpt in metal *(figs. 520, 521)*. Beginning in 1924, he ex-
ploited ideas taken from collections and collages that raised
the problem of surface in sculpture, while at the same time
he incorporated his preoccupation with structure. Contours
were broken up to make way for an opacity and surface
texture that was occasionally marked by hatch marks, a rigid
redundancy that represented the third dimension in paint-
ing, used here with a bit of humour. After the disconcerting
iron structures *(fig. 522)*, which delineated geometric figures
in space, Picasso worked diverse objects and utensils into
his sculptures. In doing so he created a tension between a
figurative interpretation and the literalness of the concrete
elements themselves *(fig. 524)*. In later sculptures one finds
forms caught within the mass: astonishing heads of women,
archaic shapes, as well as superb figurative sculptures, such
as *Man with a Sheep* done in 1944.

From 1910 to 1914, Cubism acted like a magnetic field.
Alexander Archipenko *(fig. 505)* left us with an example of
sensual Cubism while Jacques Lipchitz *(fig. 515)* applied the
style more systematically. Around 1926, individual forms of
Cubism began to appear, the results of using new materials.
Pablo Gargallo worked with new materials while retaining
traditional themes: he cut sheet iron *(fig. 519)* which he then
founded and rolled in bronze. Ossip Zadkine's art appears
rather laborious. Henri Laurens sought to solidify the action
of light through the medium of colour, and he applied
polychromy to his reliefs, sculptures, and constructions
from 1915 until 1928. Like many others, Duchamp-Villon was
influenced by Rodin, but he quickly developed his own dy-
namism through the use of large masses that he contrasted
with one another to suggest movement. His most daring
sculpture is the famous *Horse (fig. 506)* of 1914, a half-or-

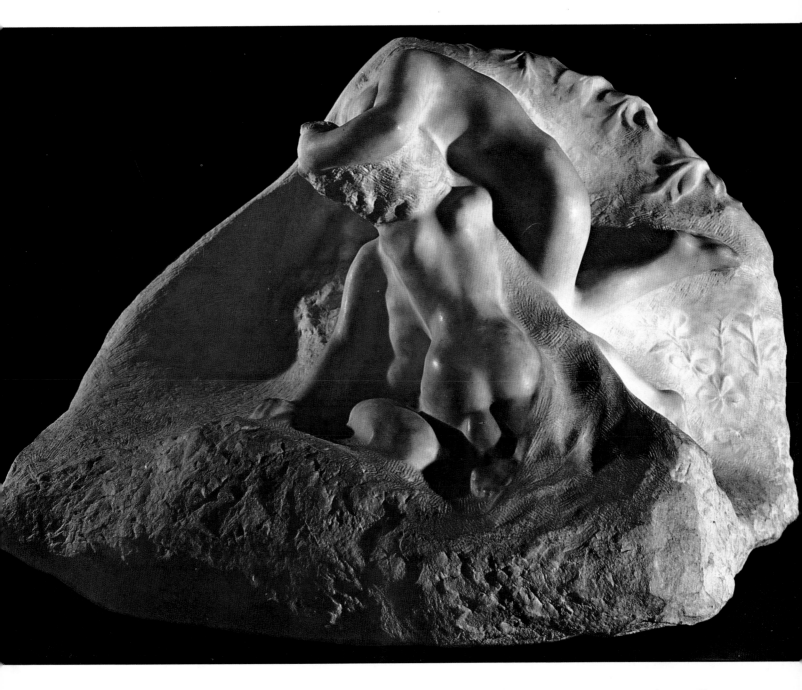

497 AUGUSTE RODIN (French, 1840 to 1917) *The Oceanides.*
1905. Musée Rodin, Paris. Rodin represents the final phase of French
Romanticism, and points, as well, to modern art. The marble *Oceanides*
group, which for some time bore the title *Springtime of Life,* was developed
from a theme appearing at the base of the *Gates of Hell*. The moving,
supple, feminine forms emerging from the rough marble are an example
of Rodin's lyricism, but they reveal equally the element of harmony and
sobriety that characterizes the last phase of his work.

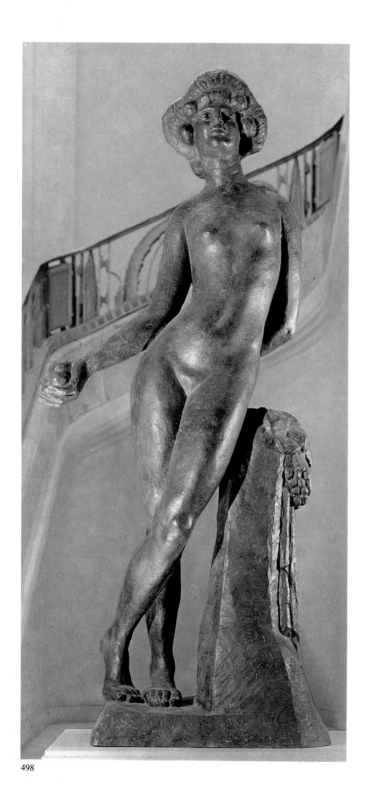

498

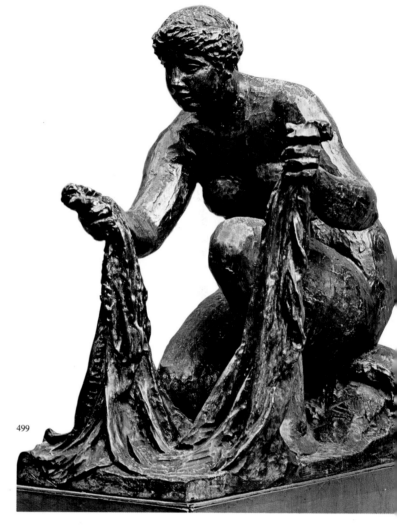

499

498 **ANTOINE BOURDELLE (French, 1861–1929)** *The Fruit.* **1907. Musée National d'Art Moderne, Paris.** Bourdelle worked with Rodin in Paris but departed from Rodin's emotive style when, after becoming acquainted with Greek art, he began to confer on his own sculptures a classicizing monumentality. The figure reproduced possesses a certain mannerism not unrelated to the Art Nouveau style. In his later art, Bourdelle drew even further away from the naturalism of Rodin, leaning towards a somewhat dry stylization.

499 **AUGUSTE RENOIR (French, 1841 to 1919)** *The Washerwoman.* **1917. Museum of Modern Art, New York.** Renoir frequented the Ecole des Beaux-Arts, then joined the Impressionist group, participating in their exhibitions. His venture into the art of sculpture, made late in life, was exceptional. *The Washerwoman*, which is only a sketch, was born of a close collaboration with the Spaniard Richard Guino. Its lifelike attitude exemplifies the ample forms and simplified volumes of Renoir's female type.

500 ARISTIDE MAILLOL, (French, 1861 to 1944) *L'Ile-de-France.*
Bronze. 1920 to 1925. Musée National d'Art Moderne, Paris. Maillol
devoted himself to painting and tapestry before becoming a sculptor at the
age of forty. The single, constant theme of this work is the female body,
in infinite variation, but always subjected to a formal and monumental
treatment. The *Ile-de-France* is based on a firm geometric framework. This
bronze version is characterized by fullness of forms and a carefully studied
balance of masses.

ganic, half-mechanical work in which smooth, taut surfaces
and curved lines form harmony out of assymetry and irreg-
ularity. In it movement becomes a symbol of the third di-
mension. Duchamp-Villon, like Umberto Boccioni, was a
victim of the First World War. Boccioni, the theoretician of
Futurism, also sought to introduce movement into sculp-
ture. In his work, forms and planes resolve themselves in
spatial syntheses through the medium of interpenetration.
Contours no longer enclose sculpture: "A sculpture must
bring objects to life by systematically and sensitively ren-
dering their extensions within space." Form-power, or
speed, becomes a metaphor for the progression of visualized
time *(fig. 504)*. The temporal becomes a visual dimension of
space the moment it takes the form of mechanical move-
ment. Futurism transformed a classical meditation on
beauty into a vision of conceptual power over a world en-
lightened by technology.

The year 1907 marked a turning point in the work of the
Rumanian sculptor Brancusi, similar to Picasso's. He at-
tracted the attention of Rodin, who invited Brancusi to work
with him, but Brancusi refused this offer. There is a marked
evolution from the marble *Sleeping Muse* of 1906 to the one
in bronze circa 1909–1910 *(fig. 502)*. At this time, Brancusi
took a decisive step toward the purity of form that charac-
terized his work, through the use of a schematic definition
and isolated but essential ideas. He obtained a shimmering
surface that incorporates light and opens the volume to the
space surrounding it. Brancusi placed the conception of the
subject in opposition to the articulation of the form. Al-
though carving played a great role in his evolution, he said
"Carving or casting means nothing. It is the finished work
alone that counts." *The Continuous Column (fig. 501)*, the
superimpositions of pedestal sculptures in wood, marble, and
bronze, gives us an idea of the influence of Brancusi's work
on an entire strain in contemporary sculpture that upholds
form over poetry and mystery.

Amedeo Modigliani's sculpture took its inspiration from
three sources: African masks, archaic sculpture, and above all
the work of Brancusi. In spite of the sculptor's influence,
Modigliani managed to develop his own style. He achieved

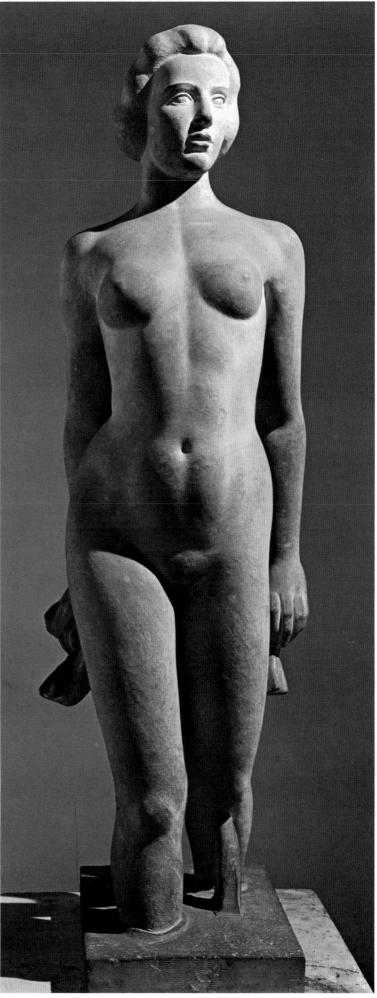

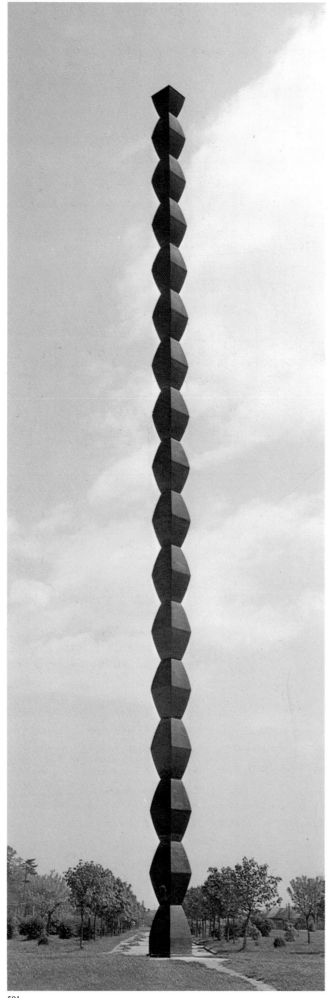

501 CONSTANTIN BRANCUSI (Rumania 1876-Paris 1957) *The Continuous Column.* **Gilded cast iron. 30 m. high. 1937. Tirgu Jiu Park, Rumania.** Brancusi conceived the idea of Tirgu Jiu Park as a "sculpture." Here his "ideal" is a sort of obstacle course marked at certain intervals by examples of his art, among them the continuous column abstractly climbing into space. A "repetitive" style, inspired by columns of wooden rhomboid shapes [superposées des cimetières roumains]. This challenge to vertical infinity was built as a memorial to war victims.

a type of serene and delicate feminine beauty in which the melodic line and the stylization common to his paintings is rediscovered *(fig. 507)*. Wilhelm Lehmbruck took a different route in his sculptural explorations. His work speaks more of the past than of the future. He was familiar with the work of Modigliani and Brancusi, but his style is characterized by a lengthening of form, a kind of "gothic" elongation *(fig. 509)*.

An opposite approach to Lehmbruck's was taken by the Expressionist sculptor Ernst Barlach, who submits form to the violence of gesture in a technique consistent with carving directly in wood. In Italy, Arturo Martini was as singular in his ways as in his means. A work such as the 1933 terra-cotta *Nativity* shows a great richness of invention within this mysterious fragment of isolated space. What remained for Martini an indecisive struggle between an archaic style and abstraction was for Marino Marini a simple problem of logic. Marini's forms possess an apparent simplicity and a special tension that appear on the surface. Marini did not treat his figures naturalistically. An expressive energy animates his shapes—symbols of an archaic past and of an occasionally terrifying present *(fig. 525)*: "The only work which is deeply artistic is that which, while drawing from the sources of nature, knows how to abstract and transcend that nature." Giacomo Manzù also remained attached to figurative sculpture *(fig. 526)*. He created sculptures that stand out by virtue of a sentimental or religious aura that emanates from a calm and sober rhythm and from the serene expressions on the figures' faces.

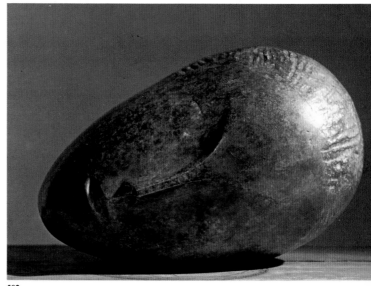

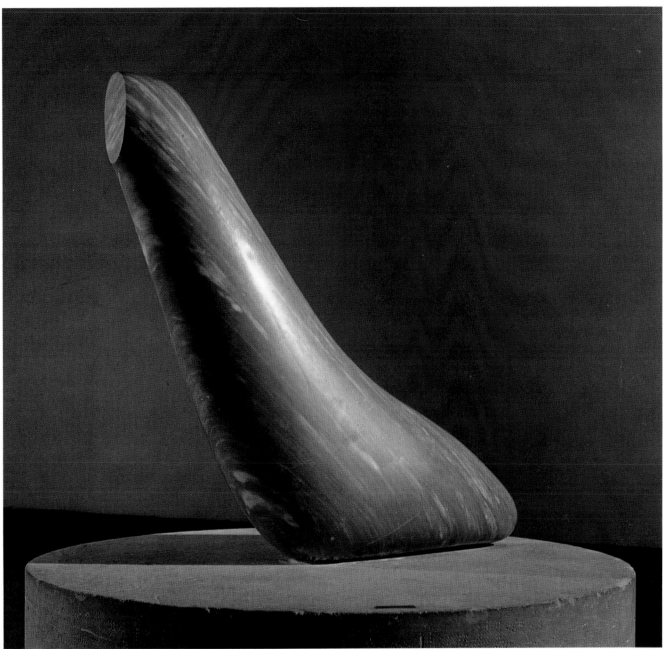

503

As a movement, Constructivism occupies an important place within 20th-century art; it explored in a complex way an entire range of questions and opened up new possibilities for art. The principal figures within the movement were Vladimir Tatline on one hand, Naum Gabo and Antoine Pevsner on the other: they offer two different understandings of Constructivism. "For Tatline, technology is manifestly in the service of a revolutionary ideology by which one could shape history. For Gabo, it is a mode of absolute knowledge through which one could determine, rather than discover,

the future," wrote C. R. Krauss. Tatlin's early art, in its liberal use of materials "in real space and with real materials" *(fig. 510)*, resembles the experiments done by Picasso circa 1914. Within a clearly more idealistic framework, the work of Gabo *(fig. 532)* and Pevsner developed along a conceptual continuum for which the model was geometry. Their goal was the unveiling of inner structure, the search for a center.

Marcel Duchamp provoked a disturbance that is still having repercussions. With his *Ready-Mades*—objects created "without intervention by the hand of the artist"—Duchamp

502 CONSTANTIN BRANCUSI *Sleeping Muse.* **1909 to 1910. Musée National d'Art Moderne, Paris.** Brancusi arrived in Paris in 1904 and revolutionized sculpture there. The bronze *Sleeping Muse* of 1909–1910 is one of the many versions and replicas of this theme that Brancusi made between 1906 and 1912. The ideal, concrete form of the egg, the symbol of the origin of life and the basis for the suggested facial features, is typical of the artist's search for the essence of things.

503 BRANCUSI *The Seal.* **1943. Musée National d'Art Moderne, Paris.** Carved from a block of grey-veined marble, *The Seal* is a variation on a work of 1936, *The Miracle.* Eliminating all detail, Brancusi arrives at an essentially timeless form. The photographs of seals that Brancusi kept in an album testify to his deep attachment to reality. The polish on the material shows prodigious craftsmanship.

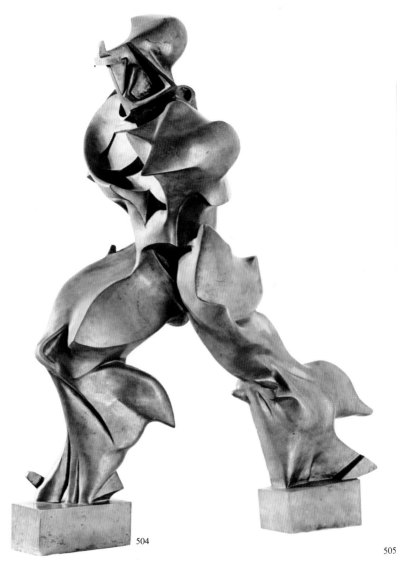

504

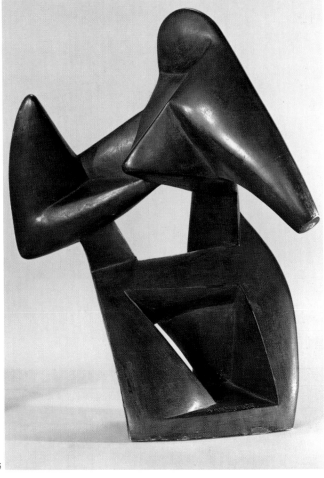

505

challenged both the current order of things and the aesthetic order, both the function of the artist and the definition of art. *Ready-Made* has no meaning, no internal significance. Its meaning is the displacement of non-art in the system of art. The functional object extracted from its utilitarian realm and transformed into an object deprived of function is also deprived of any kind of finality *(fig. 512)*. Marcel Duchamp paved the way for a series of demonstrations that once more challenge the traditional values upon which art is based.

Within the *Dada* movement, the work of Kurt Schwitters is unique. He created collages and sculptures in which he used debris and objects currently in use *(fig. 513)* in object-canvases. He named them *Merz*: "*Merz* is a prayer to celebrate the victory that puts an end to war, the victory of peace after the world has been destroyed, which one must then rebuild with the rubble. That is *Merz*." The word *Merz* is a fragment of the word *Kommerz-bank*. In 1920 Schwitters

elaborated his first *Merz-bau,* an immense edifice called *Cathédrale de la Misère Erotique,* built with daily refuse. In the spirit of Dada, the movement that he co-founded, Max Ernst created collage canvases and objects made up of heteroclite elements *(fig. 511)*. In 1934 he became seriously interested in sculpture and created fantastic beings that jut into space like totems.

The organic approach to art and the "play" of the unconscious, or better still, a certain "Anti-Constructivism" illustrated by delirious machines, are characteristic of Dada and the Surrealists. Hans Arp, one of the promotors of Dadaism, showed great diversity in his activities. After his playlike collages and constructions he gravitated, starting in 1930, toward sculpture in the round. Little by little these organic configurations *(fig. 514)* lose their humour in favor of poetic "concretizing forces which had presided over the birth of earth, stars, stone, animals, and man. Concretion is the product of

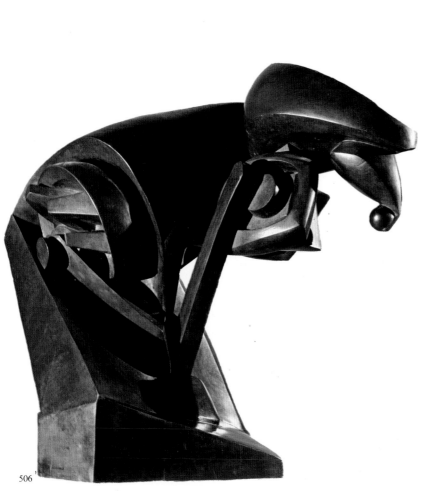

506

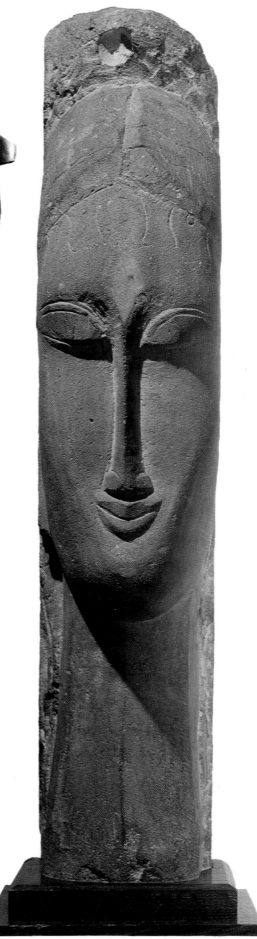

504 **UMBERTO BOCCIONI (Italian, 1882 to 1916)** *Unique Forms of Continuity in Space.* **1913. Private collection, Milan.** With the poet Marinetti, Boccioni was one of the principal ideators and signatories of the *Futurist Painters Manifesto* in 1910. The bronze *Unique Forms of Continuity in Space* shows a search for dynamic form, aimed at expressing the idea of the movement of the body in space by an interpenetration of planes and the use of forms intended to suggest the turbulence of movement vibrating in space.

505 **ALEXANDER ARCHIPENKO (Russian, 1887 to 1964)** *Boxers.* **Plaster. 1914. Guggenheim Museum, New York.** Archipenko had an early and consistent development in working with a Cubist style in sculpture. Almost from the beginning of his career he was interested in the void, the negative form, a new spatial concept. *Boxers* shows the kind of counterbalance of forms around a void, the breaking up of the solids in a dynamic way that was Archipenko's most notable contribution to early Cubist sculpture.

506 **RAYMOND DUCHAMP-VILLON (French, 1876 to 1918).** *The Great Horse.* **Bronze. 1914. Art Institute of Chicago.** In this horse, of which several versions exist, Duchamp-Villon created one of the most revolutionary pieces of sculpture of the time. The rounded masses, supple and brimming with life, are animal in character and, in quite singular fashion, work in harmony with the other elements which are linear, rigid, machine-like.

507 **AMEDEO MODIGLIANI (Italian, 1884 to 1920)** *Female Head.* **1912. Musée National d'Art Moderne, Paris.** Modigliani's sculptures are quite close to the art of Brancusi, to Cubism, and to Black art. The linear style, and the stripped, dense forms in this female head carved out of a long, flat block of granular limestone, are the expression of a personal style, in which may be found an echo of ancient traditions, notably of Tuscan Mannerism.

507

508 **ERNST BARLACH (German, 1870–1938)** *The Ecstatic One.*
Wood. 1916. Kunsthaus, Zurich. Like many of his contemporaries in the
early 20th century, Barlach's sculptural form was dependent upon clean
and simple volumes, but unlike most he was deeply attached to the subject,
to the image of man and his spiritual state. He worked most often in wood,
which lent itself well to the block-like character and the material heaviness
of his images.

509 **WILHELM LEHMBRUCK (German, 1881–1919)** *Kneeling*
Figure. **Cast stone. 1911. Museum of Modern Art, New York.** Lehm-
bruck's style developed in Paris, where he was working between 1910 and
1914, coming into contact with Brancusi, Modigliani and Archipenko. The
profound spirituality of the *Kneeling Figure* is expressed in the predomi-
nantly linear element of the calm figure and in the elongation and formal
simplifications, which already point towards the artist's final sculptures.

510 **VLADIMIR TATLINE (Kharkov 1885-Nova Devitch 1953)**
Project for the Monument to the Third International. **1919–1920. Small-**
scale model (4.20 × 3 m.) for the Paris-Moscow Exhibition, 1979.
Centre Georges Pompidou, Paris. An enthusiastic supporter of monu-
mental sculpture, this "productivist" project breaks with tradition. Con-
tained within the 400 m. high metallic spiral are four separate structures:
a cube, a pyramid, a cylinder, and a half-sphere, each spinning at a different
speed. This project is both commemorative and symbolic of a "revolution"
that never slows down.

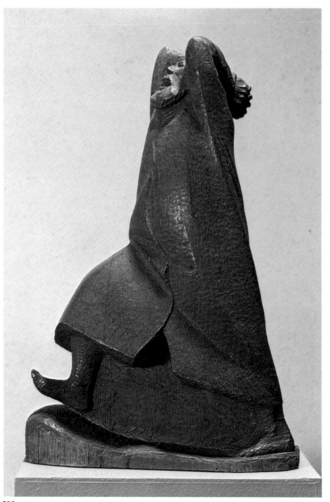

508

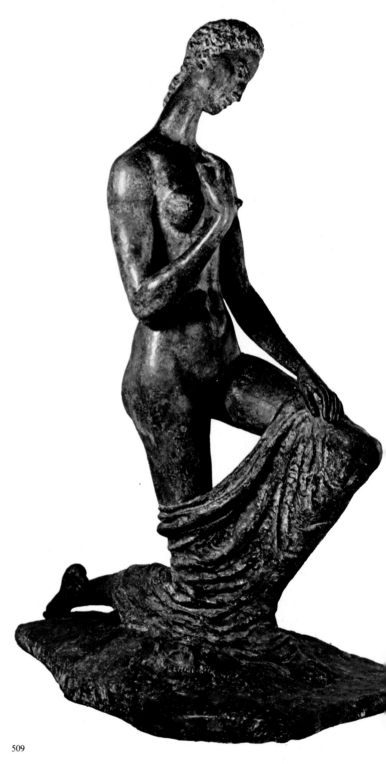

509

511

512

513

511 MAX ERNST (German, 1891–1976). *Fruit of Long Experience.* **Painted wood and metal. 1919. Collection Roland Penrose, London.** Ernst was particularly influenced by Picasso's collages, for in them he felt a freedom which he sought. He found his own style and the sense of liberation through Dada. *Fruit of Long Experience* dates from the high period of Dada in Cologne, when Ernst was constructing three-dimensional "objects" of scraps and bits of ready-made materials.

512 MARCEL DUCHAMP (Blainville 1887-Neuilly 1968) *Bicycle Wheel.* **Paris, 1913. Fourth version for the Moderna Museet, Stockholm, 1961.** "Ready-made" was the farthest idea from his mind when Marcel Duchamp thought of putting a bicycle wheel on a stool. The artistic theory did not surface again until two years later when he had to produce a replica of the wheel for his new New York gallery. In a letter dated June 26, 1955 he explains: "The inverse movement of the wheel probably pleased me most because it represented an 'antidote' to the lifestyle of the individual contemplating it." Rather than an "anartistic" work created without the artist, it is a good example of the proposed overthrow that Duchamp destines for traditional art.

513 KURT SCHWITTERS (Hanover 1887-Ambleside, England 1948) *Sailors' Shanty.* **Merz 12. Special Collection.** This "Merz" scene is characteristic of the 1920s famous series of collages. The artist's objective just after the First World War is here illustrated: to make a world out of ruins. In effect, by gathering "ruins"—refuse, waste, garbage—he created scenes while ignoring the artistic categorizing that separates painting from sculpture, or from the environment. As with the "constructivist" and geometric movements of the era, form alone concerned him—the surprising precursor of "Arte povera."

514 HANS ARP (French, 1887 to 1966) *Bird in an Aquarium.* **Wood. ca. 1920. Museum of Modern Art, New York.** In 1916 Arp began his painted wood reliefs, which remain the best plastic expression of Dada from the Zürich group. These are lively abstractions, assembled according to the laws of chance. They are playfully simple and tell no story, but underlying the vibrating effect is the symbolic language through which Arp expressed his feelings about growth and transformations within the organic life of nature.

516 HENRI LAURENS (French, 1885 to 1954) *The Bunch of Grapes.* **1922. Musée National d'Art Moderne, Paris.** The art of Henri Laurens, which followed its humble course without polemic or publicity, represents a sustained effort in a continuous evolution. All his life Laurens was preoccupied solely with problems of form, aiming to achieve in sculpture what the Cubists of 1910 had realized in painting. He was in fact initiated into Cubism by Georges Braque, whom he met in 1911.

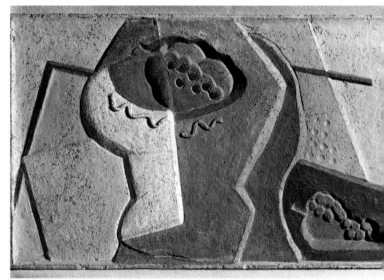

5

a growth " *(fig. 517)*. Arp wanted to create "like Nature herself."

Henry Moore is a sculptor who expresses himself in terms at once figurative and abstract *(fig. 529)*. His major themes first appeared in 1930, and have been constantly renewed since then: woman, fertility, nature. He returns periodically to one of his favourite subjects: the supine figure. Moore undertakes to hollow out and open up sculptural mass and to search for an organic equilibrium between emptiness and fullness: "Empty space ties one face to another; through it sculpture immediately acquires a more accentuated three-dimensional character. Empty space itself can have a form and a meaning, just like solid mass."

In the 1930s, Julio González made a major contribution to the development of sculpture. His originality lay not simply in his use of iron, nor in his forms, which tend to be abstract *(figs. 521, 522)*, but rather in his *space,* which he captured within material linear compositions, and in the allusive and metaphorical quality he imparted to his works. Between 1925 and 1933, at the height of Surrealism, Alberto Giacometti created an ensemble of disturbing, bizarre objects and constructions *(fig. 530)* that erupt in our space or create troubling ambiguities between real space and the imaginary space of a dream. Just like a dream, this work is a jumble of enigmatic,

515

515 JACQUES LIPCHITZ (Druskieniki, Lithuania 1891—Capri 1973) *Figure.* **Paint on plaster. 1926–1930. 2.20 m. high. Musée National d'Art Moderne, Paris.** In this sculpture, a synthesis of works dating before the artist as well as the result of his study of garden statuary, one recognizes two tendencies: a Cubist interpretation leaning toward the abstract that is strongly influenced by the barbaric and mysterious qualities of the totem pole.

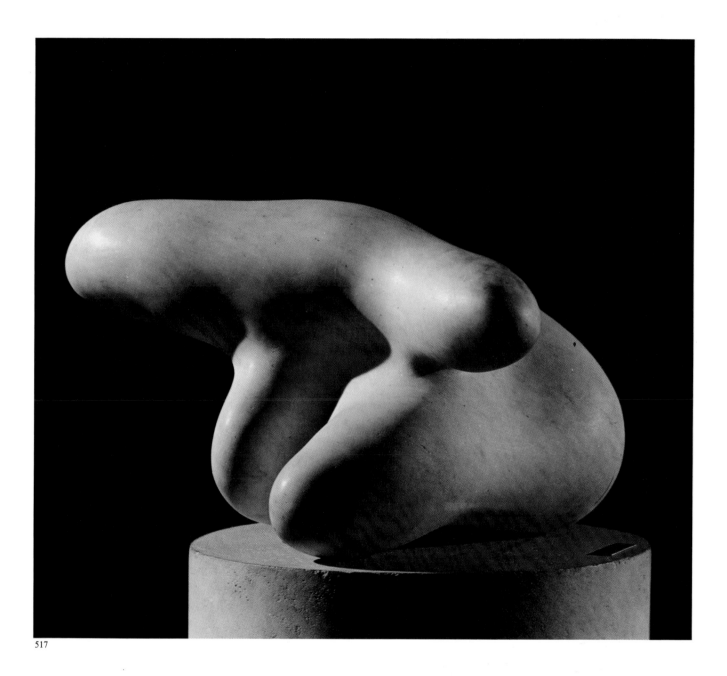

517

517 HANS ARP *Human Concretion*. **Marble. 1934. Musée National d'Art Moderne, Paris.** After 1930 Arp began to fully explore sculpture in the round and to use the traditional processes of carving and modelling. What developed were his smooth, white pure forms which he referred to as *Human Concretions*. Concretion signifies the natural process of condensation, hardening, coagulating, thickening, growing together. Concretion is something that has grown. "I wanted my work to find its humble, anonymous place in the woods, the mountains, in nature."

theatrical games. Giacometti's sculpture eventually formed an entirely new conception of space. This sculpture possesses its own spatial quality, just as his drawings and paintings manifest the relation of figures to space.

Germaine Richier never moved beyond the traditional realm of sculpture. She created a direct form using the strength of the skeleton, exploiting the factor of incompleteness in order to communicate expressions of life ravaged and torn apart.

Lázló Moholy-Nagy is a good example of those artists tempted by the new options that technology offered. His transparencies develop out of the central core of space. Constructivism had its impact on the Bauhaus as well; Moholy-Nagy taught there and Max Bill was a student. Their works look like mathematical models. The idea of sculpting with light and movement was developed later on by artists such as Nicolas Schöffer. Between 1948 and 1950, Schöffer invented what he calls "spatial-dynamism." This idea, taken from electronics, combines form, movement, and sound. Schöffer's works are animated by records and by steel blades to which light is added. His *CYSP I* was incorporated into a ballet, as was a work by Moholy-Nagy entitled *Space Modulator*. These conceptions became more and more architectural. The German Heinz Mack *(fig. 536)*, co-founder of the review *Zero* in 1958 and of a 1962 collection of work with the same title, had a similar interest in kinetics. Meanwhile, Julio Le Parc of Argentina, who has lived in Paris since 1958, founded GRAV (Groupe de Recherche d'Art Visuel) in 1960 with several like-minded artists. They were concerned with demystifying artistic tradition by creating movement from optical effects that require the participation of the spectator *(fig. 545)*. Le Parc received the international grand prix for painting at the Venice Biennale in 1966, demonstrating that kinetic art had gone beyond the boundaries of traditional categories separating painting from sculpture.

Beginning in 1954, Jean Robert Ipousteguy devoted himself exclusively to sculpture. He gave up an early tendency toward abstraction in favor of representational forms. His highly Expressionist, even Baroque, sculptures have a theatrical character that is expressed in such traditional materials as bronze

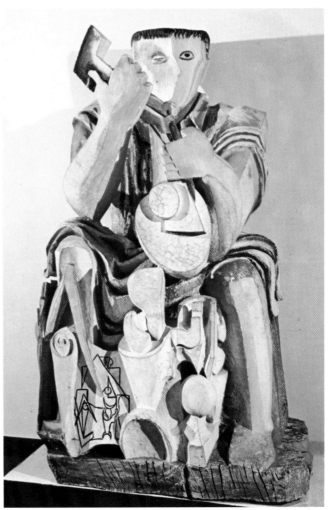

518

and marble. The materials accentuate a stiffness closely connected to the idea of death and the fantastic *(fig. 546)*.

Wood used occasionally in the form of roots was Etienne-Martin's favourite medium; this medium inspired him with strong forms that he himself refuses to call either figurative or abstract. In 1948 he experimented by making sculptures out of fabric that he called *Trimmings*. These resemble Nomadic tents or vast capes. With other body wrappings he created his *Delays (fig. 548)*, a series of sculptures that are labyrinths or proliferations.

Alexander Calder belonged to the generation of American artists who, rejecting the burden of an academicism issuing

518 OSSIP ZADKINE (1890 to 1967) *The Sculptor.* **1939. Musée National d'Art Moderne, Paris.** Zadkine, born at Smolensk in 1890, arrived in Paris in 1909 and became integrated into the Cubist movement. As was the case with Lipchitz, Cubism served him only as a point of departure. Reverting to the practice of direct carving, he found in wood and stone a stimulus for his fertile imagination, which he employed in creating a vast repertory of subjects. *The Sculptor* reveals the artist's stature and the lasting values of his work.

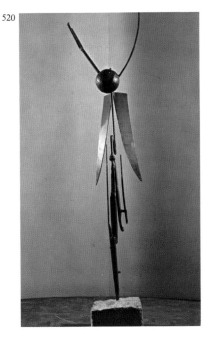

520

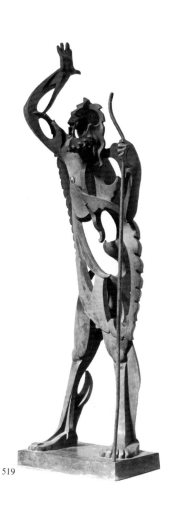

519

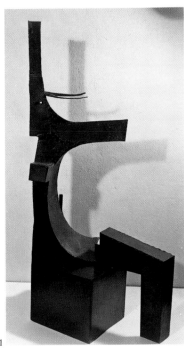

521

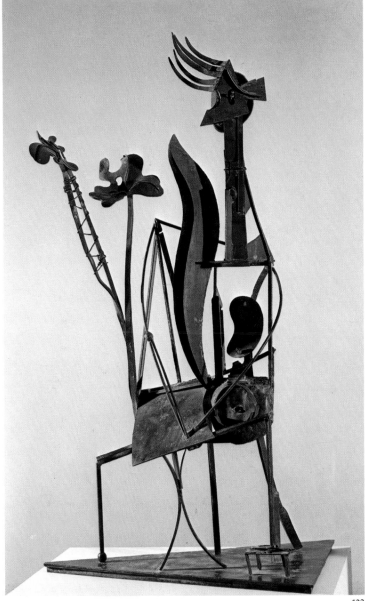

522

519 PABLO GARGALLO (Spanish, 1881 to 1934) *The Prophet.* **1933. Musée National d'Art Moderne, Paris.** Gargallo made several more or less extended stays in Paris, and his work therefore reflects the forms of contemporary French art. However, though his use of iron is *avant-garde,* in concept his sculptures often remain subject to the laws of the realist tradition. In the perforated figure of *The Prophet,* one of his most accomplished works, hollows substitute for forms in the round, and the mass presents itself as a silhouette. Inventiveness is coupled with a stylization most visible in the hands and feet. On the whole, the figure is theatrical.

520 JULIO GONZALEZ (1876–1942) *The Angel.* **Iron. 1933. Musée National d'Art Moderne, Paris.** Applying to sculpture the technique of wrought iron and the use of oxyacetylene welding, Gonzalez arrived at a new form of plastic art that led him to abstraction. A sharp outline of wire defines the form of this elegant, unreal figure of an angel, and models space as the artist wishes, "thanks to the ideal trajectory of its motion."

521 JULIO GONZALEZ (1876 to 1942) *Seated Woman.* **Iron. 1935. Collection Mme. Roberta González, Paris.** During the 1930s González' sculpture became increasingly powerful and weighty. The human figure remained his point of departure, but it became a rougher figure, more physically present but less described, such as *Seated Woman.*

522 PABLO PICASSO (born in Spain, 1881–1973). *Woman in the Garden.* **Bronze, after welded iron. 1929–30. Collection of the artist, Mougins.** In the late 1920's Picasso and González worked with new techniques in metal dependent on assemblage and welding. In *Woman in the Garden* we see one of the delicate scaffold constructions of this period and the type of work that is clearly a prototype for the assemblages by sculptors in recent years.

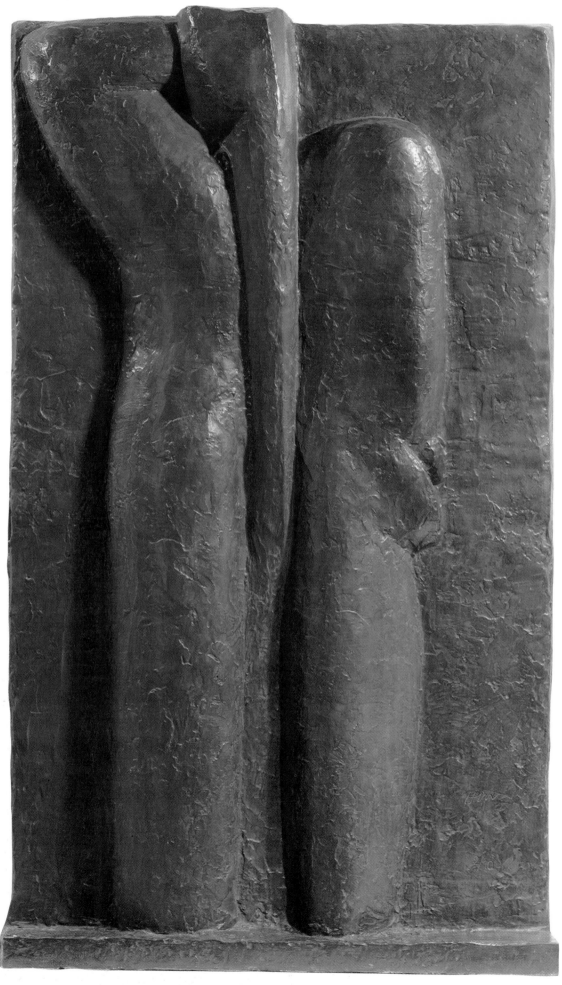

523

523 HENRI MATISSE (LeCateau 1869-Cimies 1954) *Back view of a nude,* **fourth pose. Bronze. 1.90 m. high. 1930. Musée National d'Art Moderne, Paris.** This work's extreme simplification derives from the rhythmic arrangement and symmetric organization of smooth surfaces flowing to either side of the centrally positioned tresses. Here Matisse recalls thè essence of the early "Venus" as well as the feminine archetypes that Neolithic man once carved on columns.

from the most worn-out of European traditions, embarked on a new course. Calder created a poetic universe where the comic finally found its place. It is precisely his lack of prejudice and seriousness that allowed him to construct so ingeniously his miniature *Circus,* a grouping of toys made of wood and wire. In 1932 he came out with the first kinetic sculpture that Marcel Duchamp suggested he call *Mobile (fig. 538).* Later, Calder created the *Stabiles* and *Arrows*: moving stems whose trunks leave the ground, they are like airy beams enriched by the virtues of the *Stabiles.*

David Smith was both the first great American sculptor and a pioneer in metal sculpting. Among his contemporaries, González had the greatest influence on him. His first sculptures, halfway between abstract signs and figures, have an emblematic quality that comes as much from the economy of the forms themselves as from their own extreme two-dimensionality. For Smith the totem was the hinge of several metaphors *(fig. 531).* Smith also confronted the problem of art which, through a discontinuity of form, thwarts all intellectual or sensual appropriation, as in Constructivism. In refusing the inevitable in the "logical" relationship, Smith showed where he parted ways with such contemporaries as David Hare, Ibram Lassaw, Seymour Lipton, or Isamu Noguchi.

Before meeting David Smith in 1959, Anthony Caro was a student of Henry Moore. With metal girders and sheets that he occasionally paints, Caro builds constructions in space, drawing geometric figures that shift in unpredictable ways when the viewing position is changed *(fig. 551).* Gradually Caro's work takes on a greater pictorial quality in order to affirm the necessary differences between nature, art, and the world of objects; this same criticism is implied by the use of objects in the Minimal sculpture of such artists as Carl Andre, Don Judd, Dan Flavin, and Robert Morris. By reduced intervention, these artists display objects in which the content is stripped to its barest components. One of the characteristics of their work is the occasionally systematic exploitation of one element within repeating structures: "one thing after the other." What these sculptures express is a pure exterior, an opacity that resists manipulation; they are inert

524 PABLO PICASSO (1881-1973) *Woman with Orange.* **Bronze. 1943. Dation Picasso, Paris.** Picasso's materials were of the widest possible choice—humble pieces of life—cardboard, metal caps, wire, matchboxes; but everything he used, through the power of his imaginative combinations, could be turned into expressive totemic beings, at once magical and witty.

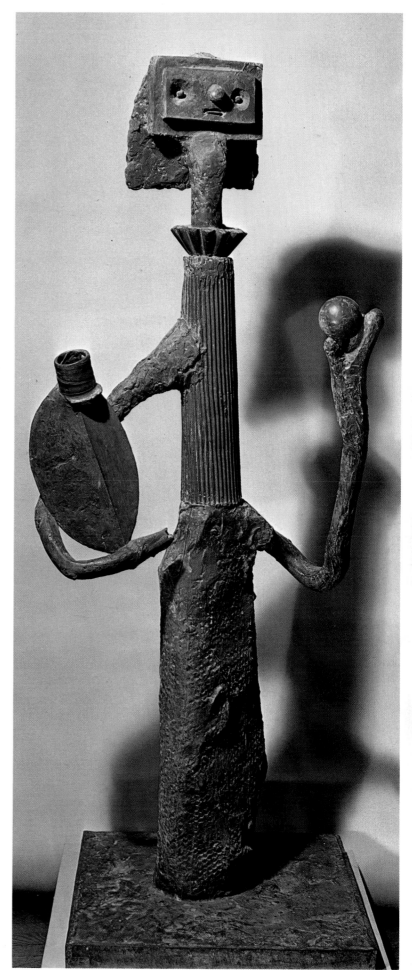

524

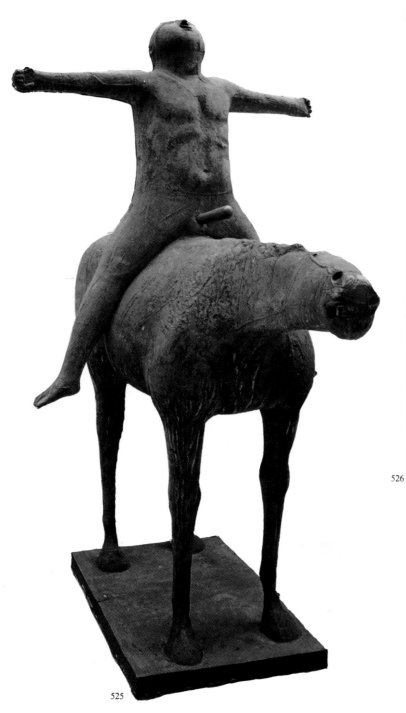

525

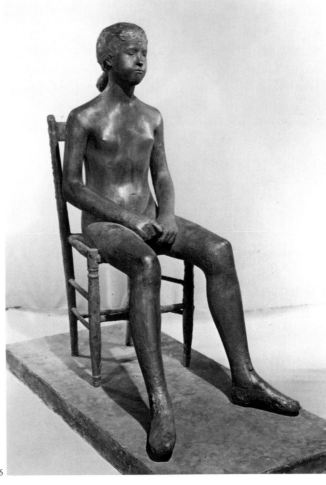

526

525 MARINO MARINI (Italian, 1901-1980) *The Angel of the City.*
1949. Collection Peggy Guggenheim, Venice. *The Angel of the City* done
in 1949 is one of the many variations on the theme of Man and Horse
which has always haunted Marini. Its impressiveness lies in its architectonic
structure and in its movement which is abruptly halted but still charged
with dramatic tension.

526 GIACOMO MANZÙ (Italian, 1908-) *Young Girl on a Chair.*
Bronze. 1955. National Gallery of Canada, Ottawa. Manzù has often
worked with religious subjects, female figures and portraits, often execut-
ing particular themes over and over again; the first study of a *Girl in a
Chair* was in 1938. His style is based on strong, simple, architectonic figures
that always display a measured degree of grace and dignity. He has been
considerably influenced by traditional Western sculpture.

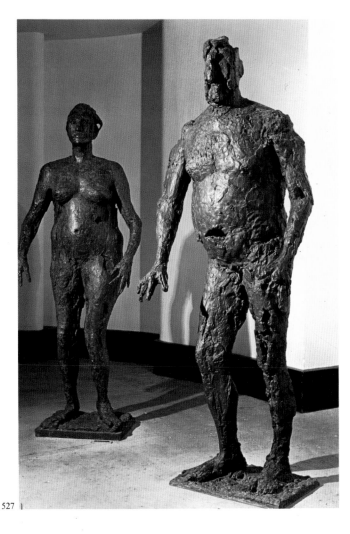

527

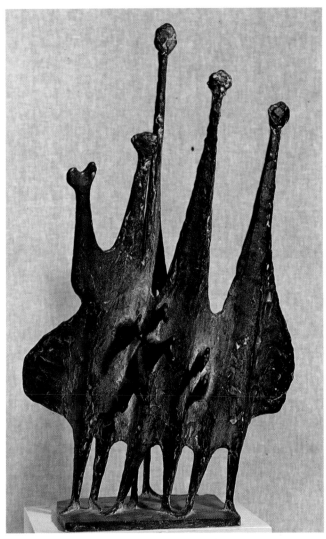

528

matter not imbued with thought. Such a step was compared with Duchamp's: these sculptures would be abstract *Ready-Mades* without content. The works of Richard Serra *(fig. 553)* and of Robert Smithson seem much less dogmatic.

Joseph Cornell was an original artist whose work stands outside the major currents of his time. His boxes, like those of Schwitters, with whom he shares some common elements, appear to be tableaux-objects linking great poetic freedom to a somewhat nostalgic mood. Cornell created unique dream spaces having no connection to the external world *(fig. 533)*. Louise Nevelson joins wood chests containing bits of common objects and pieces of furniture, also in wood, in group-

ings that can expand in height and width *(fig. 535)*. This ensemble is then grouped against a uniformly black or white wall. In their capacity as monuments, these sculptures are the extended sanctuaries of the daily object.

The 1960s are marked by a split. It would seem, as one Minimal artist says, that through the very diverse approaches of Pop art, New Realism, and Minimal art, a certain distance is taken from subjectivity: a new relationship is founded between the artist and the object that emphasizes appearance more than essence. This may develop along the lines of a game or by a radicalization that states: What you see is nothing more than what you see. Several artists have played an

527 GERMAINE RICHIER (French, 1904 to 1959) *The Storm.* **Bronze. 1947 to 1948. Musée National d'Art Moderne, Paris.** In 1940, Richier arrived at an art expressing a world of anxiety through a very personal technique. The new image of man, as expressed in *The Storm,* is a debased creature. In such threatening, mysterious bronze figures she evokes the powers and secrets of nature.

528 KENNETH ARMITAGE (British, 1916-) *People in a Wind.* **Bronze. 1950. Tate Gallery, London.** Armitage appeared after World War I and sought to establish a kind of dematerialized form in sculpture. He developed a figure style of a very summary character: people flattened out, with thin protruding limbs, often in motion and usually collective. He is a modeller, and he creates rich surfaces to be cast in bronze, often pitted or scratched and simultaneously ugly and sensuous.

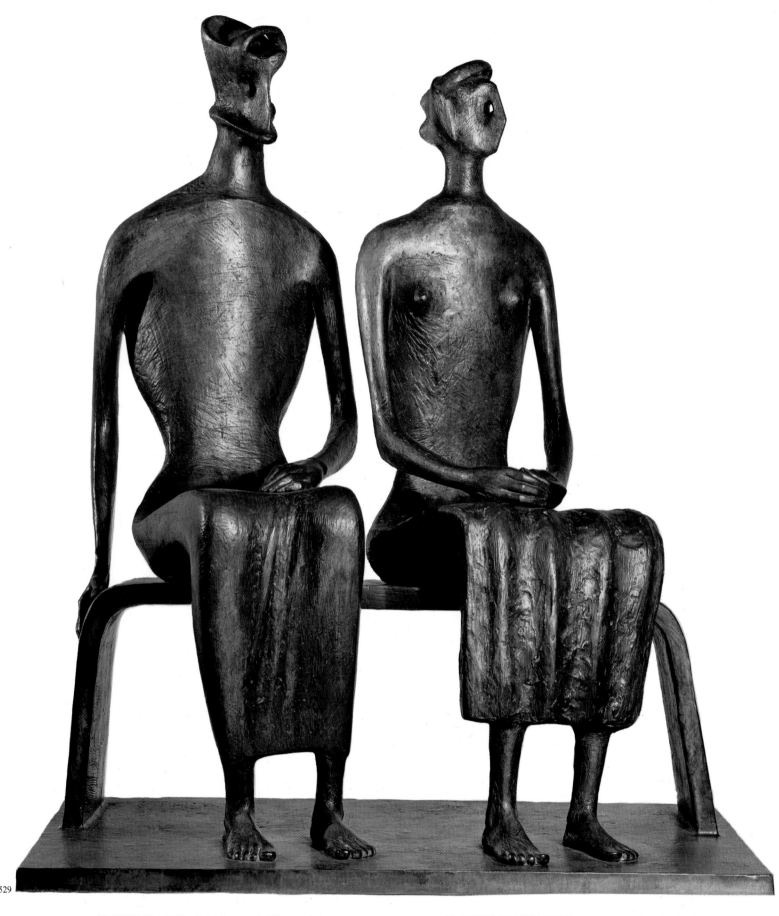

529

529 HENRY MOORE (British, 1898-) *King and Queen.* **1952 to 1953. Openhecht Museum, Antwerp.** Moore is at the root of the sculptural revival in England. Having assimilated the most varied of cultures, from Pre-Columbian art to Surrealism, he remained profoundly attached to his native land and created his work for its countryside, intending it to be displayed in the open air. This bronze is allied to the theme of family groups that he developed since 1944, but is distinguished by its mythical element.

530 ALBERTO GIACOMETTI (1901–1966) *The Chariot.* **Museum of Modern Art, New York.** Giacometti tried to conjure up the reality and inner life of the human figure by a process of extreme reduction in mass and equally extreme elongation of the form. The bronze *Chariot* was born from the memory of a cart that had impressed the artist in 1938. In 1947 Giacometti had a conception of what his sculpture was to be, and in 1950 he executed it: a solitary figure, vibrant and fascinating, a modern version of the antique charioteer.

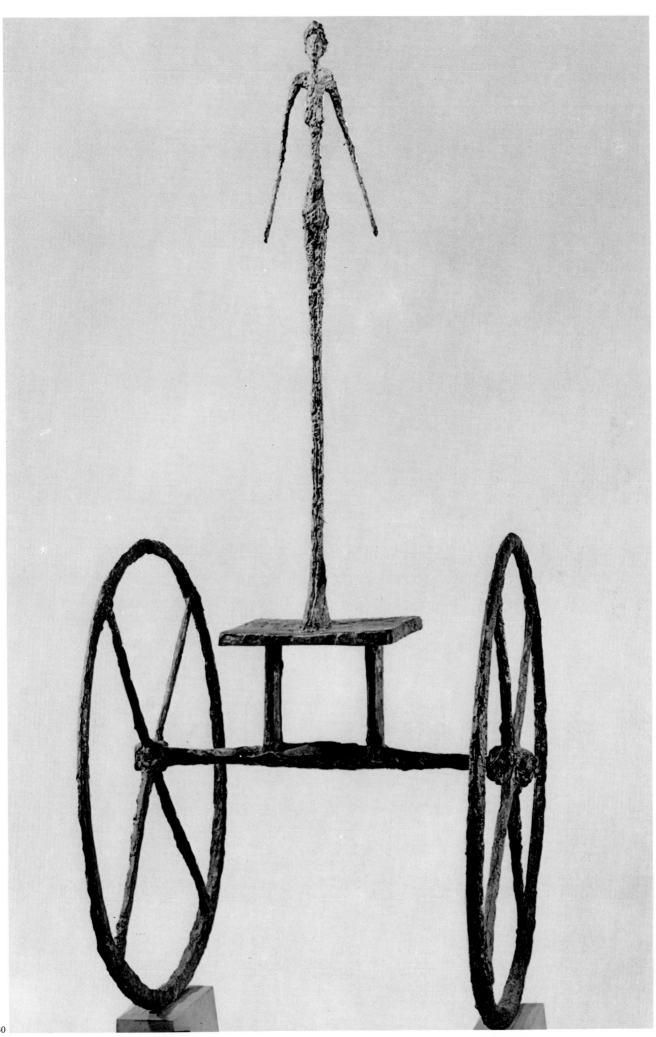

531

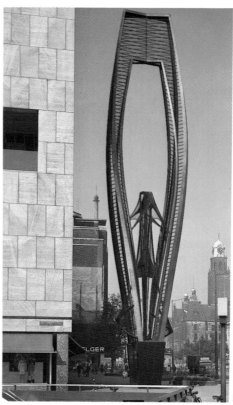

532

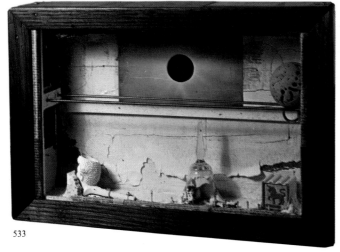

533

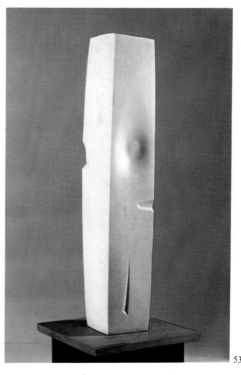

534

531 DAVID SMITH (American, 1906 to 1965) *Cubi XIX.* **Steel. 1964. Tate Gallery, London.** One of the reasons for Smith's critical position in the history of modern sculpture is his early start in metal sculpture and the extraordinary diversity of ways in which he worked with it. In 1933 he made his first wrought iron sculpture with borrowed welding equipment. His later work was more geometric, showing greater concern for surface, as we can see in the burnished steel sides of the *Cubi* series. Through this treatment the sculpture is lightened and unified with the atmosphere.

532 NAUM GABO, (Briansk 1890—Waterbury, U.S.A. 1977) *De Bijenkorf Shops.* **Stainless Steel. 1957. Rotterdam.** This sculpture by Naum Gabo, who with his brother Antoine Pevsner signed the Realist Manifesto in 1920, remains surprisingly faithful to the tenets of his youth. Dynamic strength is ironically evoked by extremely light material to "capture the essence of nature more completely than realist art ever has."

533 JOSEPH CORNELL (1903–1973) *Pipe and Glass Box (Eclipse Series),* **Construction. Private Collection.** Joseph Cornell's boxes stand uniquely apart from all 20th-century movements, at the same time that their mysterious and personal poetry seem forever relevant to the latest phase of art. They stand somewhere between painting and sculpture: they are objects and contain objects, yet the box can and does act as a frame.

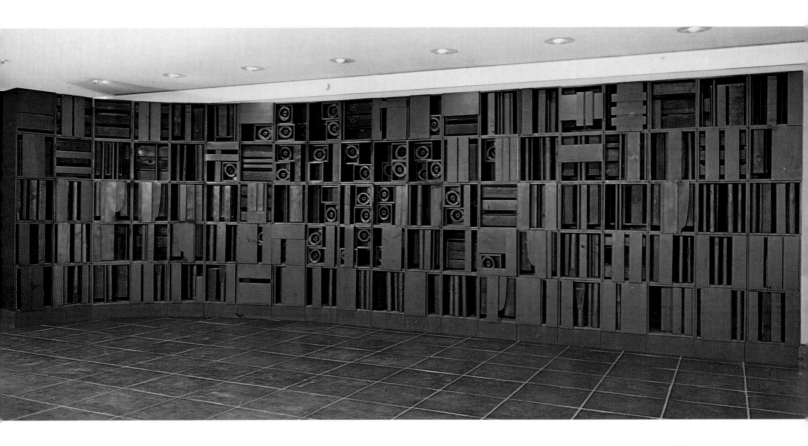

important role in stirring up the contemporary art world by appropriating in their work images or objects that stand out as landmarks of our daily lives. Since 1962, the painter Claes Oldenburg has been attracted by the problem of the common consumer object. The confrontations he provokes with huge jeering objects, the violent rifts with proportion, come to disturb our perception of a reality consisting of an inventory of consumer society. He seems to be telling us ironically that these objects make us just as we produce them.

Like Robert Rauschenberg, Oldenburg stages "Happenings." This presence of the theatre in the works of sculptors is characteristic of the 1960s. Rauschenberg is a painter who finds a way to unite images and materials through sculpture (fig. 544). He plays on the boundary between sculpture and painting in his Combine Paintings. In the "Happenings," Rauschenberg plays on the frontier between art and non-art. Artists such as Edward Kienholz and George Segal also accentuate this theatrical aspect by implying the spectator, whom they integrate into the space of the

work itself, where real and artistic space telescope. In entirely reconstructed places Kienholz incorporates sound, the element that introduces a sense of duration absent from his rather detached small works. Great violence is born from this contrast between the often dramatic scenes that are chosen and their frozen actors (fig. 543). In the same vein, he uses objects already made which he then modifies sculpturally into a sort of collage. Always a bearer of meaning and feeling, Kienholz's works have a profound moral significance. It is not realism that triumphs in these scenes but a world of the fantastic, into which the lyricism of the gaze is carried. Segal, on the other hand, accentuates the frigid size of his immobilized white-bronze characters (fig. 542). The individuals he poses in daily situations have neither identity nor history. In doing so, he creates "disquieting strangeness" in a powerful composition from which the lessons of Kasimir Malevich and Piet Mondrian are present.

In France, more emphasis is placed on the object. As in the United States, this return of several artists who regrouped

534 ISAMU NOGUCHI (1904-) *Integral.* **Marble. 1959. Whitney Museum of American Art, New York.** The vast diversity of images, projects, and objects that mark out Noguchi's career is always a bit surprising, but it has to do with the unique combinations in his background and the variety of influences that have deeply marked his development. *Integral* is a proud totem vaguely reminding us of great sculptural monuments of the past, not imitating them or nature, and yet bearing relationship to both.

535 LOUISE NEVELSON (American, 1900-) *Homage to 6,000,000 I.* **Wood. 1964. Jewish Museum, New York (on extended loan from the Albert A. List Family).** Louise Nevelson experimented in the 1940's in all media. By the 1950's she had found that her way of expression was in wood. She constructed shadowy, poetic images related to Surrealism, mostly painted black and to be seen from a vast variety of points of view. In *Homage to 6,000,000 I,* her constructivist approach has become classical.

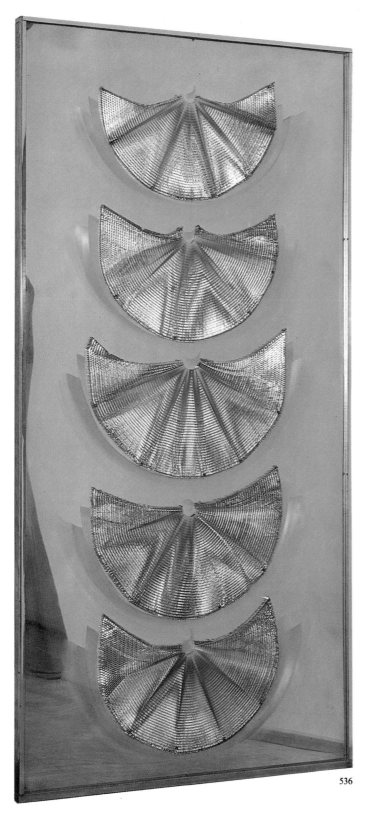

536

537

536 **HEINZ MACK** (1931-) *Five Angel Wings*. **Aluminum on wood. 1965. Wallraf-Richartz Museum, Cologne.** "Group Zero" 's manifestos cry up the purity of color, fascination with light and the beauty of movement. Mack's contributions as one of its creators is this particularly intense study that tries to capture the play of light off aluminum leaves. The aluminum has been either imprinted or cut into very thin sheets so that even the slightest vibrations suggest "luminous forests."

537 **MAX BILL** (1908-) *Figure in Space*. **Copper. 1948 to 1971. Marlborough Fine Arts, Zurich.** Max Bill tried to find new ways to organize space based on already established principles. This work is the end product of a calculated venture. While listening to music, he got the idea of giving his inspiration up to a rigorous, mathematic structure. "Art can interpret thoughts so that they are readily perceived."

538 **ALEXANDER CALDER** (Philadelphia 1898—New York 1976) *Red Petals*. **Mobile. Metal. 2.64 m. high. 1942. Collection The Art Clubs of Chicago.** The two-dimensional blades of Calder's sculptures effect complex movements according to an unpredictable rhythm. Although the base structure itself never changes, its movements are ephemeral. Calder is the father of "aleatory" sculpture. His art has the "sublimity of a tree in the wind."

539 **CÉSAR** (French, 1921-) *Compressed Motor Car.* ca. 1960. Collection Countess de Noailles, Paris. Work in metal led César Baldaccini, known as César, to an "amalgam period," during which, accumulating scrap materials, he created fantastic figures that have an authentic imaginative force and a certain humour. Through working in factories where metals were salvaged, he became sensitive to the variety and the beauty of compressed balls of metal; the hydraulic press allowed his deliberate compressions.

540 **ARMAN** (Nice 1928-) *Jugs* 1961. **Wallraf-Richartz Museum, Cologne.** Already famous for his "waste basket" art, Arman's next project involved "accumulating" various man-made, ordinary objects that were transformed via increasingly aesthetic arrangements: "With the advent of the Industrial Era we made different objects, we made *des sécrétions.*"

541 **DANIEL SPOERRI** (1930) *Still Life* (**Robert's Table**). **1961. Wallraf-Richartz Museum, Cologne.** Spoerri's early theatrical career could be the reason why some of his work seems a stage for "disillusion" art. The "trick" tables play games with reality as, for example, the meals on restaurant tables that seem real but are only still-life arrangements.

539

540

541

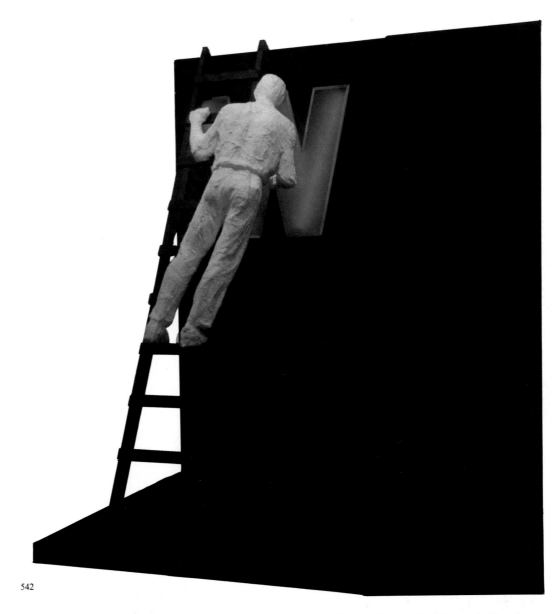

542

542 GEORGE SEGAL (New York 1925-). *Man on a Ladder.* **Plaster, wood, acrylic and neon. 1970. Neue Galerie, Aix-la-Chapelle.** George Segal's realism is a sort of revival of the "populist spirit," which is distinctly different from his contemporaries' ironic commentary. His models are such that they seem like live human beings caught between reality and artificiality, a "suggested" image rather than a true-to-life representation.

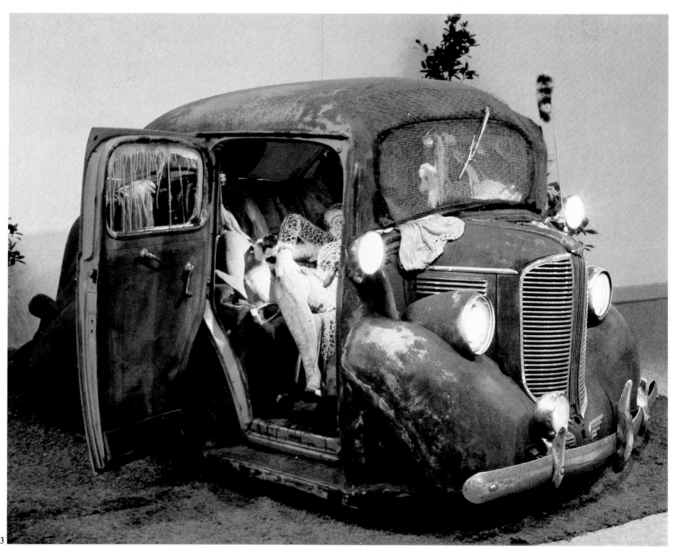

543

under the ironic heading "New Realists" was a reaction to the shower of praise that accompanied the recognition of abstraction. The *Trashcans,* the *Accumulations (fig. 540)* or the *Destructions* by Arman, the *Compressions* by César *(fig. 539),* present objects of rebuttal, as do the *Tableaux-pièges* by Daniel Spoerri *(fig. 541).* These tableaux, half painting and half sculpture, retain on their surfaces real objects caught in a trap, which seem to have come together by pure chance. Jean Tinguely created huge machines out of bandages. They are "aberrant" machines; they make noise and bubbles. Tin-

guely inaugurated the systematic exploitation of the broken-down machine. Ridiculous witnesses, these machines possess a power that invites us to question the mechanical nature of our existence. At the start of the 1970s, a hyper-realist movement appeared. It produced a sculpture of extreme realism, which finally does not go beyond a display of technique once the surprise and admiration has worn off. For Duane Hanson, this often trivial but dynamic work takes on the dimensions of a dramatic sociological, indeed ethnographic, statement.

543 EDWARD KIENHOLZ (1927–) *Back Seat of a '38 Dodge.* **1964. The Kleiner Foundation, Los Angeles.** There is no limit to the objects used by Kienholz. He approaches them very open-mindedly and with an idea of what he wants them to express: "I don't believe in art for art's sake." The car has been taken apart and reassembled; the chrome and headlights shine, but the body and windows are "dirtied" by blue streaks. Inside—a couple makes love.

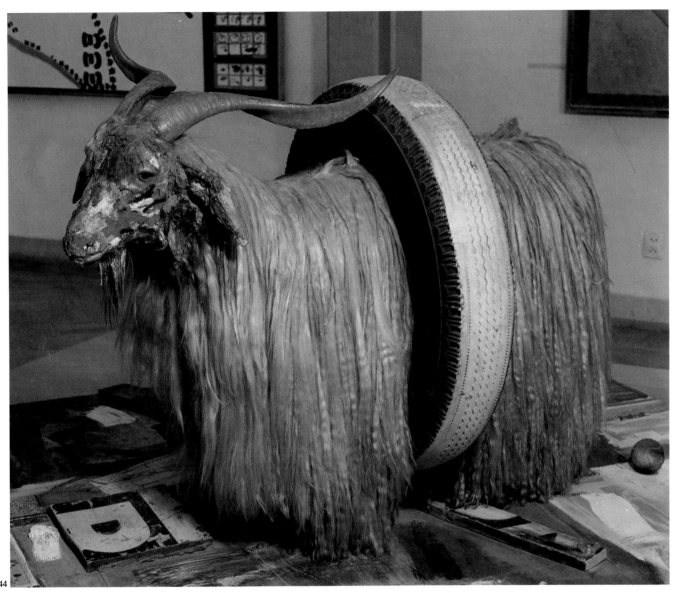

544

There is another form of sculpture, if such a term is still adequate, in which limits are expanded. These are the works that function between the environments and space; they are creations bordering on the theatrical that play on the concept of real and continuous time in a manner similar to the early experiments by the Dadaists. Sculpture could be used as a background for theatrical effects in ballets, for example, or as a generator of formal or expressionistic scenic effects during performance. This trend gathers together traditional and contemporary materials, techniques and technologies and in-

volves artists with quite diverse interests: Wolf Vostell, with his small works of powerful ideological and political content, Tetsumi Kudo and his gardens, Nam June Paik and his video-environments, and Joseph Beuys. Beuys (*fig. 550*) has for several years given himself over to experiments that are motivated by a personal mythology: "For me forms resemble ideas and anti-form is energy. . . . Proportions, measurements, etc. . . is that the question?"

In the 1970s, many artists were tempted to break completely with the notion of sculpture as object or "objet d'art."

544 ROBERT RAUSCHENBERG (Port Arthur, U.S.A. 1925-) *Monogram.* **1955-1959. Moderna Museet, Stockholm.** From 1953 to 1962, Rauschenberg's style was half-way between painting and sculpture—"combine-painting." Here groups of squares and rectangles act as background for collages of objects, sometimes in pieces.

545

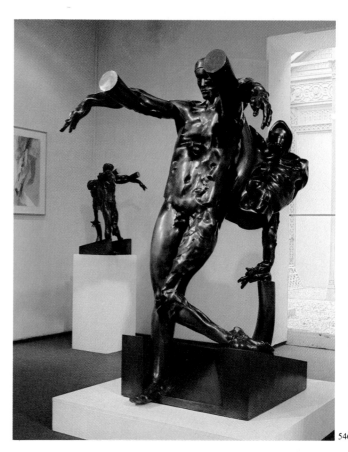

546

545 JULIO LE PARC (Mendoza, Argentina **1928-**) *Curves and colours in simultaneous progression.* **Acrylics on wood. 190 x 50 x 25 cm. 1972. Special Collection.** In his work, Julio Le Parc criticizes the attitude of artists who abuse their "freedom" by remaining slaves to a standard arrangement of shapes and colours He, on the other hand, invites the spectator's participation while playing with black and white or a gamut of fourteen colours in sequences or progressions, on the surface or in space.

546 IPOUSTEGUY (**1920-**) *Valley of Grace.* **Bronze. 2.20 × 1.60 m. 1977. Galerie Claude Bernard, Paris.** In a work that consecrates the human form, Ipousteguy revives the tradition of epic statuary in all its now-forgotten glory. The surface of this military hospital sculpture is cracked and broken to evoke the suffering of flayed and mutjlated victims—still standing, in spite of it all.

547 DENNIS OPPENHEIM (**1938-**) *Attempt to raise hell.* **Bronze, cloth, electric motor. Mannikin, 83 × 25 × 15 cm. 1974. Musée National d'Art Moderne, Paris.** Although one of the most famous "land art" artists (with a penchant for materials such as snow and sand in his "eraseable" designs), Dennis Oppenheim also creates places and machinery for momentous occasions as the "Happening" movement implies. Here, at intervals, the mannikin hits the bell with its forehead to make it ring: a cruel and theatrical representation of the absurd.

548 ETIENNE-MARTIN (**1913-**) *Coat* (pose 5). **Assorted material and cord, leather, sheet metal, screws, zipper. 1.60 × 2 × .30 m. 1962. Musée National d'Art Moderne, Paris.** Although this important work of Etienne-Martin borrows from the "Passementeries" cloth sculpture of 1948, as part of the "Demeures" series it plays with the esoteric theme of night. Here, life is reflected in a mass confusion of materials—a plastic equivalent of his hard sculpture mazes.

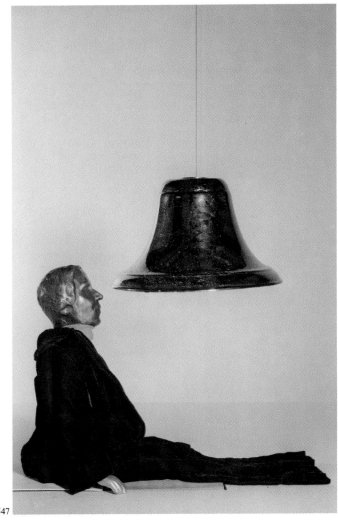

547

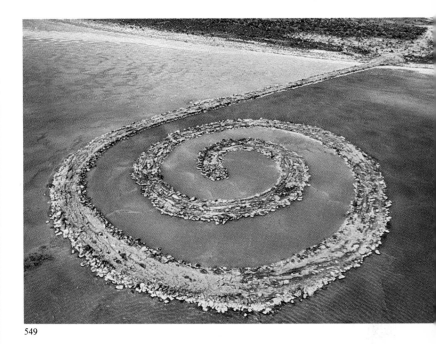

549

548

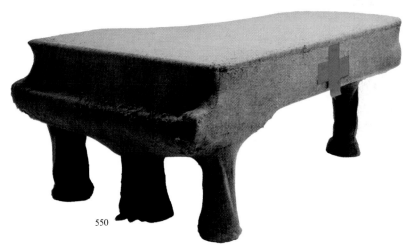

550

549 **ROBERT SMITHSON** (1938–1973) *Spiral Jetty.* Artificial pier, 500 m. long by 5 m. wide, Great Salt Lake's northern bank, Utah, 1970. More representative of "earth-work" than of "land-art", the construction of this work called for more than six thousand tons of material to be moved to this desert-like area.

550 **JOSEPH BEUYS** (1921-) *Infiltration für konzerflugel.* 1 × 1.52 × 2.40m. 1966. Musée National d'Art Moderne, Paris. Traces of the Dada and Expressionist movements and even some links with the Fluxus concerts can be found in this traditional object of German music culture. The object is stuffed with felt and there is a red cross to more authentically convey a "sick elephant" image. Its eloquence is in its silence.

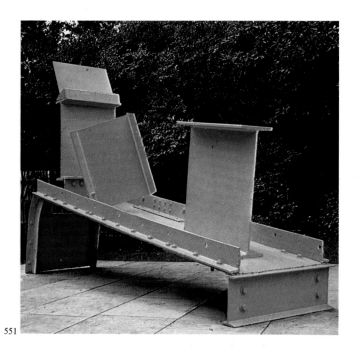

551

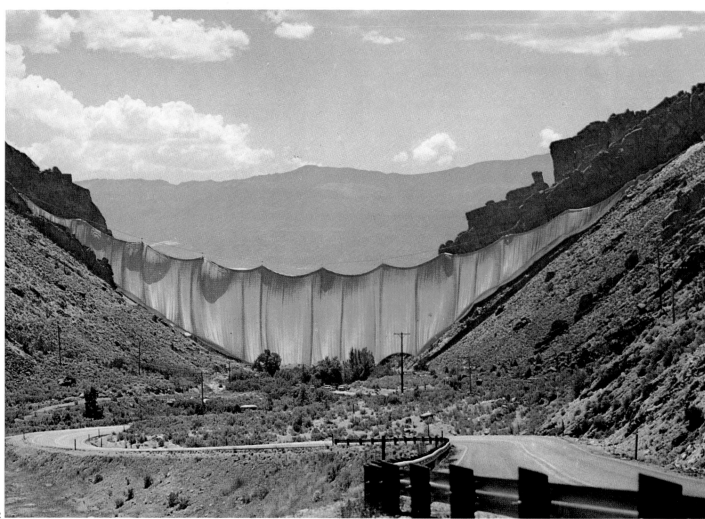

552

551 ANTHONY CARO (British, 1924-) *Mid-Day.* **Steel, painted. 1960. Collection of Mr. and Mrs. Kenneth Noland.** The year 1960 marked a definite break for Caro, and with his monumental metal constructions he opened up a new chapter in British sculpture equivalent to the decisive step taken by Henry Moore in the 1930s. *Mid-Day* was one of Caro's first works in which he moved away from the monolith, instead assembling brightly coloured fragments of steel girders.

552 *CHRISTO (Christo Javacheff)* (Gabravo, Bulgaria 1935-) *Valley curtain.* **Synthetic fabric. 417 m. long. 1970–1972. Grand Canyon, Colorado.** With an interest in theater as well as in Ledoux's and Bouleé's architectural utopias, Christo uses his huge "ephemeral" constructions to go beyond utopia. With the help of several different groups of craftsmen, he is able to produce these works. The finished products betray his former interests as they act as impetus for a complex social and legal program.

They created on one hand what may be termed "space installations": half-sculpture, half-architecture, while at the same time neither one nor the other, and on the other hand the often ephemeral architecture-sculptures that may be classified as land art. Christo *(fig. 552)*, Walter de Maria, Michael Heizer, Richard Long and Robert Smithson *(fig. 549)* attempt to create through their very different works a new relation to nature, the elements, space. This art is not unlike garden art with its ephemeral constructions, festivals, walkways, statues and fountains. Among these artists, Dennis Oppenheim is particularly interesting. He occasionally fabricates immense statues. These generating constructions function like material transformers on a purely visual plane. Thought and poetry are here produced by the organization of forms, inverting the process in which an idea finds expression in a form *(fig. 547)*.

Before and well after Rodin, the task of sculpture was to express a "divine" preexisting order that the artist revealed through the manipulation of form. The ideal of carving, which made form appear beyond the earthly matrix, or the revelation of the internal structure of the form by transparency are examples of this conception of art. It was based on the idea of a model that was to organize chaos; it implied an ideal space that existed prior to the space around us. But we do not have this illusory mastery of the world that takes in everything in one glance, and which cuts through the world appearances to "meaning." Things have a real opacity that we must explore and feel by physical, emotional, and moral confrontations. Certain Minimal artists force us to see and affirm that a geometric form does not appear the same according to its position in space, in spite of its having an individual identity. Other land-art artists ask us to believe that a volume exists more by its weight than by its appearance, and to understand that we feel this weight or that the space unfurling around us has density. Other artists confront us with a dehumanized, desensitized world—our world. These works do not reassure us by offering an illusory sense of mastery. Rather they play on the loss of this mastery, to the benefit of a mysterious feeling rich in experience, by involving us more deeply in their efforts.

553 RICHARD SERRA (1939–) *Sight point.* **"Cor-ten" steel. 12 m. high 1972–1975. Stedelijk Museum, Amsterdam.** Conceived as "Minimal Art," these three giant "Cor-ten" steel plaques that rust quickly and then stabilize at a certain colour and resistance lead into a narrow room that opens up to reveal a triangular patch of sky.

Index

Listings are followed by italic illustration numbers; page numbers, where listed, refer to placement in the text.